											y 3

Ninth Edition

TEXTILES

Sara J. Kadolph
Iowa State University

Anna L. Langford

Upper Saddle River, New Jersey 07458

Editor-in-Chief: Stephen Helba

Director of Production and Manufacturing:

Bruce Johnson

Executive Editor: Vernon R. Anthony Associate Editor: Marion Gottlieb Editorial Assistant: Susan Kegler Marketing Manager: Ryan DeGrote Managing Editor: Mary Carnis

Production Liaison: Denise Brown

Production Editor/Full-Service Production: Carol Eckhart/York Production Services

Manufacturing Buyer: Cathleen Petersen Design Director: Cheryl Asherman Senior Design Coordinator: Miguel Ortiz

Cover Design: Denise Brown

Cover Art: Neil Beer/photodisc.com (foreground photograph), Arthur S. Aubry/photodisc.com (background photograph)

Printing and Binding: Courier Westford

Cover Printer: Coral Graphics

Library of Congress Cataloging-in-Publication Data Kadolph, Sara J.

Textiles / Sara J. Kadolph, Anna L. Langford.—9th ed. p. cm.

Includes bibliographical references and index.

ISBN 0-13-025443-6

1. Textile industry. 2. Textile fibers. 3. Textile fabrics. I. Langford, Anna. II. Title. III. Title. TS1446.K33 2001

677—dc21

00-050167

Prentice-Hall International (UK) Limited, *London* Prentice-Hall of Australia Pty. Limited, *Sydney*

Prentice-Hall Canada Inc., Toronto

Prentice-Hall Hispanoamericana, S.A., Mexico Prentice-Hall of India Private Limited, New Delhi

Prentice-Hall of Japan, Inc., *Tokyo* Prentice-Hall Singapore Pte. Ltd.

Editora Prentice-Hall do Brasil, Ltda., Rio de Janeiro

Copyright © 2002 by Pearson Education, Inc., Upper Saddle River, New Jersey 07458. All rights reserved. Printed in the United States of America. This publication is protected by Copyright and permission should be obtained from the publisher prior to any prohibited reproduction, storage in a retrieval system, or transmission in any form or by any means, electronic, mechanical, photocopying, recording, or likewise. For Information regarding permission(s), write to: Rights and Permissions Department. Earlier editions copyright © 1998, 1993, 1988, 1979, 1973, 1968, 1964, 1955 by Macmillan Publishing Co., Inc. Some material reprinted from *Modern Textiles*, copyright © 1952 by Norma Hollen and Jane Saddler.

CONTENTS

Preface viii

SECTION	UNE	Introduction	to I	Toytilas
SECTION	UNL	IIILIOUULLIOII	LU I	extites

1

CHAPTER 1 3
Introduction

Product Development from a Textile Perspective

Serviceability and the Consumer 9 Performance 10 Information Sources 12

SECTION TWO Fibers

15

CHAPTER 3 17
Textile Fibers and Their Properties

Fiber Properties 18

Physical Structure • Chemical Composition and Molecular Arrangement

Serviceability 21

Aesthetic Properties • Durability Properties • Comfort Properties • Appearance-Retention Properties • Resistance to Chemicals • Resistance to Light • Environmental Impact • Care Properties • Cost • Fiber Property Charts

Fiber Identification 28

Visual Inspection • Burn Test • Microscopy • Solubility Tests

CHAPTER 4 32 Natural Cellulosic Fibers

Seed Fibers 33

Cotton • Production of Cotton • Physical Structure of Cotton • Classification of Cotton •

Chemical Composition and Molecular Arrangement of Cotton • Chemical Nature of Cellulose • Properties of Cotton • Environmental Impact of Cotton • Identification of Cotton • Uses of Cotton • Coir • Kapok

Bast Fibers 42

CHAPTER 2

Flax • Structure of Flax • Properties of Flax • Environmental Impact of Flax • Identification Tests • Uses of Linen • Ramie • Properties of Ramie • Hemp • Jute • Kenaf

Leaf Fibers 47

Piña • Abaca • Sisal and Henequen Other Cellulosic Materials 47

CHAPTER 5 49 Natural Protein Fibers

Wool 50

Production of Wool • Types and Kinds of Wool • Physical Structure of Wool • Chemical Composition and Molecular Arrangement of

Wool • Properties of Wool • Environmental Impact of Wool • Uses of Wool

Specialty Wools 58

Mohair • Qiviut • Angora • Camel's Hair • Cashmere • Llama and Alpaca • Vicuña and Guanaco • Yak

Silk 61

Production of Silk • Physical Structure of Silk • Chemical Composition and Molecular Structure of Silk • Properties of Silk • Environmental Impact of Silk • Uses of Silk

Identification of Natural Protein Fibers 65

CHAPTER 6 67 The Fiber Manufacturing Process

Fiber Spinning 69
Spinning Methods

Fiber Modifications 71

Spinneret Modifications • Molecular Structure and Crystallinity Modifications • Additives to the Polymer or Spinning Solution • Modifications in Fiber Spinning • Complex Modifications

Environmental Impact of Manufactured Fibers 76

Manufactured Fiber Consumption 77

Manufactured versus Natural Fibers 77

CHAPTER 7 79 Manufactured Regenerated Fibers

Identification of Manufactured Fibers 80 Rayon 80

Production of Rayon • Physical Structure of Rayon • Chemical Composition and Molecular Arrangement of Rayon • Properties of Rayon • Environmental Impact of Rayon • Uses of Rayon • Types and Kinds of Rayon

Lyocell 84

Production of Lyocell • Physical Structure of Lyocell • Chemical Composition and Molecular Arrangement of Lyocell • Properties of Lyocell • Environmental Impact of Lyocell • Uses of Lyocell • Types and Kinds of Lyocell

Acetate 86

Production of Acetate • Physical Structure of Acetate • Chemical Composition and Molecular Arrangement of Acetate • Properties of Acetate • Environmental Impact of Acetate • Uses of Acetate • Types and Kinds of Acetate

Other Regenerated Fibers 89

CHAPTER 8 91 Synthetic Fibers

Synthetic Fibers: An Overview 92

Common Properties of Synthetic Fibers • Common Manufacturing Processes • Identification of Synthetic Fibers • Common Fiber Modifications

Nylon 96

Production of Nylon • Physical Structure of Nylon • Chemical Composition and Molecular Arrangement of Nylon • Properties of Nylon • Environmental Impact of Nylon • Uses of Nylon • Types and Kinds of Nylon

Polyester 103

Production of Polyester • Physical Structure of Polyester • Chemical Composition and Molecular Arrangement of Polyester • Properties of Polyester • Environmental Impact of Polyester • Uses of Polyester • Types and Kinds of Polyester

Olefin 109

Production of Olefin • Physical Structure of Olefin • Chemical Composition and Molecular Arrangement of Olefin • Properties of Olefin • Environmental Impact of Olefin • Uses of Olefin

Acrylic 113

Production of Acrylic • Physical Structure of Acrylic • Chemical Composition and Molecular Arrangement of Acrylic • Properties of Acrylic • Environmental Impact of Acrylic • Uses of Acrylic • Types and Kinds of Acrylic

Modacrylic Fibers 118

Production of Modacrylic Fibers • Physical Structure of Modacrylic Fibers • Chemical Composition and Molecular Arrangement of Modacrylic Fibers • Properties of Modacrylic Fibers • Environmental Impact of Modacrylic Fibers • Uses of Modacrylic Fibers

CHAPTER 9 121 Special-Use Fibers

Elastomeric Fibers 122

Rubber • Spandex • Elastoester

Fibers with Chemical, Heat, or Fire Resistance 125
Aramid • Glass • Metal and Metallic Fibers •
Novoloid • PBI • Sulfar • Saran • Vinyon •
Vinal • Fluoropolymer • Carbon • Melamine

Other Special-Use Fibers 134

137

SECTION THREE Yarns

CHAPTER 10 139

Yarn Processing

Filament Yarns 140

Smooth-Filament Yarn • Monofilament Yarns • Tape and Network Yarns • Bulk Yarns

Spun Yarns 143

Processing Staple Fibers • Alternate Spun-Yarn Processes • Spinning Filament Tow into Spun Yarns

High-Bulk Yarns 149

Fiber Blends 150

Blend Levels • Blending Methods • Blended Filament Yarns

Environmental Impact of Yarn Processing 152

CHAPTER 11 154 Yarn Classification

Fiber Length 155

Yarn Twist 155

Direction of Twist • Amount of Twist

Yarn Size 158

Yarn Number • Denier • Tex System

Yarn Regularity 159

Simple Yarns • Sewing Thread • Fancy Yarns • Composite Yarns

Yarn Performance and Yarn Quality 165

SECTION FOUR Fabrication

CHAPTER 12 169

Basic Weaves and Fabrics

Fabric Quality 171

Woven Fabrics 171

The Loom 172

Preparing for Weaving • Loom Advancements • Environmental Impact of Weaving

Characteristics of Woven Fabrics 176

Warp and Filling • Grain • Fabric Count •

Balance • Selvages • Fabric Width • Fabric Weight

Properties of Woven Fabrics 179

Naming and Diagramming Woven Fabrics 179

Plain Weave 182

Balanced Plain Weave • Unbalanced Plain Weave • Basket Weave

Twill Weave 189

Characteristics of Twill Weave • Even-Sided

Twills • Warp-Faced Twills

Satin Weave 193

Satin Fabrics • Sateen

CHAPTER 13 197
Fancy Weaves and Fabrics

Dobby Weaves 198

Extra-Yarn Weaves • Piqué Weaves

Jacquard Weaves 202

Momie Weaves 203

Leno Weaves 204

Double Cloth 205

Double Weaves • Double-Faced Fabrics

Pile Weaves 207

Filling-Pile Fabrics • Warp-Pile Fabrics

Slack-Tension Weaves 210

Tapestry Weave 211

Narrow Fabrics 212

CHAPTER 14 213 Knitting and Knit Fabrics

Knitting 215

Needles • Stitches • Fabric Characteristics • Environmental Impact of Knitting

Filling (or Weft) Knitting 218

Machines Used in Filling Knitting • Filling-Knit Structures—Stitches • Filling-Knit Fabrics

Warp Knitting 230

Machines Used in Warp Knitting • Warp Knits versus Filling Knits • Warp-Knit Fabrics • Minor Warp Knits • Narrow Knitted Fabrics

CHAPTER 15 239 Other Fabrication Methods

Fabrics from Solutions 240

Films • Foams

167

Fabrics from Fibers 242

Nonwoven or Fiberweb Structures • Felt • Netlike Structures

Fabrics from Yarns 248

Braids • Lace

SECTION FIVE Finishing

CHAPTER 16 268 Finishing: An Overview

Routine Finishing Steps 272

Fiber Processing • Yarn Processing • Yarn
Preparation • Fabrication • Fabric Preparation •
Whitening • Further Preparation Steps •

Coloration • Finishing • Drying • Reworking

Routine Finishing Steps for Wool Fabrics 278

Carbonizing • Crabbing • Decating • Pressing
Environmental Impact of Finishing 278

CHAPTER 17 280 Aesthetic Finishes

Luster 282

Glazed • Ciré • Moiré • Schreiner • Embossed

Drape 285

Crisp and Transparent • Burned Out • Sizing • Weighting

Texture 286

Sheared • Brushed • Embossed • Pleated • Puckered Surface • Plissé • Flocked • Tufted • Embroidered • Expanded Foam • Napped • Fulled • Beetled • Coronized

Hand 293

Emerizing, Sueding, or Sanding • Abrasive, Chemical, or Enzyme Washes • Crepeing • Silk Boil-Off • Caustic Treatment • Hand Builders

CHAPTER 18 296 Special-Purpose Finishes

Stabilization: Shrinkage Control 297

Relaxation Shrinkage and Finishes • Progressive Shrinkage and Finishes

Shape-Retention Finishes 300

Theory of Wrinkle Recovery • Durable Press • Quality Performance Standards and Care

Composite Fabrics 251

Coated Fabrics • Poromeric Fabrics • Suedelike Fabrics • Tufted-Pile Fabrics • Laminates • Stitch-Bonded Fabrics • Quilted Fabrics • Supported-Scrim Structures • Fiber-Reinforced Materials

267

Animal Products 263

Leather • Furs

Appearance-Retention Finishes 303

Soil- and Stain-Release Finishes • Abrasion-Resistant Finishes • Antislip Finishes • Fume Fading–Resistant Finishes • Surface or Back Coatings • Light-Stabilizing Finishes • Pilling-Resistant Finishes

Comfort-Related Finishes 305

Water-Repellent Finishes • Porosity-Control Finishes • Water-Absorbent Finishes • Ultraviolet-Absorbent Finishes • Antistatic Finishes • Fabric Softeners • Phase-Change Finishes

Biological Control Finishes 308

Insect- and Moth-Control Finishes • Mold- and Mildew-Control Finishes • Rot-Proof Finishes • Antimicrobial Finishes • Microencapsulated Finishes

Safety-Related Finishes 309

Flame-Retardant Finishes • Liquid-Barrier Finishes • Light-Reflecting Finishes

CHAPTER 19 313 Dyeing and Printing

Color Theory 314

Colorants 315

Pigments • Dyes

Stages of Dyeing 317

Fiber Stage • Yarn Stage • Piece or Fabric Stage

Product Stage 321

Methods of Dyeing 321

Batch Dyeing • Package Dyeing • Combination Dyeing

Printing 323

Direct Printing • Discharge Printing • Resist Printing • Other Printing Methods

Recent Developments in Dyeing and Printing 333

Color Problems 333

Environmental Impact of Dyeing and Printing 337

SECTION SIX Other Issues Related to Textiles

341

CHAPTER 20 343 Care of Textile Products

Factors Related to Cleaning 344

Soil and Soil Removal • Detergency • Solvents

Laundering 347

Synthetic Detergents and Soaps • Other

Additives • Sorting

Washing 351

Horizontal- and Vertical-Axis Machines

Drying 352

Dry Cleaning 352

Dry Cleaning of Leather and Fur • Home Solvent

Cleaning

Professional Wet Cleaning 354

Storage 354

Other Cleaning Methods 355

Vacuuming • Wet Cleaning • Dry Foam

Cleaning • Hot-Water Extraction • Powder

Cleaners • Ultrasonic Cleaning

Conservation Practices 356

Environmental Impact of Cleaning 356

CHAPTER 21 358 Legal and Environmental Concerns

Laws and Regulations 359

Silk Regulation, 1932 • Wool Products Labeling Act, 1939 (Amended 1986) • Fur Products Labeling Act, 1952 (Amended 1980) • Textile Fiber Products Identification Act, 1960 (Amended) • Permanent Care Labeling Regulation, 1972 (Amended 1984) • Laws and Regulations Related to Safety • Flammable Fabrics Act, 1953, and Its Amendment • Federal Insecticide, Fungicide, and Rodenticide Act (FIFRA)

Other Label Information 365

Mandatory and Voluntary Labeling Programs

Codes 366

Tort 367

Consumer Recourse 367

Environmental Issues 367

Environmental Impact • Efforts within the Textile

Industry • Environmental Health and Safety •

Disposal and Recycling

CHAPTER 22 375 Career Exploration

Sourcing 376

Product Development 376

Quality Assurance 378

Research, Development, and Evaluation 378

Production 380

Design 380

Merchandising 382

Wholesaling 383

Marketing 383

Government 383

Education 384

Museum or Collection Work 384

Summary 384

APPENDIX A 387

Fiber Names in Other Languages

APPENDIX B 389

Fibers No Longer Produced in the United States

APPENDIX C 391 Selected Trade Names

Glossary 393

Index 415

PREFACE

Philosophy of this Book

Textiles provides students with a basic knowledge of textiles so that they understand how textiles are produced and how appropriate performance characteristics are incorporated into materials and products. With this knowledge, they have the foundation they need to make informed decisions regarding textile materials and products and to communicate effectively with buyers, suppliers, customers, and others. A solid understanding of textile components (fibers, yarns, fabrics, and finishes), the interrelationships among these components, and their impact on product performance is necessary to fulfill day-to-day responsibilities in many careers in the textile, apparel, and furnishings industry.

Serviceability of textiles and textile products is the fundamental principle emphasized throughout the book. I discuss the contributions of each component as it is incorporated in or combined with other components in a textile product. I stress interrelationships among the components. Basic information regarding how each component is processed or handled helps in understanding product performance and cost. Production of textiles is a complex process dealing with a wide variety of materials and techniques. To understand textiles, students need a basic understanding of the choices and technology involved.

This book will help students:

- use textile terminology correctly.
- know laws and labeling requirements regulating textile distribution.
- understand the impact of production processes and selection of components on product performance, cost, and consumer satisfaction.
- recognize the forces that drive industry developments.

- identify fiber type, yarn type, and fabrication method.
- predict fabric or product performance based on a knowledge of fibers, yarns, fabrication methods, and finishes in conjunction with informative labeling.
- select textile components or products based on specified end uses and target market expectations for performance and serviceability.
- select appropriate care for textile products.
- develop an interest in and appreciation of textiles.

Understanding textiles cannot be achieved only by studying this book; it also requires working with fabrics. Kits are available from several sources. In addition, many workbooks for lab use and self-study have been designed to help students learn this information.

Organization of this Book

Each section of the book focuses on a basic component or aspect of fabrics and textile products or on general issues important to the use of, production of, or satisfaction with textile products. These sections are complete and can be used in any order desired. The four main sections follow the normal sequence used in the production of textiles: fiber, yarn, fabrication, and finishing.

The first section of the book introduces the study of textiles and approaches product development from a textile perspective. Section Two focuses on fibers, their production, serviceability, effect on product performance, and use. Several new fibers or new generic classifications have been added to this section. Section Three focuses on yarn production, yarn types, the relationship of yarn type to product performance and serviceability, and sewing thread. Section Four examines fabrication methods. These chap-

ters are organized by basic fabrication method, standard or classic fabric names and types, and the relationships between fabrication and product performance. Flow charts to aid in identifying fabrics have been added. (More extensive flow charts are available in the instructor's manual.) Section Five deals with finishes, grouped by type or effect. Dyeing and printing are also included, as well as problems that consumers and producers experience with dyed or printed fabrics. The discussion of ink-jet printing has been updated to reflect the tremendous changes occurring in this area. Several new finishes have been added to this section. The final section deals with other issues related to textiles. One chapter focuses on care of textile products, new cleaning products and processes, and associated environmental issues. Another chapter investigates legal and environmental issues. The discussion on environmental issues illustrates current environmental efforts and explores recycling of textiles. The final chapter discusses career opportunities requiring knowledge of textiles.

Features of the Book

Instructors and students have always liked this book's summary and reference tables and charts, the presentation of information in a clear and consistent fashion, the emphasis on serviceability, and the numerous illustrations, graphics, and photographs. I tried to strengthen these things in this revision. I developed new flow charts to facilitate fabric identification. I revised, reorganized, or updated tables where necessary or where students or colleagues suggested improvements.

Although the basic content and flavor of *Textiles* remain intact, the changes help students recognize and focus on the most important material. Objectives and key terms for each chapter are revised so that students will be able to identify and understand the major concepts. After reading and studying each chapter, students should be able to define each term in the key terms list and describe how terms relate to each other and to the chapter content. Study questions provide students with an opportunity to test their level of understanding, focus on key concepts or applications, and integrate the information. I updated the list of readings for students who would like to investigate topics beyond the scope of the book. Many of these readings are technical in nature. There are a few articles on textiles in the popular press, but these often include little substantive information. Hence, the most valuable articles and books tend to be those written from a technical perspective.

Major Changes and Additions

The emphasis in this revision has been on updating and adding material where new processes or concerns have developed in the professional workplace, in the textile industry, or among consumers. I added explanations, expanded discussions, and clarified concepts in areas where students had indicated the need or where colleagues expressed or suggested improvements. Terminology incorporates an industry perspective so that professionals can understand and communicate with other professionals. The pronunciation guide included with some words in the glossary will help professionals pronounce and use terms correctly. I expanded the index to facilitate the book's use as a resource by professionals who need to locate information quickly regarding a specific term, process, or product. I omitted some photos and diagrams of marginal usefulness and modified others to make them current or easier to understand.

Technological advances and new industry and societal concerns that have arisen or have increased in importance since the last edition are included. The discussion of environmental impact for each major component is important to the industry and consumers. The book continues to focus on the three major end uses of textiles: apparel, furnishings, and industrial or technical products.

The discussion of dyeing and printing provides more information on the basic processes of adding color to fabric. The discussion of finishing addresses aesthetic finishes that add a softer or stressed look to goods and products. Professional wet cleaning as an alternative to dry cleaning is included in the chapter on care. In addition, recent changes in detergents and other laundry additives are described. New fiber developments are included.

The chapter on career opportunities includes updated information on starting salaries. This discussion is intended to help students understand how they will apply their knowledge of textiles and textile products in their professional work. It should help students gain a better understanding of careers and how professionals interact with each other. Although this chapter may not be assigned in a beginning textile course, students might read the chapter to explore career possibilities on their own and use the information when considering career options other than those that are most obvious to the consumer.

Ancillaries and Supplements

This book assumes that the student requires basic information regarding textiles in order to perform professional responsibilities and communicate with other professionals in an intelligent and informed manner. Hence, the book is designed to be of use as a textbook and as a part of a professional's reference library. Key terms are defined in both the text and the glossary. The expanded

glossary includes more than basic or classic fabric names as well as a pronunciation guide. Fiber modifications, finishes, and terminology related to performance have been incorporated. The expanded index will help individuals locate information needed for class or on the job. Appendix A lists fiber names in several languages that may be encountered in the international textile industry. Appendix C lists selected trade names for fibers, yarns, fabrics, finishes, and cleaning procedures.

The instructor's manual includes an updated outline of the material for each chapter, a revised list of suggested activities, a bank of test questions in various formats, and transparency masters for use in class.

Several basic textile swatch kits are available for use in conjunction with this edition of *Textiles*. The swatch kits usually consist of fabric swatches, mounting sheets, and a master list with fabric name/description/fiber content. Some also include a three-ring binder. One such swatch kit is available from Textile Fabric Consultants, 5499 Murfreesboro Rd, Suite D, LaVergne, TN 37086, 800-210-9394 e-mail: textilefc@aol.com.

Acknowledgments

I used the comments and contributions of many students and colleagues in preparing this revision. I find students' comments help the most in evaluating the approach, wording, and style of presentation, and therefore I appreciate hearing from any student or faculty

member about the book. Both positive and negative comments are incredibly helpful and invaluable in revising the book. I would especially like to thank J. R. Campbell, Natalie Johnson, Susan Herrold, Ruth Glock, Grace Kunz, and Ann Marie Fiore of Iowa State University for their suggestions and perspectives. A special thanks to Chuck Greiner of Front Porch Photography Studio, Huxley, Iowa, for his help with the photography; Susan Herrold of Iowa State University for her help with selected photos, Rita Ostdiek of JC Penney, Inc., for her assistance with some of the photographs of professionals in action; and Colette Ergenbright of Maytag Appliances for her help with some of the care photographs. Micki Johns has a great eye for detail and discrepancies. Thanks, Micki! Great thanks to Doris Kadolph, Renae Kadolph, and Lora Camacho, who assisted with last-minute details. And finally, thanks to Boom, Fuff, and Cube who contributed in their own ways to our efforts!

Revising this book is always an exciting challenge. I enjoy the opportunity to explore the textiles literature in more depth than our university responsibilities usually allow. I enjoy sharing the exciting area of textiles with so many others. I hope that this book hooks you on textiles as the third edition of this book did for me when I was a sophomore student just beginning to learn about textiles.

Sara J. Kadolph

Section 1

INTRODUCTION TO TEXTILES

CHAPTER 1

Introduction

CHAPTER 2

Product Development from a Textile Perspective

Chapter 1

Introduction

OBJECTIVES

- To recognize the diversity in textiles and textile products.
- To understand the importance of developing a professional knowledge of textiles.
- To recognize how textiles, as apparel, furnishings, and industrial products, contribute to contemporary life.

his section is divided into two chapters. Chapter 1 introduces the study of textiles by defining terms, providing examples of textile products, surveying the diversity of textiles, and describing the importance of the industry to the U.S. economy. Chapter 2 discusses the relationships among textiles, product development, and use of and satisfaction with textile products.

This book was written to aid students in learning and understanding what to expect in fabric performance and why fabrics perform as they do. Textiles change in response to changes in fashion, consumers' needs, production processes, government standards for safety and environmental quality, and international trade. These factors are discussed briefly, but the bulk of the book is devoted to basic information about textile materials, with an emphasis on fibers, yarns, fabric construction, and finishes. These interdependent elements contribute to the beauty, durability, care, and comfort of textile products.

Much of the terminology used in this book may be new to students, and many facts must be memorized. To apply a knowledge of textiles, an understanding of the basics is essential. Historical development, basic concepts, and innovations are discussed. Production processes are described in general terms to help the student develop a better understanding of, and appreciation for, the textile industry.

An ideal starting place for understanding textiles is to define several basic terms. (See Figure 1–1.)

Fabric A flexible planar substance constructed from solutions, fibers, yarns, or fabrics, in any combination.

Fiber Any substance, natural or manufactured, with a high length-to-width ratio and with suitable characteristics for being processed into fabric; the smallest component, hairlike in nature, that can be separated from a fabric.

Finish Any process used to add color and augment performance of gray goods (unfinished fabric).

Gray goods (**grey** or **greige goods**) Any fabric that has not been finished.

Textile A term originally applied only to woven fabrics, now generally applied to fibers, yarns, or fabrics or products made of fibers, yarns, or fabrics.

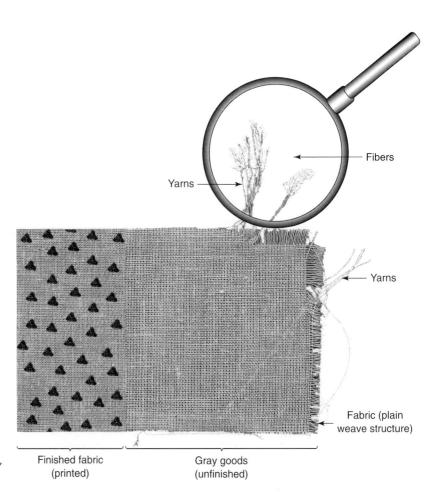

FIGURE 1-1

The components of a fabric: fiber, yarn, structure, and finish.

Yarn An assemblage of fibers that is twisted or laid together so as to form a continuous strand that can be made into a textile fabric.

Food, shelter, and clothing are basic human needs. Most clothing is made from textiles, and shelters are made more comfortable and attractive with textiles. Textiles are used in the production or processing of many items used in day-to-day living, such as food and manufactured goods.

We are surrounded by textiles from birth to death. We walk on and wear textile products; we sit on fabric-covered chairs and sofas; we sleep on and under fabrics; textiles dry us and keep us dry; they keep us warm and protect us from the sun, fire, and infection. Clothing and furnishing textiles that vary in color, design, texture, and cost are aesthetically pleasing. Table 1–1 lists examples of textiles used in industrial products that contribute to work and pleasure. Industrial and technical textiles

contribute to our current standard of living. For example, the automotive industry uses textiles to make tire cords, upholstery, carpeting, head liners, window runners, seat belts, shoulder harnesses, fan belts, gaskets, and seals; textiles are also used as reinforcement fibers in molded plastic parts.

Astronauts traveled to the moon in 20-layer, \$100,000 space suits with nylon water-cooled underwear. Life is prolonged by replacing worn-out body parts with textiles such as polyester arteries and velour heart valves. Bullet-resistant vests protect police and soldiers, and shoulder and seat belts make automobile travel safer. Three-dimensional, inflatable structures protect us from desert heat and arctic cold.

Industrial textiles surround us. We brush our teeth, hair, and clothes with bristles made of synthetic or natural fibers. Buildings are warmer with fiberglass insulation and polyethylene film barriers against wind and moisture. Roads last longer with synthetic fiberweb un-

Personal Hygiene	Transportation	Environment	Medical
Tooth & hair brushes	Tire cords	Erosion barriers	Support wraps
Medicated pads	Road bed underlays	Weed-control fabrics	Casts
Makeup brushes	Bicycle helmets	Pond liners	Surgical masks
Nail buffers	Interiors for planes, buses,	Snow & silt fences	Sutures
Incontinence pads	cars, & trucks	Drainage screens	Arteries
Feminine hygiene products	Seat belts & air bags	Shore protectors	Examination gowns
Cotton balls	Brake linings	Oil-spill-control barriers	Bandages
Dental floss	Gaskets & seals	Air & water filters	Dialysis filters
	Convertible tops		Gloves
Food	Animal Care	Agriculture	Protective Gear
Bags & sacks	Leashes	Bags & sacks	Bullet-resistant vests
Bakery filters	Blankets	Ropes	Heat/fire-resistant suits
Coffee filters	Saddles	Hoses & belts	Impact-resistant helmet
Packaging materials	Stall liners	Bale coverings	Chemical-resistant glove
Tea bags	Restraints	Tractor interiors	Abrasion-resistant glove
55 4 e s 2	Pet bed liners	Plant covers & tree wraps	Hazmat suits
Sports &	Manufactured	Miscellaneous	Building
Recreation	Goods	Products	Materials
Helmet liners	Hoses	Artificial flowers/plants	Insulation
Protective pads	Belts	Banners & flags	Covers for wiring
Balls	Loading dock covers	Book bindings	Drop cloths
String for rackets	Tarpaulins	Candle wicks	Pool liners & covers
Tents	Paint rollers	Casket linings	Wall coverings
Backpacks	Wipes	Communication lines	Venetian blinds
Life jackets	Carpet backing	Felt-tip pens	Window screens
Rafts & boat hulls	Mailing envelopes	Lampshades	Gaskets & seals
Sails	Duct tape backing	Mops & dusting cloths	Duct tape
Fishing line & nets	Conveyor belts	Sandbags	Awnings
Artificial playing surfaces	Silk-screening mesh	Personal computer boards	Moisture barriers

derlays that minimize shifting of the road base. Soil is conserved with fiber erosion-control barriers. Computer disks are protected with an olefin fiberweb. Wiring is insulated with fiberglass woven braids. Athletic performance is enhanced with carbon reinforcement fibers in golf clubs and tennis rackets. Body parts are protected with support wraps of woven or knit fabrics. Fruits and vegetables are packaged in net bags. Outdoor activities take place under tents and awnings to protect us from sun and rain. Manufactured goods are transported on conveyor belts made of textiles coated with a thin plastic film. At the gas station, gas is pumped through a fibrous filter and a fabric-supported hose. It is hard to imagine how different our lives would be if all industrial textiles were to disappear.

In the United States, the textile industry is tremendous. It includes the natural and manufactured fiber producers, spinners, weavers, knitters, throwsters, yarn converters, tufters, fiberweb producers, finishers, equipment producers, and many others. In 1999, the textile industry employed more than 562,000 people. Textile products, valued at over \$61 billion in 1999, are produced by computerized systems in the United States. The textile industry has developed from an arts-and-crafts industry perpetuated by guilds in the early centuries, through the Industrial Revolution in the 18th and 19th centuries (when the emphasis was on mechanization and mass production), to the 21st century, with its emphasis on science, technology, quality, and cost efficiency.

In the 20th century, manufactured fibers were developed and modified textured yarns were created. New fabrications were created, the production of knits in-

creased, and many finishes and sophisticated textile production and marketing systems were developed. Manufactured fibers and soil-resistant and durable-press finishes help keep textiles neat and clean.

New developments in textiles have created some problems, particularly in the selection of apparel and furnishing textiles. Many items look alike but their performance and care may differ significantly. Knitted fabrics look like woven fabrics, vinyl and polyurethane films look like leather, and acrylic and polyester fabrics look like wool. Traditional cotton fabrics may be polyester or polyester/cotton blends.

To make textile selection easier for consumers, the textile industry has set standards and established quality-control programs for many textile products. Federal laws inform consumers of fiber content and care requirements and protect them from improperly labeled merchandise and other unfair trade practices.

Energy conservation, environmental quality, noise abatement, health, and safety issues affect the textile and many other industries. The efforts of the textile industry to meet standards set by the federal government affect the consumer by raising prices for merchandise, by limiting the choices available, and by improving product and environmental quality.

Textile fabrics can be beautiful, durable, comfortable, and easy care. Knowing the components used in textile products and how these components were made will provide a better basis for their selection and a better understanding of their limitations. Knowledge of textiles and their production will result in a more appropriate and better product for a specific use and, therefore, a more satisfied user.

Key Terms

Fabric Fiber Finish Gray, grey, or greige goods

Textile Yarn

Questions

- 1. Define the key terms, explain the differences among them, and describe how these terms relate to textiles.
- 2. How do textiles contribute to contemporary life?
- 3. Make a list of all textile products you use in an average day. Be sure to consider furnishing, industrial, and apparel products. What would your life be like without these products?

4. Select a fabric and dismantle it so that you have a fiber and a yarn. What are the differences and similarities between these components?

Suggested Readings

Examine several of these trade publications to determine each one's focus and depth of information: America's Textiles International, Industrial Products Review, Interiors, Interior Design, Technical Textiles International, Textile Horizons, Textile Month, Textile Progress, Textile Research Journal, and Textile World.

Bryne, C. (1995). Technical textiles, *Textiles Magazine*, pp. 12–16.

Chapter 2

PRODUCT DEVELOPMENT FROM A TEXTILE PERSPECTIVE

OBJECTIVES

- To understand the role of textiles in product development.
- To explore the serviceability components and how they relate to textiles and textile products.
- To relate product serviceability and textile performance to target market needs and expectations.
- To identify information sources that are used in product development.

roduct development refers to the design and engineering of a product so that it has the desired serviceability characteristics, appeals to the target market, can be made within an acceptable time frame for a reasonable cost, and can be sold at a profit. Product development may involve selecting furnishings for a room, selecting materials to incorporate into an apparel or furnishing product, developing new styles, or modifying current company or competitors' styles. Product development is a process that involves many people with specialized knowledge, ranging from understanding product characteristics that will appeal to a specific target market to knowing how to produce the item so that it meets consumers' needs.

Product development activities range from basic research that leads to new fibers, applied research to minimize environmentally harmful byproducts in dyeing and finishing fabrics, developing new designs for office furnishings, making design modifications to help basic blue jeans become more fashion oriented, or creating fabric designs and colorways for contract window treatments. When selecting the materials or fabrics to be used in a product or selecting products that will be used together, you must understand textile characteristics and serviceability.

Let's use denim to illustrate the variables that are considered in selecting or developing a fabric. Denim is a basic fabric used for such divergent products as jeans, skirts, shorts, jackets, hats, bags, upholstery, wall coverings, and bed sheets. Denim can differ in fiber content from all cotton to blends of cotton and polyester to all wool. Denim can be made from new, unused cotton fiber, or polyester fiber recycled from beverage bottles. The yarns in denim can be made in many sizes by several processes. Denim can be made in many weights, from very heavy to relatively light. It can be finished to look crisp and new or faded and stressed. Denim can be dyed or printed in a variety of colors or patterns, including the traditional indigo blue. All these factors mean that many decisions are made during product development that determine the look and performance of the fabric to be used in the product. Understanding the effects of decisions related to fiber and yarn type, fabric type and weight, and fabric finishes on product serviceability is one responsibility of the product-development team.

Product development decisions occur throughout the textile industry to determine what is available in the market. When designers, merchandisers, producers, or engineers select one fabric or fiber or yarn type over another, they determine the product's performance, appearance, appeal, and cost. They have determined factors such as fabric weight, stiffness, hand, texture, yarn structure and process, fiber content, fiber modifications, coloration method, and finishes.

Sometimes, design firms negotiate with fabric producers so that some part of the fabric—for example, the color—is exclusive to that firm. Some retailers or manufacturers are large enough and control such a significant portion of the market that fabric producers are willing to modify their processes to meet the design firm's preferences. Some fabric firms, especially in the furnishings market, work with designers to produce custom fabrics or custom colors. However, many firms are small and must work with what is available.

Fabrics are presented in a variety of formats so that designers can see the way the fabric looks and drapes, examine the texture and hand of the fabric, and see how an assortment of related fabrics work together. (See Figure 2–1.) Assortment refers to a group of fabrics that share a commonality of design, structure, or color. For example, an assortment could be fabrics of the same structure available in a range of colors or one color available in several fabrications. Information may be limited to the fabric's style number, width, fiber content, and weight, or additional information related to yarn size, yarn spinning method, weave structure, and finishes may be provided. Adherence to fire safety codes for interior

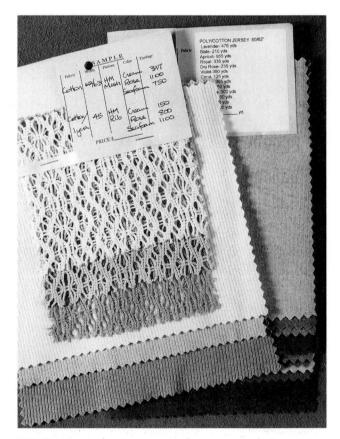

FIGURE 2-1
Fabric presentation swatches showing several assortments.

furnishings also may be provided for some furnishing fabrics.

Designers and product-development specialists examine many fabrics when developing a product line. They select fabrics based on knowledge of their target market and their company's product line and mission. In order for their company to make a profit and stay in business, they must ensure that the products satisfy consumers' expectations for serviceability and performance.

Serviceability and the Consumer

Serviceability describes the measure of a textile product's ability to meet consumers' needs. The emphasis is on understanding the target market and relating target market needs to product serviceability. The serviceability concepts that are used to organize the information are aesthetics, durability, comfort, safety, appearance retention, care, environmental impact, and cost. (See Table 2–1.)

In assessing target market expectations, a firm needs to know who its consumers are, where they shop, how they live their lives, and how all these things influence what consumers look for in textile products. Some firms have specialized market-research divisions that help iden-

TABLE 2–2 Approximate costs for a woven fabric.	e percentage
Raw fibers	23%
Yarn spinning	18%
Weaving	33%
Finishing	26%

Source: Ford, J. E. (1991). Nonwovens. Textiles, no. 4, p. 17.

tify consumer expectations. However, any firm that hopes to be successful must develop an understanding of its target market.

Cost is a very important factor to many consumers, but cost will not be discussed in much depth in this book because many outside factors, such as how a product is promoted and sold, greatly influence purchase price. Fabric cost is one component of the cost of a finished product. Table 2–2 gives approximate percentages for the costs of producing and finishing a basic woven fabric. Figure 2–2 shows one way to present wholesale market price information to the industry for several basic unfinished fabrics. Fabric information in these charts includes fabric width, number of yarns per square inch, fabric weight, current price, and price for several later delivery times.

TABLE 2-1 Serv	viceability concepts.
Aesthetics	Attractiveness or appearance of a textile product. Does the item look pleasing and appropriate for its end use? Does it make the right statement for the target market?
Durability	How the product withstands use; the length of time the product is considered suitable for the use for which it was purchased. Will the consumer be satisfied with how well it wears, how strong it is, and how long it remains attractive?
Comfort and Safety	The way textiles effect heat, air, and moisture transfer and the way the body interacts with a textile product. Its ability to protect the body from harm. Is this item comfortable for its end use in terms of absorbency, temperature regulation, hand, etc.? Will its comfort change with use or age? How does it feel? Is it safe to use or wear?
Appearance Retention	How the product maintains its original appearance during use and care. Will the item retain its new look with use and after care? Will it resist wrinkling, shrinkage, abrasion, soiling, stretching, pilling, sagging, or other changes with use?
Care	Treatment required to maintain a textile product's original appearance and cleanliness. Does the item include a recommended care procedure? Is the care procedure appropriate to maintain the product's new or nearly new look? Are these recommendations appropriate considering its end use, cost, and product type?
Environmental Impact	Effect on the environment of the production, use, care, and disposal of textiles and textile products. How has the production of this item affected the environment? How will its recommended care affect the environment? Can this product, its components, or its packaging materials be recycled? Does the product or its packaging contain any recycled materials?
Cost	Amount paid to acquire, use, maintain, and dispose of a product. How much will it cost to care for this product during its lifetime? Is the cost reasonable given the product's inherent attributes?

Market Prices/Cotton Gray Goods

Week Ending Friday, Sept. 24, 1999

	Spot			48 78x54 4.00	45-44	4 45	_	SHI	EETINGS				TWILLS		
	3rd	4th	1st	*48 78x54 4.00	40-43		_	*59 68x72 1.85	85	85	_	651/2 68x42, .95			
	Qtr	Qtr	Otr	48 96x56 3.50	54	57	_	64 60x60 1.95	_	_	_	4,	1.30	_	-
ALL-COTTON		-	Qti	TEX	TURED FILE			*63 60x60 1.95	69	_	-	65½ 68x42, .85	1.37-1.3	38 1.37	7 —
				100 78x44 2.06	70	70	_	*58 48x44 1.70	95	_	_	SH	OE DUCK		
*63 68x68 2.61	63 50	60 47	<u>-</u>	96 78x44 2.14	67-68	67-68	_	SA	ATEENS			*58 84x28 1.42	79-77	_	_
*50 68x68 3.30			47	64 78x50 2.98	55	54-55	_	58 96x56 1.33	_	_	_	*62 84x28 1.32	82-83	_	_
BLENDED PR				64 78x44 3.20	50	50	_	*58 96x56 1.33	1.05	_	_				
	ter/Cotton			48 78x44 4.23	40	40-39	_	OSN	NABURGS			AR	MY DUCK		
100 78x54 1.95	94	94	_		35 BLENDS	10 00		59 32x26 2.35	89		_	*3713.00 ounce	1.64	_	_
64 78x54 2.99	60	60	-	03/								*3710.38 ounce			
64 96x56 2.62	65	65	_		Voile			47 40x32 2.34	78	_	_		1.34	_	_
*63 96x56 2.62	54	54	_	47 60x56 2.61	461/2	42	_	57 32x26 3.07	88	88	_		NCE DUCK		
	55	55			Batiste			SAI	ILCLOTH			*60in. A-B grade	95	_	_
51 90x54 3.40			_	47 88x64 2.61	39	_	_	64 100x36 1.40	1.30	_	_	*48in. A-B grade	80	_	_
51 73x52 4.00	45	45	_	47 00X04 E.01	00			01 100000 1.10	1.00			Tomi. 71 D grado	00		

The first column represents the width of cloth; second column the count per square inch; third column the weight in yards per pound; fourth column is the spot price (immediate delivery); fifth and sixth columns usually give the succeeding quarters for which delivery is quoted. ('imported fabrics)

	COTTON Y	ARNS	90-20	CARD		Poly/cotton 10s	1.04-1.05	40-Denier Nylon Du	I/Pim 2.1	5-2.20
	COMBE		10s	1.40-1.52	1.75	Poly/cotton 18s	1.10-1.15	3-Denier Acrylic Sta	ple Branded	(net) 85-1.10
Count 16s 18s 20s 24s	Single 1.73-1.78 1.74-1.81 1.75-1.84 1.79-1.93	Plies 2.03 2.04-2.06 2.05-2.08 2.11-2.14	16s 20s 24s 30s	1.44-1.59 1.56-1.65 1.50-1.75 1.84	1.74-1.89 1.98 1.80-2.05	30s M-M F	1.26-1.28 Poly/cotton 1.35-1.38 FIBERS		COTTON RK FUTURES Close 51.20	
30s 36s	1.85-2.05 2.12-2.30	2.15-2.20	30spoly/	Prices include C		Rayon Staple	95-97		WOOL	
	LY/COMBED CO		All-cotto All-cotto All-cotto	n 18s n 26s	1.02-1.10 1.08-1.20 1.17-1.33 1.30-1.43	High Wet Modulus Rayon 150-Denier Acetate NON-CELLU Poly Blend-Staple Branded 150-Denier Polyester Feed		9/17/99 \$1.65	ALIA WOOL F Mkt. Indicator 9/10/99 \$1.64 Iollars per poun	9/18/98 \$1.45

FIGURE 2-2

Market prices for fabrics, from DNR. (Courtesy of DNR, Fairchild Publications.)

These serviceability concepts provide a framework for combining textile knowledge with consumers' expectations to develop an understanding of textiles. When consumers discuss textile products, they often touch on these concepts, although their terms may not precisely match some of the more technical terms used in this book. Consumers evaluate their purchases and determine their satisfaction with products based on these concepts. We will use these concepts throughout the book to relate textile characteristics and performance to consumer expectations.

Performance

Performance describes the manner in which a textile, textile component, or textile product responds to use or how it responds when exposed to some environmental factor that might adversely affect it. For example, we can assess how much fading or loss of strength occurs when a textile is exposed to a known amount of artificial light for a certain time. We can measure how much force or weight is required for a textile to tear. We can assess whether a fabric will bleed when washed and how much

a fabric will shrink when machine-washed and machinedried using a regular cycle with hot water.

Each material in a textile product influences the overall performance of the product. That is, textile product performance cannot be determined solely on a single component such as fiber content or fabric structure. Although these two product characteristics are important and can have a significant impact, product performance can be enhanced or negated by other factors, such as yarn type and finish, and product fit, construction, or design.

Let's use sleeping bags at the retail level as an example to illustrate differences in products, target markets, and expectations. Sleeping bag A is sold at a specialty store that carries products for outdoor enthusiasts. This bag is mummy-shaped, with an outer cover of water-repellent ripstop nylon taffeta, a filling of high-volume goose down, and an inner lining of polyester modified to enhance warmth and comfort. Bag A is very lightweight and can be compressed and packed in a relatively small space. It is expensive and requires special care because of the down filling. This bag is designed to be used outdoors; the user may not have the additional protection of a tent or other structure.

Sleeping bag B is a more traditional sleeping bag sold in a discount store. The outer layer is a cotton/polyester blend printcloth with a printed pattern that would appeal to a young child, the fiberfill is polyester, and the inner layer is cotton/polyester flannel. Bag B will not be as warm or as expensive as bag A. It is designed to be used indoors by a child. It is easy to care for and can be machine-washed and dried.

Sleeping bag C is sold through a mail-order catalog and is also a traditional shape. It incorporates a specially modified polyester fiberfill for warmth without weight; it has a solid dark-green polyester/cotton poplin outer cover and a plaid yarn-dyed cotton flannel for the inner layer. Bag C is more expensive than bag B and is also easy to care for. Bag C would appeal to an adult who is interested in a warm, comfortable sleeping bag to be used in a tent or other structure and who does not have a lot of time to shop.

The three sleeping bags differ in their materials, in their serviceability and performance, and in the way they are marketed to their specific target market.

Fabric performance may be assessed by the fabric producer, by the firm buying the fabric, or by an outside firm that specializes in assessing fabric performance. Unfortunately, some firms do not assess fabric performance, which can result in products that fail to meet performance expectations or that fail in consumers' hands. For example, items that incorporate two or more fabrics of different colors may exhibit problems with color bleeding if the designer is not aware that one of the fabrics is likely to bleed when laundered. If one fabric bleeds in laundering, then all products that combine both fabrics into a single product incorporate this inherent flaw. Thus, all these products are likely to result in consumer dissatisfaction with the product, complaints, and returns. By failing to assess how the two fabrics interact, the designer has created an unsatisfactory product and an expensive failure for the company.

In some product and performance categories, such as the flammability of furnishings in public-use areas and the flammability of children's sleepwear, performance testing is required by law. Products that do not meet minimum safety standards are not acceptable.

Fabric performance often is assessed following standard industry procedures so that performance values for fabrics can be compared. In these procedures, one or more small pieces of fabric are tested for performance in a specific criterion, such as snagging or fading. (See Figure 2–3.) Assessing fabric performance helps in selecting a fabric appropriate for the target market and the firm. Some firms have developed specifications or written descriptions describing minimum performance measures for fabrics used in their products. Their perfor-

FIGURE 2-3
Samples from performance testing: snagging (top) and resistance to sunlight (bottom), with faded portion on right side.

mance specifications are based on understanding their target market's expectations. These specifications help the firm ensure that the fabrics they buy and the products they turn out meet their target market's expectations for performance. Although performance testing eliminates many material-selection problems, it is not an absolute guarantee that all products will be perfect, since some problems may be related to accidents or spills that involve a tiny portion of a fabric. (See Figure 2–4.)

Product quality has become an important dimension in the competitive global marketplace. But the term is difficult to define because it means different things to consumers and producers. **Quality** generally refers to the sum total of product characteristics such as appearance, end use, performance, interactions of the materials in the product, consistency among identical products, and freedom from defects in construction or

FIGURE 2-4

Portion of shirt demonstrating color loss, probably due to an accident of unknown type during production.

materials (see Figure 2–5). Throughout this book, measures and dimensions of fabric quality will be addressed. Keep in mind that *fabric* quality is not the same thing as *product* quality. Fabric quality addresses the fabric used to produce the product. Other factors also influence product quality, but these other factors are beyond the scope of this book.

It must be stressed that neither this book nor any course or combination of courses in textiles will provide

the "best" single answer for any specific end use. This book will not answer the question, "What is the best combination of fiber and yarn type, fabrication method, and finish for (fill in the name of a product)?" The answer to that question is based on understanding a specific target market and end use, current fashion, lifestyle, budget, access to the market, and so on. However, this book will provide a wealth of information for developing and selecting products to meet a wide variety of target market needs.

Information Sources

Information related to textiles and the selection of textile and other materials to be used in textile products can be found in textbooks, technical journals, and industry or trade publications. Technical publications include such journals as America's Textiles International, Textile Chemist and Colorist and American Dyestuff Reporter, and Textile Research Journal. Trade publications include Knitting Times, DNR, and Home Furnishings News. In addition to print sources of information, electronic sources such as the World Wide Web include many sites that provide technical information and fabric assortments. Of course, it remains the responsibility of the reader to determine the validity and correctness of the information and to apply it in a professional and appropriate manner.

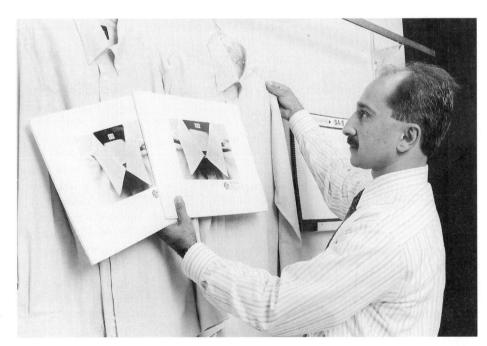

FIGURE 2-5

Appearance evaluation of shirt collars based on company standards for acceptable quality. (Courtesy of JC Penney Co., Inc.)

Key Terms

Product development Serviceability

Aesthetics

Durability

Comfort Safety Appearance retention

Care

Environmental impact

Cost

Performance

Quality

Questions

- 1. Define *product development* and describe how it determines what is on the market.
- 2. Identify consumer expectations for each serviceability concept for the following products and target markets:
 - carpet in a fast-food restaurant in an upscale shopping
 - shirt/blouse for a retail management trainee for casual Fridays
 - housecoat/robe for a resident in a physical rehabilitation center
 - upholstery for chairs in a medical clinic's waiting room adhesive bandage for a college student's heel blister

- Explain the relationship between product performance and product development.
- Compare the kinds of textile information available in a technical journal, in a trade publication, and on the World Wide Web.

Suggested Readings

- Bemowski, K. (1993, February). Quality, American style. *Quality Progress*, pp. 65–68.
- Glock, R. E., and Kunz, G. I. (2000). *Apparel Manufacturing: Sewn Product Analysis*, 3rd ed. Upper Saddle River, NJ: Prentice-Hall.
- Nielson, K. J., and Taylor, D. A. (1994). Interiors: An Introduction. Madison, WI: WCB Brown & Benchmark Publishers.
- Textiles Institute (1987). Textiles: Product Design and Marketing. Manchester, England: The Textiles Institute.
- Thomas, M. (1993, November). Homefurnishings market gears up for business. *Textile World*, pp. 46–50.
- Winchester, S. C. (1994). Total quality management in textiles. *Journal of the Textile Institute*, 85, pp. 445–459.

Section 2

FIBERS

CHAPTER 3

Textile Fibers and Their Properties

CHAPTER 4

Natural Cellulosic Fibers

CHAPTER 5

Natural Protein Fibers

CHAPTER 6

The Fiber-Manufacturing Process

CHAPTER 7

Manufactured Regenerated Fibers

CHAPTER 8

Synthetic Fibers

CHAPTER 9

Special-Use Fibers

Chapter 3

TEXTILE FIBERS AND THEIR PROPERTIES

OBJECTIVES

- To understand terms describing textile fibers and their properties.
- To use terminology correctly.
- To understand the relationships between fiber structure and fiber properties.
- To match fiber performance to enduse requirements and expectations.
- To identify common fibers based on results of simple identification procedures.

nderstanding fibers and their performance is essential because fibers are the basic unit of most fabrics. Fibers influence product aesthetics, durability, comfort, appearance retention, care, environmental impact, and cost. Successful textile fibers must be readily available, constantly in supply, and cost effective. They must have sufficient strength, pliability, length, and cohesiveness to be processed into yarns, fabrics, and products.

Textile fibers have been used to make cloth for several thousand years. Until 1885, when the first manufactured fiber was produced commercially, fibers were produced by plants and animals. The fibers most commonly used were wool, flax, cotton, and silk. These four natural fibers continue to be used and valued today, although their economic importance relative to all fibers has decreased. Natural fibers are those that are in fiber form as they grow or develop and come from animal, plant, or mineral sources. Manufactured (or manmade) fibers are made into fiber form from chemical compounds produced in manufacturing facilities.

Textile processes—spinning, weaving, knitting, dyeing, and finishing of fabrics—were developed for the natural fibers. These traditional processes have been modified for manufactured fibers. New processes have been developed specifically for manufactured fibers and sometimes modified for use with natural fibers.

For example, silk has always been a highly prized fiber because of its smoothness, luster, and softness. Early efforts in manufacturing fibers focused on duplicating silk. Rayon (called artificial silk until 1925) was the first fiber to be manufactured. Acetate and nylon also were introduced originally in silklike fabrics.

Many manufactured fibers were developed in the 20th century. Advances have been made in the manufactured-fiber industry, such as modifications of the original or parent fibers, to provide fibers with better properties for specific end uses. The manufactured fibers most commonly used in contemporary apparel and fabrics for furnishings include polyester, nylon, olefin, acrylic, rayon, and acetate. Fibers for special and industrial applications include spandex, aramid, PBI, and sulfar. From time to time, new modifications or new fibers are introduced.

Fiber Properties

Fibers contribute to fabric performance. For example, strong fibers contribute to the durability of fabrics; absorbent fibers are used for apparel that comes in contact with the skin and for towels and diapers; fire-resistant fibers are used for children's sleepwear and firefighters' clothing.

To analyze and predict a fabric's performance, start with the fiber. Knowledge of fiber properties will help you understand the fiber's contribution to the performance of a fabric and the product made from it. Fiber properties are determined by their physical structure, chemical composition, and molecular arrangement.

Some attributes of fibers are desirable and some are not. The following list of characteristics of a lowabsorbency fiber includes consumer advantages and disadvantages:

- Static cling
- Rapid drying
- Cool and slick hand
- Poor skin-comfort—clammy
- Waterborne soils do not stain
- Evaporation of perspiration may occur by wicking, but fabric is low in absorbency
- Dimensionally stable to water
- Good wrinkle recovery when laundered
- Difficult to dye, but dyes are colorfast when laundered

While fiber plays a major role in the characteristics of a product, other components are also contributors. Fibers are used to produce yarns. The type of yarn and its structure influence hand and performance. For example, yarns made from short fibers may be comfortable, but they tend to pill. The process used to produce the fabric influences the product's appearance and texture, performance during use and care, and cost. Finishes alter the fabric's hand, appearance, and performance. These three components (yarn, fabric type, and finish) will be discussed in detail in the chapters in Sections 3, 4, and 5.

Because cotton is a common consumer fiber, it is often used as a standard in the industry. It might be helpful to compare cotton's performance to that of other fibers when examining or studying Tables 3–3 through 3–8.

Fiber properties are determined using specialized equipment and following specified procedures called "standard test methods." Assessment of specific fiber properties is important in selecting an appropriate fiber for the end use.

Physical Structure

The physical structure, or morphology, can be identified by observing the fiber using a microscope. In this book, photomicrographs at magnifications of 250 to 1000× are used to show details of a fiber's physical structure. In addition, fiber dimensions influence fabric characteristics and performance and the process to be used in producing a finished fabric.

Length Fibers are sold by the fiber producer as staple, filament, or filament tow. Staple fibers are short fibers measured in inches or centimeters (Figure 3–1). They range in length from 2 to 46 cm (3/4 of an inch to 18 inches). Except for silk, all the natural fibers are available only in staple form. Filaments are long, continuous fiber strands of indefinite length, measured in miles or kilometers. They may be either monofilament (one filament) or multifilament (a number of filaments). Filaments may be smooth or bulked (crimped in some way), as shown in Figure 3–2. Smooth filaments are used to produce silklike fabrics; bulked filaments are used in more cottonlike or wool-like fabrics. Filament tow, produced as a loose rope of several thousand fibers, is crimped or textured, and cut to staple length.

Diameter Fiber diameter greatly influences a fabric's performance and hand (how it feels). Large fibers are crisp, rough, and stiff. Large fibers also resist crushing—a property that is important in products such as carpets. Fine fibers are soft and pliable. Fabrics made with fine fibers drape more easily.

Natural fibers are subject to growth irregularities and are not uniform. In natural fibers, fineness is one factor in determining quality—fine fibers are of better quality. Fineness is measured in micrometers (a micrometer is 1/1000 millimeter or 1/25,400 inch). The diameter range for these common natural fibers is 16 to 20 micrometers for cotton, 12 to 16 for flax, 10 to 50 for wool, and 11 to 12 for silk.

In manufactured fibers, diameter is controlled at several points during production. Manufactured fibers

FIGURE 3-1
Staple fibers: manufactured (left) and natural (right).

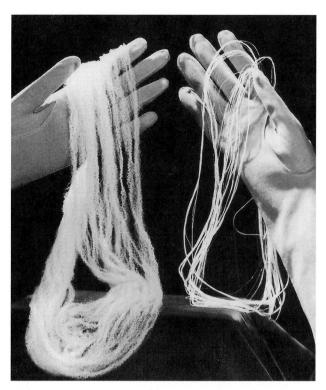

FIGURE 3-2 Manufactured filaments: textured-bulk yarn (left); smooth-filament yarn (right).

can be made uniform in diameter or can be thick-andthin at regular intervals throughout their length. The fineness of manufactured fibers is described as denier or tex. **Denier** is the weight in grams of 9000 meters of fiber or yarn. When used to describe a fiber, denier refers to the fineness or coarseness of the fiber—small numbers describe fine fibers; large numbers describe coarse fibers. **Tex** is the weight in grams of 1000 meters of fiber or yarn. Staple fiber is sold by denier and fiber length; filament fiber is sold by the denier of the yarn or tow.

Denier per filament (dpf) is a way of describing fiber size; it is often used when describing or specifying yarns. Dpf is calculated by dividing the yarn size by the number of filaments: 40 denier yarn/20 filaments = 2 denier per filament. Fine cotton, cashmere, or wool is 1 to 3 denier; average cotton, wool, or alpaca is 5 to 8 denier; carpet wool is 15 denier. Apparel fibers range from <1 to 7 denier. Carpet fibers may range from 15 to 24 denier. Industrial fibers exhibit the broadest range, from 5 to several thousand, depending on the end use. For example, fibers used for weed trimmers and towropes are much larger than those used for absorbent layers in diapers.

Denier is related to end use. For example, apparel fibers do not make serviceable carpets, and carpet fibers

do not make serviceable garments. Apparel fibers are too soft and pliable, and carpets made of apparel fibers do not have good crush resistance. Industrial or technical fibers are produced in various deniers, depending on the end use.

Cross-Sectional Shape The cross-sectional shape of a fiber affects luster, bulk, body, texture, and hand. Figure 3–3 shows common cross-sectional shapes. These shapes may be round, dog-bone, triangular, lobal, multisided, or hollow.

The natural fibers derive their shape from (1) the way the cellulose is built up during plant growth (cotton), (2) the shape of the hair follicle and the formation of protein substances in animals (wool), or (3) the shape of the orifice through which the insect extrudes the fiber (silk).

The shape of manufactured fibers is controlled by the shape of the spinneret opening and the spinning method. The size, shape, luster, length, and other properties of manufactured fibers can be varied by changes in the production process.

Surface Contour Surface contour describes the outer surface of the fiber along its length. Surface contour may be smooth, serrated, striated, or rough, and it affects luster, hand, texture, and apparent soiling of the fabric. Figure 3–3 also shows surface contours of selected fibers.

Crimp Crimp may be found in textile materials as fiber crimp or fabric crimp. **Fiber crimp** refers to the waves,

bends, twists, coils, or curls along the length of the fiber. Fiber crimp increases cohesiveness, resiliency, resistance to abrasion, stretch, bulk, and warmth. Crimp increases absorbency and skin-contact comfort but reduces luster. Inherent crimp occurs in wool. Inherent crimp also exists in an undeveloped state in bicomponent manufactured fibers in which it is developed in the fabric or the garment (such as a sweater) with heat or moisture during finishing.

Fabric crimp refers to the bends caused by distortion of yarns in a fabric. When a yarn is unraveled from a fabric, fabric crimp can easily be seen in the yarn. It also may be visible in fibers removed from the yarn.

Fiber Parts Except for silk, the natural fibers have three distinct parts: an outer covering called a cuticle or skin; an inner area; and a central core that may be hollow.

The manufactured fibers are less complex in structure. They usually consist of a skin and a core.

Chemical Composition and Molecular Arrangement

Fibers are classified into groups by their chemical composition. Fibers with similar chemical compositions are placed in the same **generic group**. The properties of fibers in one generic group differ from those in another group.

Fibers are composed of millions of long molecular chains. **Polymerization** is the process of joining small molecules—monomers—together to form a long chain,

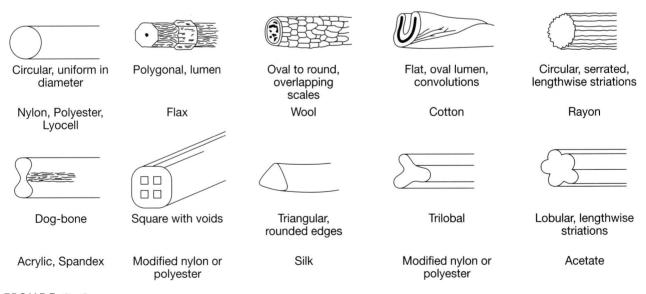

FIGURE 3-3
Cross-sectional shapes and fiber contours.

or **polymer.** The length of the polymer, which varies just as the length of fibers varies, depends on the number of molecules connected in a chain; it is described as **degree of polymerization.** Long chains indicate a high degree of polymerization and a high degree of fiber strength. Molecular chains are too small to be seen, even with the assistance of an optical microscope.

Molecular chain length also may be described by molecular weight, a factor in properties such as fiber strength and extensibility. Fibers with longer chains or higher molecular weights are stronger and more difficult to pull apart than fibers with shorter chains or lower molecular weights.

Molecular chains have different configurations within fibers. When the chains are arranged in a random or disorganized way within the fiber, they are **amorphous**. When the molecular chains are organized parallel to each other, they are **crystalline**. Molecular chains that are parallel to each other and to the fiber's lengthwise axis are oriented. Most molecular chains that are oriented have a high degree of **orientation** (highly oriented). Fibers that are highly oriented are also highly crystalline. However, highly crystalline fibers are not necessarily highly oriented (Figure 3–4). Fibers vary in their proportion of oriented, crystalline, and amorphous regions.

The polymers in manufactured fibers are in a random, unoriented state immediately after production. **Stretching,** or **drawing,** causes the chains to become more parallel to each other and to the longitudinal axis of the fiber. It also reduces fiber diameter and compacts the molecules (Figure 3–5). Fiber properties affected by crystallinity and orientation include strength, elon-

FIGURE 3-4

Polymers: (a) amorphous area; (b) crystalline, but not oriented, area; (c) oriented and crystalline area.

Unstretched or undrawn

Stretched or drawn

FIGURE 3-5

Stretching or drawing a fiber affects its molecular arrangement.

gation, moisture absorption, abrasion resistance, and dyeability.

Amorphous fibers such as wool and rayon are relatively weak and easily elongated. These fibers also have poor elasticity and good moisture absorbency, dyeability, and flexibility.

Oriented and crystalline fibers are strong and stiff. They do not stretch easily, but they recover from stretch quickly. They tend to be nonabsorbent and difficult to dye. Highly oriented and crystalline fibers include polyester, nylon, and aramid.

Molecular chains are held to one another by intermolecular forces called hydrogen bonds and van der Waals' forces. The closer the chains are to each other, the stronger are the bonds. **Hydrogen bonding** is the attraction of positive hydrogen atoms of one chain for negative oxygen or nitrogen atoms of an adjacent chain. **van der Waals' forces** are weak bonds between atoms that are physically close together. Hydrogen bonding and van der Waals' forces occur in the crystalline areas and help make crystalline polymers stronger than amorphous polymers.

Serviceability

Textile serviceability includes the concepts of aesthetics, durability, comfort, appearance retention, care, environmental impact, and cost that were introduced in Chapter 2. Properties that relate to each concept are presented in Table 3–1.

Learning the definitions of the properties will contribute to a more in-depth understanding of textile fiber performance. The tables in this chapter compare various performance aspects among fibers. Relating past experience with fabrics made of a specific fiber will contribute to a better understanding of fiber performance and serviceability.

Aesthetic Properties

A textile product should be appropriate in appearance for its end use. Aesthetic properties relate to the way

Fiber Property	Is Due to	Contributes to fabric property
Abrasion resistance is the ability of a	Tough outer layer, scales, or skin	Durability
fiber to resist damage from rubbing or surface contact.	Fiber toughness Flexible molecular chains	Abrasion resistance Resistance to splitting or pilling
Absorbency or moisture regain is the percentage of moisture a bone-dry fiber will absorb from the air when at	Chemical composition Amorphous areas	Comfort, warmth, water repellency, absorbency, static buildup Dyeability, soiling
standard temperature and relative humidity.		Shrinkage Wrinkle resistance
Aging resistance is resistance to deleterious changes over time.	Chemical structure	Fabric and product storage
Allergenic potential is the ability to cause physical reactions such as skin redness.	Chemical composition, additives	Comfort
Chemical reactivity describes the effect	Polar groups of molecules	Cleaning requirements
of acids, alkali, oxidizing agents, solvents, or other chemicals.	Chemical composition	Ability to take certain finishes
Cohesiveness is the ability of fibers to cling together during spinning.	Crimp or twists, surface contour	Resistance to raveling Resistance to yarn slippage
Compressibility is resistance to crushing.	Molecular structure, fiber diameter, and stiffness	Crush and wrinkle resistance
Cover is the ability to conceal or	Crimp, curl, or twist	Fabric opacity
protect.	Cross-sectional shape	Cost—less fiber needed
Creep is delayed or gradual recovery from elongation or strain. Density—see Specific gravity	Lack of side chains, cross links, strong bonds; poor orientation	Streak dyeing and shiners in fabric
Dimensional stability is the ability to	Physical and chemical structure,	Shrinkage, growth, care, appearance
retain a given size and shape through use and care.	coatings	ommage, grower, early appearance
Drape is the manner in which a fabric	Fiber size and stiffness	Appearance
falls or hangs over a three- dimensional form.		Comfort
Dyeability is the fiber's receptivity to coloration by dyes; dye affinity.	Amorphous areas and dye sites, chemical structure	Aesthetics and colorfastness
Elasticity is the ability of a strained material to recover its original dimensions immediately after removal of stress.	Chemical and molecular structure; side chains, cross links, strong bonds	Fit and appearance; resiliency
Elastic recovery is the degree to which	Chemical and molecular structure; side	Processability of fabrics
fibers will recover from strain.	chains, cross links, strong bonds	Resiliency and creep
Electrical conductivity is the ability to	Chemical structure; polar groups	Poor conductivity; static; fabric clin

Aging resistance is resistance to	Chemical structure	rabile and produce storage
deleterious changes over time.		
Allergenic potential is the ability to	Chemical composition, additives	Comfort
cause physical reactions such as skin		
redness.		
Chemical reactivity describes the effect	Polar groups of molecules	Cleaning requirements
of acids, alkali, oxidizing agents,	Chemical composition	Ability to take certain finishes
	Chemical composition	Ability to take certain initiales
solvents, or other chemicals.		D. istance to modified
Cohesiveness is the ability of fibers to	Crimp or twists, surface contour	Resistance to raveling
cling together during spinning.		Resistance to yarn slippage
Compressibility is resistance to	Molecular structure, fiber diameter, and	Crush and wrinkle resistance
crushing.	stiffness	
Cover is the ability to conceal or	Crimp, curl, or twist	Fabric opacity
protect.	Cross-sectional shape	Cost—less fiber needed
Creep is delayed or gradual recovery	Lack of side chains, cross links, strong	Streak dyeing and shiners in fabric
from elongation or strain.	bonds; poor orientation	
	bolids, poor offentation	
Density—see Specific gravity	Dhysical and shamical structure	Chrinkago growth care annearance
Dimensional stability is the ability to	Physical and chemical structure,	Shrinkage, growth, care, appearance
retain a given size and shape through	coatings	
use and care.		
Drape is the manner in which a fabric	Fiber size and stiffness	Appearance
falls or hangs over a three-		Comfort
dimensional form.		
Dyeability is the fiber's receptivity to	Amorphous areas and dye sites, chemical	Aesthetics and colorfastness
coloration by dyes; dye affinity.	structure	
Elasticity is the ability of a strained	Chemical and molecular structure; side	Fit and appearance; resiliency
material to recover its original	chains, cross links, strong bonds	The and appearance, residency
	chains, closs tilks, strong bolius	
dimensions immediately after removal		
of stress.		
Elastic recovery is the degree to which	Chemical and molecular structure; side	Processability of fabrics
fibers will recover from strain.	chains, cross links, strong bonds	Resiliency and creep
Electrical conductivity is the ability to	Chemical structure; polar groups	Poor conductivity; static; fabric cling
transfer electrical charges		
Elongation is the ability to be	Fiber crimp	
stretched, extended, or lengthened.	Molecular structure: molecular crimp and	Increases tear strength
Varies with conditions (wet/dry) and	orientation	Reduced brittleness
	Orientation	Provides "give"
temperatures.		
Feltability refers to the ability of fibers	Scale structure of wool	Fabrics can be made directly from fiber
to mat together.		Special care is required when fabric is
		wet
Flammability describes how a fabric	Chemical composition	Fabric's ability to ignite and burn
reacts to ignition sources.		
Flexibility is the ability to bend	Flexible molecular chain	Stiffness, drape, comfort
repeatedly without breaking.		
Hand is the way a fiber feels; tactile	Cross-sectional shape, surface	Fabric hand
sensation; silky, harsh, soft, crisp, dry.		Tabile Hallu
concations cilly harch cott crich dry	properties, crimp, diameter, length	

TABLE 3-1 (continued)

Fiber Property	Is Due to	Contributes to fabric property
Heat conductivity is the ability to transfer heat through a fabric.	Crimp, chemical composition Cross-sectional shape	Comfort: cooling effect
Heat retention is the ability to retain heat or insulate.	Crimp, chemical composition Cross-sectional shape	Comfort: warming or insulating effect
Heat sensitivity is the ability to shrink, soften, or melt when exposed to heat.	Chemical and molecular structure Fewer intermolecular forces and cross links	Determines safe cleaning and pressing temperatures
Hydrophilic or hygroscopic describes fibers with a strong affinity or attraction for water.	Chemical composition Amorphous areas	Soiling, comfort, care
Loft, or compression resiliency, is the ability to spring back to original thickness after being compressed.	Fiber crimp Stiffness	Springiness, good cover Resistance to flattening
Luster is the light reflected from a surface. More subdued than shine; light rays are broken up.	Smoothness of fiber, yarn, and/or fabric Fiber length, shape, or additive	Luster
Mildew resistance is resistance to the growth of mold, mildew, or fungus.	Low moisture absorption and chemical composition	Storage
Modulus is the resistance to stress/ strain to which a fiber is exposed.	Molecular arrangement, chemical composition	Tenacity, elongation, and elasticity
Moth resistance is resistance to insect damage.	Chemical composition	Storage
Oleophilic describes fibers with a strong affinity or attraction for oil.	Chemical composition	Soiling; care; appearance
Pilling is the formation of balls of fiber on the fabric surface.	Fiber strength High molecular weight	Pilling Unsightly appearance
Resiliency is the ability to return to original shape after bending, twisting, compressing, or a combination of deformations.	Molecular structure: side chains, cross links, strong bonds	Wrinkle recovery, crease retention, appearance, care
Specific gravity and density are measures of the weight of a fiber. Density is the weight in grams per cubic centimeter. Specific gravity is the ratio of fiber mass to an equal volume of water at 4°C.	Molecular weight and structure	Warmth without weight Loftiness Fabric buoyancy
Stiffness, or rigidity , is resistance to bending or creasing.	Chemical and molecular structure	Fabric body, low drape characteristics Difficult to make spun yarns
Strength is the ability to resist stress and is expressed as tensile strength (pounds per square inch) or as tenacity (grams per denier). Breaking tenacity is the number of grams of force to break a fiber.	Molecular structure: orientation, crystallinity, degree of polymerization	Durability, tear strength, sagging, pilling Sheerest fabrics possible with strong, fine fibers
Sunlight resistance is the ability to withstand degradation from sunlight.	Chemical composition Additives	Fabric durability
Texture is the nature of the fiber or fabric surface.	Physical structure	Luster, appearance, comfort
Translucence is the ability of a fiber, yarn, or fabric to allow light to pass through the structure.	Physical and chemical structure	Appearance, cover
Wicking is the ability of a fiber to transfer moisture along its surface.	Chemical and physical composition of outer surface	Makes fabrics comfortable Moisture transport

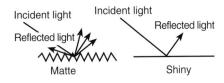

FIGURE 3-6

Smooth surfaces reflect light in a straight line and are lustrous; rough surfaces reflect light at various angles and are dull.

senses such as touch and sight contribute to the perception of the textile. In evaluating the aesthetics of a textile product, the consumer usually determines whether the appearance is appropriate for the end use.

Luster results from the way light is reflected by a surface. (See Figure 3–6.) Shiny or bright fabrics reflect a great amount of light. Lustrous fabrics reflect a fair amount of light and are used in formal apparel and furnishings. Matte, or dull, fabrics reflect little light and are used most frequently for less formal looks in apparel and furnishings. Silk fabrics are usually lustrous. Cotton and wool fabrics are usually matte. The luster of manufactured fibers can be varied during manufacturing. Fibers with high luster are referred to as bright fibers. Low-luster fibers are dull fibers. Medium-luster fibers are semibright or semidull. Yarn and fabric structure and finish and fabric structure may change fabric luster.

Drape is the way a fabric falls over a threedimensional form like a body or table. Chiffon is soft and free-flowing, chintz falls in graceful folds, and satin is stiff and heavy. Fibers influence drape to a degree, but yarns and fabric structure may be more important in determining drape.

Texture describes the nature of the fabric surface. It is identified by both visual and tactile senses. Fabrics may have a smooth or rough texture. Natural fibers tend to give a fabric more texture than manufactured fibers because of the variations inherent in natural fibers. Yarns, finishes, and fabric structure greatly affect a fabric's texture.

Hand is the way a fabric feels to the skin. Adjectives such as warm or cool, bulky or thin, slick or soft may be used to describe fabrics. Hand may be evaluated by feeling a fabric between the fingers and thumb. Both objective and subjective means of evaluating fabric hand are used to determine its suitability for an end use.

Durability Properties

A durable textile product should last a period of time adequate for its end use. Durability properties can be tested in the laboratory, but laboratory results do not always accurately predict performance when used by consumers.

Abrasion resistance is the ability of a fabric to withstand the rubbing it gets during use (Table 3–2). Abra-

Rating	Abrasion Resistance	Thermal Retention	Resiliency	Light Resistance
Excellent	Aramid	Wool	Nylon	Glass
	Fluoropolymer	Acrylic	Wool	Acrylic
L -	Nylon	Modacrylic		Modacrylic
to	Olefin	Polyester		Polyester
	Polyester			
Good	Saran	Olefin	Olefin	Sulfar
	Spandex	Nylon	Acrylic	Lyocell
	Flax	Aramid	Modacrylic	Flax
	Acrylic		Polyester	Cotton
to	PBI			Rayon
	Sulfar			PBI
	Cotton			
	Silk			
Moderate	Wool	Silk	Silk	Triacetate
ſ	Rayon	Spandex		Acetate
to	3			Olefin
Poor	Vinyon	Flax	Lyocell	Nylon
	Acetate	Cotton	Flax	Wool
	Glass	Lyocell	Cotton	Silk
		Rayon	Rayon	
		Acetate	Acetate	

sion can occur when the fabric is fairly flat, such as walking on a rug. Edge abrasion can occur when the fabric is folded, as when a pant hem rubs on a sidewalk. Flex abrasion can occur when the fabric is moving and bending, as in shoelaces that wear out where they are laced through the shoe. **Flexibility**, the ability to bend repeatedly without breaking, is an important property related to abrasion resistance.

Tenacity, or tensile strength, is the ability of a fabric to withstand a pulling force (Table 3–3). (*Breaking tenacity* for a fiber is the force, in grams per denier or tex, required to break the fiber.) The tenacity of a fiber when it is wet may differ from the tenacity of that same fiber when it is dry. Although fabric strength depends, to a large degree, on fiber strength, yarn and fabric structure are additional factors affecting fabric strength. Strength may also be described by the force needed to rip a fabric (tearing strength) or to rupture a fabric (bursting strength).

Elongation refers to the degree to which a fiber may be stretched without breaking. It is measured as percent elongation at break (Table 3–4). Elongation should be considered in relation to elasticity.

Comfort Properties

A textile product should be comfortable when it is worn or used. This is primarily a matter of personal preference and individual perception of comfort under different climatic conditions and degrees of physical activity. The complexities of comfort depend on characteristics such as absorbency, heat retention, density, and elongation.

Absorbency is the ability of a fiber to take up moisture from the body or from the environment. It is measured as moisture regain where the moisture in the material is expressed as a percentage of the weight of the moisture-free material (see Table 3–3). **Hydrophilic** fibers absorb moisture readily. **Hydrophobic** fibers have

Fiber	Fiber Tenacity (grams/denier)* Dry (wet)	Absorbency**	Density or Specific Gravity (g/cc)***
Rubber	0.34	0.8	1.1
Spandex	0.7-1.0	1.3	1.2
Vinyon	0.7-1.0	0.1	1.33-1.43
Rayon (viscose)	1.0-2.5 (0.5-1.4)	11.5-12.5	1.48
Acetate	1.2-1.4 (1.0-1.3)	6.3-6.5	1.32
Saran	1.4-2.4	0.1	1.70
Wool	1.5 (1.0)	13-18	1.32
Melamine	1.8	5.8	1.40
Modacrylic	1.7-2.6 (1.5-2.4)	2.5	1.35
Fluoropolymer	2.0	0.0	2.1
Acrylic	2.0-3.0 (1.8-2.7)	1.0-1.5	1.17
Polyester	2.4-7.0	0.4	1.34-1.38
Rayon (HWM)	2.5-5.0 (3.0)	11.0	1.48
PBI	2.6-3.0 (2.1-2.5)	15	1.43
Sulfar	3.0-3.5	0.6	1.37
Cotton	3.5-4.0 (4.5-5.0)	7–11	1.52
Olefin	3.5-4.5	0.01-0.1	0.90-0.91
Flax	3.5-5.0 (6.5)	12	1.52
Nylon	3.5-7.2 (3.0-6.5)	2.8-5.0	1.13-1.14
Vinal	3.5-6.5 (2.6-4.9)	5.0	1.26
Silk	4.5 (2.8–4.0)	11	1.25
Lyocell	4.8-5.0 (4.2-4.6)	11.5	1.56
Aramid (Nomex)	4.0-5.3 (3.0-4.1)	6.5	1.38-1.44
Glass (multifilament)	9.6 (6.7)	0.0	2.48-2.69

^{*}For fibers that are available in several lengths and modifications, the values are for dry staple fibers with unmodified cross sections. Numbers in parentheses refer to values for wet fibers. Where there are no numbers in parentheses, dry and wet values are the same.

^{**}Expressed as moisture regain (percentage of the moisture-free weight at 70°F or 21°C and 65% relative humidity).

^{***}Ratio of weight of a given volume of fiber to an equal volume of water.

TABLE 3-4	Fiber elongation	(percent elongation at brea	k) and elastic recovery.
-----------	------------------	-----------------------------	--------------------------

Fiber*	Elongation		Elastic Recovery**	
	Standard***	Wet		
Flax	2.0	2.2	65	
Cotton	3–7	9.5	75	
Glass	3.1	2.2		
Fluoropolymer	8.5	same		
Rayon, regular	8-14	16-20	95 (at 2%)	
Rayon, HWM	9-18	20	96 (at 2%)	
Melamine	12	same		
Polyester	12-55	same	81	
Vinyon	12-125	same		
Lyocell	14-16	16-18	88	
Vinal	15-30	11–23		
Saran	15-35	same		
Nylon 6,6	16-75	18-78	82-89	
Silk	20	30	90	
Aramid (Nomex)	22-32	20-30		
Wool	25	35	99	
Acetate	25-45	35-50	48–95 (at 4%)	
PBI	25-30	26-32		
Modacrylic	30-60	same	99.5 (at 2%)	
Nylon 6	30-90	42-100	98-100	
Sulfar	35-45	same		
Acrylic	35-45	41–50	92	
Olefin	70-100	same	96 (at 5%)	
Spandex	400-700	same	99 (at 50%)	
Rubber	500	same	98 (at 50%)	

^{*}A minimum of 10% elongation is desirable for ease in textile processing. For fibers that are available in several lengths and modifications, the values are for staple fibers with unmodified cross sections.

little or no absorbency. **Hygroscopic** fibers absorb moisture without feeling wet. Absorbency is related to static buildup; problems with static are more likely to develop in hydrophobic fibers because they do not conduct electrons readily.

Heat or thermal retention is the ability of a fabric to hold heat (see Table 3–2). Because people want to be comfortable regardless of the weather, a low level of thermal retention is favored in hot weather and a high level in cold weather. This property is affected by yarn and fabric structure and layering of fabrics.

Heat sensitivity describes a fiber's reaction to heat (Table 3–5). Since some fibers soften and melt and others are heat resistant, these properties identify safe pressing temperatures.

Density or specific gravity is a measure of fiber weight per unit volume (see Table 3–3). Lower-density fibers

can be made into thick fabrics that are more comfortable than high-density fibers made into heavy fabrics.

Appearance-Retention Properties

A textile product should retain its appearance during use, care, and storage.

Resiliency is the ability of a fabric to return to its original shape after bending, twisting, or crushing (see Table 3–2). An easy test is to crunch a fabric in your hand and watch how it responds when you open your hand. Fabrics that do not wrinkle easily and spring back after compression are resilient and wrinkle resistant. A fabric that wrinkles easily stays crumpled in your hand. When it is flattened out, wrinkles and creases are apparent.

Dimensional stability is defined as the ability of a fabric to retain its original size and shape through use

^{**}Percent recovery at 3% stretch, unless otherwise noted.

^{***}Standard conditions: 65% relative humidity; 70°F or 21°C.

Fiber	Melts at*	Softens or sticks at	Pressing Recommendations
	°F (°C)	°F (°C)	°F (°C)
Natural fibers			
Cotton	Does not melt		425 (218)
Flax	Does not melt		450 (232)
Silk	Does not melt		300 (149)
Wool	Does not melt		300 (149)
Manufactured fibers			, ,
Acetate	500 (260)	350-375 (176-191)	350 (177)
Acrylic		430-450 (221-232)	300 (149)
Aramid	Does not melt; carbonizes	above 700°F (Nomex) or 900°F (Kevlar)	Do not press
Fluoropolymer	Does not melt		
Glass	2720 (1493)	1560 (849)	Do not press
Lyocell	Does not melt		
Melamine	Does not melt		
Modacrylic	Does not melt		200-250 (93-121)
Nylon 6	419-430 (215-221)	340 (171)	300 (149)
Nylon 6,6	480-500 (249-260)	445 (229)	350 (177)
Olefin	320-350 (160-177)	285-330 (141-166)	150 (66)
PBI	Does not melt; decomposes	at 860°F (460)	
Polyester PET	482 (250)	440-445 (226-230)	325 (163)
Polyester PCDT	478-490 (248-254)	470 (243)	350 (177)
Rayon	Does not melt		375 (191)
Saran	350 (177)	240 (115)	Do not press
Spandex	446 (230)	420 (175)	300 (149)

^{*}Lowest setting on irons is 185-225°F.

and care, which is desirable. It includes the properties of shrinkage resistance and elastic recovery.

Shrinkage resistance is the ability of a fabric to retain its original dimensions throughout care. It is related to the fabric's reaction to moisture or heat. Items that shrink may no longer be attractive or suitable for their original end use. Residual shrinkage refers to additional shrinkage that may occur after the first care cycle.

Elasticity or elastic recovery is the ability of a fabric to return to its original dimension or shape after elongation (see Table 3–4). It is measured as the percentage of return to original length. Elastic recovery varies with the amount of elongation and with the length of time the fabric is stretched. Fabrics with poor elastic recovery tend to stretch out of shape. Fabrics with good elastic recovery maintain their shape.

Resistance to Chemicals

Different fibers react differently to chemicals. Some are quite resistant to most chemicals; others are resistant to one group of chemicals but easily harmed by others.

Resistance to chemicals determines the appropriateness of care procedures and end uses for fibers. Table 3–6 summarizes fiber reactions to acids and alkalis. Acids are compounds that yield hydrogen ions to alkalis in chemical reactions. Alkalis (bases) are compounds that remove hydrogen ions from acids and combine with the acid in a chemical reaction.

Resistance to Light

Exposure to light (both natural and artificial) may damage fibers. The energy in light, especially in the ultraviolet region of the spectrum, causes irreversible damage to the chemical structure of the fiber. This damage may appear as a yellowing or color change, a slight weakening of the fabric, or eventually, the complete disintegration of the fabric (see Table 3–2).

Environmental Impact

Environmental impact refers to the way the production, use, care, and disposal of a fiber or textile product

Fiber	Acid	Alkali
Natural fibe		
Cotton	Harmed	Resistant
Flax	Harmed	Resistant
Silk	Harmed by strong mineral acids, resistant to organic acids	Harmed
Wool	Resistant	Harmed
Manufacture	d fibers	
Acetate	Unaffected by weak acids	Little effect
Acrylic	Resistant to most acids	Resistant to weak alkalis
Aramid	Resistant to most acids	Resistant
Glass	Resistant	Resistant
Lyocell	Harmed	Resistant
Modacrylic	Resistant to most acids	Resistant
Nylon	Harmed, especially nylon 6	Resistant
Olefin	Resistant	Highly resistant
PBI	Resistant	Resistant to most
5.1		alkalis
Polyester	Resistant	Degraded by
		strong
D	111	alkalis
Rayon	Harmed	Resistant to
		weak
	5	alkalis
Spandex	Resistant	Resistant
Sulfar	Resistant	Resistant

^{*}Examples of acids: organic (acetic, formic); mineral (sulfuric, hydrochloric)

affects the environment. Many consumers assume that natural fibers have less of an environmental impact than do manufactured or synthetic fibers. However, the natural fibers' impact on soil conservation, use of agricultural chemicals, disposal of animal waste, water demands, cleaning requirements, and processing create environmental problems. Since very few textile products are disposed of in a manner that allows for biodegradation, natural fibers do not have that advantage in modern society. The environmental impact of each of the major consumer fibers will be discussed in Chapters 4–9.

Care Properties

Any treatments that are required to maintain the new look of a textile product during use, cleaning, or storage are referred to as care. Improper care can result in items that are unattractive, not as durable as expected, uncomfortable, or unusable. Fiber reactions to water, chemicals, and heat in pressing and drying will be discussed in each fiber chapter. Special storage requirements will also be discussed.

Cost

Cost is affected by how a fiber is produced, the number and type of modifications present, and how the fiber is marketed. Cost will be addressed in general terms for each fiber. Actual costs for fibers are related to supply of and demand for the fiber as well as costs of raw materials used to grow or produce each fiber.

Fiber Property Charts

The fibers within each generic family have individual differences. These differences are not reflected in the tables in this chapter, except in a few specific instances. The numerical values are averages, or medians, and are intended as a general characterization of each generic group. (The values were compiled from "Man-Made Fiber Chart," *Textile World*, August 1992; "Textile Fibers and Their Properties," AATCC Council on Technology, 1977; and Federal Trade Commission reports on new generic fibers.)

Fiber Identification

The procedure for identifying fibers in a fabric depends on the nature of the sample, the experience of the analyst, and the facilities available. Because laws require the fiber content of apparel and furnishing textiles to be indicated on the label, the consumer may only need to look for identification labels. If a professional wishes to confirm or verify the label information, some simple solubility and burn tests may be used. These procedures differ in their effectiveness in identifying fibers. Microscopic appearance is most useful for natural fibers. Solubility tests and sophisticated spectroscopic analyses are most effective for manufactured fibers.

Visual Inspection

Visual inspection of a fabric for appearance and hand is always the first step in fiber identification. It is no longer

^{**}Examples of alkalis: weak (ammonium hydroxide); strong (sodium hydroxide).

possible to make an identification of the fiber content by appearance and hand alone, because manufactured fibers can resemble natural fibers or other manufactured fibers. However, observation of certain characteristics is helpful. These characteristics are apparent to the unaided eye and are visual clues used to narrow the number of possibilities.

- 1. Length of fiber. Untwist the yarn to determine fiber length. Any fiber can be made in staple length, but not all fibers can be filament. For example, cotton and wool are always staple and never filament.
- 2. Luster or lack of luster. Manufactured fiber luster may range from harsh and shiny to dull and matte.
- **3.** Body, texture, hand—soft to hard, rough to smooth, warm to cool, or stiff to flexible. These aspects relate to fiber size, surface contour, stiffness, and cross-sectional shape.

Burn Test

The burn test can be used to identify a fiber's general chemical composition, such as cellulose, protein, mineral, or synthetic (Table 3–7). Blends cannot be identified by the burn test. If visual inspection is used along with the burning test, fiber identification can be carried further. For example, if the sample is cellulose and also filament, it is probably rayon; but if it is staple, a positive identification for a specific cellulosic fiber cannot be made.

Work in a safe, well-ventilated area or under a hood. Remove paper and other flammable materials from the area. Follow these general directions for the burn test:

- 1. Ravel out and test several yarns from each direction of the fabric to determine if they have the same fiber. Differences in luster, twist, and color suggest that there might be more than one generic fiber in the fabric.
- 2. Hold the yarn horizontally, as shown in Figure 3–7. It is helpful to roll long pieces of yarn into a flat ball or clump, as shown in the figure. Use tweezers to protect your fingers. Move the yarns slowly into the edge of the flame and observe what happens. Repeat this step several times to check your results.

Fibers	When Approaching Flame	When in Flame	After Removal from Flame	Ash	Odor
Lineiz	rtame	when in riame	Hom riame	ASII	Odor
Cellulose Cotton Flax Lyocell Rayon	Does not fuse or shrink from flame	Burns with light gray smoke	Continues to burn, afterglow	Gray, feathery, smooth edge	Burning pape
Protein Silk Wool	Curls away from flame	Burns slowly	May self-extinguish	Crushable black ash	Burning hair
Acetate	Melts and pulls away from flame	Melts and burns	Continues to burn and melt	Brittle, black, hard bead	Acrid
Acrylic	Melts and pulls away from flame	Melts and burns	Continues to burn and melt	Brittle, black, hard bead	Chemical odo
Glass	No reaction	Does not burn	No reaction	Fiber remains	None
Modacrylic	Melts and pulls away from flame	Melts and burns	Self-extinguishes, white smoke	Brittle, black, hard bead	Chemical odo
Nylon	Melts and pulls away from flame	Melts and burns	May self-extinguish	Hard gray or tan bead	Celerylike
Olefin	Melts and pulls away from flame	Melts and burns	May self-extinguish	Hard tan bead	Chemical odo
Polyester	Melts and pulls away from flame	Melts and burns	May self-extinguish	Hard black bead	Sweet odor
Saran	Melts and pulls away from flame	Melts and burns	Self-extinguishes	Hard black bead	Chemical odo
Spandex	Melts but does not pull away from flame	Melts and burns	Continues to melt and burn	Soft black ash	Chemical odo

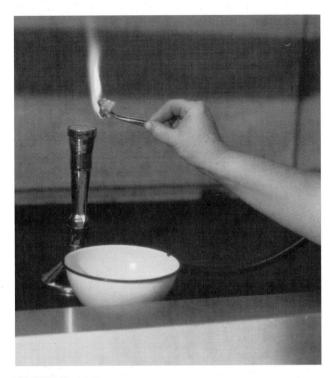

FIGURE 3-7
Fiber identification by the burn test.

Microscopy

Knowing the physical structure of fibers will be of use when using a microscope in fiber identification. Identification of natural fibers is best done by microscopy. Manufactured fibers are more difficult to identify because many of them look alike, and their appearance may be changed by variations in the manufacturing process. Positive identification of the manufactured fibers by microscopy is not possible.

A cross section of the fiber will provide additional information. Longitudinal and cross-sectional photomi-

crographs of individual fibers are included in the fiber chapters. These may be referred to when identifying unknown fibers.

The following are directions for using the microscope:

- 1. Clean the lens, slide, and cover glass.
- 2. Place a drop of distilled water or glycerin on the slide.
- **3.** Untwist a yarn and place several fibers from the yarn on the slide. Cover with the cover glass and tap to remove air bubbles.
- 4. Place the slide on the stage of the microscope. Focus with low power first. If the fibers have not been well separated, it will be difficult to focus on a single fiber. Center the fiber or fibers in the viewing field. Then move to a lens with greater magnification. As magnification increases, the size of the viewing field decreases. Thus, if fibers are not in the center of the field when a higher magnification is selected, they may disappear from the viewing field.
- **5.** If a fabric contains two or more fiber types, examine each fiber and both warp and filling yarns.

Solubility Tests

Solubility tests are used to identify the manufactured fibers by generic class and to confirm identification of natural fibers. Two simple tests, the alkali test for wool and the acetone test for acetate, are described in Chapters 5 and 7, respectively.

Table 3–8 lists solvents from weakest to strongest. Place the specimen in the liquid in the order listed. Although many solvents will dissolve some fibers, following this order will help in identifying the specific fiber. Stir the specimen for 5 minutes and note the effect. Fiber, yarns, or small pieces of fabric may be used. Remember that the liquids are hazardous—handle them with care! Use chemical laboratory exhaust hoods, gloves, aprons, and goggles.

TABLE 3-8 Solubility tests.

Solvent (in order of increasing strength)

Acetic acid, 100%, 20°C Acetone, 100%, 20°C Hydrochloric acid, 20% concentration, 1.096 density, 20°C Sodium hypochlorite solution, 5%, 20°C Xylene (meta), 100%, 139°C

Dimethyl formamide, 100%, 90°C Sulfuric acid, 70% concentration, 38°C Cresol (meta), 100%, 139°C Fiber dissolved

Acetate

Acetate, modacrylic, vinyon Nylon 6; nylon 6,6; vinal

Silk and wool (silk dissolves in 70% sulfuric acid at 38°C), azlon Olefin and saran (saran in 1.4 dioxane at 101°C; olefin is not soluble), vinyon

Spandex, modacrylic, acrylic, acetate, vinyon Cotton, flax, rayon, nylon, acetate, silk Polyester, nylon, acetate

Key Terms

Natural fiber Manufactured fiber Staple fiber

Filament fiber Filament tow Denier

Tex

Denier per filament (dpf)

Fiber crimp
Fabric crimp
Generic group
Polymerization
Polymer

Degree of polymerization

Amorphous Crystalline Orientation Stretching Drawing

Hydrogen bonds van der Waals' forces Abrasion resistance Absorbency

Aging resistance Allergenic potential Chemical reactivity Cohesiveness

Compressibility

Cover Creep Density Specific gravity Dimensional stability

Drape

Dyeability Elasticity Elastic recovery Electrical conductivity

Elongation Feltability Flammability Flexibility Hand

Heat conductivity
Heat retention
Heat sensitivity
Hydrophilic
Hydrophobic
Hygroscopic
Loft

Mildew resistance Modulus Moth resistance

Luster

Oleophilic Pilling Resiliency Stiffness Rigidity Strength Tensile stre

Tensile strength

Tenacity

Sunlight resistance

Texture Translucence Wicking

Shrinkage resistance

Questions

- 1. Define each of the key terms listed in Table 3–1.
- 2. Differentiate between the following pairs of related terms:

elongation and elasticity absorbency and wicking loft and resiliency heat conductivity and heat sensitivity hand and texture

- **3.** How would performance change when a fiber's shape is changed from round to trilobal?
- **4.** What differences in performance might you expect from fibers used to produce a T-shirt, carpet in a movie theater, and an outdoor banner?
- **5.** Describe polymerization and the possible arrangements of molecules within fibers.
- 6. What would be an efficient procedure to identify the fiber content of an unknown fabric?

Suggested Readings

AATCC Council on Technology (1977). *Textile Fibers and Their Properties*. Research Triangle Park, NC: American Association of Textile Chemists and Colorists.

American Fiber Manufacturers Association (1988).

Manufactured Fiber Fact Book. Washington, DC:
American Fiber Manufacturers Association.

American Society for Testing and Materials (1999). *Annual Book of ASTM Standards*, Vol. 7. Philadelphia: ASTM.

Man-made fiber chart (August, 1992). Textile World.
Tortora, P. G., and Merkel, R. S. (1996). Fairchild's
Dictionary of Textiles, 7th ed. New York: Fairchild
Publications.

Chapter 4

NATURAL CELLULOSIC FIBERS

OBJECTIVES

- To identify cellulosic fibers.
- To understand characteristics common to all cellulosic fibers and the differences among those most commonly used.
- To know the basic steps in processing these fibers.
- To integrate the properties of natural cellulosic fibers with market needs.

ll plants contain fibrous bundles that give strength to the stem and root, pliability to the leaves, and cushion or protect developing seeds. In some plants, these fibrous bundles can be removed from the plant in an easy and economical process and used in textile products. These natural cellulosic fibers are classified according to the plant component from which they are removed (see Table 4–1): seed, stem (bast) or leaf.

Cotton, a seed fiber, grows within a pod or boll from developing seeds. Flax, a bast fiber, is obtained from the stem and root of the plant. Sisal, a leaf fiber, is removed from the veins or ribs of a leaf.

These fibers are all cellulosic, but they differ in the percentage of cellulose present and in the physical structure. While the arrangement of the molecular chains in these fibers is similar, it varies in orientation and length. Thus, performance characteristics related to these aspects differ. Fabrics made from these fibers differ in appearance and hand but react to chemicals in essentially the same way and require similar care. Properties common to all cellulosic fibers are summarized in Table 4–2.

This chapter discusses major natural cellulosic fibers and those of more limited use that may be present in imported goods or that may be encountered during travel or in certain careers. In addition, while several of these fibers may not be common in apparel, they are important in the furnishings industry. Many other natural cellulosic fibers will not be discussed because of their minimal commercial use.

Seed Fibers

Seed fibers are from the seedpod of the plant. The first step in the production of seed fibers is to separate the fiber from the seed. (The seed may be used in producing oil and feed for animals.) By far the most important seed fiber is cotton. This section discusses cotton and some minor seed fibers.

Natural cellulosic fibers.	
Bast Fibers	Leaf Fibers
Flax	Piña
Ramie	Abaca
Hemp	Sisal
Jute	Henequen
Kenaf	
	Bast Fibers Flax Ramie Hemp Jute

Cotton

Cotton is the most important apparel fiber. In 1999, cotton met 54 percent of the worldwide demand for apparel fiber. It is an important cash crop in more than 80 countries. Its combination of properties—pleasing appearance, comfort, easy care, moderate cost, and durability—make cotton ideal for warm-weather clothing, activewear, work clothes, upholstery, draperies, area rugs, towels, and bedding. Even though other fibers have encroached on the markets that cotton once dominated, the cotton look is maintained. Cotton is a major component of many blended fabrics.

Cotton cloth was used by the people of ancient China, Egypt, India (where the cotton spinning and weaving industry began), Mexico, and Peru. In the Americas, naturally colored cotton was used extensively.

Cotton was grown in the southern U.S. colonies as soon as they were established. Throughout the 1600s and 1700s, cotton fibers were separated from cotton seeds by hand. This was a very time-consuming and tedious job; a worker could separate only one pound of cotton fiber from the seeds in a day.

When Eli Whitney mechanized the saw-tooth cotton gin in 1793, things changed. The gin could process 50 pounds of cotton in a day; thus more cotton could be prepared for spinning. Within the next 20 years, a series of spinning and weaving inventions in England mechanized fabric production. The Southern states were able to meet Britain's greatly increased demand for raw cotton. By 1859, U.S. production was 4.5 million bales of cotton—two-thirds of the world's production. Cotton was the leading U.S. export. During the time of rapidly expanding cotton production in the South, most U.S. fabrics were spun and woven in New England.

The picture again changed dramatically during the Civil War. U.S. cotton production decreased to 200,000 bales in 1864, and Britain looked to other countries to fill its needs. After the war, Western states began producing cotton and the Southern states built spinning and weaving mills. Between World War I and World War II, most of the New England mills moved south. Factors influencing this move included proximity to cotton producers, less expensive power and nonunion labor, and relocation incentives from state and local governments. By 1950, 80 percent of the mills were in the South. In the 1980s, many of the same mills closed because of increased costs and competition from imports.

Production of Cotton

Cotton grows in any place where the growing season is long and the climate is temperate to hot with adequate rainfall or irrigation. Cellulose will not form if the tem-

TABLE 4-2	Properties	common	to all	cellulosic	fibers.
-----------	-------------------	--------	--------	------------	---------

Importance to Consumer **Properties** Good absorbency Comfortable for summer wear and furnishings Good for towels, diapers, and active sportswear Good conductor of heat Sheer fabrics cool for summer wear Fabrics can be boiled or autoclaved to sterilize them; no special Ability to withstand high temperature precautions in pressing Fabrics wrinkle badly unless finished for wrinkle recovery Low resiliency Dense, high-count fabrics possible Lacks loft; packs well into compact yarns Wind-resistant fabrics possible No static buildup Good conductor of electricity Fabrics are heavier than comparable fabrics of other fibers Heavy fibers (density of ± 1.5) Harmed by mineral acids, minimal damage by organic acids Acid stains should be removed immediately Store clean items under dry conditions Attacked by mildew Resistant to moths, but eaten by crickets and silverfish Store clean items under dry conditions Flammable Ignite quickly, burn freely with an afterglow and gray, feathery ash; loosely constructed garments should not be worn near an open flame; furnishings should meet required codes Draperies should be lined Moderate resistance to sunlight

perature is below 70°F. In the United States, cotton is grown from southern Virginia to central California and south of that line.

The major producers of cotton are China (21.4 percent), the United States (18.7 percent), India (14.5 percent), Eastern Europe (9.2 percent), Pakistan (9.1 percent), Turkey (4.2 percent), and Brazil (2.5 percent). In 1999 the worldwide production of cotton was over 88.6 million bales. Mechanization and weed control have reduced the number of hours required to produce a bale of cotton, thereby increasing productivity.

Factors affecting the U.S. production of cotton include the value of the dollar as compared with other currencies, imports of cotton goods, changes in government incentives for growing cotton, weather conditions, and comparable changes in other countries.

Cotton grows on bushes 3 to 6 feet high. After the blossom drops off, the *boll* or seedpod begins to grow. Inside the boll are seven to eight seeds. Each cotton seed may have as many as 20,000 fibers growing from its surface. When the boll is ripe, the fluffy white fibers expand as they grow and eventually split open the boll (Figure 4–1).

Cotton most often is picked by machine (Figure 4–2). This cotton contains many immature fibers—an inescapable result of mechanically stripping a cotton plant. After picking, the cotton is taken to a **gin** to separate the fibers and the seeds. Figure 4–3 shows a saw gin, in which the whirling saws pick up the fiber and carry it to a knifelike comb, which blocks the seeds and permits the fiber to be carried through. The fibers, called

lint, are pressed into bales weighing 480 pounds, and sold to a spinning mill.

After ginning, the seeds are covered with very short fibers—1/8 inch in length—called **linters**. The linters are removed from the seeds and are used to a limited extent as raw material in producing rayon and acetate. Linters also are converted into cellophane, photographic film, fingernail polish, and methylcellulose, which is used in makeup and chewing gum. The seeds are crushed to obtain cottonseed oil and meal.

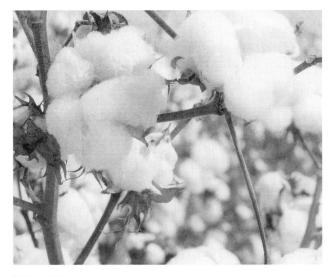

FIGURE 4-1
Opened cotton boll. (Courtesy of National Cotton Council of America.)

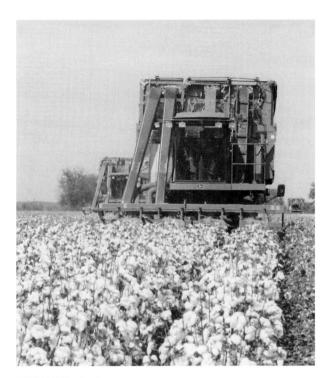

FIGURE 4–2

Harvester in a cotton field. (Courtesy of National Cotton Council of America.)

Recent advances in plant breeding have produced cottons that are insect-, herbicide-, and stress-tolerant. Cotton breeders have focused their efforts on improving fiber strength and length. These changes have contributed to higher processing speeds, finer and more uniform yarns, and more-durable fabrics. Efforts in plant breeding continue to focus on producing cotton varieties with better insect, disease, herbicide, and drought resistance and with enhanced properties for better processing ease, enhanced reactivity for dyes, and consumer performance. Some bioengineered cotton plants have been developed that incorporate a tiny percentage of polyester in the fiber. In addition, some plant breeders are focusing on performance characteristics and color options of naturally colored cotton.

Physical Structure of Cotton

Although some naturally colored cotton is produced, most raw cotton is creamy white in color. The fiber is a single cell, which grows from the seed as a hollow tube over one thousand times as long as it is thick.

Length Staple length is very important because it affects how the fiber is handled during spinning, and it relates to fiber fineness and fiber tensile strength. Longer cotton fibers are finer and make stronger yarns.

Cotton fibers range in length from 1/2 inch to 2 inches, depending on the variety. Three groups of cotton are commercially important:

- 1. Upland cottons (*Gossypium hirsutum*; the predominant type of cotton produced in the United States) are 7/8 to 1 1/4 inches in length and were developed from cottons native to Mexico and Central America. Approximately 97 percent of the U.S. crop is an Upland variety.
- 2. Long-staple cottons, which are 1 5/16 to 1 1/2 inches in length, were developed from Egyptian and South American cottons. Varieties include American Pima, Egyptian, American Egyptian, and Sea Island cottons. Cotton from Gossypium barbadense is grown in the southwestern United States and is about 3 percent of the crop.
- 3. Short-staple cottons, Gossypium arboreum and Gossypium herbaceum, are less than 3/4 inch in length and are produced primarily in India and eastern Asia.

Long-staple fibers are considered to be of higher quality and are used to produce softer, smoother, stronger, and more lustrous fabrics. Because their perceived value is higher, they are sometimes identified on a label or tag as Pima, Supima, Egyptian, or Sea Island. Or they may be referred to as long-staple or extra-long-staple (ELS) cotton.

Distinctive Parts The cotton fiber is made up of a cuticle, primary wall, secondary wall, and lumen (Figure 4–4). The fiber grows to almost full length as a hollow tube before the secondary wall begins to form.

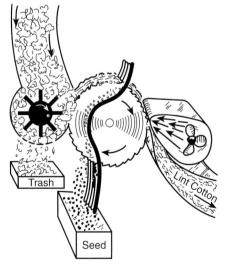

FIGURE 4-3 Cotton gin.

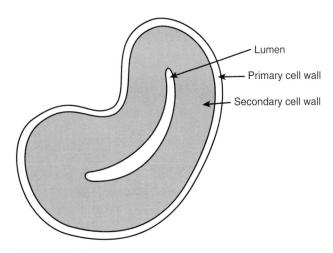

FIGURE 4–4
Cross section of mature cotton fiber.

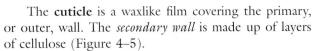

The layers deposited at night differ in density from those deposited during the day; this causes growth rings, which can be seen in the cross section. The cellulose layers are composed of *fibrils*—bundles of cellulose chains—arranged in a spiral that sometimes reverses direction. These *reverse spirals* (Figure 4–6) contribute to the development of convolutions that affect the fiber's elastic recovery and elongation. They are also 15 to 30 percent weaker than the rest of the secondary cell wall.

Cellulose is deposited daily for 20 to 30 days, until, in the mature fiber, the fiber tube is almost solid. The **lumen** is the central canal, through which nourishment travels during fiber development. When the fiber matures, dried nutrients in the lumen may result in dark areas that are visible under a microscope.

Convolutions Convolutions are ribbonlike twists that characterize cotton (Figure 4–7). When the fibers mature and force the boll open, they dry out and the cen-

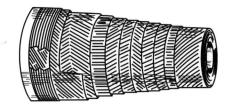

FIGURE 4-5
Layers of cellulose (schematic).

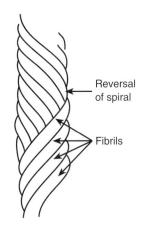

FIGURE 4-6
Reverse spirals in cotton fiber.

tral canal collapses. Reverse spirals in the secondary wall cause the fibers to twist. The twist forms a natural texture that enables the fibers to cling to one another. Thus, despite its short length, yarn spinning is easy with cotton. However, the convolutions may trap soil, requiring vigorous cleaning to remove it. Long-staple cotton has about 300 convolutions per inch; short-staple cotton has less than 200.

Fineness Cotton fibers vary from 16 to 20 micrometers in diameter. The cross-sectional shape varies with the maturity of the fiber. Immature fibers tend to be Ushaped, with a thin cell wall. Mature fibers are more nearly circular, with a thick cell wall and a very small

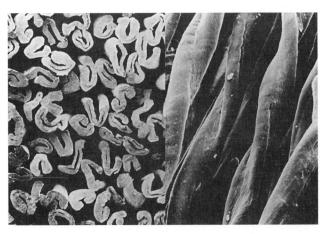

FIGURE 4-7

Photomicrographs of cotton: cross-sectional view (left); longitudinal view (right). (Courtesy of the British Textile Technology Group.)

central canal or lumen. Every cotton boll contains some immature fibers that can create problems in spinning and dyeing. In Figure 4–7, notice the variation in size and shape of the fibers.

Color Cotton is available in a range of colors. Naturally creamy white is highly desirable because it can be dyed or printed to meet fashion and consumer needs. These fibers may yellow with age. If it rains just before harvest, cotton becomes grayer.

Naturally colored cotton fibers have been cultivated for thousands of years. As commercial production replaced hand processes, these fibers declined in importance. By the early 20th century, they had become difficult to find. However, with the current interest in minimizing environmental impact, interest in naturally colored cottons has resurfaced. Naturally colored cottons produce less fiber per acre, but sell for about twice the price of white cotton. Naturally brown, rust, red, beige, and green cottons are commercially available. These colors deepen with age and care, which is contrary to the aging process of most colored fabrics. (See Figure 4-8.) Colored cottons are shorter and have less uniform properties than do white cotton, but improvements are expected as plant breeders concentrate on enhancing these properties. Naturally colored cottons are produced in Russia, India, South and Central America, and the United States, mostly in Arizona and Texas. Plant breeders hope to add blue, lavender, and yellow to the current market colors.

Picking and ginning affect the appearance of cotton fibers. Carefully picked cotton is cleaner. Well-ginned cotton tends to be more uniform in appearance and more uniform in color. Poorly ginned cotton contains brown flecks of *trash*, such as bits of leaf, stem, or dirt that decrease fiber quality. Fabrics made from such fibers include utility cloth, and may be fashionable when a "natural" look is popular.

Classification of Cotton

Grading and classing of cotton is done by hand and by machine HVI (high-volume instrument) systems. Fiber characteristics, staple length, and color of the cotton from the bale are compared with standards prepared by the U.S. Department of Agriculture.

Cotton classification describes the quality of cotton in terms of staple fiber length, grade, and character. Fiber-length classifications for cotton include very-short-staple cotton (less than 0.25 inch), short-staple cotton (0.25 to 0.94 inch), medium-staple cotton (0.94 to 1.13 inches), ordinary long-staple cotton (1.13 to 1.38 inches), and extra-long-staple cotton (>1.38 inches). Staple length is based on the length of a representative bundle of fibers from a bale of cotton. There are 19 staple lengths, ranging from less than 13/16 inch to 1 3/8 inches and beyond. A sample classified as 15/32 inch likely will have fibers ranging in length from 1/8 inch to 1 5/8 inches, as shown in Figure 4–9.

FIGURE 4-8

Naturally colored cotton fibers and fabrics. Fabrics (top swatches of pairs) become darker with laundering.

FIGURE 4-9
Cotton classed as 1 5/32 inch contains fibers that range in length from 1/8 inch to 1 5/8 inch. (Courtesy of U.S. Department of Agriculture.)

Grade refers to the color of the fiber and the absence of dirt, leaf matter, seed particles, motes or dead fibers, and tangles of fiber. Mote fibers will not absorb dyes; they lower fiber quality and cause defects in fabrics. The best-quality grade is lustrous, silky, white, and clean. There are 39 grades of cotton. The predominant grade of cotton produced in the United States is strict low-middling cotton. Strict in this case means "better than."

This grading system is used primarily for the creamy white fibers that dominate the market. Color is described in terms that range from white to light-spotted, spotted, tinged, and yellow. Color also is described in terms of lightness to darkness: plus, light gray, and gray. This factor is a combination of grayness and the amount of leaf present in white cotton grades.

Character refers to other fiber aspects, including maturity, smoothness and uniformity of fibers within the bale, fiber fineness, strength, and convolutions. Micronaire values, which reflect both fineness and maturity are sometimes assessed. Character refers to the amount of processing necessary to produce a good white fabric for commercial use. Because of yearly variations in growing conditions and variations in geographic locations, yarn and fabric producers carefully select and blend cotton so that cotton fabrics and products are as uniform as possible.

Cotton is a commodity crop. It is sold by grade and staple length. Strict low-middling cotton is used in mass-produced cotton goods and in cotton/synthetic blends. Better grades of cotton and longer-staple cotton are used in better quality shirtings and sheets. Extra-long-staple (ELS) American Egyptian cotton usually is identified by the term *Pima* and *Supima* on labels for sweaters, blouses, shirts, underwear, sheets, and towels.

Chemical Composition and Molecular Arrangement of Cotton

Cotton, when picked, is about 94 percent cellulose; in finished fabrics it is 99 percent cellulose. Like all cellu-

lose fibers, cotton contains carbon (C), hydrogen (H), and oxygen (O) with reactive hydroxyl groups. The basic monomer of cellulose is *glucose*. Cotton may have as many as 10,000 glucose monomers per molecule connected in long linear chains and arranged in a spiral form within the fiber. Chain length (average number of glucose monomers per molecule) contributes to fiber strength.

Chemical Nature of Cellulose

The chemical reactivity of cellulose is related to the hydroxyl groups (–OH) of the glucose unit. These groups react readily with moisture, dyes, and many finishes. Chemicals such as chlorine bleach damage cellulose by attacking the oxygen atom between the two ring units or within the ring, rupturing the chain or ring.

Cotton can be altered by using chemical treatments or finishes. Mercerization (treating yarns or fabrics with sodium hydroxide [NaOH]) causes a permanent physical change. The fiber swells and the cross section becomes rounder. Mercerization increases absorbency and improves the dyeability of cotton yarns and fabrics. Liquid ammonia is used as an alternative to several preparation finishes, especially mercerization. Fabrics treated with ammonia have good luster and dyeability. When these fabrics are treated to be wrinkle-resistant, they are not as stiff and harsh as mercerized wrinkle-resistant fabrics.

Properties of Cotton

Cotton is a comfortable fiber. Appropriate for year-round use, it is the fiber most preferred for many furnishings and for warm-weather clothing, especially where the climate is hot and humid. Reviewing the fiber property tables in Chapter 3 will help when comparing cotton's performance to that of other fibers.

Aesthetic Cotton fabrics certainly have consumer acceptance. Their matte appearance and low luster are the standards that have been retained with many blends used in apparel and furnishings.

Long-staple cotton fibers contribute luster to fabrics. Mercerized and ammonia-treated cotton fabrics have a soft, pleasant luster resulting from the finishes; cotton sateen's luster is due to a combination of fabric structure and finishing.

Drape, luster, texture, and hand are affected by choice of yarn size and type, fabric structure, and finish. Cotton fabrics range from soft, sheer batiste to crisp, sheer voile to fine chintz to sturdy denim and corduroy.

Durability Cotton is a medium-strength fiber, with a dry breaking tenacity of 3.5 to 4.0 g/d (grams per denier). It is 30 percent stronger when wet. Long-staple cotton produces stronger yarns because there are more contact points among the fibers when they are twisted together. Because of its higher wet strength, cotton can be handled roughly during laundering and in use.

Abrasion resistance is good; heavy fabrics are more abrasion-resistant than thinner fabrics. Fiber elongation is low (3 percent), with low elasticity.

Comfort Cotton makes very comfortable fabrics for skin contact because of its high absorbency, soft hand, and good heat and electrical conductivity (static buildup is not a problem). It has no surface characteristics that irritate the skin. Cotton has a moisture regain of 7 to 11 percent. When cotton becomes wet, the fibers swell and become more pliant. This property makes it possible to give a smooth, flat finish to cotton fabrics in pressing or finishing and makes high-count woven fabrics water-repellent. However, as cotton fabrics absorb more moisture in damp conditions, they feel wet or clammy and eventually may become uncomfortable.

Still, cotton is good for use in hot and humid weather. The fibers absorb moisture and feel good against the skin in high humidity. The fiber ends in the spun yarn hold the fabric slightly off the skin for greater comfort. Moisture passes freely through the fabric, thus aiding evaporation and cooling.

Appearance Retention Overall appearance retention for cotton is moderate. It has very low resiliency. The

hydrogen bonds holding the molecular chains together are weak, and when fabrics are bent or crushed, particularly in the presence of moisture, the chains move freely to new positions. When pressure is removed, these weak internal forces cannot pull the chains back to their original positions, so the fabrics stay wrinkled. Creases can be pressed in and wrinkles can be pressed out, but wrinkling during use and care remain a problem. However, cotton fibers can be given a durable-press finish or blended with polyester and given a durable-press finish so they do not wrinkle as easily. Unfortunately, these finishes decrease fiber strength and abrasion resistance.

Cotton's poor resiliency means that it is seldom used in pile rugs or carpets. However, research is underway to examine how to improve cotton's performance in this significant market.

All-cotton fabrics shrink unless they have been given a durable-press finish or a shrinkage-resistant finish. Untreated cottons shrink less when washed in cool water and drip-dried; they shrink more when washed in hot water and dried in a hot dryer. When they are used again, they tend to stretch out slightly—think of cotton denim jeans or fitted cotton sheets.

Shrinkage should not be noticeable for all-cotton fabrics that have been given a wrinkle-resistant or durable-press finish or that have been treated for shrinkage. However, more effort may be needed with handwoven or short-staple cotton fabrics, unless the label includes specific information about shrinkage.

Elastic recovery is moderate. Cotton recovers 75 percent from a 2 to 5 percent stretch. In other words, cotton tends to stay stretched out in areas of stress, such as in the elbow or knee areas of garments.

Care Cotton can be washed with strong detergents and requires no special care during washing and drying. White cottons can be washed in hot water. Many dyed cottons retain their color better if washed in warm, not hot, water. If items are not heavily soiled, cool water cleans them adequately. Cotton releases most soils readily, but soil-resistant finishes are desirable for some furnishing and apparel uses. Use of chlorine bleach is appropriate for spot removal, but should not be used in regular laundering because excessive bleaching weakens cellulosic fibers.

Less wrinkling occurs in the dryer if items are removed immediately after drying. Cotton fabrics respond best to steam pressing or ironing while damp. Fabric blends of cotton and a heat-sensitive fiber need to be ironed at a lower temperature to avoid melting the heat-sensitive fiber. Cotton is not thermoplastic; it can be ironed safely at high temperatures. However, cotton burns readily.

Cotton draperies should be dry-cleaned. Cotton upholstery may be steam-cleaned, with caution. If

shrinkage occurs, the fabric may split or rupture where it is attached to the frame.

Cottons should be stored clean and dry. In damp or humid conditions, mildew can form. Mildew digests cellulose and may cause holes if enough time elapses. If textiles smell of mildew, they can be laundered or bleached to remove the odor. But if the mildew areas are visible dark or black spots, they are permanent and indicate excessive fiber damage.

Cotton is harmed by acids. Fruit and fruit juice stains should be treated promptly with cold water to facilitate their removal. Cotton is not greatly harmed by alkalis. Cotton is resistant to organic solvents, so it can be safely dry-cleaned.

Cotton oxidizes in sunlight, which causes white and pastel cottons to yellow and all cotton to degrade. Some dyes are especially sensitive to sunlight, and when used in window-treatment fabrics the dyed areas disintegrate.

Table 4–3 summarizes cotton's performance in apparel and furnishing fabrics.

Environmental Impact of Cotton

Since cotton is a natural fiber, many environmentally sensitive consumers believe it is a good choice. However, although cotton is a renewable resource, it cannot be produced without some environmental impact.

TABLE 4-3	Summary of	the performance
of cotton in	apparel and fu	rnishing fabrics.

Aesthetics	Attractive
Luster	Matte, pleasant
Drape	Soft to stiff
Texture	Pleasant
Hand	Smooth to rough
Durability	Good
Abrasion resistance	Good
Tenacity	Good
Elongation	Poor
Comfort	Excellent
Absorbency	Excellent
Thermal retention	Poor
Appearance retention	Moderate
Resiliency	Poor
Dimensional stability	Moderate
Elastic recovery	Moderate
Recommended care	Machine wash and dry (apparel)
	Steam- or dry-clean with

Mainstream farming methods make extensive use of agricultural chemicals to fertilize the soil, fight insects and disease, control plant growth, and strip the leaves for harvest. Excess rain can create problems with runoff contaminated with these chemicals, many of which are toxic to other plants, insects, animals, and people. Cotton also uses large quantities of water, energy, and chemicals to clean the fiber and finish and dye the fabrics.

Cotton is a water-intensive crop requiring at least 20 inches of rain per year. In areas where rainfall is less, irrigation is used. In addition, tilling the soil contributes to soil erosion by water and wind. In many areas of the world cotton may be the only cash crop, creating potentially disastrous situations if the crop fails or prices fall.

Soil and natural waxes are removed from the raw cotton fiber before it is processed into yarn. In order to add color in dyeing and printing, cotton is bleached in a chemical and water solution and rinsed. Dyes, pigments, and finishing chemicals add to the consumer appeal of cotton products. All these steps make extensive use of water, other chemicals, and heat. Although the industry has improved recycling, reduced waste, and cleaned up wastewater, the net environmental effect of processing cotton continues to be a concern.

There is some concern about large-scale production of bioengineered cotton in terms of its unknown long-term environmental and health ramifications. Some bioengineered crops such as corn have proven to be harmful to the monarch butterfly and the non-pest insects. Environmentalists also are concerned about the potential of resistance to these bioengineered crops developing in pests.

In an effort to provide consumers and producers with more information at the point of purchase, several terms are used to describe cotton grown under more environmentally friendly conditions. **Organic cotton** is produced following state fiber-certification standards on land where organic farming practices have been used for at least 3 years. No synthetic commercial pesticides or fertilizers are used in organic farming. **Transition cotton** is produced on land where organic farming is practiced, but the 3-year minimum has not been met. **Green cotton** describes cotton fabric that has been washed with mild natural-based soap, but has not been bleached or treated with other chemicals, except possibly natural dyes. The term **conventional cotton** describes all other cotton.

Some retailers and manufacturers have made a commitment to use only organic cotton in their products. (See Figure 4–10.) Organic and transition cotton is approximately twice as expensive as conventional cotton. The additional costs are related to the lower fiber yield per acre, requirements for processing in facilities that are free of hazardous chemicals, and the smaller quantities of fibers that are processed and sold.

FIGURE 4-10

Organic cotton and linen washcloth. Fibers are grown without the aid of commercial fertilizers, herbicides, or insecticides. No bleaches or dyes were used in producing the fabric.

Identification of Cotton

Microscopic identification of cotton is relatively easy. Convolutions are generally clearly visible along the fiber. Burn tests will verify cellulose, but a more precise identification is not possible with this procedure. Fiber length helps in determining content, but remember that long fibers can be broken or cut shorter. Cotton is soluble in strong mineral acids.

Uses of Cotton

Cotton is the single most important apparel fiber in the United States. In 1999, cotton was used in approximately 50 percent of the apparel, 60 percent of the furnishings (excluding floor coverings), and 9 percent of the industrial or technical products sold in the United States. All-cotton fabrics are used when comfort is of primary importance and appearance retention is less important, or when a more casual fabric is acceptable. Cotton blended with polyester in wrinkle-resistant fabrics is easy to find on the market. These blends retain cotton's pleasant appearance, have the same or increased durability, are less comfortable in conditions of extreme heat and humidity or high physical activity, and have better appearance retention as compared with 100 percent cotton fabrics. However, removal of oily soil is a greater problem with blends.

Cotton is a very important furnishing fabric because of its versatility, natural comfort, and ease of finishing and dyeing. Towels are mostly cotton—softness, absorbency, wide range of colors, and washability are important in this end use. Durability is increased in the base fabric, as well as in the selvages and hems, by some-

times blending polyester with the cotton. However, the loops of terry towels are cotton so that maximum absorbency is retained.

Sheets and pillowcases of all cotton or cotton/polyester blends are available in percale, flannelette, jersey, and muslin. Blend levels and counts vary a great deal. Cotton blankets and bedspreads are available in a variety of weights and fabric types.

Draperies, curtains, upholstery fabrics, slipcovers, rugs, and wall coverings are made of cotton. Cotton upholstery fabrics are attractive and durable, comfortable, easy to spot clean, and retain their appearance well. Resiliency is not a problem with the heavyweight fabrics that are stretched over the furniture frame. Cotton is susceptible to abrasion, waterborne stains, and shrinkage if cleaning is too vigorous or incorrect. Small area rugs made from cotton can be machine-washed.

Medical, surgical, and sanitary supplies are frequently made of cotton. Since cotton can be autoclaved (heated to a high temperature to sanitize it), it is widely used in hospitals. Absorbency, washability, and low static buildup are also important properties in these uses.

Industrial uses include abrasives, book bindings, luggage and handbags, shoes and slippers, tobacco cloth, and woven wiping cloths.

Cotton Incorporated is an organization that promotes the use of cotton by consumers. It also promotes the use of all-cotton and Natural Blend® fabrics with at least 60 percent cotton (see Figure 4–11). The National Cotton Council is an organization of producers, processors, and manufacturers.

THE FABRIC OF OUR LIVES™

FIGURE 4-11

Cotton® seal (top) for 100 percent cotton fabrics and apparel, and Natural Blend® seal (bottom) used for fabrics and apparel made of at least 60 percent cotton. (Courtesy of Cotton Incorporated.)

Coir

Coir is obtained from the fibrous mass between the outer shell and the husk of the coconut. It is sometimes sold as cocoa fiber. The fibers are removed by soaking the husk in saline water. Coir, which is very stiff, is naturally cinnamon-brown. It can be bleached and dyed. It has good abrasion-, water-, and weather-resistance. Available from Sri Lanka, coir is an important fiber for indoor and outdoor mats, rugs, and floor tiles. Its stiff, wiry texture and coarse size produce fabrics whose weave, pattern, or design is clearly visible. These floor textiles are extremely durable and blend with furnishings of many styles.

Kapok

Kapok is obtained from the seed of the Java kapok or silk cotton tree. The fiber is lightweight, soft, hollow and very buoyant, but it quickly breaks down. The fiber is difficult to spin into yarns, so it is used primarily as fiberfill in some imported items from Java, South America, and India.

Bast Fibers

Bast fibers come from the stem of the plant, near the outer edge (Figure 4–12). Hand labor may be used to process bast fibers, and production has flourished in countries where labor is cheap. Since the fiber extends into the root, harvesting is done by pulling up the plant

or cutting it close to the ground to keep the fiber as long as possible. After harvesting, the seeds are removed by pulling the plant through a machine in a process called **rippling**.

Bast fibers lie in bundles in the stem of the plant, just under the outer covering or bark. They are sealed together by a substance composed of pectins, waxes, and gums. To loosen the fibers so that they can be removed from the stalk, the pectin must be decomposed by a process called retting (bacterial rotting). The process differs for individual fibers, but the major steps are the same. Retting can be done in the fields (dew retting) or in stagnant ponds, pools, or tanks (water retting), where the temperature and bacterial count can be carefully controlled; with special enzymes; or with chemicals such as sodium hydroxide. Chemical retting is much faster than any other method. However, extra care must be taken or the fiber can be irreversibly damaged. Retting can create problems with water quality if the retting water is released directly into streams or lakes. Dew retting is done in many areas because of its minimal environmental impact.

After the stems have been rinsed and dried, the woody portion is removed by **scutching**, a process that crushes the outer covering when the stalks are passed between fluted metal rollers. Most of the fibers are separated from one another, and the short and irregular fibers are removed by **hackling**, or combing. This final step removes any remaining woody portion and arranges the fibers in a parallel fashion. Figure 4–13 shows the plant or fiber at each step in processing.

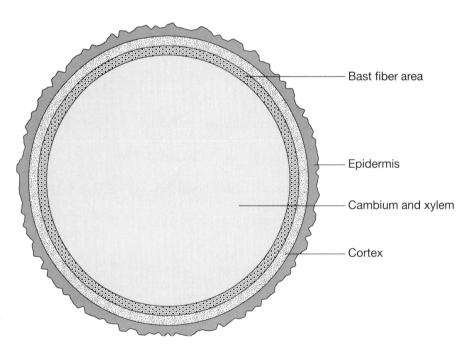

FIGURE 4-12

Bast fibers are located toward the epidermis of the plant stem.

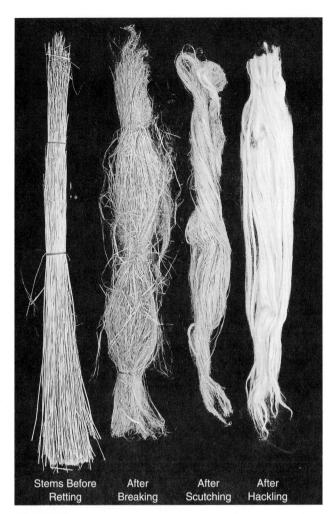

FIGURE 4–13
Flax fiber at different stages of processing.

Bast fibers characteristically have thick-and-thin variations in their appearance when processed into yarns and fabrics. This occurs because fiber bundles are never completely separated into individual or primary fibers.

Because the processing of bast fibers is time-consuming and requires specialized machinery, researchers have developed ways of speeding up the process and minimizing the need for special equipment. Cottonizing reduces a bast fiber to a length similar to that of cotton. These cottonized fibers can be processed on equipment designed for cotton, but may lack some of their more traditional characteristics related to hand, luster, and durability. Flax, ramie, and hemp are examples of bast fibers that may be cottonized.

Flax

Flax is one of the oldest textile fibers. Fragments of linen fabric have been found in prehistoric lake dwellings

in Switzerland; linen mummy wraps more than 3000 years old have been found in Egyptian tombs. The linen industry flourished in Europe until the 18th century. With the invention of power spinning, cotton replaced flax as the most important and widely used fiber.

Today, flax is a prestige fiber as a result of its limited production and relatively high cost. The term **linen** refers to fabric made from flax. However, the term *linen* may be misused when it refers to fabrics of other fibers made of thick-and-thin yarns with a heavy body and crisp hand. *Irish linen* always refers to fabrics made from flax. (Because of its historic wide use in sheets, tablecloths, and towels, the word *linen* is used to refer to bed and bath textiles.)

The unique and desirable characteristics of flax are its body, strength, durability, low pilling and linting tendencies, pleasant hand, and thick-and-thin texture. The main limitations of flax are low resiliency and lack of elasticity.

Most flax is produced in western Europe, in Belgium, France, Italy, Ireland, the United Kingdom, Germany, the Netherlands, and Switzerland. Flax is also produced in Russia, Belarus, and New Zealand.

Structure of Flax

The primary fiber of flax averages 5.0 to 21.5 inches in length and 12 to 16 micrometers in diameter. Flax fibers (*Linum usitatissium*) can be identified microscopically by crosswise markings called **nodes** or *joints* that contribute to its flexibility (Figure 4–14). The nodes may appear to be slightly swollen and resemble the joints in a stalk of corn or bamboo. The fibers have a small central canal similar to the lumen in cotton. The cross section (Figure 4–14) is many-sided or polygonal with rounded edges.

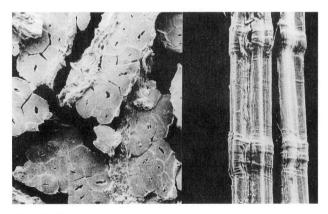

FIGURE 4-14

Photomicrographs of flax: cross-sectional view (left); longitudinal view (right). (Courtesy of the British Textile Technology Group.)

Flax fibers are slightly grayish when dew retted and more yellow when water retted. Because flax has a more highly oriented molecular structure than cotton, it is stronger than cotton.

Flax is similar to cotton in its chemical composition (71 percent cellulose). Compared to cotton, flax has a longer polymer (a higher degree of polymerization) and greater orientation and crystallinity.

Short flax fibers are called **tow**; the long, combed, better quality fibers are called **line**. Line fibers are ready for wet spinning into yarn. The tow fibers must be carded before dry spinning into yarns for heavier fabrics for furnishings.

Properties of Flax

Review the fiber property tables in Chapter 3 to compare the performance of flax with that of other fibers.

Aesthetics Flax has a high, natural luster that is softened by the irregular fiber bundles. Its luster can be increased by flattening yarns with pressure during finishing.

Because flax has a higher degree of orientation and crystallinity and a larger fiber diameter than cotton, linen fabrics are stiffer in drape and harsher in hand. Finishes that wash and air blow the fabric produce softer and more drapeable fabrics.

Durability Flax is strong for a natural fiber. It has a breaking tenacity of 3.5 to 5.0 g/d when dry and 6.5 g/d when wet. Flax has a very low elongation of approximately 7 percent. Elasticity is poor, with a 65 percent recovery at an elongation of only 2 percent. Flax also is a stiff fiber. With poor elongation, elasticity, and stiffness, repeatedly folding a linen item in the same place will cause the fabric to break. The nodes contribute greatly to flexibility, but they are also the weakest part of the fiber. Flax has good flat abrasion resistance for a natural fiber because of its high orientation and crystallinity.

Comfort Flax has a high moisture regain of 12 percent and it is a good conductor of electricity. Hence, static is no problem. Flax is also a good conductor of heat, so it makes an excellent fabric for warm-weather wear. Flax has the same high specific gravity (1.52) as cotton.

Care Flax is resistant to alkalis, organic solvents, and high temperatures. Linen fabrics can be dry-cleaned or machine-washed and bleached with chlorine bleaches. For upholstery and wall coverings, careful steam cleaning is often recommended to avoid shrinkage. Linen

TABLE 4-4 Summary of the performance of flax in apparel and furnishing fabrics.

Aesthetics	Excellent
Luster	High
Texture	Thick-and-thin
Hand	Stiff
Durability	Good
Abrasion resistance	Good
Tenacity	Good
Elongation	Poor
Comfort	High
Absorbency	High
Thermal retention	Good
Appearance retention	Poor
Resiliency	Poor
Dimensional stability	Moderate
Elastic recovery	Poor
Recommended care	Dry-clean or machine-wash (apparel)
	Steam or dry-clean (furnishings)

fabrics have low resiliency and often require pressing. They are more sunlight-resistant than cotton.

Crease-resistant finishes are used on linen, but the resins may decrease flax's strength and abrasion resistance. The wrinkling characteristics of linen make it easy to recognize. Linen fabrics must be stored dry; otherwise mildew will become a problem.

Table 4–4 summarizes flax's performance when used in apparel or furnishing fabrics.

Environmental Impact of Flax

Flax has less of an environmental impact than does cotton. The production of flax requires fewer agricultural chemicals, and irrigation is seldom required. But the practice of pulling the plants during harvest in order to get longer fibers creates problems with soil erosion. Removing the fiber from the stem requires significant amounts of water, but it may be recycled. Depending on the type of retting used, recycling and disposal of chemicals and contaminated water are other areas of concern. Changes in retting practices have occurred because of environmental issues. Dew retting has replaced water retting. Some researchers are investigating enzyme retting as a quicker alternative.

FIGURE 4-15

Linen symbol of quality. (Courtesy of the Masters of Linen/USA.)

Identification Tests

Flax burns readily in a manner very similar to that of cotton. Fiber length is an easy way to differentiate between these two cellulosic fibers. Cotton is seldom more than 2.5 inches in length; flax is almost always longer than that. However, cottonized flax will be more difficult to identify. Flax is also soluble in strong acids.

Uses of Linen

The Masters of Linen, an organization that promotes the use of linen, has developed a trademark to identify linen (Figure 4–15). Linen is used in bed, table, and bath items (22 percent), in other furnishing items for home and commercial use (16 percent), in apparel (50 percent), and in industrial products (12 percent). Linen fabrics are ideal for wallpaper and wall coverings up to 120 inches wide because their irregular texture adds interest, hides nail holes or wall damage, and muffles noise. Linen fabrics are used in upholstery and window treatments because of their durability, interesting and soil-hiding textures, and versatility in fabrication and design.

Linen apparel includes items for warm-weather use, high fashion, or professional wear. Industrial products include luggage, bags, purses, and sewing thread.

In 1998, The Center for American Flax Fiber (CAFF) was established in South Carolina. Its goal is to establish a U.S. flax industry that emphasizes short staple or cottonized flax.

Ramie

Ramie is also known as rhea, grasscloth, China grass, and Army/Navy cloth. It has been used for several thou-

sand years in China. The ramie plant is a tall perennial shrub from the nettle family that requires a hot, humid climate. Ramie is fast-growing and can be harvested as frequently as every 60 days. Thus, several crops can be harvested each year. Because it is a perennial, it is cut, not pulled. It has been grown in the Everglades and Gulf Coast regions of the United States, but it is not currently produced in those areas.

Ramie fibers must be separated from the plant stalk by **decortication**, in which the bark and woody portion of the plant stem are separated from the fiber (83 percent cellulose). Because this process required a lot of hand labor, ramie did not become commercially important until less expensive mechanized ways of decorticating ramie were developed. Because ramie is a relatively inexpensive fiber that can be cottonized and blends well with many other fibers, ramie or ramie blend items are common in the United States. Ramie is produced in China, the Philippines, and Brazil.

Properties of Ramie

Ramie is a white, long, fine fiber with a silklike luster. It is similar to flax in absorbency, density, and microscopic appearance (Figure 4–16). Because of its high molecular crystallinity, ramie is stiff and brittle. Like flax, it will break if folded repeatedly in the same place. Consequently, it lacks resiliency and is low in elasticity and elongation potential. Ramie can be treated to be wrinkle-resistant.

Ramie is one of the strongest natural fibers known; its strength increases when it is wet. It is resistant to insects, rotting, mildew, and shrinkage. Its absorbency is good, but it does not dye as well as cotton.

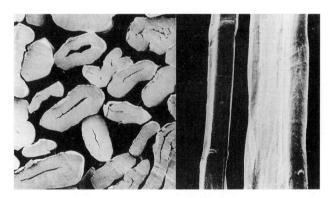

FIGURE 4-16

Photomicrographs of ramie: cross-sectional view (left); longitudinal view (right). (Courtesy of the British Textile Technology Group.)

TABLE 4-5	Summary of	the performance
of ramie in app	parel and fui	nishing fabrics.

Aesth	etics	Good
Luster	r	Matte
Textu	re	Thick-and-thin
Hand		Stiff
Durab	oility	Moderate
Abras	ion resistance	Moderate
Tenac	ity	Good
Elong	ation	Moderate
Comf	ort	Good
Absor	bency	High
	nal retention	Moderate
Appe	arance retention	Poor
Resili		Poor
	nsional stability	Poor
	c recovery	Poor
Recor	nmended care	Dry-clean or machine-wash

Uses Ramie is used in many imported apparel items, including sweaters, shirts, blouses, and suits. It is often blended with other natural fibers. Ramie is important in furnishings, often in blends with other fibers, for window treatments, pillows, and table linens. It is used in ropes, twines, nets, banknotes, cigarette paper, and geotextiles for ground-cover fabrics for erosion control.

Table 4–5 summarizes ramie's performance in apparel and furnishing fabrics.

Hemp

The history of hemp is as old as that of flax. Hemp resembles flax in macroscopic and microscopic appearance; some varieties of hemp are very difficult to distinguish from flax. Although hemp is coarser and stiffer than flax, processing and cottonizing can minimize these differences. Hemp fibers can be very long—3 to 15 feet. Depending on the processing used to remove the fiber from the plant stem, it may be naturally creamy white, brown, gray, almost black, or green. It is 78 percent cellulose and can be machine-washed and dried. Hemp is resistant to ultraviolet light and mold. It has only 5 percent elongation, the lowest of the natural fibers.

The high strength of hemp makes it particularly suitable for twine, cordage, and thread. Hemp is resistant to rotting when exposed to water. Although hemp had been an important industrial fiber for centuries, its importance began to decline in the late 1940s because of competi-

tion from synthetic fibers and regulations controlling the production of drugs—hemp (*Cannabis sativa*) is a close relative of marijuana. New varieties of hemp grown for fiber have less than 1 percent of the compound tetrahydrocannabinol (THC; the hallucinatory agent in marijuana) and are of no value as a source of the drug.

Because of its comfort and good absorbency (8 percent), hemp is used for some apparel and furnishings. Hemp is environmentally friendly and does not require the use of pesticides during its production. It grows quickly and produces 250 percent more fiber than cotton and 600 percent more fiber than flax on the same land. Most hemp fiber is imported from China and the Philippines, but it is also grown in Italy, France, Chile, Russia, Poland, and India. Commercial production of hemp is not allowed in several countries, including the United States. Hemp is found in hats, shirts, shoes, backpacks, T-shirts, and jeans. Hemp also is used as a paper fiber and as litter and bedding for animals. In some areas, it is being grown on land to extract such pollutants as zinc and mercury from the soil.

Jute

Jute was used as a fiber in Biblical times and probably was the fiber used in sackcloth. **Jute**, which is 61 percent cellulose, is one of the cheapest textile fibers. It is grown throughout Asia, chiefly in India and Bangladesh. The primary fibers in the fiber bundle are short and brittle, making jute one of the weakest of the cellulosic fibers.

Jute is creamy white to brown in color. While soft, lustrous, and pliable when first removed from the stalk, it quickly turns brown, weak, and brittle. Jute has poor elasticity and elongation.

Jute is used to produce sugar and coffee bagging, carpet backing, rope, cordage, and twine, but it is facing strong competition from olefin for these end uses. Because jute is losing its market, it is being investigated as a reinforcing fiber in resins to create preformed lowcost housing and in geotextiles.

Burlap or hessian is used for window treatments, area rugs, and wall coverings. Jute has low sunlight resistance and poor colorfastness, although some direct, vat, and acid dyes produce fast colors. It is brittle and subject to splitting and snagging. It also deteriorates quickly when exposed to water. Jute is occasionally used in casual clothing like walking shorts.

Kenaf

Kenaf is a soft bast fiber from the kenaf plant. The fiber is long, light yellow to gray, and harder and more lustrous than jute. Like jute, it is used for twine, cordage,

and other industrial purposes. Kenaf is produced in Central Asia, India, Africa, and some Central American countries. Kenaf is being investigated by U.S. researchers as a source of paper fiber and in blends with cotton.

Leaf Fibers

Leaf fibers are those obtained from the leaf of the plant. Most leaf fibers are long and fairly stiff. In processing, the leaf is cut from the plant and fiber is split or pulled from the leaf. Most leaf fibers have limited dye affinity and may be used in their natural color.

Piña

Piña is obtained from the leaves of the pineapple plant. The fiber is soft, lustrous, and white or ivory. Since piña is highly susceptible to acids and enzymes, rinse out acid stains immediately and avoid detergents or enzyme presoaks. Hand washing is recommended for piña. The fiber produces lightweight, sheer, stiff fabrics. These fabrics are often embroidered and used for formalwear in the Philippines. Piña is also used to make mats, bags, table linens, and other clothing (Figure 4–17). Current research is aimed at producing a commercially competitive piña fiber that can be blended with other fibers.

Abaca

Abaca is obtained from a member of the banana tree family. Abaca fibers are coarse and very long; some may

FIGURE 4-17 Piña place mat.

reach a length of 15 feet. Abaca is off-white to brown in color. The fiber is strong, durable, and flexible. It is used for ropes, cordage, floor mats, table linens, some wicker furniture, and clothing. It is produced in Central America and the Philippines. Abaca is sometimes referred to as Manila hemp, even though it is not a true hemp.

Sisal and Henequen

Sisal and **henequen** are closely related plants. They are grown in Africa, Central America, and the West Indies. Both fibers are smooth, straight, and yellow. They are used for better grades of rope, twine, and brush bristles. However, since both fibers are degraded by salt water, they are not used in maritime ropes.

Sisal is used for upholstery, carpet, and custom rugs that can be hand painted for a custom look. Sisal provides a complementary texture and background for many furnishing styles. Sisal may be used by itself or in blends with wool and acrylic for a softer hand. The dry extraction cleaning method (see Chapter 20) is recommended. Sisal is used in wall coverings, especially in heavy-duty commercial applications, because of its durability and ease of application to a variety of surfaces. Unfortunately, sisal has a tendency to shed and fade out and it absorbs water-borne stains.

Other Cellulosic Materials

Other cellulosic materials are important in furnishings. Rush (stems of a marsh plant), sea grass from China and Vietnam, and maize or cornhusks are used in area rugs because of their resistance to dry heat. Rush and palm fiber seats are often used on wooden frame chairs for a natural look. Yarns made from paper (wood pulp) add interest and texture to wall coverings for interiors. Wooden slats and grasses are found in window treatments. Grasses are especially appealing for wall coverings; the variable weights, thicknesses, and textures add a natural look to interiors. They can be applied to any type of wall surface, treated to be flame retardant, and colored to match the decor.

Wicker furniture is commonly made from tightly twisted paper yarns, rattan, and other such natural materials as sea grass, abaca (banana leaf), and raffia. Wall panels and wall coverings are being produced from shredded straw, bark, and old telephone books because of the interesting texture and shading produced by these materials.

Key Terms

Cotton Rippling Seed fiber Retting Bast fiber Scutching Leaf fiber Hackling Cottonize Gin Lint Flax Linters Linen Nodes Pima cotton Tow Egyptian cotton Sea Island cotton Line

Decortication Cuticle Ramie Lumen Hemp Convolutions Naturally colored cotton Jute Organic cotton Kenaf Transition cotton Piña Green cotton Abaca Conventional cotton Sisal Coir Henequen

Kapok

Questions

- 1. Explain the properties that are common to all cellulosics.
- 2. To what fiber aspects are differences among cellulosic fibers attributed?
- Compare the performance characteristics of ramie and cotton. Why are blends of these two fibers currently available?
- Identify a cellulosic fiber that would be an appropriate choice for each of the following end uses and explain why you selected that fiber.

- sheets for double bed for master bedroom tablecloth for an expensive ethnic restaurant area rug for a designer's showroom woman's sweater for summer wear socks for active 4-year-old child corduroy slacks for a student
- Explain the differences among naturally colored cotton, organic cotton, green cotton, transition cotton, and conventional cotton.

Suggested Readings

- Anonymous (1997, March). Cotton: still the core fiber for consumer textiles. *Textile Month*, pp. 32–34.
- Burnett, P. (1995, February). Cotton naturally. *Textile Horizons*, pp. 36–38.
- Cotton properties. (1994, Spring). Textiles Magazine, p. 16.
 Grayson, M., ed. (1984). Encyclopedia of Textiles, Fibers, and
 Nonwoven Fabrics. New York: Wiley.
- Kerr, N. (1999, January/February). Evaluating textile properties of Alberta hemp. Canadian Textile Journal, pp. 36–38.
- McEvoy, G. (1994–1995, December/January). Linen: one of the world's oldest fibers is ideal for the '90s. *Canadian Textile Journal*, pp. 20–21.
- Ramaswamy, G. (1995–1996, Winter). Kenaf for textiles: revival of an old fiber. *Shuttle, Spindle, & Dyepot*, 27(1), pp. 28–29.
- Schuster, A. M. H., and Walker, H. B. (1995, July/August). Colorful Cotton! *Archaeology*, 48(4), pp. 40–45.
- Thompson, J. (1994, June). Cotton, king of fibers. *National Geographic*, 185(6), pp. 60–87.

Chapter 5

NATURAL PROTEIN FIBERS

OBJECTIVES

- To know the characteristics common to protein fibers and recognize the differences among them.
- To understand the processing of the natural protein fibers.
- To integrate the properties of natural protein fibers with market needs.
- To identify natural protein fibers.

atural protein fibers are of animal origin: wool and specialty wools are the hair and fur of animals, and silk is the secretion of the silk caterpillar. The natural protein fibers are luxury fibers today. Silk, vicuña, cashmere, and camel's hair have always been in this category. Wool is a widely used protein fiber, but it is produced in smaller amounts and at a higher price than it once was.

Protein fibers are composed of various amino acids that have been formed in nature into polypeptide chains with high molecular weights, containing carbon (C), hydrogen (H), oxygen (O), and nitrogen (N). Wool also contains sulfur. Protein fibers are amphoteric, having both acidic and basic reactive groups. The protein of wool is keratin, whereas that of silk is fibroin.

The following is a simple formula for an amino acid, where R refers to a simple organic functional group:

Protein fibers have some common properties because of their similar chemical composition (Table 5–1). These fibers absorb moisture without feeling wet; they are **hygroscopic**. This phenomenon explains why items made from protein fibers are comfortable to use. Hygroscopic fibers minimize sudden temperature changes at the skin. In the winter, when people go from dry indoor air into damp outdoor air, wool absorbs moisture and generates heat, protecting the wearer from the cold. Silk and wool differ in some properties because of their physical and molecular structures.

Wool

Because of their high initial cost and the cost of their care, many consumers consider wool garments and furnishings to be investments. These factors have encouraged the substitution of acrylic, polyester, or wool/synthetic blends in many products. However, wool's combined properties are not equaled by any manufactured fiber: ability to be shaped by heat and moisture, good moisture absorption without feeling wet, excellent heat retention, water repellency, feltability, and flame-retardant.

Wool was one of the earliest fibers to be spun into yarns and woven into cloth. Wool was one of the most widely used textile fibers before the Industrial Revolution. Sheep were probably among the first animals to be domesticated. The fleece of primitive sheep consisted of a long, hairy outercoat (kemp) and a light, downy undercoat. The fleece of present-day domesticated sheep is primarily the soft undercoat. The Spanish developed the Merino sheep, whose fleece contains no kemp fiber. Some kemp is still found in the fleece of all other sheep breeds.

Sheep raising on the Atlantic seaboard began in the Jamestown, Virginia, colony in 1609 and in the Massachusetts settlements in 1630. From these centers, the sheep-raising industry spread rapidly. In 1643 in the Massachusetts Bay colony, English wool combers and carders began to produce and finish wool fabric. This was the beginning of the New England textile industry. Following the U.S. Civil War, sheep production expanded with the opening of free grazing lands west of the Mississippi. By 1884, the peak year, 50 million sheep were found in the United States; the numbers of sheep have declined steadily since then.

Production of Wool

In 1998, wool was produced by Australia (28.1 percent), China (12.2 percent), Eastern Europe (10.3 per-

Properties	Importance to Consumer
Resiliency	Resist wrinkling. Wrinkles disappear between uses. Fabrics maintain their shape.
Hygroscopic	Comfortable in cool, damp climate. Moisture prevents brittleness in carpets.
Weaker when wet	Handle carefully when wet. Wool loses about 40 percent of its strength and silk loses about 15 percent when wet.
Specific gravity	Fabrics feel lighter than cellulosics of the same thickness.
Harmed by alkali	Use neutral or only slightly alkaline soap or detergent. Perspiration weakens the fiber.
Harmed by oxidizing agents	Chlorine bleaches damage fiber so should not be used. Sunlight causes white fabrics to yellow.
Harmed by dry heat	Wool becomes harsh and brittle and scorches easily with dry heat. Use steam. White silk and woo will yellow.
Flame resistance	Do not burn readily and self-extinguish; have odor of burning hair; form a black, crushable ash.

FIGURE 5-1
Merino sheep. (Courtesy of the Wool Bureau, Inc., and International Wool Secretariat.)

cent), and New Zealand (10.2 percent). The United States ranked tenth, with only 1.1 percent of world production.

Merino sheep produce the most valuable wool (Figure 5–1). Australia produces about 43 percent of the Merino wool. Good-quality fleeces weigh 15 to 20 pounds. **Merino** wool is 3 to 5 inches long and very fine. It is used to produce high-quality products with a soft hand and luster and good drape and wear.

Fine wool is produced in the United States by four breeds of sheep: Delaine-Merino, Rambouillet, Debouillet, and Targhee. The majority of this fine wool is produced in Texas and California. It is 2 1/2 inches long. These fine wools are often used for products that compete with higher-priced Merino wools.

The greatest share of U.S. wool production is of medium-grade wools removed from animals raised for meat. These wools have a larger diameter than the fine wools and a greater variation in length, from 1 1/2 to 6 inches. They are used for products such as carpeting, where the coarser fiber contributes high resiliency and good abrasion resistance. Fifteen breeds of sheep are commonly found in the United States. The breeds vary tremendously in appearance and type of wool produced. Sheep are raised in every state of the United States, with the exception of Hawaii, but most sheep are raised in the western United States.

Sheep are generally sheared once a year, in the spring. The fleece is removed in just minutes with power shears that look like large barber's shears. A good shearer can handle 100 to 225 sheep per day. The fleece is removed in one piece with long, smooth strokes, beginning at the legs and belly. A good shearer leaves the fleece in one piece. After shearing, the fleece is folded together and bagged to be shipped to market.

As alternatives to shearing, both a chemical feed additive and an injection have been developed. When digested, the feed additive makes the wool brittle. Several

weeks later, the fleece can be pulled off the sheep. The injection causes the sheep to shed the fleece a week or so later. Both alternatives decrease shearing costs.

Newly removed wool is **raw wool** or **grease wool** and contains between 30 and 70 percent by weight of such impurities as sand, dirt, grease, and dried sweat (*suint*). Removing these impurities produces **clean** or **scoured wool**. The grease is purified to *lanolin* and used in creams, cosmetics, soaps, and ointments.

Grading and sorting are two marketing operations that group wools of like character together. **Grading** is evaluating the whole fleece for fineness and length. In **sorting**, the individual fleece is separated into sections of fibers of different quality. The best-quality wool comes from the sides, shoulders, and back; the poorest wool comes from the lower legs. Wool quality helps determine use. For example, fine wool works well in a lightweight worsted fabric, while a coarse wool works well in carpets. Fineness, color, crimp, strength, length, and elasticity are characteristics that vary with the breed of the sheep. However, research in genetic engineering of sheep is directed toward altering these physical characteristics and performance properties of wool.

Types and Kinds of Wool

Many types of wool are used in yarns and fabrics. Although breeds of sheep produce wools with different characteristics, labels on wool products rarely state that information; the fiber is simply identified as wool. The term *wool* legally includes fiber from such animals as sheep, Angora and Cashmere goats, camel, alpaca, llama, and vicuña.

Sheared wool is removed from live sheep. Pulled wool is taken from the pelts of meat-type sheep. Recycled wool is recovered from worn clothing and cutters' scraps. Lamb's wool comes from animals less than 7 months old. This wool is finer and softer. It has only one cut end: the other end is the natural tip (Figure 5–2). Lamb's wool is usually identified on a label.

Wool is often blended with less expensive fibers to reduce the cost of the fabric or to extend its use. The Federal Trade Commission defines the terms for the labels of wool garments as follows:

Virgin wool—wool that has never been processed. Use of the single term *wool* implies a virgin wool and is a helpful marketing tool.

Wool—new wool or wool fibers reclaimed from knit scraps, broken thread, and noils. (Noils are short fibers that are removed in making worsted yarns.)

Recycled wool—scraps of new woven or felted fabrics that are garnetted (shredded) back to the

FIGURE 5-2 Lamb's wool fiber: natural tip (left); cut tip (right).

fibrous state and reused. Shoddy wool comes from old clothing and rags that are cleaned, sorted, and shredded. Recycled wool may be blended with new wool before being respun and made into fabrics.

Recycled wool is important in the textile industry. However, these fibers may be damaged by the mechanical action of garnetting and/or wear. The fibers are not as resilient, strong, or durable as new wool, yet the fabrics made from them perform well. The terms *recycled wool* or *virgin wool* on a label do not refer to the quality of the fiber, but to the past use of the fiber.

Quality of wool is based on fiber fineness, length, scale structure, color, cleanliness, and freedom from damage caused by environment or processing. The best-quality wools are white, clean, long, free of defects, and fine in size and have a regular scale structure.

Physical Structure of Wool

Length The length of Merino wool fibers ranges from 1 1/2 to 5 inches, depending on the animal and the length of time between shearings. Long, fine wool fibers, used for worsted yarns and fabrics, have an average length of 2 1/2 inches. Worsted refers to a yarn type and implies long fibers, greater uniformity of fiber length, and more-compact yarns. The shorter fibers, which average 1 1/2 inches in length, are used in woolen fabrics. Woolen also refers to yarns and implies shorter, less uniformity in length, and less parallel fibers in a softer, and looser yarn. Some sheep breeds produce coarse, long wools (5 to 15 inches in length) used in specialty fabrics and hand weaving.

The diameter of wool fiber varies from 10 to 50 micrometers. Merino lamb's wool may average 15 micrometers in diameter. The wool fiber has a complex structure, with a cuticle, cortex, and medulla (Figure 5–3).

Medulla When present, the **medulla** is a microscopic honeycomb-like core containing air spaces that increase

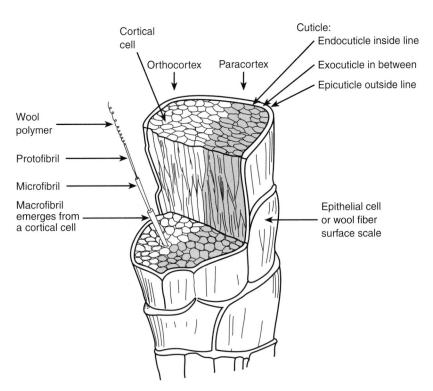

FIGURE 5-3

Physical structure of wool fibers. (Courtesy of E. P. G. Gohl. From Textile Science (1983) by E. P. G. Gohl and L. D. Vilensky. Published by Longman Cheshire, now Addison Wesley Longman Australia Pty. Limited.)

FIGURE 5-4
Natural crimp in wool.

the insulating power of the fiber. It may appear as a dark area when seen through a microscope, but is usually absent in fine wools.

Cortex The **cortex** is the main part of the fiber. It is made up of long, flattened, tapered cells with a nucleus near the center. In natural-colored wools, the cortical cells contain *melanin*, a colored pigment.

The cortical cells on the two sides of the wool fiber react differently to moisture and temperature. These cells are responsible for wool's unique three-dimensional **crimp**, in which the fiber bends back and forth and twists around its axis (Figures 5–4 and 5–5). Crimp may be as high as 30 per inch for fine Merino wool to as low as 1 to 5 per inch for low-quality wool. This irregular lengthwise waviness gives wool fabrics three very important properties: cohesiveness, elasticity, and loft. Crimp helps individual fibers cling together in a yarn, which increases the strength of the yarn. Elasticity is increased because crimp helps the fiber act like a spring. As force is exerted on the fiber, the crimp straightens

out so that the fiber is straight and flat. Once the force is released, the undamaged wool fiber gradually returns to its crimped position. Crimp also contributes to the loft or bulk that wool yarns and fabrics exhibit throughout use.

Wool is a **natural bicomponent fiber**; it has two different cell types or two components with slightly different properties in the cortex. This bicomponent nature is best illustrated by describing how wool reacts to moisture. One side of the fiber swells more than the other side, decreasing the fiber's natural crimp. When the fiber dries, the crimp returns.

Wool can be described as a giant molecular coil spring with excellent resiliency when the fiber is dry and poor resiliency when it is wet. If dry wool fabric is crushed, it tends to spring back to its original shape when the crushing force is released. Wool can be stretched up to 30 percent longer than its original length. Recovery from stretching is good, but it takes place more slowly when the fabric is dry. Since steam, humidity, and water hasten recovery, wool items lose wrinkles more rapidly when exposed to a steamy or humid environment.

Cuticle The cuticle consists of an epicuticle and a dense, nonfibrous layer of scales. The epicuticle is a thin, nonprotein membrane that covers the scales. This layer gives water repellency to the fiber, but is easily damaged by mechanical action. In fine wools, the scales completely encircle the shaft and each scale overlaps the bottom of the preceding scale, like parts of a telescope. In medium and coarse wools, the scale arrangement resembles shingles on a roof or scales on a fish (Figure 5–6). The free edges of the scales project outward and point toward the tip of the fiber. The scales contribute to wool's abrasion resistance and felting property, but they can irritate sensitive skin.

Felting, a unique and important property of wool, is based on the structure of the fiber. Under mechanical

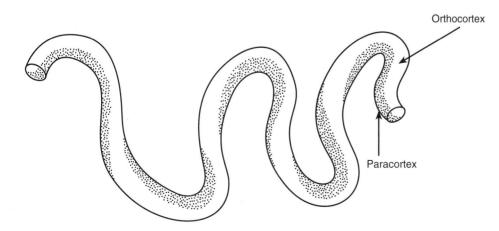

FIGURE 5-5

Three-dimensional crimp of wool fiber. (Courtesy of E. P. G. Gohl. From Textile Science (1983) by E. P. G. Gohl and L. D. Vilensky. Published by Longman Cheshire, now Addison Wesley Longman Australia Pty. Limited.)

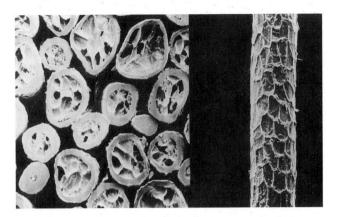

FIGURE 5-6

Photomicrograph of wool: cross-sectional view (left) and longitudinal view (right). (Courtesy of the British Textile Technology Group.)

action—combining agitation, friction, and pressure with heat and moisture—adjacent wool fibers move rootward and the scale edges interlock. This prevents the fiber from returning to its original position and results in shrinkage, or felting, of the fabric.

The movement of the fibers is speeded up and felting occurs more rapidly under severe conditions. Wool items can be shrunk to half their original size. Lamb's wool felts more readily than other wool. In soft, knit fabrics the fibers are more likely to move, so these fabrics are more susceptible to felting than are the firmly woven fabrics. While felting is an advantage in making felt fabric directly from fibers without spinning or weaving, it makes the laundering of wool more difficult. Treatments to prevent felting shrinkage (see Chapter 18) are available.

Chemical Composition and Molecular Arrangement of Wool

Wool fiber is a cross-linked protein called **keratin**. It is the same protein that is found in horns, hooves, and human hair and fingernails. Keratin consists of carbon, hydrogen, oxygen, nitrogen, and sulfur. These combine to form over 17 different amino acids. Five amino acids are shown in Figure 5–7. The flexible molecular chains of wool are held together by natural cross links—cystine (or sulfur) linkages and salt bridges—that connect adjacent molecules.

Figure 5–7 resembles a ladder, with the cross links analogous to the crossbars of the ladder. This simple structure can be useful in understanding some of wool's properties. Imagine a ladder that is pulled askew. When wool is pulled, its cross links help it recover its original

shape. However, if the cross links are damaged, the structure is destroyed and recovery cannot occur.

A more realistic model of wool's molecular structure would show this ladderlike structure alternating with a helical structure. About 40 percent of the chains are in a spiral formation, with hydrogen bonding occurring between the closer parts. The ladderlike formation occurs at the cystine cross links or where other bulky amino acids meet and the chains cannot pack closely together. The spiral formation works like a spring and contributes to wool's resiliency, elongation, and elastic recovery. Figure 5–8 shows the helical structure of wool.

The cystine linkage is the most important part of the molecule. Any chemical, such as alkali, that damages this linkage can destroy the entire structure. In finishing wool, the linkage can be broken and then reformed. Pressing and steaming can produce minor modifications of the cystine linkage. Careless washing and exposure to light can destroy the links and damage the fiber.

Shaping of Wool Fabrics Wool fabrics can be shaped by heat and moisture—a definite plus in producing wool products. Puckers can be pressed out; excess fabric can be eased and pressed flat or rounded as desired. Pleats can be pressed with heat, steam, and pressure, but they are not permanent to washing.

Hydrogen bonds are broken and reformed easily with steam pressing. The newly formed bonds retain their pressed-in shape until exposed to high humidity, when the wool returns to its original shape.

Properties of Wool

Reviewing the fiber property tables in Chapter 3 will help in understanding wool's performance.

Aesthetics Because of its physical structure, wool contributes loft and body to fabrics. Wool sweaters, suits, carpets, and upholstery are the standard "looks" by which manufactured fiber fabrics are measured.

Wool has a matte appearance. Fibers are sometimes blended with longer wool fibers, specialty wools such as mohair, or other fibers to modify the fabric's luster or texture.

Drape, luster, texture, and hand can be varied by choice of yarn structure, fabric structure, and finish. Sheer wool voile, medium-weight printed wool challis, medium-weight flannels and tweeds, heavy-weight coating, upholstery fabrics, and wool rugs and carpets demonstrate the range of possibilities.

Durability Wool fabrics are durable. Their moderate abrasion resistance stems from the fiber's scale structure and excellent flexibility. Wool fibers can be bent back on

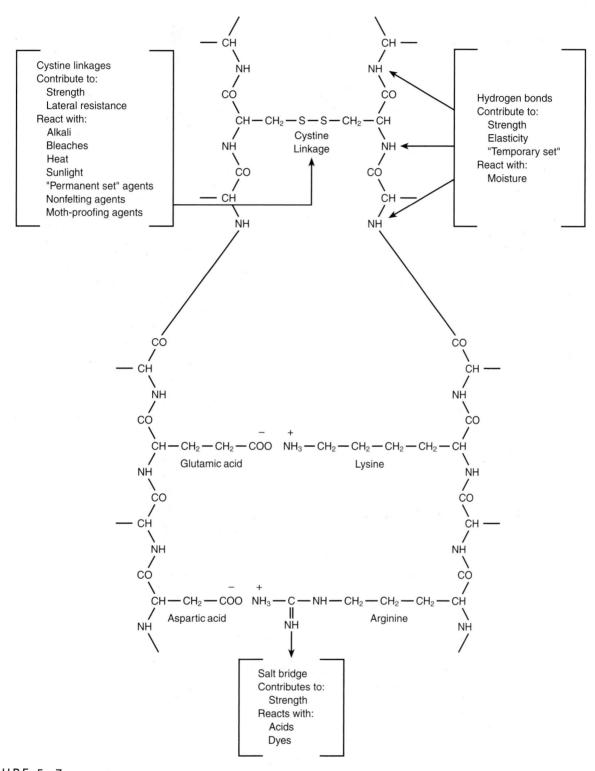

FIGURE 5-7
Structural formula of the wool molecule.

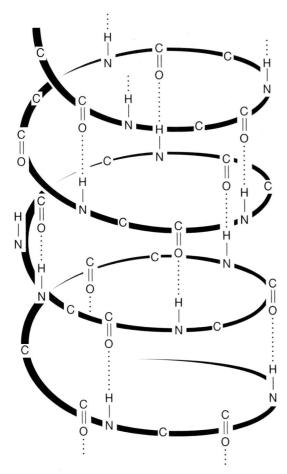

FIGURE 5-8

Helical arrangement of the wool molecule. (Courtesy of the Wool Bureau, Inc., and International Wool Secretariat.)

themselves 20,000 times without breaking, as compared with 3000 times for cotton and 75 times for rayon. Atmospheric moisture helps wool retain its flexibility. Wool carpets, for example, become brittle if the air is too dry. The crimp and scale structure of wool fibers make them so cohesive that they cling together to make strong yarns.

Wool fibers have a low tenacity, 1.5 g/d dry and 1.0 g/d wet. The durability of wool fibers relates to their excellent elongation (25 percent) and elastic recovery (99 percent). When stress is put on the fabric, the crimped fibers elongate as the molecular chains uncoil. When stress is removed, the cross links pull the fibers back almost to their original positions. The combination of excellent flexibility, elongation, and elastic recovery produce wool fabrics that can be used and enjoyed for many years.

Comfort Wool is more hygroscopic than any other fiber, with a moisture regain of 13 to 18 percent under standard conditions. In a light rain or snow, wool resists wetting and the water runs off or beads on the fabric

surface. Wool dries slowly enough that the wearer is more comfortable than in any other fiber.

Wool is a poor conductor of heat, so warmth from the body is not dissipated readily. Outdoor sports enthusiasts have long recognized the superior comfort provided by wool. Wool's excellent resiliency contributes to its warmth. Since wool fibers recover well from crushing, fabrics remain porous and capable of incorporating much air. This "still" air is an excellent insulator because it keeps body heat close to the body.

Some people are allergic to the chemical components of wool; they itch, break out in a rash, or sneeze when they touch wool. For others, the harsh edges of coarse, low-quality wools are irritating and uncomfortable.

Wool has a medium density (1.32 g/cc). People often associate heavy fabrics with wool since it is used in fall and winter wear, when the additional warmth of heavy fabrics is desirable. Lightweight wools are very comfortable in the changeable temperatures of spring and early fall.

One way to compare fiber densities is to think of blankets. A winter blanket of wool is heavy and warm. An equally thick blanket of cotton would be even heavier (cotton has a higher density), but not as warm. A winter blanket of acrylic would be lighter in weight (acrylic has a lower density than either wool or cotton). Personal preferences will help determine which fiber to choose.

Appearance Retention Wool is a very resilient fiber. It resists wrinkling and recovers well from wrinkles. (It wrinkles more readily when wet.) Wool maintains its shape fairly well during normal use. Often wool apparel is lined to maintain its shape.

When wool fabrics are dry-cleaned, they retain their size and shape well. When wool items are hand washed, they need to be handled carefully to avoid shrinkage. Follow care instructions for washable woolens.

Wool has an excellent elastic recovery—99 percent at 2 percent elongation. Even at 20 percent elongation, recovery is 63 percent. Recovery is excellent from the stresses of normal usage. Wool carpet maintains an attractive appearance for years.

Care Wool does not soil readily, and the removal of soil from wool is relatively simple. Grease and oils do not spot wool fabrics as readily as they do fabrics made of other fibers. Wool items do not need to be washed or dry cleaned after every use. Layer wool garments with washable ones next to the skin to decrease odor pickup.

A firm, soft brush not only removes dust but also gently returns matted fibers back to their original position. Damp fabrics should be dried before brushing. Garments require a rest period between wearings to recover from deformations. Hang the item in a humid en-

vironment or spray a fine mist of water on the cloth to speed up recovery.

Wool is very susceptible to damage when it is wet. Its wet tenacity is a third lower than its relatively low dry strength. When wet, breaking elongation increases to 35 percent. Resiliency and elastic recovery decrease. The redeeming properties of dry wool that make it durable in spite of its low tenacity do not apply when it is wet. Handle wet wool very gently.

Dry cleaning is the recommended care method for most wool items. Dry cleaning minimizes potential problems that may occur during hand or machine washing. Incorrect care procedures can ruin an item.

Some items can be hand washed if correct procedures are followed. Use warm water that is comfortable to the hand. Avoid agitation; squeeze gently. Support the item, especially if it is knit, so it does not stretch. Air dry flat. Do not machine or tumble dry or felting will occur. Woven or knit items that are labeled machine washable are usually blends or have been finished so they can be laundered safely (see Chapter 18). Special instructions for these items often include use of warm or lukewarm water, a gentle cycle for a short period of time and dry flat or on a clothes line.

Chlorine bleach, an oxidizing agent, damages wool. Verify this by putting a small piece of wool in fresh chlorine bleach and watch the wool dissolve. Wool is also very sensitive to alkalis, such as strong detergents. The wool reacts to the alkali by turning yellow; it then becomes slick and jellylike and finally dissolves. If the fabric is a blend, the wool in the blend disintegrates, leaving only the other fibers.

Wool is attacked by moth larvae and other insects. Regular use of mothballs or crystals is discouraged due to the toxic nature of these pesticides. However, they should be used when evidence of insects is apparent, such as when moths or traces of larvae are seen. Moth larvae also eat, but do not digest, any fiber that is blended with wool.

Unless mothproofed, wool fabrics should be stored so that they will not be accessible to moths. Wool fabrics should be cleaned before storage.

Wool burns very slowly and is self-extinguishing. It is normally regarded as flame-resistant. This is one of the reasons why wool is so popular with interior designers. However, when wool is used in public buildings, a flame-retardant finish may be needed to meet building code requirements.

Table 5–2 summarizes wool's performance in apparel and furnishing fabrics.

Environmental Impact of Wool

Since wool is a natural fiber, many consumers believe it is environmentally friendly. Although wool can be

TABLE 5-2 Summary of the performance of wool in apparel and furnishing fabrics.

Aesthetics Luster	Variable Matte
Durability Abrasion resistance Tenacity Elongation	High Moderate Poor High
Comfort Absorbency Thermal retention	High High High
Appearance retention Resiliency Dimensional stability Elastic recovery	High High Poor Excellent
Recommended care	Dry-clean (apparel) Steam-clean (furnishings)

viewed as a renewable resource, it is not produced without any impact on the environment. Sheep graze pastures so closely that soil erosion can occur if care is not taken to avoid overgrazing. Disposal of animal waste is another concern. Sheep manure is frequently spread over the ground to return nutrients to the soil. However, excessive applications can create problems with runoff contaminated with the manure. In addition, sheep producers have traditionally opposed programs that contribute to the survival of wolves and other natural predators.

Another issue is that sheep are susceptible to some diseases that can be transmitted to humans. Most of these diseases are of concern only to sheep producers; consumers of wool products are not at risk. However, customs officials and importers check imported wools from certain Third World countries for diseases that can be transmitted via contaminated fibers. Fibers contaminated in this way will not be imported. Consumers should not be concerned with imported items purchased in the United States, but they should exercise caution when purchasing wool products in Third World countries.

Other environmental issues relate to the intensive use of water, energy, and chemicals to clean the fiber, produce wool fabrics, and finish and dye them. Many wool products require dry cleaning. Some dry-cleaning solvents have been identified as possible carcinogens and restrictions regarding workplace exposure exist. See Chapter 20 for more information on dry cleaning.

Uses of Wool

Only a small amount of wool is used in the United States. In 1998 domestic consumption of wool was 190 million pounds, or approximately 1.0 percent of all fiber used in the United States. The most important use of wool is for adult apparel (Table 5–3).

Wool suits perform well and look great. They fit well because they can be shaped through tailoring. The durable fabrics drape well. They are comfortable under a variety of conditions and retain their appearance during wear and care. Suits are usually dry-cleaned to retain their appearance and shape. Suit materials also are made of synthetic fiber/wool blends.

The Wool Bureau has adopted two symbols to assist in the promotion of wool. The Woolmark® is used on all 100 percent wool merchandise that meets their quality specifications; the Woolblend® mark is for blends with at least 60 percent wool. Both symbols are shown in Figure 5–9.

Even though the amount of wool used in furnishings is low, wool constitutes the standard by which carpet appearance is judged. A major use of wool is in carpets and custom rugs, often special-order or one-of-a-kind rugs. Wool rugs can be machine-woven (Axminster or Wilton types), hand-woven, or hand-hooked. Most rugs are imported, although some are made in the United States. Wool carpets and rugs are more expensive than those made from other fibers because the rich color, texture, and appearance of wool are appreciated and valued. Wool carpets and rugs account for less than one-fifth of the floor-coverings market.

Both wool and wool-blend fabrics are used in upholstery because of their aesthetic characteristics, good appearance retention, durable nature, and natural flame resistance. For residential use, no additional flame-retardant treatment may be necessary; but for many commercial and contract uses, wool or wool-blend upholstery fabric may require a flame retardant finish.

Handcrafted wall hangings and woven tapestries are often made of wool because textile artists like the way

TABLE 5-3	Uses of wool.	
		Million
Percent	End Use	Pounds
66	Apparel	113
9	Furnishings	15
15	Carpets	26
10	Industrial	16

Source: Fiber Organon, 69 (10). October 1998.

FIGURE 5-9

Woolmark and Woolblend symbols of quality. (Courtesy of the Wool Bureau, Inc., and International Wool Secretariat.)

the fiber handles. Designers, artists, and consumers appreciate the way the finished item looks and wears.

Many school laboratories have fire-safety blankets made of wool. Stadium blankets and throws are often made of wool for warmth and an attractive appearance.

Wool is important in industrial felts, which are used under heavy machinery to help decrease noise or for a variety of other uses. Tiny balls of wool that absorb up to 40 times their weight in oil are used to clean up oil spills. Wool mulch mats are used for landscape and horticultural weed control.

Specialty Wools

Most specialty wools are obtained from the goat, rabbit, and camel families (Table 5–4).

Specialty wools are available in smaller quantities than sheep's wool, so they are usually more expensive. Like all natural fibers, specialty wools vary in quality. Most specialty wool products require dry cleaning.

Specialty wool fibers are of two kinds: the coarse, long outerhair and the soft, fine undercoat. Coarse fibers are used for interlinings, upholstery, and some coatings; the fine fibers are used in luxury coatings, sweaters, shawls, suits, dresses, and furnishing fabrics.

Mohair

Mohair is the hair fiber of the Angora goat. Major producers are South Africa, the United States, and Turkey. Texas is a major producer, but most U.S. mohair is exported. The goats (Figure 5–10) are usually sheared twice a year, in the early fall and early spring. Each adult yields about 5 pounds of fiber. The fiber length is 4 to 6 inches if sheared twice or 8 to 12 inches if sheared once. Approximately 12 percent of the crop is kid (baby goat) fiber and the remaining 88 percent is adult fiber.

Goat Family	Camel Family	Others
Angora goat—mohair	Camel's hair	Angora rabbit—angor
Cashmere goat—cashmere	Llama	Fur fibers
	Alpaca	Musk ox—qiviut
	Vicuña	Yak
	Guanaco	

Mohair fibers have a circular cross section. Scales on the surface are scarcely visible, and the cortical cells may appear as lengthwise striations. There are some air ducts between the cells that give mohair its lightness and fluffiness. A few fibers have a medulla.

Mohair is a very resilient fiber because it has fewer scales than wool and no crimp. Mohair fibers are smoother and more lustrous than wool fibers (Figure 5–11). Mohair is very strong and has a good affinity for dye. The washed fleece is a lustrous white. Mohair is less expensive than many other specialty wools.

Mohair's chemical properties are the same as those of wool. Mohair makes a better novelty loop yarn than wool or the other specialty hair fibers.

Mohair's good resiliency is used to advantage in hand-knitting yarns, pile fabrics, and suitings. Because it resists crushing and pilling, it is used in flat and pile upholstery fabrics and hand-produced floor coverings. Its natural flame resistance, insulation, and sound absorbency make it ideal for specialty drapery applications. Blankets of mohair blends retain heat well. Mohair is used to produce natural-looking wigs and hairpieces. Mohair is often blended with wool to add sheen and texture to apparel and furnishing fabrics.

FIGURE 5–10
Angora goats produce mohair fibers. (Courtesy of the Mohair Council of America.)

Figure 5–12 shows the quality symbol used on all mohair products that meet performance standards established by the Mohair Council of America.

0iviut

Qiviut (kē'-vē-ute), a rare and luxurious fiber, is the underwool of the domesticated musk ox (Figure 5–13). Attempts to domesticate the musk ox have been successful in Alaska and Canada. A large musk ox provides 6 pounds of wool each year. The fiber can be used just as it comes from the animal, for it is protected from debris by the long guard hairs and has a low lanolin content. The fleece is not shorn but is shed naturally and is removed from the guard hairs as soon as it becomes visible. Qiviut is expensive and used to produce handcrafted items by Inuit and other Native American people.

Angora

Angora is the hair of the Angora rabbit produced in Europe, Chile, China, and the United States (Figure

FIGURE 5-11

Photomicrograph of mohair: cross-sectional view (left) and longitudinal view (right). (Courtesy of the British Textile Technology Group.)

FIGURE 5-12
Mohair symbol of quality. (Courtesy of the Mohair Council of America.)

5–14). It is harvested up to four times a year by plucking or shearing. Fiber yield and quality varies with the rabbit and its health and breed and ranges from 8 to 30 oz. Of the four breeds of Angora rabbits, the two most common types are English and French. English Angoras produce a fine silky fiber; French Angoras produce a coarser fiber.

The white or naturally colored fiber is very fine, fluffy, soft, slippery, and fairly long. Angora does not take dye well and usually has a lighter color than other fibers with which it is blended. It is often blended with wool to facilitate spinning because the slick fiber has poor cohesiveness. Angora is used in apparel such as sweaters and suitings.

If a label states "rabbit hair" this means the fiber is from a common rabbit, not an angora rabbit. Rabbit

FIGURE 5-13
The musk ox of Alaska produces qiviut fiber. (Courtesy of Fairbanks Convention/Visitors Bureau.)

FIGURE 5-14The angora rabbit produces a soft, luxurious fiber. (Courtesy of Janet Lynn.)

hair is often used to make felt for hats, but it is too short to make into yarns for woven or knit fabrics.

Camel's Hair

Camel's hair is obtained from the two-humped Bactrian camel, found from Turkey east to China and north to Siberia. Camel's hair is an excellent insulator. The hair is collected as it is shed or sheared from the animals. A camel produces about 5 pounds of hair a year.

Because camel's hair gives warmth without weight, the finer fibers are valued for apparel. They are often used in blends with sheep's wool, which is dyed the tan color of camel's hair. Camel's hair is used in coats or jackets, scarves, and sweaters. Blankets of camel's hair and wool are available.

Cashmere

Cashmere is produced by a small goat raised in China, India, Nepal, and New Zealand. The fibers vary in color from white to gray to brownish gray. The goat has an outercoat of long, coarse hair and an innercoat of down. The hair usually is combed by hand from the animal during the molting season. In dehairing, the coarse hair is separated from the fine fibers. The downy fine fibers make up only a small part of the fleece, probably not more than one-half pound per goat. The fiber is solid, with no medulla and fine scales. Cashmere is used for

sweaters, coats, suits, jackets, loungewear, and blankets. Fabrics are warm, buttery in hand, and have beautiful draping characteristics. Cashmere is more sensitive to chemicals than wool.

Cashmere is sometimes mistaken for shahtoosh, an illegal fiber harvested from slaughtered Tibetan chiru antelopes. The chiru is on the endangered species list.

Cashgora is a new fiber resulting from the breeding of feral cashmere goats with angora goats in New Zealand and Australia. Although the International Wool Textile Organization has adopted cashgora as a generic fiber term, it is not recognized around the world. The fiber is coarser than cashmere and not as lustrous. It is used primarily in less expensive coatings and suits.

Llama and Alpaca

Llama and alpaca are domesticated animals of the South American branch of the camel family. The fiber from their coats is 8 to 12 inches in length and is noted for its softness, fineness, and luster. The natural colors range from white to light fawn, light brown, dark brown, gray, and black. They are used for clothing, handcrafts, and rugs. Because alpaca is soft, it is often used for apparel. However, it is more difficult to dye than most other specialty wools. For this reason, it is often used in its natural colors. Scales are less pronounced, so felting is not as big a problem as with other wools. Its soft hand, beautiful luster, and good draping characteristics are appreciated by fashion designers. As with wool, fibers from the younger llama and alpaca are finer and softer.

Vicuña and Guanaco

Vicuña and guanaco are rare wild animals of the South American camel family. In the past, the animals were killed to obtain the fiber. Vicuña and guanaco are now protected. Vicuña is the softest, finest, rarest, and most expensive of all textile fibers. The fiber is short, very lustrous, and light cinnamon in color. Research is underway to produce genetic crosses of alpaca and vicuña. As of mid-1999, it was illegal to bring into the U.S. any items containing vicuña because of the Endangered Species Act.

Yak

Yak fiber is produced by a large ox found in Tibet and Central Asia. The fiber, which is collected by combing out during the spring molt, is smooth and lustrous. Yak is often used in apparel and rope and tent covers in its native area. Yak fiber is appearing in the international market because it is mixed with the much more expensive cashmere to extend its use and lower the cost. It is coarser than cashmere and a dark brown or black color.

Silk

Silk is a natural protein fiber. It is similar to wool in that it is composed of amino acids arranged in a polypeptide chain, but it has no cross links. Silk is produced by the larvae of a moth.

According to Chinese legend, silk culture began in 2640 B.C., when Empress Hsi Ling Shi became interested in silkworms and learned how to reel the silk and weave it into fabric. Through her efforts, China developed a silk industry and a 3000-year monopoly. Silk culture later spread to Korea and Japan, westward to India and Persia, and then to Spain, France, and Italy. Silk fabrics imported from China were coveted in other countries; in India, the fabrics were often unraveled and rewoven into looser fabrics or combined with other fibers to produce more yardage from the same amount of silk filament. Several attempts at sericulture were made in the United States, but none were successful. Today, the major producers of silk are China (54 percent), India (14 percent), and Japan (11 percent).

Silk is universally accepted as a luxury fiber. The International Silk Association of the United States emphasizes this by its slogan "Only silk is silk." Silk has a combination of properties not possessed by any other fiber: It has a dry tactile hand, unique natural luster, good moisture absorption, lively suppleness and draping qualities, and high strength.

The beauty and hand of silk and its high cost are probably responsible for the manufactured fiber industry. Silk is a solid fiber with a simple physical structure. It is this physical nature of silk that some manufactured fibers attempt to duplicate. Most successful are those manufactured fibers with a triangular cross section and fine size.

Production of Silk

Sericulture is the production of cultivated silk, which begins when the silk moth lays eggs on specially prepared paper. (The cultivated silkworm is usually Bombyx mori.) When the eggs hatch, the caterpillars, or larvae, are fed fresh, young mulberry leaves. After about 35 days and four moltings, the silkworms are approximately 10,000 times heavier than when hatched and are ready to begin spinning a cocoon, or chrysalis case. A straw frame is placed on the tray and the silkworm starts to spin the cocoon by moving its head in a figure eight. The silkworm produces silk in two glands and forces the liquid silk through spinnerets, openings in its head. The two strands of silk are coated with a water-soluble protective gum, sericin. When the silk comes in contact with the air, it solidifies. In 2 or 3 days, the silkworm

has spun approximately 1 mile of filament and has completely encased itself in a cocoon. The silkworm then metamorphoses into a moth. Usually the silkworm is killed (stifled) with heat before it reaches the moth stage.

If the silkworm is allowed to reach the moth stage, it is used for breeding additional silkworms. The moth secretes a fluid that dissolves the silk at one end of the cocoon so that it can crawl out. Cocoons damaged in this way cannot be used for filament silk yarns; therefore, the staple silk from them is less valuable.

To obtain filament silk, the cocoons that have been stifled are sorted for fiber size, fiber quality and defects, then brushed to find the outside ends of the filaments. Several filaments are gathered together and wound onto a reel. This process, referred to as **reeling**, is performed in a manufacturing plant called a *filature*. Each cocoon yields approximately 1000 yards of silk filament. This is **raw silk**, or **silk-in-the-gum**, fiber. Several filaments are combined to form a yarn. The operators in the filature must carefully join the fibers so that the diameter of the reeled silk remains uniform in size. Uniformly reeled filament silk is the most valuable (Figure 5–15).

As the fibers are combined and wrapped onto the reel, twist can be added to hold the filaments together. Adding twist is referred to as *throwing* and the resulting yarn is called a *thrown yarn*. The specific type of yarn and amount of twist relate to the fabric to be produced. The simplest type of thrown yarn is a *single*, in which three to eight filaments are twisted together to form a yarn. Used for filling yarns in many silk fabrics, singles may have two or three twists per inch.

Staple silk is produced from cocoons in which the filament broke or the moth was allowed to mature, and from the inner portions of the cocoon. This silk is known as **silk noils**, or *silk waste*. It is degummed (the sericin is removed) and spun like any other staple fiber, or it is

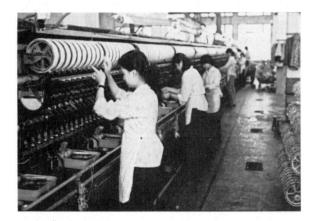

FIGURE 5-15
Reeling of silk. (Courtesy of the Textile Institute.)

blended with another staple fiber and spun into a yarn. Spun silk is less expensive, less durable, more likely to pill, and of lower quality than filament silk.

Wild silk production is not controlled. Although many species of wild silkworms produce wild silk, the two most common are *Antheraea mylitta* and *Antheraea pernyi*. The silkworms feed on oak and cherry leaves in the wild and produce fibers that are much less uniform in texture and color. The fiber is most often brown, but yellow, orange, and green also occur. Researchers are investigating the feasibility of producing fabrics from these naturally colored silks.

Since the cocoons are harvested after the moth has matured, the silk cannot be reeled and must be used as spun silk. **Tussah** silk is the most common type of wild silk. It is coarser, darker, and cannot be bleached. Hence, white and light colors are not available in tussah silk. *Tasar* is a type of wild silk from India. Some fabrics are sold simply as wild silk. "Raw silk" is sometimes used incorrectly to describe these fabrics.

Duppioni silk is another type of silk that results when two silkworms spin their cocoons together. The yarn is irregular in diameter with a thick-and-thin appearance. It is used in such linenlike silk fabrics as shantung.

Silk fabric descriptions may include the term *momme*, the standard way to describe silk fabrics. **Momme**, pronounced like "mummy" and abbreviated mm, describes the weight of the silk. One momme (momie or mommie) weighs 3.75 grams. Most silk fabrics are produced in several weights. Higher numbers describe heavier fabrics. Other terms, such as *habutai* or *crepe*, describe the yarn and fabric structure. Silk fabrics are often graded for their degree of evenness, fiber or yarn size, and freedom from defects. Grade A refers to the highest grade, only about 10 percent of the silk produced.

Japan is known for its high-quality silks. India produces handwoven wild silks with a pronounced texture. Thailand's handwoven iridescent silks are created by using two yarn colors in weaving the fabric. With over 30 countries producing silk, there is a wide range of silk types and qualities on the market. *Pure silk* and *pure dye silk* describe 100 percent silk fabrics that do not contain any metallic weighting compounds. See Chapter 21 for more information on labeling silk fabrics.

Physical Structure of Silk

Silk is the only natural filament fiber. It is a solid fiber, smooth but irregular in diameter along its shaft. The filaments are triangular in cross section, with rounded corners (Figure 5–16). Silk fibers are very fine—1.25 denier/filament. Wild silks are slightly coarser, with slight striations along the length of the fiber.

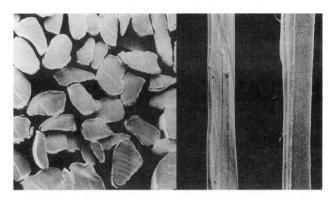

FIGURE 5-16

Photomicrographs of silk fiber: cross-sectional view (left); longitudinal view (right). (Courtesy of the British Textile Technology Group.)

Chemical Composition and Molecular Structure of Silk

The protein in silk is **fibroin**, with 15 amino acids in polypeptide chains. Silk has reactive amino (NH₂) and carboxyl (COOH) groups. Silk has no cross linkages and no bulky side chains. The molecular chains are not coiled, as in wool, but are pleated and packed closely together. Silk's high orientation contributes to its strength. Its elasticity is due to some amorphous areas between the crystalline areas.

Properties of Silk

Consult the fiber property tables in Chapter 3 when comparing the performance of silk to that of other fibers. Table 5–5 compares silk and wool.

Aesthetics Silk can be dyed and printed in brilliant colors. Since it is adaptable to a variety of fabrication methods, it is available in many fabric types for furnishing and apparel uses. Because of cultivated silk's smooth but slightly irregular surface and triangular cross section, its luster is soft, with an occasional sparkle. It is this luster that has been the model for many manufactured fibers. Fabrics made of cultivated silk have a smooth appearance and a luxurious hand.

Wild silks have a duller luster because of their coarser size, less regular surface, and presence of sericin. Fabrics made of wild silk have a more pronounced texture.

In filament form, silk has poor covering power. Before the development of strong synthetic fibers, silk was the only strong filament, and silk fabrics were often treated with metallic salts such as tin, a process called weighting, to produce better drape, covering power, and dye absorption. Unfortunately, these historic weighted silks aged quickly. Figure 5–17 shows a 19th-century silk bodice that has shattered (disintegrated). Silk has scroop, a natural rustle, which can be increased by treatment with an organic acid such as acetic or tartaric acid.

Durability Silk has moderate abrasion resistance. Because of its end uses and cost, silk seldom receives harsh abrasion.

Silk is one of the strongest natural fibers, with a tenacity of 4.5 g/d dry. It may lose up to 20 percent of its strength when wet. It has a breaking elongation of 20 percent. It is not as elastic as wool because there are no cross linkages to retract the molecular chains. When silk is elongated by 2 percent, its elasticity is only 90 percent. Thus, when silk is stretched a small amount it does

Property	Wool	Silk
Abrasion resistance	Moderate	Moderate
Breaking tenacity (dry; wet)	1.5 g/d; 1.0 g/d	4.5 g/d; 2.8-4.0 g/d
Breaking elongation (dry; wet)	25%; 35%	20%; 30%
Absorbency	13-18%	11%
Thermal retention	Excellent	Moderate
Specific gravity	1.32 g/cc	1.25 g/cc
Resiliency	Excellent	Moderate
Elastic recovery at 3% stretch	99%	90%
Resistance to strong acids	More resistant	More sensitive
Resistance to alkalis	Harmed	Harmed
Resistance to light	Poor	Poor
Fiber length	1.5–5 inches	Natural filament; available in staple for
Fiber fineness (micrometers)	10-50	11–12

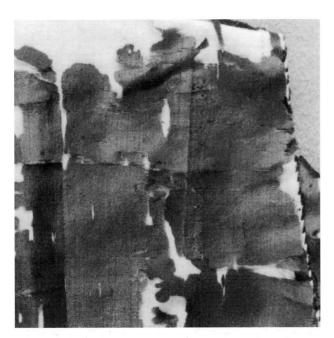

FIGURE 5-17 Shattered bodice (c. 1885) of weighted silk.

not return to its original length, but remains slightly stretched.

Comfort Silk has good absorbency, with a moisture regain of 11 percent. Silk may develop static cling because of the smoothness of the fibers and yarns and the fabric weight. Silk fabrics are comfortable in summer. Like wool, silk is a poor conductor of heat so that it is comfortably warm in the winter. The weight of a fabric is important in heat conductivity—sheer fabrics are cool, whereas heavy fabrics are warm. Silk is smooth and soft and not irritating to the skin. The density of silk is 1.25 g/cc, producing strong and lightweight silk products. Weighted silk is not as durable as regular silk and wrinkles more readily.

Appearance Retention Silk has moderate resistance to wrinkling. Because silk's recovery from elongation is low, it does not resist wrinkling as well as some other fibers.

Silk fibers do not shrink. Because the molecular chains are not easily distorted, silk swells only a small amount when wet. Fabrics made from true crepe yarns shrink if laundered, but this is due to the yarn structure, not the fiber content.

Care Dry-cleaning solvents do not damage silk. Dry cleaning may be recommended for silk items because of yarn types, dyes with poor fastness to water or laundering, or product or fabric-construction methods. Washable silk items can be laundered in a mild detergent

solution with gentle agitation. Since silk may lose up to 20 percent of its strength when wet, care should be taken with wet silks to avoid any unnecessary stress. Silk items should be pressed after laundering. Pure dye silks should be ironed damp with a press cloth. Wild silks should be dry cleaned and ironed dry to avoid losing sericin and fabric body. Silk furnishings are generally cleaned by the dry extraction method.

Silk may water-spot easily. Before hand or machine washing, test in an obscure place of the item to make sure the dye or finish does not water-spot. Silk can be damaged and yellowed by strong soaps or detergent (highly alkaline compounds) and high temperatures. Chlorine bleaches should be avoided. Cleaning agents containing hydrogen peroxide and sodium perborate are safe to use if the directions are followed carefully.

Silk is resistant to dilute mineral acids and organic acids. A crepelike surface effect may be created by the shrinking action of some acids.

Silk is weakened and yellowed by exposure to sunlight and perspiration. Furnishing fabrics of silk should be protected from direct exposure to sunlight.

Silks may be attacked by insects, especially carpet beetles. Items should be stored clean because soil may attract insects that do not normally feed on silk.

Weighted silks deteriorate even under ideal storage conditions and are especially likely to break at the folds. Historic items often exhibit a condition known as *shattered silk*, in which the weighted silk is disintegrating (see Figure 5–17). The process cannot be reversed.

Table 5–6 summarizes silk's performance in apparel and furnishing fabrics.

Environmental Impact of Silk

Silk is a natural fiber and a renewable resource. Sericulture uses leaves of the mulberry tree. These trees grow in regions where the soil may be too poor to grow other crops or in small and irregular spaces. The trees help retain soil and contribute to the income of small farms. Mulberry trees are severely pruned when the leaves are harvested and the trees do not achieve a natural shape. Since mulberry trees are deciduous, leaves are available for only part of the year and silk production is limited to one generation each year.

Silkworms are susceptible to disease and changes in temperature. Research to increase silk production is developing disease-resistant varieties, producing artificial diets, and controlling internal environments to induce year-round production. Research is also examining the production of naturally colored silks that do not require the use of chemical dyes.

Silkworms are raised for the silk they produce. Most are killed before they have matured in order to harvest filament silk. Because of this, some animal rights activists

TABLE 5-6 Summary of the performance of silk in apparel and furnishing fabrics.

Aesthetics Variable Beautiful and soft Luster **Durability** High Abrasion resistance Moderate Tenacity High for natural fibers Elongation Moderate Comfort High Absorbency High Thermal retention Good Appearance retention Moderate Moderate Resiliency Dimensional stability High Elastic recovery Moderate Recommended care Dry-clean (apparel) or dry extraction clean (furnishings)

avoid purchasing or using silk items. Some small quantities of "cruelty free" silk are available from cocoons where the mature silk moth is allowed to leave the cocoon. Silk production is labor-intensive and is concentrated in regions where labor costs are low. When silk prices fall, these regions suffer accordingly. Child labor may be used in producing silk. However, in many areas, silk production allows families to work together and each member's work contributes to a better economic situation for the family. Efforts to mechanize the production of silkworms could have a pronounced impact on regions that have traditionally relied on hand labor to produce silk.

Silk production makes extensive use of water and other chemicals to clean the fiber and remove sericin. Although the use of chemical finishes is relatively low for silk, the use of dyes is high. Dyeing silk requires use of heat, water, dye, and other chemicals. Environmental regulations are minimal in some parts of the world where silk is processed, and disposal of chemicals is done with little regard for the environment. Although not all silk products require dry cleaning, many do. Dry-cleaning solvents may harm the environment, and their use and disposal are restricted. For more information on dry cleaning, see Chapter 20.

Uses of Silk

Silk has a drape, luster, and texture that may be imitated by synthetic fibers, but cannot be duplicated exactly. Because of its unique properties and high cost, silk is used primarily in apparel and furnishing items. Other factors that contribute to the continued popularity of silk are its appearance, comfort, and strength. Silk is extremely versatile, and it can be used to create a variety of fabrics, from sheer, gossamer chiffons to heavy, beautiful brocades and velvets. Because of silk's absorbency, it is appropriate for warm-weather wear and active sportswear. Because of its low heat conductivity, it is also appropriate for cold-weather wear. Silk underwear, socks, and leggings are popular due to silk's soft hand, good absorbency, and wicking characteristics. Silk is available in a range of apparel from one-of-a-kind designer garments to low-priced discount store T-shirts.

Silk and silk blends are equally important in furnishings. Silk is frequently used in upholstery, wall-covering fabrics, and wall hangings. Some designers are so enamored with silk that they drape entire rooms in it. Silk blends are often used in window-treatment and upholstery fabrics because of its soft luster and drape. The texture and drape of wild and duppioni silks make them ideal for covering ceilings and walls. Occasionally, beautiful and expensive handmade rugs are made of silk. Liners for sleeping bags, blankets, and bed sheets of silk feel warm, soft, and luxurious next to the skin.

Although silk has limited application beyond apparel and furnishings, it is used in the medical field for sutures and prosthetic arteries.

Identification of Natural Protein Fibers

Natural protein fibers can be identified with a microscope fairly easily. Wool fibers have scales that are visible along the edge and, if the fiber is white or pastel, may be seen throughout the length of the fiber. It is difficult to distinguish among the wool fibers because of their similar appearance. For example, it is easy to distinguish wool from cotton, but it is difficult to distinguish sheep's wool from camel's hair. Correct identification of the various specialty wools is difficult but necessary because of fraudulent blends that are labeled 100 percent cashmere or other luxury fiber. Silk can be identified with a microscope, but with greater difficulty. Since silk is a natural fiber, its surface is not as regular as that of most manufactured fibers. The trilobal cross section may not be apparent, but the fiber has slight bumps or other irregularities. Natural protein fibers are soluble in sodium hypochlorite. In the burn test, these fibers smell like burning hair. However, the odor is so strong that a very small percentage of protein fiber produces a noticeable hair odor. Hence, the burning test is not reliable for blends, nor will it distinguish among the protein fibers.

Key Terms

Natural protein fibers Hygroscopic Raw or grease wool Clean or scoured wool Grading wool Sorting wool Lamb's wool Virgin wool Wool Recycled wool

Recycled wo Garnetted Medulla Merino Cortex Crimp

Natural bicomponent fiber Scales Felting Keratin Mohair Qiviut Angora Camel's hair Cashmere Cashgora Llama Alpaca Vicuña Guanaco Yak Silk

Sericulture

Sericin Reeling

Raw silk Silk-in-the-gum Silk noils Wild silk Tussah silk Duppioni silk Momme Fibroin Weighting Scroop

Questions

- 1. Describe the similarities in the properties common to all protein fibers.
- 2. For the products listed below, describe the properties of wool and silk that some manufactured fibers attempt to duplicate.

carpeting blanket blouse interview suit (wool) interview suit (silk)

3. Identify a natural protein fiber that would be appropriate for each of the end uses listed below and describe the properties that contribute to that end use:

area rug in front of a fireplace upholstery for corporate boardroom suit for business travel tie with small print pattern sweater for a professional's casual Friday

4. To what fiber aspects are the differences in properties among the natural protein fibers attributed?

Suggested Readings

Anonymous (1995). Luxury fibers. *Textiles Magazine*, 1, pp. 9–11.

Borland, V. S. (1996, August). Mohair rising in the luxury fiber ranks. America's Textiles International, pp. K/A8– K/A9.

Feltwell, J. (1990). *The Story of Silk*. London: Alan Sutton Publishing.

Hyde, N. (1988, May). The fabric of history: wool. *National Geographic*, 173, pp. 552–591.

Hyde, N. (1984, January). The queen of textiles. *National Geographic*, 165, pp. 2–49.

Parker, J. (1991). All about silk: a fabric dictionary and swatchbook. Seattle, WA: Rain City Publishing.

Rheinberg, L. (1991). The romance of silk. *Textile Progress*, 21 (4), pp. 1–43.

Ryder, M. L. (1997). Silk: the epitome of luxury, *Textiles Magazine*, 1, pp. 17–21.

Smirfitt, J. (1996). Lamb's wool. *Textiles Magazine*, 2, pp. 18–19.

Chapter 6

THE FIBERMANUFACTURING PROCESS

OBJECTIVES

- To understand the concepts related to manufacturing fibers.
- To understand the differences and similarities among natural and manufactured fibers.
- To understand the basic concepts of producing fiber modifications and their effects on product performance.
- To understand why fibers are engineered for specific end uses.

he natural fibers do not possess a perfect combination of characteristics, performance, availability, or cost. Because of this, the manufacture of new fibers has been described for centuries. In 1664, Robert Hooke suggested that if the proper liquid were squeezed through a small aperture and allowed to congeal, a fiber like silk might be produced. In 1889, the first manufactured fiber (from a solution of cellulose by Count Hilaire de Chardonnet) was shown at the Paris Exhibition. In 1910, rayon fibers were commercially produced in the United States. Acetate was produced in 1924. These first manufactured fibers made it possible for consumers to have silklike fabrics at low cost. In 1939, the first synthetic fiber, nylon, was made. Since that time, many more generic fibers with numerous modifications have appeared on the market.

A manufactured fiber is any fiber derived by a process of manufacture from a substance that at any point in the process is not a fiber. There are many different manufactured fibers available today. The differences among the fibers are due to their chemistry. Because it is very difficult for consumers to differentiate among these fibers based on their appearance or hand, generic names are used to identify each specific type. Generic names are not the same as trade names. Generic names are based on fiber chemistry (Table 6-1). Trade names are companies' names for fibers and are used in promotion and marketing. Certification requirements for use of a trade name or trademark allow the owner to set minimum performance standards for a product that carries the trade name or trademark. Generic fiber trade names, like Dacron polyester, are being used less often to market products to consumers. However, trade names for special fiber modifications, like Supplex nylon, are used widely to promote products.

The impact of manufactured fibers on the consumer and the industrial/technical markets have far exceeded original predictions. The first manufactured fibers were aimed at people who could not afford the expensive natural fibers, like silk. Yet manufactured fibers have caused tremendous changes in the way people live and the things they do. End uses that in the past were simply not possible are now commonplace because of the use of manufactured fibers. Many fashions are directly related to manufactured fibers. The combination of fit and performance found in spandex and nylon biking shorts, swimwear, and leotards is not possible with any combination of natural fibers. The common use of carpeting in homes, businesses, and other facilities is related to the low cost and good performance characteristics of nylon, olefin, and other manufactured fibers. Carpets of wool are too expensive and do not possess the characteristics appropriate for the many ways carpets are used today. The use of manufactured fibers in roadbed underlays, communication cables, and replacement human body parts are examples of new end uses for fibers. Manufactured fibers have literally revolutionized daily life!

Manufactured fibers possess the unique ability to be engineered for specific end uses. For that reason, many of these fibers are highly versatile and found in an amazing array of products. With our expanded understanding of polymer chemistry and fiber production, many problems in the original fiber have been overcome through changes in the polymer, production, or finishing steps.

With current lifestyles, it is not possible to return to only natural fibers. Table 6–2 summarizes the use of manufactured fibers in the United States in 1998. In the United States, manufactured fibers comprise 68 percent

Cellulosic	Noncellulosic a	nd Synthetic	Mineral
Acetate	Acrylic	Nytril*	Glass
Triacetate*	Anidex*	Olefin	Metallic
Rayon	Aramid	PBI	
Lyocell	Azlon*	Polyester	
	Elastoester	Rubber	
	Fluoropolymer	Saran	
	Lastrile*	Spandex	
	Melamine	Sulfar	
	Modacrylic	Vinal*	
	Novoloid*	Vinyon*	
	Nylon	•	

^{*}Not produced in the United States.

TABLE 6-2 Use of manufactured fibers.

Use Category	Percentage
Sheer hosiery	97
Socks/anklets	40
Sweaters	62
Craft yarn	83
Underwear	13
Lingerie	50
Robes and loungewear	56
Pile fabrics	100
Linings	68
Apparel lace	96
Narrow fabrics	70
Top-weight apparel	54
Bottom-weight apparel	40
Other apparel	94
Bedspreads and quilts	42
Blankets	55
Sheets	36
Towels	4
Window treatments	54
Upholstery	50
Carpet	99
Other furnishings	81
Tires	99
Hose, industrial/technical	96
Belting, industrial/technical	82
Medical, surgical uses	82
Nonwovens	100
Fiberfill	100
Felts	61
Filtration	97
Rope, etc.	92
Sewing thread	69
Reinforcement, paper and tape	68
Reinforcement, plastic and electrical	24
Coated fabrics	79
Transportation fabrics	96
Narrow fabrics, industrial	89
Bags, bagging	92
Miscellaneous	93

of the fiber market; 48 percent for apparel, 40 percent for furnishings (99 percent for floor coverings), and 91 percent for industrial/technical products. Amazingly, the manufactured-fiber industry uses only approximately 1 percent of the nation's oil and natural gas supplies. The industry is highly efficient. One 300-acre polyester facility can produce as much fiber as 600,000 acres of cotton.

Fiber Spinning

It took years to develop the first fiber-spinning solutions and invent mechanical devices to convert the solutions into filaments. The first solutions were made from dissolved cellulose. In the 1920s and 1930s we learned how to build long-chain molecules from simple starting materials.

All manufactured **fiber-spinning** processes are based on these three general steps:

- 1. Preparing a viscous dope (a thick solution).
- **2.** Forcing or extruding the dope through an opening in a spinneret to form a fiber.
- **3.** Solidifying the fiber by coagulation, evaporation, or cooling.

The raw material is a natural product such as cellulose or protein, or it is a synthetic chemical formed into resins. These raw materials are made into solutions by dissolving them with chemicals or by melting. The solution is referred to as the **spinning solution** or **dope**.

Extrusion is forcing or pumping the spinning solution through the tiny holes of a spinneret, a very important step in the spinning process. A spinneret is a small thimblelike nozzle made of platinum or stainless steel (Figure 6–1). Spinnerets are costly, and new developments are closely guarded secrets. The making of the tiny holes, usually with laser beams, is the critical part of the process. Round holes are common, but many other shapes also are used (see Figure 3-3).

Each hole in the spinneret forms one fiber. *Filament fibers* are spun from spinnerets with 350 holes or less. When these fibers are grouped together and slightly twisted, they make a **filament yarn**. *Filament tow* is an untwisted rope of thousands of fibers. This rope is made by combining the fibers from many spinnerets, each of

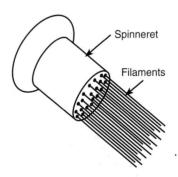

FIGURE 6-1Spinneret showing extrusion of filament fibers.

which may have thousands of holes. The tow is crimped and converted into staple by cutting or breaking to the desired length. (See Chapter 10 for methods of breaking filament tow into staple fibers.)

Spinning Methods

Spinning is done by four different methods, which are compared briefly in Figure 6–2. Details of each method are described in later chapters.

The process of developing a new fiber is long and expensive, and millions of dollars must be invested be-

fore any profit can be realized. First, a research program develops the new fiber. Then a pilot plant is built to translate laboratory procedures to commercial production. Fibers produced by the pilot plant are tested to determine end uses and evaluate suitability. When the fiber is ready, a commercial plant is built.

A patent on the process gives the producer 17 years of exclusive rights to the use of the process—time to recover the initial cost and to make a profit. The price per pound during this time is high, but it drops later. The patent owner can license other producers to use the process. Continuing research and development programs

Wet Spinning: Acrylic, Rayon, Spandex

- 1. Raw material is dissolved by chemicals.
- 2. Fiber is spun into chemical bath.
- 3. Fiber solidifies when coagulated by bath.

Oldest process Most complex Weak fibers until dry Washing, bleaching, etc., required before use

Melt Spinning: Nylon, Olefin, Polyester, Saran

- 1. Resin solids are melted in autoclave.
- 2. Fiber is spun into the air.
- 3. Fiber solidifies on cooling.

Least expensive Direct process High spinning speeds No solvent, washing, etc., required Fibers shaped like spinneret hole

Dry Spinning: Acetate, Acrylic, Modacrylic, Spandex (Major Method)

- 1. Resin solids are dissolved by solvent.
- 2. Fiber is spun into warm air.
- 3. Fiber solidifies by evaporation of the solvent.

Direct process Solvent required Solvent recovered No washing, etc., required

Solvent Spinning: Lyocell

- 1. Raw material dissolved in amine oxide.
- 2. Fiber spun into weak amine oxide solution.
- 3. Fiber precipitates out of solution.

Newest process
Relatively simple fiber production method
Solvent recovered
Fibers must be washed and dried before use

FIGURE 6-2

Methods of spinning manufactured fibers. (Courtesy of American Fiber Manufacturers Association, Inc.)

address problems that arise and produce modifications for special end uses.

Fiber Modifications

One advantage of the manufactured fibers is that each step of the production process can be precisely controlled to modify the fiber. Modifications result from a producer's continuing research program to address any limitations, explore each fiber's potential, and develop properties that will expand the fiber's versatility.

The **parent fiber** is the fiber in its simplest form. It is often sold as a commodity fiber by generic name only, without benefit of a trade name. Other terms for parent fiber include *regular*, *basic*, *standard*, *conventional*, or *first-generation fiber*.

Modifications of the parent fiber may be sold under a brand or trade name. Modifications may also be referred to as types, variants, or x-generation fibers, where the x could be any number. Some fiber producers are identifying 10th-generation and higher modifications.

There are five general ways that a fiber modification can be made.

- 1. The size and shape of the spinneret can be changed to produce fibers of different sizes and shapes.
- **2.** The fiber's molecular structure and crystallinity can be changed to enhance fiber durability.
- **3.** Other compounds can be added to the polymer or dope to enhance fiber performance.
- **4.** The spinning process itself can be modified to alter fibers
- In a more complex modification, two polymers are combined as separate entities within a single fiber or yarn.

Spinneret Modifications

The simplest way to change fiber size is by changing the size of the opening in the spinneret. Other ways of changing fiber size include controlling stretching or drawing after fiber extrusion or controlling the rate at which the solution is extruded through the spinneret. Fiber size often dictates end use. Finer fibers, those with a denier of less than 7, are most often used for apparel. Deniers ranging from 5 to 25 are used in furnishings. Industrial applications have the widest range of denier, ranging from 1 for transportation upholstery and sewing thread to several thousand for ropes and fishing line. Microdenier are fibers with deniers of less than 1.0; most range from 0.5 to 0.8 denier per filament (dpf). Ultrafine fibers are less than 0.3 dpf.

A yarn of microdenier fibers or microfibers may have as many as four times more fibers than a regular fiber yarn of the same size. Microdenier generic fibers include polyester, nylon, acrylic, and rayon in apparel and furnishings in staple and filament form. Fabrics made from these fibers are softer and are more drapeable, silklike, comfortable, and water-repellent.

Microfibers may be present by themselves in fabrics or in blends with no more than 60 percent natural or other manufactured fibers in order to retain the microfiber's characteristics. End uses include coats, blouses, suits, sleepwear, active sportswear, hosiery, upholstery, window treatments, bedding, and wall coverings. Microfiber women's hosiery has been especially successful. These very fine fibers required modifications in yarn-spinning frames, looms and sewing machines, and dyeing and finishing techniques.

Microfibers and ultrafine fibers are produced by modifying the spinning technique or by splitting or separating the filaments. Figure 6–3 shows several fiber

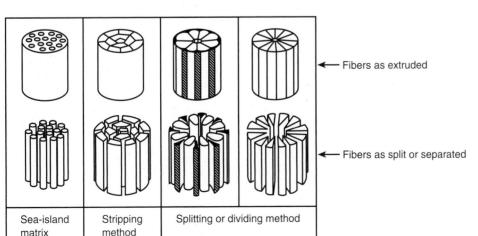

FIGURE 6-3

Typical methods of splitting or separating microfibers. (Courtesy of American Association of Textile Chemists and Colorists.) types. Polyester ultrafine fibers with modified cross sections with slight fiber irregularities are sometimes referred to as *shin gosen*, a Japanese term that means new synthetic fiber. Technical innovations in fiber production and processing result in products with exceptional consumer performance characteristics. Used primarily in women's wear, these fibers mimic the appearance of silk.

Mixed-denier filament bundling combines fibers of several denier sizes in one yarn (Figure 6–4). Microfibers (0.5 dpf) contribute the buttery hand to the fabric, while the macro or regular denier fibers (2.0 dpf) contribute drape, bounce, and durability. When the fabric is laundered, the macro fibers shrink 10 percent and force the microfibers to the surface of the fabric.

Larger sized fibers are used where greater strength, abrasion resistance, and resiliency are required. For example, carpet fibers with deniers in the range of 15 to 24 are more resilient. Higher-denier fibers resist crushing better than lower-denier fibers.

Fiber Shape Changing the cross-sectional shape is the easiest way to alter a fiber's mechanical and aesthetic properties. This is usually done by changing the shape of the spinneret hole. Many shapes are possible: flat, trilobal, quadralobal, pentalobal, triskelion, cruciform, cloverleaf, and alphabet shapes such as Y and T (see Figure 3-3).

The *flat shape* was an early variation. Ribbonlike "crystal" acetate and "sparkling" nylon are extruded through a long, narrow spinneret hole. Flat fibers reflect light much as a mirror does and produce fabrics with a glint or sparkle.

The **trilobal shape** is widely used in both nylon and polyester fibers (Figure 6–5). It is spun through a spinneret with three triangularly arranged slits. The trilobal shape produces a fabric with a beautiful silklike hand,

FIGURE 6-4

Cross section of yarn combining micro and macro fibers.

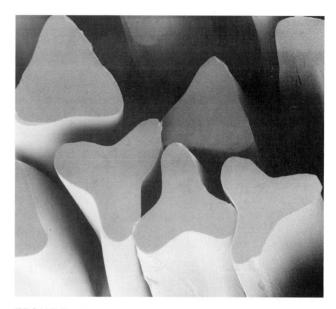

FIGURE 6-5
Stereoscan of trilobal nylon. (Courtesy of E. I. du Pont de Nemours & Company.)

subtle opacity, soil-hiding capacity, built-in bulk without weight, heightened wicking action, silklike sheen and color, crush resistance in heavy deniers, and good textured crimp.

Other fiber shapes that produce similar characteristics are *triskelion* (a three-sided configuration similar to a boat propeller), *pentalobal* (Figure 6–6), *octolobal*, and *Y-shaped*.

Thick-and-thin fiber types vary in their diameter along their length as a result of uneven drawing or stretching after spinning. The resulting fabrics have a texture like duppioni silk or linen. The thick nubby areas dye a deeper color to create interesting tone-on-tone

FIGURE 6-6Trevira polyester pentalobal cross-section (magnification, \times 312). (Courtesy of Trevira.)

color effects. Many surface textures are possible by changing the size and length of the slubs.

Hollow or multicellular fibers imitate the air cells in the hair of some animals, which provide insulation in cold weather. The hollow feathers of birds give them buoyancy. Air cells and hollow filaments in manufactured fibers are made by adding gas-forming compounds to the spinning solution, by injecting air as the fiber is forming, or by modifying the shape of the spinneret holes. For example, when the spinneret hole is in a C-shape or as two half circles, the dope flows slightly on extrusion so that the perimeter closes up and the center remains hollow.

Molecular Structure and Crystallinity Modifications

A controlled stretching of fibers immediately after extrusion produces **high-tenacity fibers**. Fiber strength is increased by (1) drawing or stretching the fiber to align or orient the molecules and strengthen the intermolecular forces, and/or by (2) chemical modification of the fiber polymer to increase the degree of polymerization. These procedures will be discussed in more detail in Chapters 7 and 8.

Low-pilling fibers are engineered to reduce their flex life by slightly reducing the molecular weight of the polymer chains. When flex-abrasion resistance is reduced, the fiber pills break off almost as soon as they are formed and the fabric retains its smooth appearance. These low-pilling fibers are not as strong as other types, but they are durable enough for apparel uses, especially knits. (Review the discussion of molecular weight in Chapter 3.)

Binder staple is a semi-dull, crimped polyester with a very low melting point. Binder staple develops a thermoplastic bond with other fibers under heat and pressure and is used in fiberwebs and related uses.

Low-elongation modifications are used to increase a fabric's strength and abrasion resistance when weaker fibers are blended with stronger fibers, as in cotton/polyester blends. Low elongation results from changing the balance of tenacity and extension. High-tenacity fibers have lower elongation properties. End uses are work clothing and other items that receive hard wear.

Additives to the Polymer or Spinning Solution

Fiber additives include introducing a new or modified monomer to the polymer chain so that it is a part of the polymer or adding a compound to the polymer solution or dope so that it is part of the fiber but it is not a part of the polymer. If too much of the additive is used, it will adversely affect physical fiber characteristics such as strength and hand.

Delustering The basic fiber reflects light from its smooth, round surface. It is referred to as a **bright fiber**. (Note that here *bright* refers to high luster, not intense color.) To **deluster** a fiber, titanium dioxide—a white pigment—is added to the spinning solution before the fiber is extruded. In some cases, the titanium dioxide can be mixed in at an earlier stage when the resin polymer is being formed. The degree of luster is controlled by varying the amount of delusterant, producing dull or semidull fibers. Figure 6–7 shows yarns of different lusters.

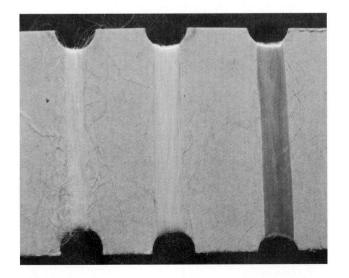

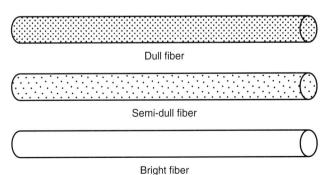

FIGURE 6-7

(Photo) Polyester yarns (left to right: dull, semi-dull, bright). (Diagram) Fibers as they would look under a microscope.

Delustered fibers can be identified microscopically by the presence of dark spots within the fiber (see Figure 6–7). The particles of pigment absorb light or prevent reflection of light. Absorbed light causes fiber degradation or tendering. For this reason, bright fibers reflect light and suffer less light damage and are better for use in window-treatment fabrics. The strength of a delustered fiber is slightly less than that of a bright fiber. Rayon, for example, is 3 to 5 percent weaker when it is delustered.

Solution Dyeing or Mass Pigmentation Solution dyeing, or mass pigmentation, is the addition of colored pigments or dyes to the spinning solution. Thus, the fiber is colored when it emerges from the spinneret. These fibers are also referred to as solution-dyed, masspigmented, dope-dyed, spun-dyed, or producer-colored. If the color is added before the fiber hardens, it is called gel dyeing. Solution dyeing provides color permanence that is not obtainable in any other way. The lightfastness and washfastness are usually excellent. Because the color is uniformly distributed throughout the fiber, color changes resulting from use are minimal.

Because of the difficulty in obtaining a truly black dye with good colorfastness properties, black pigments are often the first ones to be used. Other colors are produced as suitable colorfast pigments are developed.

Solution-dyed fibers cost more per pound than uncolored fibers. This difference may be offset later by the cost of yarn or piece (fabric) dyeing. The solution-dyed fibers are used in upholstery, window treatments, and apparel. One disadvantage of the solution-dyed fibers is that the manufacturer must carry a large inventory to be able to fill orders quickly. The manufacturer is also less able to adjust to fashion changes in color, because it is not possible to strip color from these fibers and redye them.

Whiteners and Brighteners Whiteners and brighteners are added to the spinning solution to make fibers look whiter and resist yellowing. The additive is an optical bleach or fluorescent dye that reflects more blue light from the fabric and masks yellowing. These whiteners are permanent in washing and dry cleaning. They also eliminate the need for bleaching.

Cross Dyeable Cross-dyeable, or dye-affinity, fibers are made by incorporating dye-accepting chemicals into the molecular structure. Some of the parent fibers are nondyeable; others do not accept certain classes of dyes well. The cross-dyeable types were developed to correct this limitation. The dye-affinity fibers are far easier to dye than their parent fibers. Do not confuse cross-dyeable fibers with solution-dyed fibers. Cross-dyeable fibers are not colored when they emerge from the spinneret, while solution dyed fibers emerge as colored fibers.

Antistatic Fibers Static is a result of the flow of electrons. Fibers conduct electricity according to how readily electrons move in them. If a fiber has an excess of electrons, it is negatively charged and it is attracted to something that is positively charged—anything that has a deficiency of electrons. This attraction is illustrated by the way clothing clings to the body. Water dissipates static. Because many synthetic fibers have low water absorbency, static charges build up rapidly but dissipate slowly during dry weather or when fabrics have been rubbed or tumbled together. If the fibers can be made wettable, the static charges will dissipate quickly and annoying static buildup will be minimal.

The antistatic fibers give durable protection because the fiber is made wettable by incorporating an antistatic compound—a chemical conductor—as an integral part of the fiber. The compound is added to the fiber-polymer raw material so that it is evenly distributed throughout the fiber. It changes the fiber's hydrophobic nature to a more hydrophilic one and raises the moisture regain so that static is dissipated more quickly. The moisture content of the air should be kept high enough to provide moisture for absorption—even cotton will build up static if the air is dry enough. Static control is also achieved by incorporating a conducting core into a fiber (Figure 6–8).

The soil-resistant benefits of the antistatic fibers are outstanding. The antistatic fibers retard soiling by minimizing the attraction and retention of dirt particles, and the opacity and luster in the yarn have soil-hiding properties. Soil redeposition in laundry is dramatically reduced. Oily stains, even motor oils, are released more easily.

Sunlight-Resistant Fibers Ultraviolet light causes fiber degradation as well as color fading. When ultraviolet light is absorbed, the damage results from a reac-

FIGURE 6-8
Antistatic polyester. (Courtesy of E. I. du Pont de Nemours & Company.)

tion between the radiant energy and the fiber or dye. Stabilizers such as nitrogenous compounds may be added to the dope to increase **sunlight resistance**. These stabilizers must be carefully selected for the fiber-dye combination. Estron SLR is a sunlight-resistant acetate fiber. These fibers are especially important for window treatments and other furnishings in glass office buildings. SLR fibers are also important for car interiors because of the amount of exposure to sunlight. Delustered fibers are more sensitive to sunlight than bright fibers.

Flame-Resistant Fibers Flame-resistant fibers give better protection to consumers than do topical flame-retardant finishes (see Chapter 18). Some manufactured fibers are inherently flame-retardant because of their chemical composition. These include aramid, novoloid, modacrylic, glass, PBI, saran, sulfar, and vinyon. Other manufactured fibers can be modified by changing their polymer structure or by adding water-insoluble compounds to the spinning solution. These fiber modifications make the fibers inherently flame-resistant, but they may vary in their degree of resistance to flame.

Antibacterial Fibers Antibacterial fibers protect textiles from bacteria and mildew growth, odor, and fiber damage. The antibacterial properties of modified acrylic and acetate are permanent and will not wash out. Some fibers with these modifications also claim to inhibit odorcausing bacteria and dust mites.

Modifications in Fiber Spinning

When producers started to make staple fiber, mechanical crimping was done to broken filaments and later to filament tow to make the fibers more cohesive and thus easier to spin into yarns. Other techniques give permanent crimp to rayon and acetate and provide bulk or stretch to both filament and staple fibers.

Crimping of fibers is important in many end uses: for cover and loft in bulky knits, blankets, carpets, battings for quilted items, and pillows, and for stretch and recovery from stretch in hosiery and sportswear.

For wet-spun fibers, coagulating the fiber in a slightly modified bath can produce crimp. A skin forms around the fiber and bursts, and a thinner skin forms over the rupture. The crimp develops when the fiber is immersed in water. Melt-spun fibers with a helical or spiral crimp are produced by cooling one side of the fiber faster than the other side as the fiber is extruded. This uneven cooling causes the fiber to curl. The same effect can be achieved by heating one side of the fiber during the stretching or drawing process. This helical crimp has more springiness than the conventional mechanical sawtooth crimp. These fibers are used where high levels of compressional resistance and recovery are needed.

In a process for thermoplastic fibers, the spinneret holes are drilled at an angle and turbulence is introduced where the polymer is extruded so that one side of the fiber has uneven internal tensions. This uneven tension produces a fiber with a helical or zigzag crimp.

Complex Modifications

Bicomponent Fibers A bicomponent fiber is a fiber consisting of two polymers that are chemically different, physically different, or both. If the two components would fall into two different generic classes, the term bicomponent-bigeneric may be used. Bicomponent fibers may be of several types. Bilateral fibers are spun with the two polymers side by side. In core-sheath fibers, one polymer is surrounded or encircled by another polymer. In matrix-fibril fibers, short fibrils of one polymer are embedded in another polymer (Figure 6–9).

The original discovery that the two sides of a fiber can react differently when wet was made by studying wool in 1886. In 1953, the discovery that the differences were the result of the bicomponent nature of wool produced by a difference in growth rate and in chemical composition. This differential behavior was the key to producing bilateral bicomponent fibers with latent or inherent crimp.

For example, acrylic fibers can be spun straight and made into a garment such as a sweater. When it is exposed to heat; one side of the fiber shrinks creating a helical crimp. The fiber's reaction to water occurs during laundering. As the fiber gets wet, one side swells and the crimp straightens out. As the crimp relaxes, the sweater increases in size. The crimp returns as the sweater dries and it will regain its original size if properly handled. Sweaters of this type should not be drip-dried or placed on a towel to dry because the weight of the water and the resistance of the towel prevent the sweater from regaining its original size. To dry the sweater correctly, either machine-dry it at a low temperature or place it on a smooth, flat surface and bunch it in to help the crimp recover.

An example of a bicomponent-bigeneric antistatic fiber is a fiber with a polyester core surrounded by a sheath of a polyester copolymer impregnated with black carbon particles. This fiber is used where static can create a potential explosion hazard or where static creates a nuisance. It is used in furnishing, apparel, and industrial applications.

See Chapter 10 for a discussion of blended filament yarns that are another example of a complex fiber modification.

Performance Fibers Fiber modifications that provide comfort and improve human performance are important in active sportswear. With recent advances in fiber and

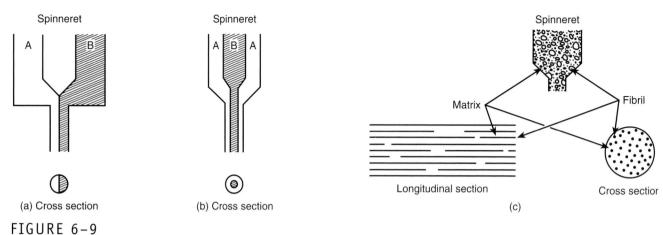

Bicomponent fiber structure: (a) bilateral; (b) core-sheath; (c) matrix-fibril.

fabric technology, more efficient materials produce lighter-weight, more comfortable products. Several materials may be combined into one product to manage moisture or wick perspiration away from the skin, to provide warmth or insulation, and to protect from wind, rain, or snow.

The moisture-management material may be a synthetic fiber with good wicking characteristics, like polyester or olefin. An alternative is a fiber with hydrophilic molecules permanently grafted onto the surface that allow for cooling by evaporation during vigorous exercise. Fiber research and development continues to focus on improving insulation. While fiber insulators build on the principle of trapped air for warmth, advances in fiber size, configuration, and placement have resulted in a variety of products that are soft, breathable, and fashionable. Microfibers, such as DuPont's Microloft and 3M's Thinsulate, provide incredibly warm, soft, and lightweight insulation. These fibers are used in outerwear, pillows, quilts, blankets, sleeping bags, and window treatments to minimize heat transfer. Fabrics made of microfibers with a special finish are waterproof and breathable.

More information on specific fiber performance and trade names is provided in the appropriate sections of Chapters 7, 8, and 9. Finishes that enhance these performance fibers are discussed in Chapter 18. Additional aspects of performance fabrics are discussed in Chapters 12 through 15, with fabrication methods.

Environmental Impact of Manufactured Fibers

Consumers may criticize manufactured fibers because they are perceived to be harmful to the environment. Although it is true that synthetic fibers are processed from petroleum sources, they use only a small fraction of the byproducts of the production of gasoline and fuel oils. Fibers like nylon, polyester, and olefin are produced from natural gases or from butadiene, a byproduct of refining crude oil. Fibers from naturally occurring polymers, like rayon from wood pulp may contribute to excess acid in the air and surface water. Some practices of harvesting trees to be processed into wood pulp, such as clear-cutting timber, cutting old-growth forests, and overharvesting national forests, are criticized by environmentalists.

Concerns with manufactured fibers regarding crude oil and hazardous chemical spills, recycling, health, and safety are real and cannot be ignored or minimized. Government regulations, concern for safety, the economic necessity of reducing costs, and public image concerns have resulted in significant efforts on the part of fiber producers to minimize the negative environmental aspects of fiber production. Modified fiber-production processes use fewer hazardous chemicals and recycle chemicals. Record-keeping practices document the production and disposal of waste materials. Materials that were disposed of at one time are now recycled within the firm or sold to other firms for their use. The generation of hazardous waste and waste-disposal problems have been reduced significantly. Besides minimizing the impact on the environment, these practices also keep costs lower and benefit the consumer with lower retail prices. Some fiber modifications enhance fiber finishing and further minimize use of hazardous chemicals.

Consumers also are concerned with the disposal of manufactured fibers that do not degrade naturally. Natural fibers will eventually degrade if exposed to nature. However, with current waste-disposal methods such as landfills, fibers do not degrade. This is as true for cotton as it is for polyester. Although the concern for

2693

3872

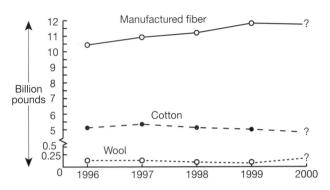

FIGURE 6-10

Domestic consumption of manufactured fibers, cotton, and wool. (Courtesy of Fiber Organon.)

synthetics in landfills is valid, consumers should be equally concerned about natural fibers.

Recycling of synthetic fibers is very important to the fiber industry. Polyester fibers produced from preand postconsumer waste include a range of products from underwear to carpeting. Items with trade names, like Polartec Recycled, DyerSport E.C.O., and Fortrel EcoSpun, are popular with environmentally conscious consumers. Some products labeled "100 percent recyclable" will be taken back by the manufacturer and recycled when the consumer is ready to dispose of them.

TABLE 6-3 U.S. manufactu production in millions of pour	
Acetate and rayon	316
Acrylic and modacrylic	329
Nylon	2830

Source: Fiber Organon, January, 2000, p. 3.

Olefin

Polvester

Manufactured-Fiber Consumption

In 1928, manufactured fibers accounted for 5 percent of fiber consumption in the United States; by 1999, manufactured fibers comprised over 69 percent of U.S. textile consumption. See Figure 6–10, which compares domestic consumption of manufactured fiber, cotton, and wool, and Table 6–3, which lists U.S. manufactured fiber production in millions of pounds.

Manufactured versus Natural Fibers

A comparison of natural and manufactured fibers is shown in Table 6–4.

Category	Natural	Manufactured
Production	Seasonal; stored until used	Continuous
Quality	Varies due to weather, nutrients, type, insects, or disease	Uniform
Uniformity	Lacking	Can be manipulated depending on end use
Physical structure	Related to plant or animal source	Depends on fiber-spinning processes and after-treatments
Chemical composition and molecular structure	Varies with plant or animal source	Depends on starting materials
Properties	Inherent; but can be changed by yarn, fabrication, and finishes	Inherent; but can be changed by varying spinning dope and conditions, fabrication or finishes
Length	Mostly staple; silk is the only filament	Any length
Versatility	Not as versatile	Versatile; changes can be made quickly
Absorbency	Highly absorbent	Absorbency related to fiber chemistry
Heat sensitivity	Not heat sensitive	Many are heat-sensitive, but some are heat-resistant
Heat setability	Requires fabric finish	Most can be heat-set
Research, development, & promotion	By trade organizations	By individual companies as well as by trade organizations
Size	Depends on type and variety	Any size can be produced

Key Terms

Manufactured fiber
Fiber spinning
Spinning solution or dope
Extrusion
Spinneret
Filament fiber
Filament yarn

Filament tow Parent fiber Fiber modification

Microdenier Denier per filament (dpf)

Ultrafine fiber Shin-gosen

Mixed-denier filament bundling Trilobal shape

Thick-and-thin fibers Hollow fibers

High-tenacity fibers Low-pilling fibers Binder staple Low-elongation modifications Fiber additives Bright fibers Deluster Solution dyeing

Mass pigmentation
Whiteners or brighteners
(fluorescent whitening

agents)

Cross-dyeable fibers Antistatic fibers Sunlight-resistance Flame-resistant fibers

Antibacterial fibers Bicomponent fiber Bicomponent-bigeneric

fiber

Questions

- 1. Explain, in general terms, how a manufactured fiber is produced.
- 2. What are the three most common spinning methods used to produce manufactured fibers? Explain briefly how they differ and give an example of a fiber produced by each of these methods.
- 3. What characteristics of manufactured fibers can be modified? Give an example of an end use that would

- benefit from each modification. How are these modifications achieved?
- 4. Do fiber modifications result in any negative effects? If so, what are they?
- 5. What modifications would be appropriate for each end use listed below? Explain how these modifications would enhance performance.

carpeting for restaurant floor window treatment for office building woman's slip ski coat fiberfill for quilt batting tow rope

Suggested Readings

American Fiber Manufacturers Association (1988).

Manufactured Fiber Fact Book. Washington, D.C.:
American Fiber Manufacturers Association.

Anonymous (1998, August). Fiber makers top 130. *Textile World*, pp. 69–98.

Grayson, M., ed. (1984). Encyclopedia of Textiles, Fibers, and Nonwoven Fabrics. New York: Wiley.

Lenox-Kerr, P. (1998, November). How to make filaments with intrinsic crimp. *Technical Textiles International*, pp. 22–24.

McCurry, J. W. (1996, August). Stretch, durability, and style among fiber trends. *Textile World*, pp. 39–46.

Rawnitzkey, M. (1994, September). How synthetics became real. *Industrial Fabric Products Review*, pp. 49–50, 52, 54.

Chapter 7

MANUFACTURED REGENERATED FIBERS

OBJECTIVES

- To be aware of the processing used to produce manufactured regenerated fibers.
- To understand the properties of rayon, lyocell, acetate, and other regenerated fibers.
- To relate fiber properties to end uses for rayon, lyocell, acetate, and other regenerated fibers.

anufactured regenerated fibers are produced from naturally occurring polymers. These polymers do not naturally occur as fibers; thus, processing is needed to convert them into fiber form. The starting materials for these fibers, also referred to as regenerated fibers, are cellulose and protein. The majority of this chapter will focus on the cellulosic fibers rayon, lyocell, and acetate, which are used in apparel, furnishings, and industrial products. In 1997, 369 million pounds of rayon, lyocell, and acetate were produced in the United States. Of that, 47 percent of the manufactured cellulosic fibers are used in apparel, 32 percent in industrial products, and 21 percent in furnishings. Table 7–1 describes the uses of regenerated cellulosic fibers.

Identification of Manufactured Fibers

The manufactured cellulosic fibers appear similar microscopically. Rayon and acetate have striations and irregular cross sections. Lyocell is more rounded and smoother. Rayon and lyocell burn like cotton or flax. Acetate burns freely, melts, and decomposes to a black char. Solubility is an easy way to identify acetate.

The acetone test is specific for acetate, since none of the other fibers dissolves in acetone. Figure 7–1 shows a procedure for testing the acetate content of a fabric. Work in a chemical hood and work quickly, since acetone evaporates easily. Use a dropper bottle, glass rod, watch glass, and tissue. Test individual yarns first to determine the presence of other fibers. Add a small amount of acetone to the watch glass. Place the fabric in the so-

TABLE 7-1 Uses of manufactured cellulosic fibers (1997).

Category*	% of Total Fiber Use
Apparel	2
Lining	39
Top weight	1
Furnishings	3
Window treatments	8
Upholstery	4
Other	7
Industrial	3
Hose	13
Medical/surgical/sanitary	10
Nonwovens	9
Miscellaneous/consumer goods	2

^{*}Categories in which fiber usage is less than 1% are not listed.

FIGURE 7-1Acetone test for identification of acetate fiber.

lution and stir. The structure does not disintegrate if only a small amount of acetate is present, but as the solvent evaporates it feels sticky and stiffens permanently. If the fabric dissolved completely, it was 100 percent acetate.

Rayon

Rayon was the first regenerated cellulosic fiber. It was developed before scientists knew how molecular chains were developed in nature or how they could be produced in the laboratory. Frederick Schoenbein discovered in 1846 that cellulose pretreated with nitric acid would dissolve in a mixture of ether and alcohol, but the resulting fiber was highly explosive. In 1889 in France, Count Hilaire de Chardonnet made rayon by changing the nitrocellulosic fiber back to cellulose. This dangerous and difficult process was discontinued in 1949.

In 1890, Louis Despeissis discovered that cellulose would dissolve in a cuprammonium solution, and in 1919 J. P. Bemberg made a commercially successful cuprammonium rayon. In 1891, in England, Cross, Bevan, and Beadle developed the viscose method.

Commercial production of viscose rayon in the United States began in 1911. The fiber was sold as artificial silk until the name "rayon" was adopted in 1924. Viscose filament fiber, the original form of the fiber to be made, was a very bright, lustrous fiber. Rayon was produced as a filament until the early 1930s, when a textile worker discovered that broken waste rayon filament could be used in staple fiber. In 1932, machinery was designed to make filament tow that would be crimped

and cut into staple fiber. Rayon was originally used in crepe and linenlike apparel fabrics. The high-twist crepe yarns reduced the rayon's bright luster. Other early rayon fabrics included transparent velvet, sharkskin, tweed, challis, and chiffon.

The physical properties of rayon remained unchanged until 1940, when high-tenacity rayon was de-

veloped. Continued research and development led to the greatest technological breakthrough in rayon—highwet-modulus rayon. Production in the United States started in 1955.

High-wet-modulus rayon is frequently referred to as HWM rayon to distinguish it from regular or viscose rayon. In fact, HWM rayon is a viscose rayon, but in

Regular or Standard		High-Wet-Modulus
Blotterlike sheets of purified cellulose		 Blotterlike sheets of purified cellulose
2. Steeped in caustic soda		2. Steeped in weaker caustic soda
3. Liquid squeezed out by rollers		3. Liquid squeezed out by rollers
 4. Shredder crumbles sheets 5. Aged 50 hours 6. Treated with carbon disulfide to form cellulose xanthate, 32 percent CS₂ 		 4. Shredder crumbles sheets 5. No aging 6. Treated with carbon disulfide to form cellulose xanthate, 39–50 percent CS₂
7. Mixed with caustic soda to form viscose solution		7. Mixed with 2.8 percent sodium hydroxide to form viscose solution
8. Solution aged 4–5 days 9. Solution filtered		8. No aging9. Solution filtered
O. Pumped to spinneret and extruded into sulfuric acid bath		10. Pumped to spinneret and extruded into acid bath
0 percent H ₂ SO ₄ 6–24 percent Na ₂ SO ₄ –2 percent ZnSO ₄	Spinning bath	1 percent H ₂ SO ₄ 4–6 percent Na ₂ SO ₄
–2 percent 211504 20 meters/minute 5–50°C	Spinning speed Spinning bath temperature Filaments stretched	20-30 meters/minute 25-35°C

common usage, *viscose rayon* refers to the weaker fiber. HWM rayon is also called high-performance (HP) rayon, or polynosic rayon. Labels of European products may use the terms *polynosic* or modal rather than *rayon*.

It is likely that the output of rayon will not be increased significantly because of the high cost of replacement machinery and the cost of wet spinning. Rayon is no longer the inexpensive fiber it once was—now it is generally comparable in price to cotton.

Production of Rayon

Wet spinning is the most common method of producing rayon. Purified cellulose is chemically converted to a viscous solution, forced through spinnerets into a bath, and returned to solid 100 percent cellulose filaments (see Figure 6–2). Compare the processes for making regular and high-wet-modulus rayon (Table 7–2). It is these differences that produce fibers with different properties. The high-wet-modulus process maximizes chain length and fibril structure.

Regular rayon produced in the United States is a viscose rayon. Some imported rayon is made using the cuprammonium process and labeled as cupra rayon under the trade name Bemberg[®].

Physical Structure of Rayon

Regular viscose is characterized by lengthwise lines called **striations.** The cross section is a serrated or indented circular shape (Figure 7–2) that results from loss of the solvent during coagulation and subsequent collapse of the cross section. This serrated shape is an advantage in dyeing because it increases the fiber's surface area. HWM and cupra rayons have rounder cross sections.

Filament rayon yarns range from 80 to 980 filaments per yarn and vary in size from 40 to 5000 denier. Staple fibers and tow range from 1.5 to 15 denier. Staple fibers are crimped mechanically or chemically.

Rayon fibers are naturally very bright, which limits use to more formal apparel and furnishing items. Use of delustering pigments (see Chapter 6) solves this problem. Solution-dyed fibers are also available.

Chemical Composition and Molecular Arrangement of Rayon

Rayon—a manufactured fiber composed of regenerated cellulose, as well as manufactured fibers composed of regenerated cellulose in which substituents have replaced not more than 15 percent of the hydrogens of the hydroxyl groups.

—Federal Trade Commission

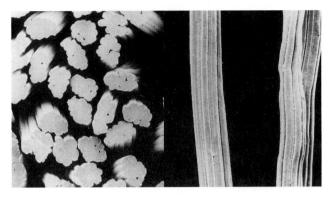

FIGURE 7-2

Photomicrographs of viscose rayon: cross-sectional view (left); longitudinal view (right). (Courtesy of the British Textile Technology Group.)

Rayon is 100 percent cellulose and has the same chemical composition and molecular structure as the natural cellulose found in cotton or flax, except that the rayon chains are shorter and are not as crystalline. The cellulose breaks down during the aging steps in the production of rayon. When the solution is spun into the acid bath, regeneration and coagulation take place rapidly. Stretching aligns the molecules to give strength to the filaments. Rayon is also known as viscose in Europe, and the Federal Trade Commission has ruled that *viscose* is an acceptable alternative term for rayon in the United States.

In high-wet-modulus rayon, the aging is eliminated and the molecular chains are not shortened as much. Because the acid bath is less concentrated, there is slower regeneration and coagulation so that more stretch and greater orientation of the molecules can be achieved. HWM rayon retains its microfibrilar structure. This means its performance is more similar to that of cotton than to that of regular rayon. Table 7–3 compares cotton with the rayons.

Properties of Rayon

Rayon fibers are highly absorbent, soft, comfortable, easy to dye, and versatile. Fabrics made of rayon have a unique soft drape that designers love. Rayon is used in apparel, furnishings, and industrial products. Table 7–4 summarizes rayon's performance in apparel and furnishings. Review the tables in Chapter 3 to compare the performance of rayon to that of the other fibers.

Aesthetics Since its luster, length, and diameter can be controlled, rayon can be made into fabrics that resemble cotton, linen, wool, and silk. Rayon can be en-

Properties	Cotton	Regular Rayon	HWM Rayon	Lyocell
Fibrils	Yes	No	Yes	Yes
Molecular chain length	10,000	300-450	450-750	_
Swelling in water, %	6	26	18	_
Average stiffness	57-60	6-50	28-75	30
Tenacity, grams/denier				
Dry	4.0	1.0-2.5	2.5-5.0	4.3-4.7
Wet	5.0	0.5-1.4	3.0	3.8-4.2
Breaking elongation, %	3-7	8-14	9-18	14-16

gineered to have physical characteristics similar to those of the other fiber in a blend. If it is used instead of cotton or to blend with cotton, rayon can simulate the look of mercerized long-staple cotton. Rayon has an attractive, soft, fluid drape. Sizing may be added to increase the body and hand. Cupra rayon has a more silklike hand and luster and may be found in smaller deniers.

Durability Regular rayon is a weak fiber that loses about 50 percent of its strength when wet. The breaking tenacity is 1.0 to 2.5 g/d. Rayon has a breaking elongation of 8 to 14 percent dry and 20 percent wet. It has the lowest elastic recovery of any fiber. All of these factors are due to the amorphous regions in the fiber. Water readily enters the amorphous areas, causing the

TABLE 7-4 Summary of the performance of rayon in apparel and furnishing fabrics.

	Regular Rayon	HWM Rayon
Aesthetics	Variable	Variable
Durability Abrasion resistance Tenacity Elongation	Poor Poor Poor Moderate	Moderate Moderate Moderate Poor
Comfort Absorbency Thermal retention	Excellent High Poor	Excellent Excellent Poor
Appearance retention Resiliency Dimensional stability Elastic recovery	Poor Poor Poor Poor	Moderate Poor Moderate Moderate
Recommended care	Dry-clean	Machine-wash Dry-clean

molecular chains to separate as the fiber swells, breaking the hydrogen bonds and distorting the chains. When water is removed, new hydrogen bonds form, but in a distorted state. Cupra rayon is not as strong as HWM rayon, but it is stronger than viscose rayon.

HWM rayon has a more crystalline and oriented structure so that the dry fiber is relatively strong. It has a breaking tenacity of 2.5 to 5.0 g/d, a breaking elongation of 9 to 18 percent dry and 20 percent wet, and an elastic recovery greater than that of cotton.

Comfort Rayons make very comfortable, smooth, soft fabrics. They are absorbent, with a moisture regain of 11.5 to 12.5 percent that eliminates static except under the most extreme conditions. Thermal retention is low. Rayon is not irritating to the skin.

Appearance Retention The resiliency of rayon is low. This can be improved in HWM rayon fabrics by adding a wrinkle-resistant finish. However, the finish decreases strength and abrasion resistance. The dimensional stability of regular rayon is low. Fabrics may shrink or stretch. The fiber is very weak when wet and has low elastic recovery. The performance of HWM rayon is better. It exhibits moderate dimensional stability that can be improved by shrinkage-control finishes. The fiber is not likely to stretch out of shape, and elastic recovery is moderate.

Care Regular rayon fabrics have limited washability because of their low strength when wet. Unless rayon fabrics are resin-treated, their tendency to shrink progressively cannot be controlled by finishes. Regular rayon fabrics generally should be dry-cleaned. Another reason to dry-clean rayon is the presence of sizings that increase the body and hand but may water-spot or streak after wetting with water.

HWM rayon fabrics have greater washability. Their stability and strength are equal to that of cotton. They can be mercerized and finished to minimize shrinkage. They also wrinkle less than regular rayon in washing and drying.

The care of furnishings of rayon or rayon blends poses some real problems. Although many items can be cleaned with water-based compounds, the lack of labels on many furnishings makes this a gamble. Items may shrink, water-spot, or lose color when cleaned. In addition, since manufacturers and suppliers of furnishings rarely distinguish among regular or HWM rayons, it is difficult for professionals to make recommendations regarding care of these products. Thus, as a general recommendation, furnishings of rayon should be cleaned when necessary, but with the understanding that the results may not be completely satisfactory.

The chemical properties of rayon are similar to those of the other cellulosic fibers. They are harmed by acids, resistant to dilute alkalis, and not affected by organic solvents. They can be safely dry-cleaned. Rayon may be damaged by silverfish and mildew.

Rayon is not greatly harmed by sunlight. It is not thermoplastic and thus can withstand a fairly high temperature for pressing. But rayon burns readily, like cotton.

Environmental Impact of Rayon

Although rayon is produced from a naturally occurring polymer, significant processing is needed to produce a usable fiber. Most rayon is produced from wood pulp. Some of the wood is harvested from tree farms located on marginal agricultural land. However, other wood used to produce rayon is cut from mature forests. Environmental issues related to cutting trees include clear-cutting—all trees in an area are cut, with no trees remaining to hold soil and provide a habitat for birds, animals, insects, and other plants; cutting old growth forests that may provide habitat for endangered species; and harvesting trees in national forests at minimal cost to lumber companies.

The processing of wood pulp uses large quantities of acid and other chemicals that may contribute to water and air pollution. Regulations describing air and water quality have resulted in changes in rayon production. Cuprammonium rayon is no longer made in the United States because producers could not meet water- and airquality requirements. The chemicals used to process rayon into fiber and to clean it after extrusion should be recovered and recycled, but these additional steps are costly to perform and monitor. U.S. producers are reducing pollutant emissions like hydrogen sulfide and carbon disulfide and decreasing wastewater effluent. Some rayon producers are working toward using a closed chemical system so that 99 percent of the waste liquor can be recovered.

Because rayon is a regenerated cellulose fiber, it is biodegradable. However, current landfill practices prevent natural degradation of buried materials. Rayon is not generally recycled. Since rayon fibers are used in many sanitary products, including disposable diapers, disposal of these products is an issue. Producing consumer goods from rayon makes extensive use of water, dyes, and finishing chemicals. Depending on how items have been finished, they may require dry cleaning. Solvents used in dry cleaning present additional hazards to the environment. See Chapter 20 for more information on dry cleaning.

Uses of Rayon

Rayon is mostly used in woven fabrics, especially in apparel and furnishings such as draperies and upholstery. Rayon also is used in nonwoven fabrics, where absorbency is important; these items include industrial wipes; medical supplies, including bandages; diapers; and sanitary napkins and tampons. Hollow cuprammonium rayon is used in dialysis machines to filter waste products from blood.

Types and Kinds of Rayon

The only way to determine a specific type of rayon is by the trade name, such as Modal or Bemberg. Unfortunately, trade names for rayon are seldom used as a marketing tool with consumers. Besides HWM rayons, other types include solution-dyed, modified cross section, intermediate- or high-tenacity, optically brightened, high absorbency, hollow, and microfibers. In addition, there are several flame-retardant rayons, including Visil rayon, which contains silica. It is used for furnishings, for which stringent flammability standards exist, and for protective apparel.

Lyocell

The development of **lyocell** was prompted in part by concern about rayon's negative environmental impact. When the fiber was first introduced in the early 1990s, it was marketed as a type of rayon. However, because of lyocell's unique combination of characteristics, the Federal Trade Commission issued a new generic classification for this fiber in 1996. Lyocell is produced in both Europe and the United States.

Production of Lyocell

Solvent spinning is the procedure used to produce lyocell (Figure 7–3; and see Figure 6–2). In solvent spinning, the cellulose polymer is dissolved in amine oxide and spun into a well-diluted bath of the solvent. Amine oxide, a chemical with low toxicity and low skin irrita-

FIGURE 7-3
Solvent spinning. (Tencel Ltd.)

tion, dissolves the cellulose in wood pulp without changing the nature of the cellulose. The major difference in the fiber-spinning process between wet and solvent spinning is the formulation of the bath and the solution's greater viscosity or thickness. In wet spinning, the bath is a weak acid solution; in solvent spinning, the bath is a weak solution of amine oxide. In both processes, the solvent precipitates the fiber. After spinning, the fiber is washed and dried. The solvent is recovered, purified, and recycled. The solvent spinning process results in a fiber that is more like cotton than any other manufactured fiber. Table 7–3 compared the properties of cotton, rayon, and lyocell.

Physical Structure of Lyocell

With this spinning process, lyocell does not collapse in on itself as rayon does, so the fiber has a more rounded cross section and smoother longitudinal structure (Figure 7–4). Lyocell is available in a variety of deniers and lengths. Filament yarns are available in various numbers of filaments per yarn, depending on end use. Staple fibers and tow range from less than 1.0 to 15 denier per filament and are mechanically crimped for use in blends and other staple fiber products.

Chemical Composition and Molecular Arrangement of Lyocell

Lyocell—a manufactured fiber composed of solvent-spun cellulose.

-Federal Trade Commission

Lyocell is 100 percent cellulose, with the same chemical composition and molecular structure as that found in natural cellulose. The polymer chain length is longer than that of rayon, but not as long as that of cotton. Drawing the fibers after spinning increases the orientation and crystallinity and makes lyocell more durable.

Properties of Lyocell

The properties of lyocell fibers are more like those of cotton than any of the other regenerated cellulose fibers. Lyocell fabrics possess a soft, flowing drape that attracts designers. Lyocell is used in apparel, furnishings, and industrial products. Table 7–5 summarizes lyocell's performance in apparel and furnishings. Compare the performance of lyocell with that of the other fibers as presented in the tables in Chapter 3.

Aesthetics As with all manufactured fibers, the luster, length, and diameter of lyocell can be varied depending on the end use. Lyocell can be used by itself or blended with any natural or manufactured fiber. It can be processed in a variety of fabrications and finishes to produce a range of surface effects. With its ability to fibrillate under certain conditions, lyocell offers unusual combinations of strength, opacity, and absorbency.

Durability Lyocell performs more like cotton than rayon. Its breaking tenacity is 4.8 to 5.0 g/d dry and 4.2 to 4.6 g/d wet. This is only a 12 percent loss in strength. It is the strongest of the cellulosic fibers. Its breaking elongation is 14 to 16 percent, and its wet elongation is 16 to 18 percent. Because of its unique combination of soft hand and good durability characteristics, it produces comfortable, long-lasting apparel and furnishings. Its

FIGURE 7-4
Photomicrograph of lyocell. (Tencel Ltd.)

TABLE 7-5	Summary	of the perf	ormance
of lyocell in a			

Aesthetics	Variable
Durability	Good
Abrasion resistance	Good
Tenacity	Good
Elongation	Poor
Comfort	Excellent
Absorbency	Excellent
Thermal retention	Poor
Appearance retention Resiliency Dimensional stability	Moderate Moderate Good
Recommended care	Dry-clean or machine-wash, gentle

high strength, especially when wet, offers some unusual possibilities in terms of wet processing and finishing. Applications that require high wet strength are ideal for lyocell. When abraded, its tendency to fibrillate (split lengthwise into tiny fibrils) produces a fuzzy, hairy texture that on smooth fabrics is unacceptable.

Comfort Lyocell is another soft, smooth fiber that makes comfortable apparel and furnishings. It has a regain of 11.5 percent, so problems with static are not likely. With its soft hand and high absorbency, lyocell is ideal for use in apparel that comes in contact with the skin and in furnishings. As with all other cellulosic fibers, thermal retention is poor.

Appearance Retention Lyocell's resiliency is moderate; it will wrinkle, but not quite as severely as rayon. The dimensional stability of lyocell is good. It will shrink some, but it does not exhibit the progressive shrinkage of some regular rayons. Its tendency to fibrillate with abrasion may create problems with fuzziness, pilling, or other surface changes over time. Elastic recovery is superior to rayon and acetate.

Care Products made of lyocell can be either machine-washed on a gentle cycle or dry-cleaned. Some research indicates that machine-washing of dark or intensely colored lyocell fabrics may produce an unacceptable alteration of hand and irregular color. Gentle agitation should minimize this problem. Dry cleaning is successful and does not produce the alteration of color and hand that machine-washing may produce.

Lyocell is sensitive to acids and resistant to dilute alkalis and most organic solvents. As a cellulosic fiber, lyocell is sensitive to damage by mildew and some insects.

Environmental Impact of Lyocell

Lyocell is produced from wood pulp and spun into a solvent bath in a closed manufacturing process. The hazardous chemicals used in the production of viscose are not used to produce lyocell. The chemicals used are significantly less hazardous to the environment than those used for the production of viscose rayon. Because the solvent is recycled efficiently and the wood is harvested from tree farms specifically developed for this end use, lyocell can be described as an environmentally friendly fiber.

As a cellulose fiber, lyocell should be biodegradable. If the fiber is disposed of in landfills, however, it will not degrade. Lyocell is not recycled. As with the other cellulosic fibers, producing consumer goods from lyocell makes extensive use of water, dyes, and finishing chemicals. Depending on how items have been finished, they may require dry cleaning. Solvents used in dry cleaning present additional hazards to the environment. See Chapter 20 for more information on dry cleaning.

Uses of Lyocell

Lyocell, not quite twice as expensive per pound as viscose rayon, is found in a variety of products: professional business wear, leotards, hosiery, casual wear, upholstery, and window-treatment fabrics. It is used in blends with wool, cotton, and other manufactured fibers. When strength and softness are required, it is used in conveyer belts. In a fibrillated form, lyocell is used for filters, printers' blankets, specialty papers, and medical dressings.

Types and Kinds of Lyocell

Because lyocell is a relatively new fiber, there are fewer modifications available for lyocell as compared with the number of modifications for other manufactured fibers. As the fiber gains market share, more modifications are expected. Current modifications related to fiber size and length enable it to be blended with other fibers. A cross-linked lyocell, Tencel 100A, exhibits significantly fewer problems with fibrillation.

Acetate

Acetate originated in Europe. Using a technique that produced a spinning solution for a silklike fiber, the Dreyfus brothers experimented with acetate in Switzerland. They went to England during World War I and perfected the acetate dope as a varnish for airplane

wings. After the war, they perfected the process of making acetate fibers. In 1924, acetate became the second manufactured fiber to be produced in the United States.

More problems had to be solved with the acetate process than with the rayon processes. Acetate is a different chemical compound. Primary acetate (**triacetate**) contains no hydroxyl groups; modified or secondary acetate (acetate fiber) has only a few hydroxyl groups. Because of the unique chemistry of the fibers, they could not be dyed with any existing dyes. Dispersed dyes were developed especially for acetate and triacetate.

Acetate was the first thermoplastic, or heatsensitive, fiber. Consumers were confronted with fabrics that melted under a hot iron. This was at a time when consumers were accustomed to ironing all apparel. The problem was further compounded when manufacturers introduced acetate as a kind of rayon.

Still another problem with acetate was fume fading—a condition in which certain dispersed dyes changed color (blue to pink, green to brown, gray to pink) when exposed to atmospheric fumes, now referred to as atmospheric pollutants. Solution-dyeing corrected this problem and is used for many manufactured fibers. In 1955, an inhibitor greatly improved dye performance under all conditions that cause fading. However, fume, or pollution fading continues to be a problem.

Production of Acetate

The basic steps in the acetate manufacturing process are listed in Table 7–6. Triacetate was produced until the end of 1986, when the last triacetate plant was closed because the Environmental Protection Agency (EPA) banned the use of the solvent methylene chloride. Some triacetate is imported into the United States, so it is important to know that triacetate is a thermoplastic fiber. It can be heat-set for resiliency and dimensional stability and is machine-washable.

TABLE 7-6 Acetate manufacturing process.

- 1. Purified cellulose from wood pulp or cotton linters
- 2. Mixed with glacial acetic acid, acetic anhydride, and a catalyst
- 3. Aged 20 hours—partial hydrolysis occurs
- 4. Precipitated as acid-resin flakes
- 5. Flakes dissolved in acetone
- 6. Solution is filtered
- Spinning solution extruded in column of warm air. Solvent recovered
- 8. Filaments are stretched and wound onto beams, cones, or bobbins ready for use

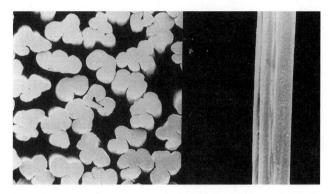

FIGURE 7-5

Photomicrographs of acetate fiber: cross-sectional view (left); longitudinal view (right). (Courtesy of the British Textile Technology Group.)

Physical Structure of Acetate

Acetate is available as staple or filament. Much more filament is produced because it gives a silklike look. Staple fibers are crimped and usually blended with other fibers. The cross section of acetate is lobular or flower petal–shaped. The shape results from the evaporation of the solvent as the fiber solidifies in spinning. Notice in Figure 7–5 that the lobes may appear as a false lumen. The cross-sectional shape can be varied. Flat filaments give glitter to fabrics.

Chemical Composition and Molecular Arrangement of Acetate

Acetate—a manufactured fiber in which the fiber-forming substance is cellulose acetate. Where not less than 92 percent of the hydroxyl groups are acetylated, the term *triacetate* may be used as a generic description of the fiber.

—Federal Trade Commission

Acetate, an ester of cellulose, has a different chemical structure from rayon or cotton. In acetate, two hydroxyl groups are replaced by bulky acetyl groups (see Figure 7–6) that prevent highly crystalline areas. There is less attraction between the molecular chains due to a lack of hydrogen bonding. Water molecules do not penetrate as readily, contributing to its lower absorbency and dye affinity. Acetate is thermoplastic.

Properties of Acetate

Acetate has a combination of properties that make it a valuable textile fiber. It is low in cost and has good draping qualities. Table 7–7 summarizes acetate's

FIGURE 7-6

Chemical structure of acetate.

performance in apparel and furnishing fabrics. Reviewing the tables in Chapter 3 will help in comparing the performance of acetate with that of the other fibers.

Aesthetics Acetate has been promoted as the beauty fiber. It is widely used in satins, brocades, and taffetas, in which fabric luster, body, drape, and beauty are more important than durability or ease of care. Acetate maintains a good white color, an advantage over silk.

Durability Acetate is a weak fiber, with a breaking tenacity of 1.2 to 1.4 g/d. It loses some strength when wet. Other weak fibers have some compensating factor, such as wool's good elastic recovery, but acetate does not. Acetate has a breaking elongation of 25 percent. Acetate also has poor resistance to abrasion. A small per-

TABLE 7-7	Summary of the performance	
	apparel and furnishing fabrics.	

Aesthetics	Excellent
Luster	High
Drape	High
Texture	Smooth
Hand	Smooth
Durability	Poor
Abrasion resistance	Poor
Tenacity	Poor
Elongation	Moderate
-	
Comfort	Moderate
Absorbency	Moderate
Thermal retention	Moderate
Appearance retention	Poor
Resiliency	Poor
Dimensional stability	Moderate
Elastic recovery	Poor
Recommended care	Dry-clean
	-

centage of nylon may be combined with acetate to produce a stronger fabric.

Comfort Acetate has a moisture regain of 6.3 to 6.5 percent and is subject to static buildup. The fiber is extremely soft, with no allergenic potential. Thermal retention is poor.

Appearance Retention Acetate fabrics are not very resilient and wrinkle during use. Wrinkles from washing are difficult to remove. Acetate has moderate dimensional stability. The fibers are weaker when wet and can be shrunk by excess heat. Elastic recovery is low, 58 percent.

Care Acetate should be dry-cleaned unless other care procedures are identified on the care label. Acetate is resistant to weak acids and to alkalis. It can be bleached with hypochlorite or peroxide bleaches. Acetate is soluble in acetone. Acetate cannot be heat-set at a temperature high enough to give permanent shape to fabrics or a durable embossed effect.

Acetate is thermoplastic and heat-sensitive; it becomes sticky at low temperatures (177 to 191°C, 350 to 375°F) and melts at 230°C (446°F). Triacetate has a higher melting point than acetate.

Acetate has better sunlight resistance than silk or nylon but less than the cellulose fibers. It is resistant to moths, mildew, and bacteria.

Comparison with Rayon Rayon and acetate are the two oldest manufactured fibers and have been produced in large quantities, filling an important need for less-expensive fibers in the textile industry. They lack the easy care, resilience, and strength of the synthetics and have had difficulty competing in uses for which these characteristics are important. Rayon and acetate have some similarities because they are made from the same raw material, cellulose. The manufacturing processes differ, so the fibers differ in their individual characteristics and uses. Table 7–8 compares rayon, lyocell, and acetate.

Environmental Impact of Acetate

Acetate is produced from cellulose and requires a significant amount of processing to produce a usable fiber. The same concerns identified in the discussion of rayon apply to the wood pulp used to produce acetate. Because acetate is dry-spun, it is easier for producers to reclaim and reuse the solvent. With current environmental regulations and economic pressures, solvent recovery and reuse is standard practice in the production of acetate. Acetate fiber is less likely to degrade naturally as compared with rayon and is not recycled. Acetate is usually dyed with dispersed dyes. Special chemical carriers may be used to move the dye into the fiber. Acetate items usually require dry cleaning. The

Rayon (Viscose)	Lyocell	Acetate
Wet-spun	Solvent-spun	Dry-spun
Regenerated cellulose	Regenerated cellulose	Chemical derivative of cellulose
Serrated cross section	Round cross section	Lobular cross section
More staple produced	Staple and filament produced	More filament produced
Scorches	Scorches	Melts
High absorbency (12.5%)	High absorbency (11.5%)	Fair absorbency (6.4%)
No static	No static	Static
Not soluble in acetone	Not soluble in acetone	Soluble in acetone
Industrial uses—absorbent products, dialysis	Industrial products, filters	Few industrial uses, fiberfill
Color may crock or bleed	Color may crock or bleed	Color may fume or pollution fade
Mildews	Mildews	Resists mildew
Moderate cost	Higher cost	Low cost
Poor resiliency	Moderate resiliency	Poor resiliency
Low strength (1.0–2.5 g/d dry; 0.5–1.4 q/d wet)	Higher strength (4.8–5.0 g/d dry; 4.2–4.6 g/d wet)	Low strength (1.2–1.4 g/d dry; 1.0–1.3 g/d wet)
Moderate abrasion resistance	Good abrasion resistance	Poor abrasion resistance
Chlorine bleaches can be used	Chlorine bleaches can be used	Chlorine bleaches can be used
Moderate light resistance	Moderate light resistance	Moderate light resistance
1.48-1.54 g/cc	1.56 g/cc	1.32 g/cc
Harmed by strong acids	Harmed by strong acids	Harmed by strong acids
Resistant to alkalis and most solvents	Resistant to alkalis and most solvents	Resistant to most alkalis; soluble i many solvents
95% elastic at 2% elongation	Unknown	48-65% elasticity at 4% elongatio
7–14% breaking elongation dry; 20% wet	14–16% breaking elongation dry; 16–18% wet	24–45% breaking elongation dry; 35–50% wet

solvents used in dry cleaning present additional hazards to the environment. See Chapter 20 for more information on dry cleaning.

Uses of Acetate

While it is a minor fiber, acetate is used in apparel, furnishings, and industrial products. One important use of acetate is in lining fabrics. The aesthetics of acetate—its luster, hand, and body—its relatively low cost, and its ease in handling contribute to its wide use here. However, since acetate is not a durable fiber, the fabric must be carefully selected for the end use or the consumer will be dissatisfied with the product.

Acetate is very important in drapery fabrics. Sunlight-resistant modifications contribute to the fiber's popularity here, as do its luster and soft drape. Antique-satin fabrics made of blends of acetate and rayon are very common. Fabrics of 50 percent acetate and 50 percent cotton are used when draperies need to match bed-spreads or lightly used upholstery. Acetate and acetate-blend fabrics come in an amazingly wide assortment of colors—nearly any decor can be matched.

Another use of acetate is in fabrics for formalwear, such as dresses and blouses in moiré taffeta, satin, and brocade.

Other important uses of acetate fabrics include bedspreads and quilts, fabrics sold for home sewing, ribbons, and cigarette filters. MicroSafe AM acetate is an absorbent antibacterial fiber produced by Celanese Corp. for use in personal hygiene products, fiberfill, and filters.

Types and Kinds of Acetate

Types of acetate are solution-dyed, flame-retardant, sunlight-resistant, fiberfill, textured filament, modified cross section, antibacterial, and thick-and-thin slublike filament.

Other Regenerated Fibers

Cornstarch is fermented and melt-spun to produce polylactide, commonly referred to as PLA. While specific characteristics have not been released, manufacturers claim that it has a luster, drape, and hand similar to silk, quick drying properties, and good wrinkle resistance. It is available in staple and filament form. It also has good flame and ultraviolet resistance. Concerns relate to its colorfastness, dyeability, and strength. It is used in apparel, agricultural and land-scaping applications, sanitary and medical products, and food packaging materials.

Alginate fibers are polysaccharides processed from brown seaweed. They are used primarily for wound dressings because they protect while allowing healing to occur.

Fine cellulosic filaments produced by certain bacteria, also known as fungal fibers, are being developed for high-performance nonwovens, filters and wound dressings.

Key Terms

Manufactured regenerated fiber Striations Acetate Acetone test Rayon Triacetate Cellulose Thermoplastic High-wet-modulus rayon Heat-sensitive Fume or pollution fading Wet spinning Lyocell Viscose rayon Cuprammonium rayon Solvent spinning

Questions

- 1. How do the properties of rayon, lyocell, and acetate differ from those of the natural cellulosic fibers?
- Explain the difference in properties among viscose rayon, HWM rayon, and lyocell.
- 3. How can the manufactured regenerated fibers be changed to enhance their performance for specific end uses?
- 4. For each end use listed here, identify a fiber discussed in this chapter that would be appropriate. Indicate why you selected that fiber as well as any fiber modifications that might enhance the fiber's performance for that end use.

inexpensive kitchen wipes draperies for formal dining room lining for suit jacket summer-weight suit

Suggested Readings

Acetate properties. (1994, Autumn). *Textiles Magazine*, p. 24. Davidson, W. A. B. (1993, April). Rayon makers clean up image. *America's Textiles International*, pp. 54–55.

Ford, J. E. (1991). Viscose fibres. Textiles, no. 3, pp. 4–8.Grayson, M., ed. (1984). Encyclopedia of Textiles, Fibers, and Nonwoven Fabrics. New York: Wiley.

Havich, M. M. (1999, June). New fabric stalks a market share. *America's Textiles International*, pp. 66.

Havich, M. M. (1999, January). Flight of fashion, *America's Textiles International*, pp. 90.

Taylor, J. (1998, July/August). Tencel—a unique cellulosic fibre. Journal of the Society of Dyers and Colourists, 114, 191–193.

Trotman, E. R. (1984). Dyeing and Chemical Technology of Textile Fibers, 6th ed. New York: Wiley.

Viscose rayon properties. (1994). Textiles Magazine, no. 2, p. 17.

Chapter 8

SYNTHETIC FIBERS

OBJECTIVES

- To know the properties common to most synthetic fibers.
- To understand the processes used in producing synthetic fibers.
- To integrate performance characteristics of the common synthetic fibers with end-use requirements.
- To recognize the use of synthetics in apparel, furnishing, and industrial products.

ynthetic fibers, a subset of manufactured fibers, have helped shape the world as we know it. The major difference between manufactured regenerated fibers and synthetic fibers is the raw material from which the fiber is formed. Regenerated fibers are produced from naturally occurring polymers. The polymers for synthetic fibers are synthesized or made from small simple molecules. Although sometimes referred to as chemical fibers and noncellulosic manufactured fibers, synthetic fibers is the most commonly used term.

Synthetic Fibers: An Overview

In producing synthetic fibers, the fiber-forming compounds are made from basic raw materials. The procedures involved in creating the fiber-forming materials from the starting materials are complex and beyond the scope of this book. Many synthetic fibers are made from petrochemicals (petroleum-based chemicals). Even though the synthetic fiber industry is huge (Table 8–1), the amount of petrochemicals used to produce fibers is less than 1 percent of the total petroleum consumed in the United States in one year.

Once the materials are available, they are polymerized or connected into one extremely large linear compound called a polymer. For many fibers, the basic unit of the polymer, the monomer, is fairly simple; for others, the monomer is more complex. Two basic polymerization processes are used: addition and condensation. In addition polymerization, a double bond between two adjacent carbon atoms in the monomer is broken and reforms as a single bond connecting two monomers, until a long-chain polymer is formed. In condensation polymerization, small molecules (hydrogen, hydroxyl, or others) are removed by a chemical reaction from the compound, and many monomers react to form the polymer. A small molecule, often water, is a byproduct of this reaction (Figure 8–1).

Different chemical compounds are used to produce nylon, polyester, olefin, acrylic, and modacrylic. These fibers are found in a wide variety of apparel, furnishing, and industrial applications and will be discussed in this

Million pounds of fiber used. TABLE 8-1 Percent Fiber 1998 5,297 30 Cotton Synthetic fibers 12,049 69 1 0ther 170 17,516 100 Total

FIGURE 8-1

Polymerization: (a) addition and (b) condensation.

chapter. The next chapter will focus on other synthetic fibers that have special properties and end uses. The synthetic fibers have many common properties and processes (Table 8–2).

Synthetic fibers have acquired a negative image in the minds of many consumers for a variety of reasons: inappropriate end uses, poor fashion image, concern for the environment, and poor comfort characteristics. Marketing strategies have strengthened the industry and changed the perception of these fibers. Synthetic fibers offer much in terms of high-tech versatility, easy care, durability, and high-fashion appeal. Research and development efforts continue to improve their performance and expand their end uses.

Common Properties of Synthetic Fibers

Heat Sensitivity Many synthetic fibers are heatsensitive. Heat sensitivity refers to fibers that soften or melt with heat; those that scorch or decompose are described as being heat resistant. Awareness of heat sensitivity is important in manufacturing because of the heat in dyeing, scouring, singeing, and other finishing and production processes. Heat sensitivity is equally important to consumers because of the heat encountered in washing, ironing, and dry cleaning.

Fibers differ in their level of heat sensitivity. These differences are shown in Table 3–5. If the iron remains in one spot too long, the heat builds up. When heat-sensitive fabrics get too hot, the yarns soften and pressure from the iron flattens them permanently (Figure 8–2). Glazing is the melting and flattening of yarns and fibers exposed to excess heat. While it is a disaster to the consumer if the iron is too hot, glazing is used in finishing to produce deliberate texture and surface effects.

Alterations are difficult to make in apparel made of heat-sensitive fibers because creases, seams, and hems are hard to press in or out. Fullness cannot be shrunk out for shaping, so patterns have to be adjusted.

Pilling Fiber tenacity is a basic factor in pilling, the formation of tiny balls of entangled fiber ends on a fab-

Properties	Importance to Consumers
Heat sensitive	Fabrics shrink and melt when exposed to excess heat. Holes may appear. Pleats, creases, and other three-dimensional effects can be heat-set. Fabric can be stabilized by heat setting. Yarns can be textured for bulk. Furlike fabrics are possible.
Resistant to most chemicals	Used in industrial applications in which chemical resistance is required
Resistant to moths, fungi, & rot	Storage is no problem. Used in geotextiles, sandbags, fishing lines, tenting, etc.
Low moisture absorbency	Products dry quickly, resist waterborne stains. Poor comfort in humid weather. Difficult to dye. Static problems more likely. Does not shrind when wet.
Oleophilic	Oil and grease absorbed by fibers must be removed by dry-cleaning agents.
Electrostatic	Static cling and shocks may occur. Static sparks may pose risk of explosions or fires in unusual situations.
Abrasion resistance good to excellent (acrylics lowest)	Resistant to wear and holes. Used in many industrial applications.
Strength good to excellent	Make good ropes, belts, and hosiery. Resist breaking under stress.
Resilience excellent	Easy-care apparel, packable for travel. Less wrinkling during wear. Resilient carpeting.
Sunlight resistance good to excellent (nylon modified to improve resistance)	Used in outdoor furniture, indoor/outdoor carpet, curtains/draperies, flags, banners, and awnings.
Flame resistance	Varies from poor to excellent. Check individual fibers.
Density or specific gravity	Varies as a group but tend to the lightweight. More product per unit mass.
Pilling	May occur in products made of staple fibers.

ric's surface. Pilling occurs on staple-fiber fabrics, where fiber ends entangle due to abrasion. The pills may break off before the item becomes unsightly, but most synthetic fibers are so strong that surface pills accumulate. Pills are of two kinds: lint and fabric. *Lint pills* are more unsightly, because they contain not only fibers from the item but also fibers picked up during care, through contact with other fabrics in use, and through static attraction. *Fabric pills* consist of fibers from the fabric and are less obvious. Pilling can be minimized by fiber modification or finishes.

FIGURE 8-2

Heat and pressure cause permanent flattening of the yarn. Glazing is a permanent change in fiber or yarn cross section.

To minimize pilling, compact weaves, high yarn twist or plied yarns, and longer-staple fibers are recommended. Resin finishes of cotton and fulling of wool also help prevent pilling.

Static Electricity Static electricity is generated by friction when a fabric is rubbed against itself or other objects. If the electrical charge is not removed, it builds up on the surface. When the fabric comes in contact with a good conductor, a shock, or electron transfer, occurs. This transfer may produce sparks that, in some environments, can cause explosions. Static tends to build up more rapidly in dry, cold regions.

Static may attract soil, dust, and lint and cause products to look unattractive. Brushing to remove the soil simply increases the problem. Static cling is another problem. Fabrics cling to equipment in production facilities and make cutting and handling fabrics more difficult. Clothes also cling to the wearer and cause discomfort and an unsightly appearance. Antistatic finishes are applied to many fabrics at the factory, but they may not be permanent. Static can be minimized for the consumer by the use of fabric softeners, when used as directed.

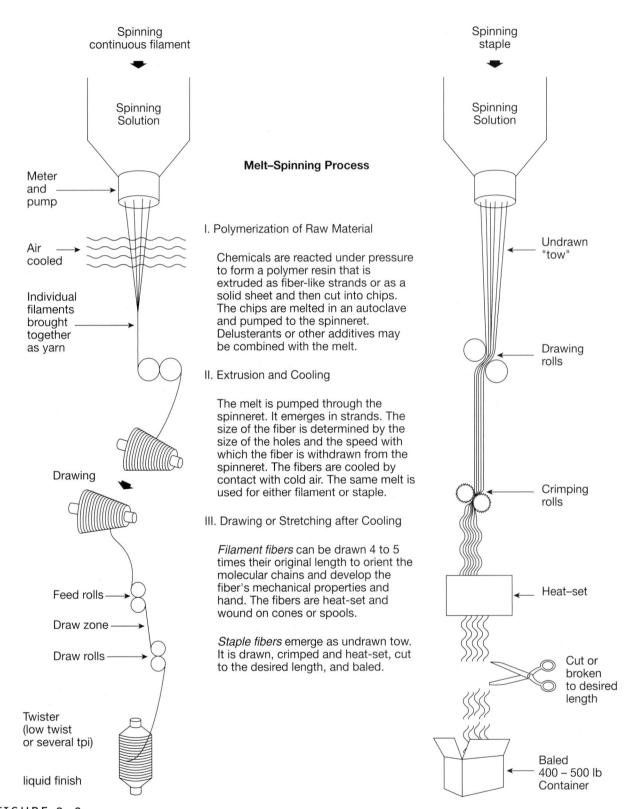

FIGURE 8-3

The melt-spinning processes: filament (left) and staple (right).

Oleophilic Fibers that have low moisture absorption usually have a high affinity for oils and greases. They are **oleophilic.** Exposure to oily substances may cause these fibers to swell. Oily stains are very difficult to remove and may require prespotting with a concentrated liquid soap or a dry-cleaning solvent.

Common Manufacturing Processes

Melt Spinning Many synthetic fibers are melt spun. The basic steps in the melt-spinning process for filament and staple fiber made from filaments are shown in Figure 8–3. Melt spinning can be demonstrated by a simple laboratory experiment using flame, tweezers, and nylon fabric. Heat the fabric until some of it has melted, then quickly draw out the melt with tweezers as shown in Figure 8–4.

In commercial melt spinning, the melt is forced through heated spinneret holes. The fiber cools in contact with the air, solidifies, and is wound on a bobbin.

Drawing After extrusion of the fiber, its chainlike molecules are in an amorphous or disordered arrangement. The filament fiber must be drawn to develop the desirable strength, pliability, toughness, and elasticity properties. Some fibers are cold-drawn; others must be hotdrawn. Drawing aligns the molecules in a more parallel arrangement and brings them closer together so they are more crystalline and oriented. The amount of draw (draw ratio) varies with intended use, determines the decrease in fiber size, and controls the increase in strength.

FIGURE 8-4
Melt spinning a synthetic fiber by hand.

Heat Setting Heat setting is a process that uses heat to stabilize yarns or fabrics made of heat-sensitive fibers. The yarn or fabric is heated to bring it to a temperature specific for the fiber being heat-set—the glass transition temperature (Tg). At this temperature the fiber molecules move freely to relieve stress within the fiber. The fabric is kept under tension until it is cool to lock this shape into the fiber's molecular structure. After cooling, the fabric or yarn will be stable to any heat lower than that at which it was set. Higher temperatures may cause shrinkage or other changes. Heat setting may be done at any stage of finishing, depending on the fiber's heat resistance and end use (Table 8–3).

Identification of Synthetic Fibers

Burn tests can be used to identify the presence of some synthetic fibers because of the melting and dripping that occurs. However, the burn test is not good for blends or for fibers that are flame-retardant or heat-resistant. The burn test also cannot be used to identify a specific generic fiber since the differences are minor or masked by fiber additives or finishes (see Table 3–7).

Microscopic appearance is not a reliable method to identify synthetic fibers because their appearance can be modified easily. Fibers in this group have no unique visible characteristics at either the microscopic or macroscopic level. Photomicrographs included in this chapter clearly illustrate this.

Solubility tests are the only procedures that differentiate among the synthetic fibers. Table 3–8 lists solvents commonly used to identify synthetic fibers. Several solvents used in the identification of fibers are toxic and hazardous. Appropriate care should be taken when using any solvent.

Common Fiber Modifications

Fiber Shape and Size Since many synthetic fibers are melt-spun, changing the fiber's cross-sectional shape is relatively easy. Altering the shape of the spinneret hole can change fiber shape. Figure 3–3 illustrates several common modifications. Hollow fibers for fiberfill provide better thermal properties and lighter weight. Trilobal, pentalobal, and multilobal fibers are used for apparel and furnishings, especially carpeting. Voided fibers help hide soil on carpeting. Flat-ribbon fibers are used in formalwear and special-occasion apparel. Channel fibers such as DuPont's CoolMax are used in active sportswear to wick moisture away from the skin's surface. Fiber size can range from very large for industrial applications to very small for apparel and furnishings.

Microfibers are filament or staple fibers with a denier per filament (dpf) of less than 1.0; most are in the

Advantages	Disadvantages
Permanent embossed designs Permanent pleats and shape Stable size, even for knits Crush-resistant pile Wrinkle-resistant apparel	"Set" creases and wrinkles are hard to remove in ironing or in garment alteration Care must be taken in washing or ironing to prevent setting wrinkles.

range of 0.5 to 0.7 dpf. These fibers are produced by conventional melt spinning, splitting bicomponent fibers, or dissolving one of the components of bicomponent fibers (see Figure 6–3). All three techniques provide commercially important microfibers for apparel, furnishing, and industrial applications. End uses include fashion apparel, intimate apparel, performance athletic apparel, upholstery, wall coverings, bedding, window-treatment fabrics, medical uses, and wiping cloths for the precision and glass industries.

Low-Pilling Fibers Low-pilling fibers are engineered to minimize pill formation. By reducing the molecular weight slightly, the fiber's flex life is decreased. When the flex abrasion resistance is reduced, fiber pills break off almost as soon as they are formed, thus maintaining the fabric's original appearance. The low-pilling fibers are not as strong as other fiber types, but are durable enough for most apparel and furnishing uses. They are especially applicable for soft knitting yarns. Some low-pilling fiber modifications are designed for blending with other fibers. For example, low-pilling polyester blends well with cotton, rayon, or lyocell.

High-Tenacity Fibers Even though synthetic fibers are known for their high strength, fiber tenacity can be increased for end uses in which high strength is needed, such as tow ropes, air bags, and parachute cords. Fiber strength can be increased in several ways. Drawing or stretching a fiber to align or orient the molecules strengthens the intermolecular forces. In addition, the molecular chain length can be varied by chemical modification or by changes in time, temperature, pressure, and catalysts used in the polymerization process. Long molecules are harder to pull apart than short molecules. Most high-tenacity fibers are produced by combining drawing with molecular-chain-length modifications.

Low-Elongation Fibers Synthetic fibers often are blended with cellulosic fibers to add strength and abrasion resistance. However, because of the greater elonga-

tion potential of synthetic fibers, more problems are created unless low-elongation varieties are used in the blend. Low-elongation varieties stretch less under force, but are as strong as regular fibers. The primary end uses are apparel and furnishing items that receive hard use, such as work clothing and heavy-duty upholstery fabrics.

Nylon

Nylon was the first synthetic fiber and the first fiber developed in the United States. In 1928, the DuPont Company established a fundamental research program as a means of diversification. DuPont hired Dr. Wallace H. Carothers, an expert on high polymers, to direct a team of scientists. The team created many kinds of polymers, starting with single molecules and building them into long molecular chains. One team member discovered that a solution could be formed into a stable solid filament. This stimulated the group to concentrate on textile fibers. By 1939, DuPont was making a polyamide fiber in a pilot plant. This fiber—nylon 6,6—was introduced to the public in women's hosiery, for which it was an instant success. The name nylon was chosen for the fiber, but the reason for that choice is not known. At that time there were no laws specifying generic names

Nylon had a combination of properties unlike any other fiber in use in the 1940s. It was stronger and more resistant to abrasion; it had excellent elasticity and could be heat-set. Permanent pleats became a reality. For the first time, gossamer-sheer fabrics were durable and machine washable. Nylon's high strength, light weight, and resistance to chemicals made it suitable for industrial products such as ropes, cords, sails, and parachutes.

As nylon entered more end-use markets, problems became apparent—static buildup, poor hand, poor comfort in skin-contact fabrics, and low resistance to sunlight. As each problem appeared, solutions were developed.

Production of Nylon

Nylon or polyamides are made from various substances. The numbers after the word *nylon* indicate the number of carbon atoms in the starting materials. Nylon 6,6 is made from hexamethylene diamine with six carbon atoms and adipic acid, also with six carbon atoms.

While nylon 6,6 was being developed in the United States, scientists in Germany were working on nylon 6. It is made from a single six-carbon substance, caprolactam (Table 8–4).

Physical Structure of Nylon

Nylon is available in multifilament, monofilament, staple, and tow in a wide range of deniers and shapes and as partially drawn or completely finished filaments. Many staple lengths are also available. Fibers are produced in bright, semi-dull, and dull lusters, with varying degrees of polymerization and strengths.

Regular nylon has a round cross section and is perfectly uniform throughout the filament (Figure 8–5). Microscopically, the fibers look like fine glass rods. They are transparent unless they have been delustered or solution-dyed.

At first, the uniformity of nylon filaments was a distinct advantage over the natural fibers, especially silk. However, the perfect uniformity of nylon produced woven fabrics with a dead, unattractive feel. Changing the fiber's shape reduces this condition. Nylon and other melt-spun fibers retain the shape of the spinneret hole. Thus, where performance is influenced by fiber shape, producers adjust the shape as needed. For example, in nylon carpets, trilobal fibers and square fibers with voids give good soil-hiding characteristics (Figures 8–6 and 8–7).

Chemical Composition and Molecular Arrangement of Nylon

Nylon—a manufactured fiber in which the fiberforming substance is any long-chain, synthetic polyamide in which less than 85 percent of the amide linkages are attached directly to two aromatic rings.

$$\begin{bmatrix} C - NH \\ 0 \end{bmatrix}$$

-Federal Trade Commission

Nylon 6,6			Nylon 6				
Made of hexamethylene diamine and adipic acid			Made of caprolactam				
_	O 0 ₄ C NH(CH ₂) ₆ NH	n		-NH(C	$ \begin{array}{c} O \\ \parallel \\ CH_2)_5C \end{array} $		
Advantages			Advantages				
Heat setting 205°C Pleats and creases Softening point 250 Difficult to dye	can be heat-set at hi	gher temps	Better dye affir Softer hand Greater elastici	: 220°C (428°F) nity than nylon 6 ty, elastic recove	,6; takes deeper sh ery, and fatigue resi ncluding better sunl	stance	
				Performance			
Performance		Elastic		Tenacity	Breaking	Elastic	
Tenacity	Breaking elongation, %	recovery, %	Fiber type	dry/wet	elongation, %	recovery, %	
Tenacity dry/wet	-		Fiber type High-tenacity filament	3	3		
Performance Tenacity dry/wet 5.9-9.8/5.1-8.0 2.3-6.0/2.0-5.5	elongation, %	recovery, %	High-tenacity	dry/wet 6.5-9.0/	elongation, %	recovery, %	

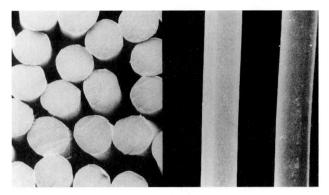

FIGURE 8-5

Photomicrographs of nylon fiber: cross-sectional view (left); longitudinal view (right). (Courtesy of the British Textile Technology Group.)

Nylons are **polyamides**; the recurring amide groups contain the elements carbon, oxygen, nitrogen, and hydrogen. Nylons differ in their chemical arrangement, accounting for slight differences in some properties.

The molecular chains of nylon are long, straight chains of variable length with no side chains or cross linkages. Cold-drawing aligns the chains so that they are oriented with the lengthwise direction and are highly crystalline. High-tenacity filaments have a longer chain length than regular nylon. Staple fibers are not cold-drawn after spinning, have lower degrees of crystallinity, and have lower tenacity than filament fibers.

Nylon is related chemically to the protein fibers silk and wool. Both have similar dye sites that are important in dyeing, but nylon has far fewer dye sites than wool.

Properties of Nylon

Nylon's performance in apparel and furnishing fabrics is summarized in Table 8–5. Compare the performance of

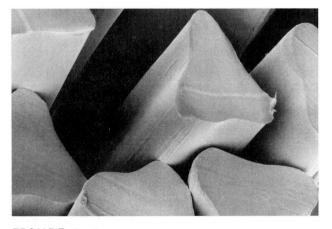

FIGURE 8-6

Photomicrographs of trilobal nylon. (Courtesy of E. I. du Pont de Nemours & Company.)

FIGURE 8-7

Nylon fiber with voids. (Courtesy of E. I. du Pont de Nemours & Company.)

nylon to that of other fibers by reviewing the tables in Chapter 3.

Aesthetics Nylon has been very successful in hosiery and in knitted fabrics such as tricot and jersey because of its smoothness, light weight, and high strength. The luster of nylon can be selected for the end use—it can be lustrous, semilustrous, or dull. Trilobal nylons have a pleasant luster.

TABLE	8-	5	Sum	mary	of	the	performance
of nylor	ı in	app	arel	and	fur	nish	ing fabrics.

Aesthetics	Variable
Durability Abrasion resistance Tenacity Elongation	Excellent Excellent Excellent High
Comfort Absorbency Thermal retention	Poor Poor Moderate
Appearance retention Resiliency Dimensional stability Elastic recovery	High High High Excellent
Recommended care	Machine-wash (apparel) Dry extraction method (furnishings)

The drape of fabrics made from nylon can be varied, depending largely on fiber and yarn size and fabric structure selected. High-drape fabrics are found in draperies, in sheer overlays for nightgowns, and in formalwear. Stiff fabrics are found in taffetas for formalwear, parkas, furnishings, or industrial uses. Very stiff fabrics include webbing for luggage handles and seat belts.

Smooth textures are frequently found. These too can be varied by using spun yarns or by changing the fabric structure. The hand frequently associated with nylon fabrics is smooth because of the filament yarn and compact structure. Textured-yarn fabrics are bulkier.

Nonround fibers are generally used in upholstery and carpets because round fibers tend to magnify soil and look dirty very quickly. Trilobal, pentalobal, and voided fibers are used because they hide soil—even though the product may be soiled, it may look fairly clean. In addition, voids and flat sides of the fibers scatter light, which assists in hiding the soil and more closely duplicates the matte luster of wool and other natural fibers (see Figures 8–6 and 8–7).

Durability Nylon has outstanding durability. Hightenacity fibers are used for seatbelts, tire cords, ballistic cloth, and other industrial uses. Regular-tenacity and staple fibers are used in apparel and furnishings.

High-tenacity (HT) fibers are stronger, but have lower elongation than regular-tenacity fibers. During production the high-tenacity fibers are drawn to a greater degree than are regular-tenacity fibers. Thus, the HT fibers are more crystalline and oriented. HT nylon fibers are used in industrial products, like towropes, where high strength and low elongation are essential.

In addition to excellent strength and high elongation, nylon has excellent abrasion resistance. A major

end use for nylon is carpet (Table 8–6). The ideal carpet is durable, resilient, and resistant to pilling, shedding, fading, traffic, abrasion, soil, and stains. Nylon meets or exceeds many of these demands. Nylon also is popular in pile upholstery fabrics because of its good durability properties.

This combination of properties makes nylon the perfect fiber for women's hosiery. No other fiber has been able to compete with nylon for pantyhose. The high elongation and excellent elastic recovery of nylon account for its outstanding performance here. Hosiery is subjected to high degrees of elongation; nylon recovers better after high elongation than other fibers do. Since nylon can be heat-set this also helps it retain its shape during wear. Filament hosiery develops runs because the fine yarns break and the knit loop is no longer secure. Sheer hosiery is less durable than opaque hosiery.

Nylon is used for lining fabrics in some coats and jackets. Nylon linings are more durable; however, the cost is greater because of the greater difficulty in sewing and higher costs as compared with acetate fabrics.

Nylon is not very durable as a curtain or drapery fabric because it is weakened by the sun. Sunlight- or ultraviolet-resistant modifications are available. These modified fibers are used in sheer glass curtains, draperies, car interiors, seatbelts, and other industrial applications.

Comfort Nylon has low absorbency. Even though its moisture regain is the highest of the synthetic fibers (4.0 to 4.5 percent for nylon 6,6 and 2.8 to 5.0 for nylon 6), nylon is not as comfortable to wear as the natural fibers.

Compact yarns of filament nylon originally were used in men's woven sports shirts. The shirts became transparent when wet from perspiration and felt clammy, especially in warm, humid weather. Today, textured and spun yarns used in knit fabrics result in more

Fiber Characteristic	Wool	Manufactured
Diameter	Coarse	15-18 denier or blend of various deniers
Length	Staple	Staple or filament blend of various length
Crimp	Three-dimensional crimp	Sawtooth crimp, three-dimensional crimp, bicomponent, textured filament
Cross section	Round to oval	Round, trilobal, multilobal, voided square 5-pointed star
Resiliency and resistance to crushing	Good	Medium to excellent
Resistance to abrasion	Good	Good to excellent
Resistance to waterborne stains	Poor	Good to excellent
Resistance to oily stains	Good	Poor
Fire retardancy	Good	Modified fiber or topical finish
Static resistance	Good	Poor to good, can be modified

comfortable shirts. Knit fabrics of nylon are more comfortable than woven nylon fabrics because heat and moisture escape more readily through the additional air spaces within the fabric.

Polymer modifications are also available to improve comfort of nylon apparel. Hydrofil nylon by Allied Signal is a hydrophilic fiber that has improved absorbency and wicking. It is used in thermal underwear, actionwear, footwear, and accessories.

The factors that make nylon uncomfortable in one set of conditions make it comfortable in other conditions. Nylon is widely used for wind- and water-resistant jackets, parkas, tents, and umbrellas. The smooth, straight fibers pack closely together into yarns that can be woven into a compact fabric with very little space for wind or water to penetrate.

With a density of 1.14, nylon is one of the lightest fibers on the market. As compared with polyester, nylon yields 21 percent more yardage per pound of fabric. This lighter weight corresponds to lighter products and lower costs for moving fabrics and finishing fabrics. Actionwear and sports gear take advantage of nylon's light weight and high durability.

Another disadvantage of low absorbency is the development of static electricity by friction at times of low humidity. This disadvantage can be overcome by using antistatic-type nylon fibers, antistatic finishes, or blends with high-absorbency, low-static fibers.

Static creates problems with comfort, soiling, and use. Antistatic fiber modifications and finishes are common carpet modifications. Sometimes, small amounts of metallic and carbon fibers are used to minimize static in carpets. Antistatic nylon also may be used in lining fabrics and slips.

DuPont's Tactel Ispira is a stretch bicomponent nylon for woven activewear and sportswear. While its stretch is less than that of spandex, this bicomponent fiber adds a greater degree of comfort stretch than previously available in all nylon woven garments.

Appearance Retention Nylon fabrics are highly resilient because they have been heat-set. The same process is used to make permanent pleats, creases, and embossed designs.

Nylon carpet yarns are heat-set before they are incorporated into the carpet. Heat setting improves the compressional resiliency of the fibers in the pile yarns. Compressional resiliency refers to the ability of the carpet fibers to spring back to their original height after being bent or otherwise deformed. Nylon has excellent compressional resiliency. Thus, traffic paths do not develop quickly. In addition, depressions from heavy furniture are less likely to be permanent. Steaming these areas can minimize marks from heavy furniture. In

addition, most carpet fibers are made in a high denier, often 15 or greater. Higher-denier fibers have improved compressional resiliency and appearance retention.

Shrinkage resistance is also high because of the heat setting and because the low-absorbency fiber is not affected by water. Elastic recovery is excellent. Nylon recovers fully from 8 percent stretch; no other fiber does as well. At 16 percent elongation, it recovers 91 percent immediately. This property makes nylon an excellent fiber for hosiery, tights, ski pants, swimsuits, and other actionwear (see Table 8–4). Nylon does not wrinkle much in use, it is stable, and it has excellent elastic recovery, so it retains its appearance very well during use.

Solution-dyed and sunlight-resistant carpet fibers are available for areas where fading, especially from exposure to sunlight, may be a problem. These carpets are specifically aimed at the low-priced contract/commercial markets and for automotive interiors. Eclipse, by Allied Signal, is an ultraviolet-resistant fiber used in flags, life-vests, and other industrial applications.

Care Nylon introduced the concept of easy-care garments. In addition to retaining their appearance and shape during use, nylon fabrics retain their appearance and shape during care.

The wet strength of nylon is 80 to 90 percent of its dry strength. Wet elongation increases slightly. Little swelling occurs when nylon is wet. Compare this to the swelling of cellulosic fibers: nylon, 14 percent; cotton, 40 to 45 percent; and viscose rayon, 80 to 110 percent.

To minimize wrinkling, warm wash water, gentle agitation, and gentle spin cycles are recommended. Hot water may cause wrinkling in some fabrics. Wrinkles set by hot wash water can be permanent; but hot water may help remove greasy and oily stains.

Nylon is a **color scavenger**. White and light-colored nylon fabrics pick up color from other fabrics or dirt that is in the wash water. A red sock that loses color into the wash water of a load of whites will turn the white nylon fabrics a dingy pink-gray and is difficult to remove. Prolonged use of chlorine bleach may cause yellowing of white nylon. Discolored nylon and grayed or yellowed nylon can be avoided by following correct laundry procedures.

Since nylon has low absorbency, it dries quickly. Hence, fabrics need to be dried for only a short time. Nylon reacts adversely to overdrying or dryers set on high heat. Figure 8–8 shows the melted and fused result of a nylon garment dried in an overheated gas dryer with socks of a different fiber content.

Nylon does have problems with static, particularly when the air is dry, so a fabric softener should be used in the washer or dryer. Nylon should be pressed or ironed at a low temperature setting, 270 to 300°F, to

FIGURE 8-8
The melted and fused remains of nylon garments dried in an overheated gas dryer.

avoid glazing. Home-ironing temperatures are not high enough to press seams, creases, and pleats permanently in items or to press out wrinkles acquired in washing.

The chemical resistance of nylon is generally good. Nylon has excellent resistance to alkali and chlorine bleaches but is damaged by strong acids. Pollutants in the atmosphere can damage nylon or create problems with dyes used on nylon. Certain acids, when printed on the fabric, create a puckered effect. Nylon dissolves in formic acid and phenol.

Nylon is resistant to the attacks of insects and fungi. However, food soil on carpet may attract insects.

Nylon has low resistance to sunlight. Bright fibers have better sunlight resistance than delustered fibers because the damaging energy is reflected and not absorbed. Sunlight-resistant modifications of nylon are also available.

Carpet soiling can be a real problem. Soiling in carpets is related to fiber cross section, carpet color, and fiber opacity/translucence. Round cross sections magnify soil. Nonround cross sections, such as trilobal, pentalobal, and voided, hide soil (see Figures 8–6 and 8–7). Soil-resistant fiber modifications are used in carpeting to minimize soil adherence and permanent staining. In addition, many carpets now combine soil-resistant fiber modifications with soil-resistant finishes. See Chapter 18 for information on soil-resistant finishes for carpets.

Environmental Impact of Nylon

Nylon is resistant to molds, mildew, rot, and many chemicals. It is resistant to natural degradation and does not degrade quickly. Although most nylon is susceptible to damage from sunlight, the damage does not occur quickly enough to minimize disposal problems with nylon products. Nylon is processed from petrochemicals, so there are concerns regarding drilling in sensitive en-

vironments, oil spills, refinement and production of the chemicals from which nylon is made, and use of and disposal of hazardous chemicals.

The processing of nylon from raw fiber into finished product uses few, if any, chemicals to clean the fiber. This is because nylon and other synthetic fibers, unlike the natural fibers, are not contaminated with soil and other materials, like leaf bits. Since nylon is a meltspun fiber, no residue from chemical baths needs to be rinsed from the fiber and no solvents, like those used with solvent or dry-spun fibers, need to be reclaimed. In addition, less water, salt, and acid is used to dye the fiber. Removal of excess dye from nylon fabrics uses less water than for some common dyes used for natural and regenerated cellulose fibers. Chemical finishes are rarely needed to enhance consumer satisfaction with nylon products because the fiber can be engineered for specific end uses. Thus, once nylon fiber is produced, further processing of nylon has minimal impact on the environment.

Nylon is made from materials that are byproducts of oil refineries. Thus, nylon uses for its raw materials substances that were once considered waste products. Although still in its infancy, nylon recycling is a reasonable alternative to disposal. Two problems with recycling nylon relate to the presence of other materials added to the melt in producing the original material and the wide variety of nylon polymers on the market.

BASF has developed a commercial carpet recycling program, "6ix Again," that economically converts nylon carpet fiber to caprolactam (a nylon 6 raw material). Carpet eligible for this recycling program is identified with a 6ix Again logo on the back. In other recycling programs for nylon carpet fiber, the fiber is shaved from the carpet's surface and mixed with plastic and concrete. The lightweight and durable composite materials of fiber

and plastic or concrete are used to make recycled picnic tables and poured concrete foundations.

Uses of Nylon

Nylon is one of the most widely used fibers in the United States. The single most important use of nylon is for carpets. Tufted carpets are an excellent end use for nylon because of its aesthetic appearance, durability, appearance retention, and ability to be cleaned in place. The combination of nylon fiber and the tufting process results in relatively low-cost and highly serviceable carpeting, contributing to the widespread use of carpeting in both residential and commercial buildings.

A second important use of nylon is for apparel. Lingerie fabrics are an end use for which nylon is an important fiber. The fabrics are attractive and durable; they retain their appearance well and are easy care. Panties, bras, nightgowns, pajamas, and lightweight robes are frequently made from nylon.

Women's sheer hosiery is an important end use of nylon. No other fiber has the combination of properties that make it ideal for that use. Very sheer hosiery is often 12 to 15 denier instead of a heavier-denier yarn or monofilament. Sheers give the look that is wanted, but they are less durable. Hosiery yarns may be monofilament or multifilament-stretch nylon and plain or textured.

Short socks or knee-high socks are sometimes made from nylon. Frequently they are nylon blends with cotton or acrylic. Nylon adds strength and stretch.

Active sportswear and actionwear in which comfort stretch is important—leotards, tights, swimsuits, and ski wear—is another end use for nylon. Nylon-taffeta windbreakers and parkas are common in cool and windy weather. Lining fabrics for jackets and coats can be made of nylon.

Some performance nylon fibers are modified to have a cottonlike hand with improved pilling resistance and are used in the inner layers of workwear, hunting apparel, and mountaineering apparel. Other nylons have been modified to be stain- and tear-resistant, quiet (making minimal rustling or other noise that might scare off game animals), quick-drying, and warm. These fabrics are used in outer layers of workwear and hunting and hiking apparel. Cordura by DuPont is a trade name for many of these products. Supplex is a DuPont microfiber nylon that has been modified to be softer, more supple, and less bulky than regular nylon so that it provides greater freedom of movement in outerwear, beachwear, and actionwear. Supplex is wind-resistant, water-repellent, breathable, and durable.

Industrial uses for nylon are varied. Within this group, an important use of nylon is for the tire cord that goes rim to rim over the curve of radial tires. Nylon is facing stiff competition in this market and losing ground

to polyester, and heat-resistant aramid, and steel because nylon has a tendency to "flat-spot." Flat spotting occurs when a car has been stationary for some time and a flattened place forms on the tire. The ride will be bumpy for the first mile or so until the tire recovers from flattening.

Car interiors are another example of the varied uses for nylon. The average car uses 25 pounds of fiber, a good share of which may be nylon. Upholstery fabric (called body cloth), carpet for the interior, trunk lining, door and visor trims, head liners on interior roofs, and seatbelt webbing may be one of several nylon fabrics. Some are modified to be sunlight-resistant, heat-resistant, or high tenacity. In addition, clutch pads, brake linings, yarns to reinforce radiator hoses and other hoses, and airbags are nylon.

Additional industrial uses include parachute fabric, cords and harnesses, glider tow ropes, ropes and cordage, conveyor belts, fishing nets, mail bags, and webbings.

The category of industrial uses also includes consumer uses, sporting goods, and leisure fabrics. Consumer uses include umbrellas, clotheslines, toothbrush and hairbrush bristles, paintbrushes, and luggage. Leisure goods include soft luggage, backpacks, book bags, camera bags, golf bags, hunting gear, and horse blankets. Cordura nylon by DuPont is used in many leisure goods. Blends of Cordura with other fibers are used in protective apparel, work wear, and career apparel.

Nylon is important in sporting goods. It is used for tents, sleeping bags, spinnaker sails, fishing lines and nets, racket strings, backpacks, and duffle bags.

Nylon microfibers are used in apparel and furnishings. These fibers are 26 to 36 percent softer than regular nylon fibers and range in size from 0.7 to 1.0 dpf, as compared with a denier of 2.0 for regular nylon. The micro nylons are used in a variety of applications. These fibers are water-repellent, wind- and wear-resistant, vapor-permeable, and comfortable. They are used in 100 percent nylon formations and in blends with natural fibers like wool and cotton (Table 8–7).

Types and Kinds of Nylon

It has been said that as soon as a new need arose, a new type of nylon was produced to fill the need. This has led

TABLE 8	3-7 Nylon m	nicrofibers	
Producer	Trade Name	Size	End Use
BASF	Silky Touch	0.8 dpf	Lingerie, swimwear
DuPont	Supplex MicroSupplex	1.0 dpf 0.7 dpf	Woven actionwear

Cross Section	Dyeability	Crimp or Textured	Others
Round	Acid dyeable	Mechanical crimp	Antistatic
Heart-shaped	Cationic dyeable	Crimp-set	Soil hiding
Y-shaped	Disperse dyeable	Producer textured	Bicomponent
8-shaped	Deep dye	Undrawn	Fasciated
Delta	Solution dye	Partially drawn	Thick and thin
Trilobal	Heather	Steam-crimped	Antimicrobial
Triskelion	Optically whitened	Bulked continuous filament	Sunlight-resistan
Trinode	,	Latent crimp	Flame-resistant
Pentagonal			Delustered
Hollow			High tenacity
Voided			Cross linked

to a large number of types of nylon that are identified by trademarks.

The list in Table 8–8 illustrates many modifications of nylon. Table 8–9 lists trade names for several producers of nylon.

Polyester

The first polyester fiber, Terylene, was produced in England. It was first introduced in the United States in 1951 by DuPont under the trade name Dacron (pronounced day-kron). The outstanding resiliency of polyester, whether dry or wet, and its excellent dimensional stability after heat setting made it an instant favorite.

Sometimes referred to as the workhorse fiber of the industry, polyester is the most widely used synthetic fiber. Its filament form is extremely versatile and its staple form can be blended with many other fibers, contributing desirable properties to the blend without destroying those of the other fiber. Its versatility in blending is one of the unique advantages of polyester.

The polyester polymer is endlessly engineerable, with many physical and chemical variations possible. These modified fibers improve the performance of the original polyester. One important physical difference has

been changing from the standard round shape to other shapes to give different properties. A high-tenacity staple polyester was developed for use in durable-press fabrics to reinforce the cotton fibers, which had been weakened by finishing. Other polyesters have a hand and absorbency more like the natural fibers.

The properties of polyester are listed in Table 8–10.

Production of Polyester

Polyester is produced by reacting dicarboxylic acid with dihydric alcohol. The fibers are melt-spun by a process very similar to the one used to make nylon. The polyester fibers are hot-drawn to orient the molecules and improve strength, elongation, and stress/strain properties. Since polyester is melt-spun, it retains the shape of the spinneret hole. Modifications in cross-sectional shape are inexpensive and easy to produce.

Physical Structure of Polyester

Polyester fibers are produced in many types. Filaments are high- or regular-tenacity, bright or delustered, white or solution-dyed. The speckled appearance of some fibers may be due to delusterant. Delustered staple fibers are available in deniers from less than 1.0 to 10. They may be regular, low-pilling, or high-tenacity. Polyester is not as

TABLE 8-9 Some trade	names and p	producers.	
Nylon 6,6 Trade Names	Producer	Nylon 6 Trade Names	Producer
Antron, Cordura, Supplex, Tactel Ultron, Wear-Dated	DuPont Solutia Inc.	Anso, Caprolan, Captiva, Eclipse, Hydrofil, StayGard, A.C.E. Natural Touch, Silky Touch, Zeftron, Zefsport	Allied-Signal BASF Fibers

TABLE 8-10 Pro	perties of polyester.
Properties	Importance to Consumers
Resilient—wet and dry	Easy-care and packable apparel, furnishings
Dimensional stability	Machine washable
Sunlight-resistant	Good for curtains and draperies
Durable, abrasion- resistant	Industrial uses, sewing thread, work clothes
Aesthetics superior to nylon	Blends well with other fibers, silklike
Aesthetics superior to	Blends well with oth

transparent as nylon fibers. It is white, so fibers normally do not need to be bleached. However, whiter types of polyester fibers have optical whiteners added to the fiberspinning solution. Regular polyester fibers are smooth rodlike fibers with a circular cross section (Figure 8–9).

A variety of cross-sectional shapes are produced: round, trilobal, octolobal, oval, hollow, voided, hexalobal, and pentalobal (star-shaped).

Chemical Composition and Molecular Arrangement of Polyester

Polyester fibers—manufactured fibers in which the fiber-forming substance is any long-chain synthetic polymer composed of at least 85 percent by weight of an ester of a substituted aromatic carboxylic acid, including but not restricted to substituted terephthalate units,

and para substituted hydroxybenzoate units,

$$p(-R-O-C_6H_4-C-O-).\\$$

—Federal Trade Commission

Polyester fibers are made from terephthalate polymers: polyethylene terephthalate (PET), 1,4 cyclohexylene-dimethylene terephthalate (PCDT), polybutylene terephthalate (PBT), and polytrimethylene terephthalate (PTT). While the properties of each polymer differ, in most cases the differences are minor and do not result in noticeable changes in consumer performance. These polymers may be homopolymers or copolymers. Most copolymers are pill-resistant, lower-strength staple fibers used primarily in knits, blends, and carpets.

FIGURE 8-9

Photomicrographs of polyester: cross-sectional view (left); longitudinal view (right). (Courtesy of the British Textile Technology Group.)

Polyester fibers have straight molecular chains that are packed closely together and are well oriented, with very strong hydrogen bonds.

Properties of Polyester

Polyester's performance in apparel and furnishing fabrics is summarized in Table 8–11. To understand polyester's performance in comparison with that of the other fibers, examine the tables in Chapter 3.

Aesthetic Polyester fibers blend well, maintaining a natural fiber look and texture, with the advantage of easy care for apparel and furnishings. The fabrics look like the natural fiber in the blend; their appearance retention during use and care clearly illustrates the presence of polyester.

TABLE 8-11 Summary of the performance of polyester in furnishings and apparel fabrics.

Aesthetics	Variable
Durability Abrasion resistance Tenacity Elongation	Excellent Excellent Excellent High
Comfort Absorbency Thermal retention	Poor Poor Moderate
Appearance retention Resiliency Dimensional stability Elastic recovery	High Excellent High High
Recommended care	Machine-wash (apparel) Dry extraction (furnishings)

Thick-and-thin yarns of polyester and rayon give a linen look to apparel and furnishing fabrics. Wool-like fabrics are found in both summer-weight and winterweight men's suit fabrics.

Silklike polyesters are very satisfactory in appearance and hand. The trilobal polyester fibers resulted when DuPont tried to find a manufactured filament that would have the aesthetic properties of silk. In cooperation with a silk-finishing company, DuPont investigated the relationship between silk-finishing processes and the aesthetic properties of silk fabrics, since silk acquired richness in fabric form.

The study of silk fabrics found that the unique properties of silk—liveliness, suppleness, and drape of the fabric; dry "tactile" hand; and good covering power of the yarns—resulted from (1) the triangular shape of the silk fiber; (2) the fine denier per filament; (3) the loose, bulky yarn and fabric structure; and (4) the highly crimped fabric structure. These results were applied to polyester. Silklike polyesters are spun with a trilobal shape and made into fabrics processed by a silk-finishing treatment. They are unique because they can be treated with a caustic soda that leaves a thinner, less uniform fiber, yarn, or fabric without basically changing the fiber.

Polyester microfibers are particularly suited to high-fashion apparel and furnishing items because of its versatility and durability. Designers find the microfibers' drape and hand exciting and challenging. Consumers are willing to pay the additional cost for products that incorporate microfibers. Microfibers yield softer and more drapeable fabrics than conventional fibers do. Figure 8–10 illustrates the differences among fiber sizes. Items of polyester microfibers, both 100 percent polyester and blends with other fibers, include coats, suits, blouses, dresses, active sportswear, wall coverings, upholstery, sleeping bags, tents, filters, and toweling.

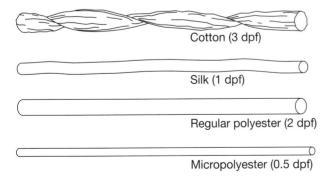

FIGURE 8-10
Comparison of fiber size: cotton, silk, regular polyester, and

microfiber polyester.

Micromattique and Micromattique XF (0.3 to 1.07 dpf) by DuPont, and Trevira Finesse and Microfinesse (0.55 to 0.9 dpf) by Trevira are examples of microfibers used for a variety of apparel and furnishings. These fibers exhibit unparalleled softness, fluidity, drape, and appearance. Shin-gosen polyesters are Japanese fibers that are the most silklike of the very fine polyesters because of slight irregularities along the fiber. Some modifications combine a microchannel with the trilobal cross section; others have tiny microcraters along the fiber's surface. The techniques used to produce the microfibers and shin-gosen fibers are similar, but not identical, and the resultant fibers have slightly different performance and appearance characteristics.

Durability The abrasion resistance and strength of polyesters are excellent. Wet strength is comparable to dry strength. The high strength is produced by hot drawing to develop crystallinity and by increasing the molecular weight. Table 8–12 shows how the breaking tenacity of polyester varies with end use. The stronger fibers have been stretched more; their elongation is lower than the weaker fibers. This is particularly dramatic in the case of partially oriented filament fibers that are sold to manufacturers who stretch them more during the production of textured yarns. Their tenacity is 2.0 to 2.5 g/d, a lower strength than staple fibers, but with an elongation exceeding that of the other fibers, 120 to 150 percent. Sold in yarn form, these polyesters are known as POY, partially oriented yarn.

Because of its better sunlight resistance, polyester often is selected for end uses in which sunlight damage decreases durability, such as vehicle interiors, tarpaulins, and seatbelts.

Comfort Absorbency is quite low for the polyesters, 0.4 to 0.8 percent. Poor absorbency lowers the comfort factor of skin-contact apparel and upholstery. Woven fabrics made from round polyester fibers can be very uncomfortable in warm, humid weather. Moisture does not escape easily from between the skin and the fabric, and the fabric feels slick and clammy.

Blends with absorbent fibers or comfort-modified fibers, a thin and open fabric structure, spun rather than filament yarns, trilobal rather than round fibers, and finishes that absorb, or wick, moisture increase comfort. Soil-release finishes improve the wicking characteristics of polyester, thus improving fabric breathability and comfort. Finishes and fiber modifications also increase the comfort of polyester.

Blends of polyester and cotton are more comfortable in humid weather than are 100-percent-polyester fabrics. Moisture is wicked along the outer surface of the polyester fibers to the fabric surface, where it evaporates.

Fiber	Tenacity,	Breaking	
Modification	g/d	Elongation, %	End Use
High-tenacity filament	6.8-9.5	9–27	Tire cord, industrial use
Regular-tenacity filament	2.8-5.6	18-42	Apparel and furnishing
High-tenacity staple	5.8-7.0	24-28	Durable-press items
Regular-tenacity staple	2.4-5.5	40-45	Apparel and furnishings

Polyester is resilient when wet, so the fabric does not mat. Polyester is light in weight and dries quickly.

Polyester exhibits moderate thermal retention. It is generally not as comfortable as wool or acrylic for cold-weather wear. Blends with wool are very successful in increasing the comfort of the wool. Polyesters have been specifically engineered for fiberfill. Fiber modifications—including hollow fibers, binder staple, and crimped fibers—perform very well.

Because of their low absorbency, polyesters are more prone to static problems than other fibers in the heatsensitive group. The static potential of polyester can be lowered by modifying the fiber's cross section, incorporating water-absorbing compounds in the spinning solution prior to extrusion, or adding topical finishes such as soil-release and antistatic compounds. Cross-sectional modifications may incorporate compounds that produce a porous fiber surface to trap moisture. Other cross-sectional modifications expand the surface area per unit mass ratio, thus slightly increasing the absorbency. The density of polyester fibers ranges from 1.22 to 1.38. Hollow variants for fiberfill are lower in density.

CoolMax Alta by DuPont is an example of a performance polyester that maintains dryness next to the skin, wicking perspiration away. It also minimizes pilling so it looks better longer.

An antistatic bicomponent core-sheath fiber combines a polyester core and a softer polyester isophthalate copolymer sheath that is impregnated with carbon-black particles. As little as 2 percent of this fiber in a blend significantly reduces static buildup. It is used in carpeting and upholstery, filters, protective outerwear, felts, electrical components, ropes, and other applications in which static buildup can be hazardous or annoying.

Stretch polyesters are appearing on the market. PTT (polytrimethylene terephthalate) and 3GT by DuPont and Genencor International Inc. have the ability to stretch 10 to 15 percent with good recovery. This is substantially better than that of regular polyester. With better stretch and softer hand, it will be ideal for many apparel products.

Appearance Retention Resiliency refers to the extent and manner of recovery from deformation. Polyester has a high recovery rate when the elongation is low, an important factor for apparel and furnishings. When only small deformations are involved, as in wrinkling, polyester recovers better than nylon. This recovery is similar to that of wool at higher elongations, which helps explain the success of polyester and wool blends. Nylon exhibits better recovery at higher elongations, so it performs better in products that are subject to greater elongation—hosiery, for example (Table 8–13).

Polyester has an advantage over wool in many uses, since wool has poor wrinkle recovery when wet. In high humidity, polyester fabrics do not shrink and are very resistant to wrinkling. However, when polyester products wrinkle and where wrinkles are set by body heat and moisture, pressing may not remove them.

Resiliency makes the polyesters especially good for fiberfill in quilted fabrics such as quilts, bedspreads, parkas, and robes, and in padding for furniture, futons, and mattresses. If the fiber is flattened on one side or made asymmetrical, it takes on a tight spiral curl of outstanding springiness. Fiberfill of a blend of fiber deniers gives different levels of support. Lumpiness in pillows can be prevented by running hot needles through the batt to spot-weld the fibers to each other. Fiberfills with one, four, or seven hollow channels are available (Figure 8–11).

TABLE 8-13 To elongation.	ensile r	ecover	y from	
Fiber	1%	3%	5%	15%
Polyester 56 (regular)	91	76	63	40
Nylon 200 (regular)	81	88	86	77

Source: E. I. du Pont de Nemours & Company. Technical Bulletin X-142 (September 1961).

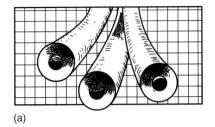

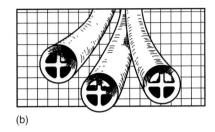

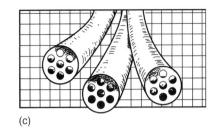

FIGURE 8-11

Hollow polyester fibers: (a) 1-Hollofil; (b) 4-Quallofil; and (c) 7-Hollofil. (Courtesy of E. I. du Pont de Nemours & Company.)

To summarize, the resiliency of polyester is excellent; it resists wrinkles and, when wrinkled, it recovers well whether wet or dry. Elastic recovery is high for most apparel items. The dimensional stability of polyester is high. When properly heat-set, it retains its size. It can be permanently creased or pleated satisfactorily.

Pilling was a severe problem with fabrics made from the unmodified polyesters. Low-pilling fiber types minimize the problem and are suitable for use in blends. The finishing process of singeing also helps control pilling.

Care Polyester has revolutionized consumer laundering. This revolution occurred because of heat setting and the advent of durable-press or wrinkle-resistant finishes. Care instructions for polyester/cotton durable-press fabrics is relatively simple: Wash in warm water; machine-dry with medium heat; remove promptly when dry; hang; and touch up with a steam iron if necessary.

The excellent abrasion resistance and tenacity, and the high elongation of polyester are the same whether the fabric is wet or dry. The low absorbency of polyester (0.4 percent) means that it resists waterborne stains and is quick to dry. The excellent resiliency of polyester keeps it looking good during use and minimizes wrinkling during care so only light pressing may be required. Because of heat setting, dimensional stability is excellent.

Warm-water washing is generally recommended to minimize wrinkling. Hot water may contribute to wrinkling and color loss. However, hot water (120 to 140°F) may be needed to remove greasy or oily stains or built-up body soil. Polyester is oleophilic and tends to retain oily soil. A familiar example of this is "ring around the collar." In polyester or polyester/cotton blend shirts, the soil usually responds to pretreatment, then laundering.

The oleophilic nature of polyester may result in redeposition of oily soil on fabrics, making them look dingy. However, polyester is not the color scavenger that nylon is. Soil-release finishes improve soil removal.

Another problem with polyester, especially noticeable with apparel, is a tendency to exhibit bacterial odor. This problem occurs when soil has built up on the fab-

ric; bacteria grow there and an odor results. Use of hotwater wash, such laundry agents as borax, which minimizes odor, or bleach to remove the soil buildup and kill the bacteria may minimize the odor. Several detergents are available that focus on this problem.

Polyester fibers are resistant to both acids and alkalis and can be bleached with either chlorine or oxygen bleach. Polyester fibers are resistant to biological attack and to sunlight damage, especially important for sheer drapery casement fabrics.

Environmental Impact of Polyester

Many environmental issues that were discussed with regard to nylon also apply to polyester. One major difference between the two is that polyester is extensively recycled. Many recycled fibers are produced primarily from bottle-grade, not fiber-grade, polyester. Production of recycled polyester creates significantly less environmental pollution than for virgin fibers made from new raw materials. Air pollution, for example, may be reduced by as much as 85 percent. Challenges that were overcome in the production of these recycled polyesters included achieving appropriate levels of purity of the polyester polymer and improving spinning methods to make fibers of appropriate quality with a comfortable hand.

Examples of trade names for recycled polyester fibers include Fortrel EcoSpun and Ecofil by Wellman, Inc., and Polartec Recycled by Malden Mills. Products made from recycled polyester include apparel and carpeting. Consumers like these products, even though the price is usually higher than that for virgin-fiber products. The United Nations Environmental Programme presented Wellman, Inc., with the Fashion Industry Award for Environmental Excellence for its pioneering developments in this area.

Uses of Polyester

Polyester is the most widely used manufactured fiber in the United States. It is very important in woven fabrics for apparel and furnishings. Polyester filament yarns may be used in one or both directions of a fabric. Frequently, spun yarns blended with cotton or rayon are finished to be durable press. Blended fabrics are attractive, durable, comfortable (except in very hot and humid conditions), retain their appearance well, and are easy care. Their excellent performance has resulted in their widespread use and continued popularity. Woven fabrics are used in top-weight and bottom-weight apparel, sheets, blankets, bedspreads, curtains and draperies, mattress ticking, table linens, and upholstery fabrics. Filaments are used in sheer curtains, where their excellent light resistance and fine denier make them particularly suitable for ninon and marquisette.

A second important use of polyester is in knitted fabrics. Polyester as well as polyester/cotton blend yarns are used. Knit fabrics of polyester wear well, are comfortable, retain their appearance well, and are easy care.

The first use of polyester filaments was in knit shirts for men and blouses for women. The use of filament polyester increased tremendously when textured yarns were developed. Both smooth and textured filaments are used in such career apparel as uniforms and in such furnishings as warp-knit upholstery and window-treatment fabrics.

A third important use of polyester is in fiberfill. Used in pillows, comforters, bedspreads, furniture padding, placemats, and winter apparel, polyester dominates the market. Other fiberfill materials include down, feathers, and acetate. The polyester used for fiberfill is engineered for resiliency and loft. The durability, comfort, and easy care of polyester also make it appropriate for this end use. Fiberfill is not visible during use—but poor performance shows up in lumpy products or hollow areas. Newer fiberfills create the soft, feathery feel of down. Primaloft is a thermal insulation developed by Albany International Research Co. The mixture of an ultrafine polyester with more conventionally sized polyester mimics the large and small components of duck down (Figure 8-12). This combination of fiber sizes produces the same warmth characteristics of down, but at lower cost. In addition, Primaloft does not lose loft or gain weight when wet.

Nonwoven or fiberweb fabrics are a fourth important use of polyester. Interfacings or interlinings, pillow covers, and furniture and mattress interlinings are examples of uses for nonwoven fabrics. They are used where the durability of rayon is inadequate and where absorbency is not needed. Olefin is a strong competitor in many industrial uses. Nonwoven polyester is used in medical softgood applications including nonabsorbent bandages and pads for heart monitors. Other fiberweb products include base fabrics for coatings and laminates.

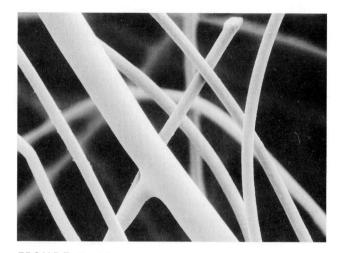

FIGURE 8–12
Primaloft thermal insulation. (Courtesy of Albany International Research Co.)

Tire cord is a fifth important use of polyester. Polyester tires do not "flat spot" as nylon tires do.

A small percentage of carpets are polyester; they have a softer hand than most nylon carpets. Polyester carpets are not as traffic-resistant as nylon carpets. However, polyester carpets perform well in low-use areas like bedrooms. Polyester carpets suffer from a "walked down" look after a period of wear in heavy-traffic areas. Heat setting the fibers by autoclave minimizes the problem. Trevira's polyester carpet fiber, Trevira XPS, has enhanced resistance to matting and crushing. However, Corterra polyester is being used in carpeting because of its inherent stain resistance, easy dyeability, low absorption, low electrostatic generation, and good resiliency.

Polyester is chosen for many other consumer and industrial uses: pile fabrics, tents, ropes, cording, fishing line, cover stock for disposable diapers, garden hoses, sails, seatbelts, filters, fabrics used in road building, seed and fertilizer bags, sewing threads, and artificial arteries, veins, and hearts. Research continues to increase industrial and technical applications. For example, a new polyester, PEN (polyethylene naphthalate) by Shell Chemical Co. is being investigated for use in industrial hoses, belts, and felts.

Types and Kinds of Polyester

Some common trade names of polyester fabrics and their producers are Fortrel by Wellman, Inc., Dacron by DuPont, and Trevira by Trevira. Tables 8–14 and 8–15 describe fiber modifications and fibers engineered for special end uses. A large variety of specific fibers or yarns may combine one or more modifications.

Cross Section	Dyeability	Crimp or Textured	Tenacity	Shrinkage	0ther
Round	Disperse dyeable	Producer-textured	Regular tenacity	High shrinkage	Pill-resistant
Trilobal	Cationic dyeable	Partially oriented	Intermediate tenacity	Normal shrinkage	Homopolyme
Triangular	Solution-dyed	Undrawn filament	High tenacity	Low shrinkage	Copolymer
Trilateral	Optically whitened		High elongation	Heat stabilized	Bicomponent
Pentalobal	Deep dye		Mid-modulus	Chemically stabilized, adhesive activated	Bigeneric
Scalloped oval	Extra bright		High-modulus		Polished high
Octolobal	Bright heather				
Heptalobal	Dark heather				Binder fiber
Hollow (1, 4, or 7 channels)					Soft luster

Olefin

In the 1920s many attempts were made to polymerize ethylene, a byproduct of the natural gas industry. Ethylene was polymerized and used as an important plastic during World War II, but filaments made from it did not have sufficiently consistent properties for use in textile fibers. In 1954 in Germany, Karl Ziegler developed a process that raised the melting point of polymerized ethylene filaments, but it still was too low for

many uses. In Italy, Giulio Natta successfully made linear polypropylene polymers of high molecular weight that were suitable for most textile applications. By 1957, Italy was producing olefin fibers; U.S. production of olefin fibers started in 1960.

Olefin fibers have a combination of properties that make them good for furnishings, apparel that does not need ironing, and industrial and technical uses. Olefin fibers are strong and resistant to abrasion, inexpensive, chemically inert, thermoplastic, and static-resistant.

TABLE 8-15 Po	olyester for specialized uses.	
Producer	Trade Name	Use
Allied-Signal	A.C.E.	Tire cord, furniture webbing
DuPont	CoolMax	Warm-weather and action wear
	Hollofil, Quallofil	Fiberfill and insulating fibers
	Sontara	Spunlaced nonwoven fabrics
	Thermostat	Cold-weather wear
	Thermoloft	Fiberfill and insulating fibers
revira	ESP	Apparel and furnishings
	Celwet	Nonwovens
	Comfort Fiber	Staple fiber for apparel uses
	Loftguard	Staple fiber for industrial uses
	Polar Guard	
	Lambda	Filament yarns with spun-yarn characteristic
	Serene	
	Superba	
	Trevira HT	Marine & military uses; ropes, cordage
	Trevira ProEarth	Recycled-content geotextiles
	Trevira XPS	Carpeting
	BTU	Cold-weather apparel

Production of Olefin

Two processes are used to produce olefin. The highpressure system (10 tons per square inch) is used to produce polyethylene film and molded materials. The lowpressure system, at a lower temperature and in the presence of a catalyst and hydrocarbon solvent, is less expensive and produces a polyethylene polymer more suitable for textile uses. The extrusion process is similar to that of nylon and polyester. Olefin is melt-spun into water or cool air and cold-drawn to six times its spun length. Olefins differ from polyester and nylon in that the solution crystallizes very rapidly (undrawn fibers are crystalline), so that spinning conditions and aftertreatment greatly affect the fiber properties. Olefin is an inexpensive fiber with extremely good performance characteristics for many end uses. The low price of olefin, coupled with its properties, explains its widespread and growing markets.

Gel spinning is a relatively new spinning method in which the dissolved polyethylene polymer forms a viscous gel in the solvent. The gel is extruded through the spinneret, the solvent is extracted, and the fiber is drawn. This process produces very-high-strength fibers. Spectra is Allied-Signal's trade name for an olefin fiber by produced by gel spinning.

Using a new method developed in Japan, ultra-highmolecular-weight polyethylene is produced as a crystalline nanofiber in sizes ranging from 30 to 50 nanometers (nm). Although not commercially available, the process promises incredibly tiny fibers with improved mechanical properties as compared with moreconventional olefins.

Physical Structure of Olefin

Olefins are produced as monofilament, multifilament, staple fiber, tow, and slit or fibrillated film yarns with variable tenacities. The fibers are colorless, often round in cross section, and have a slightly waxy feel (Figure 8–13). The cross section can be modified depending on end use.

Chemical Composition and Molecular Arrangement of Olefin

Olefin fibers—manufactured fibers in which the fiber-forming substance is any long-chain synthetic polymer composed of at least 85 percent by weight ethylene, propylene, or other olefin units except amorphous (noncrystalline) polyolefins qualifying . . . as rubber.

—Federal Trade Commission

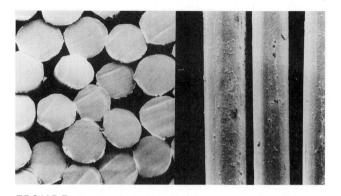

FIGURE 8-13 Photomicrographs of olefin: cross-sectional view (left); longitudinal view (right). (Courtesy of the British Textile Technology

Group.)

Olefin may be referred to as polypropylene or polyethylene. Polyethylene is a simple linear structure of repeating-CH₂-units and is used in ropes, twines, and utility fabrics. Polypropylene has a three-dimensional structure with a backbone of carbon atoms and methyl groups (-CH₃) protruding from the chain. Giulio Natta observed that three configurations could be developed when propylene was polymerized and that when all the methyl groups were on one side of the chain, the molecular chains could pack together and crystallize. Natta developed the process in which polymerization would take place in this manner. He and Karl Ziegler received the Nobel Prize in Chemistry in 1963 for their work.

Karl Ziegler's work on catalysts to polymerize ethylene and Giulio Natta's discovery of stereospecific polymerization made it possible to obtain high-molecularweight crystalline polypropylene polymers. Stereospecific polymerization means that the molecules are specifically arranged in space so that all the methyl groups have the same spatial arrangement. Natta called this phenomenon **isotactic.** In the atactic form, the methyl groups are randomly arranged, resulting in an amorphous polymer that would qualify as rubber.

Methyl groups

Olefin fibers have no polar groups. The chains are held together by crystallinity alone; the fiber is highly crystalline. The absence of polar groups makes dyeing a problem. Solution-dyeing is expensive and less versatile than other methods of adding color to fibers or fabrics. An acid-dyeable olefin is available, but dyed olefins comprise a tiny fraction of the market. Polypropylene is used in apparel, furnishings, and industrial products.

Properties of Olefin

Olefin's performance in apparel and furnishing fabrics is summarized in Table 8–16. Review the fiber property tables in Chapter 3 to help understand the performance of olefin in comparison with that of the other fibers.

Aesthetics Olefin is usually produced with a medium luster and smooth texture, but the luster and texture can be modified depending on the end use. Many sizes of olefin fibers are available. Smaller fibers are available for furnishings and apparel. Finer-denier fibers produce a softer, more natural drape.

Olefin has a waxy hand; crimped fibers with modified cross sections have a much more attractive hand and are most often used for apparel and furnishings. Drape can be varied relative to end use by selection of fiber modification, fabric construction method, and finish.

Current olefins do not look artificial, as the early olefins did. Contemporary olefins are modified easily by changing cross section, fiber size, crimp, and luster. Olefin fibers are most often solution-dyed; many pro-

TABLE 8-16	Summary of the performance of	
olefin in appa	arel and furnishing fabrics.	

olefin in apparel and furnishing fabrics.		
Aesthetic Luster	Variable Medium	
Durability Abrasion resistance Tenacity Elongation	High Very good High Variable	
Comfort Absorbency Thermal retention	Moderate Poor Good	
Appearance retention Resiliency Dimensional stability Elastic recovery	Excellent Excellent Excellent Excellent	
Recommended care	Machine-wash, dry at low temperature (apparel) Dry extraction (furnishings)	

ducers provide a wide variety of color choices for olefins designed for furnishings or apparel. Some interior designers prefer olefin to most other fibers because of its attractive appearance and other positive performance aspects, coupled with its relatively low price as compared with similar products made from different fibers.

Durability Olefins may be produced with different strengths suited to the end use. The tenacity of polypropylenes ranges from 3.5 to 8.0 g/d; that of polyethylenes from 1.5 to 7.0 g/d. Wet strength is equal to dry strength for both types. An ultra-high-strength olefin, Spectra by Allied-Signal, has a tenacity of up to 30 g/d and is used in industrial products. Fibers produced for less-demanding end uses have tenacities ranging from 4.5 to 6.0 g/d. Olefin fibers have very good abrasion resistance. Elongation varies with the type of olefin. For olefins normally used in apparel and furnishings, the elongation is 10 to 45 percent, with excellent recovery. Upholstery and commercial carpets of olefin and olefin blends combine excellent performance with low cost.

Olefin products are durable and strong. With olefin's low density, it is possible to produce highly durable, lightweight products. Resistance to abrasion and chemicals is excellent. This combination of characteristics and low cost means that olefin is very competitive with other fibers with equal or superior durability. Olefin is ideal for end uses for which durability, low cost, and low density are critical, such as ropes and cables of great size or length.

Comfort Olefins are nonabsorbent, with a moisture regain of less than 0.1 percent. Because of this, most olefin fibers are mass-pigmented or solution-dyed.

Olefins are nonpolar in nature and are not prone to static electricity. Because of its excellent wicking abilities, olefin is becoming more important in active sportswear, socks, and underwear, and as a cover stock in disposable diapers. It does not absorb moisture and minimizes leakage. In cold-weather wear and active sportswear, olefin keeps the skin dry by wicking moisture away from the skin's surface.

Olefin has good heat retention. It is also the lightest of the textile fibers. Polypropylene has a specific gravity of 0.90 to 0.91; polyethylene, 0.92 to 0.96. This low specific gravity provides more fiber per pound for better cover. As producers learned to deal with its low softening and melting temperatures, difficulty in dyeing, and unpleasant hand, olefin is popular in warmth-withoutweight sweaters and blankets. It takes 1.27 pounds of nylon or 1.71 pounds of cotton to cover the same volume as 1 pound of olefin.

ComforMax IB is an inner-layer barrier fabric manufactured by DuPont for use in activewear. The barrier

fabric combines wind resistance with air permeability and a good moisture vapor transport rate. **Moisture vapor transport rate** (MVTR) measures how quickly moisture vapor, such as evaporated perspiration, moves from the interior side of the fabric, next to the body, to the exterior. A high MVTR describes a fabric with good comfort characteristics, especially when the wearer is active.

With modifications of cross section, crimp, and fiber size, olefin upholstery fabrics can be extremely comfortable. In upholstery, olefins with deniers of 1.7 to 2.0 produce comfortable textures. Olefin fibers with a similar small denier are used in apparel. Soft and lightweight olefin fibers with excellent wicking are prized by both amateur and professional athletes for the edge they contribute to performance.

Appearance Retention Olefin has excellent resiliency and recovers quickly from wrinkling. Shrinkage resistance is excellent as long as it is not heated. It also has excellent elastic recovery. Olefin retains its attractive appearance for years. Since the fiber can be heat-set, wrinkles are minimal. Crimp and other three-dimensional effects are permanent. The fiber does not react with most chemicals, so it does not soil or stain readily. Designers find olefin carpeting and upholstery fabrics ideal for a wide variety of end uses.

Care Olefins have easy-care characteristics that make them suited to a number of end uses. They dry quickly after washing. Dry cleaning is not recommended because olefins are swollen by common dry-cleaning solvents such as perchloroethylene (perc). Petroleum-based dry-cleaning solvents are acceptable for cleaning olefins, but if perc is used, the damage cannot be reversed.

Since olefin is not absorbent, waterborne stains are not a problem. The fiber does not pick up color from stains or items that bleed in the wash. The major problems with olefin relate to its oleophilic and heat-sensitive nature. Oily stains are extremely difficult to remove. Exposure to oil may cause the fiber to swell. Exposure to excess heat causes the fiber to shrink and melt. Furnishing items of olefin should never be treated with soil-removal agents that contain perc since this solvent will alter the appearance of any treated areas.

Olefins have excellent resistance to acids, alkalis, insects, and microorganisms. They are affected by sunlight, but stabilizers can be added to correct this disadvantage. Outdoor carpeting made of olefin fibers can be hosed off.

Olefins have a low melting point (325 to 335°F), which limits their use in apparel. Warm or cold water should be used for spot cleaning or washing. Olefin fabrics should be air-dried. Olefins should be dried and ironed at low temperatures.

Environmental Impact of Olefin

Many environmental issues discussed with nylon also apply to olefin. Olefin is an easier fiber to recycle than most other fibers. It is extensively used in a basic unmodified form to protect bales of fiber and rolls of fabrics used in the apparel and furnishings industry. Many packaging materials and industrial products used in other industries are also used in a basic form that can be melted and reused with minimal effort to purify and process them back into fiber form. Tyvek ProtectiveWear by DuPont is an example of a product made of 25 percent postconsumer recycled polyethylene.

Since olefin is seldom dyed, the environmental problems related to dyeing are minimal. Because olefin can be engineered for specific end uses, the problems related to recycling or disposing of finishing chemicals are of little concern.

Probably one of the most significant impacts of olefin on the environment is its use in products that protect the environment. Erosion-control fabrics used in landscaping and along highways protect newly seeded areas and prevent soil erosion. Weed-barrier fabrics and protective covers for vegetables and flowers minimize the use of herbicides and insecticides by farmers, gardeners, and homeowners. Hazardous-waste-transport containers are lined with Tyvek, an olefin product by DuPont.

Uses of Olefin

The American Polyolefin Association (APA) promotes the use of olefin and a positive image of the fiber. Olefin is found in an ever-widening array of end uses. In apparel, it is used for underwear, socks, sweaters, glove liners, and active sportswear. Telar by Filament Fiber Technology, Inc., is a fine-denier olefin used in blends for pantyhose, saris, and swimwear. ComforMax IB by DuPont is a microdenier olefin used as a wind-, water-, and cold-barrier layer in active and outdoor wear. Thinsulate is a low-bulk, ultra-fine-microdenier fiberfill of olefin produced by 3M and used in footwear, ski jackets, and other outerwear for which a slim silhouette is desired.

In furnishings, olefin is used by itself and in blends with other fibers in carpeting as face yarns; as nonwoven, needle-punched carpets and carpet tiles; and as upholstery, draperies, and slipcovers. Olefin has almost completely replaced jute in carpet backing because of its low cost, easy processing, excellent durability, and suitability to a wide variety of face yarns, end uses, and finishing procedures. It is used for nonwoven fabrics for furniture webbing because it is versatile, efficient, easy to handle, and economic. Antimicrobial and antifungal

FIGURE 8-14 Bag woven with slit-olefin yarns.

olefins are also used in woven mattress covers and contract floor coverings.

It is in industrial applications that olefin really proves itself. Olefin's continued growth, at a time when the market for most other fibers is stable or receding, is due to its versatility, serviceability, and low cost in a wide array of applications. Olefin makes an ideal geotextiletextiles that are used in contact with the soil. It is used to produce roadbed-support fabrics, like Petromat and Petrotak, that provide a water and particle barrier between road surfaces and the underlying soil foundation. Roadbed-support and stabilizer fabrics are used on roadways, rail lines, and parking lots to extend their life.

Olefin is used in some car interiors for floor coverings, upholstery, headliners, sun visors, instrument panels, arm rests, package-shelf fabric, door and side panels, and carpeting in trunks and cargo areas. It is also a popular fiber in boats for furnishings and finishing fabrics and as surface coverings on docks and decks. It is found in dye nets, cover stock for diapers, filter fabrics, laundry bags, sandbags, banners, substrates for coated fab-

Types and kinds of olefin **TABLE 8–17** fibers.

Heat-stabilized Acid-dyeable Light-stabilized Solution-dved Modified cross section Bicomponent Pigmented Fibrillated Antimicrobial and antifungal Soil-blocking Flame retardant

TABLE 8-18 Some trade names and producers of olefins.

Spectra 900, Spectra 1000 Allied-Signal, Inc. Patlon, Marquessa Lana, Amoco Fabrics & Fibers Co. Propex III Tyvek

DuPont Herculon Hercules, Inc. Duraguard, Evolution, Kimberly-Clark

Evolution III Polyloom Typar, Biobarrier

Polyloom Corp. Reemay, Inc.

rics, ropes, and twines. Tyvek is used in wall-panel fabrics, envelopes and protective clothing. Figure 8-14 shows a rice bag made from olefin.

Tables 8-17 and 8-18 list modifications, trade names, and producers of olefin. Table 8–19 compares the characteristics of nylon, polyester, and olefin, the three melt-spun fibers discussed in this chapter.

Acrylic

Acrylonitrile, the substance from which acrylic fibers are made and from which the generic name is derived, was first made in Germany in 1893. The marketing of acrylic fibers frequently takes advantage of its wool-like characteristics. Terms like virgin acrylic, mothproof, and mothresistant appeal to consumers, but do not convey anything significant, since acrylics are inherently mothresistant and are not currently recycled.

Production of Acrylic

Some acrylic fibers are dry- or solvent-spun and others are wet-spun. In dry spinning, the polymers are dissolved in a suitable solvent, such as dimethyl formamide, extruded into warm air, and solidified by evaporation of the solvent. After spinning, the fibers are stretched hot, 3 to 10 times their original length, crimped, and marketed as cut staple or tow. In wet spinning, the polymer is dissolved in solvent, extruded into a coagulating bath, dried, crimped, and collected as tow for use in the high-bulk process or cut into staple and baled.

Physical Structure of Acrylic

The cross-sectional shape of acrylic fibers varies as a result of the spinning method used to produce them (Figure 8–15). Dry spinning produces a dog-bone shape. Wet spinning imparts a round or lima bean shape to some fibers. Differences in cross-sectional shape affect

	Nylon	Polyester	Olefin
Breaking tenacity, g/d	2.3–9.8 filament	2.8–9.5 filament	3.5–8.0 filament
	2.9-7.2 staple	2.4-7.0 staple	
Specific gravity	1.14	1.22 or 1.38	0.91
Moisture regain %	4.0-4.5	0.4-0.8	Less than 1
Melting point	482 or 414°F	540 or 482°F	325-335°F
Safe ironing temp	270-300°F	325-350°F	250°F to lowest settin
Effect of light	Poor resistance	Good resistance	Poor resistance

physical and aesthetic properties and thus can be a factor in determining appropriate end use. Round and lima bean shapes have a higher bending stiffness, which contributes to resiliency, and are appropriate for bulky sweaters and blankets. Dog-bone shape gives the softness and luster desirable for other uses.

All the production of acrylic fibers in the United States is staple fiber and tow. Staple fiber is available in deniers and lengths suitable for all spinning systems. Acrylic fibers also vary in shrinkage potential. Bicomponent fibers were first produced as acrylics. Some filament-yarn acrylic fabrics are imported, mostly in window treatments. MicroSupreme is a trade name for an acrylic microfiber made by Sterling Fibers Inc.

Chemical Composition and Molecular Arrangement of Acrylic

Acrylic fibers—manufactured fibers in which the fiber-forming substance is any long-chain synthetic

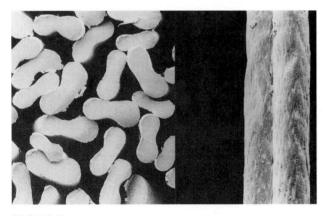

FIGURE 8-15

Photomicrographs of acrylic: cross-sectional view (left) and longitudinal view (right). (Courtesy of the British Textile Technology Group).

polymer composed of at least 85 percent by weight acrylonitrile units.

-Federal Trade Commission

Fibers of 100 percent polyacrylonitrile have a compact, highly oriented internal structure that makes them virtually undyeable. They are an example of a homopolymer, a fiber composed of a single substance. Schematically, a homopolymer could be diagrammed:

Most acrylics are produced as **copolymers**, with up to 15 percent of the mers something other than acrylonitrile. This produces a more open structure and permits dye to be absorbed into the fiber. The other mer types furnish dye sites that can be changed for specific dye classes so that cross dyeing is possible. The percentages of other mers and their arrangement in relation to each other will vary. Copolymer fibers are composed of two or more compounds and could be diagrammed:

x x x O x x x x x x O x x x x x x O x x x Copolymer

In **graft polymer** acrylics, the other mer does not become a part of the main molecular chain. It is a side chain attached to the backbone chain of the molecule. These molecular chains have a more open structure, less crystallinity, and better dye receptivity.

Some fibers have molecules with chemically reactive groups; others are chemically inert. A chemically inert

molecule can be made reactive by grafting reactive groups onto the backbone. It could be diagrammed:

Copolymer acrylics are not as strong as the homopolymers or graft polymer acrylics. Since acrylics are used mostly in apparel and furnishings, the reduced strength is not a major concern.

Properties of Acrylic

Acrylic fibers are soft, warm, lightweight, and resilient. They make easy-care fabrics. Because of their low specific gravity and high bulk, the acrylics have been called the "warmth without weight" fibers. Acrylics have been successful in end uses, such as sweaters and blankets, that had been dominated by wool. They are superior to wool in their easy-care properties and are nonallergenic. Bulky acrylic yarns are popular in socks, fleece and fakefur fabrics, and craft yarns. Table 8–20 summarizes the performance characteristics of acrylics. The fiber property tables in Chapter 3 compare the properties of acrylic to those of other fibers.

Aesthetics Acrylic fibers possess favorable aesthetic properties. They are attractive and have a soft, pleasant hand. Bulky spun yarns are usually textured to be wool-

Aesthetics	Wool-like
Durability	Moderate
Abrasion resistance	Moderate
Tenacity	Moderate
Elongation	Moderate-high
Comfort	Moderate
Absorbency	Poor
Thermal retention	Moderate
Appearance retention	Moderate
Resiliency	Moderate
Dimensional stability	Moderate
Elastic recovery	Moderate
Recommended care	Machine-wash; follow care

like. Indeed, acrylic fabrics imitate wool fabrics more successfully than any of the other manufactured fibers.

Apparel and furnishing items of all acrylic or acrylic blends are attractive. Their luster is matte as a result of delustering, the irregular cross-sectional fiber shape, and fiber crimp. Since these products are almost always staple fibers, their wool-like appearance is maintained. Bulky yarns and bicomponent fibers also contribute to the wool-like appearance and texture.

Durability Acrylics are not as durable as nylon, polyester, or olefin fibers, but in apparel and furnishings, the strength of acrylics is satisfactory. Dry tenacity is moderate, ranging from 2.0 to 3.0 g/d. Abrasion resistance is also moderate. The breaking elongation is 35 percent. Elongation increases when the fiber is wet. The overall durability of acrylic fibers is moderate, similar to that of wool and cotton.

Furnishings made from acrylics or acrylic blends are durable. They provide reasonable resistance to abrasion for upholstery fabrics. They are sufficiently strong to withstand laundering, dry cleaning, and dry-extraction cleaning, depending on the product. Pilling can be noticeable with staple fiber fabrics. However, low-pilling fiber modifications are available, and some fabric finishes reduce pilling.

A Wear Dated Traffic Control Carpet by Solutia Inc. has 88 percent nylon and 12 percent acrylic. The carpet has high bulk and is more durable than nylon alone. The fibers are blended together in the carpet yarn, twisted, and heat-set. Since the acrylic is a high shrinkage modification, it shrinks and tightens the yarn tuft, producing good durability characteristics.

Because of its exceptional resistance to weathering, acrylic is widely used in awnings and tarpaulins. Table 8–21 shows that acrylic is comparable to wool in durability properties.

Comfort The surface of acrylic fibers is much less regular than that of other synthetic fibers with irregularities and indentations on its surface (Figure 8–16). In spite of the relatively low moisture regain of 1.0 to 2.5 percent, acrylics are moderately comfortable because of their irregular surfaces. Instead of absorbing moisture and becoming wet to the touch, acrylic fibers wick moisture to the fabric's exterior, where it evaporates more readily and cools the body.

Another factor that makes acrylics comfortable is that the fibers and yarns can be made with high bulk. Acrylic fibers can be produced with a latent shrinkage potential and retain their bulk indefinitely at room temperature. The resulting bulky fabrics retain body heat well, so they are warm in cold temperatures. Bulky knit sweaters are a common example of this.

TABLE	8-21	Comparison	of the	durability	of	
acrylic	with	that of wool.				

Fiber Property	Acrylic	Wool
Abrasion resistance	Good	Fair
Breaking tenacity	2.0-3.0 g/d dry	1.5 g/d dry
	1.8-2.7 g/d wet	1.0 g/d wet
Breaking elongation	35 percent	25 percent
Elastic recovery	92 percent	99 percent

The structure of the yarn and fabric can be modified to create a warmer or cooler product. In general, acrylics are more comfortable than nylon and polyester, but not as comfortable as cotton in hot, humid weather or as wool in cold or cool, humid weather.

The density of acrylic is similar to that of nylon. Thus, the fabrics are lightweight and durable. This means that bulky sweaters made from acrylic are not as heavy as wool sweaters. Acrylic blankets are lighter than similar wool blankets.

Appearance Retention Acrylic fibers exhibit moderate resiliency and recovery from bending, thus they resist wrinkling during use and care. They have moderate dimensional stability. When appropriate yarn and fabric structures are selected, the dimensional stability of acrylic fabrics is good. Acrylics shrink when exposed to high temperatures and steam; the fibers do not hold up well under hot, wet conditions.

Acrylic fibers cannot be heat-set like nylon and polyester because acrylic decomposes and discolors

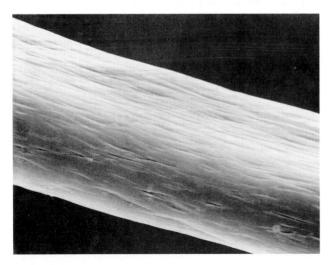

FIGURE 8-16

Acrylic that is magnified 3000 \times shows a pitted and irregular surface.

when heated rather than melting. However, some acrylics can have pleats or creases set in that are not affected by normal use or care. With the careful application of heat and/or steam, the crease or pleats can be removed.

Acrylics also differ from nylon and polyester because of their poorer dimensional stability; fabrics may shrink or stretch during care. Acrylics will pill because the fibers fibrillate, or crack, with abrasion.

Acrylics and blends with acrylic maintain their appearance well. The bulk characteristics are permanent if the product receives the appropriate care. These fibers are less likely to mat than some fibers. With solution-dyeing of some upholstery, drapery, and awning fabrics, colors are permanent. Awning fabrics of solution-dyed acrylic are popular in finishing window exteriors, entries, and outdoor entertainment areas.

Care It is especially important to follow the instructions found on the care labels for acrylics. Table 8–22 compares the care for acrylic with that for wool. There are several basic acrylic fibers with slightly differing properties due to the polymer composition, manufacturing methods, and fiber modifications.

The acrylics have good resistance to most chemicals except strong alkalis and chlorine bleaches. This is not surprising; fibers containing nitrogen are usually susceptible to damage from alkali and chlorine. Except for the furlike fabrics, acrylic fabrics have good wash-and-wear characteristics. They do not wrinkle if handled properly and if directions on the care label are followed.

Some items made from high-bulk yarns of bicomponent fibers need to be machine-dried to regain their shape after washing. If they are blocked, dried flat, or drip-dried, they may be too large or misshapen. Rewashing and tumble drying should help restore the original shape.

Some acrylics can be dry-cleaned. However, with some fabrics the finish is removed, resulting in a harsh feel. Thus, care labels should be followed. Acrylics are resistant to moth damage and mildew and have excellent resistance to sunlight.

Following the recommended care procedures for acrylic or acrylic blend products is especially important for electric blankets made from acrylic. Electric blankets should never be dry-cleaned. Dry-cleaning solvents dissolve the protective coating on the wiring of the blanket, resulting in a high risk of electric shock or fire. Steam cleaning of draperies, upholstery, and carpeting is generally not recommended because acrylics may shrink.

Antimicrobial and antifungal acrylics are used in apparel, furnishing, and industrial applications. Products include nursing uniforms, socks, shoe liners, sportswear, contract carpet and upholstery, surgical barrier fabrics, and industrial filters.

Fiber Property	Acrylic	Wool
Effect of alkalis	Resistant to weak alkalis	Harmed
Effect of acids	Resistant to most acids	Resistant to weak acids
Effect of solvents	Can be dry-cleaned	Dry cleaning recommended
Effect of sunlight	Excellent resistance	Low resistance
Stability	Generally retains shape	Subject to felting, shrinkage
Permanence of creases	Creases can be set and removed by heat	Creases set by heat and moisture—not permanen
Effect of heat	Thermoplastic—sticks at 450–490°F	Scorches easily, becomes brittle at high temperatures
Resistance to moths and fungi	Resistant	Harmed by moths; mildew forms on soiled, stored wool
Effect of water	None	May felt or mat, noticeable odor when wet

Environmental Impact of Acrylic

Acrylic is resistant to natural sources of degradation, including molds, mildew, rot, and many chemicals. Because acrylic is processed from petrochemicals, concerns include drilling in sensitive environments, oil spills, and disposal of hazardous chemicals. The chemicals from which acrylic is made require significant processing before they are polymerized to form acrylic. With wet- or dry-spun fibers, recycling of solvents is necessary to minimize the environmental impact. Wet-spun acrylics also require washing and drying to remove chemicals from the coagulating bath. Different types of acrylic are made from slightly different raw materials; potential hazards to the environment will differ depending on which raw materials and processes are used in production. Acrylic is not recycled. Because acrylics can be engineered for specific end uses, chemical finishing is not a concern. Acrylics may be dyed; therefore, processing of dye wastes is a concern.

Uses of Acrylic

Acrylic is a relatively minor fiber in terms of use. Although more acrylic is used in apparel, it is also important in furnishings and some technical products. Knitted apparel items of acrylic include fleece fabrics, sweaters, and socks. Socks of Duraspun by Solutia Inc. keep feet drier and last 35 percent longer. Fleece fabrics, available in many colors and prints, are used in jogging outfits and active sportswear and may be made from antimicrobial and ultraviolet protective fibers. Acrylic pile fabrics and fun furs are used for coats, jackets, linings, or soft stuffed animals. Antistatic acrylics are used in apparel for computer clean rooms.

Craft yarns, another important end use of acrylic fibers, are often made of a heavier denier (5 to 6 denier). Many sweaters, baby garments, vests, and afghans are

knitted or crocheted with these yarns. Acrylic yarns are also used for embroidery, weaving, and other crafts.

Upholstery fabrics have a wool-like appearance and may be flat-woven fabrics or velvets with good durability and stain resistance. Drapery fabrics of acrylic are resistant to sunlight and weathering. Acrylics are used in lightweight and winter-weight blankets. Carpets and rugs of acrylic or blends look more wool-like than several other synthetic fibers. Acrylic blankets, carpets, and rugs have easier care requirements and cost less than those of wool.

Acrylics are found in a number of industrial uses for which their chemical and abrasion resistance and good weathering properties make them suitable: awnings and tarpaulins, luggage, boat and other vehicle covers, outdoor furniture, tents, filtration fabrics, carbon fiber precursors, office room dividers, and sandbags. When exposed to chemicals, fibers with good chemical resistance show little or no loss of physical structure or fiber properties. Sunbrella mass-pigmented acrylic awnings by Glen Raven Mills, Inc., withstand exposure to sun, wind, and rain for years without fading, cracking, hardening, peeling, or rotting. A cross-linked superabsorbent acrylic, Oasis, is used in nonwoven filters to remove water from fuels, solvents, and other organic liquids, in packaging for meats, and in gaskets and seals.

Types and Kinds of Acrylic

Each company that produces acrylic in the United States identifies its fiber by a trade name:

Trade Name	Company	Туре
Acrilan, Duaspun, Pil-Trol, So-Lara	Solutia, Inc.	Staple and tow
Creslan, BioFresh, MicroSupreme, Weatherbloc	Sterling Fibers, Inc.	Staple and tow

TABLE 8-23 Types and kinds of acrylic fibers and yarns.

Homopolymer

Copolymer

Graft polymer

Bicomponent

Blends of various deniers

Blends of homopolymer and copolymer

Helical, nonreversible crimp

Reversible crimp

Surface modified

Variable cross section—round, acorn, dog-bone

Variable dyeability—cationic, disperse, acidic, basic

Solution-dyed

Fiber variants that are tailored for a specific end use or differ in performance are also produced. See Table 8–23 for a list of fiber and yarn types available.

Modacrylic Fibers

Modacrylic fibers are modified acrylics first produced in the United States in 1949. They are made from acrylonitriles, but a larger proportion of other polymers are added to make the copolymers.

Modacrylics were the first inherently flame-retardant synthetic fibers; they do not support combustion, are very difficult to ignite, are self-extinguishing, and do not drip. For these reasons, they are used in protective clothing and contract furnishings.

Production of Modacrylic Fibers

The modacrylic fibers are produced by polymerizing the components, dissolving the copolymer in acetone, pumping the solution into a column of warm air (dry-spun), and stretching while hot. Currently Solutia Inc. is the only producer of modacrylic in the United States. S.E.F. (self-extinguishing flame) is one trade name.

Physical Structure of Modacrylic Fibers

The modacrylics are creamy white and are produced as staple or tow. Their cross section is dog-bone or irregularly shaped (Figure 8–17). Various deniers, lengths, crimp levels, and shrinkage potentials are available.

Chemical Composition and Molecular Arrangement of Modacrylic Fibers

Modacrylic fibers—manufactured fibers in which the fiber-forming substance is any long-chain synthetic

polymer composed of less than 85 percent but at least 35 percent by weight acrylonitrile units except when the polymer qualifies as rubber.

-Federal Trade Commission

The chemicals used as copolymers include vinyl chloride (CH_2CHCl) , vinylidene chloride (CH_2CCl_2) , or vinylidene dicyanide (CH_2CCN_2) .

Properties of Modacrylic Fibers

Modacrylic has properties similar to acrylic, but modacrylic is flame-retardant and it has better heat resistance than acrylic.

Aesthetics Furlike fabrics, wigs, hairpieces, and fleecetype pile fabrics are made of modacrylic fibers with different amounts of crimp and shrinkage potential. By mixing several fiber types it is possible to obtain furlike fabrics with fibers of different pile heights: long, polished fibers (guard hairs), and soft, highly crimped undercoat fibers (Figure 8–18). Fabrics are sheared, embossed, and printed to enhance their resemblance to real fur.

Modacrylic has an attractive appearance, similar to that of acrylic. It can be made with a soft, matte luster to resemble wool or with a brighter luster to resemble the shiny guard hairs of fur.

Durability Modacrylics are less durable than acrylics, but they have adequate durability for their end uses. The strength of modacrylics is similar to that of wool. Abrasion resistance is similar to acrylic. Elastic recovery is superior to that of acrylic.

Comfort Modacrylics are poor conductors of heat. Fabrics are soft, warm, and resilient, but have a tendency

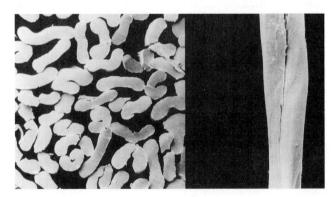

FIGURE 8-17

Photomicrographs of modacrylic: cross-sectional view (left); longitudinal view (right). (Courtesy of the British Textile Technology Group.)

FIGURE 8-18

Fur-like fabric of modacrylic. Note how the sleek guard hairs and the soft, fine underhairs simulate the appearance of fur.

to pill. Their absorbency is low, varying from 2 to 4 percent moisture regain.

Modacrylics combine flame retardancy with a relatively low density (1.35). This means that protective apparel need not be uncomfortably heavy. Flame-retardant furnishings, especially draperies, can be produced without great weight.

Appearance Retention Modacrylic fibers exhibit moderate resiliency. In typical end uses, they do not wrinkle. They have moderate dimensional stability and high elastic recovery.

Modacrylics pill more quickly, are more sensitive to heat, mat more readily, and are not as resilient as acrylics. Modacrylics tend to retain color well.

Care Modacrylics are resistant to acids, weak alkalis, and most organic solvents. They are also resistant to mildew and moths. They have very good resistance to sunlight and very good flame resistance.

Modacrylics can be washed or dry-cleaned with special care. The heat-sensitive fibers shrink at 250°F and stiffen at temperatures over 300°F. If fabrics are machine-washed, use warm water and tumble dry at a low setting. The lowest iron setting should be used. Some furlike fabrics are dry cleanable; some require special care in dry cleaning (no steam, no tumble or tumble only on cold); and some should be cleaned by a furrier method.

Modacrylics are more sensitive to loss of appearance from improper care than the acrylics. The precautions regarding steam cleaning discussed with acrylics also apply to modacrylics.

Environmental Impact of Modacrylic Fibers

Modacrylic is resistant to natural degradation. The concerns expressed for acrylic generally apply to modacrylic. Modacrylic has less of an impact on the environment than does acrylic, for two reasons. One, modacrylic is produced only using dry spinning, so concerns are limited to the dry-spinning process in which the solvent, acetone, is easy to reclaim and recycle. Two, modacrylic is a relatively minor fiber in terms of the amount produced.

Uses of Modacrylic Fibers

Modacrylics are used primarily in applications where environmental resistance is needed or where flame retardancy is necessary or required by law or building codes (see Chapter 21). One end use is in outdoor fabrics, awnings, and marine applications. Other end uses include protective clothing such as shirts and trousers for electric line personnel; furnishings, including upholstery, window-treatment fabrics, and blankets; and industrial applications, including filters. Because of its heat sensitivity, modacrylic may be used to produce realistic fake furs and wigs or hairpieces that can be curled with a curling iron. Many modacrylics are mass-pigmented rather than dyed.

Key Terms

Synthetic fibers Drawing Heat sensitivity Glazing Pilling Oleophilic Melt spinning
Heat setting
Low-pilling fibers
High-tenacity fibers
Nylon
Polyamides

Polyester
Compressional resiliency
Olefin
Gel spinning
Polyethylene
Polypropylene
Isotactic
Moisture vapor transport rate

Acrylic Dry spinning Wet spinning Homopolymer Copolymer Graft polymer Modacrylic

Questions

- 1. Explain the differences in chemical composition between these groups of fibers:
 - polyamide (nylon) and polyester polyethylene and polypropylene acrylic and modacrylic
- 2. Explain the differences in properties between the pairs of fibers listed in question 1.
- **3.** Describe the major performance characteristics of nylon, polyester, olefin, acrylic, and modacrylic.
- **4.** Identify the spinning process used to produce nylon, polyester, olefin, acrylic, and modacrylic. How does the spinning process relate to the fiber's cross-sectional shape?
- **5.** How do the characteristics of these fibers differ from those of the natural fibers and those produced from naturally occurring polymers?
- **6.** Identify a synthetic fiber that would be an appropriate choice for each end use listed below, and explain, using performance characteristics, why you selected that fiber:

carpet for department store boutique area pantyhose sweater vest for casual Friday geotextile for use as roadbed underlay lead rope for horses or ponies upholstery fabric for theater seats

Suggested Readings

- Anonymous (1998). Corterra: a new polyester fibre. *Textiles Magazine*, 1, pp. 12–14.
- Borland, V. S. (1998, January). Miracle fiber back in fashion. American Sportswear and Knitting Times, pp. K/A6, K/A8, K/A10.
- Davidson, W. A. B. (1993, April). Wellman launches Fortrel EcoSpun. America's Textiles International, pp. 80, 82.
- Ford, J. E. (1992). Acrylic fibres. *Textiles*, no. 2, pp. 10–14.
 Ford, J. (1995). Polyolefin textiles. *Textiles Magazine*, 3.
 pp. 11–15.
- Fukuhara, M. (1993). Innovation in polyester fibers: from silk-like to new polyester. *Textile Research Journal*, 63, pp. 387–391.
- Havich, M. M. (1998, June). Performance power, *America's Textile International*, p. 90.
- Jerg, G., and Baumann, J. (1990). Polyester microfibers: a new generation of fabrics. *Textile Chemist and Colorist*, 22 (12), pp. 12–14.
- Moore, R. A. F. (1989). Nylon 6 and nylon 6,6: how different are they? *Textile Chemist and Colorist*, 21 (2), pp. 19–22.
- The polycotton story. (1994, Winter). *Textiles Magazine*, pp. 8–11.
- Zeronian, S. H., and Collins, M. J. (1988). Improving the comfort of polyester fabrics. *Textile Chemist and Colorist*, 20 (4), pp. 25–28.

Chapter 9

SPECIAL-USE FIBERS

OBJECTIVES

- To differentiate among special-use fibers based on their elastomeric or protective characteristics.
- To recognize the importance of these fibers in apparel, furnishings, and industrial products.
- To integrate properties of specialuse fibers with their uses.

his chapter focuses on fibers with unique characteristics. Some of these fibers are in common consumer products, but consumers may not be aware of them. Other fibers are used in industrial and technical applications and have contributed significantly to many technological advances over the past 50 years. The fibers are grouped by the purposes they serve: elastomeric or protective.

These fibers are produced in much smaller quantities as compared with the majority of the fibers discussed in previous chapters. They are used either in small quantities in products or in items with a relatively small market segment. For example, spandex may comprise as much as 20 percent of the fiber in a swimsuit or leotard. Graphite fiber may be used in the frame of a bicycle to add structural support. The potential for growth in this segment of the textile industry is excellent. The price per pound of these fibers can be very high compared with that of common apparel and furnishing fibers. The environmental impact of these fibers is relatively small because of their low production levels. Several of the protective fibers that will be discussed later in this chapter are frequently used to remove harmful chemicals from the environment.

Elastomeric Fibers

An **elastomer** is a natural or synthetic polymer that, at room temperature, can be stretched repeatedly to at least twice its original length and that, after removal of the tensile load, will immediately and forcibly return to approximately its original length (ASTM, American Society for Testing and Materials). Elastomeric fibers include spandex, rubber, and anidex. Anidex is no longer produced in the United States.

The type of stretch and elasticity required in a textile product depend on its end use. Power stretch is important in end uses for which holding power and elasticity are needed. Elastic fibers with a high retractive force are used to attain this kind of stretch. Some end uses are foundation garments, surgical-support garments, swimsuits, garters, belts, and suspenders.

Comfort stretch is important in products for which only elasticity is desired. Comfort-stretch fabrics look like nonstretch fabrics. Their weight is lighter than that of power-stretch fabrics and they are used in apparel and furnishings.

Rubber

Rubber—manufactured fiber in which the fiber-forming substance is comprised of natural or synthetic rubber, including:

- 1. A manufactured fiber in which the fiber-forming substance is a hydrocarbon such as natural rubber, polyisoprene, polybutadiene, copolymers of dienes and hydrocarbons, or amorphous (noncrystalline) polyolefins.
- 2. A manufactured fiber in which the fiber-forming substance is a copolymer of acrylonitrile and a diene (such as butadiene) composed of not more than 50 percent but at least 10 percent by weight of acrylonitrile units

The term **lastrile** may be used as a generic description for fibers falling in this category.

3. A manufactured fiber in which the fiber-forming substance is a polychloroprene or a copolymer of chloroprene in which at least 35 percent by weight of the fiber-forming substance is composed of chloroprene units

—Federal Trade Commission

Natural rubber is the oldest elastomer and the least expensive. It is obtained by coagulation of the latex from the rubber tree *Hevea brasiliensis*. In 1905, sheets of rubber were cut into strips for yarns used in foundation garments. During and shortly after World War II, synthetic rubbers were developed. These synthetic rubbers are cross-linked diene polymers, copolymers containing dienes, or amorphous polyolefins. To develop their elastomeric properties, both synthetic and natural rubbers are vulcanized or cross linked with sulfur. Both types have a large cross section. Round fibers are extruded and rectangular fibers are cut from extruded film.

Rubber has an excellent elongation—500 to 600 percent—and excellent recovery. Its low tenacity—0.34 g/d—limits its use in lightweight garments. The finest rubber yarns must be three times as large as spandex yarns to be as strong. Because of rubber's low dye acceptance, hand, and appearance, it is covered by a yarn of another fiber or by other yarns in the fabric.

Rubber has been replaced in many uses by spandex, but it continues to be used in narrow elastic fabrics. Synthetic rubber is more common in these elastic fabrics than is natural rubber.

Even though antioxidants are added to the spinning solution, rubber lacks resistance to oxidizing agents and is damaged by aging, sunlight, oil, and perspiration. It is resistant to alkalis, but is damaged by heat, chlorine, and solvents. It should be washed with care and never dry-cleaned.

Neoprene, a type of synthetic rubber made from polychloroprene, is used as an elastomeric fiber or a supported elastic film. It is resistant to acids, alkalis, alcohols, oils, caustics, and solvents. It is found in protective gloves and clothing, wetsuits, framing for window glass, industrial hoses and belts, anticorrosive seals and membranes, and coatings for wiring.

Spandex

After many years of research, DuPont introduced the first manufactured elastic fiber, a **spandex** fiber called Lycra, in 1958. Spandex generated much interest because it was superior to rubber in strength and durability. Spandex is produced by DuPont under the trade name of Lycra and by Globe Manufacturing Company under the trade names of Glospan and Cleerspan. Spandex is known as *elastane* in many other parts of the world. The Federal Trade Commission has ruled that *elastane* is an acceptable alternative term for spandex in the United States.

Production Spandex fibers are made by reacting preformed polyester or polyether molecules with disocyanate and polymerizing. Filaments are obtained by wet or solvent spinning. The spinning solution may contain delustering agents, dye receptors, whiteners, and lubricants.

Physical Structure Spandex is produced as monofilament or fused multifilament yarns in a variety of deniers. Monofilaments are round in cross section, whereas fused multifilaments are coalesced or partly fused together at intervals and are found in fibers with deniers of 40 and above (Figure 9–1). Spandex is delustered and is usually white or gray.

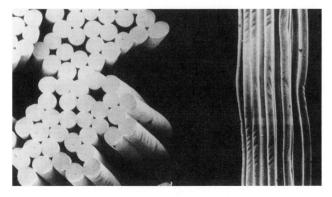

FIGURE 9-1

Photomicrographs of spandex: cross-sectional view (left); longitudinal view (right). (Courtesy of the British Textile Technology Group.)

FIGURE 9-2

Comparison of heavy 1500-denier Lycra spandex fibers (left) and fine 20-denier yarn (right). (Courtesy of E. I. du Pont de Nemours & Company.)

Deniers range from 20 to 4300. Twenty-denier spandex is used in lightweight support hosiery, in which a large amount of stretch is desirable. Much coarser yarns, 1500 to 2240 denier, stretch less and are used for support in hosiery tops, swimwear, and foundation garments (Figure 9–2).

Chemical Composition and Molecular Arrangement

Spandex—a manufactured fiber in which the fiber-forming substance is a long-chain synthetic polymer consisting of at least 85 percent of a segmented polyurethane.

—Federal Trade Commission

Spandex is a generic name, but it is not derived from the chemical name of the fiber, as are most of the manufactured fibers. The name was coined by shifting the syllables of the word *expand*.

Spandex consists of rigid and flexible segments in the polymer chain; the flexible segments provide the stretch and the rigid segments hold the chain together. When force is applied, the folded, or coiled, flexible segments straighten out; when force is removed, they return to their original positions (Figure 9–3). Varying proportions of rigid and flexible segments control the amount of stretch.

Properties Table 9–1 compares the performance of spandex and rubber in apparel and furnishing fabrics. The tables in Chapter 3 include the performance characteristics of all the fibers.

Aesthetics Spandex is seldom used alone in fabrics. Other fibers produce the desired hand and appearance. Even in power-stretch fabrics for foundation garments and surgical hose, where beauty is not of major importance, nylon, cotton, or other fibers are used. The

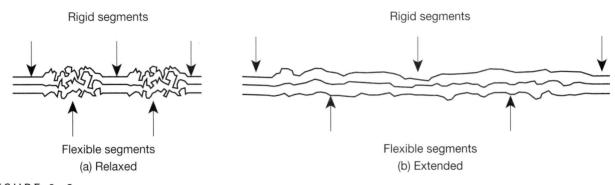

FIGURE 9-3
Spandex molecular chains: (a) relaxed; (b) extended.

characteristics of spandex that contribute to beauty in fabrics are dyeability of the fiber and good strength, resulting in fashionable colors and prints in sheer garments.

Spandex needs no cover yarns since it takes dye. Eliminating the cover yarn reduces the cost and fabric weight contributing to an attractive and comfortable lightweight fabric. However, in uses in which spandex will come in contact with the skin, it is normally covered.

Durability As shown in Table 9–2, spandex is more resistant to degradation than rubber. (Nylon is included in the table because it has more stretch than other manufactured filaments and illustrates differences between hard fibers and elastomeric fibers.)

Spandex is resistant to the body oils, perspiration, lotions, and cosmetics that degrade rubber. It also has

TABLE 9-1 Summary of the performance of spandex and rubber in apparel and furnishing fabrics.

	Spandex	Rubber
Aesthetics	Moderate	Poor
Durability	Moderate	Poor
Abrasion resistance	Poor	Poor
Tenacity	Poor	Poor
Elongation	Excellent	Excellent
Comfort	Moderate	Poor
Appearance retention	Good	Good
Resiliency	Good	Good
Dimensional stability	Good	Good
Elastic recovery	Excellent	Excellent
Recommended care	Machine-wash or dry-clean	Wash with care

good shelf life and does not deteriorate with age as quickly as does rubber. Its flex life is 10 times greater than that of rubber.

Comfort Spandex fibers have a moisture regain of 0.75 to 1.3 percent, making them uncomfortable for skin contact. Lighter-weight foundation garments of spandex have the same holding power as heavy garments of rubber. Spandex has a specific gravity of 1.2 to 1.25, which is greater than that of rubber. However, because of the greater tenacity of spandex, lower-denier yarns result in lightweight products.

Care Spandex is resistant to dilute acids, alkalis, bleaches, and dry-cleaning solvents. Spandex is thermoplastic, with a melting point of 446 to 518°F.

Spandex has superior aging resistance as compared with rubber, resists soiling, and has excellent elasticity and elongation properties. Spandex items retain an attractive appearance. However, over time the coarser spandex fibers may rupture and work through the fabric. When ends of the thick gray-white fibers appear on the surface, those areas of the fabric have lost their elasticity and elongation properties. This problem, known as **grin-through**, cannot be remedied. It occurs most often in products that have aged or have been stressed to extremes (Figure 9–4).

Uses Spandex is used to support, shape, or mold the body or to keep textiles from stretching out of shape during use (Table 9–3). It is used primarily in knit foundation garments, actionwear, compression sportswear to reduce chafing, intimate apparel, shapewear, hosiery, furnishings, and narrow fabrics. It is used in chlorine-resistant swimwear, skiwear, leotards and other dancewear, leggings, biking shorts, and other body-fitting apparel. Higher percentages of spandex in these products provide greater body contouring or support properties. Spandex is also used in woven fabrics in a

TABLE 9-2 Durability factors of spandex, rubber, and nylon.			
Fiber Property	Spandex	Rubber	Nylon
Breaking tenacity, g/d	0.6-0.9	0.34	3.0-9.5
Breaking elongation	400-700%	500-600%	23%
Flex life	Excellent	Fair	Excellent
Recovery from stretch	99% (at 50% elongation)	97% (at 50% elongation)	100% (at 3% elongation

variety of end uses, but its use here is relatively small as compared with knits. However, its use in wovens is increasing due to casual Fridays and other comfort requirements. It also has medical uses, such as surgical and support hose, bandages, and surgical wraps. It is used in fitted sheets and slipcovers. Blends of 2 to 40 percent spandex with other fibers are common.

Elastoester

An elastomer based on polyether-ester has been introduced by the Japanese textile firm Teijin, Ltd., under the trade name Rexe. Elastoester is a manufactured fiber in which the fiber-forming substance is composed of at least 50% by weight aliphatic polyether and at least 35% by weight polyester (Federal Trade Commission). The fiber has an elongation potential of 600 percent, a tenacity of 1.0 g/d, and elasticity of 80 percent at elongations over 200 percent. These properties are slightly less than the properties of spandex. However, Rexe is washable and has superior strength retention in wet heat and after treatment with alkalis. It is also superior in its resis-

FIGURE 9-4
Grin-through in a swimsuit made of nylon and spandex.

tance to chlorine bleach. It may be treated to increase dyeability and print clarity and to achieve a more silk-like hand. It is used in fashion outerwear and fitted furnishings.

Fibers with Chemical, Heat, or Fire Resistance

The protective fibers have specialized applications. In almost all cases, their costs are prohibitive for normal apparel and furnishing products. Some of these fibers cost over \$60 per pound. Compare that with prices of less than \$1 per pound for the fibers generally found in apparel and furnishings, like cotton and polyester. Clearly, these fibers provide sufficient performance for their cost or they would not be used. With their unique resistance to chemicals, heat, and flame, these fibers are very important as industrial textiles. Many of these fibers are described as high-temperature fibers. This means that they can be used continuously at temperatures over 200°C without significant decomposition and retain the majority of their physical properties.

TABLE 9-3 Stretch		properties of spandex.	
	Major End Uses	Important Properties	
	Athletic apparel	Power stretch, washable	
	Foundation garments	Power stretch,	
	(power net, tricot)	washable, lightweight	
	Bathing suits	Power stretch,	
		resistance to salt and	
		chlorine, dyeable	
	Outerwear and sportswear	Comfort stretch	
	Support and surgical hose	Power stretch,	
	-	lightweight	
	Elastic webbing	Power stretch	
	Slipcovers, bottom sheets	Comfort stretch, washable	

Aramid

Aramid—a manufactured fiber in which the fiberforming substance is a long-chain synthetic polyamide in which at least 85 percent of the amide linkages

are attached directly to two aromatic rings.

-Federal Trade Commission

Nylon is a polyamide fiber; aramid is an aromatic polyamide fiber. DuPont chemist Stephanie Kwolek developed a nylon variant with exceptional heat and flame resistance. It was introduced in 1963 under the trade name Nomex nylon. DuPont introduced another variant of nylon in 1973 as Kevlar. This fiber had exceptional strength in addition to fire resistance. The Federal Trade Commission established the generic classification of aramid in 1974 for these fibers. An aromatic ring is a six-sided carbon compound with alternating double and single bonds represented in chemical notation as a circle in the six-sided ring. The location at which the amide linkages are attached determines the type of aramid and its properties. Nomex is a meta-aramid, or m-aramid; Kevlar is a para-aramid, or p-aramid (Table 9–4).

Aramid can be wet or dry spun and is usually round or dog-bone shaped (Figure 9–5). Aramid fibers have high tenacity and high resistance to stretch and to high temperatures. Its resistance to most chemicals is good to excellent. It is only moderately resistant to sunlight. Aramids are oleophilic and prone to static buildup un-

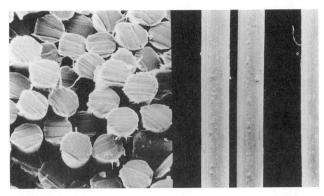

FIGURE 9-5

Photomicrographs of aramid: cross-sectional view (left); longitudinal view (right). (Courtesy of the British Textile Technology Group.)

less finished. Table 9–4 compares normal-tenacity aramids with high-tenacity aramids. These fibers maintain their shape and form at high temperatures. Aramid fibers have excellent impact and abrasion resistance.

Hollow aramid fibers are used to produce fresh water from sea water through reverse osmosis. The thin, dense skin of the fiber allows only water to pass through. Aramids are difficult to dye and have poor resistance to acids. Trade names for aramid fibers are Nomex, Kevlar, Conex, Fenilon, and Kermel. Nomex and Kevlar, trade names owned by DuPont, are most commonly found in the United States. Solution-dyed aramids are more common, but technology has been developed to dye aramid intense colors for high-visibility protective apparel.

Kevlar aramid is lightweight and fatigue- and damage-resistant. It is five times stronger than steel on

Property	m-aramid	p-aramid
Breaking tenacity, dry	4.3–5.1 g/d—filament	21.5 g/d
	3.7-5.3 g/d—staple	
Specific gravity	1.38	1.44
Moisture regain	6.5 percent	3.5-7.0 percent
Effect of heat	Decomposes at 700°F	Decomposes at 900°F
	Very resistant to flame	Very resistant to flame
	Does not melt	Does not melt
	m-aramid	p-aramid
	$\begin{bmatrix} O & O & H & H \\ \parallel & \parallel & \parallel & \parallel \\ -C & -C - N & -C - N \end{bmatrix}_n$	

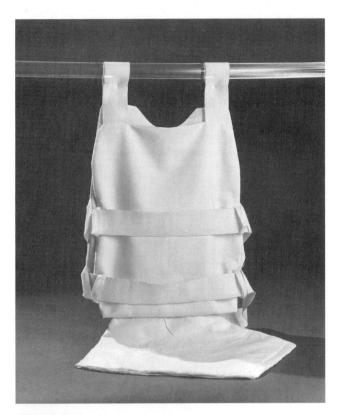

FIGURE 9-6
Body armor made from aramid.

an equal-weight basis and 43 percent lower in density than fiberglass. Kevlar is used primarily in reinforcements of radial tires and other mechanical rubber goods. Kevlar 29 is found in protective apparel, cables, and cordage, and as a replacement for asbestos in brake linings and gaskets. Body-armor undervests of Kevlar 29 are relatively lightweight and bullet- and kniferesistant (Figure 9–6). Kevlar 49 has the highest tenacity of the aramids and is found as a plastic-reinforcement fiber for boat hulls, aircraft, aerospace uses, and other composite uses.

Nomex is used where resistance to heat and combustion with low smoke generation are required. Protective clothing, such as firefighters' apparel and racecar drivers' suits, and flame-retardant furnishings for aircraft are made of Nomex. Nomex Omega by DuPont includes an expanding air layer that helps insulate firefighters from heat. Hot-gas filtration systems and electrical insulation are constructed of Nomex. This heat-resistant fiber is also found in covers for laundry presses and ironing boards.

Composites of aramid fibers intermixed in resins are being investigated for use in civil-engineering structures like bridges and elevated highway-support structures.

Glass

Glass—a manufactured fiber in which the fiberforming substance is glass.

—Federal Trade Commission

Glass is an incombustible textile fiber; it does not burn. This makes it especially suitable for end uses where the danger of fire is a problem—such as in draperies for public buildings. The problems of severe skin irritation from tiny broken fibers have limited the use of glass fibers in apparel.

The process of drawing out glass into hairlike strands dates back to ancient times. It is thought that the Phoenicians produced the first glass fiber. Glass fiber was first used commercially in the 1920s.

The raw materials for glass are sand, silica, and limestone, combined with additives of feldspar and boric acid. These materials are melted in large electric furnaces at 2400°F. For filament yarns, each furnace has holes in the base of the melting chamber. Fine streams of glass flow through the holes and are carried through a hole in the floor to a winder in the room below. The winder revolves faster than the glass comes from the furnace, thus stretching the fibers and reducing them in size before they harden. The round rodlike filaments are shown in Figure 9-7. For staple fibers, the glass flows out in thin streams from holes in the base of the furnace, and jets of high-pressure air or steam break the strands into fibers 8 to 10 inches long. They are collected on a revolving drum in a thin web, which is then formed into a sliver, or soft, untwisted yarn. Several types of glass fibers are produced. Table 9-5 summarizes the types and end uses for these fibers.

Beta Fiberglas, by the Owens Corning Fiberglas Corporation, has one-sixth the denier of common glass

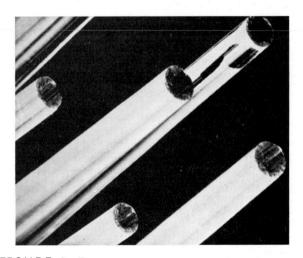

FIGURE 9-7
Photomicrograph of fiberglass. (Courtesy of Owens Corning.)

Type Comments		
Type	Comments	
Α	Alkali-containing glass used in fibers	
AR	Alkali-resistant glass used in reinforcing cement	
C	Chemically resistant glass used in fibers	
E	Almost universally accepted formulation used in many fibers and related products; high electrical resistance; used in glass-reinforced plastics	
HS	Magnesium-aluminum-silica glass; high strength	
S	Similar in composition to HS glass; used in composites	

fibers. The extremely fine filaments are resistant to breaking and are thus more resistant to abrasion. Beta Fiberglas has about half the strength of regular glass fiber, but its tenacity of 8.2 is still greater than that of most fibers. It is used in products like window-treatment fabrics, for which greater fiber flexibility is needed.

Owens Corning produces a bicomponent fiber, Miraflex[®], of two forms of glass fused together into a single filament. As the fiber cools, the components cause the filament to twist in an irregular fashion along its length. The resulting fiber is soft, resilient, flexible, and form filling. It can be carded or needled to make a fiber batt used in home insulation and composites (Figure 9–8).

Glass has a tenacity of 9.6 g/d dry and 6.7 g/d wet. Glass has a low elongation of only 3 to 4 percent but excellent elasticity in this narrow range. Glass fibers are brittle, and break when bent; they exhibit poor flex resistance to abrasion. These fibers are very heavy, with a specific gravity of 2.48 to 2.69. The fibers are nonab-

FIGURE 9-8 Miraflex bicomponent glass fiber. (Courtesy of Owens Corning.)

sorbent and are resistant to sunlight and most chemicals. Glass is flameproof and melts at 2400°F. Trade names include Fiberglas, Beta glass, Chemglass, J-M fiberglass, PPG fiberglass, and Vitron.

Machine washing of glass textiles is not recommended because it causes excessive fiber breakage. Figure 9–9 shows the remnants of a fiberglass laundry bag that was machine-washed. Tiny glass fiber bits in the washing machine will contaminate the next load and irritate the skin of people who use those textiles. Even hand washing may produce severe skin irritation. Care labels should disclose this possibility.

Glass textiles do not require frequent washing, however, because they resist soil; spots and stains can be wiped off with a damp cloth. No ironing is necessary. Items can be smoothed and hung to dry. Oils used in finishing may gray white fabrics, attract dirt and soil, and oxidize with age. Unfortunately, washing does not whiten the material, and dry cleaning is not recommended.

Glass fiber is used in furnishings such as flameretardant draperies. Here the fiber performs best if

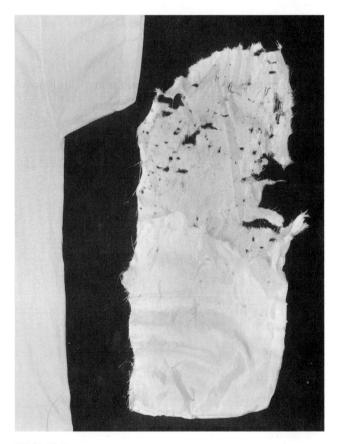

FIGURE 9-9
Glass fiber laundry bag after being washed with regular family wash.

bending and abrasion from drafts, opening/closing the fabric, and abrasion from people and pets is minimized. The weight of the fabrics may require the use of special drapery rods.

Glass fiber has wide industrial use where noise abatement, fire protection, temperature control (insulation), and air purification are needed. Glass is commonly used in insulation for buildings. Care should be exercised when working with glass because it has been identified as a possible carcinogen. Glass is common as a reinforcement fiber in molded plastics in boat, car, and airplane parts. Current research in civil engineering is evaluating glass fibers in resin as a repair material for highways and bridges. In addition, glass is found in ironing-board covers and space suits. Flame-resistant-glass mattress covers are produced for hotels, dormitories, and hospitals. A silica-glass quilt called AFRSI (advanced flexible reusable surface insulation) was used on several space shuttles. Glass is used in geotextiles. Filters, fire blankets, and heat- and electrical-resistant tapes and braids are other industrial products made of glass. A lightweight, durable, water-resistant material in fashion colors is used to support broken bones as they heal. Owens Corning is researching glass yarns suitable for apparel.

Optical fibers are very fine fibers of pure glass that use laser beams, rather than electricity, and thus are free from electrical interference. Optical fibers are found in communication and medical equipment and novelty lamps.

Metal and Metallic Fibers

Metallic—a manufactured fiber composed of metal, plastic-coated metal, metal-coated plastic, or a core completely covered by metal.

-Federal Trade Commission

Gold and silver have been used since ancient times as yarns for fabric decoration. More recently, aluminum yarns, aluminized plastic yarns, and aluminized nylon yarns have replaced gold and silver. **Metallic** filaments can be coated with transparent films to minimize tarnishing. A common film is Lurex polyester. Metal fibers are used to add a decorative touch to apparel and furnishings.

Two processes are used to make these fibers. The *laminating process* seals a layer of aluminum between two layers of acetate or polyester film, which is then cut into strips for yarns (Figure 9–10). The film may be colorless so the aluminum foil shows through, or the film and/or the adhesive may be colored before the laminating process. The *metalizing process* vaporizes the aluminum under high pressure and deposits it on the poly-

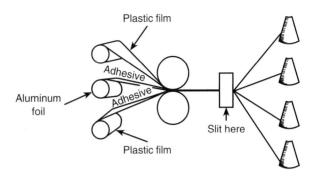

FIGURE 9-10
Laminating layers to produce a metal yarn.

ester film. This process produces thinner, more flexible, more durable, and more comfortable fibers.

Fabric containing a large amount of metal can be embossed. Ironing is a problem when metallic film yarns are used because a high temperature melts the plastic. The best way to remove wrinkles is to set the iron on its end and draw the edge of the fabric across the sole plate of the iron.

Stainless-steel fibers were developed in 1960, and other metal fibers have also been made into fibers and yarns. Stainless steel has had the most extensive development.

The use of stainless steel as a textile fiber was an outgrowth of research for fibers to meet aerospace requirements. Superfine-stainless-steel filaments (3 to 15 micrometers) are a bundle of fine wires (0.002 inch) pickled in nitric acid and drawn to their final diameter. Metal yarns require special treatment to deaden yarn twist; otherwise, the yarns act like tiny coiled springs.

Stainless-steel fibers are produced as both filament and staple. They can be used in complex yarns and can be either woven or knitted. Only 1 to 3 percent of the staple fiber is needed to blend with other fibers to reduce static permanently. The limitation on the use of stainless steel in clothing is its inability to be dyed, although some producers claim that such a small amount will not affect the color of white fabrics. Inox stainless steel is combined with Kevlar aramid and Cordura nylon to produce durable clothing for ski boarding and mountain climbing.

Static is one of the annoying problems associated with carpets in terms of comfort and soiling. Stainless steel is used in some carpets to reduce static. Brunsmet, a stainless-steel fiber from 2 to 3 inches long, can be mixed throughout any kind of spun yarn to make the yarn a good conductor. Only one or two fibers per tuft will carry the static from the face fiber to the backing. This kind of carpet yarn is used where static is a special

problem, such as in rooms where sensitive computer equipment is kept. It is also suitable for upholstery, blankets, and work clothing. Stainless-steel fibers are used for tire cord, wiring, and missile nose cones and in corrective heart surgery.

Metal fibers of stainless steel, copper, and aluminum are blended with other fibers to produce static-free clothing worn in clean rooms in computer-production facilities and in other places where static creates nuisance or hazardous conditions. Metals are much heavier than the organic materials that compose most fibers—the specific gravity of metal fibers is 7.88 g/cc, as compared with 1.14 g/cc for nylon. They cannot bend without leaving permanent crease lines, are stiff or too springy, and do not have the hand associated with textiles. Reduction in the denier of the fiber improves its properties, but the finer fibers are more expensive. Metal fibers are used in industrial products like wiring and cables (Figure 9–11). Metallic fibers are also used in cut-resistant gloves for butchers and meat cutters.

Novoloid

Novoloid—a manufactured fiber in which the fiber-forming substance contains at least 35 percent by weight of cross-linked novolac (a cross-linked phenolformaldehyde polymer).

—Federal Trade Commission

First commercially produced in 1972, **novoloid** showed outstanding flame resistance to a blaze of 2500°C from an oxyacetylene torch. Rather than melt, burn, or fuse, the yarns carbonized.

Novoloid has an elasticity of 35 percent. It has good resistance to sunlight and is inert to acids and organic solvents but susceptible to highly alkaline substances. Novoloid has a tenacity of 1.5 to 2.5 g/d, a specific gravity of 1.27 g/cc, and a regain of 6.0 percent. Produced in Japan, it is used for protective clothing and fabrics, chemical filters, gaskets, and packing materials. Fierce competition from other specialty fibers is shrinking its market.

PBI

PBI is a manufactured fiber in which the fiberforming substance is a long-chain aromatic polymer having recurring imidazole groups as an integral part of the polymer chain.

—Federal Trade Commission

PBI is a condensation polymer that is dry-spun. Its specific gravity is 1.39; if the fiber has been stabilized, the specific gravity is 1.43. PBI has a tenacity of 2.6 to 3.1 g/d and a breaking elongation of 30 percent. PBI has a high moisture regain of 15 percent, but it is difficult to dye. It is usually mass-pigmented. PBI does not burn or melt and has very low shrinkage when exposed to flame. Even when charred, PBI fabrics remain supple and intact. Because of its heat resistance, it is ideal for use in heat-resistant apparel for firefighters, astronauts, fuel handlers, race-car drivers, welders, foundry workers, and hospital workers (Figure 9–12). PBI is used extensively in space and aerospace applications. The fiber is found in upholstery, window-treatment fabrics, and carpets for aircraft, hospitals, and submarines. PBI is also used as a

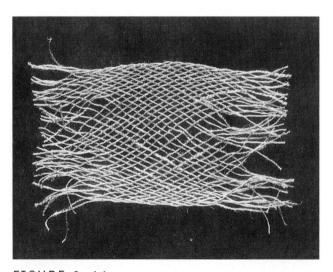

FIGURE 9-11
Copper braid used in wiring.

FIGURE 9-12
Heat resistant glove made from PBI.

flue-gas filter in coal-fired boilers and in reverse-osmosis membranes.

Sulfar

Sulfar is a manufactured fiber in which the fiberforming substance is a long-chain synthetic polysulfide in which at least 85 percent of the sulfide (–S–) linkages are attached directly to two aromatic rings. —Federal Trade Commission

Sulfar is produced by melt spinning. It is gold in color. Sulfar has a tenacity of 3.0 to 3.5 g/d and a breaking elongation of 25 to 35 percent. It has excellent elasticity. Moisture regain is low (0.6 percent), and specific gravity is 1.37. Sulfar is highly resistant to acids and alkalis and is not soluble in any known solvent below 200°C (392°F). Sulfar is used in filtration fabrics, papermaking felts, electrolysis membranes, high-performance membranes, rubber reinforcement, electrical insulation, firefighting suits, and other protective clothing. Sulfar helps maintain a clean environment because of its use in incinerator filters in plants that generate electricity by burning garbage.

Saran

Saran—a manufactured fiber in which the fiber-forming substance is any long-chain synthetic polymer composed of at least 80 percent by weight of vinylidene chloride units (CH₂CCl₂).

—Federal Trade Commission

Saran is a vinylidene-chloride/vinyl-chloride copolymer developed in 1940. The raw material is melt spun and stretched to orient the molecules. Both filament and staple forms are produced. Much of the filament fiber is produced as a monofilament for seat covers, furniture webbing, and screenings. Monofilaments may also be used in dolls' hair and wigs. The staple form is made straight, curled, or crimped. The curled form is unique in that the curl is inherent and closely resembles the curl of natural wool.

Saran has good weathering properties, chemical resistance, and stretch resistance. It is an unusually tough, durable fiber. Saran has a tenacity of 1.4 to 2.4 g/d, with no change when wet, an elongation of 15 to 30 percent with excellent recovery, and good resiliency. It is an off-white fiber with a slight yellowish tint.

Like the other melt-spun fibers, saran is perfectly round and smooth. It has a moisture regain of less than 0.1 percent. Saran absorbs little or no moisture, so it dries rapidly. It is difficult to dye; for this reason, mass pigmentation is used. Saran also has no static charge. It is heavy, with a specific gravity of 1.7. Saran does not

support combustion. When exposed to flame it softens, then chars, and decomposes at 115°C (240°F). It has excellent size and shape retention and is resistant to acids, alkalis, and organic solvents. Exposure to sunlight causes light-colored objects to darken, but no strength loss occurs. Saran is immune to biological attack.

Saran fiber is being replaced by other fibers that cost less or that have a better combination of properties for specific end uses. Saran is used as an agricultural protective fabric to shade delicate plants such as tobacco and ginseng and is used in rugs, draperies, and upholstery. Saran is more widely used in films and plastics.

Vinyon

Vinyon—a manufactured fiber in which the fiberforming substance is any long-chain synthetic polymer composed of at least 85 percent by weight of vinyl chloride units (-CH₂CHCl-).

—Federal Trade Commission

Commercial production of **vinyon** was begun in 1939. It is a copolymer of 86 percent vinyl chloride and 14 percent vinyl acetate. The raw material is dissolved in acetone and dry-spun.

Vinyon is white and somewhat translucent, with an irregular-, round-, dog-bone-, or dumbbell-shaped cross section. Vinyon is very sensitive to heat. It softens at 150 to 170°F, shrinks at 175°F, and should not be pressed or ironed. It is unaffected by moisture, chemically stable, resistant to insects and biological attack, a poor conductor of electricity, and flame-retardant. These properties make vinyon especially good as a bonding agent for rugs, papers, and nonwoven fabrics. The amorphous undrawn fibers have a tenacity of 0.7 to 1.0 g/d. These fibers have a warm, pleasant hand. Elongation ranges from 12 to 125 percent. Specific gravity ranges from 1.33 to 1.43. Moisture regain is 0.1 percent.

Imported vinyon is used for wigs, flame-retardant Christmas trees, filter pads, fishing lines and nets, and protective clothing. Some trade names of vinyon are Leavil, Teviron, and Viclon.

Vinal

Vinal—a manufactured fiber in which the fiber-forming substance is any long-chain synthetic polymer composed of at least 50 percent by weight of vinyl alcohol units (–CH₂CHOH–) and in which the total of the vinyl alcohol units and any one or more of the various acetal units is at least 85 percent by weight of the fiber.

—Federal Trade Commission

No vinal fibers are produced in the United States. Modified **vinal** fibers are imported for use in some protective clothing because of their inherent flame-retardant properties. Vinal is made in Japan and Germany under the trade names of Kuralon, Mewlon, Solvron, Vilon, Vinol, and Vinylal.

When vinal fibers are extruded, they are water-soluble and must be cross linked with formaldehyde to make them non-water-soluble. The fiber has a smooth, slightly grainy appearance with a U-shaped cross section. Vinal has a tenacity of 3.5 to 6.5 g/d, an elongation of 15 to 30 percent, and is 25 percent weaker when wet. The specific gravity of vinal is 1.26. It has a moisture regain of 5.0 percent. It does not support combustion, but softens at 200°C (390°F) and melts at 220°C (425°F). It has good chemical resistance and is unaffected by alkalis and common solvents. Concentrated acids harm the fiber. Vinal has excellent resistance to biological attack. Mass pigmentation is used to color the fiber.

In other countries, vinal is used in protective apparel. Major uses in the United States are industrial: fishing nets, filter fabrics, tarpaulins, and brush bristles. In water-soluble forms, the fiber is used as a ground fabric to create laces and other sheer fabrics. Once the fabric has been produced, the vinal ground is dissolved and the sheer fabric remains.

Vinal is used in film form, often labeled vinyl. It is used for rainwear, umbrellas, clear table coverings and upholstery protectors in showrooms.

Fluoropolymer

Fluoropolymer is a manufactured fiber containing at least 95 percent of a long chain polymer synthesized from aliphatic fluorocarbon monomers.

—Federal Trade Commission

Polytetrafluoroethylene (PTFE) is the most common fluoropolymer. It is used as a coating for cookware, as a soil-resistant finish, and as a fiber with the trade name Teflon.

The monomer is polymerized under pressure and heat in the presence of a catalyst to achieve the following repeat unit (-CF₂-CF₂-). **Emulsion spinning,** in which polymerization and extrusion occur simultaneously, is used (Figure 9–13). It has a tenacity of 1.6 g/d, with low elongation and good pliability. The fiber is heavy, with a specific gravity of 2.3, and it has unusually high resistance to heat and chemicals. It can withstand temperatures up to 260°C (500°F) without damage. It is resistant to sunlight, weathering, and aging. It also has an exceptionally low coefficient of friction and high re-

Emulsion Spinning.

- 1. Polymer is dispersed as fine particles in a carrier.
- Dispersed polymer is extruded through a spinneret and coalesced by heating.
- 3. Carrier is removed by heating or dissolving.

Expensive
Used only for those fibers that
are insoluble
Carrier required

FIGURE 9-13 Emulsion spinning.

sistance to deformation. It is tan in color, but can be bleached white with sulfuric acid.

Gore-Tex is a trade name for fabrics that have a thin microporous film of PTFE applied to a fabric for use in outerwear. It is wind and liquid-water-resistant, but water-vapor-permeable. Gore-Tex can be dry-cleaned but needs to be rinsed well to prevent impairment of the film's functions. BlisterGuard is a sock made of cotton, wool, acrylic, nylon, or polyester with fluoropolymer in the heel, pad, and toe areas to reduce friction between the foot and the shoe. Teflon by DuPont is used in HazMat protective clothing. PTFE is used industrially in filter fabrics (to reduce smokestack emissions), packing fabrics, gaskets, industrial felts, covers for presses in commercial laundries, electrical tape, and as a layer of some protective fabrics.

FIGURE 9-14Tennis racket with carbon fiber (graphite) reinforcement.

Carbon

Carbon is a fiber that is at least 96 percent pure carbon. It is made from precursor fibers such as rayon and polyacrylonitrile or from petroleum pitch. These fibers are heated to remove oxygen, nitrogen, and hydrogen. The fiber has exceptional heat resistance and does not ignite or melt. It maintains its full strength of 1.5 g/d after prolonged exposure to temperatures of more than 200°C. Carbon has a density of 1.4, a moisture regain

of 10 percent, and an elongation of 10 percent. Carbon fibers have very low coefficients of thermal expansion, are chemically inert, and biocompatible. They also dissipate static quickly. Because of these properties and its comfortable hand, carbon is used in protective clothing, to reinforce lightweight metal components in golf clubs and bicycle bodies, in aerospace uses, in bone grafts, and as a substitute for asbestos in industrial products (Figure 9–14). Civil engineers are evaluating carbon fibers in resins for use in repairing bridge and highway support

Fiber	Tenacity, g/d	Elongation, % dry	Elasticity, %	Regain, %	Specific Gravity (g/cc)	Heat/Chemical Resistance
P-Aramid	21.5	4.0	100	3.5–7.0	1.44	Difficult to ignite, does not melt, decomposes at 900°F, resistant to dilute acids and bases, degraded by strong mineral acids, excellent solvent resistance
Glass	9.6	3.1	100	0	2.48–2.69	Does not burn, softens at +1350°F, resists most acids and alkalis, unaffected by solvents
PBI	2.6–3.0	25–30	_	15	1.43	Does not ignite or melt chars at 860°F, unaffected by most acids, alkalis, and solvents
Sulfar	3.0-3.5	35–45	100	0.6	1.37	Outstanding heat resistance, melts at 545°F, outstanding resistance to most acids, alkalis, and solvents
Fluoro- polymer	0.9–2.0	19–140	_	0	2.1	Extremely heat- resistant, melts at +550°F, most chemically resistant fiber known
Carbon	15.9	0.7	100	_	1.75-2.2	Does not melt, excellen resistance to hot, concentrated acids and alkalis, unaffected by solvents, degraded by strong oxidizers (chlorine bleach)

columns. It also is used as a coating of nylon for antistatic carpeting, upholstery, apparel, and industrial brushes and belts. It is used in radar-transparent military aircraft communication satellites and rocket-motor nozzles.

Table 9-6 compares selected properties of aramid, glass, PBI, sulfar, PTFE, and carbon.

Melamine

Melamine is a manufactured fiber in which the fiber-forming substance is a synthetic polymer composed of at least 50 percent by weight of a cross-linked melamine polymer.

—Federal Trade Commission

Melamine is produced by BASF as Basofil. It has a dry tenacity of 1.8 g/d, a 12 percent breaking elongation, 5 percent regain, a specific gravity of 1.4, fair abrasion resistance, and good to excellent resistance to ultraviolet light and chemicals except concentrated acids. **Melamine** is known for its heat stability, low flammability, and resistance to solvents. Its cost is moderate. It is used in products that require resistance to high temperatures and competes with meta-aramid, PBI, sulfar, and polyimide for a market share at a lower cost. Melamine is available in white and dyeable forms.

Other Special-Use Fibers

Polyimide (PI or PEI) from polyetherimide has a dry tenacity of 3.7 g/d, a 20 percent breaking elongation, 3 percent regain, a specific gravity of 1.41, good abrasion resistance, excellent resistance to heat, and good to excellent resistance to chemicals except alkalis. It is moderately high in cost. Because of its properties and its irregular cross section, it is used in filters for hot air or gas and corrosive liquids and in gaskets and seals, protective clothing, and fire-block seating (a layer between the upholstery and the padding to minimize flame spread).

PBO (polyphenylene benzobisoxazole) is another high-temperature-resistant nonflammable polymer fiber based on repeating aromatic rings. It has a density of 1.5, a regain of 2 percent, and a breaking elongation of 3.5 percent. It has very good tensile strength and is used primarily as a reinforcing fiber in resins and for protective clothing.

Ceramic fibers are composed of metal oxide, metal carbide, metal nitride, or other mixtures. The fibers were developed because aerospace, metallurgical, nuclear, and chemical industries required fibers with better thermal resistance than glass fibers could give. These fibers are used where high strength, high thermal structural stability, and stiffness are required.

Key Terms

Elastomer Power stretch Comfort stretch Rubber Lastrile PBI Sulfar Saran Vinyon Vinal

NeopreneFluoropolymerSpandexEmulsion spinningGrin-throughGore-TexElastoesterCarbonAramidMelamine

Glass Polyimide
Metallic fibers PBO
Stainless steel Ceramic

Novoloid

Questions

- 1. Compare the performance characteristics of rubber and spandex.
- 2. What are the differences and similarities between power and comfort stretch?

- **3.** Explain why glass and metal are included as textile fibers.
- **4.** Identify a fiber from this chapter that would be an appropriate choice for each end use listed below, and explain why that fiber was selected. (Some of these fibers may actually be used in blend form in the product.)

insulation for electrical wiring support hosiery theater costume for a performance of King Lear apron for welder firefighting suit particle filter for smokestack

support fiber in resin for auto-body repair

Suggested Readings

Anonymous (1995, April). Glass fibre makers go for target markets. *Technical Textiles International*, pp. 18–20. Butler, N. (1995, March). Specialty fibres to continue to flourish. *Technical Textiles International*, pp. 12–15.

Coffee, D. R., Serad, G. A., Hicks, H. L., and Montgomery, R. T. (1982). Properties and Applications of Celanese PBI-Polybenzimidazole Fiber. *Textile Research Journal*, 52, pp. 466–472.

- Federal Register, 63, (127). (July 2, 1998). 16 CFR Part 303, Rules and Regulations, pp. 36171–36174.
- Grayson, M., ed. (1984). Encyclopedia of Textiles, Fibers, and Nonwoven Fabrics. New York: Wiley.
- Kirschner, E. N. (1997, July 28). Carbon fiber market revs up. *Chemical and Engineering News*, pp. 23–24.
- Mukhopadhyay, S. K. (1993). High-performance fibres. *Textiles Progress*, 25 (3/4), pp. 1–71.
- Reisfeld, A. (1997, September). The expanding world of high

- tech textile products. American Sportswear and Knitting Times, pp. 36–39.
- Rozelle, W. N. (1997, January). Spandex: miracle fiber now coming into its own. *Textile World*, pp. 80, 82, 84–87.
- Smith, W. C. (1995, April). Hi-temperature fibers gain in performance, market. *Textile World*, pp. 31–32, 37–38.
- Trotman, E. R. (1984). Dyeing and chemical technology of textile fibers, 6th ed. New York: Wiley.

Section 3

YARNS

CHAPTER 10

Yarn Processing

CHAPTER 11

Yarn Classification

Chapter 10

YARN PROCESSING

OBJECTIVES

- To understand the processes used to produce yarns from filament and staple fibers.
- To recognize the different types and qualities of yarns.
- To relate yarn type to end-use performance.
- To relate yarn properties to processing method.
- To integrate fiber properties with yarn properties.
- To understand why fibers are blended and their effects on product performance.

ost apparel and furnishing fabrics are produced from yarns. A yarn is a continuous strand of textile fibers, filaments, or materials in a form suitable for knitting, weaving, or otherwise intertwining to form a textile fabric (American Society for Testing and Materials [ASTM]). This chapter explores the process of making a yarn from fibers or other starting materials. For filament yarns, this is a relatively quick and easy process. Spun yarns undergo a series of operations to make the fibers parallel and cohesive.

Yarn processing attracts a great deal of industry attention, but not much consumer interest. However, yarn type and quality have a significant impact on product cost, quality, and performance. Thus, a general understanding of the making of yarn will help in understanding products made from yarns.

Many changes continue to occur in the ways yarns are made. Efforts focus on improving productivity, decreasing costs, increasing uniformity and quality, solving problems, and developing new systems or approaches to deal with changes in other segments of the industry. For example, yarn-processing systems are modified for microfibers and yarn characteristics are modified to cope with the greater speeds of fabrication equipment. In fact, yarns often limit fabric-production rates. Computer systems monitor yarn production and quality of yarns.

Filament Yarns

Filament yarns are made from manufactured fibers, except for the tiny percentage that is filament silk. Manufactured filament yarns are made by extruding a polymer solution through a spinneret and solidifying it in fiber form. Then the individual filaments are brought together with or without a slight twist (see Figure 8–3). The grouping of the filaments with the addition of twist creates the filament yarn. The spinning machine winds the yarn on a bobbin. The yarn is then rewound on spools or cones and is a finished product, unless additional treatments such as crimping, twisting, texturing, or finishing are required.

Throwing, originally a process for twisting silk filaments, evolved into the twisting of manufactured fibers and then into texturing. Throwing provides the fabricator with the specific yarn needed for a particular product. Some fiber producers texture yarns as a final step in the fiber-spinning process; occasionally a trade name is associated with a textured filament yarn.

Smooth-Filament Yarn

Filament yarns are more expensive per pound than staple fibers; however, the cost of making tow into staple and then mechanically spinning it into yarn usually equalizes the final cost. The number of holes in the spinneret determines the number of filaments in the yarn.

Regular-, conventional-, or **smooth-filament yarns** are uniform as they come from the spinneret. Their smooth nature gives them more luster than spun yarns, but the luster varies with the amount of delusterant used in the fiber and the amount of twist in the yarn. Maximum luster is obtained by the use of bright filaments with little or no twist. Very-high-twist yarns, like crepe yarns, reduce filament luster. With thermoplastic fibers, the twist can be heat-set. Filament yarns generally have either high twist or low twist.

Filament yarns have no protruding ends, so they do not lint; they resist pilling; and fabrics made from them shed soil. Filaments of round cross section pack well into compact yarns that give little bulk, loft, or cover to fabric. Compactness is a disadvantage in end uses in which bulk and absorbency are necessary for comfort. Nonround filaments create more open space for air and moisture permeability and produce greater cover. Compact yarns are used in wind- and water-resistant fabrics.

The strength of a filament yarn depends on the strength of the individual fibers and on the number of filaments in the yarn. The strength of filament fibers is usually greater than that of staple fibers. For example, with polyester, staple strength is 3 to 5.5 g/d (grams per denier); filament strength is 5 to 8 g/d.

The strength of each filament is fully utilized. In order to break the yarn, all the filaments must be broken. Fine filaments make very sheer strong fabrics possible. Filament yarns reach their maximum strength at a low twist—3 to 6 turns per inch—then strength remains constant or decreases.

Fine-filament yarns are soft and supple, but not as abrasion-resistant as coarse filaments. For durability, it is desirable to have fewer but coarser filaments in the yarn.

Monofilament Yarns

Monofilament yarns are primarily for industrial uses. These yarns are made of a single coarse-filament fiber. End uses include sewing thread, fishing line, fruit and vegetable bags, nets, and other woven or knitted fabrics for which low cost and high durability are the most important characteristics.

Tape and Network Yarns

Tape yarns are inexpensive yarns produced from extruded polymer films (Figure 10–1). *Extrusion* is the standard method of spinning fibers and some films. The *split-fiber method* is less expensive than the traditional

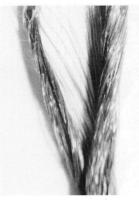

FIGURE 10-1
Yarns used in industrial products: tape (left) and network (right).

fiber extrusion process and requires a minimal investment in equipment. Although some fiber polymers cannot be processed by the split-fiber method, polypropylene is often processed in this way because it is easy and inexpensive and produces strong yarns. Tape yarns are ribbonlike in appearance but can take on the more rounded appearance of traditional yarns.

Pellets of polypropylene with appropriate additives are melted and then extruded as a film 0.005 to 0.020 inch thick onto a chilled roll or cooled quickly by quenching in water. The film is slit into tapes approximately 0.1 inch wide and heat-stretched to orient the molecular chains. The stretching can be carried to a point at which the film fibrillates (splits into fibers), or the film is passed over needles to slit it. Twisting or other mechanical action completes the fibrillation.

Yarns as low as 250 denier have been made from split fibers. Tape yarns are coarse and usually used in carpet backing, rope, cord, fishnets, bagging, and furnishing support fabrics for which ribbonlike yarn is needed.

Olefin films are slit into yarns that are used for the same textile products as split-fiber olefin. Slit-film-tape yarns are much more regular and may be thicker than fibrillated film-tape yarns. Tape yarns are slightly more expensive and their production is slower.

Network yarns are made of fibers that are connected in a network arrangement. They have a ribbonlike characteristic similar to tape yarns, but are bulkier and less dense. These yarns are produced by incorporating air into the polymer to create a foam. When the foam is extruded and stretched, tiny air cells rupture, forming an interconnected fibrous web. Although their strength is not as great as that of multifilament, monofilament, or tape yarns, these network yarns have interesting bulk and comfort characteristics. Uses include industrial prod-

ucts in which bulk and low density are more important than high strength. See Figure 10–1.

Bulk Yarns

A **bulk yarn** is one that has been processed to have greater covering power or apparent volume than that of a conventional yarn of equal linear density and of the same basic material with normal twist (ASTM). Often these bulk yarns are referred to as **bulk-continuous-filament yarns** (**BCF**). BCF yarns include any continuous-filament yarn whose smooth, straight fibers have been displaced from their closely packed, parallel position by the introduction of some form of crimp, curl, loop, or coil (Figure 10–2).

The characteristics of bulk yarns are quite different from those of smooth-filament yarns. Bulking gives filaments the aesthetic properties of spun yarns by altering the surface characteristics and creating space between the fibers. Fabrics are more absorbent, more permeable to moisture, more breathable, and more comfortable, and they have better bulk, cover, and elasticity. Static buildup is lower. Bulk yarns do not pill or shed.

There are three classes of bulk yarns: bulky yarns, stretch yarns, and textured yarns. They will be discussed after the texturing processes are described.

Texturing Filament Yarns The texturing processes discussed here are primarily mechanical methods used with thermoplastic fibers. Heat and chemical methods are used to achieve texture with bicomponent fibers.

False-Twist Process The false-twist spindle whirls at 600,000 revolutions per minute and generates such an intense sound that its effect on health and hearing is an industry concern. In the continuous process, the yarn is twisted, heat-set, and untwisted as it travels through the spindle (Figure 10–3). The filaments form a distorted

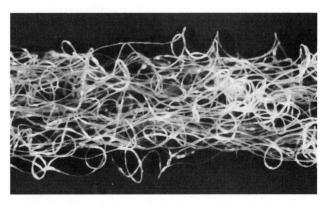

FIGURE 10-2
Typical bulk yarn. (Courtesy of Solutia Inc.)

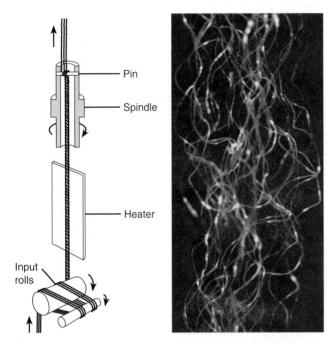

FIGURE 10-3

False-twist process (left); yarn (right). (Courtesy of Solutia Inc.)

Draw-Texturing In *draw-texturing*, unoriented filaments or partially oriented filaments are fed through the double-heater false-twist spinner, then stretched slightly, and heat-set. Draw-texturing is a much faster and cheaper way of making textured bulk yarns.

Stuffer Box The stuffer box produces a sawtooth crimp of considerable bulk. Straight-filament yarns are literally stuffed into one end of a heated box (Figure 10–4) and then withdrawn at the other end in crimped form. The volume increase is 200 to 300 percent, with some elasticity. The stuffer box is a fast, inexpensive, and popular method for carpeting yarns.

Air Jet Conventional filament yarns are fed over an air jet (Figure 10–5) at a faster rate than they are drawn off. The blast of air forces some of the filaments into very tiny loops; the velocity of the air affects the size of the loops. This is a slow, relatively costly, but versatile process. Volume increases with little or no stretch. Airjet yarns maintain their size and bulk under tension because the straight areas bear the strain and the loops remain relatively unaffected.

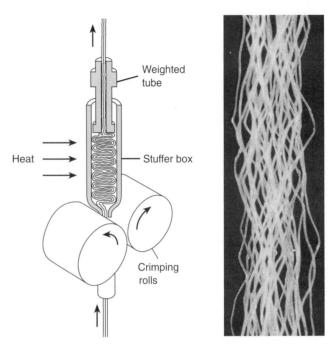

FIGURE 10-4

Stuffer-box process (left); bulky yarn used in apparel (right). (Courtesy of Solutia Inc.)

Knit-Deknit In the knit-deknit process a small-diameter tube is knit, heat-set, unraveled, and wound on cones (Figure 10–6). Crimp can be varied by changing stitch size and tension. The gauge used to make the fabric must differ from that used in texturing the yarn, or pinholes will form when the texturing gauge and knit gauge match.

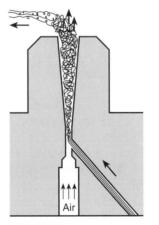

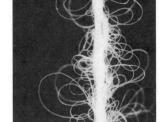

FIGURE 10-5

Air-jet process (left); bulky yarn (right). (Courtesy of Solutia Inc.)

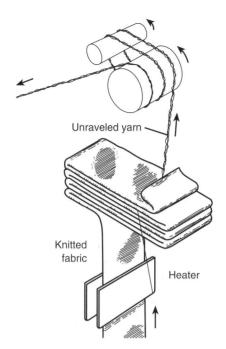

FIGURE 10-6
Knit-deknit fabric is heat-set, then unraveled.

Bulk Yarn Types

Bulky Yarns Bulky yarns are formed from inherently bulky manufactured fibers, that are hollow along part or all of their length or from fibers that cannot be closely packed because of their cross-sectional shape, fiber alignment, stiffness, resilience, or natural crimp (ASTM).

Bulky texturing processes can be used with any kind of filament fiber or spun yarn. The yarns have less stretch than either stretch or textured yarns. Bulky yarns are used in a wide array of products from carpeting to lingerie and sweaters to shoelaces.

Stretch Yarns Stretch yarns are thermoplastic filament or spun yarns with a high degree of potential elastic stretch (300 to 500 percent), rapid recovery, and a high degree of yarn curl (ASTM). Stretch yarns have moderate bulk. Stretch yarns of nylon are used extensively in men's and women's hosiery, pantyhose, leotards, swimwear, leggings, football pants, and jerseys. Stretch yarns make it possible to manufacture fewer sizes so that one-size items fit wearers of different sizes. Stretch yarns are not the same as yarns made with elastomeric fibers.

Textured Yarns Textured or bulked yarns are filament or spun yarns with notably greater apparent volume than a conventional yarn of similar filament count and linear density (ASTM). These yarns have much lower elastic stretch than stretch yarns, but greater stretch than bulky yarns. They are stable enough to present no unusual problems in subsequent processing or in consumer use. Fabrics made from these yarns maintain their original size and shape during wear and care.

Table 10–1 summarizes the three major types of bulk filament yarns.

Spun Yarns

Spun yarns are continuous strands of staple fibers held together by some mechanism. Often the mechanism is mechanical twist that uses fiber irregularities and natural cohesiveness to bind the fibers together into one yarn. The process of producing yarns from staple fibers by twisting is an old one. Methods of producing spun yarns without twist have been developed.

Spun yarns have protruding fiber ends that prevent close contact with the skin. A fabric made of spun yarn is more comfortable next to the skin than a fabric of smooth-filament yarn.

TABLE 10-1	Comparison of bulk yarns.		
Characteristic	Bulky Yarns	Stretch Yarns	Textured Yarns
Nature	Inherently bulky	High degree of yarn curl	High degree of bulk
Fiber type	May be hollow or crimped fibers	Any thermoplastic fiber	Any fiber that develops crimp with moisture, heat, or chemical treatmen
Stretch	Little stretch	300-500% stretch	Moderate amount of stretch
Characteristics	Sawtooth, loops in individual fibers	Torque and nontorque	Loopy, high bulk, crimped
Processes	Stuffer box, air jet, draw- texturing, friction texturing	False-twist, knit-deknit, draw-texturing, friction texturing	Air jet, flat-drawn textured, draw- texturing, friction texturing

Many of the insulating characteristics of a fabric are due to the structure of the yarns used in that fabric. There is more space between fibers in a spun yarn than in a filament yarn. A spun yarn with low twist has more air spaces than a spun yarn with a high twist and is better at insulating than a highly twisted yarn. For that reason, most fabrics designed for warmth have lower-twist yarns. If wind resistance is desired, fabrics with high-twist compact yarns and a high count are more desirable because air permeability is reduced.

Carded yarns of short-staple fibers have more protruding fiber ends than combed yarns, which are made of long-staple fibers. Protruding ends contribute to greater comfort and warmth, dull luster, fuzzy appearance, the shedding of lint and the formation of surface pills. Fuzzy fiber ends can be removed from the surface of the fabric by singeing (see Chapter 16).

The strength of the individual staple fiber is less important in the strength of spun yarn than it is in filament yarns. The strength of spun yarn depends on the cohesiveness or clinging power of the fibers and on the points of contact resulting from twist or other binding mechanisms used to produce the spun yarn. The greater the number of points of contact, the greater the resistance to fiber slippage within the yarn. Fibers with crimp or convolutions have a greater number of points of contact. The friction of one fiber against another also gives resistance to lengthwise fiber slippage. A fiber with a rough or irregular surface—wool scales, for example—creates more friction than a smooth fiber.

The mechanical spinning of staple fibers into yarns is one of the oldest manufacturing arts and has been described as an invention as significant as that of the wheel. The basic principles of spinning are the same now as they were when yarns were first made.

Primitive spinning consisted of drawing out fibers held on a stick called a distaff, twisting them by the rotation of a spindle that could be spun like a top, and winding up the spun yarn (Figure 10–7). The spinning wheel was invented in India and was introduced to Europe in the 14th century. The factory system began in the 18th century, when James Hargreaves invented the spinning jenny that turns more than one spinning wheel at a time. Other inventions for improving the spinning process followed and led to the Industrial Revolution, when power machines took over hand processes and made mass production possible. Machines were developed for each separate step in the spinning process.

Spinning continues to evolve. Progress has been made in reducing the number of steps, in automating the process, improving yarn quality, and making it faster, simpler, and more economical with higher production speeds and more user-friendly computerization. Spunyarn processes are shown in Table 10–2.

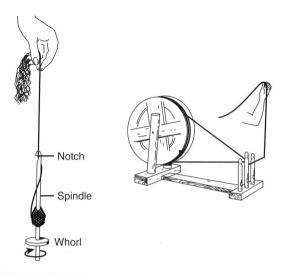

FIGURE 10-7
Hand-spinning (left); early spinning wheel (right).

Processing Staple Fibers

Ring or Conventional Spinning Ring or conventional spinning consists of a series of operations designed to (1) clean and make parallel staple fibers, (2) draw them out into a fine strand, and (3) twist them to keep them together and give them strength. Ring spinning remains the standard by which spun yarns are judged. Even with continuous spinning, higher speeds, and automation, spinning remains a long and expensive process. Ring-spun yarns are finer, have better quality, are more uniform, and create fewer problems in fabrication. Ring spinning is more automated and more versatile than alternate spinning systems. Approximately half of the spun yarns are processed by this system.

Spinning may be done by any one of five conventional systems (cotton, woolen, French, Bradford, and American), which are adapted to fiber characteristics—length, cohesiveness, diameter, elasticity, and surface contour. Because the cotton system is representative of

TABLE 10-2	Spun-yarn processes.
From Staple Fiber	From Filament Tow
Conventional ring	Tow-to-top
Direct	Tow-to-yarn
Open-end	High-bulk yarns
Friction	
Twistless	
Self-twist	

TABLE 10-3	The cotton system.
Operation	Purpose
Opening	Loosens the bale, blends and cleans fibers, forms lap.
Carding	Cleans and aligns fibers, forms carded sliver.
Drawing	Parallels and blends fibers, forms drawn sliver.
Combing	Parallels and removes short fibers, forms combed sliver (used for long-staple cotton only).
Roving	Reduces size, inserts slight twist, forms roving.
Spinning	Reduces size, twists, winds the finished yarn on a bobbin.
Winding	Rewinds yarn from bobbins to spools or cones.

the rest, it is discussed here in detail. Table 10–3 summarizes the steps in producing a spun yarn.

Opening Machine-picked cotton contains a high percentage of trash and dirt. The fibers have been compressed very tightly in a bale and may have been stored in this state for a year or more. Opening loosens, cleans, and blends the fibers. Cotton varies from bale to bale, so blending the fibers from several bales achieves more-uniform quality in the finished yarn. Manufacturers must produce yarns with consistent characteristics and performance so that basic fabrics do not differ by season or year.

Bale pluckers (Figure 10–8) pull small tufts of fiber from the bales and drop the tufts onto a screen or lattice. High-velocity air removes dirt and trash. The loosened, cleaned fibers are fed to the carding machine in sheet form.

Material removed from the bale of fiber in the opening step includes very short fibers, soil, plant debris, and other foreign matter. This waste may be discarded or purchased and recycled into yarns and other textile products such as fiber batts.

There are several possibilities for blending fibers in the opening operation. In one method, several bales of fiber are laid around the picker and fibers from each bale are fed alternately into the machine. Another method is called *sandwich blending*, in which the desired amounts of each fiber are weighed out and a layer of each is spread over the preceding layer to build up a sandwich composed of many layers. Vertical sections of the sandwich are fed into the picker. *Feeder blending* is an automatic process in which each type of fiber is fed to a mixing apron from individual hoppers (Figure 10–9).

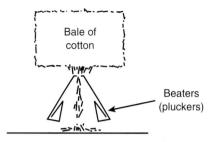

FIGURE 10-8
Beaters (pluckers) pull fibers from the bale.

Carding Carding partially aligns the fibers and forms them into a thin web that is brought together as a soft, very weak rope of fibers called a *carded sliver* (Figure 10–10). A sliver is a rope-like strand of fibers. The carding machine consists of revolving cylinders covered with heavy fabric embedded with specially bent wires or with granular cards that are covered with a rough surface similar to rough sandpaper.

Drawing Drawing increases the parallelism of the fibers and combines several carded slivers into one *drawn sliver*. This is a blending operation that contributes to greater yarn uniformity. Drawing is done by sets of rollers, each set running successively faster than the preceding set (Figure 10–11). As slivers are combined, their size is reduced and a small amount of twist is added.

The drawing step is repeated more than once. At this stage, fibers of different generic types often are combined into a blended drawn sliver. Because each fiber differs in its physical properties, conditions for the carding and initial drawing steps differ for each fiber in a blend. Blending during the drawing process also eliminates mixed wastes.

Combing If long-staple fibers are to be spun, another step is added to the process. **Combing** produces a yarn that is superior to a carded yarn in smoothness, fineness, evenness, and strength. Combing aligns fibers in a par-

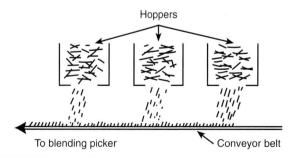

FIGURE 10-9

Fibers from various hoppers are blended on a conveyor belt.

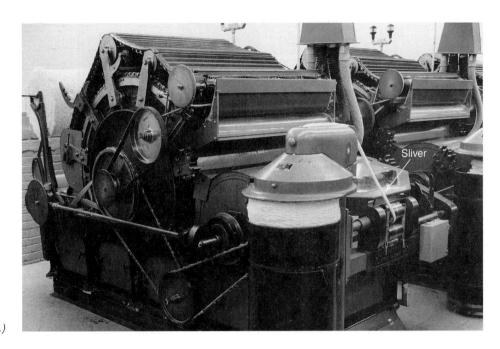

FIGURE 10-10

Carding. (Courtesy of Coats & Clark, Inc.)

allel arrangement. It also removes short fibers so that the fibers in the *combed sliver* will be more uniform in length. The combing operation and the long-staple fiber are costly. As much as one-fourth of the fiber is combed out as waste and reprocessed into short-staple carded yarns. When working with cotton or cotton blends, the term **combed yarn** is used. When working with wool or wool blends, the term **worsted yarn** is used. Yarns that have not received this process are **carded yarns** (cotton and cotton blends) or **woolen yarns** (wool or wool blends).

Roving The roving step reduces the drawn sliver, increases the parallel alignment of the fibers, and inserts a small amount of twist in the strand, now called the roving (Figure 10–12). It is a softly twisted strand of fibers about the size of a pencil. Successive roving operations may be used to gradually reduce the size of the strand.

Spinning Spinning adds yarn twist. Ring spinning draws, twists, and winds in one continuous operation. The traveler (Figure 10–13) carries the yarn as it slides

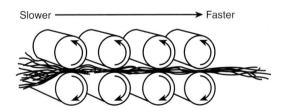

FIGURE 10-11

Drawing rolls.

around the ring, thus inserting the twist. Ring spinning is a slow process in terms of productivity, with rates of 25,000 to 30,000 rpm, as compared with rates of 110,000 to 120,000 rpm for open-end spinning. A ring-

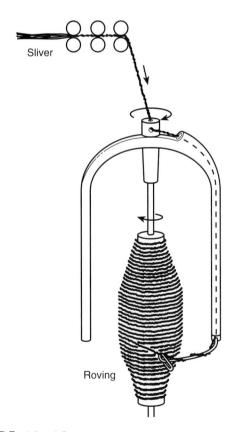

FIGURE 10-12

Roving.

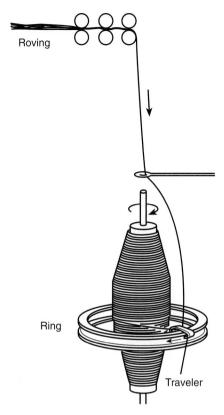

FIGURE 10-13

Ring spinning.

spinning frame holds a number of individual units (Figure 10–14).

Blending can also take place during roving or spinning because several fiber strands are combined in these

FIGURE 10-14
A spinning frame holds multiple ring spinners.

processes. Blending is usually done during roving or spinning to achieve a color blend.

Ring-frame spinning is most commonly used for woolen yarns. It is similar to ring spinning of cotton yarns.

Comparison of Carded-Combed and Woolen-Worsted Yarns The length and parallel alignment of fibers in spun yarns is a major factor in the kind of fabric produced, the cost of the yarns and fabrics, and the terminology used to designate these characteristics.

Yarns made from carded sliver are called *carded yarns*. Carded sliver of short wool fibers is made into woolen yarns and the fabrics are called woolen fabrics. (The term *woolen* refers to yarn type and is not a synonym for wool.)

Yarns made from combed sliver are called *combed* yarns. With wool, the combed sliver is referred to as top and the yarns made from top are called *worsted* yarns. The short fibers that are combed out are called *noils* and are a source of fibers for woolen yarns (Figure 10–15). Fine-combed cotton yarns are made from the fibers that are more than 1 1/8 inches long.

Carded and combed yarns are compared in Table 10–4.

Alternate Spun-Yarn Processes

These procedures shorten and simplify yarn spinning by eliminating or bypassing some of the steps in the conventional ring-spinning system. Most processes focus on eliminating one or more of these steps: drawing, roving, ring spinning, and rewinding. However, the two dominant spinning systems are ring and open-end spinning.

Open-End Rotor Spinning Open-end rotor spinning eliminates the roving and twisting by the ring.

Worsted yarns

FIGURE 10-15

Woolen and worsted yarns: short-staple wool fibers in carded or woolen yarn (top); long parallel wool fibers in combed or worsted yarn (bottom).

Component	Carded	Combed
Fiber length	Short staple	Long staple
Yarn	Less regular in size and appearance	More regular in size and appearance
	Medium to low twist	Medium to high twist
	More protruding ends	Fewer protruding ends
	Bulkier, softer, fuzzier	Parallel fibers, finer count
	More fibers present	Longer wearing, stronger
	·	Fewer fibers present
Fabric	May become baggy in areas of stress	Smoother surface, lighter weight
	Fabrics vary from soft to firm	Do not sag
	Blankets always carded	Take and hold press
	Wide range of uses	Fabrics range from sheers to suiting
	Less expensive	More expensive

Knots are eliminated, larger packages of yarn are formed, less operator supervision is needed, and production speeds are about four times that of ring spinning, but the yarns produced are coarser.

In the rotor-air-jet spinning process, sliver is broken up so that individual fibers are fed by an air stream and deposited on the inner surface of a rotating device driven at high speed. As the fibers are drawn off, twist is inserted by the rotation of the rotor, making a yarn (Figure 10–16). Rotor-spun yarns have a higher twist at the center of the yarn.

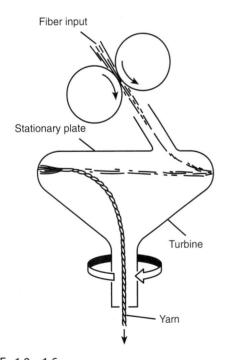

FIGURE 10-16
Open-end rotor spinning.

Friction spinning, a modification of open-end rotor spinning, combines rotor and air techniques. The sliver is separated into fibers that are spread into carding or combing rolls and delivered by air to two cylinders rotating in the same direction, which pull the fibers into a yarn. The feed angle into the cylinder controls fiber alignment. Friction-spun yarns are more even, freer of lint and other debris, and loftier, but they are weaker as compared with conventional yarns. Friction spinning may be used to process very short waste staple fiber into yarns.

Air-Jet Spinning Air-jet spinning is similar to rotor spinning, except that an even, regular yarn is formed by moving air rather than a rotor. Air-jet yarns are less elastic, weaker, and rougher than either ring- or rotor-spun yarns.

Table 10–5 compares ring spinning, rotor spinning, and air-jet spinning.

Direct Spinning Direct spinning eliminates the roving but still uses the ring-spinning device for inserting the twist (Figure 10–17). The sliver is fed directly to the spinning frame. This machine is used to make heavier yarn for pile fabrics and carpets.

Compact Spinning Compact spinning is a variation of ring spinning that condenses the roving before final twist insertion and creates a yarn with better smoothness and strength.

Twistless Spinning Twistless spinning eliminates the twisting process. A roving is wetted, drawn out, sprayed with sizing or adhesive, wound on a package, and steamed to bond the fibers together. The yarns are ribbonlike in shape and stiff because of the sizing. They lack strength as individual yarns but gain strength in the

Yarn Characteristic	Ring Spun	Open-End Rotor Spun	Air-Jet Spun
Parallelism of fibers	High	Medium	High at yarn core, less at yarn edge
Orientation of fibers	Helical in all areas	Helical in yarn core	Axial orientation in yarn core
Yarn structure	Compact	Less compact	Less compact
Insulation	Low	Moderate	Good
Yarn hairiness	High	Lower	Lower
Yarn stiffness	Low	More rigid	Depends on structure
Abrasion resistance	Medium	Low	High
Pilling propensity	Low	Pronounced	Less than rotor spun
Yarn strength	Good	Low	Medium
Surface roughness	Low	Medium	Medium
Yarn size	Wide range	Not as fine as ring	Not as fine as ring, but finer than roto
Yarn evenness	Least even	Most even	Less even than rotor
Comfort	Best	Moderate	Lowest
Thermal retention	Moderate	Moderate	Best
Hand	Medium softness	Not as soft as ring	Soft
End uses	All end uses	Heavier weight apparel, furnishings	Bedding, furnishings

fabric from the pressure between the warp and filling. The absence of twist gives the yarns a soft hand, good luster, and opacity after the sizing is removed. The yarns are easy to dye and have good durability but are not suitable to very open fabric structures.

Self-Twist Spinning In self-twist spinning, two strands of roving are carried between two rollers, which draw out the roving and insert twist. The yarns have areas of S-twist and areas of Z-twist. When the two twisted yarns are brought together, they intermesh and entangle, and, when pressure is released, the yarns ply over each other

FIGURE 10-17

Mackie direct spinner turns sliver into finished yarn—eliminates roving. (Courtesy of Mackie International Ltd.)

(Figure 10–18). This process can be used to combine staple strands, filament strands, or staple and filament strands.

Spinning Filament Tow into Spun Yarns

Filament tow of any manufactured fiber can be made into spun yarns by direct spinning without disrupting the continuity of the strand. The two systems are tow-to-top or tow-to-yarn.

Tow-to-Top (Sliver) System The tow-to-top system bypasses the opening, picking, and carding steps of conventional spinning. In this system the filament tow is reduced to staple and formed into sliver (or top) by either diagonal cutting or break stretching. The sliver is made into regular-spun yarn by conventional spinning.

The diagonal cutting stapler changes tow into staple of equal or variable lengths and forms it into a crimped sliver. In the break-stretch process, the tow is stretched and the fibers break at their weakest points without disrupting the strand's continuity. The resulting fiber varies in length.

Tow-to-Yarn System Tow-to-yarn spinning is done by a machine called a direct spinner. Light tow (4400 denier) passes between two pairs of nip rolls. The second pair of nip rolls breaks the fibers at their weakest points. The resulting strand is drawn out to yarn size, twisted, and wound on a bobbin (Figure 10–19).

High-Bulk Yarns

High-bulk yarns are yarns essentially free from stretch. Some of the fibers have assumed a relatively high random crimp caused by shrinkage of low-crimp fibers.

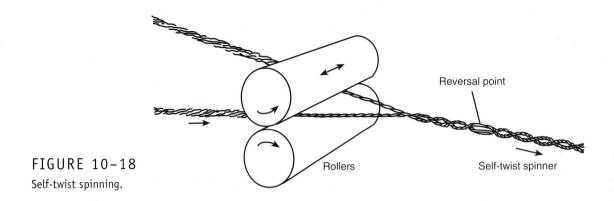

Some fibers can be produced with a latent shrinkage potential and retain their bulk indefinitely at room temperature. Latent shrinkage in a fiber is achieved by heating, stretching, and then cooling while in the stretched condition. These heat-stretched fibers are called high-shrinkage fibers and are combined with nonshrinkage fibers in the same varn, which is made into a product. Heat treatment of the product causes the highshrinkage fibers to relax or shrink, forcing the nonshrinkage fibers to bulk (Figure 10-20). This makes high-bulk sweaters, knitting yarns, and other products. High-shrinkage fibers migrate to the center of the yarn. Thus, if fine-denier nonshrinkage fibers are combined with coarse-denier high-shrinkage fibers, the fine-denier fibers concentrate on the outer surface of the varn. Regulating the heat stretching can control the bulk.

The high-bulk principle can be used to achieve interesting effects, such as guard hairs in synthetic furs and

sculptured high-low carpets. Higher-density carpet pile or furlike fabrics can be made by using a high-shrinkage-type fiber for the ground yarns. When the yarns shrink, the fibers are brought much closer together.

Fiber Blends

A **blend** is an intimate mixture of fibers of different generic type, composition, length, diameter, or color spun together into one yarn. In intimate blends, both fibers are present in the same yarn in planned proportions. Fiber types cannot be separated; they are next to each other throughout the yarn. When intimate blend yarns are untwisted and examined through a microscope, both fibers are visible in the viewing area.

Mixture refers to yarns of different generic types within a fabric. In a mixture, yarns of one fiber type are used in the warp and yarns of another type are used in

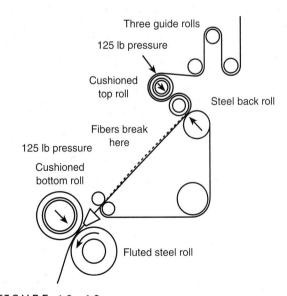

FIGURE 10-19
Direct spinning of yarn from filament tow.

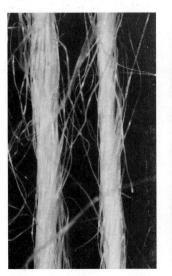

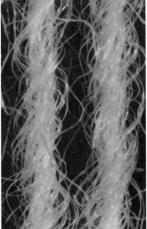

FIGURE 10-20

High-bulk yarn before (left) and after (right) steaming.

the filling. When fabrics of this type are unraveled, the fibers can be separated by placing all warp yarns in one pile and all filling yarns in another pile. In a **combination**, ply yarns are used. At least one component of the ply yarn is of a different generic fiber type from the other components of the ply yarn. For example, many fabrics that incorporate a metallic component are combinations because the metallic component is part of a plied fancy yarn.

Blends, mixtures, and combinations produce fabrics with properties that are different from those obtained with one fiber only. This discussion relates to blends because they are most common, but these comments also apply to mixtures and combinations.

Blending is done for several reasons:

- 1. To produce fabrics with a better combination of performance characteristics. Although blends never perform as well in the areas of positive performance as fabrics of only one fiber, blends help compensate for poor performance. In end uses for which durability is important, nylon or polyester blended with cotton or wool increases strength and resistance to abrasion, while the wool or cotton look is maintained. For example, 100 percent cotton fabrics are not as durable as polyester/cotton blends, and polyester/cotton blends are less absorbent than 100 percent cotton fabrics.
- **2.** To improve spinning, weaving, and finishing efficiency and to improve uniformity.
- 3. To obtain better texture, hand, or fabric appearance. A small amount of a specialty wool may be used to give a buttery or slick hand to wool fabrics, or a small amount of rayon may give luster and softness to a cotton fabric. Fibers with different shrinkage properties are blended to produce bulky, lofty fabrics or more realistic furlike fabrics.

- **4.** To minimize fiber cost. Expensive fibers can be extended by blending them with less-expensive fibers. Labeling requirements help protect consumers from unscrupulous labeling practices.
- **5.** To obtain cross-dyed or unique color effects such as heather. Fibers with unlike dye affinity are blended together and dyed at a later stage in processing.

Blending is a complicated and expensive process, but the combination of properties it provides is permanent. Blends offer better serviceability of fabrics as well as improved appearance and hand.

Table 10–6 rates selected fiber properties. Note that each fiber is deficient in one or more important properties. Try different fiber combinations to see how a blend of two fibers might be used to produce a fabric with satisfactory performance in all properties.

Blend Levels

A blend of fibers that complement each other may give more satisfactory all-around performance than a fabric made from 100 percent of one fiber. For example, compare two fabrics, one of Fiber A and the other of Fiber B, across five properties. A fabric made of 50 percent A and 50 percent B will have values for each property that are neither as high as possible nor as low as possible (Caplan, 1959) (Table 10–7). By blending the fibers, a fabric with intermediate values is obtained. Unfortunately, in a blend the real values are not in the same proportion as the fiber percentages.

Research by fiber manufacturers has determined the percentage of each fiber necessary in various products. It is very difficult to generalize about percentages because they vary with the fiber type, the fabric construction, and the expected performance. For example, a small amount of nylon (15 percent) improves the strength of wool, but

Properties	Cotton	Rayon	Wool	Acetate	Nylon	Polyester	Acrylic	Olefin	Lyocell
Bulk and loft	— — — ,	_	+++		-	_	+++		_
Wrinkle recovery	-	_	+++	++	++	+++	++	++	
Press (wet) retention		-	_	+	++	+++			_
Absorbency	+++	+++	+++	+	_		_	_	+++
Static resistance	+++	+++	++	+	+	- "	+	++	+++
Resistance to pilling	+++	+++	+	+ + + +	+			++	+
Strength	++	+	+	+	+++	+++	+	+++	+ + +
Abrasion resistance	+	_	++	_	+ + +	+++	+	+++	_
Stability	++	_	_	+++	+++	+++	+++	+++	++
Resistance to heat	+++	+++	++	+	+	+	++	_	+ + +

^{+++,} excellent; ++, good; +, moderate; -, low

performan	formance.				
		Kno	own Values		
Property	Α	В	Predicted Values of 50/50 A and B		
1	12	4	8		
2	9	12	10.5		
3	15	2	8.5		
4	7	9	8		
5	12	8	10		

60 percent nylon is needed to improve the strength of rayon. For stability, 50 percent acrylic blended with wool in a woven fabric is satisfactory, but 75 percent acrylic is necessary in knitted fabrics.

Fiber producers have controlled blend levels fairly well by setting standards for fabrics identified with their trademarks. For example, the DuPont Company recommends a blend level of 65 percent Dacron polyester/35 percent cotton in light- or medium-weight fabrics, whereas 50/50 Dacron/cotton is satisfactory for suit-weight fabrics. This ensures satisfactory performance of the fabric and maintains a positive fiber image for Dacron. The fabric manufacturer profits from the large-scale promotion by the fiber producer.

By using specially designed fiber variants, it is possible to obtain desired performance and appearance in fabrics. For example, fading, shrinkage, and softening over time are desirable characteristics for denim jeans, but are undesirable in most other apparel. For this market DuPont has developed a Dacron polyester variant for blending with cotton that fades, softens, and shrinks uniformly.

Blending Methods

Blending of staple can be done at any stage prior to the spinning operation, including opening-picking, drawing, or roving. One of the disadvantages of direct spinning is that blending cannot be done before the sliver is formed.

The earlier the fibers are blended in processing, the better the blend. Figure 10–21 shows a cross section of yarns in which the fibers were blended in opening and in which the fibers were blended at the roving stage. Long, fine fibers tend to move to the center of a yarn, whereas coarse, short fibers migrate to the outside edge of a yarn (Figure 10–21c).

Fabrics are also produced that are mixtures of bulkfilament yarns and spun yarns. These fabrics may have filament yarns in only one direction and spun yarns in the other, or they may have different yarns in bands in the warp or filling to create a design in the fabric.

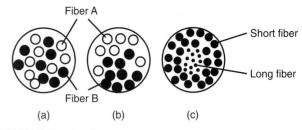

FIGURE 10-21

Cross section of yarn showing fiber location in blends: (a) blended at the opening stage; (b) blended at the roving stage; (c) blend of short and long fibers.

Blended-Filament Yarns

A blended-filament yarn has unlike filament fibers of different deniers or generic types blended together. This usually improves the performance and appearance of apparel and furnishing fabrics (Figure 10–22).

Fasciated or Rotofil Yarns These yarns combine coarse filaments for strength and fine broken filaments for softness to improve fabric texture and hand. The yarn has a low-twist staple fiber core wrapped with surface fibers that add integrity to the yarn. Air-jet spinning is used to produce these yarns.

Environmental Impact of Yarn Processing

Although yarn processing may not be recognized as having significant environmental impact, several environmental issues should be discussed. The rotors used in false-twist texturing of filament yarns rotate at such high speeds that workers in these areas may experience permanent hearing loss. Current regulations regarding

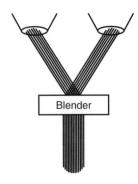

FIGURE 10-22

Blended-filament yarn. Different fibers are spun, then blended to form a yarn.

workplace safety require that workers in these areas wear hearing protection.

The opening step tends to generate large quantities of dust, fiber bits, and other airborne contaminants. In the past, operators who worked in these parts of mills often developed respiratory disorders resulting from prolonged exposure to this dust. Current regulations regarding workplace safety require dust control in these areas. Opening areas and other parts of mills are significantly cleaner now. Small vacuum heads move through the mill removing dust, loose fiber, and other airborne debris. Controlling humidity levels minimizes dust or the buildup of static electricity, which may create problems with equipment operation.

Opening, carding, and combing steps for the production of spun yarn generate a significant amount of waste, which includes very short fibers, entangled fibers,

plant debris, soil, and other foreign matter. At one time, this waste material was unusable and discarded. Now, mills sell this waste to specialists who produce yarns and other fiber products from recycled waste fiber for use in apparel, furnishings, and industrial products.

Ring spinning is concentrated in countries with lower labor costs because the technology available in those countries is not highly advanced and less-skilled labor can service and maintain ring-spinning equipment. In addition, spare parts for ring-spinning machines are more readily available and are relatively inexpensive. Power disruptions that may be experienced in less-developed countries do not create significant problems with ring spinning. Open-end and rotor spinning require higher energy consumption, more-skilled labor, more-expensive replacement parts, and more-expensive technology.

Key Terms

Filament varn Throwing Smooth-filament yarn Tape yarn Bulk yarn Bulk-continuous-filament yarn (BCF) Texturing Bulky varn Stretch yarn Textured or bulked yarn Spun yarn Combed yarn Ring or conventional spinning Opening Carding

Drawing Combing Worsted yarn Carded yarn Woolen yarn Roving Spinning Open-end rotor spinning Air-jet spinning Tow-to-top system Sliver Tow-to-yarn system High-bulk yarn Blend Mixture Combination

Blended-filament yarn

Questions

- 1. Explain the processes used to produce each of these yarns: smooth filament, BCF, carded spun yarn, worsted spun yarn.
- 2. Using the serviceability concepts, explain why cotton and polyester are often blended for furnishing and apparel items.
- **3.** Compare and contrast the appearance, processing, and performance of the yarn pairs listed:

carded and combed yarns smooth and bulk filament yarns woolen and worsted yarns BCF and woolen yarns

- **4.** How would the performance of two similar products differ if one were made of filament yarns of polyester and the other of spun yarns of polyester?
- 5. What are the differences between these two products: a blend of nylon and wool and a mixture of nylon and wool?

Suggested Readings

American Society for Testing and Materials (2000). *Annual Book of ASTM Standards*, Vol. 7.01. West Conshohocken, PA: Author.

Caplan, M. J. (1959). Fiber translation in blends. *Modern Textile Magazine*, 40, p. 39.

Deussen, Helmut (1991, March). How to match fibers to your rotor spinning needs. *Textile World*, pp. 61–62, 64.

Douglas, K. (1995, February). Producing marketable quality ring- and rotor-spun yarns. *Textile World*, pp. 61–63.

Krause, H. W., and Soliman, H. A. (July, 1990). Do higher speeds demand better yarns? *Textile Month*, pp. 19–22.

Morris, B. (1991). Yarn texturing. *Textiles*, no. 1, pp. 10–13. Nikolic, M., Cerkvenik, J., and Stjepanovic, Z. (1994).

Influence of a spinning process on spun yarn quality and

economy of yarn production. *International Journal of Clothing Science and Technology*, 6(4), pp. 34–40.

The polycotton story. (1994, Winter). *Textiles Magazine*, pp. 8–11.

Owen, P. (1999, August). Spinning: wider future options. *Textile Horizons*, pp. 16–18.

Tortora, P. G., and Merkel, Robert S. (1996). Fairchild's Dictionary of Textiles, 7th ed. New York: Fairchild Publications.

Wilson, D. K., and Kollu, T. (1991). The production of textured yarns by the false-twist technique. *Textile Progress*, 21(3), pp. 1–42.

Chapter 11

YARN CLASSIFICATION

OBJECTIVES

- To understand yarn classification based on appearance and structure.
- To identify and name the yarns in fabrics and products.
- To understand the relationships between yarn types and product performance.
- To integrate yarn selection with desired end-use performance.
- To relate yarn quality to product performance.

arns contribute significantly to fabric and product performance. Fabric producers must select from among a wide variety of yarns. Their selection may affect hand, appearance, drape, durability, comfort, and many other performance dimensions. For example, yarns with high twist create the texture in true crepe apparel and furnishing fabrics. Yarns with low twist are napped in flannel fabrics and blankets. Yarn may enhance good fiber performance or partially compensate for poor fiber performance. The effectiveness of a finish may depend on the yarn choice. There are many different yarn types available. Factors that are used to identify and classify yarns include fiber length (staple/filament), yarn twist, yarn size, and yarn regularity/irregularity along its length. This chapter explains yarn identification, classification, and performance.

Fiber Length

Most common yarn names reflect fiber length and fiber alignment in the yarn. When a typical yarn is unraveled from a fabric and examined, it may appear uniformly smooth, uniformly bulky, or fuzzy, with protruding fiber ends. It can be untwisted until it separates into individual fibers. These fibers are either short, typically 1/2 to 2 1/2 inches, or as long as the piece of fabric from which the yarn was pulled.

A **spun yarn** is composed of short-staple fibers that are twisted or otherwise bonded together, resulting in a fuzzy yarn with protruding fiber ends. Better-quality and more-expensive spun yarns are produced from longer-staple fibers.

A filament yarn is composed of long fibers grouped together or slightly twisted together. Smooth-filament yarns have straight, almost parallel fibers. Uniformly bulky yarns are called **textured-bulk-filament yarns** or just **textured-bulk yarns**. Table 11–1 summarizes the properties related to the use of these three yarn types in fabrics. Processing of all three types was discussed in Chapter 10.

Yarn Twist

Twist, the spiral arrangement of the fibers around the yarn's axis, is produced by rotating one end of a fiber strand while holding the other end stationary. Twist

TABLE 11–1 Comparison of	spun, smooth-filament, and textu	red-bulk yarns.
Spun Yarns	Smooth-Filament Yarns	Textured-Bulk Yarns (BCF)
I. Fabrics are cottonlike or wool-like.	I. Fabrics are silklike.	I. Fabrics have the strength of filament yarns, but resemble the luster and hand of spun yarns.
II. Fiber strength is not well utilized.	II. Strength of fiber is well utilized.	II. Strength not as well utilized.
III. Short fibers twisted into continuous	III. Long continuous, closely packed	III. Long continuous, irregular, porous,
strand with protruding ends.	strand.	flexible strand.
1. Dull, fuzzy look.	1. Smooth, lustrous.	1. Bulky, dull.
2. Lint.	2. Do not lint.	2. Do not lint.
Subject to pilling.	Do not pill readily.	3. Pill less readily than spun yarns.
4. Soil readily.	4. Shed soil.	Soil more easily than smooth filament.
Warm (not slippery).	Cool, slick.	Warmer than smooth filament.
Loft and bulk depend on size and twist.	6. Little loft or bulk.	Lofty, bulky, and/or stretchy.
7. Do not snag readily.	Snagging depends on fabric construction.	7. Snag easily.
8. Stretch depends on twist amount.	8. Stretch depends on twist amount.	8. Stretch depends on process.
9. More cover (more opaque).	9. Less cover (less opaque).	9. More cover (more opaque).
IV. Absorbency depends on fiber. Most absorbent type.	IV. Absorbency depends on fiber.	IV. Moderately absorbent as compared with smooth-filament yarns of same fiber.
1. Good for skin contact.	 Least absorbent type. 	1. Good for skin contact.
2. Less static buildup.	 Static can be a problem. Can be clammy. 	2. Static can be a problem.
V. Size expressed in yarn number.	V. Size in denier.	V. Size in denier.
VI. Various amounts of twist used.	VI. Usually very low or very high twist.	VI. Usually low twist.
VII. Most complex process.	VII. Least complicated process.	VII. Moderately complex process.

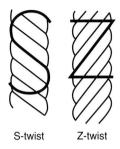

FIGURE 11-1 S- and Z-twist yarns.

binds the fibers together and contributes strength to the spun yarn. Twist is specified by the number of turns per unit length: turns per inch (tpi) or turns per meter (tpm). The number of twists affects yarn and product performance and yarn cost.

Direction of Twist

The direction of twist is described as S-twist or Z-twist. A yarn has **S-twist** if, when held in a vertical position, the spirals conform to the direction of slope of the central portion of the letter S. In **Z-twist**, the direction of spirals conforms to the slope of the central portion of the letter Z. Z-twist is more common for weaving yarns (Figure 11–1).

Amount of Twist

The amount of twist varies with (1) the length of the fibers, (2) the size of the yarn, and (3) its intended use. Increasing the amount of twist to the point of perfect fiber-to-fiber cohesion increases yarn strength. However,

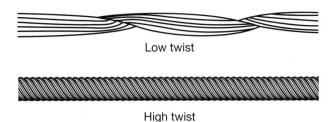

FIGURE 11-2

Twist in yarns: low and high.

excessive twist places the fibers at right angles to the yarn axis, causing a shearing action among fibers and a weaker yarn (Figure 11–2). Increasing the amount of twist also affects yarn hairiness, comfort, cost, and linting. Yarns with lower twist tend to be hairier, pill and lint more, have better comfort when in contact with the skin, and cost less.

Combed yarns with long fibers do not require as much twist as carded yarns with short fibers. Long, parallel fibers have more points of contact per unit length, producing a stronger yarn for the same amount of twist. Fine yarns require more twist than coarse yarns. Knitting yarns have less twist than filling yarns used in weaving. In better-quality yarns, twist is evenly distributed throughout the yarn and the tpi is toward the high end of the range for that yarn type. Table 11–2 and the following discussion describe yarns with different amounts of twist.

Monofilament yarns have no twist. Low twist is used to maintain integrity within smooth-filament yarns. One to two turns per inch keep filament yarns from separating into individual fibers (Figures 11–3a, 11–3b, and 11–3c). Napping twist produces lofty spun yarns. They are used in filling yarns of fabrics that are to be napped.

Amount	Example	Characteristics
Low twist	Filament yarns: 2-3 tpi*	Smooth or bulky; twist may be hard to see
Napping twist	Blanket warp: 12 tpi Filling: 6–8 tpi	Bulky, soft, fuzzy, may be weak.
Average twist	Percale warp: 25 tpi Filling: 20 tpi Nylon hosiery: 25–30 tpi	Most common, smooth, regular, durable, comfortable. Produces smooth, regular fabrics.
Voile twist	Hard-twist singles: 35–40 tpi are plied with 16–18 tpi	Strong, fine yarns. Fabrics have harsher hand due to yarn twist.
Crepe twist	Singles: 40–80 or more tpi are plied with 2–5 tpi	Lively yarns that kink and twist in fabrics with good drape and texture.

^{*}Turns per inch.

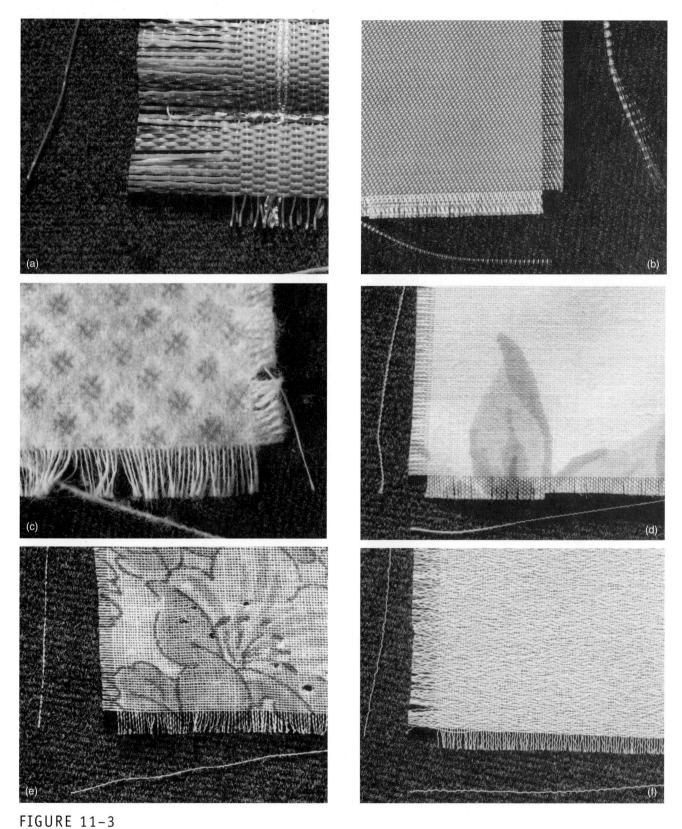

Examples of yarn twist and fabrics of these yarns: (a) monofilament, (b) low twist, (c) napping twist, (d) average twist, (e) voile twist, and (f) crepe twist.

Napping teases out the ends of the staple fibers and creates the soft, fuzzy surface. (See section on napped texture in Chapter 17.)

Average twist is used most commonly for yarns made of staple fibers, but seldom for filament yarns. Yarns with average twist are the most durable spun yarns. Combed and worsted yarns are made of long-staple fibers with a parallel arrangement. Carded and woolen yarns are made of short-staple fibers with a less parallel arrangement (Figure 11–3d).

Hard twist or voile twist yarns have a harsher hand and more turns per inch (Figure 11–3e). The hardness of the yarn results when twist brings the fibers closer together and makes the yarn more compact. This effect is more pronounced when a twist-on-twist ply yarn is used. Twist-on-twist means that the direction of twist in the single is the same as that of the plying twist and increases the total amount of yarn twist (Figure 11–4). (See the discussion of voile in the section on lightweight sheer fabrics in Chapter 12.)

Crepe yarns have the highest number of turns per inch (40 to 80) inserted in the yarn (Figure 11–3f). These spun or filament yarns are also known as unbalanced yarns, since they twist and kink when removed from the fabric. These yarns are so lively that they must be twist-set, a yarn-finishing process, before they can be woven or knitted. To identify crepe yarns, test a yarn removed from the fabric by first pulling on the yarn and then letting one end go. The yarn should resemble the shape illustrated in Figure 11–5. Most crepe fabrics have crepe yarns in the crosswise direction, although some are in the lengthwise direction, and some have crepe yarns in both directions. Crepe fabrics are discussed in Chapters 12 and 13.

Increasing the amount of crepe yarn twist and alternating the direction of twist increases the amount of crinkle in a crepe fabric. For example, a fabric made of a band of six S filling yarns followed by a band of six Z filling yarns produces a more prominent crinkle than bands of two S filling yarns followed by bands of two Z filling yarns.

FIGURE 11-4
Twist-on-twist two-ply yarn.

FIGURE 11-5

Crepe yarns knot, twist, or curl when removed from a fabric.

Yarn Size

Yarn Number

Yarn size or fineness is referred to as yarn number. For filament yarns it is expressed in terms of weight per unit length. For spun yarns, it is expressed in terms of length per unit weight. For spun yarns, the defined weights and lengths differ with fiber type. The cotton system is discussed here, since many yarns are numbered by the cotton system. It is an indirect or fixed-weight system: the finer the yarn, the larger the number. Thus, a fine yarn would be a 70 and a coarser yarn would be a 20. The yarn number or cotton count is based on the number of hanks (1 hank equals 840 yards) in 1 pound of yarn (Table 11–3). Finer yarns are an indication of better quality, but they may not be as durable as slightly coarser yarns. Examples that show the relationship between yarn size and fabric weight also are included in Table 11–3.

The woolen and worsted systems are similar, except the length of yarn in a hank differs.

Denier

Denier describes yarns made from filament fibers. The term is used for both smooth- and bulky-textured yarns.

The size of filament yarns is based on the size of the individual fibers in the yarn and the number of those fibers grouped into the yarn. The size of both filament fibers and filament yarns is expressed in terms of weight per unit of length. For both fibers and yarns, denier is the weight in grams of 9000 meters. In this system, the unit of length remains constant. The numbering system is direct, also referred to as a fixed-length system, because the finer the yarn, the smaller the number. See Table 11–4 for examples of filament yarns made in a specific denier for particular end uses.

Fabric Examples (Weight)	Yarı	Yarn Size		of Hanks Pound	Length of Yarn in One Pound (yards)	
	Warp	Filling	Warp	Filling	Warp	Filling
Sheer lawn (2.0 oz/yd²)	70s*	100s	70	100	58,800	84,000
Print cloth (4.5 oz/yd²)	30s	40s	30	40	25,200	33,600
Sailcloth (7.5 oz/yd²)	13s	20s	13	20	10,920	16,800

^{*}The "s" after the number means that the yarn is single.

Yarn denier is often used to describe filament yarn fabrics because it provides additional information to fabric specialists. Higher numbers describe larger yarns. For example, a 160-denier fabric has finer yarns than a 330-denier fabric. The 160-denier fabric will be softer and more comfortable in contact with the skin and less durable than the 330-denier fabric.

Yarn denier helps determine end-use performance. When denier is listed as a fraction, the first number describes the size of the yarn and the second describes the number of filament fibers in the yarn. When individual fiber size is important, it can be determined by dividing the first number by the second number. For example, an industrial Cordura nylon fabric by DuPont is described as 1000/280. The varn is a 1000-denier yarn; there are 280 filament fibers present. Each fiber is approximately 3.6 denier in size. This would be a relatively tough, durable, and stiff fabric for such end uses as upholstery, briefcases, or tool pouches. This method of describing yarn denier and number of filaments is used for all types of fabrics made of filament yarns, including microfiber yarns used in apparel and furnishings.

Yarn Denier	Use	Yarn Tex
20	Sheer hosiery	2.2
40–70	Tricot lingerie, blouses, shirts, support hosiery, sheer curtains	4.4–7.8
140-520	Outerwear, draperies	15.6-57.8
520-840	Upholstery	57.8-93.3
1040	Carpets, some knitting	115.6

Tex System

The International Organization for Standardization has adopted the **tex system**, which determines yarn count or number in the same way for all yarns. Tex is the weight in grams of 1000 meters of yarn. One tex is equal to 0.11 denier (tex = denier/9). Because the size can be small, the term **decitex** (**dtex**) may be used. One dtex is 10 times larger than one tex (see Table 11–4).

Yarn Regularity

Yarn regularity describes the uniformity of the yarn throughout its length in terms of its appearance and structure. Regular yarns have a similar appearance and structure throughout. There may be some slight variation due to uniformity of fiber distribution and fiber length, degree of parallelism of fibers within the yarn, and regularity of fiber size or diameter. For example, yarns with a wide variety of fiber length, unparalleled fibers, or bast fibers like flax or ramie may be slightly less regular than other yarns. Yarn quality is related to the degree of uniformity within the yarn.

Fancy or novelty yarns have deliberately introduced appearance and structural variations. These irregularities appear at a regular interval due to processing. Composite yarns include components that differ from each other. All three general yarn types will be discussed in this section.

Simple Yarns

A simple yarn is alike in all its parts. It can be described as a spun or filament yarn, based on its fiber length. A simple yarn also can be described by the direction and amount of yarn twist and by yarn size. Figure 11–6 outlines the relationship of yarns in this category to each other.

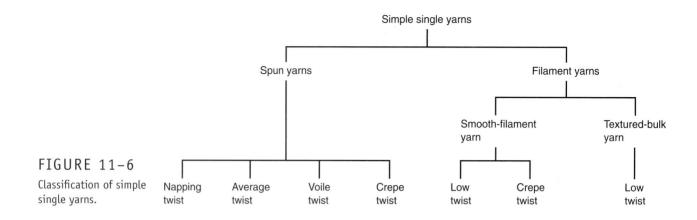

The number of strands used to produce the yarn is another means of classifying yarns. Simple yarns are classified as single, ply, or cord yarns. A **single yarn** has one strand and is the simplest type. It is the product of the first twisting operation that is performed in yarn spinning (Figure 11–7a). Simple single yarns require no additional processing once the individual yarns have been formed.

Spun, filament, and textured bulk yarns are types of simple single yarns that are most commonly found in apparel and furnishing fabrics. These simple single yarns are alike in all parts, consisting of one strand of fibers.

A **ply yarn** is made by a second twisting operation that combines two or more singles (Figure 11–7b).

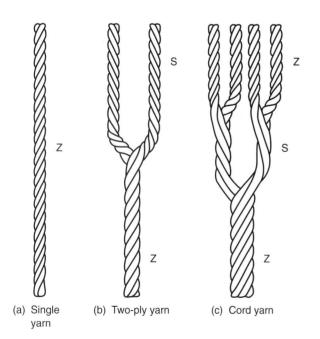

FIGURE 11-7
Parts of a yarn: (a) single yarn; (b) two-ply yarn; (c) cord yarn.

Each part of the yarn is called a ply. A machine called a twister inserts the twist. Most ply yarns are twisted in the direction opposite to that of the twist of the singles from which they are made. The first few revolutions tend to untwist the singles and straighten the fibers somewhat from their spiral position and soften the yarn slightly.

Plying increases yarn diameter, strength, uniformity, and quality. Ply yarns sometimes are used in the warp direction of woven fabrics to increase strength. Two-ply yarns are found in the best-quality men's broadcloth shirts. Ply yarns are frequently seen in knits and furnishings. They are found in sewing thread and the string used to tie packages. When simple ply yarns are used only in the filling direction, they produce some fabric effect other than strength.

A **cord** is made by a third twisting operation, which twists ply yarns together (Figure 11–7c). Some types of sewing thread and some ropes belong to this group. Cord yarns are seldom used in apparel and furnishing fabrics, but are used in industrial fabrics such as duck and canvas.

Sewing Thread

Sewing thread is a yarn intended for stitching materials together using machine or hand processes. Sewing threads are available in several sizes and structures. Examples include ply, corded, cable, braided, textured-filament, smooth-filament, monofilament, and corespun. Sewing thread is often finished with lubricant or wax so that it withstands the abrasion, stress, and manipulation required in high-speed machine sewing. Many different fibers and fiber blends are used in sewing thread. The thread selected is based on the material or materials to be stitched together, the end use, and the desired product performance. Thread size may be expressed as denier, tex, count, yarn number, or ticket number.

Fancy Yarns

Fancy yarns are yarns that deliberately have unlike parts and that are irregular at regular intervals. The regular intervals may be subtle or very obvious.

Fancy yarns may be single, plied, or cord yarns. They may be spun, filament, or textured yarns—or any combination of yarn types. They are called fancy yarns or **novelty yarns** because they produce an interesting or novel effect in fabrics made from them. Their structure may be complex and consist of several yarn plies combined into one yarn.

Fancy yarns are classified according to their number of parts and named for the effect that dominates the fabric. Usually more common in furnishing fabrics than in apparel fabrics, fancy yarns also are used by artists and crafts people to create interest in otherwise plain fabrics of many fiber types.

Fancy yarns are made on twisters with special attachments for producing different tensions and rates of delivery in the different plies. This produces loose, curled, twisted, or looped areas in the yarn. Slubs and flakes of short-staple fibers of different color are introduced into the yarn by special attachments. Knots or slubs are made at regular cycles as the machine operates.

Fancy or novelty yarns are used for a variety of reasons. Characteristics and performance vary widely by type and fiber content.

- Fancy yarns are usually plied yarns, but they seldom add strength to the fabric. Novelty yarns are often weak and sensitive to abrasion damage.
- When fancy yarns are used in one direction only, it is usually in the filling direction because it is more economical with less waste. Filling yarns are subject to less strain and are easier to vary for design purposes.
- Fancy yarns add permanent interest to plain fabrics at a lower cost.
- Fancy bulky yarns add crease resistance to a fabric, but they may make the fabric hard to handle.
- The durability of fancy yarn fabrics depends on the size of the ply effect, how well it is held in the yarn, the fiber content of the various parts, and

- the firmness of the fabric structure. Generally speaking, the smaller the novelty effect, the more durable the fabric, since the yarns are less affected by abrasion and do not snag as readily.
- The quality and cost of fancy yarns is related to the quality of the fibers and plies from which the yarn is made, the manner in which the unique visual component is produced in the finished yarn, and the regularity of the yarn structure.

Figure 11–8 classifies the most common fancy yarns according to their usual single or ply structure.

Tweed yarn is an example of a single, spun, fancy yarn. Flecks of short colored fibers are twisted into the yarn to add interest. Tweeds are often made of wool because of its cohesiveness. Tweed yarns are found in apparel, upholstery, and draperies.

A slub yarn is another single, spun, fancy yarn. This thick-and-thin yarn can be made in two ways: The amount of twist in the yarn can be varied at regular intervals for a true slub yarn; the thicker part of the yarn is twisted less; the thinner part of the yarn is twisted more. True slub yarns are found in shantung, drapery, and upholstery fabrics and in hand-knitting yarns and sweaters (Figure 11–9a). Intermittently spun flake or slub effects are made by incorporating soft, thick, elongated tufts of fiber into the yarn at regular intervals with a core or binder yarn.

Spiral or **corkscrew** fancy yarns have two or more plies. The plies may differ in color, twist, size, or type. A two-ply fancy yarn may have one spun ply combined with a filament ply (Figure 11–9b). The two parts may be delivered to the twister at different rates of speed. These yarns are used in furnishings and apparel.

Frequently fancy yarns have three basic parts: (1) the ground, or foundation, or core ply; (2) the effect, or fancy ply; and (3) the binder ply. When a fancy yarn is examined, the first ply that can be unwound from the yarn is the binder. It holds the effect ply in place. The **effect ply** is primarily responsible for the appearance and the name of the yarn. The **ground ply** forms the foundation of the yarn. Figure 11–10 shows a three-ply novelty yarn. For clarity in the illustration, each ply appears to be a simple, single, monofilament (single-fiber)

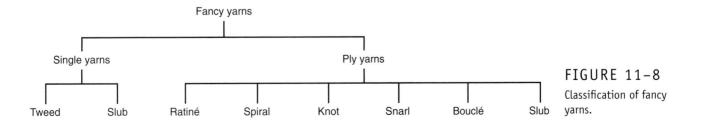

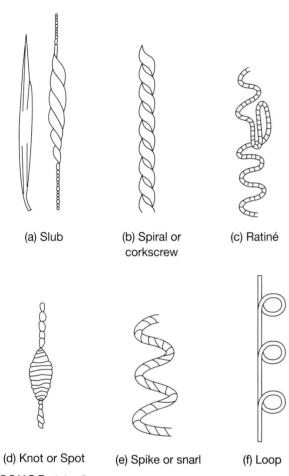

FIGURE 11-9
Effect ply for several kinds of fancy yarns.

yarn. In actuality, each ply could be spun, filament, BCF, split film, or complex. Metallic components also may be used. For example, the ground may be a simple, single, filament yarn; the effect could be two-ply, with one ply a monofilament metallic yarn and the other ply a spun yarn; and the binder could be a simple, single, spun yarn. Each ply in two or more ply fancy yarns may have a different fiber content. Endless variations are possible.

The following are typical novelty ply yarns:

- 1. In ratiné yarns, the effect ply is twisted in a spiral arrangement around the ground ply. At intervals, a longer loop is thrown out, kinks back on itself, and is held in place by the binder (Figure 11–9c). These yarns are used primarily in furnishings.
- **2.** The **knot**, **spot**, **nub**, or **knop yarn** is made by twisting the effect ply many times in the same place

- (Figure 11–9d). Two effect plies of different colors may be used and the knots arranged so the colored spots alternate along the length of the yarn. A binder is added during the twisting operation. These yarns are used in apparel and furnishings.
- **3.** In **spike** or **snarl yarn**, the effect ply forms alternating open loops along both sides of the yarn (Figure 11–9e). These yarns are used in apparel and furnishings.
- 4. Loop, curl, or bouclé yarn has closed loops at regular intervals along the yarn (Figure 11–9f). These yarns are used in fabrics to create a looped pile resembling caracul lambskin called astrakhan cloth. They are also used to give texture to other fabrics. Mohair, rayon, and acetate may be used for the effect ply in apparel and furnishings.
- 5. Metallic yarns have been used for thousands of years. See Chapter 9 for processing and use information. Metallic yarns may be monofilament fibers or combined in ply yarns. Metallic fancy yarns are used primarily in apparel. However, some metallic-looking yarns are made from ultrafine plastic fibers of nylon or polyester split film made of 200 layers. These film yarns produce luminous and iridescent

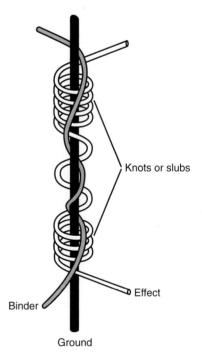

FIGURE 11-10
Fancy yarn, showing the three basic parts.

FIGURE 11-11
Fabric from which chenille yarn is cut.

effects without the comfort problems of metallic monofilaments.

6. Chenille yarn is made by cutting a specially woven ladderlike fabric into warpwise strips (Figure 11–11). The cut ends of the softly twisted yarns loosen and form a fringe. Chenille or "caterpillar" yarn may be woven to produce pile on one side or on both sides

of a fabric. If the pile is to be on one side only, the yarn must be folded before it is woven. Chenille-type yarns can also be made by flocking or gluing short fibers on the surface of the yarn. Other chenille-type yarns are made by twisting the effect yarn around the core yarn, securing it in place with the binder, and cutting the effect so it forms a fringe or pile. Chenille yarns are used in furnishings and apparel.

Table 11–5 summarizes information about yarn appearance and performance. Use it to review the major yarns and compare their performance.

Composite Yarns

Composite yarns, regular in appearance along their length, have both staple-fiber and filament-fiber components. Composite yarns include covered yarns, core-spun yarns, filament-wrapped yarns, and molten-

Yarn Type	Aesthetics	Durability	Comfort	Care
Spun	Fabrics look like cotton or wool	Weaker than filament yarns of same fiber	Warmer More absorbent because of larger surface area	Yarns do not snag readily
	Fabrics lint and pill	Ply yarns stronger than simple yarns		Soil readily
		Yarns are cohesive, so fabrics resist raveling and running		
Smooth-filament	Fabrics are smooth and	Stronger than spun	Cooler	Yarns may snag
	lustrous	yarns of same fiber	Least absorbent but more likely to wick moisture	Resist soiling
	Fabrics do not lint or pill readily	Fabrics ravel and run readily		
Bulk or textured filament	Fabric luster is similar to spun-yarn fabrics Fabrics do not lint but	Stronger than spun yarns of same fiber Yarns are moderately	same fiber than smooth-filament	Yarns likely to snag Soil more readily than filament yarns
	may pill cohe rave	cohesive, so fabrics ravel and run like spun-yarn fabrics	Moderately absorbent Stretch more than other yarns	
Fancy or novelty	Interesting texture	Weaker than filament	Warmer	Yarns likely to snag
	Larger novelty effects are less durable than smaller novelty effects	yarns Most resist raveling Less abrasion-resistant	More absorbent if one ply is a spun yarn	Soil readily
	Fabrics lint and pill			
Composite	Varies; larger yarns with spun or filament appearance	Related to process	May have stretch; larger than many other yarns	Large yarns may snag

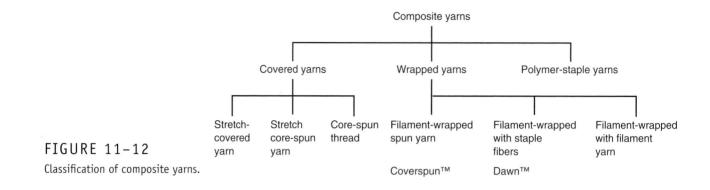

polymer yarns. The classification of composite yarns is shown in Figure 11–12. The quality of composite yarns is related to fiber and component ply quality, finished yarn structure, and yarn uniformity.

Covered yarns have a central yarn that is completely covered by fiber or another yarn. These yarns were developed to produce more comfortable rubber foundation garments and surgical hose. Stretch-covered yarns have a central core of rubber or spandex covered with at least one other yarn. Single-covered yarns have a single yarn wrapped around them. They are lighter, more resilient, and more economical than double-covered yarns and can be used in many woven and knit fabrics. Most ordinary elastic yarns are double-covered with two yarns to give them balance and better coverage. Fabrics made with these yarns are heavier and thicker (Figure 11–13). Covered yarns are subject to "grin-through" (see Figure 9–4). Although these yarns

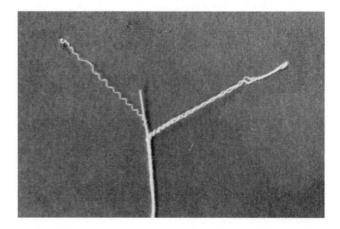

FIGURE 11–13

Double-covered stretch yarn.

include spandex, they should not be referred to as spandex varns.

An alternate way of making a stretch yarn is to make a stretch **core-spun yarn** by spinning a sheath of staple fibers (roving) around a core. When working with elastomeric cores, the core is stretched while the sheath is spun around it so that the core is completely hidden. The sheath adds aesthetic properties to the yarn, and the core provides comfort stretch. Core-spun yarns in woven fabrics produce an elasticity more like that of the knits.

Polyester/cotton core-spun sewing thread has a sheath of high-quality cotton and a high-strength filament polyester core. The cotton sheath gives the thread excellent sewability, and the polyester core provides high strength and resistance to abrasion. Polyester/cotton thread provides the slight stretch that is necessary in knits.

Wrap-spun yarns have a core of staple fibers (often a twistless yarn) wrapped or bound with filament fibers. These yarns are economical and have good evenness, strength, appearance, and finishing properties.

In **fasciated yarns**, a grouping of filament fibers is wrapped with staple fibers. The yarns are combinations of coarse filaments for strength and fine stretch-broken filaments for softness (Figure 11–14). These yarns are quick to produce and give better texture and hand to fabrics. Another variation is a filament-wrapped filament yarn (Figure 11–15).

Yarns can be produced by pressing staple fibers of any length or generic class into a molten polymer stream. As the polymer solidifies, the fibers that are partially embedded become firmly attached and form a sheath of staple fiber. The resultant yarn is about two-thirds staple fiber and one-third coagulated polymer. The polymer, which is an extruded manufactured fiber, is a less expensive product than other melt-spun filaments.

FIGURE 11–14 Fasciated yarn.

Yarn Performance and Yarn Quality

Yarn characteristics and performance are identified and measured so that an appropriate yarn is used in the fabric and product. Standard test methods determine yarn size, twist, bulk, evenness, appearance, and performance. Yarn strength is determined by measuring the load that breaks a yarn and the percent of elongation at that load. Tolerances or variations allowed in a yarn of a given type are measured so that consistency in performance and appearance can be evaluated.

Yarn quality is an important factor related to the quality of the resultant fabric and product. *Yarn quality* refers to various factors such as yarn strength and thin spots in yarns that are weaker and likely to break when the yarn is under stress. These thin spots, or nips, create thin, weak areas in fabrics or unacceptable variations in fabric appearance. Yarns must

be strong enough to withstand the stresses of looms and knitting machines. Strength demands on yarns depend on the structure of the fabric and its end use. Stress can be substantial during fabric production; yarn breaks are costly to repair and decrease fabric quality. Fabric producers demand high yarn quality and consistency of yarn characteristics at low prices. Yarn producers are responding to these demands by incorporating on-line systems to detect yarn defects to fix them as soon as they begin to develop in the spinning process.

Many factors determine the quality of a yarn. Better-quality varns have more parallel fibers, tighter twist, and are more regular than lower-quality yarns. High-quality yarns are strong enough to withstand additional processing (warping, weaving, knitting, etc.). High-quality yarns are regular in structure with few thin spots. They are relatively free of unacceptable neps and hairiness. A nep is a small knot of entangled fibers, that may be immature or dead and subsequently create problems by not accepting dye. Neps may create thick spots on varns or uncolored flecks in finished fabrics. Hairiness describes excessive fiber ends on the varn surface. Figure 11-16 shows differences in yarn hairiness due to spinning method. Hairy yarns may create problems in fabrication or in consumer use because they tend to be more sensitive to abrasion and pilling. Good-quality yarns facilitate subsequent dyeing and finishing steps. Their appearance and performance makes the finished material suitable for the end use and target market. Yarn quality affects fabric quality, performance, and cost.

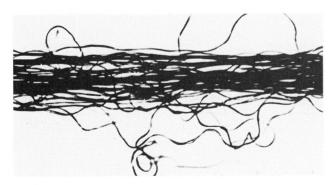

FIGURE 11-15
Filament-wrapped filament yarn. (Courtesy of Hercules, Inc.)

FIGURE 11–16
Yarn hairiness. (Courtesy of Textile World.)

Key Terms

Yarn Spun yarn Filament yarn Textured-bulk yarn Textured-bulk-filament yarn

Twist

Turns per inch (tpi) Turns per meter (tpm)

S-twist
Z-twist
Low-twist yarn
Napping twist
Average twist
Hard twist
Voile twist
Twist-on-twist
Crepe yarn
Yarn number
Denier

Single yarn Ply yarn Cord

Tex system

Simple varn

Decitex (dtex)

Sewing thread Fancy yarn Novelty yarn Tweed yarn Slub yarn Binder Slub effect yarn

Spiral or corkscrew yarn

Effect ply Ground ply Ratiné yarn

Knot, spot, nub, or knop

yarn

Spike or snarl yarn

Loop, curl, or bouclé yarn

Astrakhan cloth
Metallic yarn
Chenille yarn
Composite yarn
Covered yarn
Core spun yarn
Wrap-spun yarn
Fasciated yarn
Neps

Neps Hairiness

Questions

1. Describe the type of yarn (in terms of fiber length, yarn twist, yarn complexity, regularity, and size) that would likely be found in each of the following products. Explain the performance of each yarn selected.

percale sheeting in luxury hotel suite muslin sheeting in budget motel room tweed for woman's blazer carpet for family room upholstery for antique formal settee casual T-shirt denim jeans elastic wrap for sprained ankle casement cloth for draperies in dentist's waiting room

- 2. What differences in fiber length and turns per inch would be expected between a low-twist yarn and an average-twist yarn?
- **3.** Why are fancy or novelty yarns used? In what kinds of fabrics and for what uses are they most common?
- **4.** What are the differences and similarities between the denier and tex systems?
- **5.** What are the characteristics that differentiate between yarns of average quality and high quality?

Suggested Readings

American Society for Testing and Materials (2000). *Annual Book of ASTM Standards*, Vol. 7.01. West Conshohocken, PA.

Kadolph, S. J. (1998). *Quality Assurance for Textiles and Apparel*. New York: Fairchild Publications.

Slit film extrusion of polypropylene yarns. (May, 1990). *Textile Month*, pp. 53–54.

Tortora, P. G., and Merkel, R. S. (1996). *Fairchild's Dictionary of Textiles*, 7th ed. New York: Fairchild Publications.

Wiberley, J. S. (1984). "The analysis of textile structure." In: William J. Weaver, ed., *Analytical Methods for a Textile Laboratory*. Research Triangle Park, NC: American Association of Textile Chemists and Colorists.

FABRICATION

CHAPTER 12

Basic Weaves and Fabrics

CHAPTER 13

Fancy Weaves and Fabrics

CHAPTER 14

Knitting and Knit Fabrics

CHAPTER 15

Other Fabrication Methods

Chapter 12

BASIC WEAVES AND FABRICS

OBJECTIVES

- To understand the loom, the process of weaving, and the three basic weaves.
- To identify fabrics made using the three basic weaves.
- To name basic woven fabrics.
- To predict performance of fabrics based on fabrication, yarn structure, and fiber.

fabric is a pliable, planelike structure that can be made into two- or three-dimensional products that require some shaping and flexibility. Fabrics are used in apparel, furnishings, and many industrial products. The chapters in this section focus on methods used to produce fabrics and identify many fabrics by their current standard name for each method. Not all fabrics will be discussed for each process. Many fabrics have specialized applications; others are no longer popular due to changes in fashion or lifestyles. Some fabrics are no longer commercially available due to changes in consumer expectations, lifestyle, or production cost. Some remain important, but their names have changed.

The fabric-forming process or fabrication method contributes to fabric appearance, texture, suitability for end use, performance, and cost. The process may determine the name of the fabric, like felt, lace, double-knit, and tricot. The cost in relation to fabrication process depends on the number of steps involved and the speed of

production. The fewer the steps and the faster the process, the cheaper the fabric. Changes in fabrication have increased automation, improved quality, improved response to consumer demand, and made production more flexible so that a firm can produce a variety of fabrics with the equipment available.

Textile producers describe the shortest length of fabric they will produce to sell to another firm as *minimums* or *minimum yardage*. Firms specialize in high-quality fabrics, special fabric types, or high-volume basic fabrics. Minimum yardage depends on the firm and its area of specialization. For example, 5000 yards may be a minimum order for a basic fabric in a basic color, but 200 yards may be a minimum from a specialty-fabric producer.

Fabrics can be made from a wide variety of starting materials: solutions (films and foams), fibers (felts and fiberwebs or nonwovens), yarns (braids, knits, laces, and wovens), and fabrics (composite fabrics combining solutions, fibers, yarns, or fabrics to produce a fabric). The

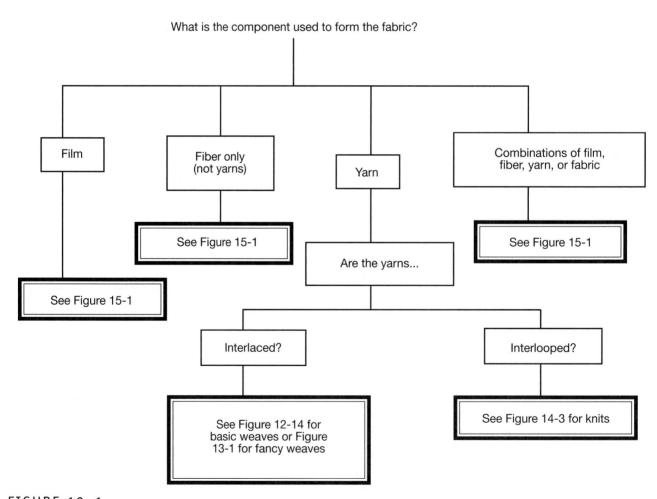

FIGURE 12-1
Fabric structure flow chart.

first three chapters of this section focus on fabrics made from yarns: woven and knitted fabrics. The final chapter focuses on all the other processes. Fabric names discussed in these chapters were selected because they are basic, commonly used fabrics. Many more named fabrics exist and can be found in the market. However, these other fabrics will not be discussed in this book. Several excellent resources are listed at the end of this chapter for additional information on fabrics not described in this book.

Determining the starting material used to make a fabric is the first step in identifying the fabric. Figure 12–1 is a flow chart to be used in determining how a fabric is named. This chart references other charts in this chapter, one of the other fabrication chapters, or Chapter 17 that will help in identifying and naming a fabric.

Fabric Quality

Fabric quality is important to textile producers, designers, retailers, and consumers because it describes many characteristics: freedom from defects, uniform structure and appearance, and performance during production and in consumers' hands. Fabric quality influences product cost, suitability for a target market, aesthetic characteristics, and consumer appeal and satisfaction. Assessment of quality can be made by inspecting or examining fabric with the eye or an instrument to identify visible irregularities, defects, or flaws. Computer-aided fabric evaluation (CAFE) systems speed this process and increase the accuracy of fabric inspection. Defects are assigned a point value based on their length or size. Fabric quality is graded by totaling the defect points of a piece of fabric. Production firms have developed lists or examples of defects or flaws and guidelines for fabric grading (Figure 12–2). Manufacturers of cut and sewn products determine the quality level suitable for their product line and target market and purchase fabric accordingly.

A second means of determining fabric quality assesses fabric performance. Standard test methods have been developed by several professional organizations to aid in performance assessment so that fabric evaluation is consistent. Standard fabric performance tests assess abrasion resistance, strength, wrinkle resistance, shrinkage during laundering or dry cleaning, colorfastness to light or perspiration, snag resistance, flammability, water repellency, consistency of color throughout a length of fabric, soil resistance, and many other characteristics. Fewer manufacturers assess fabric quality from a performance perspective than from a visual examination. Unfortunately, many consumer problems with textile products stem from minimal performance evaluation by manufacturers.

FIGURE 12–2
The defect in the center of this fabric decreases its quality and performance.

Woven Fabrics

With the exception of triaxial fabrics, all woven fabrics are made with two or more sets of yarns interlaced at right angles. Sometimes these fabrics are referred to as biaxial. The yarns running in the lengthwise direction are called **warp** yarns or *ends*, and the yarns running crosswise are called **filling** yarns, *weft*, or *picks*. The right-angle position of the warp to filling yarns produces more fabric firmness and rigidity than yarn arrangements in knits, braids, or laces. Because of this structure, yarns can be raveled from adjacent sides. Woven fabrics vary in the ways the yarns interlace, the pattern formed by this interlacing, the number of yarns per inch, and the ratio of warp to filling yarns.

Woven fabrics are widely used, and weaving is one of the oldest and most widely used methods of making fabric. Some fabric names are based on an earlier end use (hopsacking used in bags for collecting hops; tobacco cloth as shade for tobacco plants; cheesecloth to wrap cheeses; and ticking in mattress covers, once called "ticks"); the town in which the fabric was woven originally (bedford cord from New Bedford, Massachusetts; calico from Calcutta, India; chambray from Cambrai, France; and shantung from Shantung, China); or the person who originated or was noted for that fabric (batiste for Jean Baptiste, a linen weaver; and jacquard for Joseph Jacquard).

Woven fabrics used in apparel, furnishings, and industrial products have these characteristics:

- Two or more sets of yarns are interlaced at right angles to each other.
- Many different interlacing patterns give interest and texture to the fabric.

- Yarns can be raveled from adjacent sides.
- Fabrics have grain.
- Fabrics are relatively stable, with little stretch in warp or filling.

The Loom

Weaving is done on a machine called a **loom**. All the weaves that are known today have been made for thousands of years. The loom has undergone significant modifications, but the basic principles and operations remain the same. Warp yarns are held taut within the loom, and filling yarns are inserted and pushed into place to make the fabric.

In primitive looms, the warp yarns were kept upright or horizontal (Figure 12–3). Backstrap looms, used for hand weaving in many countries, keep the warp yarns taut by attaching one beam to a tree or post and the other beam to a strap that fits around the weaver's hips as the weaver stands, squats, or sits (Figure 12–3). Filling yarns are inserted by a shuttle batted through raised warp yarns. To separate the warp yarns and weave faster, alternate warp yarns were attached to bars that raised the alternate warp yarns. A toothed device similar to a fine comb pushed the filling yarns in place. Eventually, the bar developed into heddles and harnesses attached to foot pedals so the weaver could separate the warp yarns by stepping on the pedals, leaving the hands free for inserting the filling yarns.

During the Industrial Revolution, mass-production high-speed looms were developed. The modern loom consists of two beams, a warp beam and a cloth or fabric beam, holding the warp yarns between them (Figure 12-4). Warp varns that are sufficient for the length, width, and density of the fabric to be woven are wound carefully onto a warp beam. The warp will be raised and lowered by a harness-heddle arrangement. A harness is a frame to hold the heddles. The harness position, the number of harnesses, and the warp yarns that are controlled by each harness determine the weave pattern or interlacing. A heddle (headle) is a wire with a hole or eve in its center through which a warp varn is threaded. There are as many heddles as there are warp yarns in the cloth, and the heddles are held in two or more harnesses. Each warp yarn passes through the eye of only one heddle. The selection of the specific heddle and harness is a major factor in determining the structure of the fabric. Figure 12-4 illustrates how a simple two-harness loom is used to raise one harness while the other harness remains in its original position. With this arrangement, the varns form a shed through which the filling is inserted.

Carriers of several types carry filling yarns through the shed. The name of the loom often refers to the carrier used to insert the filling yarn. Originally, these carriers were fairly large, somewhat oval wooden shuttles with a bobbin of yarn in the center. In the shuttle loom, a **shuttle** is thrown through the shed by picker sticks at both sides of the loom. These sticks bat the shuttle first

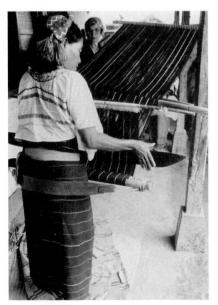

FIGURE 12-3

Hand looms: backstrap (left) and horizontal (right). (Courtesy of Mary Littrell.)

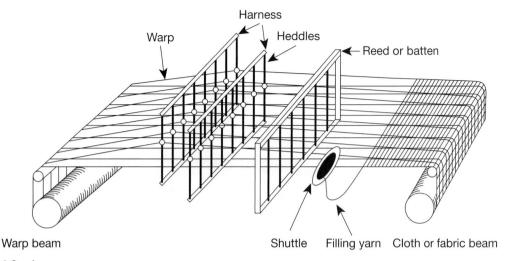

FIGURE 12-4

Simplified drawing of a two-harness shuttle loom.

from one side and then, after the shed has changed, back to the other side so quickly that the shuttle is a blur. Shuttle looms are limited to about 200 picks, or filling insertions, per minute. The noise of the picker sticks striking the shuttle is deafening. Looms with quieter and more efficient carriers, called shuttleless looms, will be discussed later in this chapter.

A **reed**, or *batten*, beats or pushes the filling yarn into place to make the fabric firm. A reed is a set of wires in a frame; the spaces between the wires are called **dents**. Warp yarns are threaded through the dents in the reed. The spacing in the reed is related to the desired number of warp yarns per inch in the woven fabric. Reeds are available with a wide variety of spacings related to the density of the yarns in the finished fabric and the size of the yarns. For example, 20-dent reeds are used for low-density fabrics with coarse yarns; 80-dent reeds are used for higher-density fabrics with finer yarns. The way the reed beats the filling yarn in place helps determine the density of filling yarns and the grain characteristics of the finished fabric. Woven fabric is rolled onto the cloth, fabric, or take-up beam as it is produced.

Weaving consists of the following steps:

- 1. **Shedding:** raising one or more harnesses to separate the warp yarns and form a shed.
- **2. Picking:** passing the shuttle through the shed to insert the filling.
- **3. Beating up:** pushing the filling yarn into place in the fabric with the reed.
- **4.** Take-up: winding finished fabric onto the fabric beam.

The most frequent type of commercial loom is a four-harness loom. This loom is extremely versatile and can be used to produce most basic woven fabrics. These fabrics comprise the greatest percentage of woven fabrics currently on the market and explain the popularity of the four-harness loom. Additional harnesses or other devices that control the position of the warp yarns are used to produce more intricate designs. However, generally six harnesses is the limit in terms of efficiency. Patterns that require more than six harnesses are made on looms that use other devices to control the warp yarns; these will be discussed later in this chapter.

Preparing for Weaving

Winding Yarns are repackaged so that they can be used to weave a fabric on a specific loom. This repackaging step is called **winding.** In this process, some spun yarns may be given more twist or combined with other singles to make ply yarns.

Creeling Yarn packages are placed on a large frame called a creel (Figure 12–5). The creel holds the yarn as it is wound onto a warp beam. To protect warp yarns from damage during weaving, they are treated with a sizing agent. After weaving, the fabric is removed from the cloth or take-up beam, washed to remove the sizing, finished to specification, and wound on bolts or tubes for sale to manufacturers or consumers. (See Chapters 16 to 19.)

Loom Advancements

Loom advancements have centered on (1) devices to weave intricate designs; (2) computers and electronic monitoring systems to increase speed, patterning capabilities, and quality by repairing problems and keeping looms operating at top efficiency; (3) quicker and more efficient means of inserting filling yarns; (4) automatic

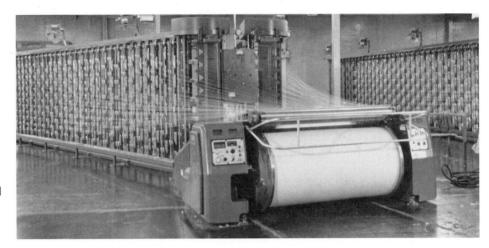

FIGURE 12-5

Creeling: spools of yarns are placed on a large creel and wound onto a warp beam. (Courtesy of West Point Foundry & Machine Company).

devices to speed the take-up of woven cloth and let-off or release more warp; and (5) devices that facilitate and speed up changing the warp.

Patterning Capabilities Devices that control the position (raised or lowered) of the warp yarns have included dobby, doup, lappet, and leno attachments and the jacquard loom. These have become so sophisticated that pictures can be woven in cloth (see Chapter 13). Warp yarns are individually controlled by microcomputers in some looms, referred to as electronic jacquards.

Computer Systems Computer and electronic devices are important in developing design tables for setting up "maximum weavability" properties, such as tightness and compactness in wind-repellent fabrics or tickings. CAD (computer-aided design) systems are used extensively to design fabric. Microcomputers control the operation of individual warp yarns to create the design. Quick Style Change (QSC) and electronic jacquards allow changes from one fabric style to another in 30 minutes or less, as compared with the several hours or more required with traditional jacquard looms. With QSC, shorter minimum yardage orders are possible.

Computerization of weaving has made tremendous advances in the past few years. Automation helps reduce fabric defects. Weaving quality and efficiency are improved. Automation of weave rooms is one goal in applying computer systems and robotics to fabric production. Some mills use automatic looms with multifunctional microcomputers. The computer alters loom operation so that high speeds of filling insertion are maintained while adjusting for minor changes in tension of both warp and filling yarns and winding up woven fabric. Computers detect incorrect filling insertions, remove the incorrect insertion, correct the problem, and restart the weaving operation. All this is done without the assistance of a human operator—weaverless weaving.

Loom Efficiency and Versatility Because of the noise and slower speeds, shuttle looms continue to be replaced with faster, quieter, more versatile shuttleless looms. Four types of shuttleless looms—air-jet, rapier, water-jet, and projectile—have higher weaving speeds and reduced noise levels. These factors are of great importance to the worker. In these looms, the filling yarns are measured, inserted, and cut, leaving a fringe along the side. These ends may make a fused selvage if the yarns are thermoplastic, or the ends may be tucked into the cloth. Shuttleless looms are more common than shuttle looms and are becoming more versatile. Many shuttleless looms can produce almost any basic weave or pattern in various varn types and sizes with multiple colors at widths up to 160 inches. Most shuttleless looms are air-jet or rapier types. Water-jet and projectile looms are less common.

Air-Jet Loom In the air-jet loom the filling is premeasured and guided through a nozzle, where a narrow jet of air sends it through the shed. The loom operates at speeds up to 1000 picks per minute and is suitable for spun filling yarns provided they are not too bulky or heavy. Good warp preparation is required. Air-jet looms weave fabrics up to 400 centimeters (157 inches) in width and are the predominant looms used in weaving sheeting and denim.

Rapier Loom The rapier loom weaves primarily spun yarns at up to 1000 picks per minute. The double-rapier loom has one metal arm about the size of a fingernail clipper, called carriers or "dummy shuttles," on each side of the loom. A measuring mechanism on one side of the loom measures and cuts the correct length of filling yarn to be drawn into the shed by the carriers. The two carriers enter the warp shed at the same time and meet in the center. The other carrier takes the yarn from the first carrier and pulls it across to the opposite side of

FIGURE 12-6
Carrier of a rapier shuttleless loom.

the loom. Figure 12–6 shows the carriers. This loom is widely used to produce basic cotton and woolen/worsted fabrics because it is more flexible than the airjet loom.

Water-Jet Loom The water-jet loom uses a high-pressure jet of water to carry the filling yarn across the warp (Figure 12–7). Water-resistant sizings must be used for the warp. Water-jet looms are used for nylon and polyester filament yarn fabrics. Excess water is removed from the loom by suction. The fabric is wet when it comes from the loom, so drying is an added cost. This loom is more compact, less noisy, and takes up less space than the conventional loom. It produces fabrics without yarn streaks or barré (a type of yarn streak). It operates at 400 to 600 picks per minute—two or three times faster than the conventional loom.

Projectile Loom In the **projectile loom**, one projectile with grippers carries the yarn across the full width of the shed. The yarn may be inserted from one or both sides. This loom is also called the missile or gripper loom and is used to produce specialty and technical fabrics.

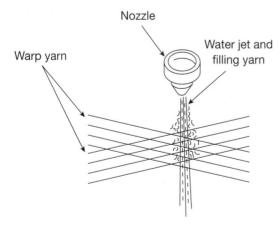

FIGURE 12-7
Water jet carries filling yarn through warp shed.

Double-Width Loom In double-width looms, twin warp beams allow two widths of fabric to be woven side by side. Because changing sheds is a time-consuming step in weaving, this loom makes optimal use of that time. Denim is often made on double-width looms.

Multiple-Shed Loom In each of the looms discussed so far one shed forms at a time. In multiple-shed weaving more than one shed is formed at a time. In warp-wave looms, just before a yarn carrier enters one portion of the warp, a shed is formed; just after the carrier leaves that area, the shed changes. This action may occur simultaneously across the width of the warp several times. In weft-wave looms, several sheds form along the length of the warp yarns and open at the same time, one filling yarn is inserted into each shed, and then the sheds change.

As many as 16 to 20 filling carriers insert the precut filling in a continuous process instead of the intermittent process of single-shed weaving. Beating up and shedding arrangements are different. In this continuous-weaving process, the number of picks per minute (ppm) is doubled. However, multiphase looms have never been extensively used in the industry.

Circular Loom Most looms weave flat widths of fabric. Circular looms weave tubular fabric, such as pillowcases. The circular loom in Figure 12–8 weaves sacks of split-film polypropylene.

Triaxial Loom This loom weaves three sets of yarns at 60-degree angles to each other (Figure 12–9). In triaxial weaving, all the yarns are usually alike in size and twist. Two yarn sets are warp and the other set is filling. Fabrics can be produced more quickly than other weaves because there are fewer picks per inch, and the speed of weaving is based on the number of picks per minute. Triaxial fabrics are stable in horizontal, vertical, and bias directions. Biaxial fabrics (two sets of yarns at right angles to each other) are not stable on the bias. Triaxial fabrics are used for balloons, air structures, sail-cloth, diaphragms, truck covers, and other technical products.

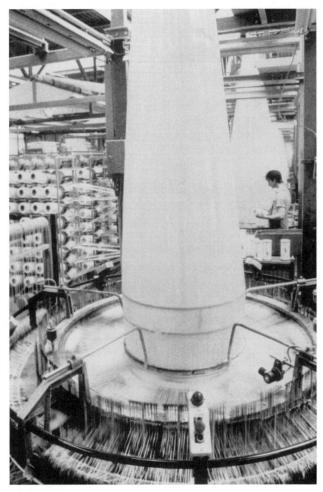

FIGURE 12-8
Circular loom used to weave bags. (Courtesy of Amoco Fabrics & Fibers Co.)

Environmental Impact of Weaving

Environmental problems associated with weaving are related to the type of loom used to produce a fabric. For example, shuttle looms are incredibly noisy. Loom operators in shuttle weaving rooms wear hearing protectors to minimize hearing loss. Water-jet looms require the use of clean water to carry the filling yarn across the fabric. This water is reclaimed and recycled. Fabrics produced with this loom must be dried before storage to reduce problems with mildew, and the energy used in drying fabrics is great.

Energy use varies significantly with the type of loom. For example, rapier looms use almost twice the energy of projectile looms, and air-jet looms use almost three times the energy of projectile looms.

Warp yarns are treated with sizing or lubricating compounds to minimize problems with abrasion in weav-

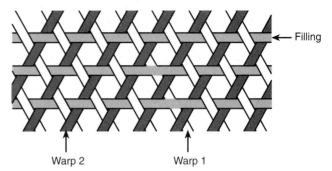

FIGURE 12-9

Triaxial weave pattern. (Courtesy of Barbara Colman Co.)

ing. Sizing and lubricating compounds are removed after the fabric has been produced and are often reclaimed, but reclamation is not 100 percent efficient and it is necessary to dispose of the residue. Lint is a problem resulting from yarn abrasion during weaving and creates fabric quality and respiratory problems. Vacuum heads attached to flexible tubing move through weaving rooms to remove lint and minimize health, quality, and equipment problems. Finally, static electricity can build up in weaving when synthetic fibers are used. Humidity is controlled to minimize static charges.

The industrywide trend of producing better-quality fabric improves efficiency and lessens the environmental impact. Fewer fabric flaws means less recutting of product pieces and fewer seconds from cut-and-sew production facilities.

Characteristics of Woven Fabrics

All yarns in furnishing and apparel woven fabrics interlace at right angles to one another (Figure 12–10). An interlacing is the point at which a yarn changes its position from one side of the fabric to the other. When a yarn crosses over more than one yarn at a time, floats are formed and the fabric has fewer interlacings.

Warp and Filling

Warp and filling yarns have different demands placed on them and may differ in their structure or fiber type. Thus, a fabric may not have the same performance characteristics for warp and filling. The warp must withstand the high tensions of the loom and the abrasion of weaving, so the warp yarns are stronger and more uniform with higher twist. Filling yarns are more often fancy or special-function yarns such as high-twist crepe yarns, low-twist napping yarns, or bouclé yarns.

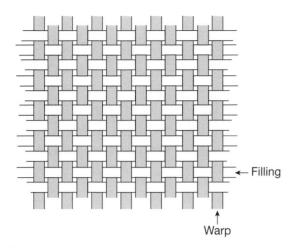

FIGURE 12-10

Warp and filling yarns in woven fabrics. Note that the yarns in this diagram interlace at 90-degree angles.

Differentiating between warp and filling is possible by carefully examining both the fabric and the lengthwise and crosswise yarns.

- 1. The selvage always runs in the lengthwise (warp) direction of all fabrics.
- 2. Most fabrics have lower elongation in the warp direction.
- **3.** The warp yarns lie straighter and are more parallel in the fabric because of loom tension.
- **4.** Fancy or special-function yarns are usually in the filling direction.
- **5.** Fabric characteristics may differentiate between the warp and filling directions. For example, poplin has a filling rib and satin has warp floats.
- **6.** Warp yarns tend to be smaller, are more uniform in structure and appearance, and have higher twist.
- 7. Fabric crimp is usually greater for filling yarns since they must bend or flex over or under warp yarns due to the way the loom operates.

Grain

Grain refers to the geometry or position of warp yarns relative to filling yarns in the fabric. A fabric that is *ongrain* has warp yarns parallel to each other and perpendicular to the filling yarns that move straight across the fabric. Lengthwise grain is parallel to the warp yarns. Crosswise grain is parallel to the filling yarns. Fabrics are almost always woven on-grain. Handling, finishing, or stress due to yarn twist, weave, or other fabric aspects may cause fabrics to distort and lose their on-grain characteristic. These fabrics are off-grain. Fabric quality has increased significantly and it is rare to find fabrics as badly off-grain as those illustrated in Figures 12–11 and 12–12.

Off-grain fabrics create problems in production and use. During finishing, off-grain causes reruns or repeating finishing steps and lowers fabric quality. Products do not drape properly or hang evenly and printed designs are not straight. Figure 12–11 shows a design that has been printed off-grain—the print does not follow the yarns or a torn edge.

There are two kinds of off-grain. **Skew** occurs when the filling yarn is at an angle other than 90 degrees to the warp. It usually occurs in finishing when one side of the fabric travels ahead of the other (see Figure 12–11). **Bow** occurs when the filling yarns dip in the center of the fabric; it usually develops when the fabric center lags behind the two sides during finishing (Figure 12–12).

Fabrics should always be examined for grain. Ongrain fabrics usually indicate high quality standards and minimize problems in matching designs or patterns, in cutting and sewing.

Fabric Count

Fabric count, count, or fabric density is the number of warp and filling yarns per square inch of gray goods (fabric as it comes from the loom). Count may increase due to shrinkage during dyeing and finishing. Count is

FIGURE 12-11
Skewed fabric.

FIGURE 12-12

Bowed fabric. Note the horizontal lines traced on the fabric. The darker line traces a yarn in the fabric; the lighter and straighter line indicates the crosswise grain of the fabric.

written with the warp number first, for example, 80×76 (read as 80 by 76); or it may be written as the total of the two, or 156. Count is not synonymous with yarn number.

Count is an indication of the quality of the fabric—the higher the count, the better the quality for any fabric. Higher count also may mean less shrinkage and less raveling of seam edges. Catalogs and e-commerce sites may include count because the customer must judge product quality from printed information rather than by examining the product.

Count can be determined with a fabric counter (Figure 12–13) or by hand. The number of yarns in each direction is counted for an inch.

Count may vary depending on the end use or quality of fabric. Often it is listed as a total and may be described on labels as thread count, even though yarns, not threads, are counted. For example, two plain-weave fabrics often used in bed sheets are percale and muslin. Percale is a higher-quality fabric made of combed yarns in counts of 160, 180, 200, or more. Muslin is a harder-wearing fabric designed for lower price points. It is usu-

FIGURE 12–13
Fabric yarn counter. (Courtesy of Alfred Suter Co.)

ally made of carded yarns in counts of 112, 128, or 140. It is frequently used in bed linens for budget motels and hospitals. Higher numbers indicate better-quality fabrics.

Balance

Balance is the ratio of warp yarns to filling yarns in a fabric. A balanced fabric has approximately one warp yarn for every filling yarn, or a ratio of 1:1 (read as one to one). An example of a balanced fabric is 78×78 print cloth. An unbalanced fabric has significantly more of one set of yarns than the other. A typical unbalanced fabric is broadcloth, with a count of 144×76 and a ratio of about 2:1.

Balance is helpful in recognizing and naming fabrics and in distinguishing the warp direction of a fabric. Balance plus count is helpful in predicting slippage. When the count is low, there will be more slippage in unbalanced fabrics than in balanced fabrics.

Balance can be determined by examining a fabric carefully. If the fabric can be raveled, unravel several yarns on adjacent edges and compare the density and size of yarn ends protruding from the fabric. In a balanced fabric, warp and filling yarns are nearly identical in size and count. In fact, in balanced fabrics, it may be difficult to differentiate between warp and filling yarns when the selvage is not present. In unbalanced fabrics, warp and filling yarn size may be significantly different or the density between warp and filling yarns may be different.

Selvages

A **selvage** is the lengthwise self-edge of a fabric. On conventional shuttle looms, it is formed when the filling yarn turns to go back across the fabric. The conventional loom makes the same kind of selvage on both sides of the fabric, but shuttleless looms have different selvages because the filling yarn is cut and the selvage looks like a fringe. In some fabrics, different yarns or interlacing patterns are used in the selvage.

Plain selvages are similar to the structure of the rest of the fabric. They do not shrink and can be used for seam edges. Tape selvages used in sheeting are made with larger or plied yarns for strength. They are wider than the plain selvage and may be a different weave to maintain a flat edge. Split selvages are used when items such as towels are woven side by side and cut apart after weaving. These edges require hemming. Fused selvages are found in narrow fabrics of thermoplastic fibers cut from wide fabric.

Fabric Width

The loom determines the width of the fabric. Handwoven fabrics are narrow, often 27 to 36 inches wide. Fabric widths have been increasing because wide fabrics are more economical to weave and allow for more efficient use of fabric in products. Traditional fabric widths are related to fiber type: cotton fabrics are 45 or 60 inches wide, wool fabrics are 54 to 60 inches wide, and silk-type fabrics are 40 to 45 inches wide. However, some basic fabrics, regardless of fiber type, now exceed 60 inches in width.

Fabric Weight

Fabric weight or *fabric mass* describes how much a fabric weighs for a given area or length of fabric. Fabric weight is important because it is used to identify fabric appropriateness for end use and in naming fabrics. Both length and area weight values are used in the textile industry. For example, yards per pound may be used in trade publications to identify current prices for basic fabrics, but fabric width is crucial in this system. Another system uses weight in ounces per square yard (oz/yd²). The metric equivalent is g/m² (grams per square meter).

Lightweight or top-weight fabrics are those that weigh less than 4.0 oz/yd². They are softer and more comfortable next to the skin and have better drape. Top-weight fabrics are used for shirts, blouses, dresses, apparel linings, bedsheets, curtains, sheer draperies, substrates for industrial products, and backing fabrics for wall coverings and bonded and quilted fabrics.

Medium-weight fabrics weigh from 4.0 to 6.0 oz/yd². They are widely used for heavier and stiffer shirts, blouses, dresses, apparel linings, winter-weight bedsheets, draperies, upholstery, wall coverings, and table linens. Many medium-weight fabrics are used in quilted and bonded fabrics and as substrates for industrial products.

Heavyweight fabrics also are described as bottomweight goods because they are used for apparel bottoms like pants and skirts. They weigh more than 6.0 oz/yd². They are durable, stiff fabrics used for outerwear, work clothing, upholstery, draperies, and bedspreads.

Properties of Woven Fabrics

Fabric properties resulting from weaving variables are summarized in Table 12–1.

The weave or interlacing pattern influences fabric properties as well as fabric appearance. Table 12–2 summarizes the various weaves. This chapter and Chapter 13 deal with woven fabrics.

Naming and Diagramming Woven Fabrics

Fabric names are based on many factors: fabric structure, fabric weight, yarn type, yarn balance, and finishes. Figure 12–14 is a flow chart that will help in determining fabric names for basic weaves. Basic weaves are those that are made on a loom without any modification. The remainder of this chapter focuses on basic woven structures and the standard fabrics made using these weaves. These fabrics are made of simple weaves that incorporate the same interlacing pattern throughout the fabric. Using the flow chart in Figure 12–14 should help in

TABLE 12-1 Pr	operties of woven fabrics.
Fabric characteristic	Properties
High count	Firm, strong, good cover and body, compact, stable, more rigid drape, wind- and water- repellent, less edge raveling.
Low count	Flexible, permeable, pliable, softer drape, higher shrinkage potential, more edge raveling.
Balanced	Less seam slippage, warp and filling wear more evenly.
Unbalanced (usually more warp)	Seam slippage with low count; surface yarns wear out first, leaving slits (common in upholstery fabrics). Add visual and tactile interest.
Floats	Lustrous, smooth, flexible, resilient, may ravel and snag, seam slippage with low count.

Name	Interlacing Patterns	General Characteristics	Typical Fabrics	Chapter Reference
Plain $\frac{1}{1}$	Each warp interlaces with each filling.	Most interlacings. Balanced or unbalanced. Wrinkles. Ravels. Less absorbent.	Batiste Gingham Broadcloth Crash Cretonne Print cloth Glazed chintz	12
Basket 2 1 2 2 2 4 4 .	Two or more yarns in warp, filling, or both directions woven as one in a plain weave.	Looks balanced. Fewer interlacings than plain weave. Looks flat. Wrinkles. Ravels more.	Oxford Monk's cloth Duck Sailcloth	12
$\frac{2}{1}$ $\frac{2}{2}$ $\frac{4}{4}$ Twill $\frac{2}{1}$ $\frac{2}{2}$ $\frac{3}{1}$	Warp yarns float over two or more filling yarns in a regular progression of one to the right or left.	Diagonal lines or wales. Fewer interlacings than plain weave. Wrinkles. Ravels more. More pliable than plain weave. High counts possible.	Serge Surah Denim Gabardine Herringbone Flannel	12
Satin	Warp yarns float over four or more filling yarns in a progression of two to the right or left.	Flat and lustrous surface. High counts possible. Fewer interlacings. Long floats may slip and snag. Ravels.	Satin Sateen Antique satin Peau de soie	12
Momie or crepe	An irregular interlacing of yarns. Floats of unequal lengths in no discernible pattern.	Rough-looking surface. Crepelike.	Granite cloth Moss crepe Sand crepe Bark cloth	13
Dobby	Many different interlacings. Used to create geometric patterns.	Simple patterns. Cord-type fabrics.	Shirting madras Huck toweling Waffle cloth Piqué	13
Jacquard	Each warp yarn controlled individually. An infinite number of interlacings is possible.	Intricate patterns.	Damask Brocade Tapestry	13
Doublecloth	Several possible patterns use three, four, or five sets of yarns.	Thick, stiff, durable, warm fabrics.	Doublecloth Suitings Coatings	13
Pile	Extra warp or filling yarns are woven in to give a cut or an uncut three-dimensional fabric.	Plush or looped surface. Warm. Wrinkles less. Pile may flatten.	Velvet Velveteen Corduroy Furlike fabrics Wilton rugs Terrycloth	13
Slack-tension	A variation of pile weave. Some warp yarns are under little tension in the loom to create texture or pile.	Crinkle stripes or pile surface. Absorbent. Nonwrinkling.	Seersucker Terrycloth Friezé	13
Leno	A doup attachment on the loom crosses one warp yarn over a second warp yarn.	Meshlike fabric. Lower-count fabrics resist slippage.	Marquisette Sheer curtain fabrics	13
Swivel	An attachment to the loom. Small shuttles weave in extra filling yarns and	Dots on both sides of fabric as filling floats.	Dotted swiss	13

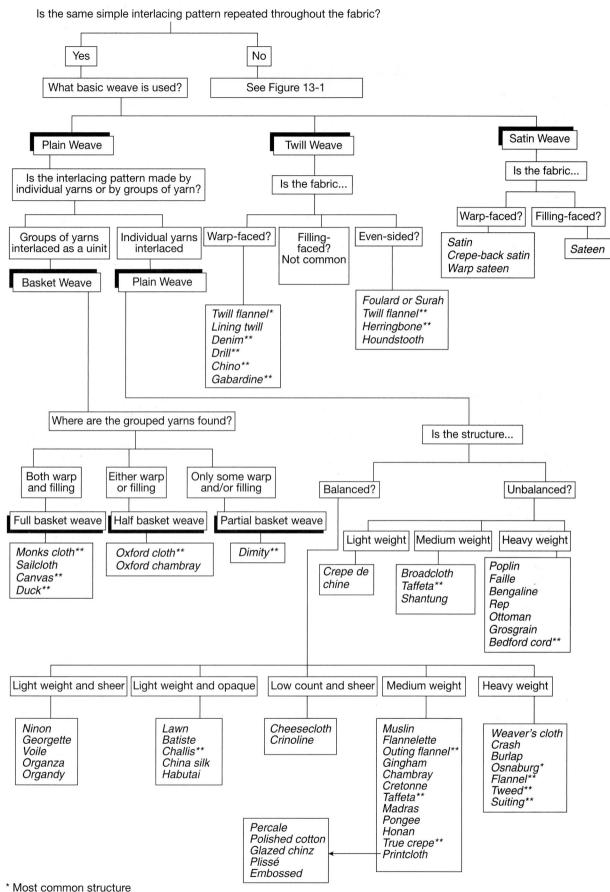

** More than one structure possible

FIGURE 12-14

Basic woven fabric flow chart.

determining what to look for when trying to differentiate among fabrics and when naming a fabric.

Fabric structure can be represented in several ways. Understanding these representations may help in recognizing how a term such as plain weave describes a fabric's structure. It may also help you learn how to identify each of the basic weaves. A basic plain weave will be used to explain these ways of representing fabric structure because it is the simplest woven fabric structure. Figure 12-15 shows several ways of diagramming a woven fabric. The top left drawing is a cross-sectional view of a fabric cut parallel to a filling yarn. The cut ends of the warp yarns appear as black circles. The filling yarn goes over the first warp varn and under the second warp varn and so on all the way across the fabric. The second filling yarn in a plain weave goes under the first warp varn and over the second warp yarn and repeats that pattern across the fabric. After the first two filling yarns, this means of representing fabric structure is not effective because the paths of filling yarns are not easy to see. However, in basic woven fabrics the interlacing pattern relates to the number of warp yarns the filling yarn passes over or passes under, and that pattern can be identified easily with this cross-sectional method of diagramming.

The photograph of the fabric on the right of Figure 12–15 shows the same plain-weave interlacing pattern as in the cross section. Since the yarns are opaque in the photograph, only yarns on the surface are visible. Hence, a pattern of dark warp yarns and light filling yarns develops. When the fabrics were photographed for this book, they all were positioned so that the warp is parallel to the up and down direction of the page and the filling yarn is parallel to the crosswise direction of the page.

The checkerboard pattern in Figure 12–15 is a simple representation of the photograph of the plain-weave example. In the checkerboard pattern, each square represents one varn on the surface of the fabric; dark squares represent warp yarns on the surface and light squares represent filling yarns on the surface. Starting at the upper left-hand corner of the checkerboard and moving across the row, a filling varn is on the surface, then a warp varn is on the surface, and so on. The second row is just the opposite and represents the interlacing pattern of the second filling varn. All woven fabrics can be diagrammed using this technique, but the pattern will differ with the specific structure being diagrammed. Of course, actual fabrics will not be as easy to identify because yarns may differ in size or count, yarns may all be the same color, and prints or finishes may make the structure harder to see. These diagramming methods are an easy way to represent interlacing patterns and to help you identify the weave in a fabric.

Plain Weave

The plain weave is the simplest of the three basic weaves. The plain weave is formed by yarns at right angles passing alternately over and under each other. Each warp yarn interlaces with each filling yarn to form the maximum number of interlacings (Figure 12–15). Plain weave requires only a two-harness loom and is the least expensive weave to produce. It is described as a $\frac{1}{1}$ weave, read as one harness up and one harness down or as one up, one down, which describes the position of the harness when forming the shed.

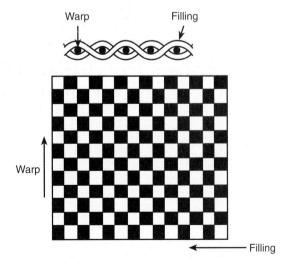

FIGURE 12-15

Three ways to show the yarn-interlacing pattern of a plain weave: cross section (top left); checkerboard (bottom left); photograph (right).

Thus, when the filling yarn is inserted and pushed into place, it goes over the first warp yarn and under the second warp yarn. In a plain-weave fabric, this pattern is repeated until the filling yarn has interlaced with all the warp yarns across the width of the loom. The second filling yarn goes under the first warp yarn and over the second. This pattern also is repeated across the width of the loom. Note how these two filling yarns interlace with the warp yarns to produce the maximum number of interlacings. In a plain weave, all odd-numbered filling yarns have the same interlacing pattern as the first filling yarn, and all even-numbered filling yarns have the same interlacing pattern as the second filling yarn.

Plain-weave fabrics have no technical face or back due to the weave. Printing and some surface finishes may create a technical face or "right" side. Plain weave's uninteresting surface serves as a good ground for printed designs and many finishes. Because there are many interlacings per square inch, plain-weave fabrics tend to wrinkle easily and be less absorbent than other weaves, but raveling may be less of a problem. However, yarn type and finishes are a significant factor in raveling. Interesting effects can be achieved by varying fiber types or by using novelty or textured yarns, yarns of different sizes, high- or low-twist yarns, filament or staple yarns, and finishes.

Balanced Plain Weave

The simplest plain weave is one in which warp and filling yarns are the same size and the same distance apart so that they show equally on the surface—balanced plain weave (see Figure 12–15). Balanced-plain-weave fabrics have a wider range of end uses than fabrics of any

other weave and are the most widely used type of woven fabric. They can be made in any weight, from very light to very heavy (Table 12–3).

One convenient way of grouping fabrics is by fabric weight. Balanced-plain-weave fabrics will be discussed in five groups: lightweight sheer, lightweight opaque, low-count sheer, medium weight, and heavyweight. All of these categories could incorporate narrow fabrics, those that are no wider than 12 inches.

Lightweight Sheer Fabrics Lightweight sheer fabrics are very thin, weigh very little, and are transparent or semitransparent. High-count sheers are transparent as a result of the fineness of yarns. Fabric weight is less than 4.0 oz/yd². Fabrics are used for lightweight apparel and curtains.

Filament-yarn sheers may be described in part by fiber content; for example, polyester sheer or nylon sheer. Ninon is a filament sheer that is widely used for sheer curtains. It is usually 100 percent polyester because of that fiber's resistance to sunlight, excellent resiliency, and easy washability. Although ninon is a plain weave, warp yarn spacing is not uniform across the fabric. Pairs of warp yarns are spaced close to each other. The space between adjacent warp-yarn pairs is greater than the space between the two yarns in the pair. Ninon has medium body and hangs well.

Georgette and chiffon are made with filament yarns, the latter being smoother and more lustrous. In georgette, the direction of the crepe twist (S or Z) for warp and filling yarns alternates. For example, even-numbered warp and filling yarns may be S-twist and odd-numbered yarns may be Z-twist. Chiffon has smaller yarns in a hard twist. Both fabrics can be a solid color or printed.

Fabric	Typical Count	Yarr	n Size	Category
		Warp	Filling	
Lawn	88 × 80	70s*	100s*	Lightweight opaque
Organdy	Similar to lawn	Similar	to lawn	Lightweight sheer
Batiste	Similar to lawn	Similar	to lawn	Lightweight opaque
Print cloth, (muslin, percale, plissé, calico, chintz)	$80 \times 80 \text{ to } 64 \times 60$	28s	42s	Medium weight
Gingham		Same as	print cloth	Medium weight
Carded	64×60 to 64×76			
Combed	84×76 to 88×84			
Suiting	48×48 to 66×76	13s to 20s		Heavyweight

^{*}The "s" after the number means that the yarn is a single yarn.

Both are very lightweight, drape well, and are used in apparel. Both fabrics were originally made of silk but now often are made from manufactured filament yarns.

Voile is a sheer fabric made with high-twist or voiletwist spun yarns that are combed or worsted. It can be solid color or printed. Voile was originally a cotton or wool fabric, but it is now available with many fiber contents.

Organdy is the sheerest cotton cloth made. Combed yarns contribute to its sheer appearance. Its sheerness and crispness are the result of an acid finish on lawn gray goods (see Chapter 17). Because of its stiffness and fiber content, it is very prone to wrinkling. Organza is the filament-yarn counterpart to organdy. It has a lot of body and a crisp hand. These sheer fabrics are used for curtains and for summer-weight apparel. Both fabrics are available in solid colors or prints.

Lightweight Opaque Fabrics Lightweight opaque fabrics are very thin and light but are not as transparent as sheer fabrics. The distinction between the two groups of fabrics is not always pronounced. Fabric weight is less than 4.0 oz/yd². End uses include apparel and furnishings.

Organdy (a sheer fabric), lawn, and batiste begin as the same gray goods. They differ from one another in the way they are finished. Lawn and batiste do not receive the acid finish and, thus, remain opaque. Betterquality fabrics are made of combed yarns. **Lawn** is often printed and is usually all cotton or cotton/polyester.

Batiste is the softest of the lightweight opaque fabrics. It is made of cotton, wool, polyester, or a blend. Tissue ginghams and chambray are similar in weight but are varn-dved.

China silk is similar to batiste, except that it is made from slightly irregular fine-filament yarns. It is a soft fabric that was originally made of silk and used for women's suit linings and matching blouses. Habutai is slightly heavier than China silk. The most common weight is 10 momme (see Chapter 5). Both fabrics can be dyed or printed.

Challis (shal'-ee) tends to be heavier than the fabrics discussed so far and, depending on fiber content and fashion, it may be a medium-weight fabric. Challis is usually made with spun carded yarns and may be slightly napped so that a few fiber ends are raised to the surface. A classic challis fabric is wool in a paisley print. It is soft and drapes well. Challis usually is printed and slightly napped and frequently is made from rayon.

Low-Count Sheer Fabrics Low-count sheer fabrics include cheesecloth, crinoline, buckram, and bunting. They are transparent because of open spaces between the yarns. They are made of carded yarns of size 28s and

30s in the warp and 39s and 42s in the filling. Count ranges from 10×12 to 48×44 . These fabrics are neither strong nor durable, are seldom printed, and differ in the way they are finished. They are functional fabrics that may be used for decorative and industrial purposes, or as shaping or support fabrics in apparel and furnishings. (See the Glossary at the end of the book for more information about these fabrics.)

Medium-Weight Fabrics Medium-weight fabrics comprise the most widely used group of woven fabrics. These fabrics have medium-sized yarns and a medium count, with carded or combed yarns. They may be finished in different ways or woven from dyed yarns. They may be called top-weight fabrics because they are frequently used for blouses and shirts. Medium-weight fabrics are also used to produce many furnishing items, such as wall and window-treatment fabrics, bed and table linens, and some upholstery fabrics. Fabric weight ranges from 4.0 to 6.0 oz/yd².

The fabrics in this group are converted from a gray goods cloth called **print cloth.** Yarns can be carded or combed, depending on the desired count, quality, and cost of the finished fabric. Yarn size ranges from 28s to 42s. Count ranges from 64×60 to 80×80 . Figure 17–1 shows the variety of ways these fabrics can be finished. Chapter 17 will explain some of the differences in fabrics due to finishing. For example, two fabrics converted from print cloth are plissé and embossed.

Percale is a smooth, slightly crisp, printed or plaincolored fabric made of combed yarns. In percale bed
sheets, counts of 160, 180, 200, and 250 are available.
Percale is called calico if it has a small, quaint, printed
design; chintz if it has a printed design; and cretonne if
it has a large-scale floral design. When a fabric is given
a highly glazed calendar finish, it is called polished cotton. When chintz is glazed, it is called glazed chintz.
Glazed chintz is made in solid colors as well as prints.
These fabrics are often made with blends of cotton and
polyester or rayon. They are used for shirts, dresses,
blouses, pajamas, matching curtains and bedspreads, upholstery, slipcovers, draperies, and wall coverings.

Any plain-woven, balanced fabric of carded yarns ranging in weight from lawn to heavy bed sheeting may be called **muslin**. It is usually available in counts of 112, 128, or 140. Muslin is also a name for a medium-weight fabric that is unbleached or white.

Napped fabrics may be of either medium or heavy weight. Flannelette can be found as both balanced- and unbalanced-plain-weave fabrics that are lightly napped on one side. It is available in several weights, ranging from 4.0 to 5.7 oz/yd². It is described as flannel and is used for sheets, blankets, and sleepwear. Outing flannel is heavier and stiffer than flannelette; it may be napped

FIGURE 12-16
Gingham fabrics: yarn-dyed checks and plaids.

on one or both sides. It is used for shirts, dresses, light-weight jackets, and jacket linings. Some outing flannels are made with a twill weave. Both fabrics may be solid color, yarn-dyed, or printed.

Ginghams are yarn-dyed fabrics in checks, plaids, or solids (Figure 12–16). Chambrays are yarn-dyed. Their color may look solid but have white filling and coloredwarp yarns, or they may have darker yarns in the filling (iridescent chambray), or they may have stripes.

Ginghams and chambrays are usually made of cotton or cotton blends. Better-quality fabrics are made with combed yarns. When they are made of another fiber, the fiber content is included in the name; for example, silk gingham. When filament yarns are used, these fabrics are given a crisp finish and called **taffeta**. In wool, similar fabrics are called wool checks, plaids, and shepherd's checks. **Madras**, or *Indian madras*, is usually all cotton, and has a lower count than gingham.

Stripes, plaids, and checks present problems that do not occur in solid-colored fabrics. The design of ginghams may be up and down, right and left, or both. In order to match the seams of plaid materials, more time is needed to cut an item out, more attention must be given to the choice of design, and more care must be taken during production.

Imitations of yarn-dyed fabrics are made by printing. However, there is a technical face (front or right side) and a technical back (back or wrong side) to the print, whereas true yarn-dyed fabrics are the same on both sides. Lengthwise printed stripes are usually ongrain, but the crosswise stripes may be off-grain.

Pongee is a filament-yarn, medium-weight fabric. It has a fine warp of uniform yarns with slub filling yarns

that are irregular in size. It was originally silk with duppioni (slub) filling yarns, but is now made of a variety of fibers. **Honan** is similar to pongee, but it has slub yarns in both the warp and the filling.

Plain-weave fabrics with crepe yarns in either warp or filling or in both warp and filling are known as **true crepe.** They can be any weight, but are most often medium weight or heavy weight. Because of their interesting texture and lively drape, these fabrics are frequently used by designers for apparel and furnishings. In apparel, true crepes are found in both weights and are used in suits, coats, and dresses. In furnishings, true crepes are common in upholstery, draperies, and wall coverings. True crepes sometimes are used in table linens.

Heavyweight Fabrics Heavyweight fabrics are also known as suiting-weight or bottom-weight fabrics. These fabrics weigh more than 6.0 oz/yd² and are heavy enough to tailor and drape well. Their filling yarns are usually larger than the warp yarns and have a slightly lower twist. Because of their weight, these fabrics are more durable and more resistant to wrinkling than are sheer or medium-weight fabrics, but they tend to ravel more because of the lower count.

Weaver's cloth is a general name for cotton suiting that is converted from a gray goods called coarse sheeting. Cotton suiting is solid color or printed.

Homespun describes furnishing fabrics with slightly irregular yarns, a lower count, and a handwoven look.

Crash is made with yarns that have thick-and-thin areas, giving it an uneven nubby look. It is often linen or a manufactured fiber or fiber blend that looks like linen. The irregular surface shows wrinkles less than a plain surface does. *Butcher rayon* or butcher cloth is a similar fabric of 100 percent rayon or rayon/polyester. Heavier weights look like linen crash.

Burlap or **hessian** has a much lower count than crash. It is used in wall coverings. It has characteristic coarse, thick-and-thin yarns and is made of jute.

Osnaburg is a variable-weight fabric most often found in suiting weight. Like muslin, it may be unbleached or bleached. In general it is a lower-quality fabric than muslin, with a lower count. Bits of leaf and bark from the cotton plant produce a characteristic spotted appearance. It is a utility fabric used as a drapery lining, upholstery support fabric, or substrate for tufted upholstery fabric. When printed or dyed, it is used in upholstery and drapery or apparel fabrics.

Flannel is a suiting fabric of woolen yarns that is napped. It is used for women's suits, slacks, skirts, and jackets. It may have a plain or twill weave.

Tweed is made from any fiber or blend of fibers and is always characterized by novelty yarns with nubs of different colors. *Harris tweed* is handwoven in the Outer

Hebrides Islands and carries a certified registered trademark. *Donegal tweed* is handwoven in Donegal County, Ireland.

Tropical worsted suitings are made from long-fiber worsted yarns and typically weigh from 6 to 10 oz/yd². They are wool-like fabrics made for men's suits, intended for use in warmer weather. Blends are common.

Heavyweight balanced-plain-weave fabrics are often used in furnishings such as wall coverings, upholstery, and draperies. Company-specific names are common.

Unbalanced Plain Weave

In an **unbalanced plain weave**, there are significantly more yarns in one direction than the other. Increasing the number of warp yarns in a plain-woven fabric until the count is about twice that of the filling yarns creates a crosswise ridge called a filling **rib**. In such a fabric, the warp yarns completely cover the filling yarns. This type of fabric may be called warp faced because the warp yarns form the surface of the fabric. Warp-faced fabrics are more durable than filling-faced fabrics. Ribs in fabric can be produced by increasing the reed pressure (pushing more yarns into the same area) or by changing yarn size. Small ridges are formed when the warp and filling yarns are the same size; larger ridges are formed when the filling yarns are larger than the warp. Typical yarn sizes are listed in Table 12–4.

When yarns differ in color, the color showing on the surface will be that of the yarn with the greater count. Figure 12–17 shows an unbalanced-plain-weave fabric and the checkerboard diagram.

Identification of an unbalanced fabric may not be easy. To assist in identification, ravel adjacent sides until a yarn

fringe can be seen. Observe the difference in density of warp and filling yarns. Broadcloth has a very thick fringe of warp yarns (144×76). Percale (78×78) has a fringe of equal density for both warp and filling (Figure 12–18).

Slippage is a problem in ribbed fabrics made with filament yarns, especially when the quality and count are lower (Figure 12–19). **Slippage** occurs when one set of yarns gets pushed to one side and exposes the yarns that are normally covered. This usually happens at points of wear and tension, such as seams, but with low-count fabrics, dragging a thumbnail across the fabric can produce slippage.

Wear occurs on the surface of the ribs. The warp yarns wear out first, and splits occur in the fabric. Filling yarns are protected from wear until the warp wears away.

Ribbed fabrics with fine ribs are softer and more drapeable than comparable balanced fabrics—broadcloth is softer than percale. Fabrics with large ribs have more body and are stiffer. A few sheer rib fabrics are used in curtains.

Lightweight Ribbed Fabrics Crepe de chine, traditionally a filling crepe-silk fabric, drapes beautifully. It has a dry, pleasant hand and medium luster. The fabric is more commonly found now as a filament polyester for blouses and linings with filament warp and fine crepetwist filling. There are many more warp yarns per inch than filling yarns, but it does not have a noticeable rib. Crepe de chine can be dyed or printed.

Medium-Weight Ribbed Fabrics Medium weight (4.0 to 6.0 oz/yd²) is the largest group of ribbed fabrics. **Broadcloth** has the finest rib of any of the spun yarn fabrics because the warp and filling yarns are the same

Fabric	Count*	Yarn Size		Category
		Warp	Filling	
Spun Yarns				
Combed broadcloth	144 × 76	100/2	100/2	Medium weight
Carded broadcloth	100×60	40s	40s	Medium weight
Filament Yarns				
Taffeta	140 × 64	75 denier	150 denier	Medium weight
Faille	200×64	75 denier	200 denier	Medium weight
Rep	88×31	30/2	5s	Heavyweight
Bengaline	92×40	150 denier	15s spun	Heavyweight
Shantung	140×44	150 denier	30/2	Heavyweight

^{*}Counts may be high for polyester/cotton and durable-press fabrics.

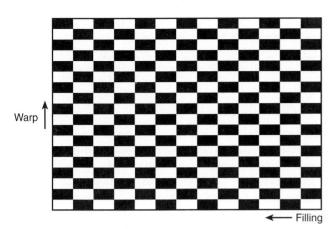

FIGURE 12-17

Unbalanced (1:2)-plain-weave diagram (left) and fabric (right). Compare this to the balanced plain weave fabric in Figure 12-15, woven with the same size yarns.

size. However, the fine rib is due to the much higher number of warp yarns (2:1 or more), as shown in Figure 12-18. Better-quality fabrics are made of long-staple combed cotton, plied yarns and may be mercerized for luster. Slub broadcloth is made with a yarn that contains slubs at regular intervals. Silk broadcloth has filament warp and staple filling. Some yarn-dyed chambrays are similar to broadcloth in weight and structure.

Taffeta is a fine-ribbed, filament-yarn fabric with a crisp hand. Note that taffeta is used to describe both balanced- and unbalanced-plain-weave fabrics. Iridescent taffeta has warp and filling yarns of different colors. Moiré taffeta has a water-marked, embossed design (Figure 12–20).

Shantung has an irregular ribbed surface produced by long, irregular areas in filling yarns. It may be medium or suiting weight and of various fiber types.

Heavyweight Ribbed Fabrics These fabrics usually weigh more than 6.0 oz/yd². **Poplin** is similar to broadcloth, but the ribs are heavier and more pronounced because of larger filling yarns. Polyester/cotton blends are widely used. Some varn-dved chambrays are similar to poplin in weight and structure.

Faille (pronounced file) has a fine, subtle rib with filament-warp varns and spun filling varns. Rep (or repp) is a heavy, coarse fabric with a pronounced rib. Bengaline is similar to faille, but it has a slightly more pronounced rib. It may be woven with two warps at a time to emphasize the rib. Ottoman has alternating adjacent large and small ribs, created by using filling yarns of different sizes or by using different numbers of filling yarns in adjacent ribs. Grosgrain (pronounced grow'-grane), usually produced in ribbon width, also has a rounded rib.

FIGURE 12-18

Compare the count and balance of percale (left) and broadcloth (right).

FIGURE 12-19 Slippage of yarns in a ribbed fabric.

FIGURE 12–20 Moiré taffeta.

Bedford cord is found most often in furnishing fabrics such as bedspreads. It has spun warp yarns that are larger than the filling yarns. Other ways of producing bedford cord will be discussed in Chapter 13.

Basket Weave

Basket weaves are made with two or more adjacent warps controlled by the same harness, and with two or more fillings placed in the same shed. The interlacing pattern is similar to a plain weave, but two or more yarns follow the same parallel path. A full basket would have the basket feature used in both warp and filling: both warp and filling are grouped. A half basket would have the basket feature in only warp or filling: only one yarn set would be grouped (Figure 12–21). The most common basket weaves are 2×2 or 4×4 , but variations include 2×1 and 2×3 . Basket-weave fabrics are more flexible and wrinkle resistant because there are fewer interlacings per square inch. The fabrics look flatter than

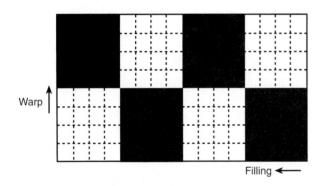

4 × 4 Full basket

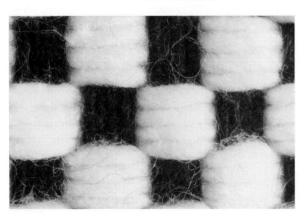

FIGURE 12–21 Basket weave: 4×4 full basket (left), 2×1 half basket (right).

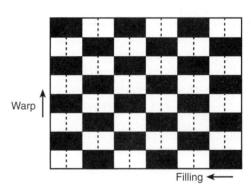

2 × 1 Half basket

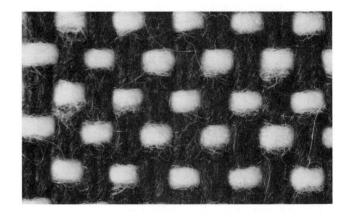

comparable regular plain-weave fabrics. However, long floats snag easily.

Dimity is a sheer unbalanced fabric used for apparel and window treatments. It has heavy warp cords at intervals across the fabric. The cords may be formed by yarns larger than those used elsewhere in the fabric or by grouping yarns together in that area. Either technique produces the unique narrow band or stripe indicative of dimity. Dimity is white or printed.

Oxford is usually a 2×1 or 3×2 basket weave. It is most common as a 2×1 half-basket weave. It may have a yarn-dyed warp and white filling and be called oxford chambray. Oxford looks like a balanced fabric because the warp yarns are finer and have higher twist than the filling. Because of soft yarns and loose weave, yarn slippage may occur. Oxford fabrics are medium weight, soft, porous, and lustrous.

Most basket weaves are heavyweight fabrics. Common ones include sailcloth, duck, or canvas. **Sailcloth** is the lightest in weight and made of single yarns. **Duck** and **canvas** are made with single or ply yarns. Different types of duck and canvas relate to which yarns (warp or filling) are plied and how many plies are used in the ply yarn. Duck is coarser. Canvas is smoother, more compact, and the heaviest of the three. Sailcloth is used in slacks, skirts, summer-weight suits, and furnishings. Usually 2×1 or 3×2 basket weaves, canvas and duck are used for slipcovers, boat covers, shoe fabrics, house and store awnings, tarpaulins, and covers for military and industrial uses.

Hopsacking is a coarse open basket-weave fabric of spun yarns. It is primarily used for coats, suits, upholstery, and wall coverings.

Monk's cloth, friar's cloth, druid's cloth, and mission cloth are some of the oldest full-basket-weave fabrics. They are usually off-white in color. These fabrics are usually found in square counts: 2×2 , 3×3 , 4×4 , or 6×6 . They are used primarily in furnishings.

Twill Weave

In a **twill weave**, each warp or filling yarn floats across two or more filling or warp yarns with a progression of interlacings by one to the right or left, forming a distinct diagonal line, or **wale**. A **float** is the portion of a yarn that crosses over two or more yarns from the opposite direction. A twill weave requires three or more harnesses, depending on its complexity. A twill weave is the second basic weave that can be made on the simple loom. Although it is possible to create fairly elaborate patterns using a twill weave, this chapter will focus only on basic fabrics and patterns.

Twill weave is often designated as a fraction—such as $\frac{2}{1}$ —in which the numerator indicates the number of harnesses that are raised, in this example 2, and the denominator indicates the number of harnesses that are lowered when a filling yarn is inserted, in this example 1. The fraction $\frac{2}{1}$ would be read as "two up, one down." The minimum number of harnesses needed to produce a twill can be determined by totaling the numbers in the fraction. For the example described, the number of harnesses is 3.

In order to weave any twill, the loom must be properly warped. To weave a $\frac{2}{1}$ twill, the threading and shedding processes described here must be followed. Any change in this process will produce something other than a $\frac{2}{1}$ twill. The first warp varn is threaded through a heddle in the first harness, the second warp yarn through a heddle in the second harness, and the third warp yarn through a heddle in the third harness. This process repeats until the entire set of warp yarns are threaded through the three harnesses. In weaving the first filling yarn, the first two harnesses are raised and the third harness is lowered. For the second filling yarn, the shed changes so that harnesses 2 and 3 are raised, harness 1 is lowered, and the yarn is inserted. The third filling yarn is inserted into a shed created by raising harnesses 1 and 3 and lowering harness 2. This produces the length of float and progression of interlacing described in the definition. This interlacing pattern is repeated until the entire fabric has been woven. Thus, by following the steps of threading and shedding, the $\frac{2}{1}$ twill has been made. A $\frac{2}{1}$ twill is shown in Figure 12–22. The distance between the arrows demonstrates the length of the float. The floats on the surface of the technical face are warp varns, making it a warp surface; it is classified as a warp-faced twill.

Characteristics of Twill Weave

Twill fabrics have a technical face and a technical back. The technical face is the side of the fabric with the most pronounced wale. It is usually more durable, more attractive, and most often used as the fashion side of the fabric. The face usually is the side visible on the loom during weaving. If there are warp floats on the technical face, there will be filling floats on the technical back. If the twill wale goes up to the right on one side, it will go up to the left on the other side. Twill fabrics have no up and down as they are woven. Check this fact by turning a fabric end to end and then examining the direction of the twill wale.

Sheer fabrics are seldom made with a twill weave. Because a twill surface has interesting texture and design, printed twills are much less common than printed plain weaves. When twills are printed, they are more

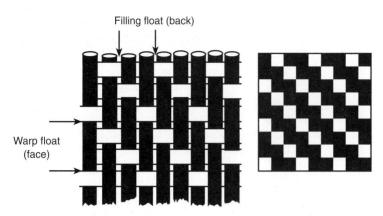

FIGURE 12-22

 $A^{\frac{2}{4}}$ twill weave.

likely to be lightweight fabrics. Soil shows less on the uneven surface of twills than it does on smooth surfaces, such as plain weaves. Thus, twills are often used for sturdy work clothing or durable upholstery because soils and stains are less noticeable on this fabric.

Fewer interlacings allow the yarns to move more freely. Fabrics are softer and more pliable and recover better from wrinkles as compared with plain-weave fabrics. When there are fewer interlacings, yarns can be packed closer together to produce high-count fabrics (Figure 12–23). If a plain-weave fabric and a twill-weave fabric have the same kind and number of yarns, the plain-weave fabric would be stronger because it has more interlacings. In twills with higher counts, the fabric is more durable and air- and water-resistant.

The prominence of a twill wale is increased by using long floats, combed or worsted yarns, plied or hard-twist yarns, yarns with twist opposite to the direction of the wale, and high counts. Fabrics with prominent wales, such as gabardine, may become shiny with wear because of wale flattening.

The direction of the twill wale traditionally goes from lower left to upper right in wool and wool-like fabrics—right-hand twills—and from lower right to upper left in cotton or cottonlike fabrics—left-hand twills. Wale or twill direction is important only in determining the face or back of a fabric. In fabrics with a very prominent wale or with white and colored yarns, design implications relative to the wale should be considered. The distinction between direction of the wale by fiber type is less significant now.

Reclining twill 35-degree angle Warp yarns per inch = 6 Filling yarns per inch = 8

Regular twill 45-degree angle Warp yarns per inch = 7 Filling yarns per inch = 8

Steep twill
63-degree angle
Warp yarns per inch = 12
Filling yarns per inch = 8

FIGURE 12-23

Wale angle depends on ratio of warp to filling. Left-handed twills are illustrated.

The angle of the wale depends on the yarn balance or the warp to filling ratio. The twill line may be **steep**, **regular**, or **reclining**. The greater the difference between the number of warp and filling yarns, the steeper the twill line. Steep-twill fabrics have a high warp count and are stronger in the warp direction. The wale angle serves as a guide in determining the strength and name of a fabric. Figure 12–23 shows how the wale changes in steepness when the warp yarn density increases and the filling yarn density remains the same. All three diagrams illustrate a $\frac{2}{1}$ left-handed twill. The only change is in the number of warp yarns, yet the wale angle changes drastically.

Filling-faced twills are seldom used. They are usually reclining twills and are less durable than other twillweave fabrics.

Even-Sided Twills

Even-sided twills expose an equal amount of warp and filling yarn on each side of a fabric. They are also known as reversible twills because they look alike on both sides, although the direction of the twill line differs. Better-quality filling yarns are used in these fabrics as compared with warp-faced twills because both sets of yarn are exposed to wear. They are most often $\frac{2}{2}$ twills and have the best balance of all the twill weaves (Table 12–5).

Foulard or **surah** is a printed or solid color filament fabric of $\frac{2}{1}$ construction. Used in silklike dresses, linings, ties, and scarves, it is soft, smooth, and lightweight.

Serge is a $\frac{2}{2}$ twill with a subdued wale with combed or worsted yarns and a clear or hard finish (not napped or brushed). Serge with fine yarns, a high count, and a water-repellent finish is used for jackets, snowsuits, and raincoats. Heavier serge, with coarse yarns, is used for work pants. Serge often weighs 10 or more oz/yd².

		Warp
Fabric	Count	Warp/Filling Yarn Size
Serge	48×34 to	Varies with fiber content
Serge	48×34 to 62×58	Varies with fiber content
Serge Flannel		Varies with fiber content Varies with fiber content

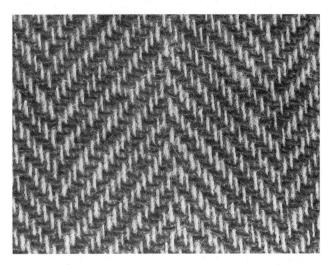

FIGURE 12-24

Herringbone.

Twill flannel is a $\frac{2}{2}$ twill. The filling yarns are larger low-twist woolen or worsted yarns, made especially for napping. Worsted flannels have less nap, take and hold a sharp crease better, show less wear, and sag less than woolen flannels. Even-sided flannel is used in apparel and upholstery.

Sharkskin is a $\frac{2}{2}$ twill with a sleek appearance. It has a small-step pattern because both warp and filling yarns alternate one white yarn with one colored yarn. Sharkskin is used primarily for slacks and suits.

Herringbone fabrics have the twill line reversed at regular intervals across the warp to produce a design that resembles the backbone of a fish, hence the name herringbone (Figure 12–24). Two different color yarns may be used to accentuate the pattern. Herringbone patterns can be very subtle or very pronounced. Herringbone is used in both apparel and furnishings.

Houndstooth is a $\frac{2}{2}$ twill fabric with a unique small eight-point pattern (see Figure 17–18). Two yarns in contrasting colors in the warp and filling are used in groups of four to create the distinctive pattern. Houndstooth fabrics also are used in apparel and furnishings.

Warp-Faced Twills

Warp-faced twills have a predominance of warp yarns on the face of the fabric. Since warp yarns are made with higher twist, these fabrics are stronger and more resistant to abrasion and pilling. Table 12–6 summarizes warp-faced twills. Twill flannel and herringbone also can be warp-faced twills, usually with a $\frac{2}{1}$ interlacing pattern.

Lining twill is a medium-weight $\frac{2}{1}$ fabric made from filament yarns and usually piece-dyed or printed in a small pattern. It resembles foulard in appearance and use.

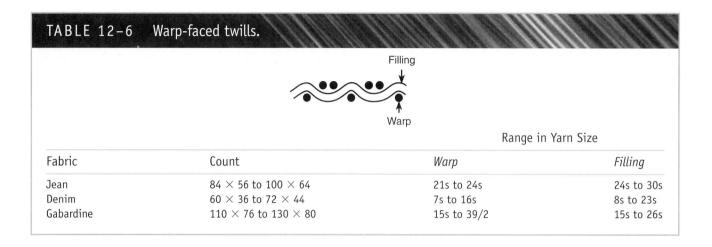

Denim is a yarn-dyed cotton twill available in several weights, ranging from 6 oz/yd² to 14 or more oz/yd² in a $\frac{2}{1}$ or $\frac{3}{1}$ interlacing pattern. Its long-term popularity has made it a fashion fabric in casual wear. It may be napped, printed, made with spandex or other stretch yarns, or otherwise modified for fashion.

Jean is a piece-dyed or printed medium-weight twill used for sportswear, draperies, slipcovers, and work shirts. Jean is not heavy enough for work pants.

Drill is a strong, medium- to heavyweight twill fabric. It is a $\frac{2}{1}$ or $\frac{3}{1}$ twill that is piece-dyed. It is usually seen in work clothing and industrial fabrics.

Covert is a twill fabric with a mottled appearance resulting from two colors of fibers combined in the yarns or from two colors of plies twisted together in one yarn. It is usually a $\frac{2}{1}$ heavyweight twill made of hard-twist worsted yarns.

Chino is a hard-wearing steep-twill fabric with a slight sheen. Usually, combed two-ply yarns are used in both the warp and the filling directions. Chino is typically a summer-weight apparel fabric.

Gabardine is a warp-faced steep or regular twill with a very prominent, distinct wale that is closely set together and raised. It always has many more warp than

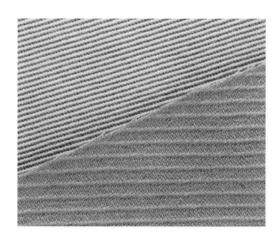

FIGURE 12–25
Examples of broken twill fabrics (left) and twill fabrics with pronounced wales (right).

filling yarns. It can be made of carded or combed single or ply yarns. The long-wearing fabric may be heather, striped, plaid, or solid color.

Cavalry twill also has a pronounced steep, double twill line in which two diagonal wales are spaced very close together and separated by a little space from the next pair of diagonal wales.

Fancy twill interlacings are used to create more interesting textures and patterns in upholstery, window treatments, wall coverings, and apparel. These twills may be altered so that the wale is not continuous, such as broken twills, or so that fairly elaborate pronounced wales are created within the fabric (Figure 12–25).

Satin Weave

In a satin weave, each warp yarn floats over four filling yarns $(\frac{4}{1})$ and interlaces with the fifth filling yarn, with a progression of interlacings by two to the right or the left (Figure 12–26); or each filling yarn floats over four warps and interlaces with the fifth warp $(\frac{1}{4})$ with a progression of interlacings by two to the right or left (Figure 12–27). In certain fabrics each yarn floats across seven yarns and interlaces with the eighth yarn. Satin weave is the third basic weave that can be made on the simple loom; however, this weave requires at least five harnesses to achieve the interlacing pattern. Thus, basic four-harness looms cannot be used to produce a satin weave. Basic fabrics made with this weave are satin and sateen.

Satin-weave fabrics are lustrous because of the long floats on the surface. The checkerboard designs in Figure 12–26 show few interlacings; the yarns can be packed close together to produce a very-high-count fabric. Note that no two interlacings are adjacent to each other. However, unless examined carefully, satin weaves resem-

ble twill weaves on the back, especially when the count is high.

When warp yarns cover the surface, the fabric is a warp-faced fabric and the warp count is high. When filling floats cover the surface, the fabric is a filling-faced fabric and the filling count is high. These fabrics are unbalanced, but the high count compensates for the lack of balance.

All satin fabrics have a face and a back that look significantly different. A high count gives them strength, durability, body, firmness, and wind repellency. Fewer interlacings give pliability and resistance to wrinkling, but yarns may slip and ravel easily.

Satin Fabrics

Satin fabrics are usually made of bright filament yarns with very low twist. Satin is almost always warp faced; warp floats cover the surface. Because of the bright fibers, low twist, and long floats, satin is very lustrous. It is made in many weights (Table 12–7) for use in dresses, linings, lingerie, draperies, drapery linings, and upholstery. It is good for linings because the high count makes it very durable and smooth. Satin makes a more pliable lining than taffeta because it does not split as readily at hems. Quality is particularly important in linings. Low-count satins pull at the seams and rough up in use. Floats may shift in position and bubble or wrinkle.

In **crepe-back satin**, the crepe yarns in the filling give softness and drapeability, and the low-twist warp give the smooth, satiny surface to the fabric. In antique satin, novelty filling yarns add visual interest to the fabric. Antique satin often is used with the technical back as the fashion side in upholstery and window treatments.

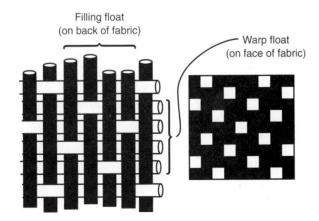

FIGURE 12-26

Warp-faced satin weave: 4/1 yarn arrangement.

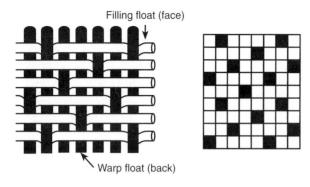

FIGURE 12-27 Filling-faced satin weave: $\frac{1}{L}$ yarn arrangement.

TABLE 12-7 Typi	cal satin fabrics.		
		Yarn Size and Type	
Fabric	Count	Warp	Filling
Satin	200 × 65	100 denier	100 denier
Slipper satin	300×74	75 denier	300 denier
Crepe-back satin	128×68	100 denier	100-denier crepe

		Yarn Size and Type	
Fabric	Count	Warp	Filling
Filling sateen	60 imes 104 (carded)	32s	38s
	84 imes 136 (carded)	40s	50s
	96 $ imes$ 108 (combed)	40s	60s
Warp sateen	84×64 (carded)	12s	11s
	160×96 (carded)	52s	44s

Sateen

Sateen is a lustrous fabric made of spun yarns. In order to achieve luster with staple fibers, medium-twist yarns form the float surface. Finishes are used to enhance the luster and durability. (See Chapter 17.)

Filling sateen is a smooth, lustrous cotton fabric used for draperies, drapery linings, and apparel. It is often made with carded yarns with a high filling count. Warp yarns are similar in size to those used in print cloth, but the filling yarns are slightly larger. Combed sateens are usually finished for added luster. (See Chapter 17.)

Warp sateens are cotton fabrics made with warp floats in a $\frac{4}{1}$ interlacing pattern. They may have a rounded wale effect that resembles a twill fabric. They are stronger and heavier than filling sateens because of the high warp count. They are less lustrous than filling sateen and used where durability is more important than luster. Warp sateens are used in slacks, skirts, bedsheets of 250 to 300 counts, pillow and bed tickings, draperies, and upholstery fabrics. If any satin fabric is printed, it is most likely a warp sateen. Table 12–8 compares filling and warp sateen.

Key Terms

Fabric Print cloth Percale Fabric quality Calico Defects Chintz Fabric grading Warp Cretonne Polished cotton Filling Glazed chintz Loom Muslin Warp beam Harness Flannelette Outing flannel Heddle Gingham Shed Taffeta Shuttle Reed Madras Pongee Dents Honan Shedding Picking True crepe

Suiting-weight fabrics Beating up Bottom-weight fabrics Take-up Crash Winding Burlap Air-jet loom Rapier loom Hessian Water-jet loom Osnaburg Flannel Projectile loom Tweed Double-width loom

Unbalanced plain weave Multiple-shed weaving

Circular loom Rib Triaxial Slippage Crepe de chine Interlacing Broadcloth Float Shantung Grain Off grain Poplin Faille Skew Bengaline Bow Ottoman Count Grosgrain Fabric density Bedford cord Balance Basket weave Selvage Dimity Fabric weight Plain weave Oxford cloth Sailcloth Balanced plain weave Narrow fabric Duck

Steep twill Organdy Regular twill Organza Reclining twill Lawn Filling-faced twill Batiste Even-sided twill Chambray Foulard China silk

Canvas

Wale

Monk's cloth

Twill weave

Habutai Surah Challis Serge

Ninon

Georgette

Chiffon Voile

Twill flannel Sharkskin Herringbone Houndstooth Warp-faced twill Lining twill Denim Tean

Chino Gabardine Satin weave Satin Crepe-back satin Sateen Filling sateen Warp sateen

Questions

Drill

- 1. Describe how a loom produces a woven fabric.
- 2. Diagram the interlacing patterns for the three basic weaves. Use both the cross-section diagram and the checkerboard.
- 3. What criteria are used to determine the name of a fabric?
- 4. Identify the similarities and differences between these fabrics:

gingham and plissé flannelette and challis organdy and georgette percale and broadcloth herringbone and gabardine denim and chambray satin and sateen

- 5. Compare and contrast the characteristics of fabrics made from the three basic weaves.
- **6.** Predict the performance of the following textile products:

100 percent olefin tweed upholstery with large-flake filling yarns and fine-filament warp yarns

50 percent cotton/50 percent polyester broadcloth shirt/blouse with combed yarns of similar size in both warp and filling

100 percent acetate antique satin drapery

100 percent nylon taffeta backpack with BCF yarns in the warp and filling

100 percent rayon challis skirt and blouse

7. Describe four factors that influence fabric quality.

Suggested Readings

Emery, I. (1980). The Primary Structures of Fabrics. Washington, D.C.: The Textile Museum.

Humphries, M. (1996). Fabric Glossary. Upper Saddle River, NI: Prentice Hall.

Krause, H. W., and Soliman, H. A. (July, 1990). Do higher

speeds demand better yarns? Textile Month, pp. 19-22. Parker, J. (1998). All About Cotton. Seattle, WA: Rain City Publishing.

- Parker, J. (1992). *All About Silk*. Seattle, WA: Rain City Publishing.
- Parker, J. (1996). *All About Wool.* Seattle, WA: Rain City Publishing.
- Schwartz, P., Rhodes, T., and Mohamed, M. (1982). Fabric Forming Systems. Park Ridge, NJ: Noyes Publications.
- Taking stock of weaving innovation. (1999, February). *America's Textiles International*, pp. 48–53.
- Tortora, P. G., and Merkel, R. S. (1996). *Fairchild's Dictionary of Textiles*, 7th ed. New York: Fairchild Publications.
- Weave from yarn to fabric. (1994, Spring). *Textiles Magazine*, pp. 11–12.
- Weaving to tomorrow. (1999, May). *Textile Horizons*, pp. 21–22.

Chapter 13

FANCY WEAVES AND FABRICS

OBJECTIVES

- To understand the production of fancy woven fabrics.
- To identify the technique or process used to produce fancy woven fabrics.
- To integrate fabrication, yarn type, and fiber in predicting product performance.
- To relate advances in fabric production to market availability and cost.

ancy fabrics differ from basic fabrics in that the design, texture, or pattern is an inherent and permanent part of the fabric's structure that cannot be removed without dismantling the fabric. Some fabrics may be finished to develop these differences fully, such as the pile fabrics that require shearing or napping.

The production process for fancy weaves is more involved than that for the basic weaves, fabric costs are higher, and the fabric may have a more specialized application. The techniques used to obtain these fabrics vary in complexity and influence the cost and serviceability of the fabric. Possibilities include patterned fabrics, open-work fabrics, and pile fabrics. These fabrics can be found in regular fabric widths and as narrow fabrics used in trim. Identifying the production technique for the fabric assists in naming it and in selecting a serviceable fabric for an end use. Figure 13–1 will help determine the specific structure and name of a fancy fabric.

Fancy weaves and woven figures are made by changing the interlacing pattern between the design area and the background. The interlacing pattern is controlled by the warp yarns' position during weaving. In a threeharness loom there are 3 possible arrangements of the warp yarns; in a four-harness loom there are as many as 12 different arrangements. As the number of harnesses increases, the possibilities for different interlacings also increase. But there is a limit to the number of harnesses that can be used efficiently. Consider the number of interlacings needed to weave a figure: If the figure is 1/4 inch in length, in an 80×80 fabric, it may require 20 different interlacings; if the figure is 1/2 inch long on a nylon-satin background (320 \times 140), it may require 70 different interlacings. Special looms, attachments, or control devices are necessary to make these fabrics competitive in price with imitations achieved by prints or finishes.

Table 13–1 compares the characteristics of the fancy weaves discussed in this chapter.

Dobby Weaves

Dobby weaves are small-figured designs that require fewer than 25 different warp arrangements to complete one repeat of the design. They are made on a loom with a dobby attachment—a **dobby loom**.

Two methods are used to create the pattern. In the older method, the weave pattern is controlled by a plastic tape with punched holes (Figure 13–2). These tapes resemble the rolls for a player piano. The holes control the position of each warp yarn in forming a shed. The newer method of creating a simple geometric pattern in the fabric uses a computer to control the position of the warp yarns. This system is faster, compatible with several

computer-aided design (CAD) systems, and allows for easy and quick pattern changes in the fabric.

Many designs made on either type of dobby loom are small geometric figures. There are many dobby fabrics; a few readily available and identifiable ones are discussed here. Figure 13–3 illustrates several generic patterned fabrics found in apparel and furnishings.

Bird's-eye has a small diamond-shaped filling-float design with a dot in the center that resembles the eye of a bird. This design was originally used in white silk fabric for ecclesiastical vestments. At one time, a cotton version was widely used for kitchen and hand towels and diapers. **Huck** or **huck-a-back** has a pebbly surface made by filling floats. It is used primarily in roller, face, and medical-office towels (Figure 13–4).

Madras or *madras gingham* has small, satin-float designs on a ribbed or plain ground. **Waffle cloth** is made with a dobby attachment and has a three-dimensional honeycomb appearance. *Waffle cloth* is used for blankets, dish and bar cloths, upholstery, and apparel.

Extra-Yarn Weaves

Additional warp or filling yarns of different colors or types are woven into the fabric to create a pattern in an **extra-yarn weave.** When not used in the figure, the extra warp or filling yarns float across the back of the fabric and are usually cut away during finishing. In handwoven fabrics the warp yarns are manipulated by hand and the extra yarns can be laid in where wanted by using small shuttles. But in power looms an automatic attachment must be used.

Extra-warp yarns are wound on a separate beam and threaded into separate heddles. The extra yarns interlace with the regular filling yarns to form a design and float behind the fabric until needed for the repeat. The floats are then clipped close to the design or clipped long enough to give an eyelash or fringed effect. Figure 13–5 shows a fabric before and after clipping.

Many of the fabrics that have small-dot designs are called dotted swiss. The dots may be extra-filling-yarn structural designs: clipped-dot designs or swivel-dot designs. Either side of these fabrics may be the fashion side. Clipped-spot or clipped-dot designs are made with low-twist filling yarns inserted by separate shuttles. By manipulating the shedding, the extra yarns interlace with some warp yarns and float across the back of others. A box loom uses a wire along the edge to prevent the extra yarns from being woven into the selvage. Clipped-dot fabrics have many yarn ends per dot. Figure 13–6 shows a clipped fabric, dotted swiss, before and after clipping.

Swivel-dot designs are made on a loom that has an attachment holding tiny shuttles. The fabric is woven so

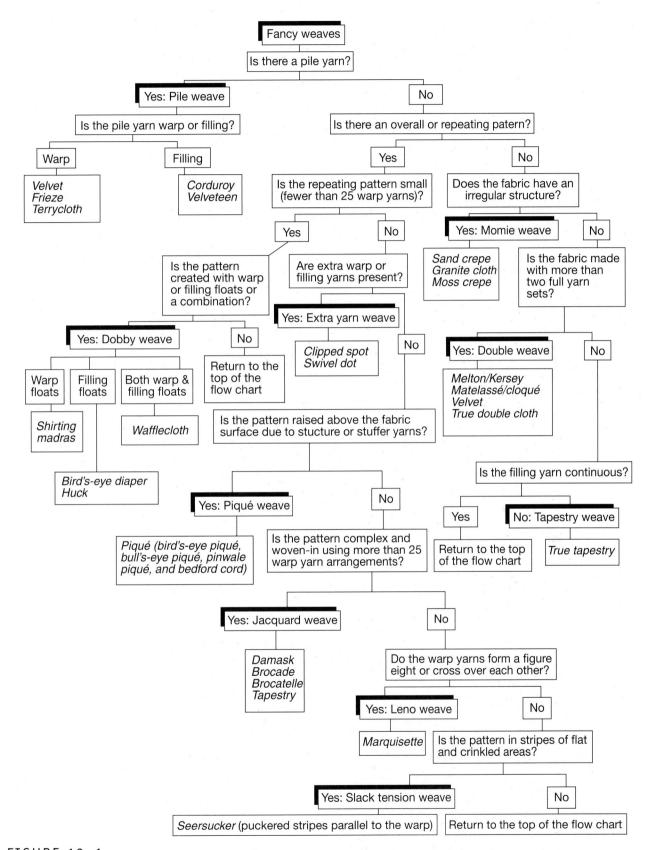

FIGURE 13-1
Fancy woven fabrics flow chart.

Weave	Fabrication Details	Appearance	Uses/Fabrics
Dobby	Warp controlled in groups	Small geometric patterns	Apparel, furnishings, bird's-eye diaper, waffle cloth
Extra yarn	Additional yarn sets in warp or filling, excess removed or on back, yarn ends add interest	Small geometric patterns, yarn fringe	Apparel, furnishings, dotted swiss, eyelash
Piqué	Dobby or jacquard technique, raised pattern areas	Floats on back or stuffer yarns create raised areas	Apparel, furnishings, bedford cord, pinwale piqué, bull's-eye piqué
Jacquard	Warp controlled individually	Elaborate, intricate	Apparel, furnishings, brocade, damask, tapestry
Momie	Irregular interlacing	Pebbly, uneven surface	Apparel, furnishings, crepe, bark cloth, moss crepe
Leno	Warp yarns cross over each other	Stable, open fabric	Apparel, furnishings, leno, casement cloth, marquisette
Double	Three, four, or five sets of yarns used	Double-faced, pockets in fabric, or thick, heavy fabrics	Apparel, furnishings, matelassé, melton, blankets, upholstery
Pile	Extra yarns in warp or filling create surface pile	Thick, bulky, warm, durable fabrics	Apparel, furnishings, corduroy, velveteen, velvet, friezé, terrycloth, Wilton carpets
Slack tension	Warp bands under different tensions during weaving	Puckered stripes in warp direction	Apparel, furnishings, seersucker
Tapestry	Discontinuous filling	Pattern created by yarn color	One-of-a-kind rugs, wall hanging fiber art

the shuttles and extra yarns are above the ground fabric. Each shuttle carrying the extra yarn wraps around the warp yarns in the ground fabric several times and then the yarn is carried along the surface to the next spot.

FIGURE 13-2
Pattern roll that controls warp shedding on a dobby loom.
(Courtesy of Crompton & Knowles Corp.)

The yarn is cut away between the spots (Figure 13–7). Swivel-dot fabrics have only two yarn ends per dot. Swivel-dot fabrics in the United States are imported designer fabrics.

Dotted swiss may also be an applied design. (See Chapter 17 for more details.) Compare several different types of dotted swiss to determine their serviceability, quality, and cost.

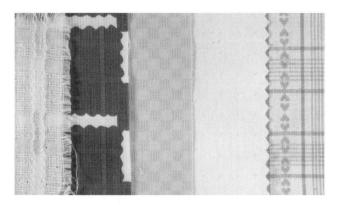

FIGURE 13-3
Dobby fabrics for use in apparel and furnishings.

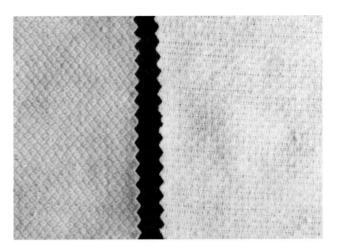

FIGURE 13-4 Bird's-eye diaper (left) and huck (right).

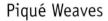

The word **piqué** (pee kay') comes from the French word meaning *quilted*, because the raised effect in these fabrics is similar to that in quilts. The piqué weave produces a fabric with ridges, called wales or cords, that are held up by floats on the back. The wales vary in width. *Wide-wale piqué* (0.25 inch) is woven with 20 or more warp yarns in the face of the wale, and then two warps form a valley in between. *Pin-wale piqué* (0.05 inch) is a six-warp wale with two consecutive filling yarns floating across the back of the odd-numbered wales and then woven in the face of the even-numbered wales. The next two consecutive yarns

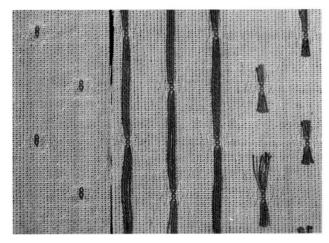

FIGURE 13-5
Fabric made with extra warp yarns: face of fabric (left); back, before clipping (center) and after clipping (right).

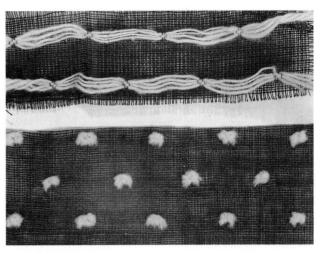

FIGURE 13-6
Dotted swiss made with extra filling yarns: before (above) and after (below) clipping.

(picks) alternate with the first two by floating across the back of the even-numbered wales. Figure 13–8 shows a cross sectional diagram of this fabric.

Stuffer yarns are laid under the ridges in betterquality piqué fabrics to emphasize the roundness, and their presence or absence is one way of determining quality. The stuffer yarns are not interlaced with the surface yarns of the fabric and may be easily removed when analyzing a swatch of fabric. Piqué fabrics are woven on either a dobby or jacquard loom, depending on the complexity of the design.

FIGURE 13-7
Dotted swiss, showing both sides of a swivel-dot fabric.

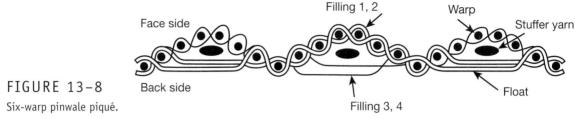

Cords or wales usually run in the lengthwise direction. Cord fabrics have a definite technical face and technical back. With abrasion, the floats on the wrong side usually wear out first. Figure 13-9 shows the face and back of a piqué fabric. Piqué fabrics are more resistant to wrinkling and have more body than flat fabrics. Better-quality piqué fabrics are made with longstaple combed varns and have stuffer varns. Cardedyarn piqués are made without the stuffer yarn and are sometimes printed.

Fabrics in this group are called piqué, with the exception of bedford cord. Bedford cord is a heavy fabric with wide warp cords used for bedspreads, upholstery, window treatments, slacks, and uniforms. Its spun warp yarns are larger than the filling yarns. Lengthwise cords at intervals across the fabric are formed by extra filling yarns floating across the back, giving a raised effect. Stuffer yarns make a more pronounced cord, which may be the same size or alternately larger and smaller.

Bird's-eye piqué has a tiny design formed by the wavy arrangements of the cords and by the use of stuffer yarns. Bull's-eye piqué is made like bird's-eye piqué but has a much-larger-scale design. Both fabrics have crosswise rather than lengthwise cords and are used for apparel and furnishings.

FIGURE 13-9

Piqué: face of fabric (left), back of fabric (right). Note stuffer yarns visible on the back and how the fabric flattens out at the bottom, where the stuffer yarns have been removed.

Jacquard Weaves

Large-figured designs that require more than 25 different arrangements of the warp yarns to complete one repeat design are jacquard weaves; they are woven on the jacquard loom. Two types of looms are used to produce jacquard weaves. In the older type of loom (Figure 13-10) each warp is controlled independently by punched cards that form a continuous strip. The position of the warp yarns is controlled by rods. When the rods hit the cards, some go through the holes and raise the warp yarns; others remain down. In this manner the shed is formed for the passage of the filling yarn. Figure 13-11 shows a picture woven with fine silk yarns on a jacquard loom. Note that this pattern does not repeat from top to bottom or from side to side. The repeat would be another picture.

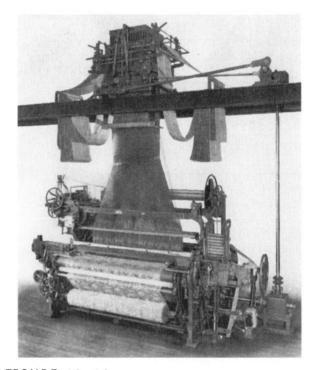

FIGURE 13-10 Jacquard loom for weaving large figured fabrics. (Courtesy of Crompton & Knowles Corp.)

FIGURE 13-11
Jacquard-woven picture.

The newer method for producing these large patterns in the fabric combines a computer with an air-jet loom and is called an electronic jacquard loom (Figure 13–12). The computer controls the position of the warp yarns and the insertion of different-colored filling yarns. The loom is fast, with weaving speeds of 600 picks per minute, compatible with several computer-aided design (CAD) systems, and allows for easy and quick pattern changes. Fabrics produced on these looms include fancy mattress ticking, upholstery, and apparel.

Fabrics made on a jacquard loom include damask, brocade, brocatelle, tapestry, and others (Figure 13–13). **Damask** has satin floats on a satin background; the floats in the design are opposite those in the ground. If the pattern is warp-faced, the ground is filling-faced. Damask

FIGURE 13–12
Electronic jacquard loom. (Courtesy of Bonas USA, Inc.)

patterns are subtle but visible because of slight differences in light reflected from the two areas. Damask can be made from any fiber and in many different weights for apparel and furnishings. Damask is the flattest jacquard fabric and is often finished to maintain that flat look. Quality and durability are dependent on count. Low-count damask is not durable because the long floats rough up, snag, and shift during use.

Brocade has satin or twill floats on a plain, ribbed, twill, or satin background (Figure 13–14). Brocade differs from damask in that the floats in the design are more varied in length and are often of several colors.

Brocatelle fabrics are similar to brocade fabrics, except that they have a raised pattern. This fabric frequently is made with filament yarns, using a warp-faced pattern and filling-faced ground. Coarse cotton stuffer filling yarns help maintain the three-dimensional appearance of the fabric when used for upholstery.

Originally, tapestry was an intricate picture that was handwoven with discontinuous filling yarns. It was usually a wall hanging and was time-consuming to weave. Today's **jacquard tapestry** is mass-produced for upholstery, handbags, and the like. This tapestry is a complicated structure consisting of two or more sets of warp and two or more sets of filling interlaced so that the face warp is never woven into the back and the back filling does not show on the face. Upholstery tapestry is durable if warp and filling yarns are comparable. With lower-quality fabrics, fine yarns are combined with coarse yarns, and the resulting fabric is not durable.

Wilton rugs are figured-pile fabrics made on a jacquard loom. These rugs, once considered imitations of Oriental rugs, are so expensive to weave that the tufting industry has found a way to create similar figures through printing techniques.

Momie Weaves

Momie (mó-mee) is a weave that presents no wale or other distinct weave effect but gives the cloth the appearance of being sprinkled with small spots or seeds. The appearance resembles crepe made from yarns of high twist. Fabrics are made on a loom with a dobby attachment or electronic control. Some are variations of satin weave, with filling yarns forming the irregular floats. Some are even-sided and some have a decided warp effect. Momie weave is also called granite or crepe weave. Any fiber can be used to make crepe-weave fabrics. An irregular interlacing pattern of crepe weave is shown in Figure 13–15. Momie fabrics are used for apparel and furnishings.

Sand crepe is a medium- to heavy-weight fabric of either spun or filament yarns. It has a repeat pattern of

FIGURE 13-13

Jacquard patterned fabrics for upholstery.

16 warp and 16 filling yarns and requires 16 harnesses. No float is greater than two yarns in length.

Granite cloth is made with a momie weave, based on the satin weave. It is an even-sided fabric with no long floats and no twill effect.

Moss crepe combines high-twist crepe yarns and crepe weave. The yarns are plied yarns with one ply made of a crepe-twist single yarn. Regular yarns may alternate with the plied yarns, or they may be used in one direction while the plied yarns are used in the other direction. This fabric should be treated as a high-twist crepe fabric. Moss crepe is used in dresses and blouses.

Bark cloth is a heavyweight momie-weave fabric used primarily in furnishings. The interlacing pattern uses spun yarns and creates a fabric with a rough texture, resembling tree bark, hence the fabric's name. The fabric

FIGURE 13-14 Brocade.

may be printed or solid. The rough texture adds visual interest and minimizes the appearance of soiling.

Leno Weaves

Leno is a weave in which the warp yarns do not lie parallel to each other. Warp yarns work in groups, usually pairs of two; one yarn of each pair is crossed over the other before the filling yarn is inserted, as shown in Figure 13–16.

Leno is made with a **doup attachment**, which may be used with a plain or a dobby loom. The attachment consists of a thin needle supported by two heddles. One yarn of each pair is threaded through an eye at the upper end of the needle, and the other yarn is drawn between the two heddles. Both yarns are threaded through the same dent in the reed. During weaving, when one of the two heddles is raised, the yarn that is threaded through the needle is drawn across to the left. When the

FIGURE 13-15 Momie weave.

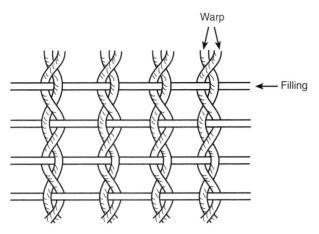

FIGURE 13-16

Leno weave: diagram (left) and fabric (right).

other heddle is raised, the same yarn is drawn across to the right.

When looking at a leno fabric, one might think that the yarns were twisted fully around each other, but this is not true. Careful examination shows that they are crossed and that one yarn of the pair is always above the other.

Fabrics made by leno weave include marquisette (Figure 13–17), mosquito netting, agritextiles to shade delicate plants, and some bags for laundry, fruit, and vegetables. Polyester marquisettes are widely used for sheer curtains. Casement draperies are frequently made with leno-weave and novelty yarns. Thermal blankets are sometimes made of leno weave. All these fabrics are characterized by sheerness or open spaces between the yarns. The crossed-yarn arrangement gives greater firmness and strength than plain-weave fabrics of a similar

FIGURE 13-17

Marquisette.

low count and minimizes yarn slippage. Snagging may be a problem in use and care, however.

Chenille yarns (Chapter 11) are made using a leno weave. The fabric is produced with fine warp, and low-twist filling. It is cut apart parallel to the warp, and the filling untwists to produce the fuzzy chenille yarn (see Figure 11–11).

Double Cloth

The two sides of double-cloth fabrics usually look different because of the fabrication method. Double cloths tend to be heavier and have more body than single cloths. A single cloth, such as percale, is made from two sets of yarns; one set of warp yarns and one set of filling yarns. **Double cloth** is made from three or more sets of yarns.

There are three types of woven double cloth fabrics:

- 1. Double cloth—coat fabrics: melton and kersey.
- 2. Double weave—apparel and upholstery fabrics: matelassé.
- **3.** Double-faced—blanket cloth, double-satin ribbon, lining fabric, and silence cloth.

Double cloth is made with five sets of yarns: two fabrics woven one above the other on the same loom, with the fifth yarn (warp) interlacing with both cloths (see Figure 13–18). This technique is used to produce velvet (see the section on "Pile Weaves," later in this chapter). True double cloth can be separated by pulling out the yarns holding the two layers together. It can be used in reversible garments such as capes and skirts. Although it can be confusing, double cloth can refer, in

FIGURE 13-18

Double cloth made with five sets of yarns.

general, to fabrics made with three or more yarn sets or to specific fabrics made with five yarn sets.

Double cloth is expensive to make because it requires special looms and the production rate is slower than for single fabrics. Double cloth is more pliable than single fabrics of the same weight because finer yarns can be used. The two specific fabrics that may be either true double cloth or single cloth are melton and kersey. Both of these heavyweight-wool coating fabrics are twill-weave fabrics that have been heavily finished so that it is difficult to identify the weave.

Melton tends to have a smoother surface than kersey. **Kersey** is usually heavier than melton and has a shorter, more lustrous nap. Both fabrics are used in winter coats, overcoats, riding habits, and military uniforms.

Double Weaves

Double weave is made with four sets of yarns, creating two separate layers of fabric that periodically reverse position from top to bottom, thus interlocking the two layers of fabric. Between the interlocking points the two layers are completely separate, creating pockets in the fabric (Figure 13–19).

Double-weave fabrics are also known as *pocket fabrics*, *pocket cloth*, or **pocket weave.** They are most commonly seen in high-quality upholstery fabrics. Their main advantages are the designs that can be achieved, their heavier weight, and their good durability.

Matelassé is a double-cloth construction with either three or four sets of yarns woven on a jacquard or dobby

FIGURE 13-19

Double weave: face of fabric (bottom); back of fabric (top).

loom. Two of the sets are the regular warp and filling yarns; the others are crepe or coarse cotton yarns. They are woven together so that the two sets crisscross, as shown in Figure 13–20. When the fabrics are finished, the crepe or cotton yarns shrink, giving the fabric a puckered appearance. Heavy cotton yarns sometimes are used as stuffer yarns beneath the fabric face to emphasize the three-dimensional appearance of the fabric. Matelassé is used in apparel and upholstery (Figure 13–21).

Double-Faced Fabrics

Double-faced fabrics are made with three sets of yarns: two warp and one filling, or two sets of filling and one set of warp. Blankets, satin ribbons, interlinings, and silence cloth are made this way (Figure 13–22).

Blankets with each side a different color are usually double-faced fabrics. One set of warp yarns is used, with two sets of different-colored filling yarns. Sometimes designs are made by interchanging the colors from one side to the other. Double-faced blankets are usually wool and are expensive.

FIGURE 13-20
Interlacing of varns between fabric surfaces of matelassé.

FIGURE 13-21
Two examples of matelassé: apparel weight (left) and upholstery weight (right).

Satin ribbons have a lustrous satin face on both sides of the ribbon and are used in designer lingerie and eveningwear. These ribbons have two sets of warp yarns that form the surface on both sides of the ribbon. They are interlaced with one set of filling yarns.

FIGURE 13-22
Double-faced blanket. One set of warp yarns and two sets of filling yarns.

A double-faced interlining fabric adds warmth to winter jackets and coats. The face of the fabric is a filament-yarn satin weave that slides easily over other clothing. The back of the fabric uses a third set of low-twist yarns that are heavily napped for warmth. Thus, the fabric functions as a combination lining and interlining fabric.

Silence cloth is a heavy cotton fabric that has been napped on both sides. Available only in white, it is used under fine tablecloths to quiet the noise of china and silverware while dining.

Pile Weaves

Woven-pile fabrics are three-dimensional structures made by weaving an extra set of warp or filling yarns into the ground yarns to make loops or cut ends on the surface (Figure 13–23). Pile comes from the Latin word *pilus*, meaning *hair*. The pile is usually short—1/2 inch or less. Woven-pile fabric is less pliable than other pile fabrics. Sometimes when the fabric is folded, the rows of pile tufts permit the back to show, or "grin-through." As tuft density increases, grin-through decreases.

Pile fabrics can be both functional and beautiful. A high, thick pile adds warmth as either the shell or the lining of coats, jackets, gloves, and boots. High-count fabrics produce beautiful and durable carpets, upholstery, and bedspreads. Low-twist yarns produce absorbent towels and washcloths. Other uses for pile fabrics are stuffed toys, wigs, paint rollers, buffing and polishing cloths, and "decubicare" pads for bedridden patients. Interesting effects can be achieved by combinations of cut and uncut pile (Figure 13–23), pile of

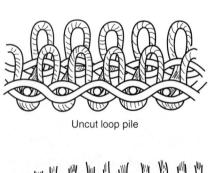

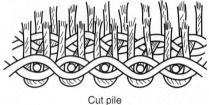

FIGURE 13-23

Cut pile and loop pile: woven fabric.

various heights, high- and low-twist yarns, areas of pile on a flat surface, flattening pile, or forcing pile into a position other than upright.

In pile fabrics, the pile receives the surface abrasion and the base weave receives the stress. A durable base structure contributes significantly to a satisfactory pile fabric. A compact ground or base weave increases the resistance of a looped or uncut pile to snagging and of a cut pile to shedding and pulling out. A dense pile stands erect, resists crushing, and gives better cover. Care must be taken in cleaning and pressing to keep the pile erect. Cut pile may look better if dry cleaned, but some pile fabrics—such as pinwale corduroy—can be washed, depending on the fiber content. Incorrect pressing may flatten the pile and result in a fabric that appears lighter in color. Special pressing aids or techniques are used with pile fabrics, like using needleboards or steaming.

Many pile fabrics are pressed during finishing so that the pile slants in one direction, giving an up-and-down look. It is important that the pile be directed in the same way in all pieces of a product. Otherwise, light will be reflected differently and the product will appear to be made of two colors. (See Figure 17–11.)

Filling-Pile Fabrics

The pile in filling-pile fabrics is made by long filling floats on the surface that are cut after weaving (Figure 13–24). Filling pile fabrics are always cut pile. Two sets of filling yarns and one set of warp are used. The ground fabric is made with one set of filling yarns and the warp yarn set. During weaving, the extra filling yarns float across the ground yarns, interlacing occasionally. In corduroy, the floats are arranged in lengthwise rows; in velveteen, they are scattered over the base fabric.

Cutting is done by a special machine with guides that lift the individual floating yarns from the ground fabric and revolving knives that cut the floats (Figure 13–25). A gray-goods corduroy with some of the floats cut is shown in Figure 13–26. When wide-wale corduroy is cut, the guides and knives can be set to cut all the floats in one operation. For narrow corduroy and velveteen, the rows are so close together that alternate rows are cut with each pass and the fabric must be run through the machine twice.

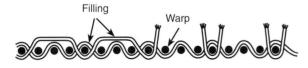

FIGURE 13-24

Filling pile. Cross section of weave in corduroy.

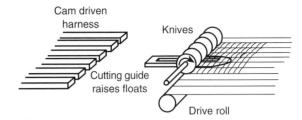

FIGURE 13-25

Process for cutting floats to make corduroy.

After cutting, the surface is brushed crosswise and lengthwise to bloom open the yarn tuft, raise the pile, and merge the separate pile tufts. Finishing gives the fabric its final appearance.

Both velveteen and corduroy are made with long-staple combed cotton for the pile. In good-quality fabrics, long-staple cotton is used for the ground as well. Polyester/cotton blends are available with polyester in the ground yarns for strength. The ground may be made with plain- or twill-weave interlacing patterns. Twill ground weaves produce a higher count and a denser pile. Corduroy can be recognized by lengthwise wales. Velveteen has more body and less drapeability than velvet. The pile is not higher than 1/8 inch. Both corduroy and velveteen are available in solid-color and printed fabrics. Table 13–2 describes characteristics of different types of corduroy.

Warp-Pile Fabrics

Warp-pile fabrics are made with two sets of warp yarns and one set of filling. One set of warp yarns and the one

FIGURE 13-26

Corduroy gray goods, showing some of the floats cut and brushed open.

TABLE 13-2	Types of corduroy.			
	Wales per inch	Ounces per square yard	Characteristics, uses	
Featherwale	18-19	5±	Shallow pile, flexible, tops & bottoms	
Pinwale	14-16	7±	Shallow pile, flexible, tops & bottoms	
Midwale	11	10±	Outerwear & bottoms, upholstery	
Wide wale	3-9	12±	Heavier and less flexible	
			Most durable corduroy, coats, upholste	

filling yarn form the ground fabric. The extra set of warp forms the pile that can be cut or uncut. Several methods are used.

Double-Cloth Method Two fabrics are woven, one above the other, with the extra set of warp yarns interlacing with both fabrics. There are two sheds, one above the other, and one filling yarn is inserted into each shed. The fabrics are cut apart while still on the loom by a traveling knife that passes back and forth across the loom. With the double-cloth method of weaving, the depth of the pile is determined by the space between the two fabrics. The interlacing pattern of the pile yarns determines their resistance to shedding, density, and durability (Figure 13-27). Pile with a W shape interlaces with more filling varns, is more resistant to shedding, is less dense, and is more durable. Pile with a V shape interlaces with fewer filling yarns, is less resistant to shedding, is denser, and is less durable. When a fabric is unraveled, pile shape can be determined easily by placing it on a surface of a contrasting color.

Velvet is made of filament yarns with a pile height of 1/16 inch or less. Velvet must be handled carefully so that no folds or creases flatten the pile.

Velvet and velveteen can be distinguished by fiber length: Velvet is usually made with filaments and vel-

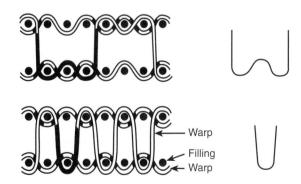

FIGURE 13-27

Warp pile: double cloth method. W-interlacing (above); V-interlacing (below).

veteen with staple. To identify warp directions in these fabrics, ravel adjacent sides. In filling-pile fabrics, the pile is pushed out as individual tufts when a filling yarn is removed. But when a warp yarn is removed, the pile tufts cling to it and it looks a little like a woolly caterpillar (Figure 13–28). In warp-pile fabrics, the opposite occurs. Pile tufts cling to filling yarns. Another way to tell warp direction is to bend the fabric. In velveteen, the pile "breaks" into lengthwise rows because the filling tufts are interlaced with the warp yarns. In velvet, the pile breaks in crosswise rows because the warp tufts are interlaced with the ground-filling yarns. This technique works best with medium- to poor-quality fabrics.

Finishing is used to create other looks for velvet. Crushed velvet is made by mechanically twisting the wet cloth. The surface yarns are randomly flattened in different directions. Panné velvet is an elegant fabric with the pile pressed flat by heavy pressure in one direction to give it high luster. If the pile is disturbed or brushed in the other direction, the smooth, lustrous look is destroyed. Velour is a warp-pile cotton fabric used primarily for upholstery and draperies. It has a deeper pile than velveteen and is heavier. Plush has a deeper pile than velour or velvet and is usually longer than 1/4 inch.

Furlike fabrics may be finished by curling, shearing, sculpturing, or printing to resemble different kinds of real fur. (Most furlike fabrics are made by other processes; see Chapters 14 and 15.)

Over-Wire Method In the over-wire method a single cloth is woven with wires placed across the width of the loom so that they are positioned above the ground warp and under the pile warp. For cut-pile fabrics, each wire has a hook at one end with a knife edge that cuts all the yarns looped over it as it is withdrawn. Uncut pile is produced using wires without hooks or waste picks of filling yarns. The wires are removed before the cloth is removed from the loom, and the waste picks are removed after the fabric is off the loom. Friezé, mohair-pile plush, and most woven pile carpets and rugs are made in this way.

Friezé, an uncut or combination cut/uncut pile fabric, is an upholstery fabric that has fewer tufts per square

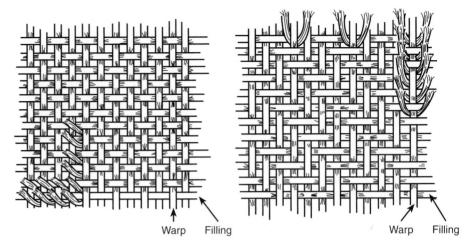

FIGURE 13-28

Comparison of filling pile and warp pile. Velvet: warp-pile yarn is interlaced with ground filling (left). Velveteen: filling-pile yarn is interlaced with ground warp (right).

inch than most other pile fabrics. The durability of friezé depends on the closeness of the weave (Figure 13–29).

Velvet can also be made by the over-wire method. Complex patterns using different-colored yarns and loops combined with cut pile result in a wide variety of fabrics.

Slack-Tension Pile Method The pile in terrycloth is formed by a special weaving arrangement in which three picks or fillings are inserted and beaten up with one motion of the reed. After the second pick in a set is inserted, there is a let-off motion that causes the yarns on the warp-pile beam to slacken, while the yarns on the ground-pile beam are held at tension. The third pick is inserted, the reed moves forward all the way, and all three picks are beaten up firmly into place (Figure 13–30). These picks move along the ground warp and push the pile-warp yarns into loops. The loops can be on one side only or on both sides. Loop height is determined by the let-off motion of the warp-pile beam.

Quality is determined by the yarn type (carded or combed), fiber (Pima, Egyptian, or regular cotton), and the number of filling yarns or picks used to create the weave. Common varieties include two- and three-pick terries. For example, a three-pick terrycloth, the highest quality, has two picks under the pile loop and one pick between loops. Figure 13–30 shows a three-pick terrycloth with closed loops on both sides of the fabric.

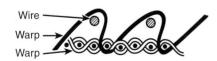

FIGURE 13-29

Friezé is woven over wires.

Terrycloth is used for bath towels, beach robes, and sportswear. Each loop acts as a tiny sponge. Sheared loops are brushed to loosen and intermesh the fibers of adjacent yarns. The surface becomes more compact, less porous, and absorbs more slowly as compared with looppile terry. Institutional cotton/polyester terry towels have blended ground yarns and cotton pile; the pile yarns are for absorbency and the polyester ground yarns are for strength and durability, especially in selvages.

There is no up and down in terrycloth unless it is printed. Some friezés are made by this method. Another slack-tension fabric, *shagbark*, has widely spaced rows of occasional loops.

Slack-Tension Weaves

In **slack-tension weaving** two warp beams are used. The yarns on one beam are held at regular tension and those on the other beam are held at slack tension. As the reed beats the filling yarn into place, the slack yarns crinkle or buckle to form a puckered stripe and the regular-tensioned yarns form the flat stripe. Loop-pile fabrics, such as terrycloth, are made by a similar weave (see the previous section). **Seersucker** is a fabric made by slack-tension weave (Figure 13–31).

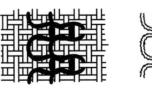

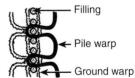

FIGURE 13-30

Warp pile: slack-tension method for terrycloth.

FIGURE 13-31

Seersucker. Note that the lighter yarns from the flat portion of the fabric are smaller and straighter. The darker-colored yarns from the puckered area are larger and more crimped.

The yarns are wound onto the two warp beams in groups of 10 to 16 for a narrow stripe. The crinkle stripe may have slightly larger yarns to enhance the crinkle. The stripes are always in the warp direction and ongrain. Seersucker is produced by a limited number of manufacturers. It is a low-profit, high-cost item because of its slow weaving speed. Seersuckers are made in plain colors, stripes, plaids, checks and prints. Seersucker is used in curtains and summer suiting, dresses, and sportswear.

Tapestry Weave

A tapestry weave is a hand-produced, filling-faced, plain-weave fabric. The discontinuous filling yarns are arranged so that as the color in the weave changes, the pattern is created. Discontinuous filling means that one filling yarn rarely travels across the fabric from one side to the other. Each color of filling yarn moves back and forth in a plain-weave interlacing pattern as long as the pattern calls for that color; then another color is used. In tapestries, filling yarns are not always straight within the fabric and may interlace with the warp at an angle other than 90 degrees. If the color changes along a vertical line, slits can develop in the structure. Different methods of structuring the fabric can enhance or eliminate the slit, depending on the effect desired by the artist.

Two types of looms are used to create tapestries: horizontal and vertical. The differences between the

FIGURE 13-32

Close-up of a tapestry rug from central Mexico. Note how the yarns dovetail where the pattern changes color. This is one method used to avoid producing slits in a tapestry.

looms relate to the size and end use of the tapestry. One-of-a-kind rugs, wall hangings, and fiber art pieces are made using this weave. Sometimes it is referred to as true tapestry to differentiate it from the jacquard-patterned tapestry. **True tapestries** usually have larger filling yarns than warp yarns. Warp yarns are covered completely by the filling. Although pictorial tapestries are common, there are many categories of tapestries based on the pattern and end use. Figure 13–32 shows a close-up of a tapestry rug from central Mexico.

FIGURE 13-33

Narrow fabric (left to right): woven fancy, grosgrain ribbon, woven satin ribbon, bias tape, zipper tape, and rick-rack.

Narrow Fabrics

Narrow fabrics encompass a diverse range of products that are up to 12 inches wide and made by a variety of techniques. Woven narrow fabrics will be discussed here. Narrow fabrics include ribbons of all sorts, elastics, zipper tapes, Venetian-blind tapes, couturier's labels, hook and loop tapes such as Velcro, pipings, carpet-edge tapes, trims, safety belts, and harnesses (Figure 13–33). Webbings are an important group of narrow fabrics used in packaging, cargo handling, furniture, and for animal

control, like leashes or lead ropes for dogs, horses, and show cattle.

Narrow-fabric looms weave many fabrics side by side. Each fabric has its own shuttle but shares all other loom mechanisms. Plain, twill, satin, jacquard, and pile weaves are used.

Woven elastics are made using a variety of weaves. They are used in apparel for which tight fit and holding power are needed, such as in undergarments. They have better stability and rigidity than knit elastics and are less prone to riding up, but are more expensive.

Key Terms

Fancy weaves
Dobby weave
Dobby loom
Bird's-eye
Huck or huck-a-back
Madras
Waffle cloth

Clipspot Clipped-dot design

Extra-varn weave

Swivel-dot fabric Piqué Bedford cord

Jacquard weave
Jacquard loom

Damask Brocade Brocatelle

Jacquard tapestry Wilton rugs Momie weave

Crepe or granite weave

Sand crepe Granite cloth Moss crepe Leno Doup attachment Marquisette Double cloth Melton Kersey Double weave Pocket weave

Matelassé Double-faced fabric

Silence cloth Pile weave

Woven-pile fabrics Filling-pile fabrics

Corduroy Velveteen Warp-pile fabrics

Velvet

Over-wire method

Friezé Terrycloth

Slack-tension weave

Seersucker Tapestry True tapestry Narrow fabrics

- **3.** What performance differences would be expected among the weaves in question 2?
- **4.** Name a fabric and end use for each of the weaves in question 2 and discuss the appearance characteristics that are useful in recognizing that fabric. Explain why that fabric is appropriate for that end use.

Suggested Readings

Emery, I. (1980). *The Primary Structures of Fabrics*. Washington, D.C.: The Textile Museum.

Humphries, M. (1996). Fabric Glossary. Upper Saddle River, NJ: Prentice Hall.

Jerde, J. (1992). *Encyclopedia of Textiles*. New York: Facts on File, Inc.

Mohamed, M. H. (1990, November/December). Threedimensional textiles. *American Scientist*, 78, pp. 530–541.

Schwartz, P., Rhodes, T., and Mohamed, M. (1982). Fabric Forming Systems. Park Ridge, NJ: Noyes Publications.

Textile machinery technology. (April, 1991). *Textile World*, pp. 61–68.

Tortora, P. G., and Merkel, R. S. (1996). Fairchild's Dictionary of Textiles, 7th ed. New York: Fairchild Publications.

Questions

- Explain why the fabrics in this chapter are referred to as fancy.
- 2. Summarize the structure of these weaves: dobby, jacquard, momie, leno, double cloth, pile, slack tension.

Chapter 14

KNITTING AND KNIT FABRICS

OBJECTIVES

- To describe the differences between woven and knit fabrics.
- To differentiate between warp- and filling-knit fabrics.
- To understand the characteristics of warp- and filling-knit fabrics.
- To integrate fabrication, yarn type, and fiber with end use.
- To understand the versatility of knit fabrics for apparel, furnishing, and industrial products.

nitting is the formation of a fabric by the interlooping of one or more sets of yarns. Knitting has been the traditional method of producing items such as sweaters, underwear, hosiery, and baby blankets. The trend toward a more casual lifestyle is reflected in increased knit furnishings and apparel.

Knitting is probably not as old a technique as weaving. Remnants of knit fabrics dating back to A.D. 250 were found near the borders of ancient Palestine. Knitting was a hand process until 1589, when the Reverend William Lee of England invented a flatbed machine for knitting cloth for hosiery that produced cloth 10 times faster than hand knitting. Circular-knitting and warp-knitting machines were developed about 200 years later. Other devices invented about that time include the ribbing device and the latch needle.

A unique advantage of knitting is that complete products such as sweaters and hosiery can be produced or fashioned directly on the knitting machine. The knitting of complete garments became possible in 1863, when William Cotton invented a machine that shaped garment parts by adding or dropping stitches.

The rate of production of knitting machines is about four times greater than looms because the machine width is not related to operating speeds. The high productivity rate should be an economic factor in favor of knitting, but the increased cost of the yarn more than offsets any savings in production costs. This is because the looped yarn shape imparts bulk and more yarn is required to produce a knit fabric than to produce a comparable woven fabric. Also, the looped structure is porous—has holes or spaces—and provides less cover than a woven fabric that has varns side by side. So, in order to achieve an equal amount of cover, small stitches (finer gauge) and finer and more-uniform yarns are used. Uniform yarns prevent the formation of thickand-thin places in the fabric and are more expensive to produce.

Knitting is a very efficient and versatile method of making fabric. This versatility has resulted from the use of computer-aided design systems with electronic-patterning mechanisms and QSC (quick style change) machine modifications that permit rapid adjustment for fashion changes. In addition, microcomputers are used in a manner similar to that for pattern weaves. Electronic controls identify the stitch type for each needle, the yarn to be used in the stitch, and the tension on the yarn. Electronic knitting machines make knitting faster, more practical, more versatile, and more efficient, with fewer fabric flaws. These machines make changing patterns much simpler and quicker. There is a knit counterpart for almost every woven fabric—knit seersucker, piqué, denim, crepe, satin, terrycloth, velour, and so on.

Other knitting-machine technological attachments expand the range of end uses by producing fabrics with stability more like that of wovens. The weft-insertion knitting machine inserts filling yarn for more crosswise stability and the warp-insertion knitting machine inserts warp yarns for greater lengthwise stability.

Other major advantages of knits are in comfort and appearance retention. Comfort relates to a knit's ability to adapt to body movement. The loop structure contributes outstanding elasticity (stretch/recovery) that is separate from any elastic properties of the fibers and yarns that are used. Loops can change shape by lengthening or widening to produce stretch in any fabric direction (Figure 14–1). However, knits may sag or snag.

Quality in knit fabrics is assessed in much the same way as for woven fabrics. (See Chapter 12.) Procedures focus on inspecting for flaws and assessing how the fabric performs in specific areas of interest. Characteristics that are used to define a high-quality knit fabric include a heavy weight for the fabric type, fiber content, and end use. Yarns are regular in appearance and may be combed or worsted, depending on the fiber. Pattern is incorporated into the fabric as part of its structure; jacquard or raschel fabrics are of higher quality than printed or embossed fabrics. Skew is minimal. Garment parts are shaped on the knitting machine rather than being cut and sewn.

Because of the unique interlooped structure of knits, they are more prone to specific problems, such as snagging and sagging. Special procedures have been developed to assess these performance characteristics of knits. The next few paragraphs describe some of these procedures.

Skew (an off-grain characteristic first discussed in Chapter 12) is common with knits, especially circular knits, because of the way they are made. In assessing skew, a fabric is placed flat on a surface and one course is followed across the fabric. A right angle is used to

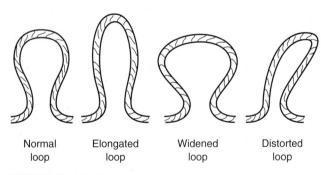

FIGURE 14-1
The loop can change its shape with force and stretch.

FIGURE 14–2
ICI snag tester. (Courtesy of SDL International Ltd.)

measure the difference between a straight course and a skewed course in the fabric.

Knitted fabrics have higher potential shrinkage than woven fabrics. The accepted standard is 5 percent for knits, whereas 2 percent is standard for wovens. However, American Society for Testing and Materials (ASTM) performance specifications recommend maximum shrinkage for woven and knit products of 3 percent in both vertical and horizontal directions.

A knit's bulky structure provides many trapped-air cells for good insulation in still air but a wind-repellent outer layer is needed to prevent chill winds from penetrating. On a warm, humid day, knits may be too warm because they conform to the body and insulate too well.

Knits are less likely to wrinkle during use, care, packing, or storage. Wrinkle recovery is related to the loop structure, but it is also strongly influenced by fiber and yarn type. *Snagging* is a serious problem with knit fabrics. When a yarn is snagged, it pulls out and stands away from the surface of the fabric. *Shiners*, or tight yarns, may form on either side of the snag. Finer yarns, smaller stitches, and higher yarn twist all contribute to snag resistance. Snag resistance can be evaluated using snag testers (Figure 14–2). If snags are cut off (rather than being worked back into their original position), a run is likely in some knits, particularly in filling knits.

A **run** occurs when the stitches in a wale collapse or pull out. A run occurs in a stepwise fashion when one stitch after another in a wale collapses due to stress on the loop when a yarn is cut.

Table 14-1 compares knitting and weaving.

Knitting

Knitting is a fabrication process in which needles are used to form a series of interlocking loops from one or more yarns or from a set of yarns. Filling, or weft, knitting is a process in which one yarn or yarn set is carried back and forth (or around) and under needles to form a fabric. Yarns move horizontally in filling-knit fabrics. Warp knitting is a process in which a warp beam is set into a machine and yarn sets are interlooped to form a fabric. Yarns move vertically in warp-knit fabrics. Figure 14-3 is a flow chart of knits that should facilitate identifying and naming fabrics. These names were borrowed from weaving and refer to the direction in which the yarns move in the fabric. In knitted fabrics, varns do not move in both directions as they do in weaving; there are not separate sets of warp and filling yarns in a knitted fabric. When a woven fabric is unraveled, both warp and filling yarns are removed. When a knit fabric is unraveled, only a row of loops is removed. Try unraveling a knit fabric and a woven fabric to compare this major distinction between the two structures. Compare the two unraveled fabrics in Figure 14-4.

Needles

Knitting is done by needles: **spring-beard**, **latch**, or **compound** (Figure 14–5). Most filling knits are formed with the latch needle. The spring-beard needle may be used to produce fully fashioned garments or knit-fleece and fine yarn fabrics. A double-latch needle is used to make purl loops. The compound needle is used primarily in warp knitting.

Stitches

Needles make stitches or loops. Stitch names are based on the way they are made. Stitches may be open or closed, depending on how the stitch is formed. Open stitches are most common in filling knitting. In warp knitting either kind may be found, depending on the design of the knit. Open or closed stitches are used in identifying the way the fabric was made and have little relationship to fabric performance.

Fabric Characteristics

Fabric density is defined by describing the number of stitches, not yarns, in a specific direction. Wales are vertical columns of stitches in the knit fabric. Courses are the horizontal rows. In machine knitting, each wale is formed by a single needle. Examine the knit fabric in

TABLE 14-1 Comparison of knit and woven fabrics.

Knitting	Weaving		
Comfort and Appearance Retention			
Mobile, elastic fabric. Adapts easily to body movement. Good recovery from wrinkles. Air permeable. Open spaces between yarns let winds penetrate. Bulky.	Stable to stress (unless made with stretch yarns). Less air- permeable, especially if count is high. Bulk and wrinkle recovery vary with the weave.		
Cover			
Porous, less opaque.	Provides maximum hiding power and cover.		
Fabric Stability			
Less stable in use and care. Higher shrinkage unless heat-set.	More stable in use and care. Many shrink less than 2 percent.		
Versatility			
Sheer to heavyweight fabrics. Plain and fancy knits. Resembles many woven fabrics.	Sheer to heavyweight fabrics. Variety of textures and designs.		
Economics			
Design patterns can be changed quickly to meet fashion needs. Process is less expensive but requires more expensive yarns. Faster process regardless of fabric width.	Machinery is less adaptable to rapid changes in fashion. Most economical method of producing a unit of cover. Wider looms weave more slowly.		
Fabric Structure and Characteristics			
Series of interconnected loops made with one or more sets of yarns. Can be raveled from top or bottom depending on the knit type (warp knits cannot be raveled). May snag and run. May be bowed or skewed. Usually heavier because more yarn is used.	Two or more sets of yarns interlaced to form the fabric structure. Yarns are essentially straight in the fabric. Can be raveled from any cut edge. May snag and ravel. May be bowed or skewed. Usually lighter because less yarn is used.		
Uses			
Apparel, furnishings, and industrial products.	Apparel, furnishings, and industrial products.		

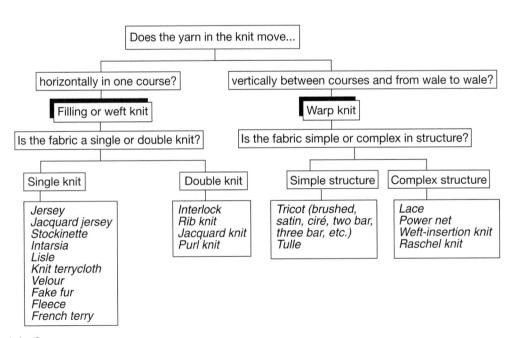

FIGURE 14-3

Flow chart of knit fabrics.

FIGURE 14-4

Woven fabrics can be unraveled by removing warp and filling yarns (left). Knit fabric can be unraveled by removing a course—yarns in a double filling knit (right).

Figure 14–4 carefully and note that in the unraveled yarn, each loop would represent a wale and the yarn represents the course. Wales and courses show clearly on filling-knit jersey (Figures 14–6 and 14–7). Fabric density is often designated as wales by courses. For example, a T-shirt jersey might have 32 wales per inch and 44 courses per inch. This fabric would have a density of 32×44 .

Gauge or cut indicates the fineness of the stitch; it is the number of needles in a specific distance on the needle bar and is often expressed as *needles per inch* (npi). Cut may be used in the textile industry to describe knit fabrics.

The higher the cut, or gauge, the finer the fabric. The finished fabric may not have the same cut as the knitting machine because of shrinkage or stretching during finishing. A fine-cut, filling-knitting machine may have 28 npi or more. A coarse one may have 13 npi or fewer.

It may be difficult to identify the technical face of the fabric. **Technical face** refers to the outer side of the fabric as knitted. This may not be the side used as the fashion side in a product. The **technical back** is the inner side of the fabric as it is knit and is used as the fashion side of such fabrics as fleece and knit terry. Identification of the technical face can be done in several ways. The technical face usually has a better finish. Finer and more expensive yarns are used on the face side. Floats on the face are less likely to snag. Fabric design is more obvious on the face side.

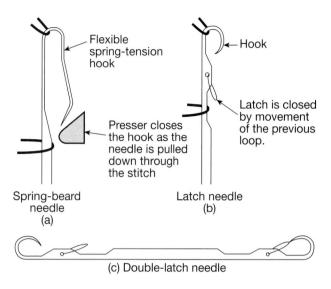

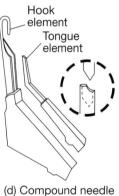

FIGURE 14-5

Knitting needles: (a) spring-beard needle; (b) latch needle; (c) double latch needle; (d) compound needle.

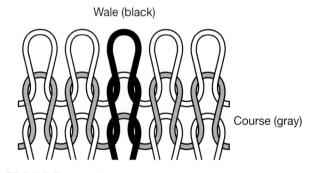

FIGURE 14-6

Wale (black) and course (gray) as seen from the technical face of filling-knit iersey fabric.

Wale (black)

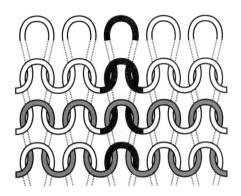

Course (gray)

FIGURE 14-7

Wale (black) and course (gray) as seen from the technical back of filling-knit jersey fabric.

Environmental Impact of Knitting

The process of knitting creates fewer environmental problems as compared with weaving. Chemicals to minimize abrasion on yarns or generation of static charges are less likely to be used with knits. There is no knit equivalent to the water-jet loom. Knitting machines are quieter than shuttle looms. Knitting produces less vibration and lint. Knitting machines also use less energy to operate than do looms.

Filling (or Weft) Knitting

Filling knitting can be done by hand or machine. In hand knitting, a yarn is cast (looped) onto one needle, another needle is inserted into the first stitch, the yarn is positioned around the needle, and by manipulating the needle the new stitch is taken off onto the second needle. The process is repeated over and over again until the product has been completed.

In machine knitting, many needles (one for each wale) are set into a machine and the stitch is made in a series of steps. By the end of the series, one needle has gone through a complete up-and-down motion, and a new stitch has been formed (Figure 14-8). In the running position, the needle moves up and the old stitch slides down the needle. In clearing, the needle is in its highest position and the old stitch has moved down to the needle's base. In feeding, the new yarn is caught by the needle's hook and the needle begins its downward stroke. In knockover, the old stitch is removed from the needle. The final step is pulling, when the new stitch is formed at the needle's hook and the needle is in its lowest position. These five steps are repeated in a continuous up-and-down motion to form a knit. Each needle in the knitting machine is at a slightly different stage in this process so that one sees a wave or undulating motion across or around the machine.

Knitting can be done on a flatbed machine in which the yarn is carried back and forth (Figure 14–9) or on a circular machine in which the yarn is carried in a spiral like the threads in a screw (Figure 14–10). Figure 14–11

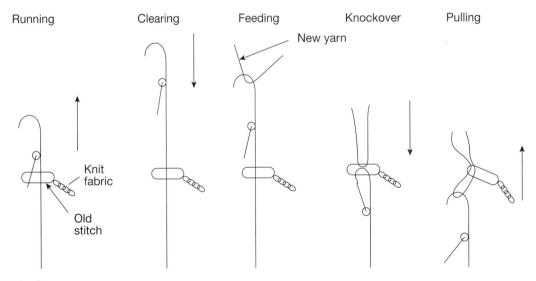

FIGURE 14-8

Latch-needle knitting action. Arrows show the direction in which the needle is moving.

FIGURE 14-9
Flat-bed knitting machine for fabric. (Courtesy of Stoll America Knitting Machinery, Inc.)

shows yarn movement in fabrics knit using these two types of machines. In hand knitting, many kinds of stitches can be made by varying the way the yarn is placed around the needle (in front or behind) and by knitting stitches together, dropping stitches, or transferring stitches. Special devices are used to obtain these variations in machine knitting.

Knits can be classified by several factors: the machine on which the knit is made, the number of yarn sets in the knit, the type of stitch or stitches used, or the type of fabric produced. Categorizing knits by the number of yarn sets is a carryover from hand knitting. Some fabrics, such as rib knits, are made with one set of yarns on a double-knit machine with two needle beds. Thus, rib knits could be categorized as a single-knit (one yarn set) or as a double-knit (machine type). In the industry and in this book, knits are categorized by the machine used to produce them.

Machines Used in Filling Knitting

Machine knitting is done on single- and double-knit circular and flatbed machines. Production is faster with circular machines; they are described by the diameter of the fabric tube they produce. Greater flexibility demands by the industry have resulted in machines that make a variety of tube diameters. Diameters can be changed with minimal down time. New yarns can be fed into the structure at any point along the diameter. Yarn feeds normally range from three to four feeds per diameter inch. With a tube diameter of only 13 inches and three feeds per diameter inch, there could be up to 39 courses between the point where a yarn began its circular pattern and where that same yarn began its second course around the fabric. High yarn feeds per diameter inch allow knitting machines to be very productive, but they produce fabrics with significant skew and potential

FIGURE 14–10
Circular knitting machine. (Courtesy of Sulzer Morat GMBH.)

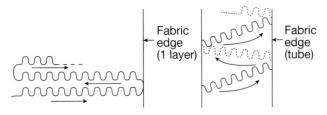

FIGURE 14-11

Yarn motion in flatbed knits (left) and circular knits (right).

problems in cutting, sewing, and consumer satisfaction. Circular machines are used to make yardage, sweater bodies, panty hose, and socks.

Flatbed machines knit a variety of fabric widths, but most flatbed knits are at least 100 inches wide. These machines are slower than circular machines, but they produce less skew in the fabric and can fashion or shape garment or product parts.

Knitting machines also may be described by the type of fabric they produce, such as simple jersey or a more-complex knit such as terrycloth. Patterned knits are produced on jacquard machines.

Filling-Knit Structures—Stitches

Filling-knit fabrics are classified by the four possible stitch types. Each stitch is controlled by the selection of cams, or guides, that control the motion of the needle. The first stitch is the knit stitch. This is the basic stitch used to produce the majority of filling-knit fabrics (Figure 14–12). These fabrics have greater elongation crosswise and less elongation lengthwise. The sides of the stitches appear on the face of jersey; the back is comprised of the tops and bottoms of the stitches. Figure 14–12 illustrates the appearance of both sides of the fabric. When jerseys are printed, they are printed on the face, since that is the smoothest and most regular surface. However, many jerseys, especially the pile types, are used with the technical back as the fashion side because of the loop formation.

The **tuck stitch** is used to create a pattern in the fabric. In the tuck stitch, the old stitch is not cleared from the needle. Thus, there are two stitches on the needle. Figure 14–13 shows how the tuck stitch looks in a fabric. In a knit fabric with tuck stitches, the fabric is thicker and slightly less likely to stretch crosswise than a basic-knit fabric with the same number of stitches. Tuck stitches create bubbles or puckers for visual interest. They may be in a pattern or added randomly to create texture. These are usually referred to as jacquard jerseys.

The **float** or **miss stitch** is also used to create a pattern in the fabric. In the float stitch, no new stitch is

formed at the needle, while adjacent needles form new stitches. The float stitch is used when yarns of different colors knit in to create the design. Figure 14–14 shows how the float stitch looks in a fabric from the technical face and the technical back. A knit fabric with float stitches is much less likely to stretch crosswise than a basic-knit fabric with the same number of stitches. In jacquard jerseys, float stitches are very common because of the combination of colors in the fabric. For example, if a fabric incorporates two or more colors in a pattern, float stitches are necessary, as one color comes to the face and the other floats in this area. A jacquard jersey made by using different yarn colors often combines tuck and float stitches in those courses.

The **purl**, or **reverse**, **stitch** forms a fabric that looks on both sides like the technical back of a basic-knit fabric. The fabric is reversible (Figure 14–15). Purl-knit fabrics are slow and expensive to knit because they require special machines. Since the face and back of a purl fabric look like the back of a jersey, manufacturers often use the technical back of a jersey as the fashion side when a purl appearance is desired. These imitation "purl" fabrics pass casual inspection by consumers and are competitive in price with other knit structures, so the consumer does not pay more for this special look.

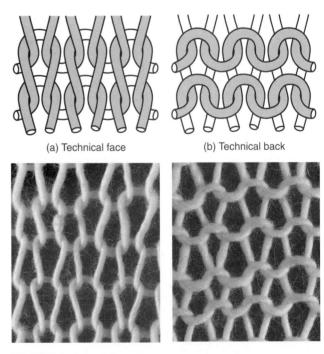

FIGURE 14-12

Jersey fabric diagram (top) and photograph (bottom). The gray part in the diagram indicates the yarn portions that can be seen from that view of the fabric.

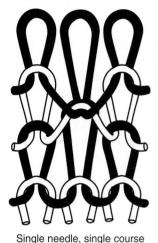

FIGURE 14-13

Tuck-stitch diagram (left) and fabric (right). (Courtesy of Knitting Times, the official publication of National Knitwear and Sportswear Association.)

Filling-Knit Fabrics

tuck stitch

Single-Filling Knits Single-filling knits are made using a circular or flatbed machine with one set of needles. Single-knits can be any pattern or weight. They are less stable than double-knits, tend to curl at the edges, and run readily, especially if made of filament yarns.

Single or Plain Jersey Single-jersey fabric is the simplest of the filling-knit structures. Wales—columns of stitches running lengthwise—may be easier to see on the face. Courses—rows of stitches running crosswise—may be easier to see on the back. Stretch a swatch of jersey

crosswise and it curls to the back at the lengthwise edges. The ends curl toward the face. Yarns ravel crosswise because they run horizontally in the fabric. Cut edges or broken yarns may create problems with runs. Single jerseys made of spun yarns resist running because of fiber cohesiveness. The single-jersey structure, or plain knit, is widely used because it is the fastest filling knit to make and is made on the least complicated knitting machine.

Jersey is a fabric of light to heavy weight; it is usually knit on a circular-jersey machine and sold in tubular form or cut and sold as flat goods. When tubular fabrics are pressed in finishing, the creases are off-grain and not parallel to the wales of the fabric. The tubular fabric does not need to be cut and opened out when

FIGURE 14-14

Float, or miss, stitch diagram (left). Jacquard jersey fabric (center and right). Note the pattern on the face (center) and the floats on the back (right). (Courtesy of Knitting Times, the official publication of National Knitwear and Sportswear Association.)

FIGURE 14-15
Purl stitch looks the same on both sides.

cutting out product parts, unless there is a specific reason for doing so. T-shirts with no side seams are made from circular knit jersey. Tube socks are another common circular knit product.

Figure 14–16 shows a T-shirt that was cut from tubular cotton jersey with yarn-dyed crosswise stripes. When purchased, the stripes were parallel and the side seams were perpendicular to the lower edge. After washing, the fabric assumed its normal position, causing the side seams to twist.

FIGURE 14-16

T-shirt showing skew of the circular knit jersey fabric. Note how the side seam twists toward the front of the shirt.

Heavier-weight jerseys are often used for simple solid color or striped sweaters, tops, and skirts. Fancy or multiple-ply yarns add body, durability, warmth, cover, or texture. **Stockinette** (or **stockinet**) usually refers to a heavier-knit jersey fabric made with a coarse spun yarn as compared with regular jerseys.

Lisle (pronounced *lyle*) is a high-quality jersey made of fine two-ply combed cotton yarns. It can be found in several weights, depending on its end use. Lisle is used for men's and women's socks, undergarments, shirts, skirts, and sweaters.

End uses for jersey include hosiery, underwear, shirts, T-shirts, dresses, and sweaters. Variations of plain knits are made by programming the machines to knit stitches together, to drop stitches, and to use colored yarns to form patterns or vertical stripes. Extra yarns or slivers are used to make pile fabrics like terrycloth, velour, and fake-fur fabrics.

Jacquard Jerseys Figured-single jerseys are made using a jacquard mechanism with electronic controls on circular-jersey machines. Patterns are produced by combinations of knit, tuck, or float stitches, combinations of yarns that vary by color or texture, or incorporation of yarns in specific areas within the fabric, much like a true tapestry weave for woven fabrics. Jacquard jerseys are the simplest of these patterned fabrics. In a jacquard jersey, the pattern develops because of different stitch types, yarn colors, or a combination of stitch type and yarn color. The photographs in Figure 14–14 show the face and back of a jacquard jersey in which the yarn color changes to create the pattern.

In a more complicated patterned single-knit fabric, the yarn used to create a pattern in the fabric is knit into the fabric in that area only. This is the knit counterpart to a true tapestry weave. This fabric is referred to as an **intarsia**. Intarsia designs in jersey are made by knitting in colored yarns. True intarsia designs have a clear pattern on both the right and wrong side of the cloth with no pattern shadows, which are characteristic of jacquard designs. Fabrics have no extra weight, and the stretch is not impaired. Mock intarsia designs are made by knitting and float-knitting (float or miss stitch), which results in a heavier-weight fabric with floating yarns on the reverse side or shadow pattern. Floats reduce the elasticity of the fabric and may snag readily. Compare both fabrics in Figure 14–17.

Pile Jerseys Pile jerseys are made on a modified circular jersey machine. The fabrics look like woven pile but are more pliable and stretchy. The pile surface may consist of (1) cut or uncut loops of yarn or (2) fibers (see the discussion of sliver knits later in this chapter). In velour and knit terrycloth, the fabric is made with two

FIGURE 14-17
Compare these two fabrics: true intarsia, face (top left) and back (top right); mock intarsia, face (bottom left) and back (bottom right).

sets of yarns. One yarn set is spun yarns and will eventually form the pile surface of the finished fabric. The other set is a bulk-continuous-filament (BCF) yarn that has been processed in such a way as to shrink when heated. Both yarn sets are knit together to form the fabric. At this point, the fabric looks like a very loose, poorquality jersey. The fabric is heat-set and the BCF yarn

shrinks. The spun yarns form the pile and the fabric is finished to produce the appropriate look.

Knitted terrycloth is a loop pile fabric used for beachwear, robes, and babies' towels and washcloths. It is softer and more absorbent than woven terrycloth but does not hold its shape as well (Figure 14–18). Velour is a cut-pile fashion fabric used in men's and women's

FIGURE 14-18

Pile-filling knit fabrics: knit terry, face (top left) and back (top right); velour, face (bottom left) and back (bottom right). Note the yarns raveled from each fabric and the side that forms the fashion side of the fabrics.

wear and in robes. Velour is knit with loops that are cut evenly. Then the yarn uncurls, giving better coverage. The fabric is dyed, tentered, and steamed (see Figure 14–18).

Sliver-pile knits are made on a special weft-knit, circular, sliver-knitting machine and are furlike high-pile or deep-pile fabrics. Figure 14–19 shows that yarns are used for the ground; the sliver furnishes the fibers for the pile. Sliver is an untwisted rope of fiber made by carding, drawing, or combing (Chapter 10).

Fibers from the sliver are picked up by the knitting needles—along with the ground yarns—and are knit into place as the stitch is formed. A denser pile can be obtained with sliver than with yarn because the amount of face fiber is not limited by yarn size or by the distance between yarns.

The surface pile can be made with heat-sensitive manufactured fibers to resemble guard hairs for a more realistic look, printed to resemble the furs of exotic protected species such as jaguar or leopard, or used in other designs for fun furs. Fibers are solution-dyed or fiber-dyed because piece-dyeing distorts the pile. Fake-fur fabrics are used for the shells (the outer layer) and for linings of coats and jackets. Some sliver knits are also used for casual upholstery fabrics and for bath rugs.

Furlike fabrics are lighter weight, more pliable, and more comfortable than real fur. They require no special storage. A dry cleaner can successfully clean furlike fabrics by using a cold tumble dryer and combing the pile rather than steam pressing it.

Weft-Insertion Jersey In weft insertion jersey, another yarn is laid in a course as it is being knit. The yarn is not knit into stitches but is laid in the loops of the stitches as they are being formed. The yarn may be novelty, large, irregular, or very-low-twist and weak and not suitable for normal knitting. The laid-in yarn increases the fabric's crosswise stability. This laid-in or inserted

FIGURE 14-19 Sliver-knit furlike fabric.

yarn is used for decoration, strength, stability, or comfort; it may be used to produce a nap during finishing. In **french terry**, no special finishing is needed. The technical back is used as the fashion side. In **fleece** the technical back is napped. Cotton, cotton/polyester, or cotton/acrylic blend fleece weighs from 7 to 11 oz/yd². French terry and fleece are used in sportswear, cardigans, dresses, and tops (Figure 14–20).

FIGURE 14-20
Weft-insertion weft or filling knit: napped side (left) and technical face with knit and laid-in yarn (right).

Shaping on the Knitting Machine Garment parts—sweater bodies, fronts, backs, sleeves, skirts, socks, seamed hosiery, and collars—can be knitted to shape on flatbed machines. The stitch used for shaping is called a loop transfer. A knit stitch is transferred from one needle to another, usually near the end of a course, so that the width of the fabric is decreased. The process, called **fashioning**, is used to shape parts like armholes, neckline curves, collar points and finish edges.

A **looping machine** is used to join the shoulders and sleeves of the shaped parts with a chain stitch that produces the effect of continuous knitting rather than an obvious seam line. This machine is also used to join collars to cut-and-sewn knit garments.

To identify fashioned garments, look for "fashion marks" accompanied by an increase or decrease in the number of wales. In Figure 14–21, the number of wales decreases from the bottom to the top. Mock fashion marks are sometimes used, but they are not accompanied by an increase or decrease in the number of wales, so no shaping is done by the mock fashion marks. In Figure 14–22, there is no change in the number of wales. Full-fashioned sweaters are often made with a jersey stitch. Circular jersey sweaters are cut and sewn.

Full-fashioned garments do not necessarily fit better than cut-and-sewn garments because fit depends on the size and shape of the pieces. But full-fashioned garments are always on-grain, look better to the discerning eye, should not become misshapen during washing due to twisted seams, and are often better-quality garments.

Hosiery Fashion and manufactured fibers have been responsible for many of the developments in hosiery. Spun yarns of any fiber are used for socks. Spandex is used in the tops of socks. Nylon or fluoropolymer reinforces the heels and toes of socks. Filament nylon yarns are used in women's hosiery and lighter-weight socks (Figure 14–23).

All hosiery is filling knit. The types include plain (or jersey), rib, mesh, and micromesh. The plain knit has stretch in both directions, and hose can be very sheer if made of fine-denier fibers or microfibers. Plain knit has the disadvantage of running readily when a loop is broken. Mesh hose are lacelike knits that do not run, but they snag, and holes will develop. Micromesh has loops knitted so that a run goes only up. Mesh and micromesh stockings are not as elastic or as smooth as plain jersey. Rib stitches, jersey, and fancy knits such as cable and argyle are often used in socks or tights.

Shaping of socks and hosiery may be done by decreasing the size of the loop gradually from top to toe. If shaping is done at toe and heel, a circular fashioning mechanism that drops stitches is used. Heavier yarn can be knit into toes and heels to give greater comfort and

FIGURE 14-21 Raglan sleeve portion of full-fashioned sweater. Note that stitches are dropped to shape the sleeve.

FIGURE 14-22 Raglan sleeve portion of cut-and-sewn sweater. Note the mock full-fashion marks.

durability. Seamless hosiery is knit in one piece as a continuous operation. After knitting, the toe is closed and the product is turned right side out.

Hosiery with shaped heels are preboarded, a process in which stockings are placed on metal leg forms of the correct size and shape and then steam pressed. Tube socks and stockings do not have shaped heels.

Panty hose are usually made from textured stretch nylon in a tube shape with a guide for slitting. The panty portion may be heavier than the stocking portion. After the panty section is slit, two tubes are stitched together with a U-shaped crotch seam with a firm, serged stitch. A separate crotch section may be inserted for better fit.

Double-Filling Knits Double-filling knits are made using a machine with two beds of needles, with the second bed or set of needles located at a right angle to the first bed of needles. Most double-knitting machines have the two needle beds arranged in an inverted V and are called V-bed machines. Double-knit fabrics may be made with one or more sets of yarns. They are categorized based on the arrangement of the needles in the double-knitting machine, or the gait of the machine. In a rib-gait machine, the two beds of needles are positioned so that both needles can knit at the same time. The needles of one bed are located opposite the spaces between the needles of the other bed. In interlock gait-

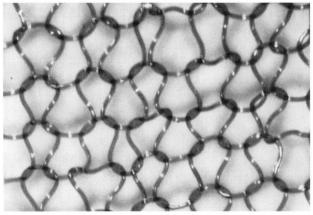

FIGURE 14-23

Nylon hosiery: (left) stretched; (right) relaxed. (Courtesy of E. I. du Pont de Nemours & Company.)

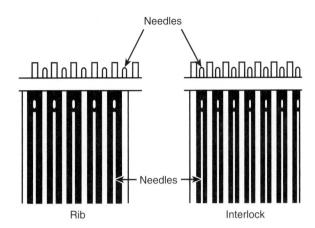

FIGURE 14-24
Gaiting: rib (left); interlock (right).

ing, the needles are positioned so that only one needle bed can knit at a time. The needles of one bed are located directly across from the needles of the other bed (Figure 14–24). In purl gaiting, both needle beds are on the same plane so that the double-latch needle can travel between the two beds. Purl gaiting is used only for a true purl knit.

Double-knit fabrics can be made with any combination of the four stitches: knit, tuck, float, or purl. In the flatbed machine, the needles from one bed pull the loops

FIGURE 14-25

Needle action in flat-bed machine. (Courtesy of Knitting Times, the official publication of National Knitwear and Sportswear Association.)

FIGURE 14-26

(a) Needlebeds and (b) knitting action in circular-knitting machine, rib gait. (Courtesy of Knitting Times, the official publication of National Knitwear and Sportswear Association.)

to the back and those in the other bed pull the loops to the front (Figure 14–25). In the circular machine, the loops are pulled to the face and back by setting one set of needles vertically in a cylinder and the other set of needles horizontally in a dial or cam (Figure 14–26).

Double-knit fabrics have two-way stretch and relatively high dimensional stability. They do not curl at the edges and are less apt to stretch out than single knits. They do not run. Double-knits can resemble any woven structure and are often given the woven fabric name—denim, seersucker, piqué, and the like.

A technique used to illustrate the production of double-knits is a diagram based on the two needlebeds and the type of gaiting. A center horizontal line represents the space between the beds. A short vertical line represents a needle. In interlock gaiting, the short vertical lines are directly opposite each other (Figure 14–27). In rib gaiting, the needle lines stop at the horizontal line

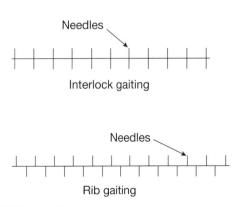

FIGURE 14-27 Interlock gaiting (top) and rib gaiting (bottom).

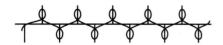

FIGURE 14-28

 1×1 rib fabric diagram (rib gaiting).

and needle lines on one side of the line are staggered with needle lines on the opposite side (Figure 14–27). In the diagram, a loop represents a knit stitch, an inverted V represents a tuck stitch, and a—represents a float or miss stitch. Thus a 1×1 rib would be diagrammed on rib gaiting, as shown in Figure 14-28. Each course required to produce the pattern is diagrammed separately and is referred to as a step. A simple interlock is diagrammed in two steps on interlock gaiting because two steps are required to create the interlock fabric (Figure 14-29). An example of a doubleknit fabric knit on interlock gaiting is a ponte de roma, that requires four knitting steps (Figure 14-30). An example of a double-knit fabric knit on rib gaiting is a la coste, which requires eight knitting steps (Figure 14–31). An easy way to identify a double-knit is to look at an edge of the fabric parallel to a course. If all loops point

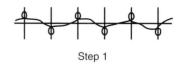

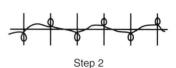

FIGURE 14-29

Interlock fabric diagram (interlock gaiting).

in one direction, it is a single-knit. If some of the loops point toward the front and some toward the back, it is a double knit. To distinguish between an interlock and a rib-gaiting fabric, look more closely. If the loops are directly opposite each other, it is made with interlock gaiting. If the loops are not directly opposite each other, it is made with rib gaiting. A magnifying glass or stereoscopic microscope aids identification.

See Table 14–2 for a summary of the differences and similarities between flatbed and circular machines from a single- and double-knit perspective.

	Single-Knit		Double-Knit	
	Jersey—Flat	Jersey—Circular	Flat (Rib/Interlock)	Circular (Rib/Interlock)
Description	Straight bar holds one set of latch needles	See Figure 14–8. One set of latch needles.	Two flat needle beds formed in inverted V position. See Figure 14–25.	See Figure 14–26. Needle sets mounted on dial and on cylinder.
	Yarn carried back and forth	Yarn carried around	Yarns carried back and forth	Multiple-feed yarns carried around circle
	Used to shape items	Range of designs possible with electronic control	Stitch-transfer carriage can switch between beds to make variety of stitches	Same as for flat double-knit
Kinds and uses	Basic knit stitch	Workhorse of knitting industry	Ribbed fabric or parts of fabric	Double-knits—plain and jacquard
	Face and back of fabric look different	Face and back of fabric look different	Same appearance face and back	Face and back may look the same or different
	Full-fashioned garments	High-volume production Seamless hose Jersey, velour, terry	Used to produce fabric with finished edge Collars, trims	Double-knit apparel and some furnishings
Advantages	Economical yarn use Fabric always on-grain Design variations possible	Fastest method	Less waste than circular rib	High-speed production Excellent design flexibility Versatile in yarn usage
Limitations	Slow in production Higher-priced products Single-feed system	Variety of pattern possibilities available	Slow speed	Complex machine Downtime can be a problem

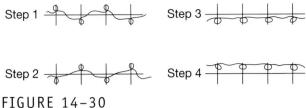

Ponte de roma (interlock gaiting).

La coste (rib gaiting).

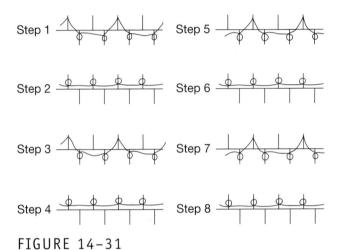

 2×2 rib 1×1 rib

FIGURE 14-32

Rib stitches: 2×2 rib (left); 1×1 rib (right).

Rib Structure A **rib** structure is made of face wales and back wales. The lengthwise ridges are formed on both sides of the fabric by pulling stitches first to the face and next to the back of the fabric in adjacent stitches or groups of stitches. These may be in various combinations, 1×1 , 2×2 , 2×3 , and so on (Figure 14–32). Figure 14–33 shows a fabric in a combination plain and rib knit. The 1×1 rib is the simplest double-knit fabric produced using rib gaiting. It usually consists of one set of varns.

Rib knits have the same appearance on the face and back and are usually much thicker than a single jersey. They may have up to twice the extensibility crosswise as that of single jersey. Rib knits do not curl at the edges, but they run. They unravel from the end knit last.

Double-knit jersey looks the same on both sides. It is made on rib gaiting, and needles from the cam and cylinder are not opposite each other but are positioned so that the needles from one bed work between the needles from the other bed. They knit a 1×1 rib.

FIGURE 14–33 Rib-knit fabric: (left) fabric relaxed, left side 2×2 rib, technical face; (right) fabric stretched to show difference in stitches.

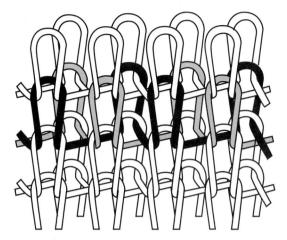

FIGURE 14-34

Interlock (diagram offset for clarity). (Courtesy of Knitting Times, the official publication of National Knitwear and Sportswear Association.)

Interlock Structure Interlock is the simplest double-knit fabric produced using interlock gaiting (see Figure 14–27). Interlock fabrics are composed of two 1×1 rib structures intermeshed. (Figure 14–34 is offset for clarity.) The two sides of the fabric look alike, and they resemble the face of single jersey. Interlock stretches like plain jersey, but the fabric is firmer. Interlocks do not curl and fabrics run and unravel from one end only. Interlock runs much more easily than a rib double-knit, but interlock is a softer, more fluid fabric. Most interlock fabrics are plain or printed. Colored yarns give spot effects or horizontal or vertical stripes.

Jacquard double-knits have almost limitless design possibilities. The intermeshing of the two yarns is the same as for the double-knit jersey but with added needle-selecting mechanisms (Figure 14–35). Although double-knits may be named for the woven fabrics they resemble, the term *double-knit* often is the only name used to identify the fabric.

Purl Structure Purl knits usually are made on machines with two needlebeds and double-latch needles with purl gaiting. Purl is the slowest form of knitting, but it is also the most versatile because it is the only filling-knitting machine that can produce all three types of filling-knit fabrics—plain, rib, and purl—as separate fabrics or combined into one fabric or product.

Fabrics produced by the purl stitch are thick, wide, and short as compared with single jersey with the same number of plain stitches. Fabrics do not curl, but they do run and may unravel from either end (Figure 14–36).

The two major end uses for purl structures are children's and infants' wear and sweaters. Purl stitches used at the shoulder seams of sweaters stabilize the garment.

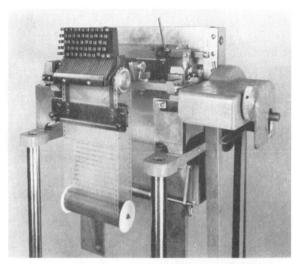

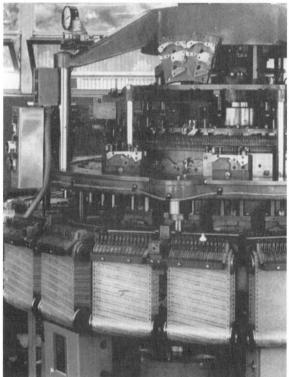

FIGURE 14-35

Jacquard knitting machine. (Courtesy of Rockwell International.)

They have less crosswise stretch as compared with plain knit stitches.

Warp Knitting

Warp knitting is unique in that it developed as a machine technique without ever having been a hand technique. Warp knitting started about 1775 with the in-

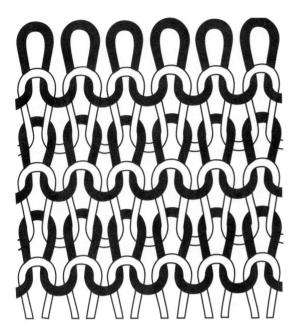

FIGURE 14-36

Purl fabric. (Courtesy of Knitting Times, the official publication of National Knitwear and Sportswear Association.)

vention of the **tricot** (pronounced *tree-ko*) **machine** by Crane of England. The tricot machine is sometimes called a warp loom because it uses one or more sets of yarns that are wound on warp beams and mounted on the knitting machine.

Warp knitting provides the fastest means of making fabric from yarns. Some say that warp knits combine the best qualities of both double-knits and wovens. Warp-knit fabrics tend to be less resilient and lighter weight

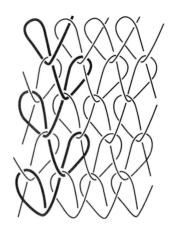

FIGURE 14-37

Warp-knitting stitch.

than filling knits. Depending on their structure, they can be stable in both fabric directions or exhibit stretch.

Warp knitting produces a vertical-loop structure (Figure 14–37). It is a machine process of making fabric in flat form using one or more sets of warp yarns that are fed from warp beams to a row of knitting needles extending across the width of the machine. Each set of yarns is controlled by yarn guides mounted in a guide bar that also extends across the width of the machine. Warp-knitting machines are wider than most looms. If there is one set of yarns, the machine will have one warp beam and one guide bar; if there are two sets of yarns, there will be two warp beams and two or more guide bars, and so on; hence the terms *one-bar tricot* and *two-bar tricot*. Each yarn guide on the bar directs one yarn to the hook of one knitting needle. More guide bars provide greater design flexibility. The loops of one course

FIGURE 14-38

Guide-bar movements, step by step, for warp-knit stitch.

FIGURE 14-39

Guide-bar movements: (a) All steps of the guide-bar movement. (b) Yarn movement following the guide-bar movement. (c) Series of yarn loops creating the warp-knit fabric.

are all made simultaneously as the guide bar rises and moves sideways, placing the yarns around the needles to form the loops, which are then pulled down through the loops of the preceding course.

Warp knits usually are diagrammed using a pointpaper notation. In this notation, each point in a horizontal row represents a needle. Arrows represent the movement of the guide bar that controls yarn movement. Thus, the diagram for each row of points represents the movement of the guide bar that creates the varn loops for a course. The next row of points represents the next course, and so on until one complete repeat has been illustrated. The diagram starts at the bottom row of points and moves up the paper from course to course. Figure 14-37 is a diagram of a warp knit. Figure 14-38 shows the steps (a through h) that are needed to create that fabric. In Figure 14-39(a), the seven steps are combined in one diagram; in Figure 14–39(b), the resulting yarn loops are shown; in Figure 14-39(c), the two repeats of the pattern are shown. Yarn from the front bar usually predominates on the surface, whereas varn from the back bars provides run resistance, elasticity, and weight. The short sides of the loops form the face and the long slanted yarns between needles form the back. Hence, the face of a tricot looks like a fine jersey while the back looks like a herringbone laid on its side (Figure 14-40).

Apparel end uses for warp knits include lingerie, underwear, sportswear, and outerwear. Warp knits are used in contract-grade carpet, upholstery, drapery and casement fabrics, and for face fabrics in wall partitions and miniblind slats. Industrial end uses are rapidly expanding and include fabrics for sun and light protection, controlling rock falls, grass collection, snow barriers and dam reinforcement. Warp-knit fabrics are used for medical implants such as artificial veins and tissue-support fabrics.

Although warp knitting is fast, warp knits are expensive because the process requires very regular yarns. Yarn costs offset the fast process speed.

Machines Used in Warp Knitting

Warp knits are classified by the machine used to produce the fabric. Tricot machines use a single set of spring-beard or compound needles. Tricot-knitting machines with computer-controlled guide bars, electronic beam control, and computerized take-up are able to knit 2000 courses per minute. Raschel machines use one or two sets of vertically mounted latch needles. Jacquard raschel knitting machines with computer-controlled guide bars produce complex structures used for apparel, furnishing, and industrial products. The differences between the fabrics produced by these machines have become less distinct. Several types of warp knitting machine are listed in Table 14–3. Tricot and raschel machines, however, account for more than 98 percent of all warp-knit goods.

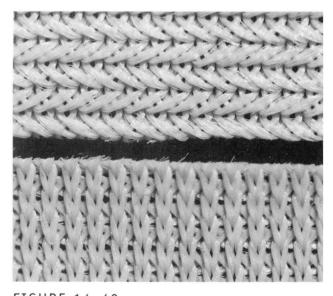

FIGURE 14-40
Two-bar tricot: technical face (bottom); technical back (top).

Tricot	Raschel	Simplex	Milanese
Single bed	One or two needlebeds	Two sets of needles	Flat—spring-beard needles
Spring-beard or compound needles	Latch needles	Spring-beard needles	Circular—latch needles
Fine gauge	Coarse gauge		
2–3–4 bars indicate number of warp yarn sets	May have as many as 78 guide bars		Yarn travels diagonally from one side of material to the other
Simple fabric	Complex fabric	Reversible, double-faced fabric with rib appearance	
High-speed, high-volume	Great design possibilities	Seldom used	Seldom used
Usually filament yarns	Spun or spun and filament yarns		
Wider fabric, 170 inches	Narrower fabric, 100 inches		
End Uses			
Plain, patterned, striped,	Sheer laces and nets	Gloves	Underwear
brushed fabric	Draperies		Outerwear
Underwear	Power net		Gloves
Outerwear	Thermal cloth		
Upholstery	Outerwear		
Industrial uses	Upholstery		
	Industrial uses		

Warp Knits versus Filling Knits

Warp and filling knits differ because techniques and machines used in their manufacture differ. The major differences are summarized in Table 14–4.

Warp-Knit Fabrics

Tricot Warp Knits The name **tricot** has been a generic name for all warp-knit fabric. *Tricot* comes from the French word *tricoter*, meaning to *knit*. It is the fabric produced on the tricot machine using the plain stitch.

The plain stitch and the lock stitch are shown in Figure 14–40. The plain stitch runs and is seldom used except for backings for quilts and bonded fabrics. The lock stitch is used in other tricots. The face of the fabric is formed of the vertical portion of loops; the back has the horizontal portion of loops. The face has a much finer appearance than the back. Tricot does not ravel. Lock-knit tricots do not run. However, tricots may split or "zip" between wales. The fabric will curl just as filling-knit jersey does. Tricot is more stable than filling knits. It has little elasticity in the lengthwise direction and some elasticity in the crosswise direction. Tricot is used for lingerie, sleepwear, shirts, blouses, uniforms, dresses, and automotive upholstery.

TABLE 14-4 Comparison of filling and warp knits.

Filling Knits Warp Knits Yarns run horizontally Yarns run vertically Loops joined one to Loops joined one to another in the same another in adjoining course Loops connect horizontally Loops connect diagonally More design possibilities Higher productivity More-compact fabric More-open fabric Crosswise stretch, little Two-way stretch lengthwise stretch Run, most ravel Most do not run or ravel Machine process only Hand or machine process Flat or circular Flat Seldom have finished Finished edges possible edges Produced as yardage only Produced as knit shaped garments, garment

pieces, or yardage

FIGURE 14-41
Warp-knitting tricot machine.
(Courtesy of Mayer Textile Machine Corp.)

The tricot machine is the mainstay of the warp-knitting industry (Figure 14–41). It is a high-speed machine that can knit flat fabric up to 170 inches wide. The machine makes a plain-jersey stitch or can be modified to make many designs. Attachments are used to lay in yarns into a tricot structure.

Plain tricot is made on a machine that uses one set of needles and two guide bars. Filament yarns are used in either smooth or textured form. In the standard ranges of 15 to 40 denier, nylon tricot is lightweight (17.5 to 6.5 yards/pound), has exceptional strength and durability, and can be heat-set for dimensional stability. One of the unique features of nylon tricot is that the same piece of gray goods can be finished under different tensions to different widths and different appearances; for example, 168-inch gray goods can be finished at 98, 108, 120, 180, or 200 inches wide.

Brushed or napped tricots have fibers raised from the surface, making it feel like velvet. The knit stitches have long underlaps. One set of yarns is carried over three to five wales to form floats on the technical back; the second set of yarns, usually nylon to provide strength and durability, interloops with adjacent yarns. The long floats are broken when the fabric is brushed in finishing. The brushed side is used as the fashion side, even though it is the technical back (Figure 14–42). It is used in evening gowns, shoes, slacks, upholstery, and draperies.

Satin tricots are made in the same way as napped tricots except that the finishing processes differ to produce a bright shine for this fabric. Satin tricots are usually 100 percent nylon or polyester with long floats.

Tricot-net fabric can be made by skipping every other needle so only half as much yarn is used and open spaces are created in the fabric. **Tulle** (pronouned *tool*) is a hexagonal net used for veiling, support fabrics, and as overlays for apparel.

Automotive tricot upholstery of a double-knit velvet is made in a manner similar to that of velvet. Two layers of fabric are knit face to face with a pile yarn connecting the two layers. The layers are separated when the pile yarn is cut. Pile height is approximately half the distance between the two layers.

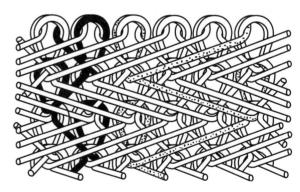

FIGURE 14-42

Warp-knit velour before napping: white and gray yarns on the technical back will be broken during finishing. (Courtesy of Knitting Times, the official publication of National Knitwear and Sportswear Association.)

Raschel-Warp Knits The raschel-warp knitting machine has one or two needlebeds with latch needles set in a vertical position and as many as 78 guide bars. The fabric comes off the knitting frame almost vertically instead of horizontally as with the tricot machine. Raschel machines knit a wide variety of fabrics, from gossamersheer nets and veilings to very heavy carpets. Raschel knits are used for a variety of industrial products, including laundry bags, fish nets, dye nets, safety nets, and covers for swimming pools.

Raschel fabrics have rows of chainlike loops called *pillars*, with laid-in yarns in various lapping configurations (Figure 14–43). These fabrics can be identified by raveling the laid-in yarn and noting that the fabric splits or comes apart lengthwise. Some window-treatment and outerwear fabrics are knitted on this machine, sometimes referred to as a raschel crochet or crochet machine.

Carpets have been knitted since the early 1950s. Since production is faster, knitted carpets are cheaper to make than woven carpets. Another technique, tufting, is the most common method for producing carpet (see Chapter 15). Knitted carpets have two- or three-ply warps for lengthwise stability, laid-in crosswise yarns for body and crosswise stability, and pile yarns. Knitted carpets can be identified by looking for chains of stitches on the underside. They seldom have a secondary backing. These carpets are usually commercial or contract carpets.

Lace and curtain nets can be made at much higher speeds and much more cost effectively on a raschel machine. Window-treatment nets of polyester with square, diamond, or hexagonal meshes are made on tricot

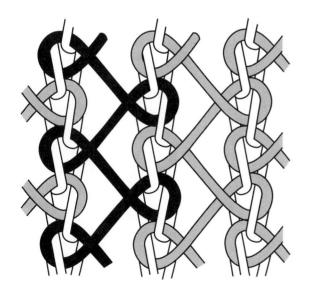

FIGURE 14-43
Raschel knit. (Courtesy of Knitting Times, the official publication of National Knitwear and Sportswear Association.)

FIGURE 14-44
Raschel mesh fabric.

machines. Light, delicate, and elaborate laces can be made quickly and inexpensively for apparel and furnishings.

Knit meshes may be made using either tricot or raschel machines, depending on their complexity, yarn size, and end use (Figure 14–44).

Thermal cloth has pockets knit in to trap heat from the body; it looks like woven waffle cloth and is used mainly for winter underwear and for some thermal blankets.

Power net is an elasticized fabric used for foundation garments and bathing suits. Nylon is used for the two-bar ground construction, and spandex is laid in by two other guide bars (Figure 14–45). Although some-

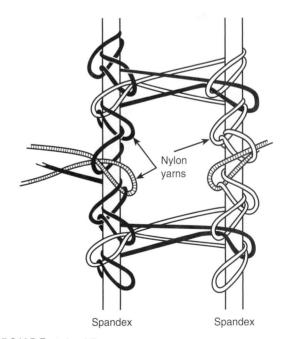

FIGURE 14-45
Raschel power-knit stitch.

times referred to as spandex, these fabrics are nylon and spandex blends.

Insertion Warp Knits Insertion of yarns in the warp-knit structure is a relatively simple concept. Yarns are laid in the stitches during the knitting process but are not used to form any stitches. These laid-in yarns provide directional stability and can be in any direction or at an angle. Fabric characteristics can be engineered for desired properties. Yarns that are not appropriate for knitting can be used, such as extremely coarse, fine, or irregular yarns and yarns of fibers such as carbon and glass that have low flexibility. Insertion fabrics are used in aircraft and aerospace components, automotive parts, boat hulls, ballistic protective clothing, structural building elements, interlinings for apparel, window treatments, and wall coverings.

Weft insertion is done by a warp-knitting machine with a weft-laying attachment. An attachment carries a single filling yarn to and fro across the machine, and this yarn is fed steadily into the needle zone of the machine. A firm selvage is formed on each side.

More-complex attachments supply a sheet of filling yarns to a conveyor that travels to and fro across the machine. The yarns are then fed into the stitching area of the machine. A cutting device trims filling yarn "tails" from the selvages and a vacuum removes the tails.

Weft-insertion fabrics combine the best properties of both woven and knitted cloth: namely, strength, comfort, cover without bulk, and weight. They are lighter weight than double-knits but have more covering power. They have the increased crosswise stability of weaves but retain the comfort of knits.

In warp-insertion warp knits, the inserted yarn is caught in a vertical chain of stitching. The insertion of

FIGURE 14-46
Warp and weft insertion. Warp-knit casement fabrics for windows.

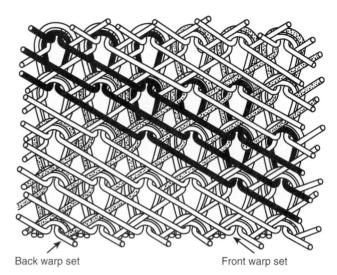

FIGURE 14-47

Milanese. (Courtesy of Knitting Times, the official publication of National Knitwear and Sportswear Association.)

warp yarn into a knit structure gives the fabric the vertical stability of woven cloth while retaining the horizontal stretch of knit fabric. These fabrics are used for hospital curtains and table linens, as well as for other furnishing and industrial uses.

Fabrics with both warp- and weft-insertion have characteristics very similar to woven fabrics. These fabrics can be much less expensive than woven fabrics and are available in wide widths. They are frequently used as window-treatment fabrics (Figure 14–46).

Minor Warp Knits

Simplex The simplex machine is similar to the tricot machine and uses spring-beard needles, two needle bars, and two guide bars. It produces a two-faced ribbed fab-

FIGURE 14-48

Hook-and-loop closure fabric: looped fabric (left); hooked fabric (right).

ric somewhat like circular double-knits. End uses are primarily fashion gloves.

Milanese The Milanese machine produces superior warp-knit fabrics. The machine can use both spring-beard and latch needles. The fabric, similar to a two-bar tricot fabric, is made from two sets of warp yarns, with one needle bar and one guide bar. But the lapping movements move so that each warp yarn travels across the full width of the fabric, one set knitting from right to left and the other from left to right. This produces a diagonal formation (Figure 14–47) that is visible up on the back of the fabric. The face has a very fine rib. The fabric is runproof and is used for gloves, lingerie, and outerwear.

Narrow Knitted Fabrics

Narrow knitted fabrics are made on a few needles on a multiknit machine, either filling- or warp-knitting machines. One of the more important types of narrow knitted fabrics is knit elastics. Knit elastics account for 35 to 40 percent of the narrow elastic market and are used in underwear, running shorts, slacks, fleece products, and hosiery. Hook and loop tape fasteners are warp-knit nar-

FIGURE 14-49

Narrow fabrics: (a) raschel knit, (b) flat filling knit, (c) circular knit.

row fabrics (Figure 14–48). Other trim and knit elastics are shown in Figure 14–49.

Many narrow knitted fabrics of thermoplastic fiber are made on regular machines in wide widths and slit with hot knives to seal the edges. These are cheaper to produce and are satisfactory if the heat sealing is properly done.

Key Terms

Latch needle Run Knitting Filling or weft knitting

Warp knitting

Spring-beard needle Compound needle

Stitch
Wale
Course
Gauge
Cut
Tachnical 6

Technical face
Technical back
Circular machines
Flatbed machines
Knit stitch
Tuck stitch
Float or miss stitch
Purl or reverse stitch

Single-filling knit Single-jersey fabric

Jersey

Stockinette (stockinet)

Lisle

Jacquard jersey Intarsia

Pile jersey

Knitted terrycloth

Velour Fake fur

Weft-insertion jersey

French terry Fleece Fashioning Looping machine Double-filling knit V-bed machine

Gait
Rib gaiting
Interlock gaiting
Purl gating

Rib

Double-knit jersey

Interlock

Jacquard double-knit

Purl knits
Tricot machine
Point-paper notation
Tricot
Brushed or napped tricot
Tulle

Lace
Power net
Warp-insertion warp knit
Weft-insertion warp knit
Simplex machine
Milanese machine
Sliver-pile knit

Questions

Raschel

- 1. Compare the characteristics of woven and knit fabrics.
- 2. Compare the characteristics of filling- and warp-knit fabrics.
- **3.** Describe the differences in appearance and performance between the following pairs of knit fabrics:

jersey and tricot jacquard jersey and raschel rib knit and interlock fleece and velour

4. Describe the performance that might be expected in the following products:

100 percent combed cotton filling-knit jersey T-shirt 100 percent modacrylic warp-insertion raschel casement

- drapery (smooth-filament yarns and inserted thickand-thin novelty yarns) for a public library
- 100 percent olefin raschel warp-knit contract carpet of BCF yarns for hallway of office building
- 80 percent nylon/20 percent spandex raschel-knit swimsuit
- **5.** Compare the characteristics of a jersey and a tricot of a similar high quality.

Suggested Readings

- Davidson, W. A. B. (1993, March). Spotlight on warp knitting. *Knitting/Apparel in Knitting Times*, pp. 29–30.
- Gajjar, B. J. (1998, February). Women's wear tricot.

 American Sportswear and Knitting Times, pp. 52–56.
- Gajjar, B. J. (1998, September). Spandex containing raschels.

 American Sportswear and Knitting Times, pp. 26–28.

- Humphries, M. (1996). Fabric Glossary. Upper Saddle River, NJ: Prentice Hall.
- Levanthal, L. (1994, July). Specialized niches available to knits in home furnishings. *Knitting Times*, pp. 33, 49.
- Little, T. (1998, September). Stretching knitwear applications. *America's Textiles International*, pp. 38–40.
- Mohamed, M. H. (1990, November/December). Three-dimensional textiles. *American Scientist*, 78, pp. 530–541.
- Reisfeld, A. (April, 1989). Multi-axial machine for weftinsertion knits. *Knitting Times*, pp. 21–22.
- Schwartz, P., Rhodes, T., and Mohamed, M. (1982). Fabric Forming Systems. Park Ridge, NJ: Noves Publications.
- Spencer, D. J. (1983). *Knitting Technology*. New York: Pergamon Press.
- Tortora, P. G., and Merkel, R. S. (1996). Fairchild's Dictionary of Textiles, 7th ed. New York: Fairchild Publications.

Chapter 15

OTHER FABRICATION METHODS

OBJECTIVES

- To understand the production of film, foam, fiberweb and netlike structures, lace, braid, composite fabrics, leather, and fur.
- To recognize fabrics made using these techniques.
- To integrate the performance of these fabrics with end-use requirements.

here are many ways of producing fabric other than weaving and knitting. This chapter is organized according to the material from which the fabric is made: solutions, fibers, varns, or fabrics. Although many of these methods and fabrics do not fit the classic definition of a textile, they are included because they are used to produce textile products, they are used as substitutes for textiles, they are made of the same chemicals as textiles, or they are made of textile components like fibers, varns, and fabrics. These fabrics are important to the apparel, furnishing, and technical markets. This discussion begins with the simplest process and components and moves to the most complex. Assessing the performance of these fabrics is often similar to assessing the performance of woven or knit fabrics. Whenever special procedures are used, they will be discussed in the appropriate section. Figure 15-1 can be used to determine the fabric structure and name.

Fabrics from Solutions

Films

Films are made directly from a polymer solution by meltextrusion or by casting the solution onto a hot drum. Film solutions are similar to fiber spinning solutions.

Most apparel and furnishing textile films are made from vinyl or polyurethane solutions (Table 15–1). The two types are similar in appearance, but they vary in the care they require. Vinyl films are washable but become stiff in dry-cleaning solvents. Urethane films are both washable and dry cleanable. Urethane films remain soft in cold weather, whereas vinyl films become brittle and stiff.

There are several structures of films. Plain films or nonreinforced films are firm, dense, and uniform. They are usually impermeable to air and water and have excellent soil and stain resistance and good recovery from deformation. Plain films such as latex, chloroprene, vinyl,

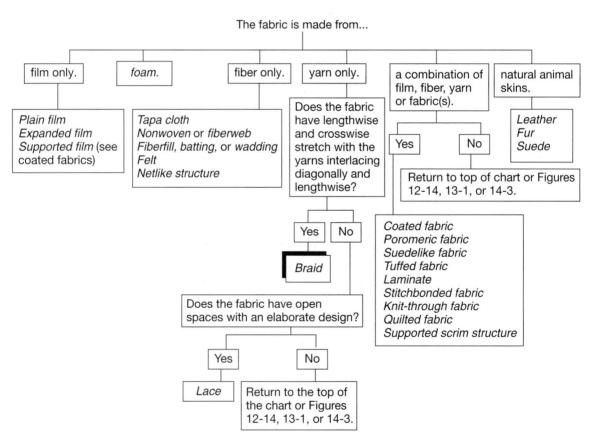

FIGURE 15-1

Flow chart for other fabrication methods.

Solution	Fiber	Film	End Uses for Film
Acetate	Acetate	Acetate	Photographic film, projection film
Polyamide	Nylon	Nylon	Cooking bags
Polyester	Polyester	Mylar*	Packaging, metallic yarns, novelty balloons, computer disk
Polypropylene	Olefin		
Polyethylene		Polyethylene	Packaging, garment and shopping bags, squeeze bottles
Polyurethane	Spandex	Polyurethane	Leatherlike fabrics
Polyvinyl chloride	Vinal	Vinyl	Packaging, garment bags, leatherlike fabrics for apparel and upholstery, seed tapes, water-soluble bags
Vinylidene chloride	Saran	Saran Wrap*	Packaging for food
Viscose (regenerated cellulose)	Rayon	Cellophane	Glitter weaving yarns—mostly in handwoven textiles

^{*}Trade names.

and nitrile are used in disposable gloves for health-care workers because they provide a barrier for fluidborne pathogens.

Expanded films are spongier, softer, and plumper because a blowing agent incorporates tiny air cells into the compound. They are not as strong or as abrasion-resistant as plain films. Expanded films are impermeable to air and water. Thousands of tiny pinholes, called micropores, punched in plain and expanded films permit air and water vapor, but not liquid water, to pass through the fabric, increasing their comfort characteristics. Nonporous films, used for inexpensive upholstery, are uncomfortable, especially in hot weather and in direct contact with skin.

Because plain films and expanded films are seldom durable enough to withstand normal use, they are usually attached to a woven, knit, or fiberweb support fabric or substrate. The end result is a **supported**, *coated*, or *reinforced* film. Supported films are composite fabrics and will be discussed later in this chapter. Supported films are more durable, more expensive, easier to sew, and less likely to crack and split than nonreinforced films.

Plastic films and coated fabrics are more waterproof than any other material. The finishing process can make them resemble almost any other textile (Figure 15–2). They vary in thickness from the very thin transparent film used to make sandwich bags to the heavy leatherette used to cover a dentist's chair. As compared with leather, films are uniform in appearance and quality, available in uniformly wide lengths, and much cheaper and easier to make into products.

This list briefly summarizes films:

• Solution is extruded through narrow slits into warm air or cast onto a revolving drum. Molding powders may be pressed between hot rolls.

- Films are waterproof, impermeable, stiff, low cost, resistant to soil, and nonfibrous.
- Films have poor drapeability and are weak unless supported by a fabric back.
- Films can be finished to look like many other fabrics or to have their own characteristic appearance.
- Films are used for shoes, shower curtains, upholstery, and plastic bags.

FIGURE 15-2 Films.

Foams

Foams are made by incorporating air into an elasticlike substance. Polyurethane is most common. The outstanding characteristics of foams are their bulk and sponginess. They are used as carpet backings and underlays, furniture padding, and pillow forms, and are laminated to fabric for apparel and furnishing textiles (Figure 15–3). Shredded foam is used to stuff accent pillows and toys.

Polyurethane foams are made with a wide range of physical properties, from very stiff to rubbery. The size of the air cells can be controlled. Polyurethane foam yellows when exposed to sunlight, but does not lose its usefulness and durability. Foams are relatively weak and are not used by themselves. Reacting diisocyanate with a compound containing two or more hydroxyl groups with a suitable catalyst produces polyurethane foam. Chemicals and foaming agents are mixed thoroughly. After the foam is formed, it is cut into blocks 200 to 300 yards long, and strips of the desired thickness are cut from these blocks.

This list briefly summarizes foams:

- Foams are made by incorporating air into an elasticlike substance. Rubber and polyurethane are the most commonly used foams.
- Foams are lofty, springy, bulky material, too weak to be used without backing or covering.
- Foams are used in pillows, chair cushions, mattresses, carpet padding, and apparel.

FIGURE 15-3
Foam carpet pad: surface view (top) and cross-sectional view (bottom).

Fabrics from Fibers

Some fabrics are made directly from fibers or fiberforming solutions; thus, there is no processing of fibers into a yarn. These operations include very old and very new processes. The origins of felt and tapa cloth are lost in antiquity; netlike structures used to bag fruits and vegetables use new technologies; composite fabrics are made by combining fibers with other materials to form fabrics.

The first fiberweb, **tapa cloth**, is made from the fibrous inner bark of the fig or paper mulberry tree. It was used for clothing by people in many areas of the Pacific Islands and Central America. The cloth is made by soaking the inner bark to loosen the fibers, beating them with a mallet, smoothing them out into a paperlike sheet, and decorating them with block prints (Figure 15–4).

Today, fabrics made from fibers are the fastest-growing area of the textile industry. These fabrics most often have industrial uses, but some are used in apparel and furnishing items. Research and development focusing on industrial fabrics expands markets for fiber companies.

These fabrics are often referred to as **nonwovens**, meaning that they are not made from yarn. However, the term *nonwoven* creates confusion because knits are nonwovens as well. Nonwoven refers to a wide variety of fabric structures. In the textile industry, *nonwoven* usually refers to a fiberweb structure.

Increased usage of these fabrics is related to the increased cost of traditional textiles related to labor costs,

FIGURE 15-4
Tapa cloth from Samoa.

fluctuating costs of natural fibers; production and promotion of some manufactured fibers; easier cutting and sewing for unskilled labor; and new technologies that produce made-to-order products inexpensively.

Nonwoven or Fiberweb Structures

Nonwoven or fiberweb structures include all textilesheet structures made from fibrous webs, bonded by mechanical entanglement of the fibers or by the use of added resins, thermal fusion, or formation of chemical complexes. Fibers are the fundamental units of structure, arranged into a web and bonded so that the distances between fibers are several times greater than the fiber diameter. Nonwovens are more flexible than paper structures of similar construction.

The properties of nonwovens are controlled by selection of the geometrical arrangements of the fibers in the web, the properties of the fibers used in the web, and the properties of any binders that may be used.

Web Production Fiberwebs are quick and inexpensive to produce. Nonwoven fabrics of the same weight and fiber type as woven fabrics are generally 50 percent cheaper.

The basic steps include selecting the fibers, laying the fibers to make a web, and bonding the web together to make a fabric. Any fiber can be used to make the web. The inherent characteristics of the fibers are reflected in the fabric. Filaments and strong staple fibers are used where strength and durability are important; rayon and cotton are used for absorbency; thermoplastics are used for spun-bonded webs.

Web formation is a more involved process. The five techniques are dry-laid, wet-laid, spun-bonded, spun-laced, and melt-blown. Fiber orientation, an important factor in controlling web characteristics, describes both the parallelism among fibers in the web and that between the fibers and the machine direction. Machine direction describes the direction in which the supporting conveyor belt moves. Webs with fibers parallel to each other are *oriented*. Webs in which the fibers are highly parallel to each other and to the machine direction are oriented in the lengthwise direction. Webs with fibers that are not parallel to each other are random. Lengthwise-oriented webs have a grain; strength and drape properties are related to fiber orientation.

Dry-laid fiberwebs are made by carding or air laying the fibers in either a random or an oriented fashion. Carding is similar to the yarn process that produces a parallel arrangement of fibers. Webs can be cross-laid by stacking the carded web so that one layer is oriented lengthwise and the next layer crosswise to give added

strength and pliability. Cross-laid webs do not have a grain and can be cut more economically than woven or knitted fabrics. Air-laid, or random, webs are made by machines that disperse the fibers by air. While similar to the cross-laid web, this web has a more random fiber arrangement. Oriented webs have good strength in the direction of orientation, but poor cross-orientation strength. Since random webs have the fibers oriented in a random fashion, strength is uniform in all directions. End uses for dry-laid fiberwebs include wipes, wicks, battery separators, backing for quilted fabrics, interlining, insulation, abrasive fabric bases, filters, and base fabric for laminating and coating.

Wet-laid fiberwebs are made from a slurry of short, paper-process—length and textile-length fibers and water. The water is extracted and reclaimed, leaving a randomly oriented fiberweb. The advantage of these webs is their exceptional uniformity. Typical end uses for wet-laid fiberwebs include laminating and coating bases, filters, interlining, insulation, roofing substrates, adhesive carriers, wipes, and battery separators.

Spun-bonded or spun-laid webs are made immediately after fibers are extruded from spinnerets. The continuous hot filaments are laid down in a random fashion on a fast-moving conveyor belt and, in their semimelted state, fuse together at their cross points. They may be further bonded by heat and pressure. Spunbonded fiberwebs have high tensile and tear strength and low bulk (Figure 15–5). Typical end uses for spunbonded fiberwebs include carpet backings such as Typar by Du Pont, geotextiles, adhesive carriers, envelopes like Tyvek by Du Pont, tents and tarps, wall coverings, housewrap vapor barriers, tags and labels, bags, protective apparel, filters, insulation, and roofing substrate.

FIGURE 15-5
Spun-bonded filament fabric.

FIGURE 15-6
Hydroentangled or spun-lace fabric.

Hydroentangled or spun-lace webs are similar to spun-bonded webs except that jets of water are forced through the web, shattering the filaments into staple fibers and producing a wovenlike structure (Figure 15-6). These webs have greater elasticity and flexibility than spun-bonded fabrics. These fabrics are also known as water-needled fabrics. This technique makes products that are not possible with any other process. Water from high-pressure jets on both sides of the fabric entangles the fibers. The water is reclaimed, purified, and recycled. The degree of entanglement is controlled by the number and force of jets and the fiber type. Computer controls maintain a uniform quality in the fabric. Hydroentangled textiles are used in medical gowns and drapes, battery separators, interlinings, roofing substrates, mattress pads, table linens, household wipes, wall coverings, window-treatment components, protective clothing, and filters. Sontara is a hydroentangled polyester produced by Du Pont. Another Du Pont product, ComforMax IB, combines microdenier olefin and hydroentangling to produce an activewear fabric that is impermeable to wind, cold, and liquid water.

Melt-blown fiberwebs are made by extruding the polymer through a single-extrusion orifice into a high-velocity, heated-air stream that breaks the fiber into short pieces. The fibers are collected as a web on a moving conveyor belt and are held together by a combination of fiber interlacing and thermal bonding. Because the fibers are not drawn, the fiberweb strength is lower than expected for a specific fiber. Olefin and polyester are used in this process to produce hospital/medical products and battery separators. Kimberly-Clark has introduced an automobile protective cover that combines a layer of

melt-blown polypropylene sandwiched between two layers of spun-bonded polypropylene.

Fabric Production Webs become fabrics through a mechanical needling process, the application of chemical substances or adhesives, or heat.

Needle punching or needling consists of passing a dry-laid web over a needle loom as many times as is necessary to produce the desired strength and texture. A needle loom has barbed needles protruding 2 to 3 inches from the base (Figure 15–7). As the needles stitch up and down through the web, the barbs pull a few fibers through it, causing them to interlock mechanically with other fibers. The construction process is relatively inexpensive.

Blankets, carpeting, and carpet backing are examples of needle-punched products. Fiber denier, fiber type, and product loft may vary. Indoor/outdoor needle-punched carpeting made of olefin is used extensively for patios, porches, pools, and putting greens because it is impervious to moisture. Needled carpet backings are used with some tufted carpets.

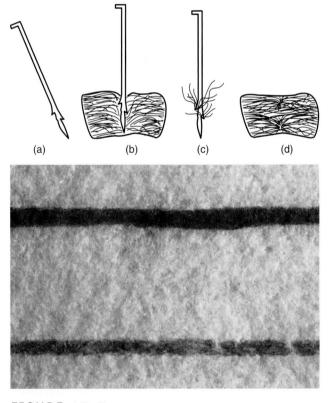

FIGURE 15-7

Needle-punch process: (a) Barbed needle, (b) needle pulling fibers through web, (c) entangled fibers in a web cross section, (d) needle-punched web, (bottom) photo of fabric.

Needled fabrics can be made of a two-layer web with each layer a different color, often of solution-dyed fibers. By pulling colored fibers from the lower layer to the top surface, geometric designs are possible. Fibers pulled above the surface produce a pile fabric. Needle-punched fabrics are finished by pressing, steaming, calendering, dyeing, and embossing.

Other techniques include the use of a closed needle that penetrates the web, opens, grabs some fibers, and draws them back as a yarnlike structure that is then chain-stitched through the web. These fabrics are related to the stitch-through fabrics discussed later in this chapter. Some bulletproof vests are made from needle-punched fabrics. Needle-punched fabrics also are used for tennis ball felts, blood filters, papermaking felt, speaker-cover fabrics, synthetic leathers, oil-absorbent pads, and insulator padding.

Chemical adhesives are used with dry-laid or wetlaid webs to bond the fibers together. These adhesives include vinyl acetate, vinyl acrylic, and acrylic polymers. Each type has characteristics that make it more appropriate for certain applications. The adhesive is applied in a liquid, powder, or foam form and heated and pressed to adhere fibers together in the web.

Heat and pressure are used to bond thermoplasticfiber webs (Figure 15–8). Several techniques are used. In *area-bond calendering*, the fibers are heated and pressed to form a permeable film-like structure that is stiff, inextensible, and strong. In *point-bond calendering*, the heated fiber web passes through a pair of calender

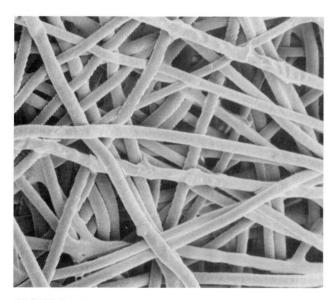

FIGURE 15-8 Mirafi 140 fabric: a thermally bonded fiberweb. (Courtesy of Dominion Textiles of Canada.)

rolls: one is engraved and the other is smooth. The engraved roller presses the web onto the smooth roller and the fibers adhere to each other. Characteristics relate to the size and density of the bond points, but the fabrics are usually moderately bulky, elastic, and soft and are used for medical, sanitary, and filtration applications.

Miratec, produced by Polymer Group Inc., is a fabric formed directly from fibers using a combination of high-pressure water jets and laser imaging that has two-way stretch and can be made to resemble fabrics such as corduroy, denim, and brocade. End uses include dyed and printed wall coverings, upholstery, pillows, comforters, and window treatments. Depending on the fiber content, Miratec fabrics have been laundered 50 times with no problems detected.

Fiberfill Batting, wadding, and fiberfill are not fabrics, but they are important components in apparel for snowsuits, ski jackets, quilted robes, and coats, and in furnishing textiles for quilts, comforters, furniture paddings, pillows, mattresses, and mattress pads.

Batting is made from new fiber, **wadding** is made from waste fiber, and **fiberfill** is a manufactured fiber staple made especially for use as a filler for these end uses. Carded fibers are laid down to the desired thickness and may be covered with a sheet of nonwoven fabric.

Fiber density describes the weight or mass per unit volume. Fiber density is important for these components and is used to match components to end-use requirements for resiliency and weight. Resiliency is important because fabrics that maintain their loft incorporate more air space. When fibers stay crushed, the fabric becomes thinner and more compact, losing bulk, insulating power, and padding characteristics. Shifting resistance is important in maintaining a uniform fabric thickness. For instance, down comforters need to be shaken often because the filling shifts to the outer edges. Thermoplasticfiber batts can be run through a needle-punch machine in which hot needles melt the parts of the fibers that they touch, fusing them into a more stable batt, often referred to as a bonded web. The ability of a batt or fiberfill to insulate is based on the amount of still air trapped in a volume of fabric and the number of fibers present. In apparel there is a limit to the thickness, however, because too much bulk restricts movement and limits styling. For this reason, microfibers are popular in low-profile fiberfills (Table 15-2). Several fiberfills are made from recycled polyester solutions.

Two polyester fiberfills for apparel by Du Pont are Thermoloft, a high-loft insulation, and Thermolite, a thin insulation made with microfibers. Other Du Pont fiberfills used in both apparel and furnishings include Hollofil and Quallofil. They incorporate voided areas to increase the loft and insulation while decreasing weight.

TABLE 1	5-2 Co	mparison of p	properties of	commonly used batti	ngs.
Fiber	Cost	Density	Resiliency	Shifting Resistance	Care
Down Acetate Polyester Cotton	High Low Medium Low	Lightweight 1.30 1.30–1.38 1.52	Excellent Fair Good Poor	Poor Poor Good—can be bonded Poor	Dry-cleanable Washable, dries more quickly than cottor Washable, quick-drying Washable, but slow-drying

Primaloft is a microdenier polyester fiberfill by Albany International Research Company; it mimics down in weight and loft and is used in bedding. Polarguard and Trevira Loft by Trevira are other fiberfills used in apparel.

Although not fibers, down and feathers are used as fiberfill. These fills are defined by the Federal Trade Commission in the Code of Federal Regulations. **Down** refers to the undercoating of waterfowl and relates to the fine, bulky underfeathers. Items labeled 100 percent down must meet specified requirements for the condition of the down. Down-filled items must be 80 percent down or down fiber and may include up to 20 percent other feathers. Down is rated by its loft capacity—the volume one cubic ounce of down will fill. For example 650 down is warmer and more expensive than 550 down. The range is generally 300 to 800.

Down is lightweight and warm. However, it has a tendency to shift, and when wet, it mats and loses its warmth. It is difficult to maintain down's original loft, and it is difficult to clean. People with allergies to feathers may have difficulty with down products. Down is used in apparel, bedding, and padding for pillows and soft furniture.

Fusible Nonwovens Fusible nonwovens contribute body and shape to garments as interfacing or interlinings in shirts, blouses, dresses, and outerwear.

A fusible is a fabric that has been coated with a heat-sealable, thermoplastic adhesive. It also may be a thin, spider-web-like fabric of thermoplastic filaments (Figure 15–9). When applied to the back of a face fabric, the layers are bonded by heat and pressure.

The adhesives used are polyethylene, hydrolyzed ethylene vinyl acetate, plasticized polyvinyl chloride, and polyamides. The adhesive is printed on the substrate so as to produce the desired hand in the end product.

Fusibles eliminate the need for stitching in some coat and suit lapels. Less-skilled labor is required to produce garments, and when the proper technique and correct selection are combined, productivity is increased. However, fusibles may generate these problems for producers and consumers: differential shrinkage and separa-

tion of layers during care, bleedthrough of adhesive to the face fabric, and difficulties in predicting changes in hand and drape.

End Uses of Nonwovens Nonwovens are used for disposable goods, such as diapers and wipes, durable goods that are incorporated into other products, or alone for draperies, furniture, mattresses, mattress pads, and some apparel (Table 15–3).

To summarize, nonwovens are:

- Produced by bonding and/or interlocking fibers by mechanical, chemical, thermal, or solvent means, or combinations of these processes.
- Cheaper than woven or knitted fabrics. Widely used for disposable or durable items. Some have grain.
- Used for apparel, furnishing, and industrial purposes.

FIGURE 15-9
Fusible interlining. Tape under web demonstrates its sheerness.

Durable	Type	Disposable	Туре
Bedding and coated fabrics, mattress ticking, backing for quilting, dust cloth for box springs	Spun-bonded	Diapers, underpads, sanitary napkins/tampons	Dry-laid
		Surgical packs and accessories	Dry-laid, melt-blown
		Wipes and towels	Dry- or wet-laid
Carpet backing, coated fabrics Filters	Needled, spun-bonded, dry-laid	Packaging	Spun-bonded
Interfacings	Dry- or wet-laid		
Interlinings	Needled, dry-laid		
Draperies, upholstered furniture, backings, facings, dust covers, automotive,	Dry- and wet-laid, spun- bonded, hydroentangled, melt-blown		
shoe parts, geotextiles, labels, backings for wall coverings, leatherlike fabrics			

Felt

True **felt** is a mat or web of wool, or mostly wool, fibers held together by the interlocking of the wool scales. Felting is one of the oldest methods of making fabrics. Primitive peoples made felt by washing wool fleece, spreading it out while still wet, and beating it until it had matted and shrunk together in fabriclike form. Figure 15–10 shows a Numdah felt rug made in India. In modern factories, layers of wool or wool blends are

FIGURE 15-10 Numdah felt rug.

built up until the desired thickness is attained and then heat, soap, and vibration are used to mat the fibers together. Finishing processes for felt resemble those for woven fabrics.

Felts do not have grain and do not ravel. They are stiff, less pliable, and weaker than other structures. The quality of felt depends on the quality of the fibers used.

Felt has many industrial and some clothing uses. It is used for padding, soundproofing, insulation, filtering, polishing, and wicking. Felt has been used under machinery to absorb sound, but cheaper foams have replaced felt in this end use.

Felt is not used for fitted clothing because it lacks the flexibility and elasticity of fabrics made from yarns. However, it is widely used in products such as hats, slippers, clothing decorations, and pennants. Because felt does not fray, it needs no seam finish. Colored felt letters or decorations on apparel may fade in washing and should be removed before washing or the garments should be dry-cleaned.

The following are characteristics of felt:

- Wool fibers are carded (and combed), laid down in a thick batt, sprayed with water, and agitated, causing the fibers to entangle (Figure 15–11).
- Felt has no grain; it does not fray or ravel.
- Felt has poor pliability, strength, and stretch recovery.
- Felt is used in apparel accessories, crafts, and industrial matting.

FIGURE 15-11 Felt (magnified).

Netlike Structures

Netlike structures include all textile structures formed by extruding one or more fiber-forming polymers as a film or a network of ligaments or strands. In the *fibrillated-net process*, the extruded and noncoagulated film is embossed by being passed through a pair of heated rollers that are engraved to form a pattern on the fabric. When the film is stretched biaxially, slits occur in the fabric, creating a netlike structure. In the *extruded-net process*, the spinneret consists of two rotating dies. When the polymer is extruded, the fibers form as single strands that interconnect when the holes of the two rotating

dies coincide. The process produces tubular nets, which are used for packaging fruit and vegetables, agricultural nets, bird nets, and plastic fencing for snow and hazards (Figure 15–12).

Fabrics from Yarns

Braids

Braids are narrow fabrics in which yarns interlace lengthwise and diagonally (Figure 15–13). They have good elongation characteristics and are very pliable, curving around edges nicely. They are used for trims, shoelaces, and coverings on components in industrial products such as wiring and hoses for liquids like gasoline and water. Three-dimensional braids are made with two or more sets of yarns. Their shape is controlled by an internal mandrel (Figure 15–14).

The characteristics of braid include the following:

- Yarns are interlaced both diagonally and lengthwise
- Braid is stretchy and easily shaped.
- Flat or three-dimensional braid is used for trim and industrial products.

Lace

Lace is another basic fabric made from yarns, using several different fabrication methods. Yarns may be twisted around each other to create open areas. Lace is an openwork fabric with complex patterns or figures, handmade or machine-made on special lace machines or on raschel

FIGURE 15–12
Netlike structures.

FIGURE 15-13 Braid.

FIGURE 15-14
Braiding machine with mandrel.
(Courtesy of Albany International
Research Co.)

knitting machines. Lace is classified according to the way it is made and the way it appears.

It is difficult to determine the machine used to make a fine lace fabric without the aid of a microscope. However, it is a fairly simple matter to determine the origin of many laces. Some imitation lacelike fabrics are made by printing or flocking (Figure 15–15). The quality of lace is based on the fineness of yarns, number of yarns per square inch or closeness of background net, and intricacy of the design.

Lace was important in fashion between the 16th and 19th centuries, and all countries in Europe developed lace industries. Lace remains important today as a trim or accessory in apparel and furnishings. Lace names often reflect the town in which the lace was originally made. For example, the best-quality needlepoint lace was made in Venice in the 16th century—hence the name Venetian lace. Alençon and Valenciennes laces are made in French towns.

Handmade Lace Handmade lace remains a prestige textile. With the contemporary interest in crafts, many of the old lace-making techniques are experiencing renewed interest. Handmade lace is used for wall hangings, belts, bags, shawls, afghans, bedspreads, and tablecloths. Handmade laces include needlepoint, bobbin, crochet, and Battenberg.

Needlepoint lace is made by drawing a pattern on paper, laying down yarns over the pattern, and stitching over the yarns with a needle and thread. The thread network forming the ground is called *reseau* or *brides*. The

solid part of the pattern is called *toile*. Needlepoint designs may include birds, flowers, and vases.

Bobbin lace is made on a pillow. The pattern is drawn on paper and pins are inserted at various points. Yarns on bobbins are plaited around the pins to form the lace (Figure 15–16).

Crocheted lace is done by hand with a crochet hook. Examples are Irish lace and Syrian lace.

Battenberg lace is a handmade lace with loops of woven tape caught together by yarn brides in patterns (Figure 15–17). Making Battenberg lace was a common hobby in the United States in the early part of the 20th century. Contemporary pieces are imported from Asia, especially China, for apparel and furnishing accessories.

Machine-made Lace In 1802 in England, Robert Brown perfected a machine that made nets on which lace motifs could be worked by hand. In 1808 John Heathcoat made the first true lace machine by developing brass bobbins to make bobbinet. In 1813, John Leavers developed a machine that made patterns and background simultaneously. A card system, similar to the technique used on card jacquard looms, made it possible to produce intricate designs with the Leavers machine.

The warp yarns and oscillating brass bobbins of the Leavers machine are set in frames called *carriages*. The carriages move back and forth, with the bobbins swinging around the warp to form a pattern. These bobbins, holding 60 to 300 yards of yarn, are thin enough to swing between adjacent warp yarns and twist themselves

FIGURE 15-15

Lace and lacelike fabrics: Cordonnet or re-embroidered lace made on Leavers lace machine (upper left); raschel-warp-knit lace (upper right); purl-knit lace (center left); woven lace (center right); and imitation lace (cotton percale printed with a lacelike design) (bottom right).

around one warp before moving to another yarn (Figure 15–18). The Leavers machine may have 20 bobbins per inch. A machine 200 inches wide would have 4000 brass bobbins side by side.

Leavers lace is fairly expensive, depending on the quality of yarns used and the intricacy of the design. On

some fabrics, a yarn or cord outlines the design. These are called **Cordonnet**, or reembroidered, lace (see Figure 15–15).

Raschel knitting machines (see Chapter 14) make patterned laces that resemble Leavers lace. Raschel laces are produced at much higher speeds and thus are less ex-

FIGURE 15-16
Bobbin lace: handmade (left); machine-made (right).

pensive. Filament yarns are commonly used to make coarser laces that are used as tablecloths, draperies, and casement fabrics (Figure 15–19).

Care of Lace Because lace has open spaces, it can easily snag and tear. Fragile laces should be washed by hand-squeezing suds through the fabric rather than rubbing. Some laces can be put into a protective bag and machine-washed or dry-cleaned.

FIGURE 15-17 Close-up view of a Battenberg lace tablecloth.

Composite Fabrics

Composite fabrics are fabrics that combine several primary and/or secondary structures, at least one of which is a recognized textile structure, into a single structure. This broad category includes such diverse fabrics as coated fabrics, tufted and flocked structures, laminates, and stitch-bonded structures.

Coated Fabrics

A coated fabric combines a textile fabric with a polymer film. The woven, knit, or nonwoven fabric substrate provides characteristics such as strength and elongation control. The coating or film provides protection from environmental factors such as water, chemicals, oil, and abrasion. Commonly used films include rubber and synthetic elastomers such as polyvinyl chloride (PVC), neoprene, and polyurethane. PVC-coated fabrics are most common and are used in window shades, book covers, upholstery, wall coverings, apparel, and shoe liners and uppers. Neoprene is used for protective clothing such as chemical gloves and wetsuits. Most polyurethane-coated fabrics are used in shoe uppers and apparel. Heavy polyurethane-coated fabrics are used in tarpaulins.

The coating is added to the fabric substrate by several methods. The most common method is lamination, in which a prepared film is adhered to fabric with adhesive or heated to slightly melt the back of the film before the layers are pressed together. In another method, calendering, the viscous polymer is mixed with filler, stabilizing agent, pigment, and plasticizer to control the opacity, hand, color, and environmental resistance of the coating layer. The mixture is applied directly to a preheated fabric by passing the fabric and the mixture between two large metal cylinders, or calenders, spaced close together. A third method is coating, in which a more fluid compound is applied by knife or roll. The degree that the mixture penetrates into the fabric substrate is controlled by allowing the mixture to solidify or gel slightly before it contacts the substrate. Composite sails for racing yachts often combine Mylar polyester films with a Kevlar aramid or Spectra olefin to reinforce scrim and polvester woven fabric.

Several other methods of coating are also used. In the *rotary screen technique*, the coating is applied to the fabric through a rotating open screen in contact with the fabric. A smoothing blade closes up and smoothes out the coating compound to produce a continuous surface. This technique is used for lightweight upholstery fabrics in which flame retardancy is required or for which some air permeability is desired. In the *slot die technique*, the solution is extruded over the substrate's full width at the desired thickness. The *foam technique* applies the

Brass bobbins (left) carry the thread and twist around warp yarns (center) to form the lace fabric (right). (Reproduced from Textiles, 1973, Vol. 2, No. 1, a periodical of the British Textile Technology Group, United Kingdom, formerly the Shirley Institute.)

FIGURE 15-19
Raschel crochet (top); raschel lace (bottom).

coating as a foam. It is often used for thermal drapery fabrics and blackout curtains. In the *spray technique*, a thin solution is sprayed onto the surface of the substrate. Under heat or pressure, the solution flows over the surface and forms a continuous layer. In *transfer coating*, the coating compound is applied to release paper, dried, and then applied to the substrate. Transfer coating is used only when other techniques cannot be used.

Coated fabrics are also referred to as supported films and can be printed or embossed. They may resemble real leather and may be sold as "vegetarian" leather. They are used for apparel, shoe uppers and liners, upholstery, vinyl car tops, floor and wall coverings, window shades, bandages, acoustical barriers, filters, soft-sided luggage, awnings, pond and ditch liners, and air-supported structures and domes.

Bion II, by Biotex Industries, is a monolithic, or solid, polyurethane coating that is waterproof, breathable, and flame-retardant. It is used in running suits, parkas, diaper covers, mattress covers, and incontinence products. It can be applied to most fibers in woven or knit forms.

Coated fabrics are impermeable to water in liquid and vapor forms. They make clothing feel hot and clammy. When used in upholstery, coated fabric sticks to exposed skin. In order for these fabrics to be comfortable, they can be modified in several ways. One method punches tiny holes in the fabric. In another method, coated fabrics incorporate a nonporous hydrophilic membrane or film. Sympatex, by Akzo, incorporates a hydrophilic polyester film and is washable or drycleanable. (Another method uses a microporous film, which will be discussed in the next section.) Sympatex can be laminated to an outer shell, a lining fabric, or a

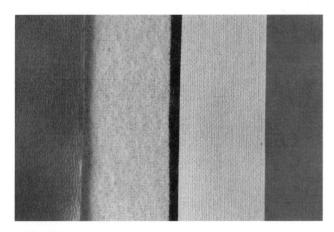

FIGURE 15-20

Coated fabrics: knitted base fabric (left); woven base fabric (right). The outer portions show the technical face of each fabric. The inner portions show the technical back of each fabric.

lightweight insert fabric, such as tricot or fiberweb, for use in skiwear. Stomatex, by MicroThermal Systems, adds thermal comfort and breathability to protective and extreme sports clothing by using a closed-cell foam layer of Neoprene or polyethylene. A series of tiny convex domes are vented with a microporous opening at the apex of each dome. As the wearer moves, a pumping action is created that releases excess moisture in a controlled fashion.

A summary of coated fabrics includes these aspects:

- Coated fabrics are produced by applying semiliquid materials (neoprene, polyvinyl chloride, and polyurethane) to a fabric substrate (Figure 15–20).
- Coated fabrics are stronger and more stable than unsupported films.
- Coated fabrics are used for upholstery, luggage and bags, and apparel (Table 15–4).

TABLE 15-4 End uses for films and coated fabrics.

Air-supported roofings
Self-lined draperies
Hospital-bed coverings
Hose container for fuel and
water
Inflatable flood gates
Leatherlike coats, jackets
Shower curtains

Tablecloths and placemats
Umbrellas
Upholstery
Waterproof apparel:
 mittens, raincoats, and
 boots
Wetsuits
Chemical protective
 clothing and gloves

Poromeric Fabrics

Poromeric, or *microporous*, **fabrics** incorporate films, but they are considered a separate category because the film is very thin and microporous. These two major distinctions determine many characteristics of the resulting fabric. The poromeric, or membrane, layer is stretched in both directions and annealed to impart micropores in the fabric that are small enough to allow the passage of water vapor, but not liquid water. A water-vapor droplet is 250,000 times smaller than a droplet of liquid water. Hence, poromeric fabrics are water vapor–permeable and much more comfortable in apparel.

Poromeric films can be made from polytetrafluoroethylene (Gore-Tex) (Figure 15–21) or polyurethane. These products are waterproof, windproof, and breathable. The film can be applied to a wide variety of fabrics and fibers and is used in protective and comfortable apparel. These fabrics are used for active sportswear and rugged outdoorwear such as hunting clothes. Other uses include tents, sleeping bags, medical products, filters, coatings for wires and cables, and protective apparel. Other poromeric fabrics include Dartexx, a warp knit with a polyurethane membrane, and Entrant and Breathe-Tex, which have polyurethane membranes. Several of these fabrics are used in the medical field because they present a barrier to bodily fluids.

The enhanced performance of poromeric fabrics is reflected in their price. Fabrics that are both comfortable and waterproof incorporate expensive components and processes.

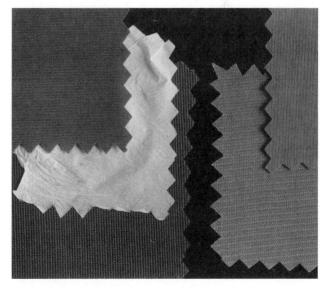

FIGURE 15-21

Gore-Tex fabric: face fabric, polytetrafluoroethylene film, backing (left); face and back of fabric (right).

Suedelike Fabrics

Because of the beautiful texture and hand of suede and the problems encountered in its care, suedelike fabrics have been developed. These fabrics are needle-punched fabrics made from microdenier fibers combined with a resin coating and nonfibrous polyurethane. The microdenier fibers are arranged in a manner that reproduces the microscopic structure of natural suedes. The fabric is dved and finished. The process was developed by Toray Industries in Japan. Ultrasuede® and Ultraleather®, registered trade names of Springs Industries, are used in apparel and furnishings. Ultrasuede[®] is made of 60 percent microfine polyester and 40 percent polyurethane foam. Ultraleather[®] is 100 percent polyurethane with a knit back of 70 percent rayon and 30 percent nylon. The embossed fabric is lightweight, soft, and water-repellent and it has a comfort stretch. Ultrasuede® may be backed with a woven fabric when used for upholstery. Belleseime® is a similar fabric made from 65 percent polyester/20 percent nylon matrix fiber on a 15 percent polyurethane-foam substrate produced by Kanebo Company of Japan.

Suedelike and leatherlike fabrics are used in apparel, upholstery, wall coverings, and accessories. These fabrics are made in various ways (Table 15–5). The process can be summarized as follows:

 Fibers and polyurethane solution are mixed together, cast on a drum, or forced through a slit to make the fabric, and then napped on both sides.

- The fabric looks and feels like suede, but is uniform in thickness, appearance, and quality; it is sold by the yard or meter.
- The fabric is machine-washable and dry-cleanable.

Tufted-Pile Fabrics

Tufting is a process of making pile fabrics by stitching extra yarns into a fabric base or substrate. The ground fabric ranges from thin sheeting or nonwoven to heavy burlap or coarse warp knit; it may be woven, knitted, or nonwoven. Tufting developed as a hand craft when early settlers worked candle wicks into bedspreads to create interesting textures and designs. The making of candlewick bedspreads and hooked rugs grew into a cottage industry. In the 1930s, machinery was developed to convert the hand technique to mass production (Figure 15–22). Carpets, rugs, bedspreads, and robes are produced in many patterns and colors at low cost.

Tufting is done by a series of needles (Figures 15–23 and 15–24), each carrying a yarn from each spool held in a creel. The substrate is held in a horizontal position and the needles all come down at once and go through the fabric to a predetermined depth, much as a sewing machine needle goes through fabric. For each needle, a hook moves forward to hold the loop as the needle is retracted. In loop-pile fabrics, the loop remains when the hook is removed. For cut-loop pile, a knife incorporated with the hook moves forward as the needles are retracted to cut the loop. The fabric moves forward at a

Construction Technique	Characteristics	Trade Name
Composite fabric—polyester fibers and polyurethane mixed, cast on drum, napped or embossed	Washable, dry-cleanable Looks like leather or suede	Ultrasuede® Ultraleather® Belleseime®
Composite fabric	Easy care Looks like suede	
Woven cotton/polyester substrate, surface coating of polyurethane	Dry-cleanable Washable	
100% polyester-pile fabric with suedelike finish	Dry-cleanable Washable	
Flocked cotton	Least expensive and least effective imitation Flock may wear off at edges	
100% polyester warp-knit, napped	Washable, dry-cleanable	Super-suede
Leather (cow, pig, lamb, or other animal)	Natural product, irregular in nature, available in wide variety of finishes, cleanability may not be good	None
Suede (cow, pig, lamb, or other animal)	Natural product, irregular in nature, cleanability may not be good	None

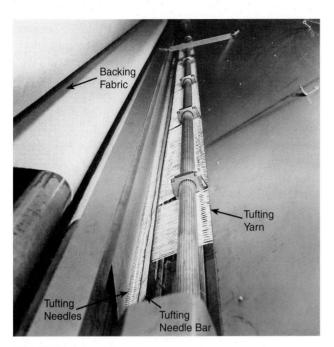

FIGURE 15-22

Needle area of commercial tufting machine.

predetermined rate, and the needles move downward again to form another row of tufts.

With cut loops, the yarn ends or tufts are held in place by blooming or untwisting the yarn, by shrinkage of the ground fabric in finishing, or by use of a coating on the back of the ground fabric. **Tuft density** refers to the number of tufts per square inch and is related to the number of needles per inch and the number of stitches per inch (needles/inch × stitches/inch = tuft density). Any pile fabric with low pile density is subject to grinthrough, a problem of the ground structure showing through the pile. This problem is obvious when the fabric is bent or rolled and is common with carpets, especially when it is used on stairs.

Computers control the process. Patterns are created quickly and easily by changing yarn color or type, tuft

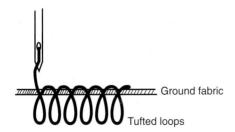

FIGURE 15-23 Tufting.

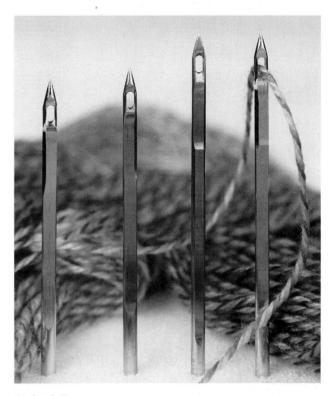

FIGURE 15-24
Tufting needles and yarn.

depth, and tuft type (cut or uncut). Thousands of patterns are possible. The use of carpets in homes, businesses, and industrial facilities is directly related to tufting, a low-cost method of producing carpet.

Tufting is an inexpensive method of making pile fabrics because it is extremely fast and involves less labor and time to create new designs. Furlike tufted fabrics have been used for shells or linings of coats and jackets, but there are few other tufted apparel fabrics. Tufted bed-sized blankets can be made in less than 2 minutes.

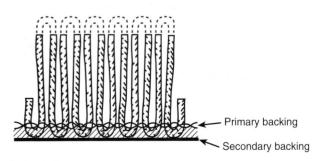

FIGURE 15-25

Tufted carpet. Tufts are punched through primary backing. Secondary backing is bonded to primary backing to lock pile in place.

Furlike Fabr Woven-Warp Pile Fibers used Cotton ground. We acrylic, rayon, polyester pile. Cost Most expensive Pile firmly held in Tendency to grinthrough in lowfabrics. Types and kinds Wilton Axminster	Furlike Fabrics-Used for Coat and Jacket Shells, Linings, Decubicare Pads, and Accent Rugs	for Coat and Jacket Shells	abed oversiding against	C -	
s used Co Mc acteristics Pil		כו כסמר מוום סמכולכר שווכנוש,	LIIIIIgs, Decubicale raus,	and Accent Kugs	
s used Co Mc acteristics Pil W s and kinds Wi	oven-Warp Pile	Sliver Knit	Tufted		
Mc Pil seteristics Pil W Wis and kinds Wi	Cotton ground. Wool, acrylic, rayon, polyester pile.	Cotton, olefin, or modacrylic ground. Acrylic, modacrylic pile.	Cheesecloth or sheeting substrate of cotton or cotton/polyester. Acrylic, modacrylic pile.		
	Most expensive Pile firmly held in place. Tendency to grin- through in low-count fabrics.	Variable Most widely used Dense, underfibers and guard hairs possible, like real fur. Denser surface possible. Carpets	Least expensive Mostly used for sheepskin-type goods. Blooming of yarns and shrinkage of ground holds tufts in place.		
	Woven-Warp Pile	Filling Knit, Raschel Knit	Chenille Yarns	Tufted	Flocked
Velvet	lton minster Vet	Laid-in pile yarn	Usually woven to order	Most widely used. All kinds of textures. Tufts held by backings	Not very durable Limited pile height
Cost Most expensi	Most expensive	Raschel knits expensive	Expensive	Inexpensive to moderate in cost	Inexpensive

		Velour	
	Woven-Warp Pile	Filling Knit—Jersey	Warp Knit
Fiber content	Cotton, wool, acrylic, blends	Cotton, polyester	Nylon, acetate
Characteristics	Heavy fabric, durable drapeable	Medium, weight, soft	Medium to heavy weight
End uses	Upholstery, draperies	Robes, shirts, casual apparel	Robes, nightwear
		Velvet	
	Woven-Warp Pile	Tufted	Flocked
Fibers	Rayon, nylon, cotton, acetate, polvester	Nylon, olefin	Nylon
Characteristics	Filament—formal, pile flattens Durability related to fiber and pile density	Pile not held in as firmly as woven, less expensive	Least expensive
End uses	Apparel and upholstery	Upholstery U _l Terrycloth	Upholstery, draperies, bedspreads th
	Slack-Tension Weave	Filling Knit—Jersey	
Characteristics	Usually cotton Holds its shape	All fibers. Soft, stretchy. Cotton does not hold its shape well. Very pliable.	
End uses	Towels, washcloths, robes	Baby towels and washcloths Baby sleepers, adult sportswear, socks	

Tufted blankets have not been successful in the United States but are used in Europe.

Tufted upholstery fabric is made in both cut and uncut pile and is widely available. The back is coated to hold the yarns in place.

Carpeting of room-width size was first made by tufting in 1950; today tufting is the most widely used method of producing carpets. A tufting machine can produce more than 650 square yards of carpeting per hour, as compared with an Axminster loom, which can weave about 14 square yards per hour. Tufted carpets are shaped to fit a space and are easily removed and replaced.

Gauge refers to the distance in inches between the tufting needles. In general, carpets for home or lower-traffic areas differ in gauge from carpets for commercial, industrial, and high-traffic areas. Typical carpet gauges for commercial carpets range from 5/32 inch (0.16 inch) to 1/16 inch (0.063 inch). Tufting specifications also would include stitches per inch and pile height.

Variations in texture are possible by varying loop height. Cut and uncut tufts can be combined. Tweed textures use different-colored plies in the tufting yarns. Special dyeing and printing techniques produce colored patterns or figures in which the color penetrates the tufts completely. A latex coating is put on the back of the carpet to help hold the tufts in place (Figure 15–25). *Face weight* refers to the mass or weight of the tuft yarns used in the carpet. In general, the higher the face weight, the more expensive and durable the carpet. Face weights of 25 oz/yd² or more are common for commercial carpets.

Du Pont has developed a guide sheet for predicting carpet performance based on five factors: color, design, density, pile texture, and fiber. The guide sheet describes a way to quantify carpet characteristics and relate them to end-use requirements. *Color* is included because it is an important factor in hiding soil. *Design* describes how colors are blended and also relates to hiding soil. *Density* refers to the number of tufts per unit area. The denser the carpet, the better it is at resisting soiling and compacting. *Pile texture* describes the tuft loop structure and yarn type used, which also influence resistance to soiling and compacting. *Fiber* addresses the performance of the fibers used in the carpet pile yarns. Carpet fibers are specifically engineered for soil and static resistance.

Tables 15–6 and 15–7 compare the different methods of producing pile fabrics. Tufted fabrics can be summarized as follows:

- Yarns carried by needles are forced through a fabric substrate and formed into cut or uncut loops.
- Tufted fabrics are cheaper than woven or knitted pile fabrics.
- Tufted fabrics are used in carpets and rugs, upholstery, coat linings, and bedspreads.

Laminates

Laminates are fabrics in which two layers of fabric are combined into one with an adhesive or foam. *Laminate* usually refers to a fabric in which an adhesive was used.

Method	Types and Kinds	Fabrics—End Uses	Identification
Weaving	 Filling floats cut and brushed up 	1. Velveteen, corduroy	Filling pile
	Made as double cloth and cut apart	2. Velvet, velour	Warp pile
	3. Overwire	Friezé, Wilton, and velvet carpets	Warp pile
	4. Slack tension	4. Terrycloth, friezé	Warp pile
Knitting	Filling knit: laid-in yarn or sliver knit	Velour, terry, fake fur, fleece	Stretchy—rows of knit stitches on back
	Warp knit: laid-in yarn or pile loops		More stable
Tufting	Yarns punched into substrate	Rugs and carpets Robes, bedspreads Upholstery Fake furs	Rows of machine stitches on wrong side
Flocking	Fibers anchored to substrate	Blankets, jackets, upholstery Applied fabric designs	Stiff fiber surface
Chenille yarns	Pile yarns made by weaving Chenille yarns woven or knitted into fabric	Upholstery Outerwear fabric	Ravel adjacent yarn and examine novelty yarn

Bonded usually refers to a fabric in which a foam was used. However, the two terms are used interchangeably.

Introduced in 1958, bonding was originally a way to deplete inventories of tender (weak) or lightweight fabrics. Some marginal operators, not interested in quality, could buy two hot rolls discarded by finishers and be in business. The fabric could be stretched as it was processed. Consequently, many problems were associated with these bonded fabrics: layers separated (delaminated) or shrank unevenly, and blotchy colors occurred when the adhesive bled through to the technical face. Because of these problems, laminated fabrics developed a poor reputation. However, the textile industry has improved the quality of laminated fabrics, and current laminates have good performance. Some advantages and limitations are given in Table 15–8.

Laminating Process With knits, random nonwovens usually are used as the backing fabric because they give when the face fabric is stretched. Acetate and nylon tricot also are used because of their low cost. Using a different color for the backing can be a decorative feature in bonded laces.

Three methods of bonding are used (Figure 15–26):

- 1. Wet-adhesive method using aqueous acrylic adhesive or solvent urethane adhesive
- 2. Foam-flame method
- **3.** Hot-melt method using polyamides (nylon), polyester, polyolefin, or polyurethane adhesives.

In the **wet-adhesive method**, the adhesive is applied to the underside of the face fabric, and joined to the liner fabric when it is passed through pressure rollers. The fabric is heated twice, the first time to drive out solvents and to give a preliminary cure, and the second

TABLE 15-8 Lamin	ated fabrics.
Advantages	Limitations
Less costly fabrics are upgraded.	Top-quality fabrics are not bonded.
Self-lining gives comfort.	Backing does not prevent bagging, so a lining may be needed.
Stabilized if good quality.	Uneven shrinkage possible.*
Reduces time in sewing.	May be bonded off-grain.
Interfacings may be eliminated.	May delaminate.*
Underlinings, stay-stitching, and seam finishing are not needed.	Layered areas (hems, seams, etc.) are stiff or boardy. Do not hold sharp creases

^{*}These are the two major problems.

time to produce a permanent bond. Monolithic membranes and microporous films are combined with fabrics using this method. These durable and washable fabrics are breathable, drapeable, and comfortable. They are used for protective clothing because they protect from heat, chemicals, biological organisms, radiation, abrasion, and particulates.

In the **foam–flame process**, polyurethane foam is the adhesive. Foam laminates consist of a layer of foam covered by another fabric or between two fabrics. The foam is made tacky first on one side and then on the other by passing near a gas flame. The final thickness of the foam is 0.015 inch. This method gives more body but reduces the drapeability of the fabric. Another foam process generates the foam at the time it is to be applied, flowing it onto the fabric and curing on the fabric. Many kinds and qualities of foam-laminate fabric with many different thicknesses of foam are possible. Some firms will laminate or back upholstery fabrics for interior designers.

Flame laminates are widely used to produce automotive upholstery because the method is economical and produces a product with a soft hand and good compression strength and recovery power. Unfortunately, the technique also produces unacceptable volumes of pollutants from the melting and combustion of the foam, and alternative procedures are being developed that have less environmental impact.

Hot-melt lamination is becoming the preferred method for bonding because it is versatile and environmentally friendly. The adhesive determines the bond strength and its resistance to heat, washing, and drying. The adhesive form determines the fabric's drape, hand, and breathability. Webs and nets of any of the four polymers are most commonly used because they are readily available and easy to use. A sandwich is formed of an outer fabric, the adhesive, and the liner fabric and adhered with heat and pressure (see Figure 15–26). Hotmelt laminates are used for tailored garments, shoes, medical drapes, sportswear, protective clothing, geotextiles, luggage, upholstery wall coverings, filtration, automotive seating and door panels, and tents.

Hytrel by Du Pont is made of a polyether/ester block copolymer monolithic film laminated to a textile with hot-melt adhesives that are aqueous or solvent-based. Hytrel offers a unique combination of strength, elasticity, flexibility, and good chemical resistance with windproof and waterproof characteristics. It is used for ski, snowboard, and hunting apparel; operating room gowns and personal protective apparel; bedding covers for allergy control; and disposable medical apparel.

Laminated fabrics can be summarized as follows:

- Two or more fabrics are adhered together by a wet or hot-melt adhesive or foam-flame process.
- The laminating process is less expensive than double-weave or double-knit processes.

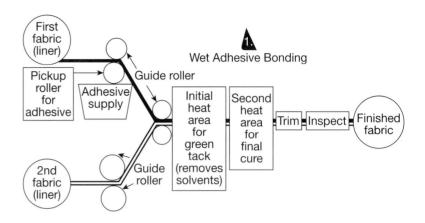

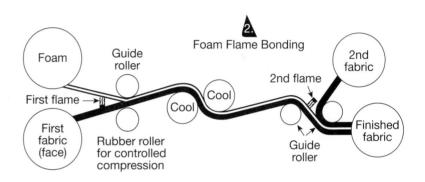

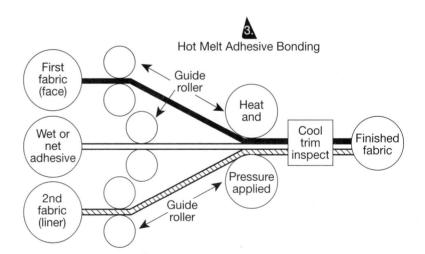

FIGURE 15-26

Basic methods for producing bonded textiles. (Wet adhesive and foam flame diagrams reprinted from American Fabrics & Fashions, 1985, No. 132. Reprinted with permission from Bobbin Magazine. Copyright Bobbin Blenheim Media. All rights reserved.)

- Laminating gives warmth without weight, when foam is one layer.
- Laminating produces lightweight fabrics for outerwear.
- Laminated fabrics have body, but do not hold sharp creases.
- Fabrics may be off-grain or may delaminate.
- Laminates are used in apparel, furnishings, shoes, and industrial products.

Stitch-Bonded Fabrics

Stitch-bonded fabrics combine textile structures by adhering fabric layers with fiber or yarn loops, chemical adhesives, or fusion of thermoplastic fibers. They are divided into knit-through fabrics and quilted fabrics. Stitch-bonded fabrics can be produced from nonwovens and any woven or knit fabric.

Knit-through or sew-knit fabrics are made in sev-

eral ways. In the first process, a raschel warp-knitting machine knits yarns through a fiberweb or nonwoven structure. Knitting fibers or knitting yarns around laid (not woven) warp and filling yarns is the second method. To make these knit-through fabrics, needles are used to create interconnected loops from yarns or fibers to stabilize the structure. These fabrics look like wovens, but careful examination shows that the lengthwise and crosswise yarns are not interwoven.

Araknit[®] is a knit-through fiberweb fabric used as a coating substrate. Arachne[®] and Maliwatt[®] are trade names for fabrics made by warp-knitting yarns through a fiberweb structure. These knit-through fabrics are produced at high speeds and are used for furnishings (upholstery, blankets, and window treatments) and industrial uses (insulation and interlining). Malimo[®] uses warp or filling (or both) laid-in yarns with warp-knitting yarns (Figure 15–27). These fabrics are produced at very high speeds and are used for tablecloths, window-treatment fabrics, vegetable bags, dishcloths, and outerwear.

Some knit-through fabrics use split-polymer films from recycled carbonated-beverage bottles. These fabrics are used in the carpet, geotextile, and bale-wrap industries.

Quilted Fabrics

Quilted fabrics are composite fabrics consisting of three layers: face fabric, fiberfill or batting, and backing fabric. The three layers are stitch-bonded with thread, chemical adhesive, or fusion by ultra-high-frequency sound, often in a pattern. The actual area physically bonded together is a tiny percentage of the fabric's surface so that the high loft and bulky appearance desired in quilted fabrics are not sacrificed.

Most quilted fabric is made by stitching with thread. The thread and type of stitch used in quilting are good indicators of the quality and durability of the finished fabric. A durable quilt will have a lock-type stitch with a durable thread. Twistless nylon-monofilament thread is sometimes used because of its strength and abrasion resistance and because it is transparent and becomes hidden in the colors of the face fabric.

Almost any thread can be used, but those designed for quilting have different performance characteristics as compared with regular sewing thread. Quilting threads must be durable. The disadvantage of thread stitches in quilting is that the threads may break from abrasion or snagging. Broken threads are unsightly and the loose fiberfill is no longer held in place.

Any fabric can be used for the shell or covering. A fashion fabric is used on one side. If the article is reversible or needs to be durable or beautiful on both sides, two fashion fabrics are used. If the fabric is to be lined or used as upholstery or a bedspread, the underlayer is often an inexpensive fabric such as cheesecloth, tricot, or a nonwoven fabric. The batting may be foam, cotton, down, or fiberfill. Fiberfill is a manufactured fiber modified so that the loft is maintained.

Quilting is done in straight or curved lines. In upholstery, quilts, comforters, and bedspreads, the stitching may outline printed figures. This is an expensive process in which the machine quilting is guided by hand. Fabric beauty is important for all end uses. For ski jackets and snowsuits, a closely woven water- and wind-repellent fabric is desirable; for comforters, resistance to slipping off the bed is important; for upholstery, durability and resistance to soil are important.

Chemical adhesive quilts are seldom used at present. Chemical adhesives were applied in a pattern, but these fabrics were not as appealing or as durable as those produced by the other quilting methods.

Ultrasonic quilting requires thermoplastic fibers. Heat generated by ultra-high-frequency sound or ultrasonic vibrations melts thermoplastic fibers, fusing several

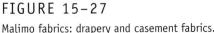

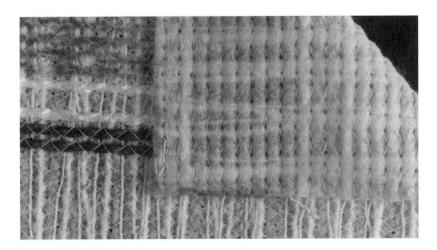

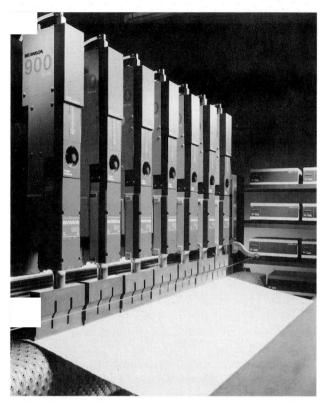

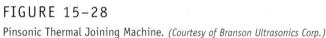

layers. Figure 15–28 shows a Pinsonic Thermal Joining machine that heat-seals thermoplastic materials by ultrasonic vibrations. The machine quilts seven times as quickly as conventional quilting machines. This process is used on some mattress pads and lower-priced bed-spreads. It eliminates the problem of broken threads—a boon for institutional bedding in the hospitality industry. However, the outer layer may tear along the quilting lines. Figure 15–29 shows a Pinsonic fabric.

Quilted fabrics can be summarized as follows:

- One or two fabrics and fiberfill, wadding, batting, or foam are stitched together by machine or by hand or are welded by sonic vibrations.
- Quilted fabrics are bulky, warm, and decorative.
- Quilted fabrics are used in ski jackets, robes, comforters, quilts, and upholstery.

Supported-Scrim Structures

Supported-scrim structures include the foam- and fiber-type blankets currently on the market. These fabrics use a lightweight nylon scrim, a loose warp-knit fabric, between two thin layers of polyurethane foam. Short nylon-flock fiber is adhered to the surface. These blan-

kets are attractive, durable, easy care, and inexpensive. Vellux and Vellux-Plus are trade names.

Other types of supported-scrim fabrics include those that are needle-punched with a scrim between the fiberweb layers. These fabrics are used for roadbed-support fabrics and other high-stability applications.

FIGURE 15–29
Mattress pad. Two layers of fiberweb fabric and fiberfill batt joined by a Pinsonic Thermal Joining Machine.

Fiber-Reinforced Materials

Fiber-reinforced materials are composites that combine a fibrous component with a polymer resin, metal, or ceramic matrix. The reinforcing fiber adds strength and pliability, minimizes weight, and increases stability. Composite materials are very important in industrial applications and have contributed to major advances in transportation technology for lightweight automobiles and airplanes and more-durable road surfaces. A common example is the fiberglass-polymer resin used to make boat hulls and car bodies. Polyester fibers are mixed with other materials to provide additional durability in concrete for poured road surfaces and building components.

Animal Products

The category of animal products includes leather and fur. These products are animal skins that are processed to maintain flexibility after being removed from the animal. In order to use the skin, the animal must be killed. Animal-rights activists object to using animals in this way. Many people find products made of skins or hides attractive and functional regardless of their source.

Leather

Leather is processed from the skins and hides of animals, reptiles, fish, and birds. It is an organic substance derived from living animals and varies greatly in uniformity. Most leather in the United States is from cows, pigs, or lambs. These animals are raised primarily for meat or fiber, not for their hides or skins. Leather is a relatively unimportant byproduct.

The hides from different animals vary in size, thickness, and grain. **Grain** is the marking that results from the skin formation and varies not only from species to species and from animal to animal but also within one hide. Other factors influence the surface of hides. Animals fight and bite or scratch each other, run into barbed-wire fences or nails, and are bitten by ticks and insects, causing scars that cannot be erased. Brand marks or skin diseases also mar hides. In addition, vein marks, wrinkles, or pronounced grain marks may be viewed as undesirable irregularities. It is estimated that fewer than 5 percent of hides are suitable for conversion into smooth top-grain leather in aniline finish, 20 percent are suitable for smooth leathers with a pigment finish, and the remaining 75 percent must be embossed, buffed, snuffed, or corrected in some fashion.

Dried skins and hides are stiff, boardy, nonpliable, and subject to decay. **Tanning** is the process in which skins and hides are treated with a chemical agent to make them pliable and water- and rot-resistant. *Vegetable*

tanning, the most expensive process, is done with a bark extract. Chrome tanning uses a solution of bichromate of soda, sulfuric acid, and glucose and makes soft, pliable leather. Oil tanning is used to make chamois. Alum tanning is used for white leather. Because of environmental concerns, vegetable tanning is becoming more common since chromium-containing waste is highly toxic. A new tanning process by Daikin Industries uses fluorochemicals that cross link the collagen in leather. Lezanova® leather is waterproof, shrink- and stainresistant, breathable, washable, and soft.

Skins go through many processes to become leather: salting; cleaning to remove the hair and epidermis; tanning; bleaching; stuffing; coloring or dyeing; staking; and finishing by glazing, boarding, buffing, snuffing, or embossing, depending on the desired end use. The many processes explain why leather is an expensive product.

The appearance of leather can be modified extensively in processing. Many finishes, including stuffing, snuffing, and buffing, are designed to camouflage flaws, scars, wrinkles, or irregularities in the skins. Fillers improve the appearance by covering these irregularities with a chemical compound, much like cosmetics are used to hide complexion flaws. Bleaching whitens the skin prior to dyeing. Staking is a tension drying process that minimizes shrinkage. Dyeing, printing, glazing, and embossing are finishing steps that add color, gloss, or texture. Many finishes add to leather's appeal. Unfortunately, many of these finishes do not hold up to the leather drycleaning processes and are removed or altered during cleaning. In addition, fillers may be removed, allowing hide irregularities to appear. Dyes and prints may not be fast. Most leather cleaners are adept at finishing or reworking leather items so that the consumer is never aware that the original appearance has been replaced. However, the high cost of leather cleaning clearly reflects the additional efforts required of the dry cleaner.

Leather is a nonseparable-fiber product. As shown in Figure 15–30, the fibers are very dense on the skin side and less dense on the flesh side. Thick hides are often split or shaved into layers to make them more pliable and economical (Figure 15–31).

The first layer is called **top grain** and has the typical animal grain on its outer surface. It takes the best finish and wears well. It is also the highest quality and most expensive. **Split leather** has a looser, more porous structure. Because it is cut across the fibers, it is not as smooth as top grain and tends to roughen up during use. Most split leathers have an embossed or suede finish. Although splits are not identified as such on product labels, top grain is usually mentioned. Splits are less expensive and lower in quality. The quality of splits decreases with each layer; the lowest-quality leather is next to the animal's flesh. *Full-grain leather* has not been split.

FIGURE 15-30

Cross-sectional drawing of a strip of leather, showing variations in fiber density.

Leather is a durable product. It may have a noticeable odor. It varies greatly in quality—not only from skin to skin but within one skin. Leather from the backs and sides of the animal is better, whereas that from the belly and legs tends to be thin and stretchy or very coarse.

Leather picks up oils and grease readily. It requires special care in cleaning since it is stiffened by solvents. Most dry cleaners send leather and suede items to a specialist for cleaning to remove soil, odor, and oil from the skin. Unfortunately, screen prints, dyes, and fillers may also be removed. Scars and other flaws like wrinkles, vein marks, and texture differences may appear. The oil can be replaced fairly easily. Dry cleaners can redye to bring the item closer to its original appearance. Thus, it is always wise to have all items of the same color cleaned at the same time in case a problem develops. However, screen prints and wrinkles create problems that cannot be handled as easily (Figure 15–32). Many consumers assume the dry cleaner is at fault when these problems occur. Although this could be the case, frequently the problem lies with the manufacturer, who selected the incorrect hide, process, chemical, or component to use in

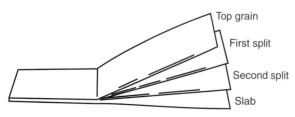

FIGURE 15-31

Split leather.

FIGURE 15-32

Pigskin suede after dry cleaning. The strip superimposed on the sample illustrates the original color and texture. Scars and other hide flaws are clearly visible.

the item. For example, fusible interlinings in jackets may separate or shrink, causing bubbling or puckering of the leather, or screen prints may not have been tested for fastness to dry cleaning before application to the leather.

Leathers are used for apparel, upholstery, wall coverings, athletic gear (balls, gloves, and saddles), luggage and bags, and accessories like wallets, lamp shades, and coasters. Product design is limited by the size of the skins; therefore, leather products usually have more seams as compared with other materials.

Reconstituted leathers have been made by grinding up leather, mixing it with urethane, and forming it into sheets. This "leather" product is uniform in thickness and quality and is not limited in length and width.

Suede Suede is a popular leather for coats, jackets, dresses, trims, and furnishings such as upholstery and wall coverings. The soft, dull surface usually is made by napping (running the skin under a coarse emery sander) on the flesh side or on one side of a split to pull up the fibers. Grain-sueded, or nubuck, leather has been napped on the grain side and has a velvetlike hand. Suede is a very durable product, but it requires special care. Rain, wet snow, and other moisture damage suede. Cleaning of suede should be done by specialists.

Furs

A fur is any animal skin or part of an animal skin to which the hair, fleece, or fur fibers are attached. Most

fur is used in apparel, but fur is also used for throws and rugs, wall hangings, and animal toys. Fur garments are considered luxury items by the U.S. government. Consumers usually purchase furs because of their beautiful appearance rather than for their warmth, durability, or easy care. It is important to know about the kinds of fur, how fur garments are made, and how to care for them in order to make wise selections and to maintain the beauty of the garment.

Furs are natural products and vary in quality. Goodquality fur has a very dense pile. If the fur has guard hairs, they are long and very lustrous. The fur is soft and fluffy. The quality depends on the age and health of the animal and the season of the year in which it was killed. Furs are usually harvested in late fall because the coat is most dense and has minimal sun and abrasion damage.

Fur trapping has long been an important industry in all parts of the world. Since fur farming began in 1880, it has been a boon to the fur industry because better pelts are produced as a result of scientific breeding, careful feeding and handling of the animals, and slaughtering them when the fur is in prime condition. Silver fox, chinchilla, mink, Persian lamb, and nutria are commonly raised on ranches. By crossbreeding and inbreeding, new and different colored furs have been produced. However, efforts by animal-rights activists to decrease the use of furs have had a negative impact on fur farming and demand for fur products.

The cost of fur depends on fashion, the supply and demand for fashionable furs, and the work involved in producing the item. Chinchilla, mink, sable, platina fox, and ermine have always been very expensive. Skins are gathered together from all over the world and sold at public auction.

Furs go through many processes before they are sold as products. The dressing of fur is comparable to the tanning of leather, and the purpose is the same—to keep the skins from putrefying and make them soft and pliable. Dressing must be more carefully done than with leather so that the surface hairs or fibers are not damaged. After tanning, pelts are combed, brushed, and beaten. The final process is drumming in sawdust to clean and polish the hair and to absorb oil from the leather and fur. The sawdust is removed by brushing or vacuuming.

Many furs are dyed. Furs may be dyed to make less-expensive furs look like expensive ones. For example, muskrat may be dyed to resemble seal, and rabbit may be stenciled to look spotted. Furs are also dyed to improve their natural color as well as to give them unnatural colors—red or green, for example. Tip-dyeing is brushing the tips of the fur and guard hairs with dye. Furs also are dip-dyed, a process in which the entire skin is dipped in dye. Some furs are bleached and some are bleached and then dyed.

Furs require special care to keep them beautiful. They should not be stored in damp or hot, humid places and never in plastic bags. Between seasons, if possible, garments should be sent to a furrier for cold storage; the furs are kept in special vaults in which the temperature and humidity are controlled. To restore luster and clean the garment, it is usually best to send it to a furrier once a year. Furs should never be dry-cleaned, unless the furrier method is used. In this fur-cleaning method, the fur is tumbled in an oil-saturated, coarsely grained powder. The powder absorbs soil, adds oil to the fibers and skin, and cleans the fibers without excessive abrasion and matting. The item must be carefully brushed and vacuumed to remove the excess powder. Sometimes after furs have been cleaned, a small amount of the powder may be found in the pockets.

Furs should be protected from abrasion. Avoid sitting on fur garments. Hang them on a wide, well-constructed hanger and allow plenty of space between garments. Shake garments rather than brushing them.

Key Terms

Film
Plain film
Expanded film
Supported film
Foam
Tapa cloth
Nonwoven
Fiberweb structure
Dry-laid fiberweb
Wet-laid fiberweb

Spun-bonded web Hydroentangled web Spun-lace web Melt-blown fiberweb Needle punching Chemical adhesive Batting Wadding Fiberfill Fiber density Shifting resistance
Down
Fusible nonwovens
Felt
Netlike structure
Braid
Lace
Handmade lace
Needlepoint lace
Bobbin lace
Crocheted lace
Battenberg lace

Leavers lace
Cordonnet or
re-embroidered lace
Raschel lace
Composite fabric
Coated fabric
Poromeric fabric
Suedelike fabric
Tufting
Tuft density
Gauge
Laminated fabric

Wet-adhesive method Foam-flame process Hot-melt lamination Stitch-bonded fabric

Stitch-bonded fabric Stitch-through or sew-knit fabric Stitch-bonded fab

Quilted fabric Supported-scrim structure Leather

Grain

Tanning Top grain Split leather Suede

Grain-sueded, or nubuck, leather

Fur

Fur cleaning

Questions

- 1. Why are nonwoven or fiberweb structures so important in the industrial products markets?
- **2.** Identify each fabrication method discussed in this chapter and its component(s): solution, fiber, yarn, or fabric.
- **3.** Give an example of a fabric for each fabrication method and explain its advantages and limitations.
- **4.** What performance can be expected from the following products?
 - a vinyl film (jersey supported) upholstered recliner chair
 - a 100 percent polyester Leavers lace casement drapery for a master bedroom
 - a quilted bedspread and matching draperies (50 percent polyester/50 percent cotton) for a hotel room
 - a pair of leather slacks
 - wall covering of a suedelike structure
 - a poromeric raincoat of 65 percent polyester/35 percent cotton (outer fabric)
- **5.** Explain the relationship of these methods to products likely to be encountered by professionals in the apparel or furnishing industry.

Suggested Readings

Anand, S. (1996, September). Nonwovens in medical and health care products. Part 1. Fabric formation. *Technical Textiles International*, pp. 22–28.

- Brown, S. G. (1994, July/August). The making and coloration of leather. *Journal of the Society of Dyers and Colourists*, 10, pp. 213–214.
- Crabtree, A. (1999, March). Hot-melt adhesives for textile laminates. *Technical Textiles International*, pp. 11–14.
- E. I. Du Pont de Nemours & Company. (no date). A formula for gauging carpet performance. Wilmington, DE:
 Commercial Carpet Fibers Division, Fibers Marketing
 Center.
- Earnshaw, P. (1982). A dictionary of lace. Aylesburg, Bucks, United Kingdom: Shires Publications.
- Ford, J. E. (1991). Nonwovens. Textiles, 4, pp. 17-21.
- Grayson, M., ed. (1984). Encyclopedia of Textiles, Fibers, and Nonwoven Fabrics. New York: Wiley.
- Humphries, M. (1996). *Fabric Glossary*. Upper Saddle River, NJ: Prentice Hall.
- Judd, P. T. (1992). Base fabrics used in interlining construction. *Textiles*, 4, pp. 14–16.
- Landmann, A. (1994, July/August). The effect of "natural" defects on leather dyeing. *Journal of the Society of Dyers and Colourists*, 10, pp. 217–219.
- Magic membrane for all-weather clothing. (1995, January). *Textile Month*, pp. 20–22.
- Mohamed, M. H. (1990, November/December). Threedimensional textiles. *American Scientist*, 78, pp. 530–541.
- Ondovcsik, M. (1999, February). Riding the wave. *American's Textiles International*, pp. 40–43.
- Schwartz, P., Rhodes, T., and Mohamed, M. (1982). Fabric Forming Systems. Park Ridge, NJ: Noves Publications.
- Sutton, K. D. (1998, August & November). Spec smarts. *Interiors*, pp. 47 & 58.
- Tortora, P. G., and Merkel, R. S. (1996). *Fairchild's Dictionary of Textiles*, 7th ed. New York: Fairchild Publications.
- Ward, D. (1996, March). Domotex growing despite industry's mixed fortunes. *Textile World*, pp. 8–11.

Section 5

FINISHING

CHAPTER 16

Finishing: An Overview

CHAPTER 17

Aesthetic Finishes

CHAPTER 18

Special-Purpose Finishes

CHAPTER 19

Dyeing and Printing

Chapter 16

FINISHING: AN OVERVIEW

OBJECTIVES

- To understand the general steps and sequence involved in fabric finishing.
- To understand how finishing affects fabric cost, quality, performance, and appearance.
- To relate finishing to fabric quality, end-use suitability, and product performance.

he four chapters in this section focus on converting a fabric from a raw form to the form consumers expect. In finishing, fabric performance and appearance are enhanced.

A finish is any process that is done to fiber, yarn, or fabric either before or after fabrication to change the *appearance* (what is seen), the *hand* (what is felt), or the *performance* (what the fabric does). All finishing adds to the cost of the end product and to the time it takes to produce the item.

The sequence normally followed in textile processing is an involved one. Often several steps are repeated. A common sequence is fiber processing followed by yarn processing. Fabrication (producing a fabric) usually follows some preparation steps. In preparation, the yarn or fabric is made ready for additional steps in processing. Bleaching is almost always done before dyeing. Col-

oration usually is done before finishing and reworking (repairing). Figure 16–1 shows a typical sequence used to produce a fabric.

Finishing may be done in the mill where the fabric is produced or it may be done in a separate establishment by a highly specialized group called **converters**. Converters perform a service for a mill by finishing goods to order, in which case they are paid for their services and never own the fabric; or they buy the fabric from a mill, finish it according to their needs, and sell it under their trade name.

Vertically integrated firms are an important part of the industry and often direct and control every step of processing for the fabrics used in their products, from opening bales of raw fiber to cutting and sewing the finished products. Vertical firms convert or finish fabrics in facilities they own and operate.

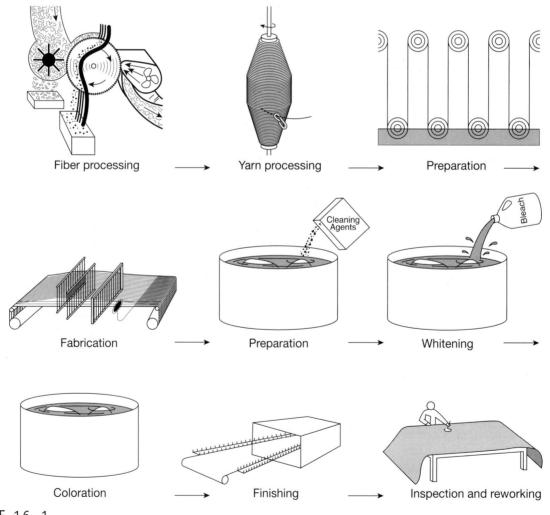

FIGURE 16-1
Typical production sequence for textile fabrics.

Finishes can be classified by how long they are effective. A permanent finish, such as mercerization, lasts the life of the item. A durable finish, such as wrinkle resistance, may last for the life of the product, but the effectiveness diminishes with use or age. These finishes require some effort or manipulation on the part of the user as the fabric ages. With wrinkle-resistant finishes, older items often require some ironing. A temporary finish, such as simple calendering, lasts until the item is washed or dry-cleaned. A renewable finish, such as some water-repellent finishes, can be applied by the consumer, or it is reapplied by the dry cleaner. Dyeing, printing, embossing, and some other finishes are easy to recognize because they are visible. Other finishes—such as wrinkle resistance—are not visible but affect fabric performance. Consumers may have difficulty understanding the higher costs for fabrics with invisible finishes, like wrinkle- and soil-resistant finishes. Improved performance is a benefit from both the visible finishes and the nonvisible finishes. The improved performance resulting from finishing adds to the inherent value and therefore to the cost of the product.

Many finishing processes are used on all kinds of fabric. The processes are similar regardless of fabric type. However, because of their importance and greater likelihood of being finished, the emphasis here will be on woven and knitted fabrics. The major differences that exist between finishing woven or knitted fabrics occur in the way the fabric is handled and moved. Woven fabrics have little give or stretch. Knits have a much greater potential for stretch; hence precautions need to be taken to minimize stretching during the finishing of knits. Pile fabrics are handled so that the pile does not flatten.

Gray (grey, greige, or loom state) **goods** are fabrics (regardless of color) that have been produced but have received no wet- or dry-finishing operations. Some graygoods fabrics have names, such as print cloth and soft-filled sheeting, that describe only the gray goods. Other gray-goods names, such as lawn, broadcloth, and sateen, also are used as names for the finished fabric. Many gray-good names are found in commodity price listings in trade publications like the *Daily News Record* (see Figure 2–2).

Converted, or finished, goods have received wetor dry-finishing treatments such as bleaching, dyeing, or embossing. Some converted goods retain the gray-goods name. Others, such as madras gingham, are named for the place of origin; still others, such as silence cloth, are named for the end use. Figure 16–2 shows a print-cloth gray goods and the various looks of the fabric with different finishing procedures. Mill-finished fabrics are sold and used without further finishing. Some may be sized before they are sold.

FIGURE 16-2 Print-cloth gray goods: as produced, bleached, printed, and piece-dyed (from left to right).

For years, water-bath finishing was standard because water is a good solvent, it is readily available, and it is relatively inexpensive. In water-bath finishing, the chemical is placed in a water solution and padded onto the fabric by immersing the fabric in the solution and squeezing out any excess. The fabric is heavy with water, often as much as five times heavier. Moving and drying a fabric required a lot of energy. A great deal of water was used to scour or clean the fabric. Recently, with water pollution and environmental concerns and energy costs, foam finishing has become an alternative means of adding a finish. Foam finishing uses a foam rather than a liquid to apply the finishing chemical to the fabric. A foam is a mixture of air and liquid that is lighter in weight than a solution of the liquid. Foam finishing is used because of the low-wet pickup (a much smaller amount of liquid is used and absorbed by the fabric). In addition, energy is conserved in moving and drying the lighter fabric. With higher production speeds, the costs of foam finishing are kept low. In foam finishing less water is used in scouring and cleaning. Foam is used to add routine and special-purpose finishes to the fabric. One of its major limitations is that as the amount of water in the process decreases, the ability to apply a finish uniformly throughout the fabric also decreases.

Another development in finishing is the use of solvents other than water, referred to as **solvent finishing**. Solvent finishing responds to a need to decrease water pollution and energy costs. In solvent finishing, a solvent is used to mix the solution. It is not as popular as foam finishing because of the cost of solvents, expensive reclaiming processes, environmental concerns, regulatory issues, and health problems.

Computers are an essential part of finishing. Computers provide automatic correction of processes, fabric tension, solutions, and temperatures. Computerization makes planning easier and incorporates built-in menus to facilitate changing of finish additives. These systems minimize environmental problems by allowing for efficient treatment of residue and recycling of recoverable chemicals from finishing.

Combining finishing steps is a trend in the industry. Combining steps minimizes space, chemicals, energy, water, and costs. In single-stage preparation, desizing, bleaching, and scouring occur in one step rather than the three traditional steps formerly required. These processes will be discussed separately, but the three often occur simultaneously.

This chapter discusses routine finishing. Routine finishing includes the steps in finishing that are done to most fabrics to prepare them for dyeing and special-purpose aesthetic and functional finishes. These routine finishes are often referred to as **preparation**. The normal order of production of a basic commodity cotton/polyester, bottom-weight, plain-weave fabric will be used as the basis for discussion. Because many steps of production are discussed in detail elsewhere, these steps are included in the discussion for continuity, but see other chapters for review. Routine finishing steps for other fiber or fabric types are discussed at the end of this chapter.

Routine Finishing Steps

Fiber Processing

In *fiber processing*, the cotton fibers are processed separately from the polyester fibers because of the differences in the properties of the two fiber types. If used in filament form, synthetic fibers such as polyester generally require little additional processing once the fiber has been produced. However, since this fabric is to be a cotton/polyester blend, staple polyester fibers will be needed for blending. Thus, the polyester fibers were produced as filament tow, crimped and cut or broken into staple fibers, baled, and shipped to the yarn-spinning facility.

Since cotton is a natural fiber, considerably more processing is necessary. The fiber is grown, picked at the appropriate time, ginned, baled, and shipped to the yarn-processing facility. The cotton's grade must be assessed because the suitability of the cotton fiber is matched to the end use based on its grade. Higher grades of cotton demand higher prices in the market. These prices fluctuate on a daily and seasonal basis, as do most agricultural commodities. Hence, the price of cotton is more likely to vary than that of the polyester fibers. The pro-

cessing of these two fiber types is discussed in more detail in Chapters 4 and 8.

Yarn Processing

In varn processing the fibers are aligned, blended, and twisted. Both fiber bales are opened and dirt and soil are removed. The compact fibers are loosened and aligned in a parallel fashion before the yarns are produced. Several different bales of cotton will be blended to ensure that fabric performance and quality will be consistent from season to season and from year to year. However, since the properties of these two fibers differ significantly, the processing is separate until well into the yarn-production process; for blends, fibers are often combined at the roving stage. Once the fibers are blended, the appropriate amount of twist is added to the yarns. In general, the warp yarns have a slightly higher twist to facilitate the weaving process. After the varns have been spun, they are wound on bobbins and shipped to the mill to be processed into fabric. Yarn processing is discussed in Chapter 10.

Yarn Preparation

Preparation involves several steps. The first steps involve the yarns and will be discussed before the fabrication step.

Slashing In slashing the warp yarns are treated before being threaded into the loom for weaving. These yarns are usually wound onto a creel and then coated with a mixture of natural starches, synthetic resins (polyvinyl alcohol or polyacrylamide), and other ingredients so that they resist the abrasion and tension of weaving. Slashing adds a protective coating to the yarn to obtain optimal weaving efficiency, increase yarn rigidity, and decrease varn hairiness. This has become more important with the faster, shuttleless looms. The sizing may contain a starch, metal-to-fiber lubricant, preservative, defoamer, or a combination of these ingredients. Recipes vary by fiber type. For our cotton/polyester-blend fabric, the sizing is probably a mixture of a starch and a lubricant or polyvinyl alcohol. The filling yarns generally receive little if any treatment prior to weaving. The sizing must be removed after weaving in order for dyes and finishes to bond with the fibers.

Fabrication

Fabrication normally follows slashing. In the fabrication step, the fabric is woven, knitted, or created in some other manner. At the mill, the cotton/polyester yarns are repackaged into the appropriate-size unit for weaving.

Warp yarns are threaded through the heddles in the harnesses and the spaces in the reed after slashing. Filling yarns are packaged for the specific type of loom to be used in weaving. Since shuttleless looms are common in the U.S. textile industry, assume that this fabric will be made on such a loom. The filling-yarn length is measured during weaving and the yarns are cut so that only the length needed for one insertion is available at any time. The filling yarn is inserted in a shed that has every other warp yarn raised to create a plain weave. When the length of warp yarns has been woven, the fabric is removed from the loom and the cloth beam is transported to the finishing plant for further finishing. For a more detailed discussion of weaving see Chapter 12.

Fabric Preparation

Handling Handling refers to the physical form of the fabric during finishing. The two components that influence how a fabric will be handled are its width and length. The choices made with regard to handling influence cost, quality, and minimums. Minimums describe the smallest quantity of a fabric a buyer can purchase from a mill. Firms that allow for shorter minimums tend to charge higher prices because the cost per yard of finishing short pieces or short runs of fabrics is higher. Run describes the quantity of fabric receiving the same processing at the same time. In general, as the length of a run increases, the cost per yard decreases. Thus, in general, it is cheaper for a mill to process a longer piece of fabric than to process several shorter pieces of fabric.

In terms of fabric width, the first option is **open-width finishing,** during which the fabric is held out to its full width. Open-width finishing is often done with the fabric mounted on a tenter frame. Tentering will be discussed later in this chapter.

In the second option, the fabric is allowed to roll and fold in on itself to form a tube or rope. This form of finishing is referred to as **rope** or **tubular finishing**. Heavier-weight woven fabrics are usually finished at open width because of the likelihood of creasing and wrinkles or tube marks being set in the fabric if it were finished in rope form. Fabrics for prints or whites can be finished in tube form because rope marks will be removed or hidden during bleaching or printing. However, lighterweight woven fabrics, especially polyester/cellulose blends, give better results if finished in open-width form. Knit fabrics are usually finished in tube form because of the difficulties in controlling the knit structure in open-width form.

Tube finishing is more economical, but it may create problems with penetration of finishes and dyes into interior portions of the rope or tube. Creasing and wrin-

kling tend to occur more readily when fabrics are finished in tube form, and some machine-induced creases, wrinkles, and marks may be permanent. New techniques and use of different processing chemicals minimize these problems with tubular finishing.

A second component of handling refers to whether the fabric is handled in a batch or a continuous process. Batch processing describes when a relatively small amount of fabric, say several hundred yards, is processed as a unit at one time in one machine. The entire quantity of fabric is immersed in a solution at the same time. Continuous processing works with longer pieces of fabric that move in and out of solution. Continuous processing is more economical but requires larger quantities of fabric to achieve its full potential for minimizing costs per yard. In addition, the size of the finishing equipment requires fairly long pieces of fabric in order to engage all parts of the equipment. It also consumes huge quantities of water and energy. Because the heavyweight-blend fabric used as the example in this chapter is a commodity fabric, continuous open-width processing will be used.

Desizing In desizing, the sizing added to the warp yarns in the slashing step is removed. Desizing is necessary so that dyes and finishes will bond to both warp and filling yarns. For desizing to be effective, the finisher needs to know the sizing agent used in order to select the best means of desizing. Physical, biological, or chemical desizing may be done, depending on the sizing agents and the fiber content of the fabric. Although sizing is present only on the warp yarns, all yarns in the fabric are treated since they cannot be separated. In cotton-blend fabrics, a combination of physical desizing (agitation) and biological desizing using an amylase enzyme may be used to destroy the starch.

Cleaning All gray goods must undergo cleaning to be made ready to accept any finish. Gray goods contain a warp sizing, which makes the fabric stiff and interferes with the absorption of liquids. Sizing residue must be removed before further finishing can be done. Also, fabrics are often soiled during fabrication and storage and must be cleaned for that reason. Warp sizing, dirt, and oil spots are removed by a washing process. Degumming of silk usually is done in boiling water with detergent, although acid degumming and enzyme degumming are also used. Kier boiling or boiling-off of cotton is done in an alkaline solution at high temperature and under pressure in large tanks called kiers. Scouring of wool is a gentler washing process under less-alkaline conditions.

Singeing Singeing burns any fiber ends projecting from the surface of the fabric. These protruding ends

cause roughness, dullness, and pilling and interfere with finishing. Singeing may be the first finishing operation for smooth-finished cotton or cotton-blend fabrics and for clear-finished wool fabrics. The fabric is passed between two gas flame bars or hot plates to singe it on both sides in one step. Fabrics containing heat-sensitive fibers such as cotton/polyester blends must be singed carefully and often are singed after dyeing because the melted ends of the polyester may cause unevenness in color. Singeing is one way to minimize pilling.

Bio-polishing Bio-polishing is the use of a cellulase enzyme treatment to remove surface fuzz from spun varns of cellulose or cellulose blends. At present, the process is most often applied to cotton or cotton/polyester blend fabrics. Bio-polishing, a trade name by Novo Nordisk, is a permanent finish. The finished fabric has a soft, smooth appearance with very little surface fuzz. Protruding fiber ends that would constitute the fuzz in most spun-yarn fabrics are destroyed by the enzyme treatment. By removing the fiber ends, the potential for fabric pilling during use is decreased. Colors look brighter because the fabric's smooth surface does not scatter the light as much as a fuzzy surface would. Although the surface properties and appearance of the fabric are improved, a slight decrease of 3 to 10 percent in tensile strength usually occurs. Some products may be marketed with a hang-tag, indicating that they have been bio-polished. This process may be used instead of singeing.

Scouring Scouring is a general term referring to removal of foreign matter or soil from the fabric prior to finishing or dyeing. The specific procedure is related to the fiber content of the fabric. The foreign matter involved may be processing oils, starch, natural waxes, soils, and tints or color added to aid in fiber identification during production. Scouring usually involves the use of detergents and alkaline solutions. It is repeated during finishing to wet the fabric or to remove excess chemicals or soil. Bio-scouring, using enzymes is an alternative procedure. Wetted fabrics are easier and more efficient to finish than are dry fabrics.

Whitening

Bleaching Bleaching is the process of whitening fibers, yarns, or fabrics by removing irregular natural color. Most bleaches are oxidizing agents; the actual bleaching is done by active oxygen. A few bleaches are reducing agents and are used to strip color from poorly dyed fabrics. Bleaches may be either acid or alkaline in nature. In bleaching, the goals are uniform removal of hydrophobic fabric impurities and a high, uniform de-

gree of fabric whiteness in order to achieve clear uniform colors when dyeing, which is especially important for pastel colors.

The same bleach is not suitable for all fibers. Because chemical reactions differ between fibers, bleaches are selected with regard to fiber content.

Any bleach will damage fibers. Since damage occurs more rapidly at higher temperatures and concentrations, these two factors must be carefully controlled. Bleaches clean and whiten gray goods. The natural fibers are an off-white color because they contain impurities. Because these impurities are easily removed from cotton, most cotton gray goods are bleached without damage. Bleaching may be omitted with wool because it has good affinity for dyes and other finishes even if it is not bleached.

Peroxide bleaches are common industry bleaches for cellulose and protein goods. Hydrogen peroxide is an oxidizing bleach. Peroxide bleaches best at a temperature of 180 to 200°F in an alkaline solution. These bleaching conditions make it possible to bleach cellulose gray goods as the final step in the kier boil. However, fiber damage can occur if the process is not closely monitored. In the peroxide cold-bleach procedure, the fabric is soaked overnight or for a period of 8 hours. This procedure is used on most cotton-knit goods and wool to preserve a soft hand.

Peracetic acid bleaching is an alternative used at cooler temperatures with little fiber damage. It is used for nylon, cotton, and flax.

Optical Brighteners Optical brighteners are also used to whiten off-white fabrics. They are fluorescent whitening compounds, not bleaches. These compounds are absorbed by the fiber and mask yellow. At the mill, optical brighteners work best when used with bleach rather than as a substitute for it. They are also added to the spinning solution of some manufactured fibers to optically brighten them, since bleach may not be effective on these fibers. Optical brighteners can be used with delustered and nondelustered fibers without affecting the luster of the fiber.

Further Preparation Steps

Mercerization Mercerization is the process of treating a cellulosic fabric or yarn (cotton, flax, HWM rayon, or lyocell) with an alkali (caustic soda, also known as sodium hydroxide). Although Native Americans used wood ash (lye) to strengthen plant fibers, modern mercerizing was discovered in 1853 by John Mercer, a calico printer. He noticed that cotton fabric shrank and became stronger, more lustrous, and more absorbent after filtering the caustic soda used in dyeing. Mercerization

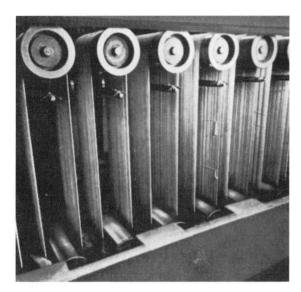

FIGURE 16-3
Mercerization of warp yarn. (Courtesy of Coats and Clark, Inc.)

was little used until H. Lowe discovered in 1897 that fabrics under tension became lustrous and silky.

Mercerization is used on cotton, linen, and some rayon fabrics. It increases luster, softness, strength, and affinity for dyes and waterborne finishes. Plissé effects can be achieved with cotton fabrics (see Chapter 17). Cotton yarn, fabric, and sewing thread are mercerized.

Yarn mercerization is a continuous process in which the yarn under tension passes from a warp beam through a series of boxes with guide rolls and squeeze rolls, a boil-out wash, and a final wash (Figure 16–3).

Fabric mercerization is done on a frame that contains rollers for saturating the cloth; a tenter frame for tensioning the fabric both crosswise and lengthwise while wet; and boxes for washing, neutralizing the caustic soda with dilute sulfuric acid, scouring, and rinsing. In tension mercerization the fabric or yarn being mercerized is held under tension. The concentration of the sodium hydroxide solution is high, generally around 20 percent, which causes the fiber to swell. Because the fibers are under tension during swelling, they become rounder in cross section and more rodlike, and the number of convolutions decreases (Figure 16–4). The smoother fiber reflects more light. A small percentage of cotton, primarily long-staple cotton yarns and fabrics, is mercerized for the increase in luster.

Mercerization increases absorbency because the caustic soda causes a rearrangement of the molecules, making more of the hydroxyl groups available to absorb water and waterborne substances. Moisture regain improves to approximately 11 percent. Dyes enter the fiber

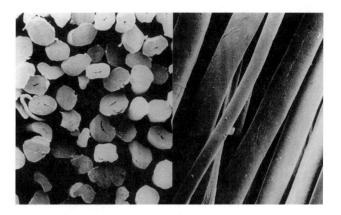

FIGURE 16-4
Photomicrographs of mercerized cotton: cross-sectional view (left); longitudinal view (right). (Courtesy of the British Textile Technology Group.)

more readily and have better colorfastness. For the same reason, mercerized fabrics take resin finishes better.

Mercerized cotton fibers are stronger because in the swollen fiber the molecules are more oriented. When stress is applied, the end-to-end molecular attraction is harder to rupture than in the more spiral fibril arrangement. The increase in fiber strength is approximately 30 percent.

In **slack mercerization**, cotton fabric is dipped, at low tension, into a weaker caustic soda solution for a shorter time before neutralizing and washing. As the fabric shrinks, yarn crimp increases. Straightening the crimp when stress is applied produces stretch. Slack mercerization increases fiber absorbency and improves dyeability.

Ammoniating Finishes An ammoniating finish is an alternative to mercerization used on cotton and rayon. Yarns or fabrics are treated with a weak ammonium solution at -33°C and are then passed through hot water, stretched, and dried in hot air. The finish is similar to mercerization but is less expensive and less polluting. The ammonia swells the fiber, but less than sodium hydroxide does. Fabrics that have been treated with ammonia have good luster and dyeability, but not to the same depth as mercerized fabrics. Because less resin is needed than with mercerized fabrics, ammonia-treated fabrics have better crease recovery with less loss of strength and abrasion resistance when treated to be wrinkle-resistant. Ammonia-treated fabrics are also not as stiff and harsh as mercerized fabrics. Ammonia-treated fabrics have an increase in tensile strength of 40 percent and an increase in elongation two to three times that of untreated cotton. These fabrics also are less sensitive to thermal degradation. Duralized and Sanforset are trade

names for easy-care cotton fabrics. Liquid ammonia treatments are a common substitute for mercerization of cotton sewing threads.

Coloration

Color is normally added to the fabric at this stage. Properly prepared goods are critical to the quality of the dye or print. Dyeing and printing are discussed in detail in Chapter 19.

Finishing

Special-Purpose Finishes Special-purpose finishes that might be appropriate for the cotton/polyester-blend fabric include wrinkle resistance, soil-release, and a fabric-softening finish. These finishes usually follow dyeing to avoid interfering with dye absorption by the fibers. These finishes are discussed in Chapter 18.

Tentering Tentering, one of the most important finishing operations, applies crosswise and lengthwise ten-

sion to a fabric while it dries. Its main function is to produce fabric that meets specifications for width and width uniformity, and warp and filling count. Tenter frames are either pin tenters or clip tenters (Figure 16–5). The mechanisms on the two sides move around like a caterpillar tractor wheel, holding the fabric selvage by a series of pins or clips. More tension can be exerted by the clip tenter. The pin tenter is used for stretch and knit fabrics that must be tentered at slower speeds to keep the fabric from stretching. To minimize lengthwise shrinkage or to minimize stretching of knits, overfeeding is used. In overfeeding, the fabric is fed into the tentering frame faster than the frame moves. The marks of the pins or the clips may appear along the selvage (Figure 16–6).

Tentering is an important finishing step in terms of the fabric's quality. If the filling yarns are not exactly perpendicular to the warp yarns, the fabric is off-grain. When the filling yarn does not cross each warp yarn at a 90-degree angle, the fabric exhibits skew. When the center of the fabric moves at a slower speed than the two edges, the fabric exhibits bow (see Chapter 12). Both of these off-grain problems can be eliminated by proper

FIGURE 16-5

Tenter frames: (a) Clip tenter, (b) Drawing of pin-tenter frame, (c) Modern tentering line. (Courtesy of Marshall & Williams Co.)

FIGURE 16-6

Fabric selvages of clip tentering (top fabric) and pin tentering (two bottom fabrics). Clip tentering rarely leaves easily visible marks. Pin tentering almost always leaves telltale holes along the edge.

tentering. However, when a fabric is tentered off-grain, it also will be printed off-grain. Most tentering frames have electronic sensors that minimize off-grain problems. The fabric may go through a tentering frame several times during finishing. Tentering is usually the last opportunity to correct the fabric variations that develop during finishing.

Drying

Because of the frequent wetting of textiles in finishing, drying also is frequent, especially with cellulosics, to minimize mildew and weight. The drying process usually blows hot air past the textiles in a large convection oven to remove the water quickly by evaporation. Fabrics in convection ovens are usually tentered. Other, less-efficient means of drying fabrics include contact with hot metal rollers (conduction drying) and use of an infrared lamp, radio waves, or microwaves (irradiation). Drying should not create wrinkles or creases. Overdrying of cotton can create problems in dyeing.

Loop Drying Fabrics with a soft finish, towels, and stretchy fabrics such as knits are not dried on the tenter frame but on a *loop dryer* without tension. Many rayon fabrics are dried on loop dryers because of their lower wet strength and soft hand.

Heat Setting In **heat setting**, the fabric is usually placed on a tenter frame and passed through an oven, where the time of exposure and the temperature are

carefully controlled based on the fiber content and resins added to the fabric. The cotton/polyester fabric would require heat setting if it had been given a wrinkle-resistant or soil-release finish or if the percentage of polyester was 50 percent or more to achieve a degree of shrinkage control. Heat setting must be carefully controlled because the heat history of polyester and other synthetic fibers can affect their dyeability. Heat setting of synthetics can set yarn twist, weave crimp, and wrinkle resistance.

Calendering Calendering is a mechanical finishing operation performed by a series of rollers between which the fabric passes. The types of calendering include simple, friction, moiré, schreiner, and embossing. Each type produces a different finish. However, since most calenders are used to modify the fabric's appearance, they will be discussed in Chapter 17.

Calender machines have from two to seven rollers. Hard-metal rollers alternate with softer rollers of foam, solid paper, or fabric-covered metal. Two metal rollers never run against each other.

The *simple calender* produces a smooth, flat, ironed finish on the fabric. The fabric is slightly damp before it enters the calender. The metal roll is heated. The fabric travels through the calender at the speed that the rollers rotate, so they exert pressure to smooth out the wrinkles and give a slight sheen (Figure 16–7).

Reworking

Reworking is a general term that includes inspecting fabric for defects or flaws and repairing those problems wherever possible.

FIGURE 16-7 Calender machine.

Inspecting Fabric inspection is done by moving fabrics over an inverted frame in good light. Fabric inspectors mark flaws in the fabric and record its quality at the same time. Flaws may be marked on the fabric, usually on the selvage, so that subsequent cutting and sewing operators can avoid working with and adding value to product parts that incorporate flaws. Computers and electronic sensors are also used to assess fabric quality. Fabric quality is a complex area that takes into account the number of flaws, their severity, and their length or size. Mills and buyers work together to define quality levels acceptable to both parties.

Repairing Flaws marked by the inspectors are *repaired*, if economically feasible or possible. Broken yarns are clipped, snagged yarns are worked back into the fabric, and defects are marked so that adjustments can be made when fabrics are sold. The fabric is then wound on bolts or cylinders, ready for shipment.

Routine Finishing Steps for Wool Fabrics

Carbonizing

Carbonizing, the treatment of wool yarns or fabrics with sulfuric acid, destroys plant matter in the fabric and allows for more level dyeing. Recycled wool is carbonized to remove any cellulose that may have been used in the original fabric. Carbonizing gives better texture to allwool fabrics, but the acid must be neutralized to avoid problems in dyeing or in consumer use.

Crabbing

Crabbing is a wool-finishing process used to set wool fabrics. Fabrics are immersed first in hot water, then in cold water, and passed between rollers as in simple calendering.

Decating

Decating produces a smooth, wrinkle-free finish and lofty hand on woolen and worsted fabrics and on blends of wool and manufactured fibers. The process is comparable to steam ironing. A high degree of luster can be developed by the decating process because of the smoothness of the surface. The dry cloth is wound under tension on a perforated cylinder. Steam is forced through the fabric. Moisture and heat relax tensions and remove wrinkles. The yarns are set and fixed in this po-

sition by cooling in cold air. For a more permanent set, dry decating is done in a pressure boiler. Wet decating often precedes napping or other face finishes to remove wrinkles that have been acquired in scouring. Wet decating as a final finish gives a more permanent set to the yarns than does dry decating. Decating may also be used with rayon and other manufactured fiber, blend fabrics, or with knits.

Pressing

Pressing is the term used with wool or wool blends. In pressing, the fabric is placed between metal plates that steam and press the fabric.

Environmental Impact of Finishing

Finishing transforms a harsh and unattractive fabric into an attractive one. Unfortunately, the environmental impact of this transformation can be significant. Almost every step in finishing a fabric has a potential for damaging the environment. The textile industry is acutely aware of the situation and is becoming more proactive to safeguard the environment. Finishing facilities incorporate systems for air-pollution control, pollution prevention, and hazardous waste disposal. These systems minimize discharge into any part of the environment (air, land, or water).

Finishing makes use of significant quantities of water and energy. In the 1970s, it was not unusual for a large finishing facility to use more than 2 million gallons of water daily! Water use has decreased, but it continues to be used to dissolve chemicals and to remove waste and soil from the system. The quality of the water supply is a growing concern. Foam finishing and other less water-intensive processes are increasing in importance. Better and more efficient means of extracting water from fabrics prior to drying and heat-recovery systems minimize energy use.

Finishing uses quantities of potentially hazardous chemicals. There are restrictions on the discharge of waste with high biological oxygen demand (BOD), such as sizing agents, and high chemical oxygen demand (COD), such as chlorine-containing compounds. Hazardous, toxic, and carcinogenic finishing chemicals are being replaced with less hazardous, nontoxic, and noncarcinogenic chemicals. Biodegradable finishes are becoming more common.

In addition, changes in technology and good operating practices that ensure that fabrics are finished cor-

rectly limit excessive use of chemicals, water, and energy and minimize environmental impact. Many finishers have preliminary treatment facilities on site so that they can reclaim and reuse chemicals and remove contaminants before discharging waste to municipal systems. Membrane technology and reverse osmosis provide effective means of producing high-quality discharge by separating salts, metals, organic compounds, and other contaminants before water leaves the finishing plant's treatment facility.

Key Terms

Finish
Converters
Permanent finish
Durable finish
Temporary finish
Renewable finish
Gray goods
Finished, or converte

Finished, or converted, goods

Mill-finished Water-bath finishing Foam finishing Solvent finishing Preparation Slashing Fabrication Handling Minimum

Open-width finishing Rope or tubular finishing Batch processing

Continuous processing

Desizing

Cleaning Singeing Bio-polishing Scouring Bio-scouring Bleach

Optical brighteners Mercerization

Tension mercerization Slack mercerization

Ammoniating finish Tentering

Drying
Heat setting
Calendering
Reworking
Repairing
Fabric inspection
Carbonizing
Crabbing
Decating
Pressing

Questions

- 1. Describe the differences among permanent finish, durable finish, temporary finish, and renewable finish.
- 2. Why are yarns finished before fabrication? What finishes are used?
- 3. At what stage is bleaching normally done? Why is it done at that time?

- **4.** What problems can occur if tentering is improperly done? How does this affect fabric quality?
- **5.** What differences may occur in finished fabrics between open-width and tubal or rope finishing?
- 6. Where would changes in finishing occur for these fabrics?

Acetate velvet Cotton knit velour Silk crepe de chine

Suggested Readings

Etters, J. N., and Annis, P. A. (1998, May). Textile enzyme use: a developing technology. *American Dyestuff Reporter*, pp. 18–23.

Fulmer, T. D. (1992, November). Cotton preparation is crucial. *America's Textiles International*, pp. 52, 53, 55.

Gebhart, G. (1995, September). Comparing mercerizing concepts: chain vs chainless systems. *American Dyestuff Reporter*, pp. 76–78, 80, 82, 84.

Isaacs, M. (1999, September). Tenterframes: finishing plant workhorses. *Textile World*, pp. 110, 112–115.

Needles, H. (1986). Textile Fibers, Dyes, Finishes, and Processes. Park Ridge, NJ: Noyes Publications.

Perkins, W. S. (1996, February). The two sides of warp sizing. America's Textiles International, pp. 79–80.

Perkins, W. S. (1996, January). Advances made in bleaching practice. *America's Textiles International*, pp. 92–94.

Powderly, D. (1987). Fabric Inspection and Grading. Columbia, SC: Bobbin International.

Thomas, Howard (1994, April). The current state of weaving preparation. *America's Textiles International*, pp. 71–73.

Trotman, E. R. (1984). Dyeing and Chemical Technology of Textile Fibers. New York: Wiley.

Zein, K. (1994, July). Teamwork needed to combat industry's environmental problems. *Textile Month*, pp. 9–13.

Chapter 17

AESTHETIC FINISHES

OBJECTIVES

- To understand how finishes can alter aesthetic aspects of fabrics.
- To know the ways that aesthetic finishes can be applied to fabrics.
- To predict the performance of textiles with aesthetic finishes.
- To differentiate between applied designs and structural designs and their implications for quality and performance.

esthetic finishes change the appearance and/or hand of fabrics. The finished fabric's name often reflects the change in appearance or the technique. For example, eyelet embroidery, ciré satin, and organdy are made by aesthetic finishes. Figure 17–1 shows several fabrics that were converted from print cloth: percale (printed), chintz (waxed and friction calendered), plissé (caustic soda print), and embossed cotton (embossed calendered). This fabric also could be flocked, embroidered, or surface coated.

Aesthetic finishes are an **applied design.** They are quicker and less expensive than incorporating the design as the fabric is produced (structural design). Table 17–1 compares applied and structural design.

Aesthetic finishes can be grouped by the change produced in the fabric: luster, drape, texture, and hand.

The process, its effect, and the relationship of the finish to the fabric name will be explained for each group. Some aesthetic finishes determine or influence the name of a fabric. Other finishes give certain fabrics their traditional luster, drape, texture, or hand. Fabrics that have received aesthetic finishes are shown in Figure 17–2.

Many of these finishes are additive finishes that produce texture (body, stiffness, softness), luster, embossed designs, and abrasion resistance in the fabric. Some are **subtractive finishes:** something is removed from the fabric during finishing. Some finishes mechanically distort or alter the fabric with heat or pressure; others chemically change the fabric. Finish permanence depends on the process, the fiber content, and the type of finish itself.

FIGURE 17-1

Fabric converted from print cloth: (a) gray goods (upper left); (b) roller printed (upper right); (c) waxed and friction calendered (center left); (d) printed with caustic soda (center right); (e) embossed (bottom left).

TABLE 17-1 Comparison of structural and applied designs.

Structural Designs	Applied Designs	
Usually more expensive Decisions are made earlier in the process; more time- consuming	Usually less expensive	
Permanent design	Permanent, durable, or temporary	
Woven designs usually on-grain (some may be skewed)	Figures may be off- grain May tender or weaken fabric	
Fabrics not damaged by process		
Kinds and Types		
Woven—jacquard, dobby, extra yarn, swivel dot, lappet designs, piqué, double cloth	Printed Flocked Tufted Embroidered Burned out	
Knitted—jacquard single-knits, jacquard double-knits	Embossed Plissé Napped	
	Mappeu	
Lace	Emerized Abrasive or chemical wash	
Lace Typical Fabrics	Abrasive or chemical	

The **padding machine** is used to apply dyes and finishing chemicals in either liquid or paste form to a fabric (Figure 17–3). *Padding* is done by passing the fabric through the solution, under a guide roll, and between two padding rolls. The type of roll depends on the finish to be applied. The rolls exert tons of pressure on the fabric, forcing the finish into the fiber or yarn to ensure good penetration. Excess liquid is squeezed off. The fabric is then steamed, cleaned, and dried.

The **backfilling machine** is a variation of the padding machine. It applies the finish to one side only, usually to the back of the fabric (Figure 17–4).

Luster

Luster finishes produce a change in a fabric's light reflectance. Most of these finishes increase light reflectance and improve the fabric's luster or shine. The increase in luster may be over the entire fabric—as in the glazed, ciré, and schreiner finishes—or it may be a localized increase in luster—as in the moiré and embossed finishes. These finishes are done by calendering—passing the fabric between two cylinders. The cylinders exert pressure on the fabric. Different calenders produce different effects on the fabric: glazed, ciré, moiré, schreiner, and embossed.

Glazed

Glazed chintz and polished cotton are two fabrics that receive surface glazing. A friction calender produces a highly glazed surface. If the fabric is first saturated with starch and waxes, the finish is temporary. If resin finishes are used, the glaze is durable. The fabric is passed through the finishing solution and partially dried. It is then calendered. The speed of the metal roller is greater than the speed of the fabric, and the roller polishes the surface. (See Figure 17–1c.)

Ciré

A ciré finish is similar to a glazed finish, except that the metal roll is hot. The hot roller produces greater luster on the fabric's surface. When thermoplastic (heatsensitive) fibers are used, the fiber surface that comes in contact with the metal roll melts and flattens slightly and produces the highly polished fabric. Ciré is a taffeta, satin, or tricot fabric hot-friction-calendered to give a high gloss, or "wet" look.

Moiré

Moiré fabrics have a wood grain or watermarked appearance. Two techniques are used to produce a **moiré pattern** on a fabric. In *true moiré*, two layers of an unbalanced plain-weave rib fabric such as taffeta or faille are placed face to face, so that the ribs of the top layer are slightly off-grain in relation to the underlayer. The two layers are stitched or held together along the selvage and are then fed into the smooth, heated-metal-roll

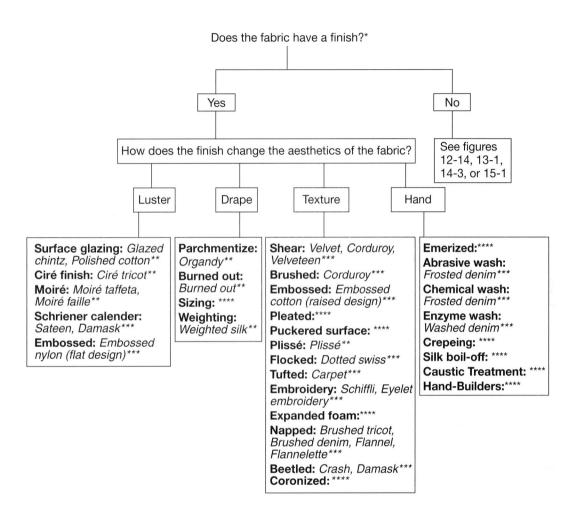

- * Only some finishes create a visual or tactile change in the fabric
- ** Fabric name influenced by this finish
- *** Examples of fabrics with this finish
- **** Finish is not used to determine a fabric name

FIGURE 17-2

Flow chart of fabrics with aesthetic finishes.

calender. Pressure of 8 to 10 tons causes the rib pattern of the top layer to be pressed into the bottom layer and vice versa. Flattened areas in the ribs reflect more light and contrast with unflattened areas. This procedure can be modified to produce patterned moiré designs other than the traditional watermarked one.

In the second technique, an embossed-metal roll is used. The embossed roll has a moiré pattern engraved on it. When the roll passes over a ribbed fabric, the ribs are flattened in areas and a moiré pattern is created. If the fabric is thermoplastic and the roll is heated, the finish is permanent (Figure 17–5).

FIGURE 17-3 Padding machine.

Schreiner

Fabrics with a schreiner finish have a softer luster than most of the other luster finishes. The **schreiner calender** (Figure 17–6) has a metal roller engraved with 200 to 300 fine diagonal lines per inch that are visible only under a magnifying glass. (The lines should not be confused with yarn twist.) Unless resins and thermoplastic fibers are used, this finish is temporary and removed by the first washing. This finish scatters light rays and produces a deep-seated luster, rather than a shine. It also flattens the yarns to reduce the space between them and increase smoothness and cover. It can upgrade a lower-quality fabric. A schreiner finish is used on cotton sateen and table damask to make them more lustrous and on nylon tricot to increase its cover.

Embossed

Embossed designs are created using an embossing calender that produces either flat or raised designs on the fabric. Embossing became a more important finish with the development of the heat-sensitive fibers because it became possible to produce a durable, washable, embossed pattern. Fabrics made of solution-dyed fibers can be embossed directly off the loom and sold.

FIGURE 17-4
Backfilling machine.

FIGURE 17-5 Moiré taffetta.

The embossing calender consists of a heated hollow, engraved-metal roll and a solid paper roll twice the size of the engraved roll (Figure 17–7). The fabric is drawn between the two rollers and is embossed with the design. Embossing can be done to both flat and pile fabrics.

The process differs for the production of flat and raised designs. Raised embossed designs will be discussed later in this chapter in the section on texture. Flat embossed designs are the simplest to produce. A metal,

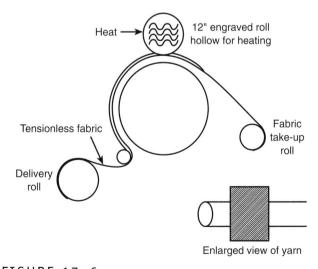

FIGURE 17-6
Schreiner calender machine for tricot.

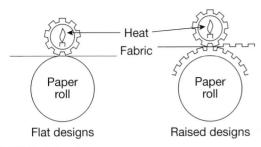

FIGURE 17-7 Embossing process.

foam, or plastic roll engraved in deep relief (Figure 17–8) revolves against a smooth paper roll. The hot, engraved areas of the roll produce a glazed pattern on the fabric. Embossed brocades are an example of this type of design. The effect can be seen as a difference in luster, but the fabric's texture does not change.

Drape

Drape finishes change the way a fabric falls or hangs over a three-dimensional shape. These finishes make the fabric stiffer or more flexible. They usually add a chemical

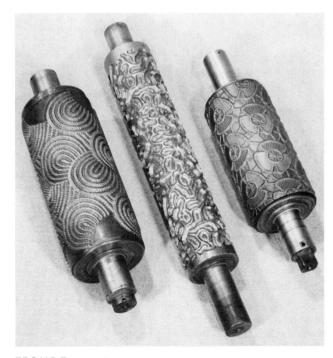

FIGURE 17-8
Embossing rolls. (Courtesy of Consolidated Engravers Corp.)

compound to the fabric (additive finish) or dissolve a portion of the fibers present (subtractive finish).

Crisp and Transparent

Transparent or parchment effects in cotton fabrics are produced by treatment with sulfuric acid; this is called **parchmentizing.** The fabric may then be referred to as *parchmentized*. Since acid dissolves cotton, this subtractive process must be very carefully controlled. Split-second timing is necessary to prevent **tendering** (weakening) of the fabric. Several effects are possible: an allover, a localized, or a plissé effect.

Because *all-over parchmentizing* produces a transparent effect, a sheer combed lawn is used. The goods are singed, desized, bleached, and mercerized. Mercerization may be repeated after the acid treatment to improve the transparency. The fabric is then dyed or printed with colors that resist acid damage. The fabric is immersed in the acid solution and the fiber surface is partially dissolved. This surface rehardens as a cellulosic film and, when dry, it is permanently crisp and transparent. After the acid treatment, the cloth is neutralized in a weak alkali, washed, and calendered to improve surface gloss. This all-over treatment produces *organdy* fabric.

In *localized parchmentizing*, if the design is a small figure with a large transparent area, an acid-resistant substance is printed on the figures and the fabric is run through the acid bath. The acid-resistant areas retain their original opacity and contrast sharply with the transparent background (Figure 17–9). If a small transparent

FIGURE 17-9
Localized parchmentizing (acid finish)

Localized parchmentizing (acid finish) yields a transparent background. Coin in the center illustrates the change in fabric opaqueness with this finish. design is desired, the acid is printed on in a paste form and then quickly washed off.

Burned Out

Burned-out effects are produced by printing a chemical solvent on a blend fabric made of fibers from different groups, such as rayon and polyester. One fiber, usually the less expensive or more easily dissolved fiber, is dissolved, leaving sheer areas. Figure 17–10 shows a burned-out rayon/polyester fabric. The rayon has been dissolved by acid. This finish is also known as etched or devoré because part of the fibers are removed by this subtractive finish.

Sizing

In sizing, or starching, the fabric is immersed in a mixture containing waxes, oils, glycerine, and softeners to add or control fabric body. For added weight, talc, clay, or chalk may be used, but these are often used with lower-quality fabrics. Gelatin is used on rayons because it is a clear substance that enhances the natural luster of the fibers. Sizing adds stiffness, weight, and body to the fabric. Its permanence is related to the type of sizing and method of application. If the sizing is resin-based and heat-set, it will be permanent. If the sizing is water-soluble, it will be removed during washing or it may create problems for consumers. Gelatin, for example, may

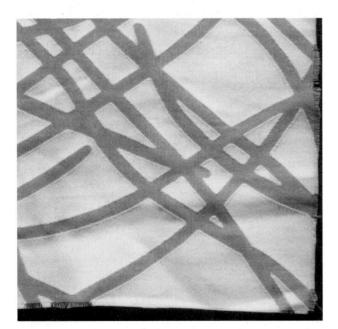

FIGURE 17-10 Burned-out design.

create water spots on rayon if condensation or other water drops onto the fabric. These spots are difficult to remove.

Weighting

Weighting is another technique used to add weight and body to a fabric. A metallic salt such as stannic chloride is used. Salts that bond with the fiber are durable; others produce temporary surface coating. Weighted silk was common once, but is rare today. Weighted silks are sensitive to light damage and do not age well.

Texture

Texture finishes modify fabric texture or add components that completely change the fabric's original texture.

Sheared

A sheared fabric is a pile or napped fabric in which the surface has been cut to remove loose fiber or yarn ends, knots, and similar irregularities or surface flaws. **Shearing** is a finishing process done by a machine similar to a lawn mower to control the length of the pile or nap. It may create a smooth surface or a patterned or sculptured effect by flattening portions of the pile with an engraved roller, shearing off the areas that remain erect, and steaming the fabric to raise the flattened and now taller portions. Most pile fabrics and many napped fabrics, including cut-pile carpet, are sheared.

Brushed

After shearing, the fabric surface usually is brushed to clean off the fiber ends. When **brushing** is combined with steaming, the nap or pile is set so that it slants in one direction, producing an up-and-down direction for pile and nap fabrics such as corduroy (Figure 17–11).

Embossed

Some *embossed fabrics* have a raised design or pattern. The embossed design is permanent if the fabric has a thermoplastic-fiber content or if a resin is used and heat-set. To create raised, or relief, designs a more complicated routine is used. The paper roll is soaked in water and revolved against the engraved roll without fabric until its pattern is pressed into the paper roll. The temperature is adjusted for the fabric, which is then passed between the rolls. This process creates three-dimensional designs that can be seen and felt.

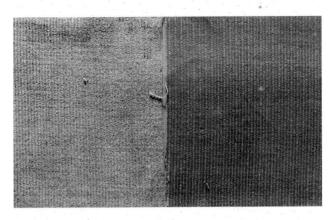

FIGURE 17-11

When the nap in corduroy does not match, two pieces may look as if they are different colors.

Pleated

A pleated fabric is made using a variation of embossing. Pleating is a highly specialized operation done by either the paper-pattern technique or by the machine process.

The paper-pattern technique is a more costly hand process, but it produces a wider variety of pleated designs. Partially completed garment components, such as hemmed skirt panels, are placed in a pattern mold by hand. Another pattern mold is placed on top so that the fabric is pleated between the pleating papers. The three layers are rolled into a cone shape, sealed, and heat-set in a curing oven.

The *machine-pleating process* is less expensive. High-precision blades pleat the fabric as it is inserted between two heated rolls in the machine. A paper backing is used under the pleated fabric, and paper tape holds the pleats in place. After leaving the heated-roll machine, the pleats are set in an aging unit. Stitching the pleats in place produces permanent three-dimensional effects in apparel, upholstery, wall coverings, window treatments, and lampshades. Pleated fabric without stitching is used in similar products, but the pleats soften with use.

Puckered Surface

Puckered surfaces are created by partially dissolving the surface of a nylon or polyester fabric. Sculptured and "damasque" effects are made by printing phenol on the fabric to partially dissolve or swell it. As the fabric dries, it shrinks and creates the puckered surface.

Plissé

Plissé is converted from either lawn or print-cloth gray goods by printing sodium hydroxide (caustic soda) onto the fabric in the form of stripes or designs. The alkali shrinks the fabric in the treated areas. As this shrinkage occurs, the untreated stripes pucker. Shrinkage causes a slight difference in count between the two stripes. The treated or flat stripe is denser. The upper portion of the fabric in Figure 17–12 shows the fabric before finishing, and the lower portion shows the crinkle produced by the caustic-soda treatment. This piece of goods is defective because the roller failed to print the chemical in the upper area.

The crinkle stripes can be narrow, as shown in Figure 17–12, or wide. In piece-dyed fabrics, the flat, treated area may be a deeper color than the puckered area. The texture change is permanent but can be flattened somewhat by steam and pressure.

Seersucker, plissé, and embossed fabrics can be similar in appearance. These fabrics are frequently found in the same price range. Table 17–2 compares these and other similar fabrics.

Flocked

In a flocked fabric a fine natural or synthetic surface fiber is applied after a base fabric has been produced. **Flocking**

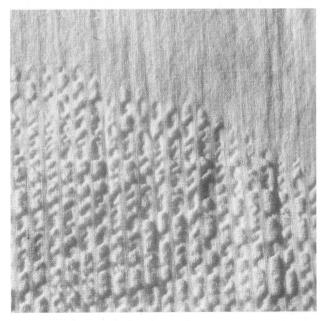

FIGURE 17-12

Plissé, showing treated (bottom portion) and untreated (upper portion) areas.

Crepe Yarns, Natural or Manufactured	Crepe Yarns, Thermoplastic	Bulky Yarn	Weave	Finish
Permanent crinkle Flattens during use Moisture will restore	Permanent crinkle Retains appearance during use and care	Permanent crinkle Does not flatten or need ironing	Crinkle does not flatten during use	Crinkle may flatten after washing
High potential shrinkage	Low potential shrinkage	Low potential shrinkage	Lower potential shrinkage	Lower potential shrinkage
Good drapeability	Good drapeability	Less drapeable	Less drapeable	Less drapeable
Stretches	Moderate stretch	Low stretch	Low stretch	Low stretch
Resilient, recovers from wrinkles	Resilient	Does not wrinkle	Rough surface hides wrinkles	Rough surface hides wrinkles
Dry cleaning preferable	Easy care	Easy care	Fiber and finish determine care	Fiber and finish determine care
Typical fabrics:	Typical fabrics:	Typical fabrics:	Typical fabrics:	Typical fabrics:
Wool crepe	Chiffon	Silky synthetics	Sand crepe	Plissé
Crepe de chine	Georgette		Granite cloth	Embossed
Matelassé			Seersucker	
Chiffon				
Georgette				
Silk crepe				

can be localized to imitate extra yarn weaves or all-over to imitate pile fabrics.

Flock fibers are very short, straight (not crimped) fibers attached to a fabric surface by an adhesive to create an inexpensive pile. Flocking was used to decorate walls as early as the 14th century, when short silk fibers were applied to freshly painted walls. Flock can be applied to such base materials as fabric, foam, wood, metal, and concrete, or it can be applied to an adhesive film and laminated to a base fabric. Current aqueous-based acrylic, nylon, or polyester adhesives have good flexibility, durability, drape, and hand and are colorless and odorless.

The two basic methods of applying the flock fibers are mechanical and electrostatic. In both processes the flock is placed in an erect position and oven-dried. Table 17–3 compares the two methods. Overall flocking, or area flocking, can be done by either method. A rotating screen is used to deposit the flock. Examine Tables 15–6 and 15–7 to compare flocking with other methods used to produce fabrics with a pile or imitation pile surface.

Rayon fibers are inexpensive and easy to cut, and are used in large quantities for wall coverings, toys, and garments. Cotton is used in packaging and greeting cards. Nylon for upholstery and blankets has excellent abrasion resistance and durability. Acrylics, polyesters, and olefins also are used for weather stripping, sealing applications, and automotive squeak and rattle controls in window channels and dashboards. Another end use for polyester and olefin fibers is for flocked marine surfaces (boat

hulls, docks, and ballast tanks) to protect against barnacles, mussels, and other marine life. Flocking is an alternative to paints containing heavy metals that had been used for this purpose and that are now banned in some countries. As the fiber length increases, the denier also must increase so that the fiber will remain erect in the fabric. Fibers that are cut square at the ends anchor more firmly in the adhesive (Figure 17–13).

Flocking has two safety issues. Fiber dust may create a potential fire hazard. In addition, a lung disease nicknamed "flock worker's lung" may be related to tiny airborne fiber particles found in many flocking facilities. To address these issues, producers are installing industrial vacuuming systems and requiring that workers wear respirators and masks for certain processes.

Tufted

Tufted fabrics also imitate more-expensive pile fabrics. In tufting, a surface yarn is stitched to the fabric to create a pile or three-dimensional effect. **Tufting** can be all over the fabric, as in carpeting and upholstery, or in localized areas to create an imitation extra yarn weave or a fabric like that used in chenille bedspreads. See Chapter 15 for details of the process.

Embroidered

Embroidered fabrics can be produced by hand or by machine. These fabrics are decorated with a surface-

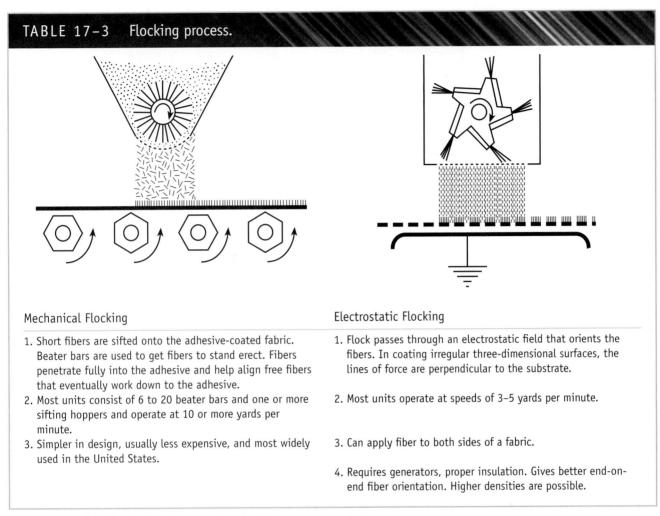

Source: Courtesy of the Fibers Division of Monsanto Chemical Co., a unit of Monsanto Co.

applied thread. Machine-embroidery uses compact zigzag stitches of various lengths. Two machines are used for embroidery: the shuttle and the multihead. The shuttle embroidery machine produces all-over embroidered fabrics such as eyelet (Figures 17–14 and 17–15). Schiffli embroidery describes earlier machines that used

FIGURE 17–13
Flock with square-cut ends is attached more firmly.

punched cardboard rolls to produce all-over embroidered fabrics. Contemporary shuttle embroidery machines use computers to control the pattern.

Multihead embroidery creates flat embroidery or pile embroidery. They are called multihead because several machines are operated by the same computer system simultaneously (Figure 17–16). Multihead machines are extremely versatile and can work with a variety of threads, ribbons, or bead/sequin strands. They can incorporate one or more colors of threads to create elaborate or simple designs in small or large scale. They create designs and emblems that are sewn to products such as letter jackets, hats, and shirts, or they are used to stitch crests, logos, and other designs on finished items (Figure 17–17).

Embroidered figures are very durable, often outlasting the ground fabric. The fabric is more expensive than the same fabric unembroidered. Like other applied designs, the figure may or may not be on-grain.

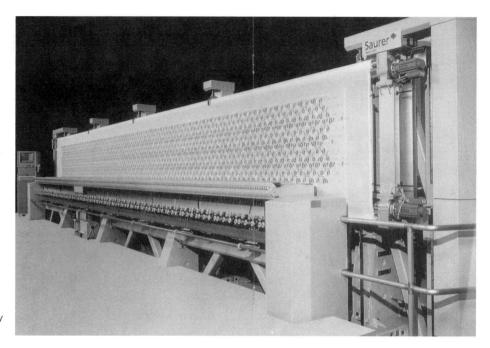

FIGURE 17–14
Shuttle embroidery machine. (Courtesy of Sauer Textile Systems Charlotte.)

Eyelet is an embroidery fabric with small, round holes cut in the fabric with stitching completely around the holes. The closeness and amount of stitching, as well as the quality of the background fabric, vary tremendously.

Expanded Foam

Another technique to create surface texture uses **expanded foam.** A colored compound printed on the

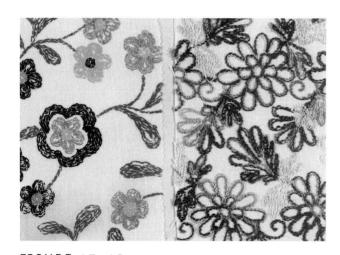

FIGURE 17-15
Embroidered linen (right); printed to look like embroidery (left).

fabric expands during processing to give a threedimensional texture to the fabric. These foams are durable but create problems with pressing.

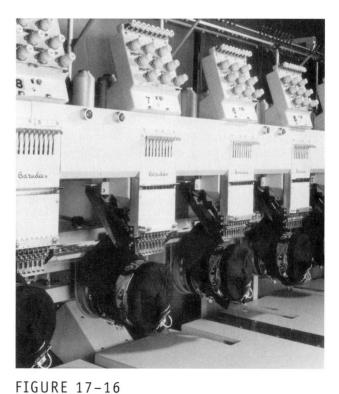

Multihead embroidery machine. (Courtesy of Barudan America, Inc.)

FIGURE 17-17 Multihead embroidered design.

Napped

Nap is a layer of fiber ends raised from the ground weave of the fabric by a mechanical brushing action. Thus, napped fabrics are literally "made" by a finishing process. Figure 17–18 shows a fabric before and after napping.

Napping was originally a hand operation using several teasels or dried plant burrs to gently brush up fiber ends. Napping is less expensive than many other ways of producing a three-dimensional fabric.

Napping is now done by pile rollers covered by a heavy fabric in which bent wires are embedded (Figure 17–19). Napping machines may be single-action or double-action. Fewer rollers are used in the single-action machine. The bent wire ends point in the direction in which the fabric travels, but the identical rollers are all mounted on a large drum or cylinder that rotates in the same direction as the fabric. The pile rolls must travel faster than the fabric to do any napping.

In the double-action napping machine, every other roll is a counterpile roll, with wires that point in the di-

Before Napping

After Napping

FIGURE 17-18
Fabric before and after napping.

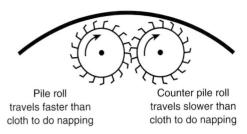

FIGURE 17-19
Napping rolls.

rection opposite that of the pile roll. The counterpile roll travels more slowly than the fabric to produce a nap. When the pile rolls at slower speed and counterpile rolls at faster speed, a "tucking" action occurs, in which the raised fibers are pushed back into the fabric, making a smooth surface.

Napping produces a fabric with appealing characteristics. A napped surface combined with soft-twist filling yarns increases the air volume. The fabric is soft, attractive, and a good insulator. A dense mat of fiber ends on the surface imparts a degree of water repellency.

The amount of nap does not indicate fabric quality. The amount may vary from the slight fuzz of flannel to the thick nap of imitation fur. A short compact nap on a fabric with firm yarns and a closely woven ground wears best. Stick a pin in the nap and lift the fabric; a durable nap will hold the weight of the fabric. Hold the fabric up to the light and examine it. Move the nap aside and examine the ground weave. A napped surface may be used to cover defects or a sleazy construction. Rub the fabric between your fingers and then shake it to see if short fibers drop out. Thick nap may contain very short fibers or flock. Rub the surface of the nap to see if it is loose or likely to pill.

Napped fabrics are made from gray goods in which the filling yarns are made of low-twist staple (not filament) fibers (see Chapter 11 for information about yarn twist). This difference in yarn structure makes it easy to identify the lengthwise and crosswise grain of the fabric. Figure 17–20 shows warp and filling yarns from a fabric before and after napping.

Fabrics can be napped on either or both sides. The nap may have an upright position or it may be "laid down" or "brushed." A heavy nap sometimes indicates that the yarns have been weakened.

Yarns of either long- or short-staple fibers are used in napped fabrics. Worsted flannels are made of long-staple wool. The short-staple yarns used in woolen flannels have more fiber ends per inch, which produce a heavier nap. In wool blankets, which may be heavily napped for maximum loft, a fine-cotton (core) ply is sometimes used in the yarn to give strength.

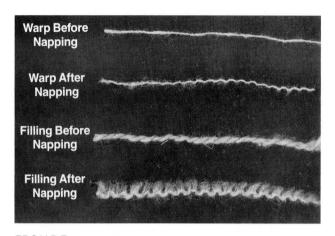

FIGURE 17-20
Yarns before and after napping.

Napped fabrics may be plain or twill weave, or knit. More filling yarn is exposed on the surface in a $\frac{2}{2}$ twill or a filling-faced twill, and a heavier nap can be raised on twill fabrics. Napped knit fabrics are used for extremely soft and flexible items. Napped, knitted fabrics may be given pile-fabric names such as velvet, velour, or fleece.

Flannel is an all-wool napped fabric made in dress, suit, or coat weights. It may be made with either worsted or woolen yarns, which may be yarn-dyed. Worsted flannels are important in suits and coats. They are firmly woven with a very short nap. They wear well, are easy to press, and hold a press well. Woolen flannels are fuzzier, less firmly woven fabrics. Because napping causes some weakening of the fabric, 15 to 20 percent nylon or polyester may be blended with the wool to improve the strength. Fleece is a coat-weight fabric with a long brushed nap or a short clipped nap.

Cotton flannels flatten under pressure and do not insulate as well as wool because cotton is less resilient. Because the fibers are shorter, there is more shedding of lint from cotton flannels. These fabrics are used in robes, nightwear, baby clothes, and sweatshirts. Flannelette is a plain-weave fabric that is converted from a gray goods fabric called soft-filled sheeting. It has a short nap on one side only and is often printed. Small pills will form on the nap and the fabric is subject to abrasion. Suede and duvetyn also are converted from the same gray goods but are sheared close to the ground to make a smooth, flat surface. Of the two, duvetyn is lighter weight. Outing flannel is a yarn-dyed, white, or printed fabric that is similar in fabric weight and nap length to flannelette but is napped on both sides. Since the warp yarns in these fabrics are standard yarns, it is easy to identify fabric grain.

Fulled

Fulling is performed on wool fabrics to improve their appearance, hand, thickness, softness, body, and cover.

Fabrics are fulled by moisture, heat, and friction in a very mild, carefully controlled felting process. Fulled fabric is denser and more compact in both warp and filling directions (Figure 17–21). Almost all woven wool fabrics and many knit wool fabrics are fulled. Some are lightly fulled while others are heavily fulled. *Boiled wool* is an example of a heavily fulled jersey.

Beetled

Beetling is a finish originally used on linen and fabrics resembling linen. As the fabric revolved slowly over a wooden drum, it was pounded with wooden hammers until the yarns flattened into an oval, not round, cross section. The weave appeared tighter than it really was. The greater surface area increased fabric luster, absorbency, and smoothness.

A contemporary method of producing a beetled fabric uses high pressure, resin, and thermoplastic fibers. In this case, the pressure flattens the yarns into the oval shape associated with beetled fabrics. The heat and resin result in a permanent flattening of the yarns. This finish is used on damask, crash, and other linenlike fabrics.

Coronized

Coronizing is a process for heat setting, dyeing, and finishing glass fiber in one continuous operation. Since the flexibility of glass is low, the yarns resist bending around one another in the woven fabric. Heat setting at a temperature of 1100°F softens the yarns so that they bend and assume yarn crimp. Coronized fabrics have greater wrinkle resistance and softer draping qualities.

After heat setting, the glass fabric is treated with a lubricating oil before adding color and a water-repellent finish using the Hycar-Quilon process. Hycar is an acrylic latex resin with colored pigment that is padded on the fabric and cured at a temperature of 320°F. This is followed by a treatment with Quilon, a water-repellent substance, and the fabric is again cured. The resin increases fiber flexibility. Screen printing and roller printing can be done by this process, since the color paste

FIGURE 17-21
Wool cloth before (left) and after (right) fulling.

dries so quickly that one screen follows another. It gives good resistance to rubbing off (crocking), a disadvantage of other coloring methods.

Hand

Hand finishes are used to alter the hand or touch of a fabric.

Emerizing, Sueding, or Sanding

Emerizing, sueding, sanding, or peach skin is a process used on fine silky fabrics of natural or manufactured fibers. The different terms describe different starting plain- or twill-weave fabrics and different surface effects produced by the process. It may be applied to polyester microfiber fabrics to improve their hand and comfort. The finish is usually applied to washed fabrics before they are heat-set or dyed. The fabric moves at a speed of 15 to 20 meters per minute under two or more rollers with fine emery paper on the first roller to more abrasive paper on each successive roller. The process abrades the surface, causing fibrils to split from the fibers, producing a soft hand and sueded texture to the fabric. Too much abrasion or too coarse an abrasive rips or tears the fabric. Too little abrasion may generate sufficient heat to produce a harsh hand with thermoplastic fibers. The process damages the fabric and can decrease its tensile strength by as much as 60 percent. After treatment, the fabrics are heat-set and washed to remove the dust. Dyeing follows. These fabrics need to be handled carefully. Machine-washing may abrade the fibrils and destroy the look of the fabric. Peach-skin finishes can be applied to silk, nylon, polyester, and cotton blended with nylon or polyester.

Abrasive, Chemical, or Enzyme Washes

Abrasive, chemical, and enzyme washes are processes that were used originally on denim garments and have been popular in that application for years under such names as acid, frosted, pepper, and enzyme wash. These finishes are modified for application to other fabrications and fibers. The washing process alters the surface of the fabric and damages it to some degree.

Many manufacturers use these finishes on their products. The washing can be done at the sewing facility in an area referred to as the laundry. These processes require special equipment and knowledge and cannot be duplicated in the home. Some consumers have attempted stone washing at home with real stones resulting in expensive washing-machine repair or replacement.

Abrasive Washes With the abrasive washes, pumice or some other abrasive material is saturated with a chemical such as potassium permanganate and tumbled with the fabric or garment for varying times up to several hours, depending on the desired change in hand and appearance. The abrasive material is removed and the chemical is neutralized in a bath. With fabrics such as cotton, the abrasion is controlled by the length of time the fabric is tumbled and the style and type of pumice or stone used. With lighter-weight fabrics like silk, the abrasion may result from tumbling against other fabrics in the chamber. Fabrics finished in this manner are described by a variety of terms, including stone-washed denim, sanded or mud-washed silk, and sand-washed nylon.

Chemical Washes In the chemical wash process a special chemical is added to the wash solution to alter the fiber's surface. Chemicals include alkalis, oxidizing agents, and others that are specific to the fiber being treated. These chemicals partially destroy the fiber and create irregularities, pits, pores, or other surface aberrations. Note that even though the term *acid wash* may be used, acid is not used in the process. This technique is used to produce fashion denims, comfort polyesters, and washed silks.

Enzyme Washes Enzyme washes are similar to chemical washes except that they use cellulase, an enzyme that dissolves part of the cellulose molecule. The process has a permanent effect on the surface of the fabric, and the hand becomes softer. The enzyme removes surface fuzz, reduces the chance of pilling with use or care, and decreases fabric weight, with a strength loss of less than 10 percent (Figure 17–22). Cellulase, produced by the fermentation of molds, is a naturally occurring protein used to degrade the surface fuzz. Relatively small concentrations of these biodegradable enzymes are used with little

FIGURE 17-22

Enzyme-polished cotton fibers: original fibers (left) and bio-polished fibers (right). (Reprinted with permission from the Canadian Textile Journal, Vol. 109, No. 10, December 1992.)

negative environmental effect as compared with that of chemical washes. After treatment with the enzyme, mechanical action removes the weakened fiber ends. In some instances, abrasive stones are combined with the enzyme to produce the mechanical abrasion. Enzyme washes, also known as bio-polishing or bio-finishing, increase productivity with fewer seconds. They increase moisture absorption and dyeability. Enzyme treatment at the yarn stage is not yet widely used but has commercial potential.

Crepeing

Crepeing is a special compacting process to produce a fabric with a soft hand. In crepeing, the fabric is fed into the machine by a special blade at a faster rate than it is removed from the machine. Crepeing can create an allover texture or a localized plissé effect and add comfort stretch with soft drape.

Silk Boil-Off

Sericin makes up about 30 percent of a silk fabric's weight. The **boil-off** process removes the sericin and creates a looser, more mobile fabric structure. If the fabric is in a relaxed state when the sericin is removed, the warp yarns take on a high degree of fabric crimp. This crimp and the looser fabric structure together create the liveliness and suppleness of silk, a suppleness that has been compared with the action of the coil-spring "Slinky" toy.

The properties are quite different when the boil-off is done under tension. The fabric crimp is much less,

and the response of the fabric is more like that of a flat spring; thus, the supple nature is lost. This explains some of the difference between qualities of silk fabric.

Caustic Treatment

To create a synthetic with a hand and texture like silk, caustic treatment is used. Finishing starts with heatsetting to stabilize the fabric to a controlled width, remove any wrinkles, and impart resistance to wrinkling. The next step is a caustic-soda (alkali) treatment to dissolve a controlled amount of the fiber, usually 5 to 18 percent. Similar to the degumming of silk, this step gives the fabric structure greater mobility, with a slight loss in tensile strength and abrasion resistance. The fabric is more hydrophilic and more comfortable. In all remaining finishing, the fabric is completely relaxed to achieve maximum fabric crimp. Figure 17-23 shows the effect of the alkali treatment on a fabric made of a circular-cross-sectional polyester. With the microfibers, caustic treatment is less important. However, because microfibers are so expensive, caustic treatment is a more economical alternative.

Hand Builders

Hand builders are compounds, such as silicone softeners and cellulase enzyme, that soften fabric hand. These compounds produce a dryer hand as compared with compounds previously used. Better wrinkle resistance and improved durability occur with some of the silicone softeners.

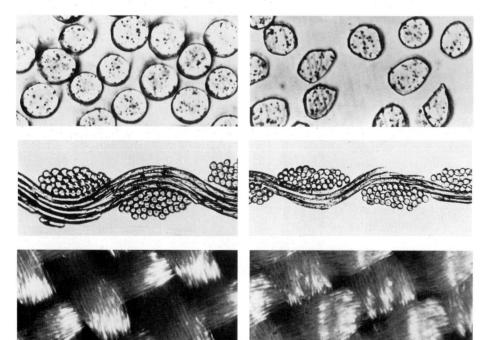

FIGURE 17-23

Photomicrographs showing the effect of heat-caustic treatment. Original fabric on left; treated fabric on right. Dacron polyester fiber cross section 1000× (top); fabric cross-section 200× (center); fabric surface 50× (bottom). (Courtesy of E. I. du Pont de Nemours & Company.)

Key Terms

Aesthetic finishes Applied design Subtractive finish Padding machine Backfilling machine Luster finish Glazed Friction calender Ciré finish Moiré pattern

Additive finish Parchmentizing Tendering Burned-out

Schreiner calender

Embossed fabric

Sizing
Starching
Shearing
Brushing

Pleated fabric Puckered surface Plissé Flocking Tufting

Embroidered fabric Schiffli embroidery Multihead embroidery Eyelet embroidery Expanded foam

Nap
Napping
Fulling
Beetling
Coronizing

Emerizing, sueding, or

sanding Abrasive wash Chemical wash Enzyme wash Crepeing Boil-off

Caustic treatment Hand builders

Questions

- Explain the differences between embossed and plissé in terms of process and fabric.
- **2.** Explain the changes in serviceability of a fabric after it has been napped.
- 3. What is the purpose of shearing? What kinds of fabrics are generally sheared?
- **4.** Describe the manner in which each fabric of these pairs was produced. Which are applied designs and which are structural?
 - swivel dotted swiss and flocked dotted swiss extra yarn eyelash fabric and burned out

plissé and seersucker tufted velvet and true velvet flocked corduroy and napped flannel

- **5.** Predict the serviceability of each fabric listed in question 4.
- **6.** Which of these finishes would be permanent and which would diminish with time or use? Why?

heat-embossed nylon tricot pressure-embossed cotton

burned-out rayon/polyester sheer drapery

fulled wool gabardine

water-soluble sizing on 100 percent cotton print cloth 65 percent polyester/35 percent cotton glazed chintz upholstery (resin compound)

caustic-treated 100 percent polyester crepe de chine

Suggested Readings

Cegerra, J. (1996, November). The state of the art in textile biotechnology. *Journal of the Society of Dyers and Colourists*, 112, pp. 326–329.

Creswell, F. (1994, October/November). Finishing Fabrics in the Nineties. *Canadian Textile Journal*, pp. 28–29.

Goldstein, H. G. (1993). Mechanical and chemical finishing of microfabrics. *Textile Chemist and Colorist*, 25(2), pp. 16–21.

McCurry, J. W. (1999, February). Flocking: a niche of niches. *Textile World*, pp. 91–92, 94.

Morgan, N. (1997, June). Environmentally friendly finishing using enzymes. *Technical Textiles International*, pp. 12–14.

Needles, H. (1986). Textile Fibers, Dyes, Finishes, and Processes. Park Ridge, NJ: Noves Publications.

Scott, K. (April, 1990). A look at the denim processing scene. Laundry and Cleaning News International, pp. 4–7.

Taylor, M. (1993). What is moiré? Textiles, no. 1, p. 14.

Trotman, E. R. (1984). Dyeing and Chemical Technology of Textile Fibers. New York: Wiley.

Chapter 18

SPECIAL-PURPOSE FINISHES

OBJECTIVES

- To recognize how special-purpose finishes influence fabric performance and consumer satisfaction.
- To understand how special-purpose finishes are applied.
- To relate special-purpose finishes to aspects such as fabric, yarn, and fiber types and end use.

pecial-purpose finishes or functional finishes are applied to fabrics to enhance performance in a specific area. Although these finishes usually do not alter the appearance of fabrics, they do address some consumer problem or performance deficiency with textile products or make the fabric more suitable for a specific purpose. This chapter is organized by performance categories.

Special-purpose finishes add to product cost, but their impact on performance may be difficult for consumers to recognize. The effect of some finishes may be invisible or beyond consumer perception, especially at the point of purchase. Even during use, assessment is difficult. For example, how does one assess the effectiveness of a soil-resistant finish if the fabric stays cleaner longer? Unfortunately, for some finishes, improved performance in one area may mean a loss of performance in another.

Many functional finishes are topical—a chemical compound is added to the surface of the fabric, but it may not penetrate to the interior of fibers or yarns. Finishes applied in liquid form often are referred to as **wet processes.** Although finishing traditionally has been done to fabrics, it is not uncommon to find garments that are wet-processed, especially as a means of satisfying consumer demands for quick responses.

Stabilization: Shrinkage Control

A fabric is stable when it retains its original size and shape during use and care. Unstable fabrics shrink or stretch, usually as a result of cleaning. *Shrinkage*, the more serious and more frequent problem, is the reduction in size of a product. Shrinkage is reported as a percentage of the original length and width dimension, for example, 2.5 percent warp and 1.5 percent filling.

Shrinkage potential is introduced in spinning, fabrication, and finishing. Yarns are under tension during spinning and slashing. Fabrics are under tension during fabrication. In wet finishing, fabrics may be pulled through machines in long continuous pieces and may be dried and set under excessive tension, which leaves the fabric with high residual shrinkage. Shrinkage occurs when tensions are released by moisture and heat, as in laundering or steam pressing. It is difficult to predict lengthwise and crosswise shrinkage since many factors contribute to it: fiber type, blend level, yarn process, fabrication type, and number and type of finishing processes. Some manufacturers of sewn products try to address this problem during pattern-making by oversizing the pattern, but these efforts are inaccurate at best.

Shrinkage is a plus in the processing of some fabrics, as in fulling or shrinkage of crepe yarn in matelassé. But,

it is a problem for manufacturers and consumers when it changes product dimensions.

The two major types of shrinkage of interest here are relaxation shrinkage and progressive shrinkage. Relaxation shrinkage occurs during washing, steam pressing, or dry cleaning. Most relaxation shrinkage occurs during the first care cycle. However, many manufacturers and retailers test for shrinkage through three or more cleaning cycles because shrinkage often continues at smaller rates for several additional care cycles; this is progressive shrinkage. If the care is mild in the first cycle and more severe in later cycles, the product may shrink more during these later cycles. For example, if the item was dried flat in the first cycle and machine-dried later, shrinkage will be more severe with machine-drying. The following list groups fibers by the kind of shrinkage they normally exhibit:

Cotton, flax, lyocell, and high-wet-modulus rayon exhibit relaxation shrinkage and little progressive shrinkage.

Regular rayon exhibits high relaxation shrinkage and moderate progressive shrinkage.

Wool exhibits moderate relaxation shrinkage and high progressive shrinkage.

Other properly heat-set manufactured fibers exhibit relaxation shrinkage and no progressive shrinkage.

Relaxation shrinkage can be eliminated by mechanical-control methods or heat. Chemical-control methods are used to prevent progressive shrinkage.

Relaxation Shrinkage and Finishes

Knit Fabrics Knit fabrics shrink because the loops may elongate lengthwise from 10 to 35 percent in knitting and wet finishing (Figure 18–1). During laundering, the stitches return to their normal shape and the item becomes shorter and wider.

Shrinkage of knits can be minimized in finishing by overfeeding the fabric between sets of rollers to induce lengthwise shrinkage or by using loop drying (see Chapter 16). Heat setting of thermoplastic fibers or

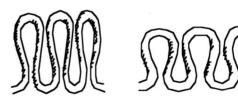

FIGURE 18-1

Knit stitches: after finishing (left); as produced (right).

blends with at least 50 percent thermoplastic fibers also stabilizes knits.

Woven Fabrics Woven fabrics shrink when wetting relaxes the strains of yarn production, weaving, preparation finishes, and wet finishing. The warp yarns are under tension while they are on the loom, and the filling is inserted as a straight yarn. The filling takes on crimp as it is beaten back into the fabric, but the warp stays straight (Figure 18–2). When the fabric is thoroughly wet and allowed to relax, the yarns readjust themselves and the warp yarns take on a lesser amount of crimp (Figure 18–2). This crimp shortens the fabric in the warp direction. With the exception of crepe fabrics, less change occurs in the filling direction.

In compressive shrinkage, a thick felt blanket is used to maximize shrinkage. The moist cloth adhering to the blanket's surface is passed around a feed-in roll. In this curved position, the outer surface stretches and the inner surface contracts. The blanket then reverses its direction around a heated drum. The outer curve becomes the shorter, inner surface, and the fabric adhering to it is compressed. The fabric against the drum is dried and set with a smooth finish. The count will increase, and the fabric will actually be improved after compressing (Figures 18–3 and 18–4). Compressive shrinkage is used on many woven fabrics, but because of its high swelling and wet elongation rayon will not hold a compressive shrinkage treatment.

However, even with a compressive-shrinkage finish, improper laundering may shrink fabrics. Tumble-drying also may compress yarns beyond their normal shrinkage.

London shrunk is an 18th-century relaxation finish for wool fabrics that removes production strains. A wet wool or cotton blanket is placed on a long platform, a layer of fabric is spread on it, and alternate layers of blanket and fabric are built up. Weight is placed on top for about 12 hours to force the moisture from the blankets into the wool. The fabric is hung to dry naturally. When dry, the fabric is layered with special pressboards.

FIGURE 18-2

Position of the warp (black yarns) on the loom (left); after the fabric relaxes (right).

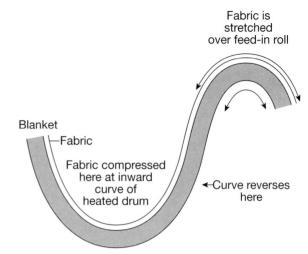

FIGURE 18-3
Reversal of curve changes the size of the fabric.

Preheated metal plates are inserted at intervals and on the top and bottom of the stack. This setup of fabric, boards, and plates is kept under 3000 pounds of pressure for 10 to 12 hours. London shrunk is used for fine worsteds, but not for woolens.

The label "Genuine London Process" or similar wording is licensed by the Parrot Group of companies to garment makers all over the world. The permanent-set finish Si-Ro-Set for washable, wrinkle-free wool fabrics is applied to some London-shrunk fabrics during processing.

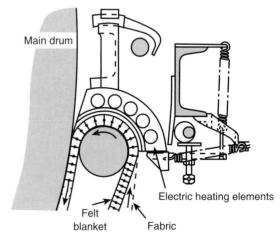

FIGURE 18-4

Close-up of compressive-shrinkage process. The heated area holds the fabric against the outside of the blanket. When the blanket collapses on straightening out, the fabric is shrunk accordingly. (Courtesy of the Sanforized Company.)

Progressive Shrinkage and Finishes

Thermoplastic Fibers Thermoplastic fibers are stabilized by heat setting, a process in which fabrics are heated at temperatures at or above their glass transition temperature (Tg: the temperature at which the amorphous regions of the fiber are easy to distort) and then cooled. The glass transition temperature is lower than the melting point of a fiber, and it differs for each fiber type. When properly heat-set, fabrics have no progressive shrinkage, and relaxation shrinkage is controlled (Figure 18–5).

Wool Fibers Washable wool is important in apparel and some furnishings and in blends with washable fibers. If wool is to improve its position in its competition with wool-like easy-care fibers, wool must be finished to keep its original size and surface texture during laundering. Figure 18–6 illustrates the shrinkage of wool.

To prevent felting shrinkage, a finish must alter the scale structure and reduce the differential-friction effect that prevents wool fibers from returning to their original position in the fabric. The effectiveness of felting shrinkage treatments depends on the kind and amount of finish used and on the yarn and fabric construction. Worsteds need less finish than woolens. Low-count fabrics and low-twist yarns need more finish to give good washability. Treated-wool fabrics may be machinewashable, but care should be taken to use warm (not hot) water, gentle agitation, and a short agitation period. Hand-washing is preferred, because soil is easy to remove from the fiber, and hand-washing ensures a lower

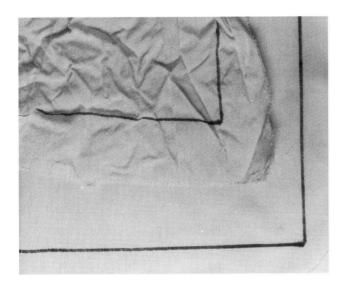

FIGURE 18-5 Comparison of wrinkling and shrinkage of thermoplastic fiber fabrics: not heat-set (top); heat-set (bottom).

FIGURE 18-6
These socks were the same size when purchased. Nylon (left); wool (right).

temperature and less agitation. Machine washing may produce a fuzzy or slightly pilled surface.

Two methods are used to smooth off the free edges of the wool scales: surface coating and halogenation treatment. **Surface coatings** of a polyamide solution (a very thin, microscopic film applied to fiber surfaces) enables the fibers to move back and forth without entangling. In addition to controlling shrinkage, the coating minimizes pilling and fuzzing (a problem with washable wool), gives the fabrics better wash-and-wear properties, and increases resistance to abrasion. Total Easy Care Wool is promoted as having the same attributes (hand, comfort, and resiliency) of untreated wool while being able to be washed repeatedly without shrinkage.

Halogenation treatments, primarily with chlorine, partially dissolve the fiber scales and reduce felting shrinkage. These finishes cost little, can be applied to large batches of small items such as wool socks, do not require padding or curing equipment, and are fairly effective. The process damages the fibers and must be carefully monitored to minimize damage. The scales are more resistant to damage than the interior of the fiber and should not be completely removed or the fabric will feel harsh and rough and be lighter weight and less durable. To maintain the strength of the fabric, nylon fiber often is blended with the wool. Halogenation is especially good for hand-washable items. A process combining chlorination and resin makes wool knits machinewashable and -dryable. Shrinkage is less than 3 percent in length and 1 percent in width, and goods retain their loft and resiliency. Superwash® is the trade name of a fabric that has undergone halogenation treatment.

Both surface coating and halogenation significantly alter the hand of wool and affect moisture absorbency. The processes produce a wool that is washable, but handwashing is generally preferred to machine-washing.

Environmental issues are restricting the use of chlorine. Hence, alternative methods that use other oxidizing agents and enzymes are being investigated.

Rayon Fibers The shrinkage of regular rayon depends on the handling of the wet fabric during finishing. Since wet fabric can be stretched easily, overstretching may occur. If it dries in this stretched condition, the fabric will have high potential shrinkage. It will shrink when wet again and dried without tension. It is almost impossible to determine this without laboratory or home testing.

Shrinkage-control treatments for rayon reduce fiber-swelling properties and make it resistant to distortion. Resins form *cross links* that prevent swelling and keep the fiber from stretching. The resin also fills up spaces in the amorphous areas of the fiber, making it less absorbent. Aldehyde resins are superior to other resins because they do not weaken the fabric, do not retain chlorine, and have excellent wash-fastness. Treated rayons are machine-washable if the wash cycle is short. High-wet-modulus rayon is also resin-treated, mainly for durable-press purposes, because its shrinkage can be controlled by relaxation shrinkage—control methods.

Shape-Retention Finishes

Even though care of contemporary textiles is timeconsuming, imagine the time and physical effort that it required in the past. Almost every item of apparel and bedding needed ironing! With thermoplastic fibers, shape-retention finishes, and modern washers and dryers, easy-care textiles are the norm. Now, it is only occasionally that items need the extra effort of ironing.

Theory of Wrinkle Recovery

Wrinkles occur when fabrics are crushed during use and care (creases and pleats made by pressing are desirable style features, however). Wrinkle recovery depends on cross links, which hold adjacent molecular chains together and pull them back into position after the fiber is bent, thus preventing the formation of a wrinkle. Fibers with strong intermolecular bonds have good molecular memory and resist wrinkling and creasing. Fibers with weak bonds wrinkle and crease readily.

The cellulosic fibers lack strong natural cross links. Molecular chains are held together by weak hydrogen bonds, which break with the stress of bending. New bonds hold the fiber in this bent position and form a

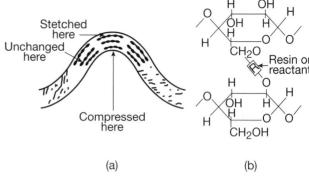

FIGURE 18-7

(a) Effect on internal structure when fiber is bent; (b) resin cross link.

wrinkle. Resin cross links give fibers a "memory" and good wrinkle recovery (Figure 18–7).

Resin finishes were first used in England in 1920 and in the United States in 1940 on rayon, cotton, and linen fabrics. Urea formaldehyde was the first resin used to prevent wrinkles; significant improvements in resins have occurred since then. Although fabrics treated with these resins were smooth, flat, and wrinkle-resistant, they had problems with abrasion resistance, tear strength, yellowing, chlorine retention from bleach, hand, affinity for oily soils, static, pilling, odor, frosting, dye migration because of high curing temperatures, and construction problems with seam pucker or alterations.

The use of formaldehyde resin has been restricted because it is possibly a carcinogen. Other resins have become available because of the restrictions on formaldehyde use. Modified glyoxal-based reactants decrease the formaldehyde release to a tiny fraction. The polycar-boxylic acid derivatives produce fabrics with better abrasion resistance, good durable-press performance, and low shrinkage. While performance problems continue; they are less pronounced with the new resins. Unfortunately, both new resins are significantly more expensive. Hence, many durable-press finishes continue to incorporate some DMDHEU (dimethyloldihydroxyethylene urea) in the process.

Durable Press

Durable press describes items that retain their shape and their pressed appearance even after many uses, washings, and tumble dryings. The terms *durable press, wrinkle-free*, and *permanent press* are used interchangeably, but *durable* is a more realistic description because the effectiveness of the finish decreases with age. Older items may require some touch-up ironing to meet appearance standards. The term *wrinkle-free* is misleading because

many almost new products require some touch-up ironing to meet consumer standards. Other terms are *wrinkle-resistant*, *anticreasing*, and *crease retention*. Most often, the fabric is cotton, rayon, linen, or a blend of one or more of these fibers with polyester.

Several processes for durable-press items and fabrics are outlined here. These processes differ as to when the chemical is applied and the stage at which cutting, sewing, and pressing take place. In the **precured** and **postcured** processes, the finish is applied to the fabric (Figures 18–8). In the **immersion**, **metered-addition**, and **vapor-phase** processes, the finish is applied to the garment or product (Figures 18–9). Table 18–1 summarizes these processes.

The Precured Process

- 1. Saturate the fabric with the resin cross-linking solution and dry.
- **2.** Cure in a curing oven to form cross links between molecular chains.
- 3. Cut and sew item. Press.
- **4.** Used for shirting, draperies, and other items that do not require set-in creases or pleats.
- 5. Common with cotton/polyester blends.

The Postcured Process

- 1. Saturate the fabric with a resin cross-linking solution and dry.
- **2.** Cut and sew the item and press shape with hothead press.
- **3.** Cure the pressed item in a curing oven at 300 to 400°F.
- **4.** Curing gives shape to the cellulosic fibers. The thermoplastic fibers were set by the hothead pressing.

- **5.** Used for skirts, slacks, and other products with setin creases or pleats.
- 6. Common with cotton/polyester blends.

The Immersion Process

- 1. Dye and finish the product for a specific fashion look.
- **2.** Immerse the garment or product in the finishing agent and extract excess finish. Dry the product.
- **3.** Hand and performance are modified with fabric softeners and other compounds so that the finished product will appeal to consumers.
- **4.** Press desired features (creases, pleats, etc.) into garment with special hothead press.
- **5.** Cure product in curing oven at 300°F for 5 to 15 minutes.
- 6. Used for fashion apparel of 100 percent cotton.
- 7. Also known as the garment or product dip process.

Metered-Addition Process

- 1. Dye and finish the product for a specific fashion look.
- **2.** Spray garment or product with the finishing agent in a rotating chamber. Tumbling continues until product is uniformly processed.
- **3.** Hand and performance can be adjusted with fabric softeners and other compounds so that the finished product will appeal to consumers.
- **4.** Press desired features (creases, pleats, etc.) into garment with special hothead press.
- **5.** Cure the product in curing oven at 300°F for 5 to 15 minutes.
- **6.** Used for fashion apparel and furnishings (bed linens and toweling) of 100 percent cotton.

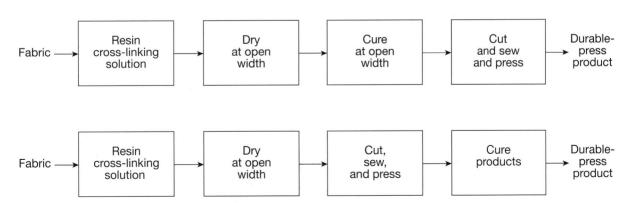

FIGURE 18-8

Shape-retention finishes: precured process (top) and postcured process (bottom).

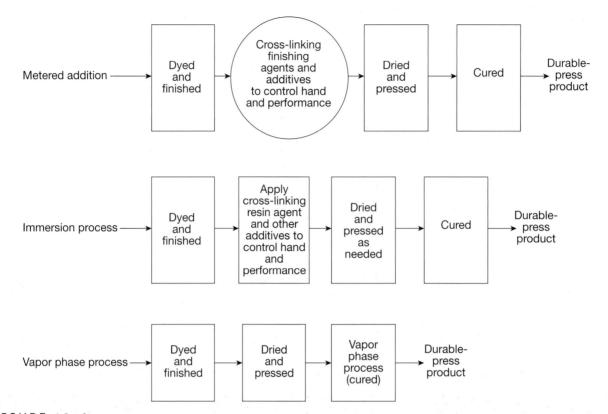

FIGURE 18–9
Shape-retention finishes: metered-addition process (top), immersion (center), and vapor-phase process (bottom).

	Precure	Postcure	Immersion	Metered Addition	Vapor Phase
Applied to	Fabric	Fabric	Product	Product	Product
Stage of curing	Fabric	Product	Product	Product	Product
Advantages	Smooth fabric	Smooth fabric	Uses untreated fabric	Uses untreated fabric	Uses untreated fabric
	Dimensionally stable	Dimensionally stable	No premature setting	No premature setting	No premature setting
	Lowest-cost process	Crease retention	Wet-finished goods used	Wet-finished goods used	Wet-finished goods used
	Minimal seam puckering	Control performance, hand, aesthetics	Control performance, hand, aesthetics	Control performance hand, aesthetics vapor phase	
		Greater flexibility	Greater flexibility Wet on wet processing possible	Greater flexibility Uses less chemicals	
creases Puckered sean Strength loss	No permanent creases Puckered seams	Higher costs May set prematurely	Higher costs Process control difficult	Higher costs Process control difficult	Higher costs Process contro
		Overfinished areas	Fabric preparation critical	Fabric preparation critical	Fabric preparation critical

Vapor-Phase Process

- 1. Dye and finish the product for a specific fashion look.
- **2.** Press desired features (creases, pleats, etc.) into garment with special hothead press.
- **3.** Hand and performance can be adjusted with fabric softeners and other compounds so that the finished product will be appealing to consumers.
- **4.** Apply finish in a vapor form to the product in a closed chamber and cure while it is in the chamber.
- **5.** Used for cotton and other natural fibers, uses less finishing chemicals so the effect on hand, abrasion resistance, and staining is less.

Problems continue to be associated with resin finishes. Blends of cotton/polyester use less resin than 100 percent cotton. The high strength and abrasion resistance of polyester make these fabrics much more durable. Cotton pretreated with liquid ammonia or mercerized under tension minimizes the strength lost due to the finish. Polymer sizing added to the yarns before curing increases abrasion resistance. Although most curing is done using forced-air convection ovens, microwave ovens produce a more uniform cure for lighter-weight fabrics such as shirtings.

Coneprest, by Cone Mills, is a process in which precured fabrics are made into garments. Where creases are desired a substance is sprayed on the garment to temporarily inactivate the wrinkle-resistant finish. The garments are then pressed under pressure to reactivate the finish.

Creaset is a silicone-based finish, made by the Creaset company, for all-wool and all-cotton fabrics. Other durable-press trade names include PressFree cotton by McGregor, Presset by Cotton, Inc., and Process 2000 by Farah U.S.A.

Durable-Press Wool Wool has good resiliency when it is dry, but its durable-press characteristics are poor when it is wet. Durable-press wool is achieved with combination resin treatments to impart durable press characteristics and control wool's excessive shrinkage. Several procedures are used, but the one described here is typical. Si-Ro-Set is a trade name.

- 1. Flat fabric is treated with 1 to 2 percent of the durable-press resin and steamed for 3 to 5 minutes.
- 2. The item is made up, sprayed with more durablepress resin, and pressed to achieve a permanentcrease effect.
- **3.** Shrink-resistance resin is mixed with a dry-cleaning solvent and the item is dry cleaned. The resin is cured in the item for 3 to 7 days before it can be laundered.

Durable-Press Silk Since silk wrinkles easily when wet, polycarboxylic acid is used to produce durable-press or wrinkle-resistant silk. The finish is durable to laundering but produces a 20 percent loss in strength, increase in stiffness, and decrease in whiteness.

Quality Performance Standards and Care

Because performance standards had not been developed during the wash-and-wear era, there was wide variation in fabric performance. To avoid problems with consumer confidence, the industry developed **quality performance standards** for durable press. Registered trade names indicate to the consumer that the product has met standards related to performance, hand, and minimal odor.

General care guidelines for durable-press items include the following:

- Wash items frequently because resins have a strong affinity for oil and grease so that soil penetrates deeply and builds up.
- Pretreat stains, collars, and cuffs. Use a spotremoval agent on grease spots.
- Keep wash loads small to minimize wrinkling.
- Avoid setting in wrinkles with heat. Keep washing and drying temperatures cool.
- Remove items promptly when dry.

Appearance-Retention Finishes

Soil- and Stain-Release Finishes

Soil-release finishes reduce the degree of soiling of the fabric by repelling the soil or by preventing formation of a bond between soil and fabric. They improve a fabric's performance in resisting soil, releasing soil, and retaining whiteness by resisting redeposition of soil from the wash water. Finished fabrics are easier to clean than those without such finishes. Fluorochemicals and silicon-based compounds are durable and effective soil-resistant finishes that are commonly used. These finishes may only be durable enough to last through 20 to 30 washings. The lack of permanence is due to the finish's surface application. These finishes are also known as soil-repellent, stain-resistant, and antisoil or antistain finishes.

Soil-release finishes were developed as a reaction to the tendency of durable-press items to pick up and hold oily stains and spots. Soil-release finishes either attract water to permit the soil to be lifted off the fabric or coat the fibers to prevent the soil from penetrating the coating and bonding with the fiber. Many cotton/polyester blends are treated to be durable-press. Untreated cotton is hydrophilic and has excellent oily soil-release performance—it releases oily soil when laundered. A resin finish, however, is hydrophobic and does not release the oily soil. Since polyester is hydrophobic and oleophilic, it must be spottreated to remove oily soil from areas such as shirt collars. When the polyester is coated with resin, as it is in durable press, its oil affinity is increased. Finer fibers soil more readily than coarse fibers, and soil can penetrate low-twist yarns more easily than high-twist yarns. Soil-release finishes make the surface less attractive to oil and more easily wetted—more hydrophilic.

Soil release finishes are mechanically or chemically bonded to the surface. Many are organic silicone substances. Soil-release finishes include Scotchgard and Scotch Release by 3M, Visa by Milliken, and Teflon by DuPont.

Soil resistance for carpets is especially important given their wide use and exposure to soil. The process for carpets is a three-part program that combines a special carpet fiber (larger denier, modified cross section, and antistatic modification) with a fluorocarbon stainrepellent finish and a compound to block the dye sites on the fibers. When the dye sites are blocked, the fibers no longer accept color from stains. These blockers concentrate near the fiber's surface, the area most susceptible to staining. They are most effective against the coloring agents (acid dyes) found in food and beverages and are not effective against other staining agents. The stain-resistant treatments are not easily wetted by oil or water, but may yellow with exposure to heat, ultraviolet light, or high relative humidity. Ultraviolet light may also destroy the stain blocker part of this program. A side benefit is that these carpets are more resistant to fading from exposure to ozone.

There are several companies that can be hired by design firms or consumers to add a chemically protective soil- and stain-resistant finish on site to products such as carpeting, upholstery, and wall coverings. The firms provide a follow-up service as needed, a cleaning kit, and care instructions. There are also soil-resistant finishes a consumer can apply on site. However, research has shown that some of these finishes may actually increase soiling (Reagan et al., 1990).

Abrasion-Resistant Finishes

Abrasion-resistant finishes are thermoplastic acrylic resins that fix fibers more firmly into the yarns so they do not break off as readily. They are used on lining fabrics, especially for pockets, waistbands, and other areas that receive significant abrasion. The resin may increase the wet soiling of the fabric. Blending nylon or polyester

with cotton or rayon produces better abrasion resistance as compared with finishes, but blend fabrics may cost more than finished fabric.

Antislip Finishes

Antislip finishes are used on low-count, smooth-surfaced fabrics. When fabrics are treated with resins, stretched, and dried under tension, the yarns are bonded at their interlacing points. Antislip finishes reduce seam slippage and fraying. Seam slippage occurs when the yarns near the seam slide away from the stitching line. Thus, in the area next to the seam, only one set of yarns is seen. Slippage is especially noticeable where warp and filling yarns differ in color. Areas that have experienced seam slippage have poor abrasion resistance and an unacceptable appearance. In some cases, seams can ravel completely. Antislip finishes are also called *slip-resistant*, or *nonslip*, finishes. The most effective and durable finishes are resins of urea or melamine formaldehyde.

Fume-Fading-Resistant Finishes

Fume-fading-resistant finishes are used on dye-fiber combinations that are susceptible to fading when exposed to atmospheric fumes or pollutants. The most common problem is with acetate dyed with disperse dyes. Of course, this problem disappears with mass pigmentation. However, in cases in which mass pigmentation is not economically practical, fume-fading-resistant finishes of tertiary amines and borax are used. Other names for the finish are anti-fume-fading finish and atmospheric-fading protective finishes. They are used primarily for furnishing fabrics, especially draperies.

Surface or Back Coatings

Metallic, plastic, or foam coatings are used on the backs of fabrics to reduce heat transfer, alter fabric appearance, lock yarns in place, control porosity, and minimize air- and water-permeability. Metallic or aluminum coatings are used on apparel and window-treatment fabrics. A very thin layer of aluminum is bonded to the back of a drapery fabric for greater heat retention or to block heat transfer. In apparel, these coatings are found in winter coats for cold climates and specialized protective apparel for extreme temperature conditions such as firefighters' uniforms and spacesuits. Some of these finishes will be discussed in the section on comfort.

Plastic coatings reduce fabric soiling and give a leatherlike look to fabrics. (See "Coated Fabrics," in Chapter 15.) Metallic and plastic coatings may crack and peel. In order to increase the life of these fabrics, follow care instructions.

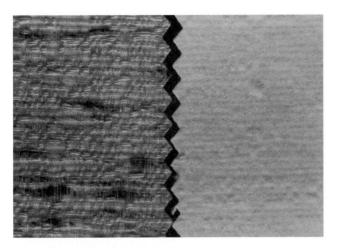

FIGURE 18-10 Window-treatment fabric with acrylic-foam coating: face (left) and back (right).

Acrylic-foam back coatings, common on drapery fabrics, minimize air movement through the draperies, give a greater comfort factor by increasing the thickness of the fabric, and improve opacity, thereby minimizing the need for a separate lining fabric. Draperies with the foam-back coating may be sold as self-lined draperies (Figure 18–10).

Latex or polyurethane back coatings are used on tufted fabrics for furnishing uses. Tufted carpet and tufted upholstery use back coating to lock the tufted yarns in place and to add dimensional stability to the fabric. Back coatings also add durability to low-count upholstery fabrics, but they may create problems with comfort because of their low air and moisture permeability. Outgassing of fumes from the back coating can also create environmental problems.

These coatings may have poor resistance to aging. They may separate, peel, flake off, or experience a change in hand with age or exposure to environmental conditions such as heat or light. For example, acrylic-foam backings may become tacky or sticky. When used on draperies, the fabric may stick to itself when the drapes are opened.

Back coating is also used as a means of delivering water-based polymers for finishes such as flame retardancy.

Light-Stabilizing Finishes

Light-stabilizing finishes incorporate light-stabilizing or ultraviolet-absorbing compounds to minimize damage from light exposure. This is important for furnishings and industrial products. Products that are exposed to sunlight or interior lighting that has a high percent-

age of ultraviolet light may require this finish. Artificial light sources that may contribute to fading include the fluorescent lights found in many office buildings and retail establishments. Products that require light stabilizers include tarpaulin and awning fabrics, tents, sewing thread for outdoor products, outdoor furniture, car interiors, window treatments, and some carpeting and upholstery.

Pilling-Resistant Finishes

Pilling-resistant finishes minimize the possibility that tiny balls of fiber bits will accumulate on a fabric's surface. The fabric is exposed to short-wavelength ultraviolet radiation and then immersed in a mild oxidation solution. Surface fiber ends are thus weakened and much less likely to form pills. This experimental finish, SiroflashTM, is used on wool and cotton blends.

Comfort-Related Finishes

Water-Repellent Finishes

A water-repellent fabric resists wetting, but if the water strikes with enough force, it will penetrate the fabric. A waterproof fabric will not wet regardless of the amount of time it is exposed to water or the force with which the water strikes the fabric. Waterproof fabrics are almost always films or coated fabrics. Waterproof, water-repellent, and microporous fabrics are compared in Table 18–2. (The Federal Trade Commission has suggested using the terms *durable* and *renewable* in describing water-repellent fabrics.) Fabrics that are water-repellent because they incorporate a membrane were discussed in Chapter 15.

Water repellency depends on surface tension and fabric penetrability. It is achieved by a combination of fabric structure and finish. Compounds that make fabric water-repellent include fluorocarbons, wax emulsions, metallic soaps, and surface-active agents. These chemicals are applied in a water-based solution to fabrics with a very high warp count and small regular yarns. A newer option, the plasma technique, uses ionized vapor to modify the fiber's surface and allows for a more effective and uniform finish. Some fluoropolymer waterproof finishes are applied using this technique.

Fluorocarbons are popular for improving both water and oil repellency. Water repellency decreases significantly with washing but recovers with heat treatment. See the earlier discussion on soil- and stain-resistant finishes for more detail.

Wax emulsions and metallic soaps coat the yarns but do not fill the interstices, or spaces, between the

Waterproof Fabrics	Water-Repellent Fabrics	Water-Repellent Microporous Fabric
Films or low-count fabrics with a film coating	High-count fabrics Finish coats yarns but does not block space between yarns.	Composite fabrics
	Characteristics	
No water can penetrate.	Heavy rain will penetrate.	Liquid water and wind will not penetrate.
Films may stiffen in cold weather.	Fabric is pliable, similar to untreated fabric.	Fabric is pliable.
Cheaper to produce.	Fabric "breathes" and is comfortable for rainwear.	Expensive to produce. "Breathes," but pores may stretch or fil with soil.
Permanent	Durable or renewable finish	Permanent

yarns. These finishes are removed in cleaning, but can be renewed.

Surface-active agents have molecules with one end that is water-repellent and one end that reacts with the hydroxyl (OH) groups of cellulose. After these agents are applied, heat bonds the finish to the fabric. This finish is permanent to washing and dry cleaning.

Silicone is the most commonly used water-repellent chemical. Combination with durable-press chemicals produces finishes that are durable and fabrics with good drape, soft hand, and stain resistance.

Some water-repellent finishes hold greasy stains more tenaciously than untreated fabrics. However, some water-repellent finishes, such as the trade-name finishes Unisec, Scotchgard, and Teflon, impart resistance to both oilborne and waterborne stains. Hydro-Pruf and Syl-mer are silicone finishes that resist waterborne stains. Teflon, Scotchgard, and Fybrite are trade names for fluorocarbon finishes.

Although not a finish, microporous composite fabrics also produce a water-repellent effect. See Chapter 15 for more details.

Porosity-Control Finishes

Porosity-control or air-impermeable finishes are used to limit penetration of the fabric by air. These finishes are used for industrial air filters and use low-density foam as a back coating.

Water-Absorbent Finishes

Water-absorbent finishes increase the moisture absorbency of the fabric, but they also increase its drying

time. They may aid in the dyeing process. The durability of absorbent finishes is fair. They are applied as surface coatings on synthetic fabrics to be used for towels, diapers, underwear, and sportswear. On nylon, a solution of nylon 8 is used; on polyesters, the finish changes the molecular structure of the fiber surface so that moisture is broken up into smaller particles that wick more readily; on cellulosics, the finish makes them absorb more moisture. Fiber modifications and different fabric structures may be more effective than some finishes. Fantessa, Visa, and Zelcon are trade names. Hydrolon is a trade name for a polymer finish applied to nylon, polyester, and acrylic that improves surface wicking. Capilene® is a finish that wicks perspiration to the outer layer of a garment.

Ultraviolet-Absorbent Finishes

Ultraviolet-absorbent finishes incorporate chemical compounds that absorb energy in the ultraviolet region of the electromagnetic spectrum. Because of the everincreasing incidence of skin cancer, clothing is an important means of reducing exposure to ultraviolet radiation. Fabrics can be treated with ultraviolet inhibitors that absorb energy in this region.

These finishes are also referred to as *sun-protective* and *ultraviolet* or *UV blockers*. Other ways of improving the sun-protective factors of fabric include using thicker fabrics and manufactured fibers modified to be sunlight-resistant or modified with sunlight blockers. In addition, many dyes and fluorescent whitening agents absorb ultraviolet energy. Fabrics with these finishes or modifications may be promoted with a sun-protective factor (SPF).

Antistatic Finishes

Antistatic finishes are important in both the production and use of fabrics. Static buildup on fabrics causes them to cling to machinery in the factory and to people, attract dust and lint, and produce sparks and shocks.

Controlling static buildup on natural-fiber fabrics is done by increasing humidity and using lubricants, but these controls were inadequate with thermoplastic fibers. Antistatic finishes are available that (1) improve the surface conductivity so that excess electrons move to the atmosphere or ground; (2) attract water molecules to increase fiber conductivity; or (3) neutralize the electrostatic charge by developing a charge opposite to that on the fiber. The most effective finishes combine all three effects. Most finishes use quaternary ammonium compounds, which are not durable and must be replaced during care. Washing aids such as fabric softeners also help to control static. A new finish, R.Stat, coats nylon fibers with a very thin (0.2 micron) coating of copper sulfide that gives a reddish brown color to the fiber. It is intended for use in floor and wall coverings, gas filtration, and protective clothing.

Incorporating antistatic substances into the fibers produces the best static control. Most manufactured fibers are produced in antistatic form, especially for rugs, carpets, lingerie, and uniforms (see Chapter 6). Some trade names of antistatic nylon variants are Ultron (Solutia, Inc.), Antron (Du Pont), Staticgard (Du Pont), and Anso (Allied Signal).

Fabric Softeners

Fabric softeners or hand builders improve the hand of harsh textiles, which may develop as a result of resin finishes or heat setting of synthetics. Softener types include anionic, cationic, and nonionic. Anionic softeners are usually sulfonated, negatively charged fatty acids and oils that must be padded onto the fibers because they lack fiber affinity. Anionic softeners often are used commercially on cellulosic fibers and silk. Cationic softeners, most often used in domestic washing, have good fiber affinity. They tend to yellow with age and may build up on the fiber if used frequently, reducing the absorbency of the fabric. Cationic softeners may contain quaternary ammonium compounds, and these compounds may confer some incidental antimicrobial properties. Nonionic softeners are padded onto the fabric. These commercial softeners are usually a fatty acid.

Silicone softeners produce a dryer hand as compared with that of the other compounds listed here. Better wrinkle resistance and durability occur when these softeners are combined with durable-press finishes.

Phase-Change Finishes

Phase-change finishes minimize heat flow through a fabric. They insulate against temperature extremes: very hot or cold conditions.

Several hundred phase-change chemicals exist. Only a few are used in textile finishes because they have the ability to absorb or release heat in a relatively narrow temperature range as they undergo phase change. The chemicals change phase from solid to liquid (absorb heat) or liquid to solid (release heat). Thus, the wearer is warmed or cooled depending on the change that is occurring. The time span of these phase changes is relatively brief—approximately 20 minutes—and their overall effectiveness has been questioned by independent researchers. They are used on active sportswear. Aside from the heat aspects, phase-change chemicals also contribute antistatic characteristics, water absorbency, resiliency, soil release, and pilling resistance.

One phase-change finish is Outlast® by Gateway Technologies, Inc. The phase-change chemical is microencapsulated and applied in a thin coat onto a hydroentangled nonwoven fabric (Figure 18–11). The coating adds only 0.002 inch to the thickness of the nonwoven fabric. The insulation properties are not affected by compression, washing, or moisture. The chemicals change phase at temperatures very close to skin temperature. This finish is used in gloves, boots, socks, garment liners, sleeping bags, ski and winter wear, wetsuits, jackets, blankets, and hats. The phase-change chemical has also been incorporated as an additive in acrylic fibers for enhanced comfort.

FIGURE 18-11
Microencapsulated phase-change thermal finish. (Courtesy of Gateway Technologies, Inc.)

Biological-Control Finishes

Insect- and Moth-Control Finishes

Moths and carpet beetles are likely to damage protein fibers such as wool. In addition, insects may damage other fibers if soil is present. More than 100 species of insects and spiders, including silverfish, crickets, and cockroaches, have been known to damage textiles. In most cases, an insect-infestation problem develops when there is soil as a food source and under proper environmental conditions. Manufactured fibers are not immune, but natural fibers are more likely to be damaged by insects.

Insect- and moth-control finishes are also known as fumigants, insecticides, insect-repellent finishes, and other terms that imply resistance to a specific insect pest, such as silverfish or moths. Both moths and carpet beetles damage 100 percent wool and blends of wool and other fibers. Although they can digest only the wool, the insects eat through the other fibers. The damage is done by the larvae, not the adults. Clothes moths are small, about 1/4 inch long. The larvae shun bright sunlight and live in the dark. Thus, it is necessary to clean often under sofas and furniture cushions, in the creases of chairs and garments, and in dark closets.

Most wool furnishing fabrics are treated with a moth-control or mothproofing agent. Approximately 70 percent of mothproofing agents are used by the carpet industry; wool and wool blend carpets obtain the "Wool Mark" standard of quality. If information to that effect is not on the label, check into it.

Traditionally, mothproofing used a chemical, often Permethrin, at the scouring or dyeing stage. Because excess chemical would be flushed into nearby water systems, killing invertebrates, methods of applying Permethrin via foam processes are being developed.

Permethrin repels and kills spiders, ticks, mosquitoes, and other crawling and flying insects. It also is applied to tents of all kinds and canvas used in fold-down camping trailers and hunting blinds. Expel®, by Graniteville, is odorless and resistant to washing, heat, and ultraviolet light.

Means of controlling insect damage are listed below.

- Cold storage decreases insect activity so that damage is much less likely to occur. Museums use freezing to control insect problems in storage areas because the extreme conditions kill the insects. This technique is generally not practical for consumer use.
- **2.** *Odors* can repel insects. Paradichlorobenzene and naphthalene (mothballs) are used in storage. These insecticides are poisons, and should be used with caution and only when absolutely necessary.
- **3.** *Stomach poisons* such as fluorides and silicofluorides are finishes for dry-cleanable wool.

- **4.** Contact poisons such as DDT are very effective but DDT has been banned in the United States and elsewhere.
- **5.** Chemical additives in the dye bath permanently change the fiber, making it unpalatable to the larvae. Surface and on-site applications may yellow carpet fiber or cause color loss.

Mold- and Mildew-Control Finishes

Mold and mildew will grow on and damage both cellulosic and protein textiles, although the problem is far more common on cellulosics. They also will grow on, but not damage, thermoplastic fibers. Finishes to prevent this growth are also known as fungicides or mildew-preventive finishes.

Prevention is the best solution to the problem because cures are often impossible. Mildew is an attack in which the microorganism feeds on the fiber surface, creating tiny pits and craters. The color associated with mildew is due to shadows from the pits. To prevent mold or mildew, keep textiles clean and dry. Keep soiled items dry, and wash them as soon as possible. Frequent sunning and airing should be done during periods of high humidity. Use an electric light and dehumidifiers in dark, humid storage places.

If mildew occurs, wash the article immediately. Mild stains can be removed by bleaching. Mold and mildew growth is prevented by many compounds. Salicylanilide is often used on cellulosic fibers and wool under the trade names of Shirlan and Shirlan NA.

Rot-Proof Finishes

Rot-proof finishes are used primarily on industrial products that are used outdoors to improve their durability and longevity. Textiles rot when they are exposed to moist, warm conditions for several days or more. Soil microbes secrete enzymes that disintegrate the textile. Cellulosic textiles are most susceptible to rotting, but protein fibers will rot under certain conditions. Finishing agents N-methylol and glyoxal impart rot resistance to cotton canvas for tents, tarpaulins, awnings, lawn and deck furniture, and other outdoor applications.

Antimicrobial Finishes

Antimicrobial finishes inhibit the growth of bacteria and other odor-causing germs, prevent decay and damage from perspiration, control the spread of disease, and reduce the risk of infection following injury. Antimicrobial finishes are also known as antibacterial, bacteriostatic, germicidal, permafresh, antiodor, or antiseptic finishes. Ideally, these finishes should be safe for consumers and producers, be easy to apply, be durable to repeated washings, and not adversely affect the fabric.

FIGURE 18-12

Microencapsulated insect-repellent finish. (Reprinted with permission from Nelson, G. (1991). Microencapsulates in textile coloration and finishing. Review of Progress in Coloration, 21, pp. 72-85. Published by the Society of Dyers and Colourists, Bradford, U.K.)

These finishes are used in clothing that comes in contact with the skin, shoe linings, hospital linens, and contract carpeting. The chemicals used are surface reactants such as quaternary ammonium compounds, zirconium peroxides, or N-halamines for cotton fabrics. Liquid solutions incorporating the active ingredient usually are applied by padding, but spraying is used for some fiberweb fabrics. These chemicals can be added to the spinning solution of manufactured fibers for use in wall coverings and upholstery. Diaper-services add the finish during each laundering. Eversan and Sanitized are trade names.

These finishes include chemical treatment, gas treatment, and irradiation treatment. Chemical antimicrobial finishes may cause yellowing and fading on nylon—a major problem for carpet. Ethylene oxide gas treatment is used in some cases. Since it is a hazardous material, it is being replaced with irradiation sterilization, also known as *electron-beam sterilization*. This treatment is cheaper, simpler, safer, and ideal for medical products such as bandages, sutures, and surgical gloves. Since the beam penetrates thermoplastic and foil packaging, items are packaged and then treated to maintain the sterile environment until the package is opened.

Microencapsulated Finishes

Microencapsulated finishes incorporate a water-soluble or other material in a tiny capsule form. The capsules are between 5 and 50 microns and may contain fragrance, insect repellents, disinfectants, cleaning agents, activated charcoal, or other materials (Figure 18–12). The microcapsules are sprayed onto a fabric and held in place with a polyvinyl alcohol or acrylic binder. The finished fabric may be durable for up to 10 washings for some products. Toxicological tests show that they cause no skin irritation. End uses for microcapsules with fragrance include ribbons,

handkerchiefs, scarves, curtains, fur-nishings, women's hosiery, sweaters, ties, and T-shirts. Normal physical forces during wear rupture the capsules and release the fragrance. Insect-repellent microcapsules have been used in apparel, in bedding to control dust mites, and in tents. Extra repellent can be released by squeezing the fabric. Mothproofing agents have been microencapsulated for application to wool carpet. Microcapsules containing bactericidal agents are applied to hospital gowns and bed linens, protective clothing worn in the pharmaceutical and food industries, socks, underwear, and activewear. Activated charcoal is used as a deodorant finish to absorb body odor and for gym wear and hunter's clothing.

Safety-Related Finishes

Flame-Retardant Finishes

Each year a large number of fatalities and injuries result from fires associated with flammable fabrics. The financial losses from such fires are estimated to be in the millions of dollars. Five common causes of these fires are smoking in bed, starting fires with flammable liquids, children playing with matches and lighters, burning trash, and being trapped in a burning structure.

Fabrics that burn quickly are sheer or lightweight fabrics and napped, pile, or tufted surfaces. Some items made from these fabrics ignite quickly, burn intensely, and are difficult to extinguish. "Torch" sweaters (a sweater that presents a fire hazard), fringed cowboy chaps, and chenille berets are examples of some apparel items that catch fire and cause tragic accidents. Style features such as long, full sleeves, flared skirts, ruffles, frills, and flowing hems present a fire hazard.

Many terms are used when discussing the ability of a fabric to resist ignition, burn more slowly than normal, or self-extinguish once the source of ignition has been removed from the fabric. The following definitions are from the American Society for Testing and Materials (ASTM):

- **Fire retardance:** The resistance to combustion of a material when tested under specified conditions.
- Flame resistance: The property of a material whereby flaming combustion is prevented, terminated, or inhibited following application of a flaming or nonflaming source of ignition, with or without subsequent removal of the ignition source.
- **Flammability:** The characteristics of a material that relate to its ease of ignition and its ability to sustain combustion.

Fabrics are made flame-resistant by using inherently flame-resistant fibers or fiber variants that have been made flame-resistant by additives to the spinning solution, or by applying flame-retardant finishes to the fabrics.

The burning characteristics of fibers are listed in Table 3–7. Fibers that are inherently flame-resistant are aramid, modacrylic, novoloid, saran, PBI, sulfar, and vinal/vinyon matrix fibers. Flame-retardant additives are used in the spinning solution of some acetates, nylons, polyesters, and rayons.

Flame-retardant (FR) finishes function in a variety of ways. The finish may block the flame's access to fuel and hinder further flame propagation. A foam-containing, flame-extinguishing gas may be produced. The solid may be modified so that the products of combustion are not volatile or require excess heat to continue the fire.

Flame-retardant finishes are used on cotton, rayon, nylon, and polyester fabrics. Flame-retardant finishes must be durable (able to withstand 50 washings), nontoxic, and noncarcinogenic. Ideally, they should not change the hand and texture of fabrics or have an unpleasant odor. Most finishes are not visible, and they add significantly to the cost of the item, so the consumer is asked to pay for something that cannot be seen.

Flame-retardant finishes can be classified as durable and nondurable. Durable finishes are specific to fiber type and are usually phosphate compounds or salts, halogenated organic compounds, or inorganic salts. Examples of durable finishes for polyester and cellulosics include the trade names of Antiblaze and Pyroset. Many other flame-retardant finishes are sold by trade names in addition to these mentioned here, but few consumer products are sold with the finish identified by trade name.

Flame-retardant finishes are less expensive than flame-resistant fibers or fiber variants. Knitted or woven gray goods are given a topical flame-retardant finish when necessary, a more economical process for fabric producers.

In general flame-retardant finishes require the addition of a fairly large amount of finish to the fabric. **Addon** describes the percentage by weight of solids left on a fabric after finishing and drying. Normal rates for cellulosics range from 5 to 30 percent of the fabric's weight. For polyester, the normal rates are 1 to 10 percent of the fabric's weight. The range of add-on is related to the specific chemical used, the product's performance expectations, and the cost of the finish.

The finishes for cotton are of two general types. The first is the ammonium cure, which provides excellent flame-retardance protection with minimal strength loss; it is most often used on apparel. However, it requires the use of special equipment, so the investment in capital is great. The second type is the pyrovatex process by Ciba-Geigy, which uses conventional finishing equipment and a resin. The resin results in greater strength loss and is therefore used more commonly for furnishings.

Cost, durability, and care of FR finishes are the greatest problems for the consumer. The costs of research and development for fibers and finishes, testing of fabrics and products, and liability insurance result in

higher costs for apparel and furnishings. Because the items look no different, the consumer may think the item is overpriced. Government standards limit consumer choices. For example, even people who do not smoke in bed pay a higher price for mattresses, because only mattresses that pass flammability standards can be sold in interstate commerce. The safety component is present regardless of the consumer's preference.

Most of the topical finishes require special care in laundering to preserve the flame resistance. Labels should be followed carefully: do not bleach, do not use soap, and do not use hot water. Excess soil can block the effectiveness of a finish, so frequent cleaning may be required.

Flame-retardant-treated fabrics are more expensive. The hand may be harsh. The fabric may be weaker and less abrasion-resistant than it would be without the finish. Also, the finish may give the wearer a false sense of security; even though the finish makes the fabric flame-retardant, it will not prevent the fabric from igniting or burning. The finish just causes the ignition and rate of burning to be slower.

Liquid-Barrier Finishes

Liquid-barrier finishes protect the wearer from liquids penetrating through a fabric. These finishes are important to health-care professionals because of the presence of viral and bacterial pathogens in body fluids. Agricultural and chemical workers also require liquid-barrier protection because of the toxic and hazardous liquids with which they work. It is difficult to develop finishes that provide the degree of protection and comfort required. Researchers continue to work with materials that look promising. Often these finishes are very thin, impermeable films applied to the fabric face or back.

Antipesticide protective finishes protect from pesticides penetrating through the fabric and aid in pesticide removal during washing. Research in this area continues.

Light-Reflecting Finishes

Light-reflecting finishes are used on fabrics to increase the visibility of its wearers in low-light conditions. There are two types that are painted or printed on the fabric's surface: fluorescent dyes and small glass retroreflective materials. Fluorescent dyes will be discussed in more detail in Chapters 19 and 20. Small glass retroreflective spheres or prisms are used on apparel (Figure 18–13). The glass surface alters the angle of reflected light and makes objects more visible. Bonding agents are used with the retroreflective finish. These finishes are expensive and durable to a limited number of washings and are used most often on trim for footwear and action wear. Occasionally, these finishes are used on fabric for social events because of the effect with black light.

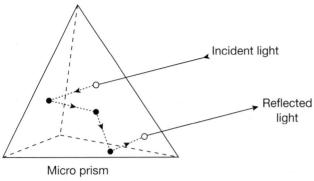

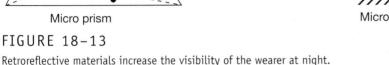

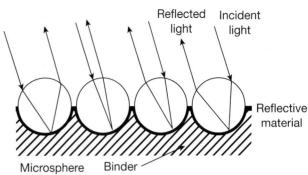

Key Terms

Special-purpose finish Stabilization Shrinkage control Functional finish Wet process Relaxation shrinkage Progressive shrinkage Compressive shrinkage London shrunk Heat setting Glass transition temperature (T_g) Surface coating Halogenation Shape-retention finish Cross links Wrinkle-resistant finish Durable press Precured process Postcured process Immersion Metered addition Vapor phase Quality performance standards Soil-release finish Stain-release finish Abrasion-resistant finish Antislip finish Fume-fading-resistant finish Anti-fume-fading finish

Metallic coating

Plastic coating Foam coating Light-stabilizing finish Pilling-resistant finish Water-repellent finish Waterproof fabric Porosity-control finish Air-impermeable finish Water-absorbent finish Ultraviolet-absorbent finish Antistatic finish Fabric softener Hand builder Phase-change finish Insect- and moth-control finish Mold- and mildew-control finish Rot-proof finish Antimicrobial finish Microencapsulated finish Fire retardance Flame resistance Flame-retardant finish Flammability Add-on Liquid-barrier finish Antipesticide protective finishes Light-reflecting finish

Questions

1. Explain how the stabilization finishes work for these products:

100 percent wool sweater

65 percent cotton/35 percent polyester upholstery of glazed chintz

100 percent acetate antique satin draperies

100 percent cotton flannelette bedsheets

- **2.** Describe the differences in process and product performance for methods used to apply durable press to a fabric or a product.
- **3.** Compare and contrast water-repellent and stain-repellent/soil-release finishes.
- **4.** For what end uses are metallic, plastic, and foam coatings used? What purpose do they serve?
- 5. Explain how these finishes enhance comfort:

water-repellent fabric softener antistatic phase change finish

- **6.** For what fibers and products are moth-control finishes likely to be used? How do they function?
- 7. How can flame retardancy be achieved with fabrics?
- **8.** Explain how these finishes affect fabric properties such as comfort, care, durability, and appearance.

halogenated wool antistatic nylon durable-press cotton flame-retardant rayon

Suggested Readings

- Carpets: mothproofing the ecology-safe way. (1994/1995, December/January). Canadian Textile Journal, p. 28.
- Bain, P. J. (1995, March). The post-sew phenomenon. *Bobbin*, pp. 82, 84–88.
- Davies, B. (1999, June). Buoyant prospects for flame retardant cellulosic fabrics. *Technical Textiles Inter*national, pp. 19–22.
- Dunn, K. L. (1995, May). The evolution of durable press products. *American Dyestuff Reporter*, pp. 1, 53.
- Harris, P. W., and Hangey, D. A. (1989). Stain resist chemistry for nylon 6 carpet. *Textile Chemist and Colorist*, 21(11), pp. 25–30.
- Havich, M. (1999, September). Don't be afraid of the dark. *America's Textiles International*, pp. 86.
- Heal, M. (1995, March). Visibility is the key to reduced accidents. *Technical Textiles International*, pp. 22–25.
- Hilfiker, R., Kaufman, W., Reinert, G., and Schmidt, E. (1996). Improving sun protection factors by applying UV absorbers. *Textile Research Journal*, 66(2), 61–70.
- Jackson, D., and Shinall, K. (September, 1988). Taking the heat. *Industrial Fabric Products Review*, pp. 63–65.
- Johnson, A. S., Gupta, B. S., and Tomasino, C. (1994, June). Topical treatments of nylon carpets: fluorochemicals and stainblockers. *American Dyestuff Reporter*, pp. 17–21, 39.
- Leigh, I. (1998, February). Foam textile backcoatings. *Technical Textiles International*, pp. 18–21.

- Lennox-Kerr, P. (1998, July/August). Outlast technologies adapts space-age technologies to keep us comfortable. *Technical Textiles International*, pp. 25–26.
- Nelson, G. (1991). Microencapsulates in textile coloration and finishing: *Review in the Progress of Coloration*, 21, pp. 72–85.
- Payne, J. (1997, February). From medical textiles to smell-free socks. *Journal of the Society of Dyers and Colourists*, 113, pp. 48–50.
- Powell, C. S. (1998, September). Phosphorus-based flame retardants for textiles. *American Dyestuff Reporter*, pp. 51–53.
- Reagan, B. M., Dusaj, S., Johnson, D. G., and Hodges, D. M. (1990). Influence of aftermarket carpet protectors on the soiling, flammability, and electrical resistivity of nylon 6. *Textile Chemist and Colorist*, 22(4), pp. 16–20.
- Refal, R. (1992, May). Rot proofing and easy care properties of cotton and modified cotton fabrics through treatment with glyoxal. *American Dyestuff Reporter*, pp. 40, 42, 44, 46, 47, 49, 50.
- Stipe, M. (1997, November). Easy care wool promoted by the wool bureau. *American Sportswear and Knitting Times*, p. 45.
- Yang, C. Q. (1999, May). Durable press garment finishing without formaldehyde. American Dyestuff Reporter, pp. 13–17.
- Zeronian, S. H., and Collins, M. J. (1988). Improving the comfort of polyester fabrics. *Textile Chemist and Colorist*, 20(4), pp. 25–28.

Chapter 19

DYEING AND PRINTING

OBJECTIVES

- To understand the theory and processes of dyeing and printing textiles.
- To relate quality and performance to the materials and processes used in dyeing or printing.
- To identify the stages of dyeing and types of printing.
- To relate dyeing and printing to the performance of textile products.
- To identify problems related to dyed and printed textiles and textile products.
- To understand the basics of color matching.

olor is one of the most significant factors in the appeal and marketability of textile products. This chapter discusses the characteristics of color from an identification perspective (when color was added to the product), a process perspective (how color was added to the product), a serviceability perspective (how color affects the serviceability of the product), and a problemsolving perspective (what kind of problems can develop because of color).

Although home dyeing has been a common practice, most consumers are not happy with the process because it is difficult to predict the final color, to achieve a fast color, to produce uniform and level colors, and to clean up the mess after dyeing. Commercial dyeing uses specialized equipment and dyes or pigments not available to the consumer. In addition, dyers and printers have a great deal of training and experience that minimize problems with the process and finished product.

The goal of adding color to textiles is to produce an appealing, level, fast color on a product at a reasonable price, with good performance characteristics and with minimal environmental impact. Level describes a color that is uniform and looks the same throughout the product. Colorfastness refers to dyes and prints that do not shift hue or fade when exposed to light and other environmental factors and that do not move onto other fabrics or material during storage, processing, use, or care. Poor colorfastness can create problems in production, storage, and use. Colorfastness is evaluated for conditions that a fabric may experience in finishing in textile mills, heating and pressing in production facilities, storage in warehouses and distribution centers, and use and care by consumers.

Color has always been important in textiles. Until 1856, plants, insects, and minerals were the sources for natural dyes and pigments. When William Henry Perkin discovered mauve, the first synthetic dye, a new industry—synthetic dyeing—came into being. Europe was the center for synthetic dyes until World War I interrupted trade with Germany and a dye industry developed in the United States. Today there are hundreds of colorants or coloring agents from which to choose.

Consumers are not aware of the challenges involved in achieving a particular color in a uniform manner on a textile product. They expect that the color will remain vivid and uniform throughout the life of the product and that it will not create problems in use, care, or storage. It is remarkable that color generates as few complaints from consumers as it does, since achieving uniform or level dyeing is a difficult process. Slight differences in fabric due to minor irregularities in fiber, yarn, fabric, or finishing can result in subtle color variations that can be very obvious in finished products when seams join parts cut from different bolts.

Adding color to a textile product is an involved process. Fiber chemistry plays an important role. Differences in the chemical compositions of fibers were discussed in Chapters 3 through 9. These differences can be seen in various properties and performance characteristics. A match between the chemistry of the dye and that of the fiber is needed in order for the color to be permanent. Any colored textile product may be exposed to a wide variety of potential color degradants, such as detergent, perspiration, dry-cleaning solvents, sunlight, and makeup. To achieve a permanent or fast color, the dye must be permanently attached to or trapped within the fiber by using a combination of heat, pressure, and chemical assistants. Since access to the fiber's internal regions is critical, crystallinity, chemical finishes, and fabric and yarn structure are factors that influence the success of dyeing.

Color Theory

Color theory describes a complex phenomenon that combines the physics of light, the chemistry of colored objects, the biology of the eye, the behavioral sciences in terms of what colors mean to society or to individuals, and aesthetics—the appreciation of what one sees. These elements interact to determine what is seen and how it is perceived. Understanding these interactions helps us understand why color is hard to perceive in low light, why color matching is a problem, and why some colors are used in certain settings.

The color we see depends on the light source, the colorant used, and the human eye. Color vision or color blindness may restrict the perception of colors. Even when we work with textiles that are 100 percent cotton, the colors may not match. In **metamerism**, two colors match under one light source, but not under another. In the **Bezold effect** two or more colors merge into one new color. This effect is seen when small-scale prints or yarn-dyed fabrics are viewed from a distance. Each individual color is not seen, but rather a new color that blends the individual colors together. This effect was used by Impressionist painters and is used in color inkjet printers.

Color measurement, the process of assigning numerical values to a color, is done to facilitate color matching and shade sorting. Color measurement can be done with the trained human eye or with instruments that assess color in three or more dimensions. Many different instruments and systems are used in this process. Color matching describes the process of developing a formula to reproduce a color, such as when designers submit a color swatch or when coordinating fabrics are desired. Shade sorting, grouping fabrics by color, is done so

that all fabrics of one color purchased by a manufacturer match. Thus, when fabric is layered prior to cutting out product parts, there is less concern that parts from different layers will not match when sewn into a completed product.

Colorants

Color can be added to textile objects by either dyes or pigments. Most colored textiles are achieved by dye or pigment mixtures rather than a single dye or pigment. Because there are major differences between these coloring substances and the ways they are added to fabrics, this section will discuss the characteristics of pigments and dyes.

Pigments

Pigments are insoluble color particles that are held on the surface of a fabric by a binding agent. Their application is quick, simple, and economical. Any color can be used on any fiber, because the pigments are held on mechanically. Fabric problems such as stiffening, crocking, and fading may be encountered.

Pigments are very important in coloring fabrics. More than 80 percent of the printed fabrics on the U.S. market are colored with pigments. At one time pigment prints were considered to be of low quality and cheap, but that is no longer true. Pigments are used on all kinds of goods at all quality levels and price points for a variety of reasons. Pigmented fabrics do not require a wash-off step to remove excess colorant from the fabric. However, washdown with fabrics laundered by consumers can be a problem if the binder has poor resistance to water or abrasion. Pigments' popularity is due to their relatively simple process, ability to be applied to almost all fibers and fabrics, extensive color range, excellent light-fastness, potential to combine some finishing with pigment coloration, and low cost. Ink is a term for pigments when they are combined with other ingredients in a paste form. Besides being used in printing, pigments are used to color some solid-colored garments during garment "dyeing."

Pigments must be bonded to the fiber surface. The binder works like a glue and holds the pigment to the fiber. The specific binder is determined by the fiber content of the fabric and the performance expectations for the product. Binders can be used to produce soft and flexible fabrics. Ideally, binders should not interfere with the color of the pigment or with the fabric's hand and function. Binders are activated by heat or catalyst. Pigments can be added in liquid or paste form. Pigment solutions sometimes are referred to as pigment dyes. Pigment pastes are used in printing.

Pigment pastes combine several ingredients to produce the desired appearance. Catalysts help bond the pigment to the fiber. Opacifiers produce a pigment with good covering power. Opacifiers can be selected to produce a range of lusters from dull and matte to full gloss to pearlescent or metallic. Thickeners produce dark shades and a paste that does not migrate or spread from the area applied. Thinners or reducers are used with pastes that are too thick. Antibleeding agents keep the edges of a print sharp and clear and eliminate the halo effect. Softeners maintain a flexible hand after printing. Retarders slow the drying rate. This is especially important in screen printing to keep the screens working. Dryers speed the drying of slow-drying inks.

Pigments produce the color of the paste, although some other ingredients may alter the color. Pigment colors are easier to match than are dye colors because the color is held on the surface and does not chemically combine with the fiber. Dyes are more difficult to match because the chemical reactions of dyeing may cause the dye to shift color. The hue shift is more difficult to control in dyeing as compared with pigment printing. Some problem areas with pigments are the change in hand with some inks, washdown problems, and poor drycleaning fastness of some binders.

Pigments also may be added to the spinning solution of manufactured fibers. Mass pigmentation of manufactured fibers will be discussed with the stages of dyeing.

Dyes

A **dye** is an organic compound composed of a chromophore, the colored portion of the dye molecule, and an auxochrome, which slightly alters the color. The auxochrome makes the dye soluble and is a site for bonding to the fiber. Figure 19–1 shows examples of dye molecules.

Dyes are molecules that can be dissolved in water or some other carrier so that they will penetrate into the fiber. Any undissolved particles of dye remain on the outside of the fiber, where they can bleed and are sensitive to surface abrasion. Dyes have great color strength; a small amount of dye will color large quantities of fabric. Pigments have much lower color strength; much more pigment is needed to color an equal amount of fabric. Most dyes bond chemically with the fiber and are found in the interior of the fiber, rather than on the surface, where pigments are found. Dyes can be used in either solutions or pastes. Dye pastes are used for printing.

A fluorescent dye absorbs light at one wavelength and re-emits that energy at another. Fluorescent dyes are used for many applications. In detergents, they make whites appear whiter and mask the yellowing of fibers.

FIGURE 19-1

Dye molecules: (a) C. I. Acid Red 1; (b) C. I. Disperse Red 1; (c) Direct Dye Congo Red, (d) C.I. Reactive Red 12. (Courtesy of Colour Index.)

Fluorescent dyes are used in clothing to increase the wearer's visibility at night, in costumes and protective clothing to produce intense glow-in-the-dark effects, and in some medical procedures.

A dye process describes the environment created for the introduction of dye by hot water, steam, or dry heat. Chemical additives, such as salt or acid, are used to regulate penetration of the dye into the fiber. A knowledge of fiber–dye interactions, methods of dyeing, and equipment produces a better understanding of color behavior.

The stage at which color is applied has little to do with fastness but has a great deal to do with dye penetration. It is governed by fabric design, quality level, and cost. In order for a fabric to be colored, the dye must penetrate the fiber and either be combined chemically with it or be locked inside it. Fibers that are absorbent and have chemical sites in their molecular structure that will react with the dye molecules will dye easily. The dye reacts with the surface molecules first. Moisture and heat swell the fibers, causing their polymer chains to move farther apart so that sites in the internal regions of the fiber are exposed to react with the dye. During cooling and drying the chains move back together, trapping the dye in the fiber. Wool dyed with an acid dye is a good example of a fiber that is absorbent and has many sites that chemically react with the dye to color the fiber.

The thermoplastic fibers can be difficult to dye because their absorbency is low. However, most of these

fibers are modified to accept different classes of dyes. This makes it possible to achieve different color effects or a good solid color in blends of unlike fibers by piece-dyeing.

Dyes are classified by chemical composition or method of application. Table 19–1 lists major dye classes along with some of their characteristics and end uses. No one dye is fast to everything, and the dyes within a class, a grouping of similar dyes, are not equally fast. A complete range of shades is not available in each of the dye classes; for example, some dye classes are weak in greens. The dyer chooses a dye or mixes several dyes to achieve the color desired based on the fiber content, the end use of the fabric, the performance expectations of the product, and the dye and process costs. The dyer must apply the color so that it penetrates and is held in the fiber. Occasionally the manufacturer or the consumer selects fabrics for uses for which they were not intended. For example, an apparel fabric used for draperies may not be fast to sunlight. Suppliers or retailers should be notified when products or fabrics do not give satisfactory performance.

Dye cards are used by dye manufacturers to demonstrate the colors that selected dyes produce on specific fibers. These cards help dyehouses meet designer's color specifications (Figure 19–2). The cards may include information regarding how a dye responds to washing, exposure to light, or other factors that cause dyes to bleed, shift hue, or fade.

Dyes	End Uses	Characteristics
Acid (anionic). Complete color range. Azoic (naphthol and rapidogens). Complete color range. Moderate cost.	Wool, silk, nylon, modified rayon. Modified acrylic and polyester. Primarily cotton. May be used on manufactured fibers such as polyester.	Bright colors. Vary in lightfastness. May have poor washfastness. Good to excellent lightfastness and washfastness. Bright shades. Poor resistance to crocking.
Cationic (basic). Used with mordant on fibers other than silk, wool, and acrylic. Complete color range.	Used on acrylics, modified polyester and nylon, direct prints on acetate, and discharge prints on cotton.	Fast colors on acrylics. On natural fibers, poor fastness to light, washing, perspiration. Tend to bleed and crock.
Developed , direct. Complete color range. Duller colors than acid or basic.	Primarily cellulose fibers. Discharge prints.	Good to excellent lightfastness. Fair washfastness.
Direct (substantive). Commercially significant dye class. Complete color range.	Used on cellulosic fibers.	Good colorfastness to light. May have poor washfastness.
Disperse. Commercially significant dye class. Dye particles disperse in water. Good color range.	Developed for acetate, used on most synthetic fibers.	Fair to excellent lightfastness and washfastness. Blues and violets on acetate fume fade
Fluorescent brighteners. Specific types for most common fibers.	Used on textiles and in detergents. Used to achieve intensely bright colors.	Mask yellowing and off-whiteness that occur naturally or develop with age and soil.
Mordant. Fair color range. Duller than acid dyes. Natural or vegetable. Derived from plant, animal or mineral sources. Earliest dyes used.	Used on same fibers as listed for acid dyes. Minor dye class; used to dye some apparel and furnishings. Primarily used on natural fibers.	Good to excellent lightfastness and washfastness. Dull colors. Fastness varies. Limited colors and availability.
Reactive or fiber-reactive. Combines chemically with fiber. Produces bright shades.	Used on cotton, other cellulosics, wool, silk, and nylon.	Good lightfastness and washfastness. Sensitive to chlorine bleach.
Sulfur. Insoluble in water. Complete color range except for red. Dull colors.	Primarily for heavyweight cotton. Most widely used black dye.	Poor to excellent lightfastness and washfastness. Sensitive to chlorine bleach. Stored goods may become tender.
Vat. Insoluble in water. Incomplete color range.	Primarily for cotton work clothes, sportswear, prints, drapery fabrics. Some use on cotton/polyester blends.	Good to excellent lightfastness and washfastness.

Stages of Dyeing

Color may be added to textiles during the fiber, yarn, fabric, or product stage, depending on the color effects desired and on the quality or end use of the fabric. Better dye penetration is achieved with fiber-dyeing than with yarn-dyeing, with yarn-dyeing than with piecedyeing, and with piece-dyeing than with product-dyeing. Good dye penetration is easier to achieve in

products in which the dyeing liquid or liquor is free to move between adjacent fibers. This freedom of movement is easiest to achieve in loose fibers. It is more difficult to achieve in products in which yarn twist, fabric structure, and seams or other product features minimize liquor movement.

Manufacturers and producers want to add color to products as late in processing as possible. But this puts tremendous demands on dyeing. It is absolutely essential for goods to be prepared well in order for good

S PROF	ERTIES							Appropriate the second
ACID AND ALKALINE PERSPIRATION	SUBLIMATION (325 F - 30 SEC.)	WASH TEST NO. 3	NO.	ORCOZINE	COLOR SAMPLE ON ORLON 75	NO.	ORCOZINE	COLOR SAMPLE ON ORLON 75
5	5	SC 5 ST 5		YELLOW L B.Y. 13			YELL. 7GLL	
5	3	SC 5 ST 5				2	200% B.Y. 21	
5	5	SC 5 ST 5		YELLOW R		4	YELLOW 6DL B.Y. 29 ORANGE G	
5	5	SC 5 ST 5	3	SUPRA B.Y. 11				
5	5	SC 5 ST 5		GOLDEN				
5	4-5	SC 5 ST 5	5	YELL GL B.Y. 28		6	200% B.O. 21	
5	4-5	SC 4-5 ST 5		7 CHRYSOIDINE Y EX. CONC. B.O. 2			ORANGE RS B.O. 1	1020000
5	4-5	SC 5 ST 5	7			8		
5	5	SC 4-5 \$7.5		BRILL. RED			RED GTL	
5	5	SC 5 ST 5	9	4GB 200% B.R. 14		10	B.R. 18	
5	5	SC 5 ST 5		BRILL.		10	RED GRL	
4-5	4-5	SG 4-5 ST 5	11	RED 5G		12	B.R. 46	
4-5	4-5	SC 4 ST 5		BRILL. RED FBB			RED B	
5	4-5	SG 5 ST 5	13	B.R. 49		14	B.R. 22	
5	4-5	SC 5 ST 5		BRILL. 15 RED BN		40	FUCHSINE SB	
4-5	4-5	SC 4-5 ST 4-5	15	B.R. 15		16	B.V. 14	
4-5	3	SC 5 ST 4-5		RHODINE BL	Action of the	40	BLUE RGL	and the second
4-5	5	SC 4 ST 5	17	17 200% B.V. 16	Li alel	18		
5	5	SC 5 ST 5	10	BLUE NF	interespendid	200	ROYAL BLUE S	
5	4-5	SC 4 ST 5	19			20	- DEGE 3	

FIGURE 19-2

Dye card showing colors and colorfastness ratings.

dyeing to occur. The earlier in processing color is added, the less critical is the uniformity or *levelness* of the dyeing. For example, in fiber dyeing, two adjacent fibers need not be exactly the same color since minor color differences in the yarn will be masked because of the small surface area of each fiber that is visible. However, the color must be level in products that are sewn before the color is added. Areas where the color is slightly irregular will be apparent to the casual observer and will result in the item being labeled a second. Level commercial dyeing is not easy, as anyone who has attempted dyeing on a small scale can attest.

This section discusses the stage at which the dye or pigment is added to the textile (Table 19–2.) Dyeing can be done at any stage; printing is usually done at the fabric stage. However, some yarns are printed and some finished products are printed. Current product printing is usually in the form of a design applied to one area of the product, such as the designs on the fronts or sleeves of active sportswear. This section does not address colorgrown fibers such as wool from a black sheep or naturally colored cotton. For information regarding colorgrown fibers, see Chapters 4 and 5.

Fiber Stage

In the **fiber-dyeing** process, color is added to fibers before yarn spinning. Fiber-dyed items usually have a slightly irregular color, like a heather or tone-on-tone gray.

Mass pigmentation is also known as solution-dyed, spun-dyed, dope dyeing, mass coloration, or producer-colored. It consists of adding colored pigments or dyes to the spinning solution before the fiber is formed. Thus, when each fiber is spun it is colored. The color is an integral part of the fiber and fast to most color degradants. This method is preferred for fibers that are difficult to dye by other methods, for certain products, or where it is difficult to get a certain depth of shade. Colors are generally few because of inventory limitations. Examples of mass-pigmented fibers include many olefins, black polyester, and acrylics for awnings and tarpaulins.

Another type of dyeing similar to mass pigmentation is *gel dyeing*. The color is added to the acrylic fiber while it is in the soft gel stage. This occurs in the narrow time frame between fiber extrusion and fiber coagulation.

Stock, or fiber, dyeing is used when mottled or heather effects are desired. Dye is added to loose fibers before yarn spinning. Good dye penetration is obtained, but the process is fairly expensive (Figure 19–3).

Top dyeing gives results similar to stock dyeing and is more commonly used. Tops, the loose ropes of wool from combing, are wound into balls, placed on perforated spindles, and enclosed in a tank. The dye is pumped back and forth through the wool. Continuous processes with loose fiber and wool tops use a padstream technique.

Yarn Stage

Yarn dyeing can be done with the yarn in skeins, called *skein dyeing;* with the yarns wrapped on cones or packages, called *package dyeing;* or with the yarn wound on warp beams, called *beam dyeing*. Yarn dyeing is less costly than fiber dyeing but more costly than fabric or product dyeing and printing. Yarn-dyed designs are more limited and larger inventories are involved (Figure 19–4).

Yarn-dyed fabrics are more expensive to produce because larger inventories of yarns, in a variety of colors, are required and more time is needed to thread the loom or set up the knitting machine correctly. In addition, whenever the pattern of color is changed, time is needed to rethread the loom or change the setup for the knitting machine. Yarn-dyed fabrics are considered to be better-quality fabrics, but it is rare to find solid-color yarn-dyed fabrics. It is much cheaper to produce solid-color fabrics

Stage	Industry Term	Advantages	Disadvantages	Identifying Features
Prefiber	Mass pigmentation or solution dyeing. Gel-dyeing.	Excellent fastness. Good for hard-to- dye fibers and products that require exceptional fastness.	Cannot respond to rapid fashion change. High cost. Limited to manufactured fibers.	Solid uniform color throughout fiber; used for hard-to- dye fibers.
Fiber	Stock or top* dyeing.	Heather and tone-on- tone fashions possible. Good dye penetration. Considered high quality.	Slower response to rapid fashion change. High cost.	Color tends to vary from fiber to fiber.
Yarn	Skein, package, or beam dyeing.*	Used for structural design plaids, stripes, and patterns. Good dye penetration. Considered high quality.	Slow response to rapid fashion change. High cost. Used to produce patterned fabric.	Can trace yarn path in fabric. Rare with solid colors. Yarn color forms pattern.
Fabric	Piece-dyeing. Flat or rope dyeing.* Cross or union dyeing.**	Inexpensive process. Quick response to fashion changes. Low cost.	Rope form may cause irregular color. Continuous process may contribute to ending problems.	Solid-color fabric of single fibers and union-dyed blends patterns or heathe effect with crossdyed blends.
Sewn Product	Garment (for apparel). Product (for other items).	Least expensive process. Quickest response to fashion change. Low cost. Distressed looks and other product finishes possible.	Requires well-prepared materials. Layered areas may have poor penetration. Difficult to match all parts, thread, trim, and fasteners.	Solid color fabric (trims and other materials may not match). Labels may be tinted

^{*}Describes the form of the textile or the manner in which it is handled. **Refers to presence of two or more generic fiber types.

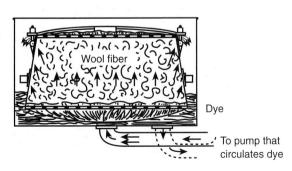

FIGURE 19-3 Stock or fiber dyeing: process and tweed-fabric example (cross dyeing).

FIGURE 19-4

Yarn dyeing: process and fabric.

by other processes. Yarn-dyed fabrics include stripes, plaids, checks, or other patterns that result from yarns of different colors in different areas of the fabric. Examples of yarn-dyed fabrics include gingham, chambray, and many woven or knit fancy or patterned fabrics.

Piece or Fabric Stage

When a bolt or roll of fabric is dyed, the process is referred to as **piece dyeing**. Piece dyeing usually produces solid-color fabrics. It generally costs less to dye fabric than to dye loose fibers or yarns. With piece dyeing, color decisions can be delayed so that quick adjustments to fashion trends are possible. Solid-color piece-dyed fabrics of one fiber are common, but piece dyeing offers additional possibilities for dyeing multiple color patterns into a fabric. When a fabric incorporates yarns representing two or more fibers of different dye affinities or dyeresisting capabilities, cross dyeing presents many color combinations and pattern options. Union dyeing is just the opposite. Here, the goal is for a solid color even though different fibers are combined or blended in the fabric.

Cross Dyeing Cross dyeing is piece dyeing of fabrics (Figure 19–5) made of fibers from different generic groups—such as protein and cellulose—or by combining acid-dyeable and basic-dyeable fibers of the same generic group. Each fiber type or modification bonds with a different dye class. When different colors are used for each dye class, the dyed fabric has a yarn-dyed appearance. An example is a fabric made of wool warp and cotton filling dyed with a red acid dye and a blue direct dye, respectively. In this example, the warp would be red and the filling blue.

Garment cross-dyeing also is used with 100 percent cotton knits that are dyed in two separate steps with two

classes of dyes. For instance, a T-shirt is dyed with a direct dye, treated to prevent the direct dye from bleeding, and colored with a pigment. This process produces a unique iridescent look for the shirt.

Union Dyeing Union dyeing is another type of piece dyeing of fabrics made with fibers from different groups. Unlike cross dyeing, union dyeing produces a finished fabric in a solid color. Dyes of the same hue, but of a type suited to each fiber to be dyed, are mixed together in the same dye bath. Union dyeing is common—witness all the solid-color blend fabrics on the market. A problem with these fabrics involves the different fastness characteristics of each dye class. Aged, union-dyed fabrics may look like a heather because of the differences in colorfastness of the dyes. Piece dyeing is done with various kinds of equipment.

FIGURE 19-5

Cross-dyed fabric: dark yarns are 100 percent cotton; light yarns are 100 percent polyester.

FIGURE 19-6
Product-dyed items: corduroy slacks, washcloth, and gloves.

Product Stage

Before **product dyeing**, the fabric is cut and sewn into the finished product. Once the color need has been determined, the product is dyed. Properly prepared gray goods are critical to good product dyeing. Great care must be taken in handling the materials and in dyeing to produce a level, uniform color throughout the product. Careful selection of components is required, or buttons, thread, and trim may be a different color because of differences in dye absorption between the various product parts. Product dyeing is important in the apparel and furnishing industries, with an emphasis on quick response to retail and consumer demands (Figure 19–6).

Methods of Dyeing

The method chosen for dyeing depends on fiber content, fabric weight, type of dye, and degree of penetration required in the finished product. In mass production, time is money, so processes in which the goods travel quickly through a machine are used whenever possible. Dyeing and afterwashing require a great deal of water, and waste water contributes to stream pollution. Minimizing the environmental impact of dyeing and finishing continues to be a major industry goal and current efforts are discussed at the end of this chapter.

Many methods and processes are used in dyeing. The methods tend to involve one of three ways of combining the dye bath with the textile: the textile is circulated in a dye bath; dye bath is circulated around

the textile; or both textile and dye bath are circulated together.

Batch Dyeing

Batch dyeing is also known as exhaust dyeing. In this process, the textile is circulated through the dye bath. Batch dyeing can be used for textiles in any stage of production from fiber to product but tends to be used for smaller lots or shorter yardages. The process has good flexibility in terms of color selection, and the cost is low, especially if done close to the product stage. Temperature can be controlled for the dye–fiber combination. Equipment used includes the beck, pad, and jig.

Beck, Reel, or Winch Dyeing The oldest type of piece dyeing is beck, reel, or winch dyeing (Figure 19–7). The fabric, in a loose rope sewn together at the ends, is lifted in and out of the dye bath by a reel. Most of the fabric is immersed in the dye bath except for the few yards around the reel. Penetration of dye into the fiber is obtained by continued immersion of slack fiber or goods rather than by pressure on the wet goods under tension, as is done in some other processes. This method is used on lightweight fabrics that cannot withstand the tension of the other methods, and on heavy goods, especially woolens.

In beck dyeing, a pressurized liquor ratio of 5:1 or 4:1 is used. Liquor ratio refers to the weight of solution as compared with the weight of the textile to be dyed. Thus, liquor ratios of 5:1 have five times as much liquid as textile by weight. Beck dyeing is generally used for fabric lengths ranging from 50 to 100 meters in rope or full width forms. It is simple, versatile, and low cost. Fabrics are subjected to low warp tension and bulking of yarns occurs. Beck dyeing uses large amounts of water, chemicals, and energy. It also causes abrasion, creasing, and distortion of some fabrics when dyed in rope form.

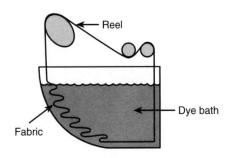

FIGURE 19-7 Winch dyeing.

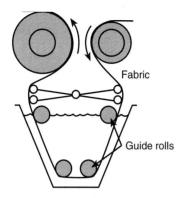

FIGURE 19-8 Jiq dyeing.

Jig Dyeing Jig dyeing uses a stationary dye bath with two rolls above the bath. The fabric is carried around the rolls in open width and rolled back and forth through the dye bath every 20 minutes or so. It is on rollers for the remaining time. Level dyeing is a challenge with this process. Acetate, rayon, and nylon are usually jig-dyed (Figure 19–8).

In jig dyeing, much larger runs of fabric at open width are used; several thousand meters are common. The way the fabric is moved in the process creates great warp tension. Fabrics that may crease in rope form are dyed in this manner, such as carpet, some twills, and some satins.

Pad Dyeing In pad dyeing, the fabric is run through the dye bath in open width and then between squeeze or nip rollers that force the dye into the fabric with pressure (Figure 19–9). Because the pad box holds a very small amount of dye bath or dye liquor, this is an economical way to piece-dye. The cloth runs through the machine at a rapid rate, 30 to 300 yards a minute. Padsteam processes are common methods of dyeing fabric.

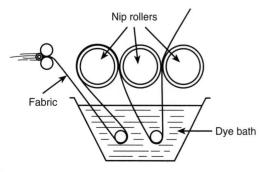

FIGURE 19-9 Pad dyeing.

Package Dyeing

In package dyeing, the dye bath is forced through the textile. Normally, the textile is in the yarn stage and the yarn is wound on a perforated core of stainless steel, plastic, or paper and placed on a perforated spindle in a pressurized machine. This technique is also used for some fiber and fabric dyeing. In beam dyeing, the yarn or fabric is wound on perforated beams. This method is practical for fabrics whose warp is one color and filling another. In skein dyeing, the yarn skeins are hung in the machine and the dye circulates around the hanging skeins. Package dyeing is used primarily for bulky yarns such as acrylic and wool for knits and carpet. Liquor ratios are high to ensure uniformity of the dyeing, usually ranging from 10:1 to 4:1 (depending on the process), dye-fiber combination, and quality desired.

Combination Dyeing

In combination dyeing, both the textile and the dye bath are circulated. Techniques include jet dyeing, paddle machines, rotary drums, tumblers, and continuous dyeing.

Jet Dyeing Jet dyeing is similar to beck dyeing. Here, the fabric is processed as a continuous loop. The technique is especially useful for delicate polyester fabrics; but, depending on the machine, almost any weight, structure, or fiber type can be used. It involves vigorous agitation of the dye bath and the textile. Because of its rapid speed (200 to 800 meters per minute), fabric wrinkling is minimal. Low warp tension helps develop bulk and fullness. High temperatures result in rapid dyeing, increased efficiency of dyes and chemicals, good fastness characteristics, and lower use of energy. However, equipment and maintenance costs are high, foaming can be a problem, and some fabrics may be abraded in the process.

Paddle Machines, Rotary Drums, or Tumblers Paddle machines and rotary drums are used primarily for product dyeing (Figure 19–10). Both the dye bath and the product are circulated by a paddle or by rotation of the drum. Tumblers are similar to rotary drums except that they tilt forward for easier loading and unloading. Tumblers are used in product dyeing and in abrasive or chemical washes.

Continuous Machines Continuous machines, called ranges, are used for large fabric lots. Ranges include compartments for wetting-out, dyeing, aftertreatment, washing, and rinsing.

Both fabrics and yarns are dyed. Yarns are usually warp yarns for denim; fabrics are often cotton/polyester blends or carpeting. About 25 percent of all carpet is

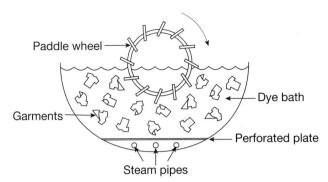

FIGURE 19-10 Paddle dyeing.

colored in this way. **Continuous dyeing** is efficient for long runs, but color tolerances may be relaxed for this method because of the variables involved. This technique is most commonly used in union dyeing of blends, but it also is used in cross dyeing. In one-bath dyeing, both dyes are present in one bath. One-bath processes are used for disperse/direct dye combinations in many medium-dark shades. The two-bath process is used for heavier-weight goods, darker shades, or dyes that cannot be combined in one bath. In this process, the dye is added from two separate dye baths, one for each dye type.

The **Thermosol process** was developed for polyester. It is a continuous method in which the dye is padded onto the fabric and dry heat is used to move the dye into the fiber and fix it there.

The long-chain method is continuous dyeing of yarns. It usually involves indigo or a sulfur dye. Yarn is immersed in the dye, squeezed to remove excess dye, and **skyed** (exposed to air) to oxidize and develop the color and fix the dye inside the fiber. Consecutive dips and skying progressively darken the shade until the desired color is reached. Indigo yarns may undergo as many as 16 separate dips to achieve a very dark navy blue. The ranges normally run at 30 to 35 yards per minute.

Printing

Color designs are produced on fabrics by printing with pigments or dyes in paste form or by positioning pigments or dyes on the fabric with specially designed machines. **Printing** is used to add color in localized areas only. Printed fabrics usually have sharp edges in the design portion on the face, with the color seldom penetrating completely to the back of the fabric. Yarns raveled from printed fabrics show the color unevenly positioned on them.

Printing allows for great design flexibility and relatively inexpensive patterned fabric. Patterns can be achieved with printing that are not possible from any other method. Some firms such as Brunswig and Fils allow custom coloring of their prints.

With the advent of computer-aided design (CAD) and computer-aided manufacturing (CAM), and the relatively low cost and increasingly powerful personal computer system, the design and preprinting process has shifted from a manual one to a computer one. The design is created on-screen or a hand-drawn and colored design is scanned in and manipulated and recolored as desired. Using CAD, the textile designer can experiment with changes in scale and color. CAD allows designers to quickly create coordinating prints for apparel and furnishing uses by selecting a portion of the original design and copying it.

Different colorways, variations in scale, or changes in pattern detail can be examined in seconds with a few simple commands. **Colorways** describes changing one or more colors in a fabric. Some fabrics are produced in one color combination only, but most are available in several colorways. This helps fabric designers keep product development costs down.

A paper or fabric copy of the design is printed using a color printer. With improvements in the capabilities of color printers, inks, and textile fabrics prepared for ink-jet printers, ink-jet printing of samples speeds up the process and significantly decreases development and preproduction time.

TABLE 19-3 Prir	nting process.		
Direct	Discharge	Resist	Other
Block	Discharge	Batik	Jet
Direct roller	3	Tie-dye	Heat transfer
		Ikat	Electrostatic
Warp		Screen	Differential
		Flat	Foil printing
		Rotary	
		Stencil	

Stage	Name	Advantages	Disadvantages	Identifying Features
Direct print on fabric	Block print	Handmade craft.	Expensive process.	Irregular depth of
		Used to produce unique, one-of-a- kind items.	Slow. Pattern alignment difficult.	color. Repeat blocks may b out of alignment. One to several colors in pattern.
Direct print on fabric	Roller print	Multiple colors. Less expensive method. Versatile in colors, pattern, and scale. Duplex prints possible.	Number of colors limited by equipment. Creating engraved rollers expensive. Out-of-register prints. Scale limited by size of roller.	From 1 to 16 colors in pattern. Scale of repeat can vary.
Direct print on yarn	Warp print	Soft edge to pattern. Unique look.	Expensive process. Not quick response.	Hazy, irregular edge to pattern in fabric, becomes more distinct whe filling removed.
Dyed fabric printed with discharge paste	Discharge print	May be less expensive than other methods, depending on design.	Discharge paste may tender fabric. Limited to patterns with few colors and dark ground.	Patterned areas tend to show ground color on back; usually white or one to two colors with dark ground.
Wax-resist on fabric, then dyed	Batik	Hand process. Multiple color patterns. Unique look.	Expensive. Wax removal difficult. Slow, labor-intensive process.	Fabric may have wax cracks or drips. Patterns vary from simple to elaborate.
Fabric tied, then dyed	Tie-dye	Hand process. Unique look. May use many colors.	Hand process. Expensive. Labor-intensive.	Sunburst ray effect and undyed groun in tied areas. Patterns vary from simple to elaborat
Yarn tied, dyed, and woven	Ikat	Warp, filling, or double ikat possible. Hand process. Unique look. May combine many colors and bands of ikat with solid color.	Labor-intensive. Hand process. Requires careful planning. Expensive.	Woven-in pattern du to planned variations in yarn color in warp, filling, or both. Simple to elaborate patterns possible.
Print fabric or product with resist screens	Screen print	Fine detail possible. Many colors possible with overprinting. Inexpensive process. Quick response. Applicable to fabric and product. Minimal down time. Quick colorway changes. Hand or commercial process. Can imitate many other techniques.	Registration of screens critical to process. Change of fabric hand can be a problem. Separate screen for each color of print. Quality of screen related to quality of fabric.	Most common method of printing.

Stage	Name	Advantages	Disadvantages	Identifying Features
Resist stencil on fabric, then painted	Stencil print	Hand process. Unique look.	Expensive. Easily duplicated with other processes. Color may be irregular.	Most often simple patterns.
Fabric and carpet	Ink-jet print	Inexpensive. Quick response. Minimal down time. Quick colorway changes. Mass customization possible. Unique designs possible.	Currently commercially limited to carpet. Fineness of detail limited. Difficulties in adapting four-color process to textiles. Fastness and fabric hand problems. Production speed and fabric width limitations. Image-quality issues.	Most common method of printing carpet.
Print paper, transfer to fabric/product	Heat-transfer print or sublimation transfer print.	Quick response. Minimal down time. Detailed designs possible. Minimal environmental impact from dyes. Inexpensive. Low capital and space needs.	Disposal of waste paper. Limited to sublimable disperse dyes and synthetic fibers. Storage conditions may cause dye transfer.	Sharp print on face; little, if any, transfer to fabric back.
Powdered dye applied to fabric	Electrostatic print	No washdown needed. Minimal environmental impact from dyes. Inexpensive.	Powder difficult to control. Minor technique limited to synthetic fibers and disperse dyes.	Printed face, unprinted back.
Dye applied to carpet fibers with different dye affinities.	Differential print	Unique looks possible. Quick response.	Limited to carpet. Difficult to control design.	Carpet with less- precise patterns.
Adhesive applied to fabric, heat-transfer printed	Foil print	Metallic film designs possible. Can combine with screen or heat-transfer printing for multicolor patterns.	Detailed and time- consuming process. Expensive.	Metallic film design.

Screens are created and sample yardage is printed, if necessary, or bulk production occurs immediately. Computer systems also are used to engrave the screens, predict color matches, and prepare print pastes for bulk production. These systems make it possible to create designs and convert them into fabrics in a matter of hours or days rather than months. Computer use increases automation of the process and decreases costs associated with labor, raw materials, and inventory.

Wet prints use a thick liquid paste; dry prints use a powder. Foam prints have the colorant dispersed in a foam. The foam is applied to the fabric and then collapses. The small amount of liquid limits color migration. Foam printing has less environmental impact than some other printing methods.

Table 19–3 lists the various methods of creating printed designs. Table 19–4 summarizes the characteristics of the various printing methods.

Direct Printing

In **direct printing**, color is applied directly to the fabric in the pattern and location desired in the finished fabric. Direct printing is a common method of printing a design on a fabric because it is easy and economical.

Block Printing Block printing is a hand process; it is probably the oldest technique for decorating textiles. It is seldom done commercially because it is expensive and slow. A pattern is carved on a block. The block is dipped in a shallow pan of dye paste and stamped on the fabric (Figure 19–11). More than one color print is possible, but a separate block is needed for each color. Extra time and attention are needed to align blocks correctly. Slight irregularities in color register or positioning are clues to block prints, but these can be duplicated by other techniques.

Direct-Roller Printing Direct-roller printing was developed in 1783, about the time all textile operations were becoming mechanized. Figure 19–12 shows the essential parts of the printing machine. The fabric is drawn around a metal or high-density foam cylinder during printing. A different printing roller applies each color. The engraved printing roller is etched with the design. There are as many different rollers as there are colors in the fabric. Furnisher rollers are covered with hard rubber or brushes made of nylon or hard-rubber bristles. They revolve in a small color trough, pick up the dye paste, and deposit it on the rollers. A doctor blade scrapes off excess color so that only the engraved portions of the roller are filled with dye when it comes

FIGURE 19-11
Carved wooden block and sample of printed fabric.

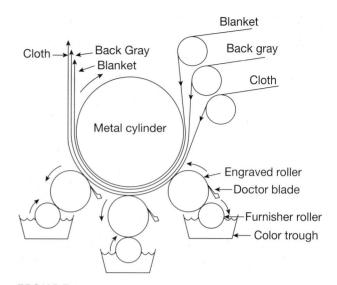

FIGURE 19–12

Direct-roller printing. This diagram shows the setup for a three-color print.

in contact with the fabric. The fabric to be printed, a rubberized blanket, and a unfinished-back fabric pass between the cylinder and the engraved rollers. The blanket gives a good surface for sharp printing; the gray goods protects the blanket and absorbs excess dye.

Rayon and knitted fabrics are usually lightly coated with a gum sizing on the back to keep them from stretching or swelling as they go through the printing machine. After printing, the fabric is dried, steamed, or treated to set the dye. The sizing may cause water spotting during use or care.

Duplex printing is roller printing that prints a pattern on both sides of the fabric. In duplex prints, both sides of the fabric may be printed at the same time. However, in the more common method, the face and back are printed in two steps.

Warp Printing In warp printing, the warp yarns are printed prior to weaving. This technique gives an interesting, rather hazy pattern, softer than other prints. To identify it, ravel adjacent sides. The design is in color only on the warp yarns. Filling yarns are white or solid color. Imitations have splotchy color on both warp and filling yarns. Warp printing is usually done on taffeta, satin ribbons, or cotton fabric, and on upholstery or drapery fabric (Figure 19–13). Since the practice is time-consuming and expensive, it is not common.

Discharge Printing

Discharge prints are piece-dyed fabrics in which the design is made by removing color from selected areas of

FIGURE 19-13

Warp-printed fabric. Note the difference in yarn appearance and clarity of design between woven and raveled areas.

the fabric (Figure 19–14). Discharge printing is usually done on dark backgrounds. The fabric is first piece-dyed by any appropriate method. A discharge paste containing chemicals to remove the color is printed on the fabric using roller or screen techniques. Dyes that are not harmed by the discharging chemicals can be mixed with printing solution if color is desired in the discharge areas. The fabric is then steamed to develop the design, as either a white or a colored area. Discharge printing is done because better dye penetration is obtained with piece dyeing than with printing, and it is difficult to get good dark colors except by piece dyeing.

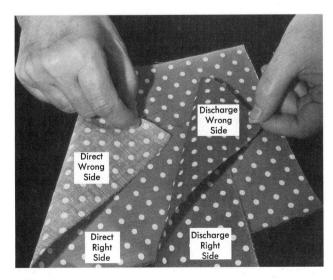

FIGURE 19-14
Discharge print versus direct print.

Discharge prints can be detected by examining the back of the fabric. In the design area the background color may not be completely removed, especially around the edges of the design. Background colors must be from dyes that can be removed by strong alkalis. Unfortunately, the discharge chemical or bleach may cause tendering or weakening of the fabric in the areas where the color was discharged.

Resist Printing

Resist prints are fabrics in which color absorption is blocked during yarn or fabric dyeing.

Batik Batik is generally a hand process in which hot wax is applied to a fabric in the form of a design. When the wax has set or hardened, the fabric is piece-dyed. Penetration of dye is prevented in the wax-covered portions. Colors are built up by piece dyeing light colors first, waxing new portions, and redyeing until the design is complete. The wax is later removed by a solvent or by boiling. Figure 19–15 shows a hand-produced batik from Indonesia.

Tie-Dye Tie-dye is a hand process in which yarn or fabric is wrapped in certain areas with thread or string. The yarn or fabric is dyed and the string removed, leaving undyed areas (Figures 19–16 and 19–17). Manufacturing techniques using fabric in rope form have been developed to imitate tie-dyed fabric.

FIGURE 19-15 Hand-produced batik.

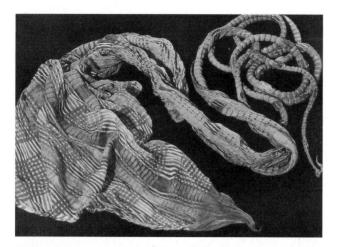

FIGURE 19-16

Tie-dye. This fabric was rolled on the bias, tied, and piece-dyed. A second dyeing was done with the fabric rolled in the opposite direction.

Ikat Ikat (é-köt or I'-kat) is an ancient form of resist printing. In ikat, the yarn is tied, dyed, then woven. The technique can be applied to only the warp yarns (warp ikat), only the filling yarns (filling ikat), or to both sets of yarns (double ikat). These designs do not have precise edges. Ikat requires great skill to determine the placement of the design in the finished fabric (Figure 19–18).

Screen Printing Screen printing is an incredibly versatile, yet simple, process. A mesh screen is coated with a compound that seals all openings in the screen and prevents the dye paste from moving through the screen, except in the areas to be printed according to the de-

FIGURE 19-17

Tie-dyed fabric showing thread used to make the design.

FIGURE 19-18

Double ikat from Guatemala.

sign. One screen is used for each color. The paste is forced through the openings within the screen by a squeegee. Fabrics with up to 24 colors, in widths up to 10 feet, can be printed at speeds of 40 to 85 yards per minute. Figures 19–19 and 19–20 show a close-up and a screen used in screen printing.

FIGURE 19-19

Close-up of a screen used in screen printing. Note the larger clear area where the paste is forced through the screen.

FIGURE 19-20
Screen used in flatbed screen printing.

Flat-screen printing is done commercially for yardages from 50 to 5000 yards and often is used for designs larger than the circumference of the rolls used for roller printing. Approximately 18 percent of print fabrics worldwide are flatbed screen prints.

In the hand process, the fabric to be printed is placed on a long table. Two people position the screen on the fabric, apply the color, move the screen to a new position, and repeat the process until all the fabric is printed with that color. Then they repeat the process until all the colors have been applied. For screen-printing products, a similar process is used, but the equipment is specifically adapted to the type of product. Figure 19–21 shows a screen printer for T-shirts.

In the automatic-screen process, the fabric to be printed is placed on a conveyor belt. A series of flat screens are positioned above the belt and are lowered automatically. Careful positioning of the screen is required to be sure print edges match. On screen-printed yardage, small color squares or blocks along the selvage aid in print alignment and help identify a screen print. Color is applied, and the fabric is moved automatically and fed continuously into ovens to be dried.

Rotary-screen printing is done with cylindrical metal screens that operate in much the same way as the flat screens, except that the operation is continuous rather than the discontinuous starting and stopping of the flat process (Figure 19–22). Rotary screens are cheaper than the copper rollers used in roller printing (Figure 19–23). Rotary screen printing is more common than flatbed screen printing.

Screen printing is useful for printing almost any size design on fabrics. Approximately 80 percent of the printed fabrics in the U.S. market are screen prints. **Differential printing** describes screen printing on carpets tufted with yarns that have different dye affinities.

Stencil Printing In stencil printing, the precursor of screen printing, a separate pattern is cut from a special waxed paper or thin metal sheet for each color. Color, in a thick solution or paste, is applied by hand with a brush or sprayed with an air gun. Stenciling is done on limited yardage.

Other Printing Methods

Ink Jet Printing In ink-jet (digital) printing, microdrops of colored liquid ink are applied through tiny nozzles onto the fabric surface at precise points.

FIGURE 19–21
Printer for printing items after sewing. (Courtesy of Advance Process Supply.)

FIGURE 19–22
Rotary screen printing. (Courtesy of Stork Brabant, B.V.)

Computers control the specific-color ink jet, amount of ink, and location of the microdrops. Ink-jet printers (Figure 19–24) operate with four basic colors (yellow, magenta, cyan, and black), which poses unique challenges in mixing colors for textiles.

There are several types of ink-jet printers, including continuous ink jet (CIJ) and drop on demand (DOD). High numbers of separate, tiny nozzles are used for each color. Development and refinement of ink-jet printers

FIGURE 19–23
Screen used in rotary screen printing. (Courtesy of Stork Screens B.V.)

for textiles is a slow process because of the technical limitations for nozzles and the different types of inks and pastes. Ink-jet printers are used to print carpet (Figure 19–25) and samples by textile designers (Figure 19–26) and limited commercial or production yardage. Ink-jet printing is expected to revolutionize small-lot printing. *Proofing* is the printing of samples to check the pattern, color, and design. It allows the print facility to get customer approval before preparing equipment for commercial or full-scale production and significantly speeds up the production process (Figure 19–27).

One of the biggest limitations is its incredibly slow production speed (less than 2 yards per minute) as compared with other commercial printing methods. Image resolution and crispness can also be problems with these prints. Limitations in fabric width, fastness of the print inks and pastes, and changes in fabric hand are also concerns with ink-jet–printed fabrics.

Heat-Transfer Printing In heat-transfer printing, designs are transferred to fabric from specially printed paper by heat and pressure (Figure 19–28). The paper is printed by one of several paper-printing techniques: gravure, flexograph, offset, or converted rotary screen. The fabric, yarn, or item is placed on a plastic frame and padded with a special solution. Paper is placed over the fabric and then covered with a silicone-rubber sheet.

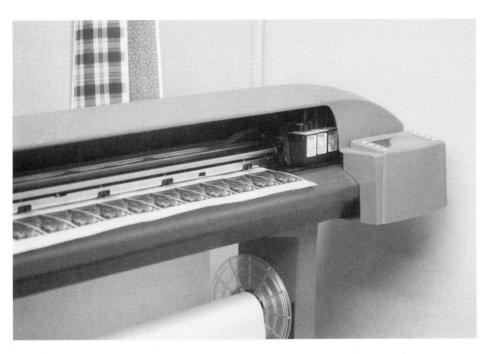

FIGURE 19-24 Ink-jet (digital) printer for fabric.

These layers are compressed under high pressure at a temperature of 200°C for a few seconds so that the print sublimes and migrates from the paper to the fabric. In sublimation, a solid evaporates and recondenses as a solid in a new location. Pressure ensures that the edges of the print are sharp and clear.

The advantages of heat-transfer printing are better penetration and clarity of design, lower production costs,

FIGURE 19-25 Jet-dyed carpet.

and elimination of pollution problems. (However, disposal of waste paper is a problem.) Clear, photographic prints are possible with this technique. Transfer printing can be done on three-dimensional fabrics such as circular knits without splitting them and on three-dimensional products such as garments.

Heat-transfer printing is successful with high-polyester/cotton blends and nylon. Cotton fabrics and 50/50 blends of cotton/polyester are treated with a resin that has an affinity for disperse dyes. Print papers with acid dyes for nylon, silk, and wool and with cationic

FIGURE 19-26

Ink-jet-printed fabrics designed by J. R. Campbell. (Courtesy of J. R. Campbell.)

Conventional printing Sample production: 2–8 weeks Print yardage production*: 3–12 weeks

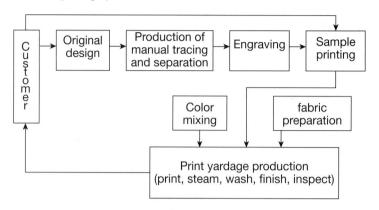

Inkjet and CAD systems Sample production: 2–3 days Print yardage production*: 1–5 weeks

*includes sample production

FIGURE 19-27

Ink-jet printing of samples saves time: conventional printing (top) and ink-jet printing (bottom). (Revised from J. Provost, (1995). "Dynamic response in textile printing." Textile Chemist and Colorist, 27(6), 11-16.)

FIGURE 19-28

Heat-transfer printing: design on paper (left) is transferred by heat to fabric (center). Design on paper is lighter after printing (right).

dyes for acrylics are available. Although these other options exist, synthetic fibers and disperse dyes are the most common combination on the market. Heat-transfer or sublimatic printing is used for apparel, drapery fabrics, upholstery, shower curtains, and floor coverings.

Electrostatic Printing Electrostatic printing is similar to electrostatic flocking. A prepared screen is covered with powdered dye mixed with a carrier that has dielectric properties. The screen is positioned about 1/2 inch above the fabric. When passed through an electric field, the dye powder is pulled onto the material, where it is fixed by heat.

Foil Printing In foil printing, a special adhesive is applied to the fabric by a flatbed or rotary screen. The fabric is dyed and partially cured. The foil combines a thin polyester film with a heat-sensitive release coating, a very thin layer of aluminum, and a clear or tinted lacquer. The metallic foil is heated on a heat-transfer press

and foil bonds only where the adhesive pattern exists on the fabric.

Recent Developments in Dyeing and Printing

Recent advances in commercial coloration include a photosensitive dye in selected areas of a pattern that changes hue when exposed to ultraviolet light or sunlight and returns to the original color when removed from sunlight. When heat-sensitive dyes are combined with another dye, body heat causes dramatic color changes, such as purple to bright blue.

A system by Kanebo of Japan incorporates tiny liquid crystals in a surface coating. The crystals change color depending on temperature. The coating is used on swimwear and trim; the high cost of the system limits its application to other products.

Holographic prints used for swim, rain, and ski wear combine a urethane coating, holographic image, and a textile backing.

In a new process, a small amount of very tiny metal particles (nanometers in size) can be used to dye natural and synthetic fibers. The fabric is soaked in a special solution, dried, then dipped in a salt solution of the metal and dried. Chromium produces a golden sheen, while gold gives a purple cast.

Some techniques combine dyeing and printing, such as ginghams from India that have a batik top dye. Another example is yarn-dyed denim that is printed or overdyed. In overdyed denims, the yarn-dyed fabric is dyed another color. Often the overdyeing follows an abrasive or chemical wash. (See Chapter 17.)

Processes that improve fixation rates while decreasing energy costs and waste generation are being researched. Ultrasonic and indirect electrochemical dyeing are two such processes.

Other developments in coloration relate to changes in the textiles industry, including technological advances and computer applications in dyeing and printing. The shift away from large runs of the same color or print continues. Speeds of 100 meters per minute do not contribute to extremely high quality or intricate prints. As quality increases in importance, production speeds and length of standard runs decrease. For example, in the 1950s and 1960s standard runs were 100,000 yards. By the 1980s, standard runs were less than 10,000 yards. In the 1990s, standard runs as short as 250 yards became more common. Even with this decrease in standard run size, costs are higher for shorter runs. The processing cost for runs of 10,000 yards is approximately \$120 per 1000 yards; for 5000 yards, it is \$130;

and for 1000 yards, it is \$240. Thus, shorter runs will cost more.

Specialization of fabric or design continues. The industry is strongly committed to minimal seconds, strict color control, and decreased dead time. **Dead time** refers to the time the equipment is not operating because of the need to change equipment components, like screens, or to change colors for different patterns. Dead time in screen printing has decreased to less than 30 minutes for most systems and patterns.

Efficient use of dyes, chemicals, and water or other solvents is another concern of the industry. For example, with reactive dyes, standard utilization rates were 60 to 80 percent. New reactive dyes with utilization rates of 80 percent or more are available. Solvent dyeing systems, that are standard for some fibers like aramid, require high recovery rates, such as 98 percent, to be economically feasible. Solvent dyeing has great potential, especially as water costs and water-quality standards become greater. With solvent dyeing, dyeing could expand into regions where dyeing has not been feasible due to the limited availability of water.

Computer monitoring of dyeing and printing processes decreases the environmental impact as manufacturers recognize the direct costs of inefficient use of materials and energy and incorporate closed-loop recycling of chemicals, solvents, water, and energy. Dye chemists use computers to calculate formulas to match swatches submitted by designers and monitor dyeing or printing processes so color is consistent. Computers automatically register each color in a print so that edges match.

The progress in printing techniques has been so great that predictions for capabilities by the year 2010 include making direct imaging techniques available in retail stores. Consumers will be able to select the product and the ground or base color, select a pattern to be applied to the product (or design their own pattern), and have it applied as they wait. Research on techniques currently used in color xerography on paper show that this technique can be modified for use on textiles. Fabric width, chemicals used in the process, and the relatively slow printing rate are some of the concerns limiting adaptation of this technique to textiles.

Color Problems

Good colorfastness is expected, but it is not always achieved. When considering all the variables connected with dyeing and printing and the hostile environment in which fabrics are used, it is amazing how good most colored fabrics are. The factors that influence colorfastness are:

- 1. Chemical nature of fibers
- 2. Chemical nature of dyes and pigments
- 3. Penetration of dyes into the fabric
- 4. Fixation of dyes or pigments on or in the fibers

The coloring agents must resist washing, dry cleaning, bleaching, and spot and stain removal with all of the variables of time, temperature, and substances used. Colorants must be resistant to light, perspiration, abrasion, fumes, and other factors. Dyes for certain products, like car interiors and outdoor furniture, must be ultraviolet-light–stabilized. Textiles used in furnishings may experience color problems from exposure to acne medication, bleaches, acids, and alkalis. These colordamaging agents are found in a host of materials with which furnishing textiles are likely to come in contact, such as vomit, drain and toilet cleaners, urine, plant food or fertilizers, insecticides, furniture polish, and disinfectants and germicides found in bathroom cleaners.

If the color is not fast in the fabric as purchased, it is not possible to make it fast. Salt and vinegar are used as exhausting agents for household dyes, but research does not support the theory that they will "set" color. If the dye could not be set using the knowledge of the dye chemist, the specialized equipment available in the dyehouse, and selected dyeing chemicals, the consumer will not be able to accomplish this task at home with salt, vinegar, or any other common household ingredient identified on some improper care labels.

Color loss occurs through bleeding, crocking, and migration or through chemical changes in the dye. **Bleeding** is color loss in water. In bleeding, other fibers present in the wash load may pick up the color. **Crocking** is color loss from rubbing or abrasion. In crocking, some color may be transferred to the abradant. For example, some tight-fitting dark denim jeans may color the front of the thighs during wear. **Migration** is shifting of color to the surrounding area or to an adjacent surface. An example of migration occurs with some red-and-white striped fabrics when the white closest to the red takes on a pinkish cast. Figure 19–29 shows a shirt whose embroidery was not fast to washing. Atmospheric gases (fume fading), perspiration, and sunlight may cause fading as a result of a chemical change in the dye.

Certain vat and sulfur dyes **tender**, or destroy, cotton cloth. Green, red, blue, and yellow vat dyes and black, yellow, and orange sulfur dyes are the chief offenders. Manufacturers know which dyes cause the trouble and can correct it by thoroughly oxidizing the dye within the fiber or aftertreating the fabric to neutralize the chemical causing tendering. The damage is increased by moisture and sunlight, a problem that is sometimes critical in draperies. Damage may not be evident until the

FIGURE 19-29
Bleeding of embroidery on shirt pocket. Note the halo of dye around the embroidered emblem.

draperies are cleaned, and then slits or holes occur (Figures 19–30 and 19–31). Sunlight, smog, and acidic atmospheric gases, as well as dyes, cause fabric damage. Some reactive dyed cotton shirtings that have been commercially laundered may experience weak or tender areas.

FIGURE 19-30

Cotton-and-rayon drapery fabric. After dry cleaning, yellowish streaks indicating fiber photodegradation were obvious; after washing, slits had occurred in the fabric, resulting from fiber swelling in water and abrasion in the washer.

FIGURE 19-31

Tendering of cotton draperies caused by sulfur dye, atmospheric moisture, and heat.

Frosting occurs when wear removes the colored portion of fibers or yarns (Figure 19–32). Frosting also occurs with blends and with durable-press garments that have been union-dyed. During wear, the surface is abraded and becomes lighter in color, while the unabraded or more-durable area maintains its color.

The movement of yarns during use may cause undyed fibers to work their way to the surface. Color streaks may result from uneven removal of sizing before the dye is applied. Some resin-treated fabrics show this color problem because either the dye was applied with the resin and did not penetrate sufficiently, or the fabric was dyed after being resin-treated, in which case there were not enough dye sites available to anchor the dye. The best way to check the dye penetration in heavy fabrics is to examine the fabric. With fabric, ravel a yarn to see if it is the same color throughout. With finished products, look at the edge of seams. In heavy prints, look at the reverse side. The more color on the back, the better the dye penetration.

A defect in printed fabrics occurs when two colors of a print overlap each other or do not meet. This defect is referred to as **out-of-register** (Figure 19–33).

Printed fabrics may be printed off-grain. Off-grain prints create problems because the fabric cannot be both straight with the print and cut on-grain. If cut offgrain, the fabric tends to assume its normal position when washed, causing twisted seams and uneven hemlines. If cut on-grain, the print will not be straight. In an allover design this may not be important, but in large checks and plaids or designs with crosswise lines, matching at seams becomes impossible and slanting lines across the fabric are not pleasing. Off-grain prints are created by incorrect finishing of the fabric. The gray goods are started into the tentering machine crooked or the mechanism for moving the fabric does not work properly so that the two selvages move at slightly different speeds, or the fabric is not properly supported in the center of its width. The off-grain problem can be corrected at the mill before printing.

Other problems related to dyeing and printing are concerns of the producer and manufacturer. These are problems related to the consistency of the color throughout the width and length of the fabric or from dye lot

FIGURE 19-32
Denim jeans; loss of surface color.

FIGURE 19-33
Printed fabric: out-of-register (left); in register (right).

to dye lot. Manufacturers of apparel and furnishing items require a fabric that is consistent in color. The color needs to be the same from side to side (selvage to selvage); side to center (selvage to center), and end to end (from one end of the roll of fabric to the other). If the color is not consistent, the producer will have problems with *off-shade* or with product parts not matching in color. When several rolls of the same color fabric are required, it is important that all the rolls be consistent in

color. Color-matching equipment, like a colorimeter, is commonly used to assess color uniformity within or among fabric rolls.

The fastness of the dye often determines the method of care that should be used. The consumer must depend on the label, but some knowledge of color problems that occur in use and care will allow for more intelligent choices. Table 19–5 summarizes these basic color problems.

Problem	Component	Description	Cause
Bleeding	Fiber	Dye loss in water that may color other items in water.	Poor fiber-dye bond, poor washfastness. Poor washdown (excess dye on fabric).
Crocking	Fiber	Color transfers to other fabrics, skin, etc.	Dye sits on fiber surface.
Migration	Fiber	Color moves to other areas or materials.	Poor fiber-dye bond; dye migrates.
Fume fading	Disperse dye (most common)	Fading or hue shift when exposed to some atmospheric pollutant.	Dye sensitive to pollutants.
Poor fastness to sunlight, perspiration, etc.	Dye	Fading or hue shift when exposed to the degrading factor.	Energy in sunlight degrades dye. Chemical reaction of dye with perspiration, deodorant chemicals, or reaction with bacterial enzymes.
Tendering	Fiber	Fabric becomes weak or sensitive to abrasion.	Dye-fiber interaction.
Frosting	Fiber	With abrasion, white areas appear on fabric, seams, or hems.	Poor dye penetration into fiber. As colored portion o fiber is abraded away, uncolored portion shows through. Also seen in blends where one fiber is more abrasion-resistant.
Out-of-register	Fabric	Edges of print do not match.	Poor alignment of screens or rollers in printing.
Off-grain	Fabric	Fabric printed off-grain.	Fabric not tentered properly and defect not detected before printing.
Off-shade	Fabric	Products, components, thread, other materials, or coordinating fabrics don't match in color or don't meet color specifications.	Contributing factors: evaluation of color match under different lights, chemical composition requires dyes from differer classes, poor control of bath or paste.

Environmental Impact of Dyeing and Printing

Dyeing and printing textiles can have a significant impact on the environment from discharge of dyes, pigments, and other chemicals into water systems. Components that contribute to problems include color, salt, acids, and heavy metals. Some materials create problems because of high biological oxygen demand (BOD); others have high chemical oxygen demand (COD). High BOD and COD materials create environments that are hostile to aquatic plants and animals and may create problems with future use of the water. Color in water creates problems with photosynthesis of aquatic plant life.

Most textiles are colored in one manner or another because consumers demand color. One option to decrease environmental impacts is to use fewer dyed or printed textiles. White textiles create problems with the use and disposal of chemical bleaches. Even though consumers purchase beige and off-white goods, they will probably continue to demand a broader range of colors. Another option is to use color-grown textiles, such as the naturally colored cottons and wools. However, a full color spectrum is not available and these natural colors tend to be low in intensity.

Another alternative is using natural dyes (Figure 19–34). Some natural dyes are used commercially. In order to compete with synthetic dyes and pigments, natural dyes must be economical, consistent in quality, and available in quantity. Mordants used with natural dyes should be restricted to those that have little, if any, impact on the environment. Examples of commercial natural dyes from Caracol and Allegro Natural Dyes include indigo, madder, cochineal, cutch, and osage. Natural dyes are used on cotton, wool, and silk fabrics for apparel and furnishing uses.

Color in water systems in very dilute concentrations can be detected by the unaided eye. Unfortunately, color is very difficult to remove by traditional waste (sludge) treatment facilities. Alternatives for treating color in water systems include use of hyperfiltration, electrochemical methods, ozonation, and chemical coagulation. Reconstitution and reuse of textile dyeing water is another possibility being investigated.

Efforts are being made to limit the use of salt and other chemicals. For example, current reactive dyes use

FIGURE 19-34

Scarf dyed with "orsalia," a natural lichen dye developed by
Karen Diadick Casselman, Nova Scotia, Canada. Resist areas were
bound with wire before dyeing. (Photo credit: Ted Casselman.)

large amounts of salt, but new Remazol EF reactive dyes by DyStar LP use significantly less salt and have higher fixation rates. New lower-sulfide sulfur dyes are replacing older higher-sulfide sulfur dyes. Use of heavy metals in dyes, catalysts, or after treatments is restricted. Dye producers are developing dyes that incorporate iron rather than chromium because iron is much safer. Dyes and pigments with low environmental impact will continue to be a major thrust in preparing goods with consumer appeal.

Using liquid carbon dioxide or supercritical carbon dioxide as the carrier rather than water for dyeing polyester and high-performance fibers is another research focus. Liquid carbon dioxide dyeing increases dye-fixation rates, decreases energy use, and decreases treatment of waste. In addition, this process does not require use of salt or other dye-bath chemicals, and drying is not needed. The process is quick and efficient, with good leveling. Carbon dioxide can be recycled and is readily available, nontoxic, and economical.

Key Terms

Level
Colorfastness
Metamerism
Bezold effect
Color measurement
Color matching
Shade sorting
Pigment
Wash-off
Washdown
Dye
Fluorescent dyes

Fluorescent dyes
Dye process
Acid dyes
Azioc dyes
Cationic dyes
Developed dyes
Direct dyes
Disperse dyes
Mordant dyes

Natural dyes
Reactive dyes
Sulfur dyes
Vat dyes
Fiber dyeing
Mass pigmentation
Solution-dyed
Producer-colored
Stock dyeing
Yarn dyeing
Piece dyeing

Union dyeing Product dyeing Batch dyeing Winch dyeing Liquor ratio

Cross dyeing

Jig dyeing Pad dyeing Package dyeing Jet dyeing

Continuous dyeing Thermosol process

Skye (sky)
Printing
Colorways
Foam printing
Direct printing
Block printing
Direct-roller printing
Duplex printing
Warp printing
Discharge printing
Resist printing
Batik

Batik Tie-dye Ikat

Flat-screen printing
Rotary-screen printing
Differential printing
Stencil printing
Ink-jet printing
Heat-transfer printing
Electrostatic printing
Foil printing
Digital printing
Dead time
Bleeding

Crocking Migration Tendering Frosting Out-of-register Off-grain print

Questions

- 1. What are the factors that influence the color seen and how do these factors interact?
- 2. What are the visual clues to determine if a fabric has been dyed or printed? How can the stage or the technique used in dyeing or printing be determined?
- **3.** Identify the coloration process (stage of dyeing or type of print) that was probably used for the following products: solid blue cotton and nylon upholstery velvet patterned carpet of nylon for hotel lobby

100 percent cotton chambray work shirt

irregular or fuzzy plaid gingham floral pattern 100 percent rayon faille dress 100 percent cotton T-shirt with local ski club name cartoon print on 100 percent polyester quilt for child's bed

100 percent wool tweed upholstery

4. Describe the appearance of and problems created by these color defects:

poor leveling frosting migration bleeding

- **5.** What factors influence colorfastness? How can colorfastness be determined?
- 6. What dye class(es) are commonly used for these fibers? cotton, rayon, flax, or ramie acetate, polyester wool, nylon, or silk olefin leather acrylic

Suggested Readings

- Anton, A. (2000). Piece dyeing for style and performance. Textile Chemist and Colorist and American Dyestuff Reporter, 32(3), 26–32.
- Aspland, J. R. (1993). Pigments as textile colorants: pigmenting or pigmentation. *Textile Chemist and Colorist*, 25(10), pp. 31–37.
- Broadbent, A. D. (1994, March, May, June, October/ November, and 1995, April/May). Colorimetry. Parts 1 to 5. *Canadian Textile Journal*, pp. 15–18, 16–19, 18–21, 19–22, 14–18.
- Fulmer, T. D. (1991, December). The how-to of pigment dyeing. *America's Textiles International*, pp. 105–107.
- Fulmer, T. D. (1995, January). Where is garment dyeing today? *America's Textiles International*, pp. 94, 96.
- Gibson, J. W. (1996). History and development of the thermosol process. *Textile Chemist and Colorist*, 28(2), 17–22.
- Glover, B. (1995). Are natural colorants good for your health? Are synthetic ones better? *Textile Chemist and Colorist*, 27(4), pp. 17–20.
- Glyn-Woods, S. (1992, March). Developments in transfer printing. *America's Textiles International*, pp. 89–91.
- Liles, J. N. (1990). The art and craft of natural dyeing: traditional recipes for modern use. Knoxville, TN: University of Tennessee Press.
- McConnell, B. L. (1996). Yarn dyeing—the future. *Textile Chemist and Colorist*, 28(8), 69–70.

- Owens, P. (2000). Digital printing: realities and possibilities. Textile Chemist and Colorist and American Dyestuff Reporter, 32(2), 22–27.
- Park, J., and Shore, J. (2000). Dyeing blended fabrics—the ultimate compromise. *Textile Chemist and Colorist and American Dyestuff Reporter*, 32(1), 46–50.
- Perkins, W. S. (1995, June). The principles of textile dyeing. *America's Textiles International*, pp. 86, 88–89.
- Perkins, W. S. (1995, September). The fundamentals of textile printing. *America's Textiles International*, pp. 246, 248.
- Provost, J. (1995). Dynamic response in textile printing. *Textile Chemist and Colorist*, 27(6), 11–16.
- Sharma, J. P. (1999). A review of discharge Printing. *Textile Chemist and Colorist and American Dyestuff Reporter*, 31(13), 28–30.

Section 6

OTHER ISSUES RELATED TO TEXTILES

CHAPTER 20

Care of Textile Products

CHAPTER 21

Legal and Environmental Concerns

CHAPTER 22

Career Exploration

Chapter 20

Care of Textile Products

OBJECTIVES

- To understand the theory of detergency.
- To relate care requirements to the product's fiber, yarn, fabrication, finish, dye, and construction.
- To recognize the differences and similarities among the common cleaning methods.
- To know the function of the various components used in cleaning textiles.
- To relate cleaning and storage to product serviceability.

are refers to the manner in which textile products are stored and the cleaning procedures used to remove soil and return products to new or nearly new condition. Table 20-1 summarizes standard care terminology.

Factors Related to Cleaning

In discussing care, it is important to understand the nature of soil and soiling, the manner in which a detergent and solvent interact, and the additives that are used to improve the removal of soil or the appearance of the cleaned item.

Soil and Soil Removal

Soil can be classified into several categories based on the soil type and how it is held on the fabric. Soils such as gum, mud, or wax are held on the fabric mechanically and can be removed mechanically by scraping or agitation. However, excessive agitation can abrade fabrics. Figure 20-1 shows the effects of different types of mechanical agitation. Lint and dust soils are held on the fabric by electrostatic forces. When the electrostatic force is neutralized, the soil is removed. Because water is such an excellent conductor of electricity, immersing the fabric in water, as is done in laundering, neutralizes any static charge on the fabric's surface. Water-soluble soils, such as coffee and prepackaged beverages, are absorbed into hydrophilic fibers. When the fabric is immersed in water, the water dissolves the soil. Organic soils such as grease, oil, and gravy can be absorbed by oleophilic fibers and require the chemical action of a detergent, an organic solvent (dry cleaning), heat, or thermal energy to be removed. Of course, many soils are mixtures and are removed by a combination of thermal, mechanical, and chemical actions. If one aspect of removal is decreased, another aspect must be increased in order to maintain the degree of soil removal. For example, if the water temperature is decreased, either more detergent or

TABLE 20-1 Standard care terminology.

1. Washing, Machine Methods

- a. Machine wash—A process by which soil may be removed from products through the use of water, detergent or soap, agitation, and a machine designed for this purpose. When no temperature is given, e.g., "warm" or "cold," hot water up to 150°F (66°C) can be regularly used.
- b. Warm—Initial water temperature setting 90 to 110°F (32 to 43°C) (hand comfortable).
- c. Cold—Initial water temperature setting same as cold water tap up to 85°F (29°C).
- Do not have commercially laundered—Do not employ a laundry that uses special formulations, sour rinses, extremely large loads, or extremely high temperatures or that otherwise is employed for commercial, industrial, or institutional use. Employ laundering methods designed for residential use or use in a self-service establishment.
- e. Small load—Smaller than normal washing load.
- Delicate cycle or gentle cycle—Slow agitation and reduced time.
- q. Durable-press cycle or permanent-press cycle—Cool-down rinse or cold rinse before reduced spinning.
- h. Separately—Alone.
- i. With like colors—With colors of similar hue and intensity.
- j. Wash inside out—Turn product inside out to protect face of fabric.
- k. Warm rinse—Initial water temperature setting 90 to 110°F (32 to 43°C).
- l. Cold rinse—Initial water temperature setting same as cold water tap up to 85°F (29°C).
- m. Rinse thoroughly—Rinse several times to remove detergent, soap, and bleach.
- n. No spin or Do not spin—Remove material at start of final spin cycle.
- o. No wring or Do not wring—Do not use roller wringer or wring by hand.

2. Washing, Hand Methods

- a. Hand wash—A process by which soil may be manually removed from products through the use of water, detergent or soap, and gentle squeezing action. When no temperature is given, e.g., "warm" or "cold," hot water up to 150°F (66°C) can be
- b. Warm—Initial water temperature 90 to 110°F (32 to 43°C) (hand comfortable).
- c. Cold—Initial water temperature same as cold water tap up to 85°F (29°C).
- d. Separately—Alone.
- e. With like colors—With colors of similar hue and intensity.
- f. No wring or twist—Handle to avoid wrinkles and distortion.
- g. Rinse thoroughly—Rinse several times to remove detergent, soap, and bleach.
- h. Damp wipe only—Surface clean with damp cloth or sponge.

TABLE 20-1 (continued)

3. Drying, All Methods

- a. *Tumble dry*—Use machine dryer. When no temperature setting is given, machine drying at a hot setting may be regularly used.
- b. Medium—Set dryer at medium heat.
- c. Low—Set dryer at low heat.
- d. Durable press or permanent press—Set dryer at permanent-press setting.
- e. No heat—Set dryer to operate without heat.
- f. Remove promptly—When items are dry, remove immediately to prevent wrinkling.
- g. Drip-dry—Hang dripping wet with or without hand shaping and smoothing.
- h. Line dry—Hang damp from line or bar in or out of doors.
- i. Line dry in shade—Dry away from sun.
- j. Line dry away from heat—Dry away from heat.
- k. Dry flat—Lay out horizontally for drying.
- l. Block to dry—Reshape to original dimensions while drying.
- m. Smooth by hand—By hand, while wet, remove wrinkles, straighten seams and facings.

4. Ironing and Pressing

- a. Iron—Ironing is needed. When no temperature is given, iron at the highest temperature setting may be regularly used.
- b. Warm iron—Medium temperature setting.
- c. Cool iron—Lowest temperature setting.
- d. Do not iron—Item not to be smoothed or finished with an iron.
- e. Iron wrong side only—Turn article inside out for ironing or pressing.
- f. No steam or Do not steam—Do not use steam in any form.
- q. Steam only—Steam without contact pressure.
- h. Steam press or Steam iron—Use iron at steam setting.
- i. Iron damp—Articles to be ironed should feel moist.
- i. Use press cloth—Use a dry or a damp cloth between iron and fabric.

5. Bleaching

- a. Bleach when needed—All bleaches may be used when necessary.
- b. No bleach or Do not bleach—No bleaches may be used.
- c. Only nonchlorine bleach, when needed—Only the bleach specified may be used when necessary. Chlorine bleach may not be used.

6. Washing or Dry Cleaning

a. Wash or dry clean, any normal method—Can be machine-washed in hot water, can be machine-dried at a high setting, can be ironed at a hot setting, can be bleached with all commercially available bleaches and can be dry-cleaned with all commercially available solvents.

7. Dry Cleaning, All Procedures

- a. Dry-clean—A process by which soil may be removed from products or specimens in a machine that uses any common organic solvent (for example, petroleum, perchloroethylene, fluorocarbon) located in any commercial establishment. The process may include moisture addition to solvent up to 75 percent relative humidity, hot tumble drying up to 160°F (71°C) and restoration by steam-press or steam-air finishing.
- b. *Professionally dry clean*—Use the dry-cleaning process, but modified to ensure optimal results either by a dry-cleaning attendant or through the use of a dry-cleaning machine that permits such modifications or both. Such modifications or special warnings must be included in the care instruction.
- c. Petroleum, fluorocarbon or perchloroethylene—Employ solvent(s) specified to dry clean the item.
- d. Short cycle—Reduced or minimum cleaning time, depending on solvent used.
- e. Minimum extraction—Least possible extraction time.
- f. Reduced moisture or Low moisture—Decreased relative humidity.
- g. No tumble or Do not tumble—Do not tumble dry.
- h. Tumble warm—Tumble dry up to 120°F (49°C).
- i. Tumble cool—Tumble dry at room temperature.
- j. Cabinet dry warm—Cabinet dry up to 120°F (49°C).
- k. Cabinet dry cool—Cabinet dry at room temperature.
- l. Steam only—Employ no contact pressure when steaming.
- m. No steam or Do not steam—Do not steam in pressing, finishing, steam cabinets, or wands.

8. Leather and Suede Cleaning

a. Leather clean—Have cleaned only by a professional cleaner who uses special leather- or suede-care methods.

FIGURE 20-1

Effect of different methods of mechanical agitation: original fabric (left); fabric after gentle agitation (center); fabric after harsh agitation (right). (Courtesy of Maytag Corp.)

more agitation will be required for the cleaning process to be as effective. As temperature decreases, cleaning power, even when cycles are repeated, decreases (Figure 20–2).

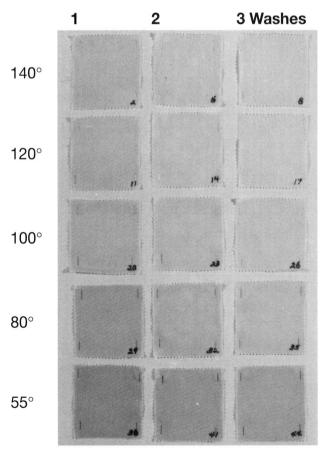

FIGURE 20-2
Effect of water temperature on cleaning. (Courtesy of Maytag Corp.)

Detergency

Detergency refers to the manner in which the soap or detergent removes soil. Adding soap or synthetic detergent to solvent lowers the surface tension of the solvent, allowing things to wet more quickly. The solvent does not bead up but spreads over and wets the surface. A soap or detergent molecule includes an organic "tail" that has an affinity for organic soils and a polar "head" that has an affinity for the solvent. As a result of its nature, the two parts of the soap or detergent molecule literally dislodge the soil. Agitation breaks the soil into very tiny globules that are held in suspension until they are rinsed away (Figure 20–3). If hot solvent and agitation are used, oily soils soften and break into small globules.

Removes soil from fabric

FIGURE 20-3

Mechanism of soil removal: detergent surrounds soil and lifts it off the fabric.

Because of the different functions of each ingredient in detergents, the amount of detergent needs to be sufficient to clean. Recommendations, based on research, for the proper amount of detergent to use are included on labels. Consumers should use a measuring cup to ensure use of the correct amount. Some containers incorporate a specially designed top or scoop to facilitate this. If too much detergent is used, it may build up on textiles or be wasted and flushed down the drain. If too little detergent is used, soil will remain on the textiles.

Detergent or soap is needed to remove most soils. Such alternative laundry products as disks, globes, and doughnuts of plastic or ceramic materials claim to replace detergents. Researchers have demonstrated that these laundry gimmicks are no more effective than water used alone in cleaning soil from fabric.

Solvents

A **solvent** is a liquid that dissolves other materials. Solvents dissolve common soils such as salt from perspiration or body oils. The most common and widely used solvent is water. Other cleaning solvents include organic liquids such as perchloroethylene. The choice of a particular solvent is based on the soil types present, the cost and availability of the solvent, and the textile product's characteristics. As basic care methods, washing and dry cleaning differ by the solvents and equipment used.

Water Water is used as the solvent in washing because it is cheap, readily available, nontoxic, and can be used with no special equipment requirements. Hardness, temperature, and volume are water characteristics that affect cleaning. Water hardness refers to the type and amount of mineral contaminants present. Water that contains mineral salts is referred to as hard water. The more mineral salts dissolved in the water, the harder it is. Hard water makes cleaning more difficult. In order to soften the water, the minerals must be removed, or sequestered (bonded to another molecule). Commonly, water is softened by adding a water-softening agent, such as sodium hexametaphosphate, to the water or by using an ion-exchange resin in a water softener.

Water temperature determines the effectiveness of the cleaning additives used and in removing some soils. Some additives are more effective at certain temperatures. The following water-temperature ranges are identified by the Federal Trade Commission in the Care Labeling Rule: cold water is 85°F, or the initial water temperature from a cold water tap; warm water is 90 to 110°F, or hand comfortable; and hot water is up to 150°F. However, these temperatures may not correspond to actual home water temperatures.

Water volume is controlled to allow for agitation, to remove and keep soil suspended, and to avoid wrinkling items in the load. Actual water volume relates to the amount of fabric present in the machine.

Other Solvents Organic solvents are used in dry cleaning, spot removal or spotting agents, and carriers for other spotting materials. Perchloroethylene, also known as perc or PCE, is the solvent most often used in dry cleaning. Trichloro-trifluoroethane (also known as CFC 113), a high-flash-point hydrocarbon known as DF 2000, and glycol ether are other organic solvents used in commercial dry cleaning plants in the United States, Canada, Europe, and elsewhere. These solvents dissolve oils, greases, and other stubborn stains that are difficult to remove in water-based systems.

Perc and CFC 113 have been popular dry-cleaning solvents because they create fewer problems with fabric shrinkage, do not affect water-soluble dyes, and are non-flammable. Both solvents are hazardous to the environment. CFC 113 is being phased out of use because of its detrimental effect on the ozone layer. Perc is carefully regulated and has been labeled a possible carcinogen and identified as contributing to forest decline.

Research has identified some solvents that equal or exceed perc's effectiveness in some areas of cleaning, but no one solvent is consistently equal to perc in all areas. These other solvents include petroleum distillates with high flash points, dibasic esters, iso-octane, isopropyl lactate, and limonene. Petroleum distillates are used as solvents in some stain-removal compounds and by some dry cleaners as their primary solvent in cleaning. Cyclic siloxane solution is another alternative to perc. Although currently under evaluation at several U.S. sites, little objective information is known about its performance.

Liquid carbon dioxide is used by a few dry cleaners as another alternative to perc. Specialty cleaning additives and high pressure are needed, but the process is effective at cleaning and does not subject items to the high temperatures used to remove perc in traditional systems.

Laundering

Laundering is the most common means of cleaning consumer textiles. Table 20–2 summarizes the care required for generic fibers. Care also depends on dye, fabrication, finish, product construction, other materials present in the product, type of soil, and extent of soiling. This section focuses on additives and methods.

Synthetic Detergents and Soaps

Synthetic detergents and soaps are used to remove and suspend soils, minimize the effects of hard water, and alter the surface tension of water and other solvents.

Fiber Group	Cleaning Method	Water Temperature	Chlorine Bleach Use	Dryer Temperature	Iron Temperature	Storage Consideration
Acetate	Dry-clean*	Warm(100-110°F)	Yes	Low	Very low	Avoid contact with nail polish remov
Acrylic	Launder	Warm	Yes	Warm	Medium	_
Cotton	Launder	Hot (120-140°F)	Yes	Hot	High	Store dry to prevent milde
Polyester/ cotton DP	Launder	Hot	Yes	Warm	Medium	
Flax	Launder	Hot	Yes	Hot Do not press in sharp creases	High	_
Glass	Hand wash only	Hot	Yes	Line dry	Do not iron	Prevent fiber breakage by storing flat
Lyocell	Dry clean or launder	Warm	Yes	Warm	Hot	Minimize agitation
Modacrylic	Launder	Warm	Yes	Low	Very low	_
Nylon	Launder	Hot	Yes	Warm	Low	_
Olefin	Launder	Warm	Yes	Warm	Very low	_
Polyester	Launder	Hot	Yes	Warm	Low	_
Rayon	Launder	Hot	Yes	Hot	High	Store dry to prevent mildew
Silk	Dry clean*	Warm	No	Warm	Medium	_
Spandex	Launder	Warm	No	Warm	Very low	_ '
Wool	Dry clean*	Warm	No	Warm	Medium, with steam	Protect from moths; do not store in plastic bags

^{*}Or hand wash, avoiding excessive agitation and stretching.

Synthetic Detergents Synthetic detergents are mixtures of several ingredients. The recipe depends on the type of detergent. Detergent formulas differ throughout the country. The differences are related to the type of soil, water conditions, and laws. In this text the term detergent will be used to refer to the box, tablet, or bottle of general cleaning compound.

Surfactants are organic compounds that are soluble in hard water and do not form an insoluble curd. They are vigorous soil-removal agents and are frequently sulfonated, linear, long-chain fatty acids. Surfactants include nonionic, anionic, and cationic types. Nonionic surfactants, such as ethers of ethylene oxide, are used in liquids and recommended for use in cold or warm water because they are less soluble at high temperatures. Anionic surfactants are good at removing oily soils and clay-soil suspension. These surfactants are usually biodegradable linear alkyl sulfonates (LAS). Powder anionic surfactants are most effective in warm and hot wa-

ter. Liquid anionic surfactants are used in liquid detergents. Cationic surfactants are used primarily in disinfectants and fabric softeners.

Builders are not present in large quantities in ultra or concentrated formulations. Builders soften the water, add alkalinity to the solution, since a pH of 8 to 10 is best for maximum cleaning efficiency, emulsify oils and greases, and minimize soil redeposition. Builders include phosphates (usually sodium tripolyphosphate), carbonates (sodium carbonate), citrates (sodium citrate), and silicates (sodium silicate). Of these, phosphate builders offer the best performance over the widest range of laundering conditions. Phosphate builders have been replaced in the United States by other builders because of their role in water pollution. However, researchers in Sweden have found that phosphates may have the lowest lifecycle costs and are urging reevaluation of phosphate bans. Although carbonate builders do not contribute to water pollution, they combine with hard-water minerals to

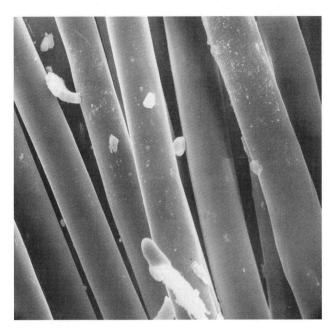

FIGURE 20-4
Residue forms on fabrics laundered with carbonate builders in hard water.

form water-insoluble precipitates that may harm the washing machine, fabric, and zippers (Figure 20–4). Carbonate builders have replaced phosphates in powdered detergents. Citrate builders are much weaker at softening hard water and are used in liquid detergents. Sodium silicate functions as a builder when present in large concentrations. However, sodium silicate is often present in small concentrations because it also works as a corrosion inhibitor. Zeolites, insoluble ion-exchange compounds, are used in most heavy-duty detergents.

Enzymes, an important ingredient in detergents, remove fuzz resulting from the abrasion of cellulosic fibers. Since cotton or cotton blends comprise up to 80 percent of the fabrics in a normal load, this ingredient is having a profound effect on home laundering. Enzymes prevent the formation of pills and keep textile products looking newer longer. By removing fuzz, enzymes also minimize physical entrapment of soil in worn areas of fibers. Use of biodegradable enzymes may slightly decrease the product's life because a tiny portion of the fibers are destroyed with each laundering.

Other ingredients that enhance product appearance are antifading agents and color-transfer inhibitors. Antifading agents maintain original color intensity by minimizing color bleed in the wash. Dye-transfer inhibitors usually contain borax compounds to prevent any dye that bled in the wash from redepositing on lighter-colored products (Figure 20–5).

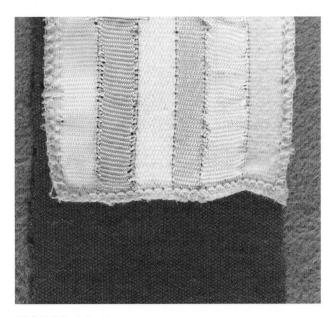

FIGURE 20-5 Color-transfer inhibitors would minimize the stains on this multifiber test fabric laundered with a fabric sample that bled. Darker stripes in the test fabric indicate greater color transfer during washing.

Fillers, such as sodium sulfate in powder detergents and water and alcohol in liquid detergents, are used to add bulk to the detergent, allow for a uniform mix of the ingredients, increase the size of the micelle (the grouping of detergent or soap molecules that remove soil from fabric), protect washer parts, and minimize caking in powders. Fillers are used in very small amounts in ultra or concentrated formulations. Antiredeposition agents, such as sodium carboxymethylcellulose or organic polymers, minimize fabric picking up soil from the wash water. Perfumes are designed to mask the chemical smell of detergents and to add a "clean" smell to the wash. *Dyes* make the detergent look better and function as bluing. Perfume-free and dye-free formulations are available.

Fluorescent whitening agents are also known as fluorescent brightening agents, optical whitening agents, and optical brightening agents. These compounds are low-grade or weak dyes that fluoresce, or absorb, light at one wavelength and re-emit the energy at another wavelength. Thus, it is possible to have whites that are "whiter than white." These ingredients do not contribute to soil removal; they mask soil and make yellow or dingy fabrics look white.

Other ingredients that may be found in detergents include *fabric softeners* and *bleaches* (to be discussed later in this chapter), processing aids that keep powders from caking and liquids from separating, suds-control agents,

and foam-control agents. *Processing aids* include sodium sulfate in powders and water, alcohol, and propylene glycol in liquids. *Alcohol* dissolves some ingredients of the detergent, assists in stain removal, and acts as an antifreeze during shipping in colder climates. *Opacifiers* give a rich, creamy appearance to some liquid detergents. A **soil-release polymer** may also be present in some detergents. It is deposited on the fabric in the first wash, soil binds with it in use, and the soil is released in the wash. *Ultraviolet (UV) absorbers* and *antibacterial compounds* may be incorporated in detergents in the near future.

Soaps Soaps are salts of linear, long-chain fatty acids produced from naturally occurring animal or vegetable oils or fats. Soaps react with hard-water minerals and produce insoluble curds that form a greasy, gray film on textiles and a ring on tubs or sinks. Soaps are effective in removing oily or greasy stains, but they are not vigorous soil-removal agents and have been replaced by synthetic detergents in almost all applications.

Other Additives

Other additives include bleaches, fabric softeners, water softeners, disinfectants, presoaks, pretreatments, starches or sizing, and bluing. Some are seldom used today.

Bleach Most bleaches are oxidizing agents. The actual bleaching is done by active oxygen. A few bleaches are reducing agents, which are used to strip color from dyed fabrics. Bleaches may be either acid or alkaline. They are usually unstable, especially in the presence of moisture. Bleaches that are old or have been improperly stored lose their oxidizing power.

Any bleach will cause damage, and because damage occurs more rapidly at higher temperatures and concentrations, these factors should be carefully controlled.

Because fibers vary in their chemical composition, the choice of bleaches should relate to fiber content. When the sock in Figure 20–6 was bleached with chlorine bleach, the wool-ribbed cuff section became discolored while the cotton foot remained white.

Liquid chlorine bleaches are a common household bleach. They are cheap and efficient bleaches for cellulosic fibers. The bleaching is done by hypochlorous acid, which is liberated during the bleaching process. Because this tenders cellulosic fibers, the bleach must be thoroughly rinsed out. Chlorine bleaches will cause yellowing on protein and thermoplastic fibers. As effective bactericidal agents (disinfectants), they also are used for sterilizing fabrics.

Powdered-oxygen bleaches, also known as all-fabric bleaches, may be used safely on all fibers and colored

FIGURE 20-6
Cotton-and-wool sock after bleaching. Chlorine bleach caused wool in ribbed top to yellow and stiffen.

fabrics. Their bleaching effect is much milder than that of chlorine bleaches. These bleaches include sodium perborate and sodium percarbonate.

Powdered sodium perborate combines with water and forms hydrogen peroxide. It is a safe bleach for home use with all fibers. However, since perborates are harmful to plant life, sodium percarbonate is a safer and equally effective alternative. Powder bleaches are recommended for regular use to maintain a fabric's original whiteness rather than as a whitener for discolored fabrics. Liquid hydrogen peroxide bleaches also are available.

Acid bleaches, such as oxalic acid and potassium permanganate, have limited use. Citric acid and lemon juice, also acid bleaches, are used as rust-spot removers.

Fabric Softener Fabric softeners coat the fabric to increase its electrical conductivity, minimize static charges, and decrease fabric stiffness. Some softeners incorporate compounds to minimize wrinkling during washing and drying. The types of fabric softeners include those added in the final rinse, those present in detergent, and those added in the dryer. The instructions for the use of any fabric softener need to be followed or problems may result. For example, fabric-softener sheets for the dryer should be added to a cold dryer. If they are added to a warm or hot dryer, oil from the fabric softener may spot synthetic items. Fabric softeners have a tendency to build up on fabrics in a greasy layer, resulting in less-absorbent fabrics. Therefore, it is not recommended that a fabric softener be used every time a product is laundered. Every other time or every third time may be sufficient.

Water Softener Water-softeners are found as builders in detergent or as separate ingredients that can be added to increase the efficiency of the detergent if the water is especially hard. If a water-softening additive is used, a nonprecipitating type is recommended to avoid buildup of precipitates on washer parts and items in the wash.

Disinfectant Disinfectants include pine oil, phenolics, chlorine bleach, and coal-tar derivatives. These items are used occasionally to disinfect sickroom garments and bed and bath linens. Any product with an EPA (Environmental Protection Agency) registration number on the label has met EPA requirements for disinfectants. Not all disinfectants with these ingredients will meet EPA requirements, so be sure to check the label.

Presoak Enzymatic presoaks are used to remove tough stains. These additives contain enzymes—such as protease (for protein stains), lipase (for fat stains), and amylase (for carbohydrate stains)—that aid in the removal of specific soils. Enzymatic presoaks require more time to work than most other additives, so a presoak of one-half hour or longer, even overnight, is recommended. Presoaks often include a builder and a surfactant to improve its performance. These additives are not safe with protein fibers such as silk, wool, and specialty wools.

Pretreatment Pretreatments are used to remove difficult stains. They usually are added directly to the stain shortly before the item is laundered. Pretreatment products contain a solvent, a surfactant, and a builder.

Starch or Sizing Starch or sizing is used after washing to add body and stiffness to fabrics. Laundry starch is seldom used today, but spray starches and sizings to be applied during ironing are available.

Bluing Bluing is a weak blue dye that masks yellowing in fabrics. Bluing is seldom used by itself but it may be present in detergents as a dye. Use of fluorescent whitening agents in detergents may make it unnecessary to add bluing.

Special Products There are many specialized products for cleaning for a variety of textile items. Products available in the fabric-care section of grocery and discount stores are designed for home use.

Compounds for cleaning items containing down minimize clumping of down and damage by alkaline detergents. Sometimes manufacturers' care labels suggest placing tennis balls or other objects in the dryer with down-filled items to minimize clumping. These items may cause problems: the rubber in the ball may not be sufficiently resistant to heat; dye may transfer; and balls may become wedged between the baffles and the bulkhead, creating expensive repair problems. Stopping the dryer periodically and shaking the item vigorously reduces clumping.

Special soaps and detergents for hand washing of wool and other items work in cooler water and remove body and other light soils and perspiration. Some detergents are formulated to remove baby formula and diaper-accident soils.

Compounds in powder or spray form remove stains from carpet and home or car upholstery and mask or neutralize odor. Other products retard the soiling of leather, upholstery, carpet, and outdoor textiles. Antistatic sprays minimize problems with static soiling from dust and lint. Still other sprays are available to remove odors from a variety of textile products, including upholstery, draperies, car interiors, carpets, and clothing. They incorporate ring-shaped organic chemicals that capture odor.

Specific laundry aids for removing grease and rust stains should be used with caution because they may damage fibers or may cause minor chemical burns when they come in contact with skin.

Laundry aids to absorb excess dye and color from soil are often cotton terrycloth that has been saturated with a chemical that scavenges color from the wash solution. The fabric with dye absorber is simply washed with any item that may be expected to bleed in the wash. With the increasing concern for health and environmental protection, some laundry compounds include all-natural ingredients. Others are free of perfume and dye. A final product incorporates compounds to remove dust mite matter from textiles—especially important to consumers who are allergic to dust mites.

Sorting

Before laundering, consumers should **sort** the items to be washed in order to minimize problems and remove soil as efficiently as possible. Sort by color, type of garment (for example, work garments separate from delicate items), type of soil, recommended care method, and propensity of fabrics to lint. Consumers should close zippers and buttons so they do not snag other items in the wash. Pockets should be checked for pens, tissues, and other items that may create problems during washing. Also check items for stains, holes, or tears and treat or repair as needed.

Washing

Most contemporary washing machines allow for easy use by providing predetermined wash cycles for today's textiles. Consumers can select wash and rinse water temperatures, agitation speeds, and time. But, spin speed, type of agitation, number of deep rinses, and other factors are determined by the washing-machine producer. Instruction booklets for each machine help the consumer understand more of the science of laundering; the machine's performance will be enhanced if these instructions are followed. Wash-cycle information for textiles is provided on care labels and should be followed to minimize dissatisfaction with laundry performance.

Horizontal- and Vertical-Axis Washing Machines

Traditional vertical-axis machines clean by agitating items in a pool of water with detergent and other additives. These machines are efficient at cleaning but consume large quantities of water and energy with every load washed. Because of this high energy and water consumption, the federal government has required that laundry equipment manufacturers change machine design to reduce energy and water use. Hence, horizontalaxis machines, common in Asia and Europe for years, are being introduced to the U.S. consumer. These machines clean by rotating clothes in a manner similar to that used in dryers. The items are tumbled through a shallow pool of water with detergent and other additives many times during the wash cycle. Savings are estimated to be 40 percent for water, 65 percent for energy, and 30 percent for drying, since extraction is so much better in the spin cycle. Specially formulated high-efficiency (HE) detergents should be used in the horizontal-axis machine.

Drying

The **drying** procedure usually is specified on the care label. Machine-drying is considered the most severe method because of the abrasion and agitation. Line drying also may be too severe for some items because wet fabrics are extremely heavy. Wool, rayon, and other fibers that are weaker when wet may be damaged if the item is hung to dry. Drying flat is the least severe method because the fabric is under little stress. Prototype microwave dryers are being consumer-tested for home use. These dryers may be available in the next few years and should cut drying time in half.

Vent-free dryers do not exhaust moisture-saturated air outdoors. They use a closed circuit in which air inside the dryer is heated and circulated among the wet items. The hot air absorbs moisture and passes through a heat exchanger, where the water is condensed and drained off. The air is reheated and the process continues until the items are dry.

Dry Cleaning

In dry cleaning, the solvents include the following: perchloroethylene (perc), a petroleum solvent (Stoddard's solvent), or a fluorocarbon solvent (Valclene or CFC 113). Of these, perc is most common. However, concerns regarding the toxicity and environmental impact of perc and Valclene have resulted in new efforts to find replacement solvents, and replacements are expected over the next several years. If asked, most dry cleaners will tell consumers what solvents they use. Many machine-washable items also may be dry cleaned.

A professional organization, the International Fabricare Institute (IFI), trains and educates dry cleaners, establishes a fair-claims adjustment guide for use in consumer complaints, and provides an evaluation service for members when problems develop. Members display an IFI plaque at their place of business.

When items are brought to the dry cleaners, they are identified with a tag that includes special instructions, the owner's identification number, and the number of pieces in the group. Items are inspected. Because a solvent is used, stains that are water-soluble and other hard-to-remove spots are treated at the spot board before cleaning. Customers who identify stains for the dry cleaner make the cleaning task easier and ultimately improve their satisfaction with the cleaned product.

After treatment at the spotting board, items are placed in the dry-cleaning unit to be tumbled with a charged solvent (solvent plus detergent plus a small percentage of water) (Figure 20–7). After tumbling, the

FIGURE 20-7
Dry-cleaning unit.

solvent may be reclaimed in the dry-to-dry unit or in a separate unit called a reclaimer. The reclaimer serves the same function as a dryer in laundering, except that the solvent is condensed and filtered to be used again. Reclaimers are being replaced with dry-to-dry units because reclaimers allow for too much solvent loss during transfer. Use of dry-to-dry units, more efficient equipment, and better management practices have reduced perc consumption substantially. Solvents are reclaimed to minimize environmental impact and because of their high cost. Filtering and distilling remove soil, color, odor, and other residue and allow the solvent to be reused many times.

After the items are dry, they go to the pressing area, where steam and special steam-air forms give a finished appearance to the item. For example, pants are pressed with a topper that presses the top part of the pants. Each leg is pressed separately with a press. Jackets, shirts, and blouses are finished with a suzie, a steam-body torso form (Figure 20–8).

Many dry cleaners also will replace buttons; make minor repairs to items; replace sizing, water repellency, and other finishes; add permanent creases to pants; and clean fur and leather. Some dry cleaners can also clean and sanitize feather pillows and clean and press draperies.

Many dry cleaners offer a combination service for wedding dresses that includes cleaning the gown, preparing it for storage, and providing a special box for storage. Although this service is appealing, it may not completely protect the gown from aging, and the dry cleaner may not use archival materials in the box or packing materials. Some specialty gowns with lots of bead and sequin trim may require a special cleaning process that was developed specifically for them. The process is expensive and time-consuming because most gowns must be sent away to undergo this special process.

Other unique items, such as quilts, old laces, and embroideries also require special care. Dry cleaners may refuse to work with some of these items if the dyes are not fast (a problem that may occur with pieced quilts and embroideries) or if the fabric is fragile, as it is with some old laces. Dry cleaners that work with unique or historic items of this nature may require a signed disclaimer form because of the fragile nature or use of incompatible materials.

Dry Cleaning of Leather and Fur

Products made of leather and fur, and those that contain these materials, should be cleaned by specialists because of their complex and special requirements. Leather and fur (furrier) dry cleaning must remove soil without damaging the dye or finish and restore oils that cleaning removes. This is a complex and expensive process. Wide variations in hides or skins and processing create potential problems for the consumer and dry cleaner. Frequently, the leather/fur cleaner is required to redye or refinish the item to restore it to a form that will satisfy the customer. Because of this additional processing, leather and fur cleaning is expensive. Most dry

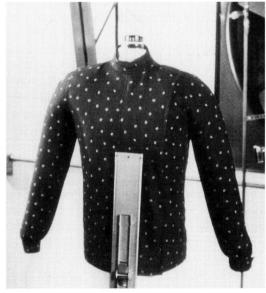

FIGURE 20-8
Pressing equipment: pants press (left); inflatable "suzie" for steaming blouses and shirts (right).

cleaners do not clean these items themselves but send them to a specialist.

Dry cleaners frequently see problems with leather dyes that are not fast to dry cleaning. This is especially common with high-fashion items and items that combine leather trim with woven or knit fabrics. The problem is more common with apparel because apparel items are more likely to have leather trim. However, furnishing items made of leather or trimmed in leather may also present problems in dry cleaning.

Home Solvent Cleaning

A product for freshening dry-clean-only items is available in a kit that includes a stain-removal solution, a bag for use in a home dryer, and a solvent-treated moist cloth. Consumers should test items for colorfastness before cleaning them. Consumers also should pretreat stains, place the moistened cloth in the bag with the garments, and place the bag in an otherwise empty dryer that is vented to the outside. Heat from the dryer activates the solvent, which removes light soil and some odor. Items need to be removed promptly and hung to minimize wrinkling. The product works best with lightly soiled items and items that do not require special care or pressing. Examples of such items include simple slacks and skirts and wool sweaters. The kit is not as effective as commercial dry cleaning, but it will decrease the number of times many products will need dry cleaning.

Professional Wet Cleaning

Because of concern about using organic solvents such as perc, **professional wet cleaning** is a commercial alternative to traditional dry cleaning for items labeled "dry clean only." This process is more complex than home laundering and requires training in selecting and using the proper technique.

Almost every type of dry-cleanable fabric can be wet-cleaned, provided there is careful control of temperature, mechanical action, moisture levels, soap, and other cleaning additives. Before cleaning, products are sorted by fabric type, not color; they are checked for the presence of water-soluble dyes; and stains are treated. The process is labor-intensive and uses controlled applications of heat, steam, and natural soaps to clean textiles and pressing techniques to restore the item's appearance. Even though water is used, these computer-controlled wet cleaning and drying machines differ from home washing machines and dryers. The item may not be fully immersed in water during the process. The cleaner selects from steam cleaning, spot removing, hand washing, gentle machine washing, tumble drying, and

vacuuming. Microwave drying is used to minimize shrinkage during drying. The method selected depends on the garment and fabric type, degree of soiling, and fabric condition. Research has found that approximately 80 percent of the items labeled "dry clean only" can be wet cleaned successfully.

Consumers have found that wet cleaning offers essentially the same cleaning potential as dry cleaning and especially appreciate the lack of solvent odor on wetcleaned items. Consumers also are pleased with the short-term effects on general cleanliness, shrinkage or stretching, and overall appearance; however, some shrinkage, wrinkling, and color loss may occur.

Because the process uses less-expensive equipment, less capital is needed to open a plant. Wet cleaning makes significant use of water and energy during the cleaning process, but there are fewer risks in terms of the flammability, health problems, and environmental contamination that are associated with traditional dry-cleaning solvents. To clean 100 items, wet cleaning uses only one-fourth to one-third the electricity and approximately 1.4 times more natural gas/steam and 1.2 times more water than dry cleaning. Discharge from wet-cleaning facilities has not created problems in water-treatment facilities.

Storage

Storage is another important aspect to consider for textile products. Most textile materials are placed in storage during one or more stages of their production. With quick response and just-in-time initiatives expected of producers and distribution centers, the amount of storage time in the production sequence has decreased for many items. Nevertheless, storage continues to generate concerns regarding the potential for damage that may occur. The conditions under which textile materials and products are stored may influence their appearance, quality, and performance. For example, natural fibers are stored from the time they are harvested until they are cleaned and processed into yarns. If storage conditions are poor, the fibers might develop mildew problems, become infested with insects, or discolor. Incorrect storage of finished fabrics or products may result in permanently set wrinkles, discoloration from contact with other materials and dye or print transfer, and damage from insects, mold, or heat. Storage concerns also relate to conditions in transportation and shipping, especially with so many items being produced offshore.

Most products should never be stored in direct contact with raw wood, raw wood products, wood finishes, brown paper, newspaper, or cardboard. Raw wood and wood pulp papers and cardboard produce acid as they

FIGURE 20-9

Yellowed cotton tablecloth stored next to wooden drawer bottom for several years.

age. Cellulosic fibers are degraded by acid, and brown or yellow stains may develop as a result of exposure to the wood (Figure 20–9). Plastic bags from dry cleaners are provided as a service to avoid soiling freshly cleaned items during transport. These bags often incorporate phenolic antioxidants and are not intended for storage. They should be discarded immediately after the product is brought into the house. Items stored in dry-cleaning bags may discolor because of the materials in the bag; build up static and attract dust; or trap moisture, creating an ideal environment for mildew. For more information regarding storage, see the appropriate fiber chapter.

Other Cleaning Methods

This section discusses methods of cleaning carpets and upholstery. Table 20–3 lists upholstery cleaning codes.

TABLE 20-3 Upholstery cleaning codes.

- W Use water-based upholstery cleaner only.
- S Use solvent-based upholstery cleaner only.
- WS Can use either water- or solvent-based upholstery cleaner.
- X Do not clean with either water- or solvent-based upholstery cleaner; use vacuuming or light brushing only.

Vacuuming

Vacuuming is the most common and important method of cleaning carpets. Vacuuming removes soil that has not adhered to the fibers, especially particulate soil such as dust, lint, and dirt. Large particles such as small rocks and paper clips may not be removed by vacuuming and may need to be swept or picked up by hand. Vacuuming also is used to remove dust and soil from upholstered furniture and wall and window coverings. However, remember that vacuuming removes only particulate soil. Other types of soil must be removed by other means. For industrial and commercial carpets, the vacuum cleaner must have a heavy-duty rating so that it cleans deeply into the surface pile and can withstand frequent, heavy use. Most home vacuum cleaners are not of this type.

On any carpet, localized spots and stains should be treated as soon as possible after soiling. Carpet manufacturers provide a list of recommended cleaning compounds for specific stains. If carpets accumulate oily soils or airborne dust and dirt that is not removed with regular vacuuming, corrective action should be taken. A variety of procedures are discussed in this chapter. However, before attempting any of these other methods, a thorough vacuuming should be done first to remove surface soil and separate and loosen packed pile.

Wet Cleaning

Wet cleaning or shampooing of carpets is a method that uses water-based detergents and may require a long time to dry. A diluted water-detergent solution is worked into the pile with rotating brushes (thus, this method also is referred to as the rotary brush method). A thorough wet vacuuming follows, to remove the soil-laden solution. Some carpets may require several days before they are completely dry. Testing the cleaning solution on an inconspicuous area of the carpet is recommended before the entire surface is cleaned in this manner.

Over-wetting carpets can cause fading and shrinkage. Solutions may not be completely removed, causing brown stains to appear on the surface of the pile yarns. Brush action may permanently distort pile yarns. Choose detergents that prevent dulling of the surface of the carpet, minimize rapid resoiling of the carpet, avoid creating problems with static electricity, and disinfect the carpet. After wet cleaning, problems with static electricity may develop if a water-based antistatic agent was originally applied to the carpet and not restored after wet cleaning. If compounds containing chlorine, such as bleach, are added to the shampoo, a yellow discoloration may appear on the carpet. This is a real problem in communities where chlorine is used to treat the water.

Dry-Foam Cleaning

Dry foam cleaning or aerosol cleaning of carpet is done by hand with a foam sprayed onto the carpet or by employing a machine that deposits a detergent solution as a foam on the carpet just ahead of an agitating brush. The brush works the solution into the carpet, loosens soil particles, suspends them in the foam, and the vacuum removes the soil. The application of the foam, agitation, and vacuuming can be almost simultaneous. Hence, complete wetting of the carpet is avoided. Dry foam cleaning does not remove deeply embedded soil because the solution works more on the surface. Dry foam processes allow the carpet to be used soon after cleaning, often within the hour. Dry foam also may be used to clean upholstery.

Hot-Water Extraction

In the hot-water extraction method a hot-water-detergent solution is injected into the carpet. The solution is under pressure and wets the carpet quickly but is removed almost immediately by a vacuum. As the water is removed by vacuuming, so too is the soil. Overwetting of the carpet occurs if an area is treated too slowly. To minimize rapid resoiling, the detergent must be completely removed. Since no brushes are used in this process, pile distortion is minimized. Although sometimes referred to as steam cleaning, no steam is used in the process.

Powder Cleaners

Powder cleaners are absorbent powders combining detergents and solvents. The powder is applied in a dry form, sprinkled on the surface of the carpet or upholstery and brushed or otherwise worked into the pile. The powder combines with the soil and holds it in suspension until it is removed by vacuuming. The powder should remain in contact with the fabric's surface for a brief time before being removed by vacuuming. The method is fast, requires no time for drying, but removes surface soil only. Pile distortion is related to the vigor with which the powder is worked into the pile. This method is also known as dry extraction cleaning, absorbent powder cleaning, or absorbent compound cleaning.

Ultrasonic Cleaning

Ultrasonic cleaning requires that the carpet be removed from the use site and taken to a special cleaning facility. High-frequency sound waves attract the soil and remove it from the carpet fibers. At present, this method is not used on carpets that cannot be removed from the location. Ultrasonic cleaning in conjunction with water-

based and solvent-and-water-based systems is being investigated as an alternative to solvent dry cleaning.

Conservation Practices

Vintage and collectible textiles in private and museum collections require different methods of handling, cleaning, and storage because many are one-of-a-kind, irreplaceable items. Conservators use special techniques that require training, specialized equipment, and mild chemicals.

These special textiles are analyzed in detail before cleaning to determine fiber content, type of other materials present, condition, and colorfastness of all colors and materials to water and detergent. Cleaning normally includes hand removal of particulate soil and lint, carefully controlled vacuuming, supported immersion soak in a solution of warm water and mild detergent, and flat drying. The goal of cleaning in conservation is not the same as in the other processes discussed in this chapter. Conservation cleaning removes harmful materials from the textile, but stains and soil may remain once cleaning has been completed. Harsh and potentially damaging spot-removal agents and bleach are rarely used in conservation cleaning because they threaten the integrity of the item.

Proper storage is especially important for these textiles since they will spend most of their time in storage. Techniques that protect items from light, dust, insects, abrasion, tension, environmental pollution, and changes in temperature and humidity are used. Materials that neutralize damaging byproducts of aging and provide protection from the surrounding environment support and cushion each item individually.

Environmental Impact of Cleaning

The environmental impact of cleaning textile products is profound and multidimensional. The newer drycleaning solvents that have replaced highly flammable ones have been linked to cancer and environmental hazards. In addition, ground contamination by drycleaning solvents leads to contamination of water systems. Several communities have experienced problems with perc contamination of water because of accidental or deliberate spills. Therefore, dry cleaners have modified the way they handle perc. Cleaners also have changed the handling of all items cleaned with any solvent and are converting to dry-to-dry equipment to minimize the loss of solvent by evaporation.

Phosphate builders in laundry detergents have been largely replaced in the United States and Europe be-

cause of their suspected contribution to accelerated eutrophication of ponds and lakes; but research from Sweden indicates that these builders may have the least impact on the environment as compared with other builders when one also considers the costs and efficiency of water treatment. Phosphate builders generally have not been restricted or banned in other cleaning compounds, such as bathroom cleansers and dishwashing detergents. Bans on phosphates in detergents have had little effect on the problems with water systems that the bans were designed to address.

In the 1960s detergent manufacturers voluntarily switched to biodegradable surfactants. Manufacturers have changed formulations of detergents to concentrated ultra forms for liquids and powders, which incorporate smaller amounts of builder and filler and require

less packaging. In addition, recycled plastic and paper packaging is used. Refillable containers decrease the use of packaging materials even more. Some ingredients in the new formulations are multifunctional. This decreases the number of ingredients and reduces the environmental impact of producing many different ingredients to be combined in laundry detergents. In addition, the ultra formulations decrease transportation costs.

Each load of home laundry consumes between 35 and 50 gallons of water and a significant amount of energy in washing and drying. Few consumers hang items to air dry. Concerns with the high amounts of energy and water use have prompted development of horizontal-axis washing machines, which use less water and energy. New microwave dryers should decrease the energy consumed in drying textiles.

Key Terms

Care
Soil
Detergency
Detergent
Soap
Solvent
Water
Surfactant
Builder
Enzyme

Color-transfer inhibitor Antifading agent

Dye-transfer inhibitor

Filler

Antiredeposition agent

Perfume

Fluorescent whitening agent Soil release polymer

Bleach

Fabric softener
Water softener
Disinfectant
Pretreatment
Starch
Sorting
Drying
Dry cleaning
Leather cleaning
Fur cleaning

Professional wet cleaning

Storage

Vacuuming

Wet cleaning (shampooing)

Dry foam cleaning Hot-water extraction Powder cleaner Ultrasonic cleaning Conservation

Questions

- Define detergency, and explain what happens when a soiled textile product is cleaned.
- Explain how a soap can be adversely affected by hard water.
- 3. Why is water used in laundering and many other methods of cleaning?
- 4. How does dry cleaning differ from laundering?
- Identify the ingredients and their function that may be present in your favorite laundry detergent.
- 6. What ingredients have been incorporated in one container to make doing the laundry easier?

- 7. How does carpet or upholstery cleaning differ from laundering? How should one select a specific method?
- **8.** What effect has environmental concern had on how textile products are cleaned?
- 9. What textile problems can develop during storage?

Suggested Readings

American Association of Textile Chemists and Colorists (1996). *Technical Manual*, 71. Research Triangle Park, NC: author.

Dry cleaning. (1994). *Textiles Magazine*, no. 2, pp. 11–13. Environment Canada Staff and Green Clean Project
Participants (1995, October). Final Report of the Green Clean™ Project. Toronto, Ontario, Canada.

Keesee, S. H., and Wentz, M. (1999). Dynamics of change in professional garment cleaning. *Textile Chemist and Colorist and American Dyestuff Reporter*, 1(4), 38–40.

Kesselring, J., and Gillman, R. (1997, January-February). Horizontal-axis washing machines. *EPRI Journal*, pp. 38–40.

Lumley, A. C., and Gatewood, B. M. (1998). Effectiveness of selected laundry disks in removing soil and stains from cotton and polyester. *Textile Chemist and Colorist*, 30(12), 31–35.

McCoy, M. (2000, January 24). Soaps and detergents. Chemical and Engineering News, pp. 37–46. (Each January, this journal has an in-depth article on soaps and detergents.)

Novina, T. (1993, April). Breakthrough in care of colored cotton. *America's Textiles International*, p. 96.

Perkins, W. S. (1998, August). Surfactants—a primer. America's Textiles International, pp. 51–54.

Reznikoff, S. C. (1989). Specifications of Commercial Interiors. New York: Whitney Library of Design.

LEGAL AND ENVIRONMENTAL CONCERNS

Chapter 21

OBJECTIVES

- To understand laws and regulations related to textiles and textile products.
- To understand federal requirements for labeling textiles and textile products.
- To understand professional and consumer rights and responsibilities in terms of legal and environmental concerns.
- To recognize how textiles and textile products affect the environment.
- To realize efforts within the textile industry to minimize environmental, safety, and health problems related to the production, use, and care of textiles and textile products.

he textile industry is affected by federal regulations and laws related to fair trade practices, information labeling, worker and consumer safety, and environmental protection. Laws and regulations will continue to affect the textile industry in the areas of general operations, label requirements, environmental issues, design aspects, and health and safety concerns. This chapter focuses on the pertinent laws and regulations. It is beneficial to understand how these issues affect the industry and to recognize where professional responsibilities imply legal responsibility.

Laws and Regulations

This chapter discusses U.S. laws and regulations. Many countries have laws or regulations of a similar nature, but specific details often differ. In addition, this discussion encompasses only those U.S. laws and regulations that relate to producing safe products and providing the consumer with product information. It does not include laws and regulations regarding import/export and other trade practices. Professionals need to know, understand, and abide by all laws and regulations related to label requirements for textiles and textile products in any country in which they work. Many regulations and laws relating to textiles and textile products focus on providing the ultimate consumers with information so that they are better prepared to make decisions regarding purchase, use, and care of textile products (Figure 21–1). In general, the interpretation and enforcement of these laws and regulations are the responsibility of the Federal Trade Commission (FTC). The activities of the FTC are designed to protect not only the ultimate consumer, but also legitimate segments of the industry itself. The

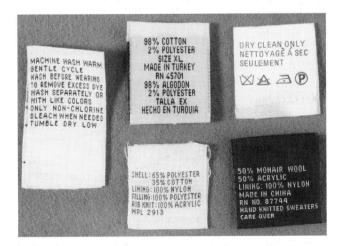

FIGURE 21-1 Garment labels.

FTC is responsible for preventing unfair or deceptive trade practices, e.g., the marketing of a rayon/polyester blend crash in such a way as to suggest that it was made of flax, implied by the use of the term *linen*. Trade publications frequently carry articles describing current efforts of the FTC to prevent unfair or deceptive trade practices in the industry.

The first four laws and regulations deal with "truthin-fabrics." For these to be beneficial, the consumer must have some knowledge about fibers and fabrics.

Silk Regulation, 1932

Silk may be weighted (treated with a solution of metallic salts) to increase the fabric's weight and hand and improve its dyeability. However, weighted silk is not as durable as regular silk, and it wrinkles more easily. Because of these problems, the FTC ruled in 1932 that anything labeled **pure silk** or **pure dye silk** could contain no more than 15 percent weighting for black and no more than 10 percent for all other colors. Anything exceeding these levels is weighted silk. At present, very little silk on the market is weighted. However, museum collections have many weighted silk items that are disintegrating and shattering.

Wool Products Labeling Act, 1939 (Amended 1986)

Wool may be blended with less expensive fibers to reduce the cost of the fabric or to extend its use. The Wool Products Labeling Act of 1939 (amended in 1986) was designed to protect consumers as well as producers, manufacturers, and distributors from the unrevealed presence of substitutes and mixtures and to inform the consumer of the source of the wool fiber. This act applies to any textile product containing wool, unless otherwise exempt. Major exemptions include carpets, rugs, mats, and upholstery. The law requires that the label must give the fiber content in terms of percentage and the fiber source. The term fur fiber can be used for the fiber from any animal other than sheep, lamb, angora goat, cashmere goat, camel, alpaca, llama, and vicuña. Under the act, the fiber produced from those animals can be referred to as wool. The name of the manufacturer or the registered identification number of the manufacturer also must be on the label. The registered number is designated WPL or RN. The WPL number is the wool product label number, and RN number is the registered number. Finally, the act requires that the label list the name of the country where the product was manufactured or processed. These labels must be sewn into the item; their location is designated in the act. The act does not state or imply anything regarding the quality of the fibers used in the product. Consumers must rely on their knowledge to determine the quality and suitability of the product.

The terms that appear on the labels of wool items are defined by the FTC as follows:

- 1. Wool—new wool or wool fibers reclaimed from knit scraps, broken thread, and noils. (Noils are short fibers combed out in the making of worsted wool.)
- Recycled wool—scraps of new woven or felted fabrics that are garnetted or shredded back to the fibrous state and used again in the manufacture of woolens.
- 3. Virgin wool—wool that has never been processed in any way; thus knit clips and broken yarns cannot be labeled virgin wool.

Fur Products Labeling Act, 1952 (Amended 1980)

The Fur Products Labeling Act applies to furs—items of animal origin with the hair/fiber attached. The act requires that the true English language name of the animal be used on labels for wearing apparel and that dyed furs be so labeled. In addition, the country of origin must be identified. The presence of used, damaged, or scrap fur must also be identified. The act has been amended to identify animals by name and has expanded the list of modifications to the natural fur to include tip dyeing, pointing (coloring the tips of the guard hairs), and other means of artificially altering the color or appearance of the fur. This law does not provide for a quality designation; poor-quality fur is available.

The law protects consumers from buying furs sold under names implying expensive furs. For example, prior to this law, rabbit was sold under such highly imaginative and blatantly false names as lapin, chinchilette, ermaline, northern seal, marmink, Australian seal, Belgian beaver, and Baltic leopard. "Hudson seal" was muskrat plucked and dyed to look like seal.

Textile Fiber Products Identification Act, 1960 (Amended)

In 1958 Congress passed legislation to regulate the labeling of textiles in order to protect consumers through the enforcement of ethical practices and to protect producers from unfair competition resulting from the unrevealed presence of substitute materials in textile products. The **Textile Fiber Products Identification Act** (TFPIA) covers all fibers except those already covered by the Wool Products Labeling Act, with certain other exceptions.

Although the law was passed in 1958, it became effective in 1960. The list of manufactured fiber generic names in Table 6–1 was established by the FTC in cooperation with the fiber producers. This list is updated when new generic fiber names are approved. A **generic name** is the name of a family of fibers all having similar chemical composition. (Definitions of these generic names are included with the discussion of each fiber.)

TFPIA does not require that the label be sewn into the item, but that the information be available at the point of sale. Hangtags or printed packaging materials like those used for some garments or bedding may list fiber content. Hangtags may combine fiber-content information as required by TFPIA with such promotional information as suggested price, size, style number, trade name, or trademark. Since hangtags are removed before use and often discarded or lost, many manufacturers combine fiber-content information with other required information and sew it into the item as a permanent label. Often, care instructions, manufacturer identification information, and fiber content are combined into one label (see Figure 21–1).

The following information is required, in English, on the label of most textile items, including apparel, outer coverings of furniture and mattresses/box springs, bedding, and toweling.

1. The percentage of each natural or manufactured fiber present must be listed in the order of predominance by weight and correct within a tolerance of 3 percent. This means that if the label states a fiber content of 50 percent cotton, the minimum can be no less than 47 percent and the maximum can be no more than 53 percent.

If a fiber or fibers represent less than 5 percent by weight of the item, the fiber cannot be named unless it has a clearly established and definite functional significance. When the fiber has a definite function, the generic name, percentage by weight, and functional significance must be listed. For example, a garment that has a small amount of spandex may have a label that reads "96% Nylon, 4% Spandex for elasticity."

- 2. The name of the manufacturer or the company's registered WPL or RN number must be stated. Often the company's registered number is listed with the letters and the number. (Trademarks may serve as identification, but they are not required information. A trademark may be listed with the generic fiber name.)
- **3.** The first time a trademark appears in the required information, it must appear in immediate conjunction with the generic name and in type or lettering of equal size and conspicuousness. When the trade-

- mark is used elsewhere on the label, the generic name must accompany it in legible and conspicuous type the first time it appears.
- 4. The name of the country where the product was processed or manufactured must be stated, such as "Made in USA." Country of origin is identified as the country where the item was assembled. That can be very confusing since the law allows labels to identify when products have been made of components assembled elsewhere. For example, jeans may be labeled "Made in USA" if they were completely assembled in the United States from domestic fabric. If the most labor-intensive parts were assembled in Jamaica, the jeans would be labeled "Made in USA of imported components" or "Made in USA of components made in Jamaica." For fabrics, country of origin refers specifically to the country where the fabric was finished. Jeans made in the United States from imported fabric would be labeled "Made in USA of imported fabric."

Permanent Care Labeling Regulation, 1972 (Amended 1984)

In 1971 the Federal Trade Commission issued the Care Labeling Regulation. Because of some problems with the regulation, an amended version became effective in 1984. The rule requires manufacturers or importers of textile wearing apparel and certain piece goods to provide an accurate, permanent label or tag that contains regular-care information and instructions (about washing, drying, ironing, bleaching, warnings, and dry cleaning) and that is permanently attached and legible. The regulation specifies the location of the label by product type. For example, labels for most shirts and blouses should be attached at the center back neckline. Pants and trouser labels should be at the center back waistband.

The regulation was developed because of consumer complaints regarding care instructions. Various revisions of the rule have required more specific, detailed information concerning only one care method for a product. The label should use common terms that have a standard meaning (see Table 20–1). The instructions must be described in carefully defined words or in standard symbols (Figure 21–2). When products are produced offshore and sold in the United States, they must meet U.S. care-labeling requirements. When a label identifies washing, it must state the washing method, water temperature, drying method, drying temperature, and ironing temperature, when ironing is necessary. Procedures to be avoided must be identified, such as "Only nonchlorine bleach, when necessary." If multiple

care methods are appropriate for that product, the manufacturer is not required to list them on the label. If the care-label instructions are followed and some problem develops during care, the manufacturer is liable. However, if the care-label instructions are not followed, the manufacturer is not liable for any problems caused by improper care.

The rule applies to most apparel. It does not apply to leather, suede, fur garments, ties, belts, and other apparel not used to cover or protect a part of the body. Certain other apparel items, such as reversible garments, are required only to have removable, not permanent, care labels. For piece goods, the information must be supplied on the end of the bolt, but neither the manufacturer nor the retailer is required to provide a label to be sewn to the finished product. The rule does not apply to remnants. Although furnishing textiles are not required to have care labels, voluntary care labels appear on most sheets, towels, and other items.

The Federal Trade Commission and the International Fabricare Institute (IFI) work together to identify problems with compliance with the labeling regulation and to minimize future problems with inadequate and incorrect care labels. The IFI had found that many problems encountered in cleaning are due to faulty or misleading care labels.

Laws and Regulations Related to Safety

Laws and regulations dealing with textile products and safety issues generally require that selected textile products meet a predetermined level of performance in terms of flammability. The procedure for flammability testing and a pass/fail scale identifying acceptable performance are included in these laws and regulations. Federal regulations often are referred to by the designation CFR (Code of Federal Regulations), with the identifying numbers indicating the product category into which they fall (Table 21-1). Various governmental agencies are responsible for the enforcement of these safety standards, including the Consumer Product Safety Commission (CPSC, a subdivision of the FTC) and the Department of Transportation. These performance requirements may be identified as part of federal, state, or local building codes for interior furnishings for publicuse areas. However, when more stringent requirements are identified, these must be met by any textile product used in a structure.

Flammable Fabrics Act, 1953, and Its Amendment

Congress enacted the first national law dealing with flammable fabrics in 1953, following several deaths from

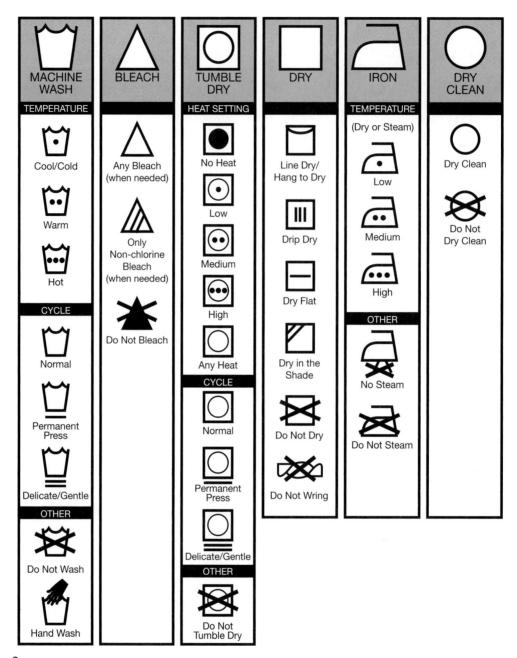

FIGURE 21–2
Care symbols. (Courtesy of the Soap and Detergent Association.)

fire involving apparel. The Flammable Fabrics Act prohibits the marketing of dangerously flammable material, including all wearing apparel, regardless of fiber content or construction. The act covers both imported items and those in interstate commerce. One purpose of the law was to develop standards and tests to separate dangerously flammable fabrics from normally combustible ones.

The act was amended in 1967 to cover a broader range of apparel and furnishings. In 1972 the Consumer Product Safety Act was passed, establishing the Consumer Product Safety Commission (CPSC), which has broad jurisdiction over consumer safety. The responsibilities and functions, as stipulated in the Flammable Fabrics Act, were transferred to the CPSC. Federal standards were established under the direction

TABLE 21–1 product.	Flammability categories of	
Designation	Product Category	
16 CFR 1610	Clothing textiles	
16 CFR 1611	Vinyl plastic films used in appare	
16 CFR 1615	Children's sleepwear, sizes 0-6X	
16 CFR 1616	Children's sleepwear, sizes 7-14	
16 CFR 1630	Large carpets and rugs	
16 CFR 1631	Small carpets and rugs	
16 CFR 1632	Mattresses and mattress pads	

of the Department of Commerce and later under the CPSC as shown in Table 21–2. These standards and/or test methods may be modified in the future, depending on further research and evaluation.

It takes considerable time to develop a standard. First, facts must be collected to indicate a need. Then a notice is published in the *Federal Register* that there is a need for a standard. Interested persons are asked to respond. Test methods are developed and published in a second notice. A final notice, which includes details of the standard and test method, is published with the effective date of compliance. One year is usually allowed so that merchandise that does not meet the standard can be sold or otherwise disposed of, and new merchandise can be altered as necessary to meet the standard.

Over the past several years, the CPSC has recalled several dangerously flammable garments that did not meet performance requirements. Sweatshirts, skirts, and jackets made from a fleece-type fabric and lined rayon and imported rayon/cotton chiffon skirts are some of the items recalled.

Mandatory standards have been issued for children's sleepwear, sizes 0 to 6X and 7 to 14, large and small carpets and rugs, and mattresses and mattress pads. The **Upholstered Furniture Action Council (UFAC)** has issued voluntary standards for upholstered furniture. Figure 21–3 shows a UFAC label.

Some cities and states have established standards for additional textile items. Various sectors of the industry have adopted voluntary standards for items such as tents, blankets, and career clothing for people who work near open flame.

Assessment of Textile Flammability Because of space restrictions, summaries of procedures and pass/fail scales are given here rather than full specifications. The type of textile product category determines the procedure and pass/fail scale used to assess performance. These procedures are described briefly because flamma-

bility is the only performance category specifically identified by federal law because it deals with human safety.

For large and small carpets and rugs, the methenamine pill test is required by CFR 1630. In this procedure, a piece of carpet 9 inches in diameter is placed in the bottom of an enclosed cube (open on the top) and held in place by a metal template with an 8-inch-diameter opening. The methenamine pill is placed in the center of the carpet sample and ignited. Samples that burn to within 1 inch of the metal template fail. Eight samples are tested and seven must pass for the carpet or rug to pass the test (Figure 21–4).

The Steiner tunnel test is another procedure used to assess carpet and rug flammability. It is required by many state codes and some federal agencies. In this procedure, a much larger sample (24 feet long, 20 inches wide) is placed on the ceiling of a tunnel. A double gas jet burns for 10 minutes while an air draft pulls the flame into the carpet tunnel for a distance of approximately 4 feet. The distance the carpet sample burns is used to assess the flame-spread rating. Flame-spread ratings are based on a 100-point rating scale, where 0 represents materials that will not burn and 100 represents the flammability of red oak flooring (classification A, flame spread 1 to 25; B, flame spread 26 to 75; C, flame spread 76 to 200).

The flooring radiant panel test is a third procedure used to assess carpet and rug flammability. This test is used by many federal agencies. In this procedure, a sample 39 inches long by 8 inches wide is mounted horizontally, preheated, and ignited. The burn distance is measured and converted into a flame-spread index. Higher numbers indicate greater resistance to flame spread and therefore greater safety.

Children's sleepwear testing requires that the fabric meet minimum flammability performance standards after 50 care cycles in order for products to be sold. The procedures are similar for 16 CFR 1615 and 16 CFR 1616. In both cases, the fabric is suspended vertically in a draft-free cabinet and exposed to an ignition flame for 3 seconds. Pass/fail ratings are based on burn time and burn length.

Regular apparel covered by 16 CFR 1610 is tested at a 45-degree angle (see Figure 21–5). Ignition is not necessarily guaranteed, since the ignition time is 1 second. Based on burning behavior, fabrics are classified as Class 1 (fabrics suitable for apparel, with a flame spread time greater than 7 seconds), Class 2 (fabrics suitable for apparel, with intermediate flame spread), and Class 3 (fabrics unsuitable for apparel, with flame spreads of less than 3.5 seconds). There are distinctions within the class ratings for brushed-surface fabrics that are not included in this discussion.

Because of concern about the flammability of upholstered furniture used by consumers, the Upholstered

Effective Date	Item	Requirements	Test Method
1954	Flammability of clothing Title 16 CFR 1610 (formerly CS 191–53)	Articles of wearing apparel except interlining fabrics, certain hats, gloves, footwear.	A 2 × 6 inch fabric placed in a holder at a 45-degree angle exposed to flame for 1 second will not burn the length of the sample in less than 3.5 seconds for smooth fabrics or 4.0 seconds for napped.
1954	Flammability of vinyl plastic film Title 16 CFR 1611 (formerly CS 192–53)	Vinyl-plastic film for wearing apparel.	A piece of film placed in a holder at a 45-degree angle will not burn faster than 1.2 inches per second.
1971	Large carpets and rugs Title CFR 1630 (formerly DOC FF1–70)	Carpets with one dimension greater than 6 feet and a surface area greater than 24 square feet. Excludes vinyl tile, asphalt tile, and linoleum. All items must meet standards.	"Pill" test: 9×9 inch specimens exposed to methenamine table placed in center of each specimen does not char more than 3 inches in any direction.
1971	Small carpets and rugs Title 167 CFR 1631 (formerly DOC FF2–70)	Carpets with no dimension greater than 6 feet and a surface area no greater than 24 square feet. May be sold if they do not meet standards if labeled: Flammable. (Fails U.S. Department of Commerce Standard FF2-70.)	Same as for large carpets and rugs.
1972	Children's sleepwear, sizes 0–6X Title 16 CFR 1615 (formerly DOC FF3–71)	Any item of wearing apparel up to and including size 6X, such as nightgowns, pajamas, or other items intended to be worn for sleeping. Excludes diapers and standard underwear. All items must meet requirements as produced and after 50 washings and dryings.	"Vertical Forced Ignition" test. Each of five 3.5 × 10 inch fabrics is suspended vertically in holders in a cabinet and exposed to a gas flame along the bottom edge for 3 seconds Specimens cannot have average char length of more than 7 inches.
1973	Mattresses (and mattress pads) Title 16 CFR 1632 (formerly DOC FF4–72)	Ticking filled with a resilient material intended for sleeping upon, including mattress pads. Excludes pillows, box springs, sleeping bags, and upholstered furniture. All items must meet standards.	"Cigarette" test. A minimum of 9 cigarettes allowed to burn on smooth top, edge, and quilted locations of bare mattress. Cha length must not be more than inches in any direction from any cigarette. Tests also conducted with 9 cigarettes placed between two sheets on the mattress surface.
1975	Children's sleepwear, sizes 7–14 Title 16 CFR 1616 (formerly DOC FF5–74)	Same as preceding. All items must meet standards.	Same as preceding.

Furniture Action Council has developed a voluntary flame-retardant upholstery standard. Two categories of ignition propensity are identified. Class I, the safer category, indicates no ignition occurred in the fabric classification test and char lengths were less than 1.75 inches. Class II identifies fabrics that ignited in the fabric classification test. A hangtag is used to indicate the flammability rating.

FIGURE 21-3

UFAC label. (Courtesy of the Upholstered Furniture Action Council.)

In addition to the voluntary UFAC program, interior furnishings are regulated by several federal departments and agencies. The Department of Health, Education, and Welfare sets fire-safety standards for health-care facilities.

Several states are considering including in their fire codes California's standards to limit fires related to upholstered furniture, especially the incorporation of a **fire block** layer in upholstered furniture and mattresses to minimize their flammability.

Federal Insecticide, Fungicide, and Rodenticide Act (FIFRA)

The Federal Insecticide, Fungicide, and Rodenticide Act (FIFRA), administered by the Environmental Protection Agency (EPA), may apply to textile products that incorporate antibacterial or antimicrobial agents such as fiber additives or finishes. This act requires that product labels provide information regarding content and safety precautions.

FIGURE 21-5

The 45-degree angle test for apparel. (Courtesy of Atlas Electric Devices Co.)

Other Label Information

Mandatory and Voluntary Labeling Programs

Mandatory labeling describes acceptable and legal commercial practices for companies to follow. The law requires that the information be available and accurate, but requirements do not extend beyond that. Mandatory labeling includes care labels and fiber-content information as specified in several laws.

FIGURE 21-4

The methenamine pill test for carpets.

Voluntary practices and labeling programs are often used in marketing textile products. Voluntary programs include certification, licensing, and warranty programs, and trademarks and trade names. In many cases, a voluntary program also implies a quality-control program, since products must meet company performance and quality specifications.

Warranties can be implied or written. Implied warranties indicate that the product is suitable for the purpose for which it was marketed. For example, an implied warranty for a raincoat suggests that it will not shrink significantly when wet. The written warranties offered for some apparel and furnishing items are legally binding and imply performance at a predetermined level.

Licensing describes the situation in which one company legally uses another company's trademarks and expertise to make, use, and/or sell a product. Licensing agreements usually are restricted to specific geographic areas. For example, Company A has a licensing agreement with Company B to produce and sell in the United States a print featuring one of Company B's cartoon characters. Company A cannot sell the print outside the United States, nor can it incorporate another character in the print without negotiating another licensing agreement with Company B.

Certification programs describe agreements between fiber and fabric producers regarding product performance and trade names or trademarks. A fabric manufacturer must demonstrate that a fabric meets specified end-use performance requirements as identified by the fiber producer before the end product can be certified. For example, pillows marketed with a company's certification mark first must be tested to verify that the pillows meet its end-use specifications.

A fiber may be given a **trade name** or **trademark** that distinguishes the fiber from other fibers of the same generic family that are made and sold by other producers. A producer may adopt a single trade name, word, or symbol, which may be used to cover all (or a large group) of the fibers made by that company. Trade names are often protected by quality-control programs.

The fiber producer assumes the responsibility for promoting the fiber. The company must sell not only to its customers, the manufacturers and retailers, but also to their customer's customer—the consumer. Trademarks and trade names for finishes, yarns, and fabrics are used for the same reason as for fibers.

Codes

Codes are systematic bodies of laws or regulations that enforce adequate standards of practice and uniformity of work. Codes generally provide minimum levels of performance and are designed to ensure safety for people who live, work, shop, or otherwise use these buildings. All too often codes are developed following a tragedy that results in great loss of life, such as night club or hotel fires. Federal, state, and local city or county codes for interiors often include in their purview such textile products as upholstery, wall and floor coverings, and window-treatment fabrics. Frequently, codes deal with fire prevention and control the flammability of textiles used in interiors. Most fire-prevention regulations are based on occupancy classification (business, apartment, industrial, mercantile, health care, educational, etc.); fuel-load classification (museum, office building, retail shop, paint shop, warehouse, mobile home, underground structure, etc.); occupancy load (number of people); and type of occupancy (adults, children, elderly, or physically disabled). Unfortunately, building codes from the various agencies and government groups are not uniform. For example, federal agencies have adopted the Unified Building Code (UBC) and all standards and codes of the National Fire Protection Association (NFPA) and the American National Standards Institute (ANSI). However, county, city, and state codes often reflect situations that may be unique to their geographic region, such as specific codes for high-rise apartment and office buildings.

The jurisdiction of codes depends on several factors, briefly discussed here. In general, federal codes are applicable to federal buildings or those built with federal funds, such as hospitals. State codes apply to state-owned buildings such as schools, state hospitals, and public buildings where large crowds are common. City and county codes often are incorporated in zoning ordinances. If two codes are applicable in a specific situation, the more stringent code prevails. Designers need to be sure that the textile products they select meet the specified code requirements. This may mean that products be tested following the standard procedure specified in the code and that adequate performance records be kept.

In addition to knowing code requirements, designers should check with insurance company representatives early in the design process, since their decisions may significantly affect insurance rates for interiors. Designers must know that some finishes and fabrication methods may interfere with inherently flame-retardant fiber characteristics. All products, including those made from inherently flame-retardant fibers, should be tested to ensure that they meet code requirements. For example, the toxicity rule for the state of New York requires that companies register their products with the state if they wish to sell in New York. This rule has fire-gas toxicity ratings for carpets and for curtains, draperies, and wall coverings. The registration system removes the requirement of having each fabric individually tested at a substantial cost per fabric.

Codes applicable to upholstery fabrics include those listed for window-treatment fabrics. The procedures listed in these codes assess flammability by several methods. However, all regulate the length of time allowed for self-extinguishment of the flame and afterglow. The methods also identify the maximum allowable length or area of fabric that may burn or char during the test. Samples tested include pieces of fabric, mock-ups of the upholstery and padding, and full-scale tests that use a real piece of upholstered furniture.

Wall coverings are rated for flammability, durability, and stain resistance and, depending on the applicable code, may need to meet any or all requirements. Window treatments usually are not regulated by codes, but those that cover more than 10 percent of the wall area may be considered an interior finish. The codes most often cited for window-treatment fabrics are those of the cities of Boston and New York, the state of California, and the commonwealth of Massachusetts.

The NFPA 701 Small Scale Test and the NFPA 702 Large Scale Test are used to assess the flammability of curtains, draperies, upholstery, and wall coverings. In these procedures, the sample is ignited and afterflame and length of char for both warp and filling directions are measured. The length of afterflame cannot exceed 2 seconds. In the large-scale test, dripping also is assessed. In the small-scale test, length of permissible char depends on fabric weight; in the large-scale test, it cannot exceed 10 inches, or 35 inches if the fabric is folded.

Interior textiles in airplanes and motor vehicles are regulated by the Federal Aviation Administration and the Department of Transportation, respectively. Flame retardancy is mandated for all textiles used in these interiors, including seat cushions and backs, seat belts, and interior roof, side, and wall panels. The standard also extends to other items to augment the crashworthiness and emergency evacuation equipment of airplanes.

Tort

The category of **torts** includes behaviors that interfere with personal rights. Torts generally are categorized as either negligence or intentional torts. Negligence torts include substandard performance with regard to legal and regulatory requirements and contracts. Acceptable levels of performance are described as professional standards of care and usually are identified in professional codes of ethics. An example of substandard performance could include a designer failing to verify that a fabric meets appropriate flame-retardance requirements.

Intentional torts are wrongful acts performed in a deliberate fashion and may include deliberate misrepresentation and strict liability. For example, deliberate misrepresentation would include knowingly labeling a rayon/polyester crash as all-linen crash. Strict liability generally applies to the physical harm caused to a user or consumer if a product is defective and unreasonably dangerous. Strict liability, which holds people liable even in circumstances in which they were not negligent, applies to manufacturers, suppliers, retailers, and others.

Consumer Recourse

When consumers purchase products, they enter into an implied contract. They expect the product to perform and to meet their needs. In most cases, textile products perform satisfactorily. However, at times products do not meet the consumer's expectations. Reasons for failure range from improper care labels to improper dyeing or finishing to improper use by consumers.

Problems with care labels are a great concern to both consumers and the industry. When care-label instructions are followed and the result is disastrous, consumers expect to be compensated for their loss. Many stores take returns of this nature; however, some do not. In these cases, the consumer can complain to the manufacturer or the Federal Trade Commission, since incorrect care labels are prohibited by the Care Label Regulation. Other reasons for product failure include poor design, improper selection of dyes or finishes, inappropriate combination of materials in a product, improper fabric processing, or poor fabric selection for an end use. In all cases, manufacturers should be informed of the problem either by direct notification or by returning the item to the place of purchase. The address of the regional office of the Federal Trade Commission is in most telephone directories. Consumers should write to or call the FTC and include the manufacturer's name or RN/WPL number. The FTC can then identify the manufacturer and provide the consumer with the address for direct correspondence.

Industry professionals usually take a stronger position when products result in consumer complaints. Frequently, the professional is responsible for dealing with the unhappy consumer or for some production process. In either case, the professional's responsibility is to identify the source of the problem and suggest a solution that will satisfy both the consumer and the company.

Environmental Issues

Environmental issues affect production of fiber, yarn, fabric, finishes, dyes, and pigments; distribution of components or finished goods; and waste disposal. These areas concern producers, retailers, consumers, and others.

Two federal agencies work to protect the environment and create safe working conditions. The Environmental Protection Agency (EPA) enforces and regulates air, water, and noise pollution and waste disposal. The Occupational Safety and Health Administration (OSHA) develops and enforces standards for safety and educational training programs for workers. States also have environmental and worker safety departments. Many other countries are concerned with environmental quality. Some have adopted standards more severe than those of the United States.

Consumers greatly influence what is available in the market by their demand for "green" or "eco" products that claim to have minimal environmental impact. Many products are sold based on this claim, regardless of its validity. At present, there are no legal restrictions or standards for these claims and no restrictions on their use in marketing or advertising. However, some products are evaluated by recognized certification organizations to verify their environmental claims. The Scientific Certification Systems (SCS) is a multidisciplinary scientific organization that verifies environmental claims and provides complete environmental profiles of products and packaging based on life-cycle analysis. Figure 21-6 shows the SCS Green Cross certification mark. Oeko-Tex Standard 100, a European certification standard, identifies acceptable limits for extract pH, heavy-metal content, colorfastness, carcinogenic and sensitizing dyes, pesticides, emissions of volatile substances, and other aspects of textile products that are hazardous to the environment or the user. Textiles dved with a few specific azo dves (the dve structure incorporates one or more -N=N- groups) are banned in some countries.

Consumer practices also have a significant environmental impact. Consider the diaper dilemma. A conservative estimate is that each baby will use 5000 diapers in the first 30 months, with an annual total of 19 billion diapers in the United States alone! Disposable diapers

FIGURE 21-6

The Green Cross certification symbol. (Courtesy of Scientific Certification Systems, Inc.)

were introduced in the early 1960s. Approximately 60 percent of all babies in the United States wear only disposables from birth through toilet training. Reusable cloth diapers may leak, require special handling, and use significant amounts of water and laundry additives in cleaning. Disposable diapers are easy to use, convenient, and readily available. But they make up at least 2 percent of landfill material and must be disposed of properly to avoid fecal contamination of ground water.

Consumers and professionals are faced with many difficult choices when it comes to textile products. Environmental correctness adds another dimension to the decisions to be made. Which of two shirt materials is better for the environment—polyester or cotton? While the choice may seem obvious, the polyester shirt is made from recycled beverage bottles and the 100-percent cotton shirt is made from cotton produced using current large-scale farming practices.

Identifying the complete environmental ramifications of the production, distribution, use, care, and disposal of textile products is a complex and multidimensional problem. Many assumptions made by consumers are far too simplistic. For example, assuming that all natural fibers are better for the environment as compared with any synthetic fiber ignores many environmental issues related to land use, current farming or harvesting practices, fiber-processing needs, use and care of the product by consumers, and disposal or recycling of the product once the consumer is finished with it. A full lifecycle analysis of a product is an involved process. Unfortunately, much of the information is conflicting, misleading, or missing so that the total picture is not clear.

Manufacturers who have developed corporate environmental policies require that suppliers meet their standards. Engineers visit textile facilities to ensure that wastewater treatment and recycling programs meet the firm's expectations. All environmentally conscious companies face stiff competition from companies who operate in countries where environmental concerns and regulations are minimal.

Professionals deal with these kinds of problems on a daily basis. Although an in-depth exploration of all elements regarding environmental correctness is not possible here, several concerns and efforts within the textile industry will be addressed to provide some information to help individuals deal with these complex issues.

Environmental Impact

At one time, the textile industry discharged great quantities of water contaminated with dyes, finishing chemicals, cleaning compounds, wax and lanolin removed from natural fibers, and compounds used to produce

manufactured and synthetic fibers into rivers, streams, and lakes. Emissions into the air included excess heat, fly ash, carbon dioxide, formaldehyde, and sulfurous and nitrous compounds that contribute to acid rain. Excess packaging, discarded cardboard and paper goods, empty metal drums, and hazardous and toxic chemicals were deposited in landfills. Other environmental problems have included high-intensity noise in spinning and weaving rooms and dust and airborne debris in opening and spinning areas. The processing of textiles from raw materials into finished products used large amounts of water and energy. It is no wonder that the industry has been recognized as a major polluter. However, significant efforts continue to be made in the processing of textiles to reduce their energy use and impact on the environment and to improve the perception of the industry by the public.

Understanding begins with exploring the components of wastewater and the way it is handled in a normal water treatment facility. The presence and level of polluting materials in wastewater is assessed in several ways. Biological oxygen demand (BOD) describes the amount of oxygen necessary for the decomposition of organic wastes in the water. Chemical oxygen demand (COD) describes the amount of oxygen necessary to reduce a soluble organic compound to carbon dioxide and water. A high BOD or COD indicates a large amount of pollution, which might kill fish and other aquatic life. Wastewater from homes, businesses, and industry is treated to speed up natural purification processes and to reduce pollutants that might interfere with these natural processes.

Treating wastewater is done in a series of steps. In preliminary treatment, large debris such as wood and sand is physically removed by screening or slowing the water and allowing the sand and other heavy materials to settle out. In primary settling, the water spends several quiet hours in large tanks, where most of the suspended solids (raw sludge) settle to the bottom. Bottom scrapers remove the sludge while surface skimmers collect oil and grease from the top of the tank. Biological oxidation uses microorganisms in oxygen-rich trickling filters or activated sludge tanks to speed up the natural decay of waste. Four to 12 hours later, in final clarification, the microorganisms are removed from the wastewater by settling or straining.

Wastewater from fiber processing, dyeing, and finishing receives additional processing to remove salts, dyes or pigments, other organic compounds, heavy metals, and finishing chemicals. These processes include activated carbon adsorption to remove organic compounds, color, and chlorine; ultrafiltration to reduce turbidity; reverse osmosis and electrodialysis to remove dissolved solids; oxidation and ozonation to remove

color; and demineralization to remove salts. With membrane technology, materials such as latex used in carpet manufacturing, salt used in dyeing, and sizing materials used in weaving and finishing can be recovered and recycled.

The EPA's Design for the Environment (DfE) Garment and Textile Care Program is working with researchers and the textile-cleaning industry to identify alternative technologies for cleaning textiles and textile products. Regulations restricting the use of chemicals such as perc have far-reaching ramifications.

Environmental Laws and Regulations At least a dozen significant laws and regulations have been passed since the establishment of the Environmental Protection Agency. This discussion focuses on those that have had the greatest impact on how the textile industry operates.

The Pollution Prevention Act of 1990 focuses on waste minimization (Figure 21–7). Efforts focus on source reduction, environmentally sound recycling, treatment of toxic chemicals, and disposal of waste materials in registered toxic-dump landfills. Source reduction minimizes waste generation by substituting less-hazardous or less-harmful materials when possible, and emphasizes product reformulation, process modification, improved cleaning standards and practices, and environmentally sound, closed-loop recycling. These efforts are extremely cost effective and pay for themselves quickly. The act also requires that companies maintain a toxic-release inventory. The inventory helps companies improve practices from both profit and environmental perspectives.

The Clean Air Act of 1970 focuses on air quality and addresses acid rain, toxic air emissions, and ozone. Acid rain is produced when water droplets in the air combine with air pollutants such as sulfur dioxide and nitrous oxides. Because the textile industry uses large quantities of hot water and steam, limiting stack emissions from steam-generating units or boilers has received much attention. Efforts include minimizing fly ash from coal-burning units, sulfur dioxide and nitrogen oxide (byproducts of burning fuels that contribute to acid rain), and fume emissions from processes.

The Clean Water Act of 1972 is concerned with toxic pollutants and the contamination of groundwater or surface water. The textile industry has modified the handling of wastewater so that discharges meet or exceed current standards.

The Resource Conservation and Recovery Act of 1976 (RCRA) regulates solid- and hazardous-waste disposal from generation to final disposal, including transportation, treatment, and storage of hazardous materials. It also directs the EPA to determine which wastes pose a human health or environmental hazard.

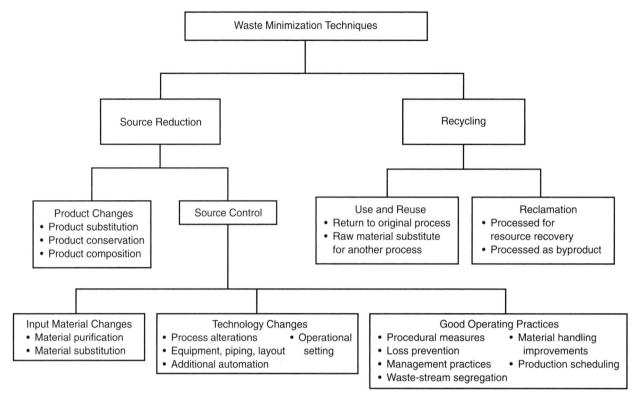

FIGURE 21-7
Waste minimization within the textile industry. (Courtesy of Textile World.)

Efforts within the Textile Industry

Figure 21–8 shows a textile-processing material balance model that identifies what happens to substances used to process raw materials into finished textile products. Any substance that is used in the process leaves the system as either a component of a finished product or as waste. Waste from a plant is discharged into the air or water or onto the land. The industry is working hard to minimize the negative aspects of each discharge category.

The textile industry has reduced the amount of waste generated in textile processing by 40 percent or more in many facilities by changing methods and materials so that the facility generates less waste. For example, jet-dyeing machines traditionally have used a ratio of 10 parts of water to 1 part of fiber. Newer machines use ratios of water to fiber of no more than 6 to 1. Continuous dyeing, which used huge quantities of water, dyes, and chemicals, has been replaced to some degree with beck dyeing, which uses smaller quantities of these materials.

Low-impact dyes and pigments are available. New sulfur dyes eliminate sulfide wastes, metal-free dyes replace metal-complex dyes, direct dyes use less salt, acid and mordant dyes have replaced chromium with iron, reactive dyes have greater use efficiencies, and more disperse dyes work in water-based systems. More pigment inks are water-based rather than solvent-based, and many are formaldehyde free. The metal content of pigment inks has decreased.

By focusing on improving the quality of fabrics, doing things right the first time also means less use of stripping agents to remove color and less redyeing of fabrics that were not dyed correctly the first time. Thus, a better quality of goods is produced with less waste.

Encouraging Environmental Excellence (E3) is a program of the American Textile Manufacturers Institute (ATMI); it has 10 guidelines that encourage and promote environmentally sound practices within the textile industry. The E3 list of approved practices includes producing polyester fabrics from recycled beverage bottles; growing organic cotton without using any agricultural chemicals; producing lyocell (solvent spun with recycled chemicals), wool in natural sheep colors, and colorgrown cotton; using low-impact, low-sulfide dyes that use little salt; using natural dyes from plants and trees and water-based dyes that replace solvent-based dyes;

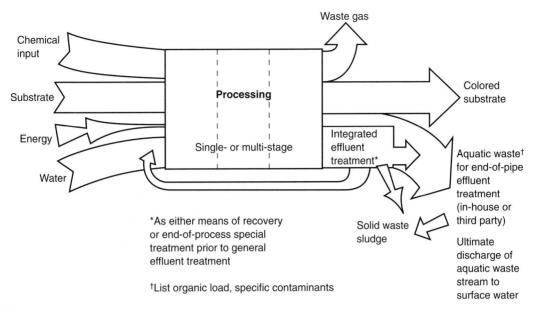

FIGURE 21-8

Dyeing process balance sheet. (Reprinted with permission from Nelson, G. (1991). Microencapsulates in textile coloration and finishing. Review of Progress in Coloration, 21, pp. 72-85. Published by the Society of Dyers and Colourists, Bradford, U.K.)

and producing stone-washed denim without using stones and with fewer chemicals. E3 companies, representing all segments of the textile industry, from fiber and yarn producers to knitting and weaving mills to dyehouses, printing facilities, and finishing plants, have met or exceeded the guidelines of ATMI.

Environmental Health and Safety

The EPA has issued permissible exposure levels for hundreds of chemicals that are known to be or are likely to be human carcinogens. In addition, OSHA develops standards for air quality in the workplace. OSHA's formaldehyde standard became effective in 1988. Formaldehyde has been identified as a carcinogen and is found in some durable-press treatments, leather finishing, and dyeing applications. Exposure limits included in the standard relate to a permissible exposure limit (PEL), a short-term exposure limit (STEL), and an action level (AL) for workers in facilities where formaldehyde is used. Off-gassing (releasing fumes or gases from a material into the air) formaldehyde at levels from 0.1 ppm or more creates problems with indoor air quality and may adversely affect the health of those working or living in that environment.

Another chemical on the EPA list is perchloroethylene (perc), one of the solvents most commonly used in dry cleaning. Regulations at federal and state levels restrict the use and disposal of perc.

Indoor air quality has become a major concern. Indoor air pollution develops from many sources that may emit volatile organic compounds (VOCs), including textile products. Carpeting, carpet padding, fabrics used in furnishings and apparel, latex backcoatings, finishes, and dyes on textiles have all been identified as contributing to this problem. Buildings with poor ventilation and indoor air pollution are often referred to as having "sick building syndrome." Carpet and carpet padding manufacturers have changed production materials and methods to reduce off-gassing problems.

Health hazards that have been addressed by the textile industry relate to reducing noise and dust levels in fiberand yarn-processing areas and in weaving rooms. Exposure to toxic and hazardous chemicals has been substantially reduced as procedures are modified to use less-toxic and less-hazardous chemicals or as human exposure has been limited when the use of alternative chemicals is not feasible. Safety devices have been incorporated into equipment at the design stage or added to older equipment to minimize risk in the workplace. The dry-cleaning industry has decreased the use of perc in cleaning textile products.

Multiple chemical sensitivity is a chronic problem for some people. Carpet and installation materials (glues, pads, etc.), fabric finishes, dyes, components in printing inks used on printed textiles, and cleaning compounds contribute to the problem. Some products incorporate no bleaches, finishes, or dyes.

Disposal and Recycling

Concern for the environment also extends to disposal of textiles. Currently, very few textiles are **recycled**, although the percentage is increasing with new technologies and changes in industry practices. Recycling facilities often refuse textiles because of the numbers of different fibers present, the small quantities of materials in each item, and the difficulties of shredding these items. Textiles tangle shredders and cause malfunctions or excess wear.

Studies of landfills have shown that normally easily biodegradable items such as newsprint, textiles, and grass do not degrade under landfill conditions. Many communities require recycling of newspaper, junk mail, cans, clear glass bottles, plastic materials of specific types, and yard waste so that landfill space is reserved for hazardous materials. At present, textile products are not included in the list of products that must be recycled. Many consumers try to recycle apparel and furnishings by giving items to organizations that collect these products. Member firms of the Council for Textile Recycling divert 93 percent of the 2.5 billion pounds of postconsumer textile product waste from landfills to used clothing dealers, exporters, rag graders, and various parts of the textile industry for use in recycled products.

Textile products use a significant amount of packaging materials. Environmentally sound packaging includes minimizing use of materials, use of recycled materials (hangtags, plastic wraps, and cardboard), and use of quickly degradable materials. Some firms have decreased the amount and number of different types of packaging materials for consumer products. This decreases the costs of materials and labor for packaging and the weight of packaged goods. It also decreases the amount of packaging with which the consumer must deal. For example, shirts that had been packaged with six straight pins, tissue paper, a cardboard flat, a cardboard collar stand, and a plastic bag are now packaged with only the plastic bag and two straight pins.

A significant quantity of the chemicals used in producing manufactured and synthetic fibers are recycled. For example, membrane filtration systems allow for the recovery and reuse of sizing from warp yarns. Not only does this process allow for reuse of a chemical, but it also minimizes the processing needed to purify water discharge from the plant. In the manufacture of lyocell, the solvent is recycled and reused numerous times.

Production methods have been revised to limit the variety of fiber types present in such products as carpet to facilitate its recycling once the consumer discards it. Since nylon 6 is made from a single monomer, its recycling is a simpler process than that required for recycling other polymers. The 6ix Again program for nylon carpet fiber makes use of BASF's patented repolymerization

FIGURE 21-9
The Eco-spun label. (Courtesy of Wellman, Inc.)

process to produce new carpet from used carpet. Wellman, Inc. Fibers Division has developed Fortrel EcoSpun[™] polyester by recycling plastic beverage bottles (Figure 21–9). Other recycled polyesters, olefins,

FIGURE 21–10
A T-shirt made from recycled polyester fibers.

FIGURE 21-11
Recycling denim: pencils made from scraps, and a rag rug.

Denim scrap is recycled into yarn, pencils, paper, stationery, sludge for compost to improve garden soil, and denim fabric of 50 percent reprocessed and 50 percent new fiber (Figure 21–11). Textile waste fiber is used extensively in nonwoven products for furniture, wiping cloths, coating substrates, filters, geotextiles, floor coverings, car interiors, floor mats, mattresses, and shoulder pads (Figure 21–12). Waste cotton fiber is recycled and used in apparel, furnishings, and industrial products such as mop yarns and in other materials for the absorbent trade.

FIGURE 21-12
Floor mat made from recycled materials.

Materials used to protect textiles during shipping are being recycled. Fabric rolls are wrapped in reusable polyethylene wrap, replacing the older method of using multiple materials that were difficult to handle and reprocess. Many firms have developed methods to decrease the use of cardboard tubes and plastic wraps while not compromising fabric condition or quality. In addition, many firms use recycled or recyclable tubes and wraps for fabric and finished products.

Companies have established on-site recycling facilities to recycle materials such as cardboard, paper, aluminum, scrap iron, wood pallets, ink waste, and fiber waste. Other companies use recycled dyes whenever possible. Coats American recycles returned thread packages into new cones and tubes for packaging thread. Efforts to increase recycling of textiles continue so that fewer items will be deposited in landfills.

Key Terms

Federal Trade Commission
(FTC)
Pure silk or pure dye silk
Wool Products Labeling Act
WPL number
RN number
Fur Products Labeling Act
Textile Fiber Products
Identification Act
Generic name

Care Labeling Regulation Labeling requirements Code of Federal Regulations (CFR) Consumer Product Safety Commission Flammable Fabrics Act Upholstered Furniture Action Council Fire block Federal Insecticide, Fungicide, and Rodenticide Act (FIFRA)
Warranties
Licensing
Certification programs
Trade name
Trademark
Codes
Torts
Environmental Protection
Agency (EPA)

Occupational Safety and
Health Administration
(OSHA)
Green or eco products
Wastewater treatment
Biological oxygen demand
(BOD)
Chemical oxygen demand
(COD)
Pollution Prevention Act
Clean Air Act
Clean Water Act

Resource Conservation and Recovery Act Formaldehyde Recycling

Questions

- 1. What information is required by law to be on sewn-in labels? What information is required to be presented to consumers at point of purchase?
- 2. What rights do consumers have if they are dissatisfied with the performance or serviceability of a textile product?
- 3. What are the legal responsibilities of manufacturers, producers, and their employees regarding textile products?
- 4. What law or regulation deals with issues of safety?
- 5. What additional requirements might furnishings be required to meet depending on building codes?
- 6. What are the requirements for a textile product to be marketed as a "green" product?
- 7. What steps has the textile industry taken to minimize environmental impact in terms of production, distribution, and disposal of textiles or related materials?
- Describe how recycling can be beneficial to the consumer of the product and to the environment.

Suggested Readings

Damant, G. H. (1994). Recent United States developments in tests and materials for the flammability of furnishings. *Journal of the Textile Institute*, 85(4), pp. 505–525.

- Domina, T., & Koch, K. (1997). The textile waste life cycle. Clothing and Textile Research Journal, 15(2), 96–102.
- Elliott, E. J. (1996, February). Recycling: saving money and the environment, *Textile World*, pp. 72–74.
- Federal Trade Commission (March, 1984). Writing a care label. Washington, D.C.: Federal Trade Commission.
- Gale, M. E., Shin, J., and Bide, M. (2000). Textiles and the environment from AATCC. *Textile Chemist and Colorist and American Dyestuff Reporter*, 32(1), 28–31.
- Geisberger, A. (1997, July/August). Azo dyes and the law—an open debate. *Journal of the Society of Dyers and Colourists*, 113, 197–200.
- Glover, B., and Hill, L. (1993). Waste minimization in the dyehouse. *Textile Chemist and Colorist*, 25(6), p. 20.
- Gross, E. (1999, September). Home textiles listen to the eco movement. *Textile World*, pp. 81–82, 84, 86, 88.
- Harmon, S. K. (1994). The Codes Guidebook for Interiors. New York: Wiley.
- Heuer, C. R. (1989). Means Legal Reference for Design and Construction. Kingston, MA: R. S. Means Company.
- Pullen, J. (1995, March). D-13 textile and apparel care labeling standards. ASTM Standardization News, pp. 42–47.
- Reznikoff, S. C. (1989). Specifications for Commercial Interiors. New York: Watson-Guptill Publications.
- Sewekow, U. (1996). How to meet the requirements for ecotextiles. *Textile Chemist and Colorist*, 28(1), pp. 21–27.
- Tortora, P. G., and Merkel, R. S. (1996). Fairchild's Dictionary of Textiles, 7th ed. New York: Fairchild Publications.

Chapter 22

CAREER EXPLORATION

OBJECTIVES

- To understand how a knowledge of textiles is used by professionals.
- To recognize the need to communicate textiles information quickly and accurately to other professionals and consumers.
- To be aware of the diverse career options requiring a knowledge of textiles.

ow that the science of textiles has been explored in some depth, it may be helpful to know how this information relates to and is used in various careers. General terms and sample job titles are used here, since each company, firm, or agency may be organized differently. The ability to use terms correctly when communicating with others, to apply knowledge, and to analyze products is a key component of many jobs in the textile, apparel, and furnishings industries. The specific knowledge and approach will depend on the textile product and the focus of the company, organization, or agency in which one is employed. For example, the handling and marketing of a fabric being sold to a company that will sew it into a product differs from that of a fabric being sold to the individual customer.

Each section includes a general discussion of that area, position types, responsibilities, and the ways that a knowledge of textiles contributes to fulfilling the position's expectations and responsibilities. Obviously, some careers require a more extensive knowledge of textiles than do others. Careers that require a more in-depth knowledge of textiles are listed first, followed by those in which only a basic understanding of textiles is required. Although this chapter explores many career possibilities, it is not a complete exploration. The goal is to demonstrate how a knowledge of textiles will help you obtain a position and advance in your career. In several sections, portions of conversation with professionals are included. Whenever possible, salary information from 1998 to 1999 gives an idea of starting salaries in the field. The American Apparel and Footwear Association includes salary information on its Web site (americanapparel.org)

Sourcing

Materials and production sourcing deals with identifying the firm that can supply the item needed. Sourcing specialists need to understand textiles, textile products, production, marketing, performance and quality evaluation, and products or services. The ability to develop and understand specifications of products or services is critical. Sourcing specialists need to have good communication skills and a global perspective. For example, if a retailer wants to carry a specific item, a production manager in the retail firm would investigate companies who produce items similar to what is needed, evaluate sample products, cost the products, and analyze the ability of each company to meet production deadlines. The sourcing specialist usually recommends one or more companies with whom the firm should negotiate for sample runs or contract terms. Sourcing production involves contractor selection and management of products throughout production.

Sourcing specialists are often responsible for followup to ensure that the contract will be met, that items are shipped on time, and that shipping is handled in the agreed-on manner. When the source of production is offshore, sourcing specialists must be familiar with import/export requirements and regulations. For example, quotas refer to specific quantities of goods allowed to be imported from one country to another. Quotas result from agreements between the importing and the exporting countries. U.S. quotas are the most elaborate and detailed of any in the world. Imports are divided by product category. For apparel, they are further divided by fiber type and gender. Sourcing specialists frequently work with customs officials to minimize problems or to solve them as they develop. Sourcing positions require some industry experience. A sourcing agent is a specialist who works in a specific country and is an essential individual for international full-package sourcing. This person deals with all aspects of sourcing offshore, including materials sourcing, production, and import/ export issues.

Directors or managers of human resources deal with sourcing issues of another kind: employees within the firm. They interview potential employees and determine whom to hire based on the positions available and the knowledge and skills of the applicants. Human resource directors also may be involved with negotiating employee benefits and salaries.

Product Development

Product development specialists must have extensive product knowledge. Product developers work with target-market and consumer-expectation information provided by marketing. Prototypes (original product samples) are developed in a time-consuming process that may involve large numbers of people (Figures 22-1 and 22-2). For highly innovative products, product development works with research and development, or the two may be combined in one department. Prototypes are evaluated by combining performance testing with user, wear, or product testing. For example, in performance testing, a new product may be tested for tensile strength, abrasion resistance, washability, and comfort using standard test methods and specialized testing equipment. At the same time, in product testing, identical products may be used by consumers to see how the product performs for them and how they react to it. This evaluation may occur several times as the prototype is modified based on analyses of cost, consumer reaction, and performance.

Product development does not cease once the product is on the market. Follow-up studies assess how the

FIGURE 22-1 Computer-aided design (CAD) used in the production of patterned textiles. (Courtesy of Stork Screens, B.V.)

general public accepts the product. Modifications may help the product remain competitive. Note how often new detergents come on the market or how often detergents are labeled "new and improved." Development of a laundry detergent is just one area in which knowledge of textiles is appropriate for a position in product development. The professional in this area needs a basic knowledge of textiles to understand the components of the item being developed.

Product development involves developing the design, selecting the most appropriate fabrication for the design, and merchandising accessories to go with the

item. For example, a firm may realize that it is losing market share to a less expensive competitor. Thus, to remain competitive, the firm needs to produce its products for less. One way of remaining competitive is to use a less expensive, but equally serviceable fabric. A firm may work with several mills to identify fabrics that meet their requirements and test these fabrics to determine their performance. Once performance has been determined, the firm may negotiate with a mill so that the most serviceable fabric is further modified to meet the firm's performance expectations at a price level appropriate for the final product. A similar kind of sequence

FIGURE 22–2
Developing colorways for upcoming seasons. (Courtesy of JC Penney Co., Inc.)

may occur in-house as design modifications and product groupings are evaluated. Product development is an area in the textile industry that is increasing in importance. Starting salaries range from \$24,000 to \$35,000, with an average of \$28,450.

Quality Assurance

Quality assurance (QA), quality control (QC), and total quality management (TQM) are important areas within the textile industry. In general, quality specialists deal with producing an item at a specified level of quality in a manner that is as safe, cost effective, and efficient as possible. Company standards and specifications identify requirements that products must meet: fabric characteristics, including weight and count; appearance aspects, including matching of stripes and levelness of hems; consistency of product dimensions; functioning of zippers and other closures; and fabric performance for colorfastness and dimensional stability. QA technicians, technical designers, engineers, and managers develop these standards and specifications, work with suppliers to see that components and materials meet specifications, and test to be sure that products meet specifications and perform at the prescribed level. QA staff may develop the procedures or methods to make assessments quickly and accurately in order to identify and solve problems in purchasing, product specifications, or production in a timely manner. QA professionals need to understand textiles so that they can assess the quality of purchased items and identify possible sources of problems in production. For example, if seam puckering occurs in a tightly woven fabric, the sewing thread may be too large, causing the yarns in the fabric to be distorted.

Starting salaries range from \$24,000 to \$32,500 with an average of \$28,850.

Research, Development, and Evaluation

Many research and development (R&D) positions require research and data-processing skills, specialized understanding of the field, and statistical knowledge that are developed at the master's or doctoral level. R&D positions can be found throughout the textile industry. For example, researchers study polymer science, fiber chemistry, yarn production, fabrication efficiency and flexibility, effects of dyeing and finishing on the environment, development or modification of production machinery, and application of new technology to solve problems such as meeting clean air and water requirements and dealing with competition from imports. Thread development is a continuing area of research, as new materials and end uses require changes in thread. Researchers evaluate the appropriateness of textile products for specific end uses, develop new end uses for existing textiles, or evaluate products to ensure consistent quality and performance. (Figures 22–3 through 22–6). Beginning positions in research and development may

FIGURE 22-3 Evaluating a top's size and fit on a Wolfe form. (Courtesy of JC Penney

Co., Inc.)

FIGURE 22-4
Conducting a du-pro (during production) inspection of quality. (Courtesy of J.C. Penney Co., Inc.)

be as a technician, a research scientist, or an assistant engineer. R&D positions in the textile industry require a general knowledge of textiles and specific knowledge in a focus area.

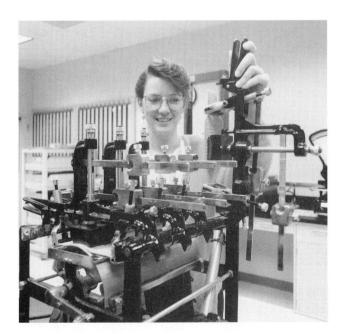

FIGURE 22-5
Evaluating the wear resistance of upholstery fabric. (Courtesy of JC Penney Co., Inc.)

Kelly is a merchandise evaluation engineer with six years of experience in an international retail firm with a diverse product mix:

I evaluate product performance against our company standards and customer expectations. I need to know what our competitors are doing so that our products are reasonably competitive in both performance and price. I make sure that we know what our customer wants, and I work with our buyers to make sure we offer a range of products to satisfy our target market's needs. My division provides direct support to the merchandising division, especially when we are working with fibers or fabrics with which we don't have much experience. I spend a lot of time educating our staff and our suppliers so we get the quality of merchandise we need. I help suppliers, especially new ones or experienced ones who are working with a new product, understand our dimensions of quality and suggest ways that they can check their work to make sure it meets our requirements. I really like being proactive in that way rather than policing products once they have been shipped. I also work with field inspectors (people who travel to production facilities to check the production process) and fabric evaluators who work here in our evaluation center. I facilitate ways to correct problems or improve products. It's a great job that allows for a lot of creativity and gives me a lot of diversity in the things I do and the people I work with.

FIGURE 22-6

Testing performance of textiles in a quality-assurance lab. (Courtesy of JC Penney Co., Inc.)

Starting salaries in product or textile testing range from \$21,000 to \$32,500, with an average of \$25,900.

Production

Production deals with manufacturing the textile or the textile product. There are positions at all levels of the industry, from the raw material stage prior to fiber production, to the spinning of fiber and yarn, and production of fabric, to the dyeing and finishing of fabrics or products. Other positions are in sewn-product facilities such as apparel, furnishing, and industrial production plants throughout the world. With the move of many production facilities offshore, there is a great demand for production managers who are able to work in the exciting and often very challenging international arena. Beginning positions are assistant engineers, production managers, or sourcing specialists. These positions require a combination of people skills and knowledge of the materials with which the facility works, as well as how the equipment works with or processes the materials. Obviously, essential knowledge includes understanding textile properties such as ease of handling, melting point of thermoplastic fibers, elongation potential of knits, and so on.

Melee works for a national firm and was promoted to senior production engineer after one year of experience:

My product mix includes luggage, tote bags, dog beds, apparel, and other miscellaneous textile products. My knowledge of textiles gives me a starting point for problem solving. When I talk with designers and product-development specialists, we spend a lot of time discussing how fabrics interact, why some fabrics are traditionally used for some products and not others, and what problems, like shrinkage or pilling, might occur with these fabrics. I spend a lot of my time working with sewing machine operators and helping them understand the characteristics of the different fabrics they sew. This gives them a better understanding of why some fabrics work one way and other fabrics work another way. I need quick access to basic reference material, especially when we run into problems with sourcing fabrics or fabrics create problems on the line. I spend a lot of time communicating with others on a wide variety of special issues related to the products we sew in this plant and the fabrics we work with. Even though I am an engineer, I also search for ways to expand our product mix.

Starting salaries for assistant engineers range from \$28,500 to \$39,000, with an average of \$31,300.

Design

Designers create the concept, idea, or design for a product or select the components for a room setting. They work at all levels in the industry and may work with such components as yarns, fabrics, or patterns for prints, or apparel items, furnishing items, rooms, or other settings. Their creativity is of great importance but it is focused

on a specific product type, price range, and target market. Designers forecast trends and need to know what will sell, what will satisfy the consumer, what is within the capability of the company and its equipment, and what is within the price range of the target consumer. They need to understand the performance of the textiles with which they work and select the appropriate materials to produce the serviceability desired in the finished product. The two career paths for design are creative and technical. When working in manufacturing, designers need to understand the sewability of materials and fabrics. For example, fabrics that are difficult to sewheavy stiff fabrics like cotton denim and lightweight slippery fabrics like polyester ninon—demand higher piece rates because sewing machine operators cannot work as quickly with these fabrics.

Designers need to ensure that their work meets the appropriate laws, regulations, and codes. They may need to be flexible enough to work at several quality levels and to work with knock-offs (less expensive copies) of higher priced items. Most design work means problem solving and satisfying the company's target market while making a profit. Beginning positions in design include design assistant, assistant designer, or pattern maker. Design positions may be found in product-development areas, especially in manufacturing firms and retail businesses. The use of computers in design is common, and designers need experience working with systems and software appropriate to their specialization. CAD (computer-aided design) experience can be essential in securing a position or advancing within a firm (Figure 22-7). Knitwear design is a rapidly growing area and requires an even greater understanding of materials and their performance. This is especially important in terms of pattern-design, since elasticity and elongation vary with the type of knit and fiber content.

Design positions are also available in the entertainment field, but they are difficult to obtain. Designers create the set or stage and dress the cast to convey the visual aspects of the production. A designer may have to spend several years as an assistant before achieving recognition as a set or costume designer. Some designers sell a small portion of their work to the entertainment area, but the greatest share of their work is focused on other markets.

Fabric designers develop prints and structural design fabrics, primarily for woven and knit fabric for apparel and furnishings. An understanding of fabric structure and graphic design are important in this area. These designers work with CAD systems to create the design, modify it, develop colorways, and design related patterns to complete assortments. Fabric designers may use digital printing or a small-scale printing system to proof their designs.

Design includes the artist or craftsperson who creates one-of-a-kind items (Figure 22–8). Most artists specialize in one medium or type of object. For example, an artist may specialize in weaving large tapestries for public buildings or office spaces. Another artist may specialize in creating wearable art, employing a variety of techniques, including weaving, screen printing, and quilting. The artist must select appropriate materials and be sufficiently adept to produce the piece. Becoming a self-employed artist requires tremendous effort, talent, and discipline.

FIGURE 22-7
Using CAD to develop designs for upcoming seasons. (Courtesy of JC Penney Co., Inc.)

FIGURE 22-8

Blanket woven using pseudo ikat technique developed and dyed by Karen Diadick Casselman, Nova Scotia, Canada. Resist areas were knotted and tied before weaving. (*Photo credit: Ted Casselman.*)

Motoku, a contract interior designer with three years' experience, describes her day as being

very busy meeting with architects, conducting onsite visits to make sure that carpet and wall coverings are being installed correctly and that everything is on schedule, visiting showrooms, and doing my design work. Good communication skills and a technical vocabulary are absolutely essential! I spend a lot of time talking to suppliers and contractors to facilitate shipping or installation. I verify that fabrics for walls, windows, or furniture are available in the quantity and colorway desired and that the various separate pieces work well together and achieve the effect my clients want. I work with clients to help them understand how various textiles will perform and why fabrics differ in look, performance, and cost. I find my job very challenging and exciting, yet very busy and demanding.

Motoku says that her work with CAD programs as a student gave her computer skills that make her job a little easier.

Starting salaries in interior design range from \$18,500 to \$29,000, with an average of \$25,200.

Dana has been a technical pattern maker for five years and has worked for three firms during that time. Her current company

designs and produces women's sleepwear and lounge wear and is a contractor for several large retailers. I develop the patterns for production based on designers' specifications and design samples. We are given shrinkage information and have to enlarge and adjust our pattern pieces so that it still fits the customer after washing. I have to know how various fabrics hang and work together so that the pattern works out. I often work with only the name of a fabric, not a real sample, so I have to visualize how the fabric works on the body when I'm developing a pattern. When garments don't spec out, I talk to the designer to figure out how to make it (the pattern) do what Gail (the designer) wants it to do. I spend a lot of my time checking accuracy and making sure fabric use is high so waste is low and the company still makes a profit. If production has a problem with any part of the garment, they come to me, so I have to know how production works, too.

Starting salaries for pattern makers range from \$20,000 to \$26,000, with an average of \$23,000. One year of experience with computerized pattern making can increase annual salary by several thousand dollars, but often requires moving to another firm. Apparel designers generally start as assistant designers, with a salary range from \$21,000 to \$30,000, with an average of \$25,800.

Merchandising

Working in the retail setting as a merchandise buyer or manager is an exciting career goal for many students. However, many positions in **merchandising** exist beyond the retail setting. There are buying positions in companies throughout the industry. For example, yarn companies buy fiber. Weavers and knitters buy yarn. Converters and dyers and finishers buy dyes and chemicals to finish fabrics. Sewing facilities buy fabric, wood and metal for furniture frames, padding, zippers, buttons, and other materials and components used in producing the finished item. Product coordinators track

components, deadlines, and activities so that the finished product is available on schedule.

Direct marketing (mail order and electronic retail) is another possibility. Just as with many other merchandising positions, these relate to buying or developing merchandise to be presented to the consumer. Production of the catalog or Web site and product presentation are other important positions.

Managers of departments, divisions, stores, or merchandise categories require a knowledge of textiles. Although managers may not buy the merchandise, they suggest products for their store from among those purchased by the buying office based on their specific target market. They also promote products to generate sales. Visual merchandisers deal with how the merchandise is presented to the customer. Entrepreneurs and small-business owners handle every part of running a business, from identifying the target market and product mix, to promoting and selling the merchandise, to hiring staff, to dealing with financial arrangements and budgets, to maintaining the store. In direct marketing, the nonstore retailer sells merchandise such as cosmetics, interior decorating items, kitchen supplies, and some apparel directly to the consumer through in-home parties and telephone sales.

Lou was promoted to merchandise manager after working for a national chain for fourteen months:

I track sales, promote merchandise within the store, keep track of inventory, and work with staff to help them know the merchandise. My product mix includes domestics and housewares and is about one-third of the store's floor space. Other merchandise managers ask me to help in selecting merchandise appropriate for a season. Since I had a knowledge of textiles, I help them out. Since my store does no merchandise training, I also work with my sales staff in educating them about the differences among the textile products we sell. With my education, I am familiar with the store's just-in-time inventory system and I understand merchandise buying.

Starting salaries for merchandising positions for fashion merchandising graduates range from \$23,000 to \$30,750, with an average of \$25,560. Compare this with salaries for business graduates: starting salary range of \$22,000 to \$31,300, with an average of \$25,290.

Professionals must be able to select products that will appeal to and satisfy the consumer. Often consumers assume that the employees of a retail establishment are knowledgeable about the products they carry. Consider the questions consumers ask sales associates: Will this item stain? How should it be laundered? Will it last? Will it be comfortable? To be answered correctly, these questions require knowledge of textiles.

Wholesaling

Producers of textile products need someone to represent their product line to the retailer. Often this presentation takes place in a company showroom located at headquarters or in a merchandise center where similar merchandise lines are grouped together. Showroom managers and staff explain the company's line to retail buyers, apparel designers, or interior designers. Sales representative positions require self-starters who are willing to travel. Reps are paid well for their work. Sales reps may represent several companies, product lines, or product types that complement each other. For example, one sales rep may carry the line of one company that produces women's dresses, a line of another company that produces coordinates aimed at the same target market, and jewelry that could be worn with either of these two lines. Another rep may represent three firms: upholstered furniture, accent rugs, and household accessories. Fabric reps specialize in selling fabric to producers, interior or apparel design firms, or consumer fabric stores. Rep positions are seldom starting positions. Reps work on commission. Showroom assistant managers' starting salaries range from \$21,000 to \$28,500, with an average of \$26,500.

Marketing

Marketing positions require people with an understanding of what motivates consumers to buy. Marketing specialists develop the presentation of the product and create its image. Marketing positions may be in areas as diverse as advertising, marketing research, journalism, and display. These professionals must understand their target market fully so that they can help the consumer become aware of their product, recognize its usefulness or desirability, and decide to purchase the product. Knowledge of a product's special features or design aspects will assist in marketing it. Textile knowledge may give a firm a boost in its marketing by focusing on product quality. Other firms focus on product serviceability and highlight their product testing programs and high performance ratings. Still other firms focus on the high fashion aspects of their products. A knowledge of textiles provides an understanding of the product and an expanded vocabulary useful in marketing the product. Starting salaries in marketing range from \$20,000 to \$30,000, with an average of \$26,390.

Government

The U.S. government is one of the world's largest consumers of textile products, and it employs many people

with a knowledge of textiles. Purchasing officers locate producers of specific textile products and verify that items meet government requirements and performance by testing and examining a sample of items. The performance of these items is evaluated by textile testing engineers using Federal Test Methods and Standards (FTMS). Since textile products purchased by the government must be domestically produced, sourcing specialists are in demand. Customs officials and inspectors ensure that all imported goods meet the appropriate requirements in terms of quotas and labeling requirements, and are free from insects and disease organisms. For example, wool from certain countries is checked for anthrax, a highly contagious disease in sheep. Government employees may develop, enforce, or interpret standards, laws, and regulations. Government employees work with industry and business so that current guidelines and standards are met. Many positions are in the military, either as a member of the military or as a civilian employee. Research and development positions in government research facilities focus on textile products such as uniforms for adverse weather conditions, space suits, interiors for space vehicles and submarines, and suits that offer protection from biological and chemical warfare.

Education

Education positions can be formal, such as university/college or secondary school educator, or informal, such as home economist or consumer education specialist in extension, business, or industry. In the formal setting, an advanced degree or periodic additional coursework may be necessary. Many colleges and universities require a Ph.D. College/university faculty members teach specific classes related to their area of specialization and often do research, create artistic works, or judge design competitions. A secondary teacher may be involved in several areas, including family and child development, food and nutrition, at-risk programs, and sex education. Secondary teachers may have additional responsibilities including advising a student group or club.

In the growing informal setting, professionals have a wide variety of possible job descriptions. Some positions involve working with other employees of the company so that they better understand the consumer. For example, some **consumer education specialists** may help engineers understand problems consumers have with automatic washers and dryers. Many trade associations and businesses employ people with a background in education and textiles to write brochures describing the product, develop educational materials such as brochures to be handed out in class, write instructional books describ-

ing how to properly use a specific machine, or produce teaching aids such as videotapes or slide sets. Specialists may teach workshops to consumers or sales representatives and may be responsible for dealing with consumers who have questions related to the use of the product or who have a complaint with the product. It is not surprising, with this list of responsibilities, that an understanding of basic textiles is essential for these positions.

In extension positions, job titles include extension specialist or extension home economist. These professionals develop programs for state and regional use related to wide-ranging current concerns, including cleaning clothing soiled with pesticides, disposing of leftover cleaning aids, recycling textiles in an environmentally safe manner, or storing textile heirlooms. They answer thousands of questions from consumers on an amazing array of topics, assess special needs in their geographic areas, and develop programs and materials to meet these needs. Extension professionals develop and present educational materials to diverse and specific audiences including pesticide applicators, day care workers, or 4-H club members.

Museum or Collection Work

Professionals in the museum field need an in-depth knowledge of textiles, production techniques, and evolution of design, since dating an item and determining its cultural significance is often based on these specific details. Curators are responsible for the items in a museum's collection. This responsibility includes identifying items for display, selecting items to be added to the collection, and maintaining the collection in good condition. In museums with thousands of objects, this is a challenging position. The conservator performs handson cleaning, restoration, and repair and prepares objects for storage. Conservation requires an in-depth knowledge of the objects, how they were made, the materials and components in the objects, and how these materials age and react with environmental factors such as light, dust, and stains. Many positions require a graduate degree. Starting salaries range from \$23,500 to \$30,600, with an average of \$28,975.

Summary

Many exciting and challenging professional positions are possible with a background in textiles. The variety and diversity of positions make it possible for anyone, regardless of individual interests, strengths, working habits, or geographic preferences, to find a position in the textile industry or a closely related area.

All professional positions require a continual updating of information. The responsibility of finding information and keeping current is one that all professionals recognize. Many of the books used in classes are excellent resources for a professional library. To keep current, make a habit of regularly reading professional journals

and publications related to your area. Many professions have organizations, so that members can meet others with similar interests on a regular basis and update their knowledge. In addition, workshops or short courses are offered through colleges/universities, professional organizations, or private concerns.

2. Based on your current career goal, how will you use your

knowledge of textiles in performing job responsibilities?

3. What efforts can you take on a regular basis to update

your textiles knowledge as required in your future job or

Key Terms

Sourcing
Product development
Prototype
Performance testing
Product testing
Quality assurance
Quality control
Technical designer
Research and development
(R&D)
Production
Designer
Artist

Merchandising
Manager
Visual merchandiser
Direct marketing
Nonstore retailer
Marketing
Customs official
Consumer education
specialist
Extension specialist
Curator
Conservator

Consumer education ent specialist Bolles, R. N. (1999). What Color is Your Parachute? 2000. Berkeley, CA: Ten Speed Press.

career?

Suggested Readings

Bureau of Labor Statistics. Occupational Outlook Quarterly.

Washington, DC: Government Printing Office.

Krannick, R. L. (1995). The Best Jobs for the 1990s and into the 21st Century. Manassas Park, VA: Impact Publications.

U.S. Department of Labor (2000). Occupation Outlook Handbook. Bureau of Labor Statistics.

Questions

1. Talk to a professional in your area of interest to determine the relationship of textiles knowledge to that career and to identify the responsibilities of the job.

FIBER NAMES IN OTHER LANGUAGES

English	Chinese	French	German	Italian	Korean	Japanese	Spanish
acetate		acetate/acétate	Acetate faser	acetato	*	sakusan	acetato
acrylic		acrylique	Acryl nachgestellf	_	*	akuriru	acrilico
cotton	mianhua	coton/ cottonade	Baumwolle	cotone	myun	momen	algodón
linen	mah bou	lin/linge	Leinen	tela di lino	ma	asa or asa/ amanuno	lino/lilo de lino
nylon	nilong	nylon	Nylon	nàilon	*	nairon	nilón
olefin	_	_	_	_	*	ourehin	olefina
polyester	huaxian	_	Polyester	poliestere	*	*	poliestero
ramie		_	_	_	mo shi	ramii	rame
rayon	_	rayonne	Reyon, Kunstseide	ràion	*	reyon	rayón
silk	sichou	soie	Seide	seta	kyun	kina	seda
wool	yanqmao	laine	Wolle	lana	mo	keito	lana

^{*}English term used.

FIBERS NO LONGER PRODUCED IN THE UNITED STATES

Anidex A manufactured fiber in which the fiber-forming substance is any long-chain synthetic polymer composed of at least 50 percent by weight of one or more esters of a monohydric alcohol and acrylic acid (CH₂=CH–COOH).*

Azlon A manufactured fiber in which the fiber-forming substance is composed of any regenerated naturally occurring proteins.*

Lastrile A type of rubber fiber that is made from a diene and at least 10 percent but no more than 50 percent by weight of acrylonitrile.

Nytril A manufactured fiber containing at least 85 percent of a long-chain polymer of vinylidene dinitrile (-CH₂C(CN)₂-), in which the vinylidene dinitrile content is no less than every other unit in the polymer chain.*

Triacetate A type of acetate in which not less than 92 percent of the hydroxyl groups are acetylated.

Vinal A manufactured fiber in which the fiber-forming substance is any long-chain synthetic polymer composed of at least 50 percent by weight of vinyl alcohol units (-CH₂-CHOH-) and in which the total of the vinyl alcohol units and any one or more of the various acetal units is at least 85 percent by weight of the fiber.*

Vinyon A manufactured fiber in which the fiber-forming substance is any long-chain synthetic polymer composed of at least 85 percent by weight of vinyl chloride units (-CH₂-CHCl-).*

Appendix C

SELECTED TRADE Names

Fibers

Cotton

FoxFibre by Natural Cotton Colours Inc.

Lyocell

Fibro, Tencel by Acordis Cellulosic Fibers, Inc. Lyocell by Lenzing (Lenzing Fibers Corp.)

Spandex

Lycra by DuPont

Glospan, Cleerspan, DC-100, DC-700 by Globe Manufacturing Co.

Dorlastan by Bayer

Aramid

Kevlar, Nomex by DuPont

Olefin

Alpha, Condesa, Essera, Impressa, Marvess, Propex, Telar, Trace by American Fibers & Yarn Co.

Tyvek, ComforMax IB by DuPont

Thinsulate by 3M

Fibrilawn, Fibrilon by Fibron Corp.

Herculon by Hercules, Inc.

Duraguard, Evolution, Evolution III by Kimberly-Clark

Polyloom by Polyloom Corp.

Typar, Biobarrier by Reemay, Inc.

Spectra, Spectra 900, Spectra 1000 by Honeywell, Inc.

Rayon

Bemberg by Bemberg SpA.

Fibro, Galaxy by Accordis Cellulosic Fibers, Inc.

Modal, Modal Micro, Viscose by Lenzing Fibers Corp.

Nylon

Antron (and all related names), Assurance, Avantige, Cantrece, Cordura, Hytel, MicroSupplex, Natrelle BCF, Stainmaster (and all related names), Supplex, Tactel (and all related names) by DuPont

Durasoft, Duratrek, DyeNAMIX, NoShock, OPTA, Traffic Control Fiber, Ultra mirage, Ultron (and all related names), Wear Dated (and all related names) by Solutia Inc.

Wellon, Wellstrand by Wellman, Inc.

Anso (and all related names), Caprolan, Dry Step, Silky Touch, Softglo by Honeywell, Inc.

Eclipse, Hardline, Hydrofil, Matinesse, MicroTouch, Nylon 6ix, Powersilk, Shimmereen, Sportouch, Stay Gard, UltraTouch, Zefsport, Zeftron by BASF Corp.

Modacrylic

S.E.F Plus by Solutia Inc.

Acrylic

Acrilan, Bounce-Back, Duraspun, Piltrol, SoLara, Ware-Dated by Solutia, Inc.

Sunbrella by Glenn Raven Mills, Inc.

BioFresh, Creslan, Cresloft, MicroSupreme, WeatherBloc by Sterling Fibers, Inc.

Acetate

Celanese (and all related names), Chromspun, Eastman, Estron SLR by Eastman Chemical Products Inc.

Polyester

Trevira, Trevira XPS, Trevira Fitness, Microfiness by Trevira Comfortrel, Filwell (and all related names), Fortrel (and all related names), Fortrel Ecospun, Ecofil, Wellene by Wellman, Inc.

CoolMax, Dacron, Hollowfil, Quallofil, Qualloform, Mylar, Microloft, Micromatique (and all related names), Thermastat, ThermaxCorebond, Thermoloft, Thermolite, Comforel by DuPont

Primaloft by Albany International Research Co.

A.C.E. Polyester, DSP, Fiberbrite 2000, StayGard, Substraight by Honeywell Inc.

Avora FR, Celbond, Corterra, ESP, Loftguard, Microtherm, Polyguard, Serelle, Serene by KoSa

Colorfine, Nature Tex by Martin Color-Fi, Inc.

Diolen by Accordis Industrial Fibers, Inc.

Tairilin by Nan Ya Plastics Corp., America

Other

Kuralon (vinal by Kuraray Co. Ltd.) Mewlon (vinal by Unitika Kasei Co., Ltd.) Teflon (fluoropolymer by DuPont)

Cordelan (vinal/vinyon by Kohjin)

Ryton (sulfar by Phillips Fibers Co.)

Miraflex, Beta, Fiberglas (glass by Owens-Corning Fiberglass Corp.)

Lurex (metal coating by DuPont) Leavil (vinyon by Montefibres, SpA.) Treviron (vinyon by Teijin Ltd.) Basofil (melamine by BASF Corp.)

Rexe (polyether ester by Teijin)

Yarns

Superla by National Spinning Co., Inc. Lanese by Trevira The Smart Yarn by Solutia, Inc.

Fabrics

Poromeric

Goretex by W. L. Gore & Assoc. Entrant, Entrant Hi-Resist, Entrant Thermo by Toray

Hydroentangled

Sontara by DuPont

Warp Knit

Velcro by 3M

Imitation Leathers/Suedes

Ultrasuede, Ultraleather by Springs Industries Belleseime, Supersuede by Kanebo Company

Spunbonded

Typar by DuPont & Reemay, Inc. Tyvek by DuPont

Composite

Bion (and all related names) by Biotex Industries Stomatex by Microthermal Systems

Other

Miratec by Polymer Group, Inc.

Finishes

Enzyme Wash

Biopolish by Novo Nordisk

Antimicrobial

Sanitized by Sanitized Inc.

Insect-Resistant

Expel by Graniteville

Shrinkage Control

Sanfor, SanforKnit, Sanforset, Sanforized by Sanforized Co. London Shrunk by Parrot Group

Water-Resistant

Scotchgard, Scotch Release by 3M Teflon by DuPont

Absorbent

Visa by Milliken Zelcon by DuPont

Durable Press

Coneprest by Cone Mills Press Free Cotton by MacGregor Presset by Cotton, Inc. Creaset by Creaset Process 2000 by Farah U.S.A. Si-Ro-Set

Thermal

Polytherm by Neutratherm Outlast by Gateway Technologies, Inc.

Soil-Resistant

Scotchgard, Scotch Release by 3M Visa by Milliken Teflon by DuPont Zelcon by DuPont

Cleaning Procedures

Green Clean by Environment Canada

GLOSSARY

- **Abaca** is a leaf fiber obtained from a member of the banana tree family.
- **Abrasion resistance** is the ability of a fiber to withstand everyday rubbing or abrasion.
- **Abrasion-resistant finish** is a process that improves the abrasion resistance of fabrics; used in linings and pocket facings.
- **Abrasive wash** is a finish that abrades a small portion of the fabric's surface to soften its hand to produce a slightly worn look in the finished product.
- **Absorbency** is the percentage of moisture a bone-dry fiber will absorb from the air under standard conditions of temperature and moisture. Also known as moisture regain.
- **Absorbent finish** improves fabric absorbency and comfort, also known as water-absorbent finishes.
- **Acetate** is a manufactured fiber in which the fiber-forming substance is cellulose acetate.
- Acetone test is a solubility test used to identify acetate.
- **Acid dyes** are a dye class used primarily with natural protein fibers and nylon.
- **Acrylic** is a manufactured fiber in which the fiber-forming substance is any long-chain synthetic polymer composed of at least 85 percent by weight acrylonitrile units.
- Additive finish is a finish that adds a chemical compound to improve some fabric performance or aesthetic characteristic
- **Add-on** refers to the amount of finish or dye added to a fabric based on its original dry weight, usually given as a percentage
- **Aesthetic finishes** are finishes that alter the way a fabric looks or feels.
- **Aesthetics** describes the attractiveness or appearance of a textile product.
- Aging resistance is resistance to deleterious changes over time.
- Air-impermeable finish (See Porosity-control finish.)
- **Air-jet loom** is a type of loom in which the filling yarn is inserted in the shed with a puff or jet of air.
- Air-jet spinning is a process of creating a spun yarn by using carefully controlled, rapidly moving jets of air.

- **Alençon** (ah-lehn-sahn') is needlepoint lace with a hexagonal mesh.
- **Allergenic potential** is the ability to cause physical reactions such as skin redness.
- **Alpaca** is the fiber produced by the South American alpaca.
- **Aluminum coating** is a very thin layer of aluminum metal designed to minimize heat flow through a fabric or to add a metallic sparkle to the product. *See* surface or back coatings.
- Ammoniating finish increases the absorbency of cotton and some other cellulosic fibers. Often used in conjunction with durable-press finishes to minimize their negative effects.
- **Amorphous** a random or disorganized arrangement of molecular chains within a fiber.
- Angora is the hair fiber produced by the Angora rabbit.
- Antibacterial finish (See Antimicrobial finish.)
- Antifading agents minimize color bleed in the wash; present in some detergents to help fabrics maintain their original color
- Anti-fume-fading finish minimizes the effect of atmospheric fumes on sensitive dve-fiber combinations.
- **Antimicrobial finish** inhibits the growth of bacteria or destroys bacteria on textiles.
- **Antipesticide protective finish** minimizes fabric wicking or absorption of pesticides, and protects the wearer from exposure.
- Antique satin is a reversible satin-weave fabric with satin floats on the technical face and surface slubs on the technical back created by using slub-filling yarns. It is usually used with the technical back as the fashion side for drapery fabrics and often made of a blend of fibers.
- Antiredeposition agent is a compound used in detergents to keep soil suspended and prevent it from being deposited back on the fabric, which would cause a uniform grayish soiling.
- Antiseptic finish (See Antimicrobial finish.)
- **Antislip finish** minimizes yarn slippage in fabrics; especially important in low-count, smooth filament-yarn fabrics in a satin weave.

- Antistatic finish adds a compound to a fabric's surface to absorb moisture, conduct electricity, or neutralize the buildup of static charges.
- **Appearance retention** describes how a product maintains its original appearance during use, care, and storage.
- **Applied design** includes those appearance aspects related to luster, drape, texture, hand, or design that are added to the fabric after it has been produced.
- **Aramid** is a manufactured fiber in which the fiber-forming substance is a long-chain synthetic polyamide in which at least 85 percent of the amide linkages are attached directly to two aromatic rings.
- **Astrakhan cloth** is a fabric made with bouclé, loop, or curl yarns.
- **Average twist** is the most commonly used amount of twist, in the range of 20 to 30 tpi for yarns.
- **Azoic dyes** are a solubility-cycle dye class used primarily with cotton and some polyester.
- **Backfilling machine** is a variation of a padding machine that adds finish to only one side of a fabric.
- Bacteriostatic (See Antimicrobial finish.)
- **Balance** refers to the ratio of warp to filling yarns or describes twist in spun yarns when a loop will not curl or twist back on itself.
- **Balanced plain weave** is a plain weave in which the ratio of warp to filling yarns is approximately 1:1.
- **Basket weave** is a type of plain weave in which two or more adjacent warp yarns are controlled by the same harness and in which two or more filling yarns are inserted in the same shed.
- Bast fiber refers to fiber removed from the stem of a plant.
- **Batch dyeing** is dyeing a relatively small amount of fabric as a unit at one time in one machine or piece of equipment.
- **Batch processing** describes handling a relatively small amount of fabric as a unit at one time in one machine or piece of equipment.
- Batik (buh'-tēk) is a hand process of one or more steps in which wax is applied in a design to the fabric to prevent dye takeup and create a design.
- Batiste is an opaque, lightweight, spun-yarn, plain-weave fabric with a smooth surface. When made of cotton or cotton/polyester, the yarns are usually combed. It can be made of all wool, silk, or rayon.
- **Battenberg lace** is a hand-produced lace fabric made with narrow fabric tapes connected with fine yarn stitches or brides.
- **Batting** is a loose assemblage of new fibers used in textile products as lining and support layers.
- **BCF** (*See* Bulk-continuous-filament yarn.)
- **Beating up** is the weaving step of pushing the filling yarn into place by the reed.
- **Bedford cord** is a heavy, warp-faced, unbalanced pique-weave fabric with wide warp cords created by extra filling yarns floating across the back to give a raised effect.
- **Bengaline** is a lustrous, durable, warp-faced fabric with heavy filling cords completely covered by the warp.
- **Beetling** is a finish for linen or linenlike fabrics. The yarns are flattened to create a fabric that looks more regular and tighter.

- **Bezold** (bē'-zōld) effect describes how two or more colors seem to merge into one new color, as when small-scale prints or yarn-dyed fabrics are viewed from a distance.
- **Bicomponent-bigeneric fibers** refers to bicomponent fibers whose two polymers are from two different generic classes.
- **Bicomponent fibers** refers to fibers made of two polymers that are chemically different, physically different, or both.
- **Binder** is the ply of a fancy yarn that holds the effect ply in place.
- **Binder staple** is a semidull, crimped fiber with a very low melting point so that it bonds with other fibers when exposed to heat above its melting point.
- **Biochemical oxygen demand (BOD)** describes the amount of oxygen in the water necessary for the decomposition of organic wastes.
- **Bio-polishing** is a cellulase enzyme treatment for cotton and other cellulosic fabrics to produce a softer hand and fewer problems with linting and surface fuzzing.
- **Bio-scouring** is a finish in which the fabric is treated with cellulase enzyme to produce a smooth texture and remove fiber ends.
- **Bird's eye** is a dobby fabric with an all-over small diamondshaped filling-float design with a small dot in the center of each diamond.
- **Bleach** is a chemical that destroys the color compounds on fabrics. It is used to destroy fabric stains or yellowing.
- **Bleeding** is a problem that occurs when dye leaves the fiber when it gets wet, as in laundering. Dyes that bleed may be absorbed by and stain other fibers.
- **Blend** is a fabric that consists of two or more generically different fiber types.
- **Blended-filament yarn** is a yarn of unlike filaments of different deniers or generic types blended together.
- **Block printing** is a means of printing a fabric with a relief carved block so that only areas protruding from the block transfer dye paste to the fabric.
- Bobbin lace includes Cluny, a coarse, strong lace; Duchesse, which has a fine net ground with raised patterns; Maltese, with the Maltese cross in the pattern; Mechlin, with a small hexagonal mesh and very fine yarns; Torchon, a rugged lace with very simple patterns; Valenciennes, with a diamond-shaped mesh; and Chantilly, with a double ground with a filling of flowers, baskets, or vases.
- BOD (See Biochemical oxygen demand.)
- **Boil-off** can be used to describe cleaning of cotton fabrics during routine or preparation finishes; the process to remove sericin from silk fabric and create a lively supple hand; or the removal of wax resist from batik.
- **Bonding** produces a thick fabric from two thinner fabrics by use of an adhesive; also a means of producing a fabric from fibers with heat.
- **Bottom-weight fabrics** are fabrics that weigh at least 6 oz/yd²; they are used for pants, trousers, skirts, and outerwear.
- **Bouclé** (boo-klay') is a woven or knit fabric with bouclé yarns. The loops of the novelty yarns create a mock-pile surface.

Bow is a type of off-grain fabric. The filling yarn is not straight in the center between the selvages.

Braid is a method of producing fabric by diagonal interlacing yarns; also a term describing any fabric made by this method.

Breaking elongation describes the amount a fabric or fiber stretches at the breaking point.

Brightener (See Fluorescent whitening agent.)

Bright fiber refers to a fiber in its original luster, without delusterant.

Broadcloth is a close plain-weave fabric with a soft, firm hand made of cotton, rayon, or blended with polyester. It has a fine rib in the filling direction, caused by slightly larger filling yarns, lower-twist filling yarns, or a higher warp-yarn count. High-quality broadcloth is made with plied warp and filling yarns. It may be mercerized. The term also refers to a plain- or twill-weave lustrous wool or wool-blend fabric that is highly napped and then pressed flat.

Brocade is a jacquard-woven fabric with a pattern that is created with different-colored yarns or with patterns in twill or satin weaves on a ground of plain, twill, or satin weave. It is available in a variety of fiber types and qualities.

Brocatelle (brohk'-uh-tel) is similar to brocade, but the pattern is raised and often padded with stuffer yarns. The pattern is warp-faced and the ground is filling-faced. Brocatelle may be a double cloth used in furnishings.

Brushed tricot is tricot that has been brushed to create a fibrous texture on the surface of a fabric.

Brushing is a finishing step that removes fiber ends from a fabric's surface. Common with pile fabrics.

Buckram is a heavy, very stiff, spun-yarn fabric converted from cheesecloth gray goods with adhesives and fillers. It is used as an interlining to stiffen pinch-pleated window treatment fabrics.

Builders are compounds used in detergents to augment the cleaning power of the surfactant. Builders sequester hardness minerals and adjust the pH of the solution to a more alkaline level.

Bulk-continuous-filament yarn is made of textured or crimped filament fibers.

Bulk yarn is a yarn that has been processed to have greater covering power or apparent volume as compared with a conventional yarn.

Bulky yarn is a yarn formed from inherently bulky fibers. (*See also*, Textured yarn.)

Bunting (See Cheesecloth.)

Burlap is a coarse, heavy, loosely woven plain-weave fabric, often made of single irregular yarns of jute. It is used in its natural color for carpet backing, bagging, and furniture webbing. It is also dyed and printed for furnishing uses.

Burned-out is a fiber-blend fabric. One fiber is dissolved in a selected area to create a pattern.

Butcher cloth is a coarse-rayon or rayon-blend fabric. It is made in a variety of weights. A Federal Trade Commission ruling prohibits the use of the word *linen* for this type of fabric.

Calendering is a common finishing technique in which fabric is passed between cylinders to achieve a specific effect. See the specific types of calendering: embossing, friction, moiré, Schreiner, and simple.

Calico is a print cloth of cotton or cotton blend with a small busy pattern.

Cambric is a fine, firm, starched plain-weave balanced fabric with a slight luster on one side. It is difficult to distinguish from percale.

Camel's hair is the fiber produced by the Bactrian camel.

Canvas is a heavy, firm, strong fabric made of cotton or acrylic and used for awnings, slipcovers, and boat covers. It is produced in many grades and qualities. It may have a soft or firm hand. It is made in plain or basket weave.

Carbon is a fiber made of at least 96 percent pure carbon.

Carbonizing is a treatment for wool in which acid removes cellulosic matter and prepares the fiber for dyeing.

Carded yarn is a slightly irregular spun yarn with short-staple fibers and protruding fiber ends.

Carding is one step in yarn spinning. Staple fibers are drawn together in a somewhat parallel arrangement to form a very weak rope of fibers called a carded sliver.

Care refers to the treatment required to maintain a textile product's original appearance.

Care Labeling Regulation is a federal regulation that defines care label information, location, and terminology for textile products.

Casement cloth is a general term for any open-weave fabric used for drapery or curtain fabrics. It is usually sheer.

Cashgora is a fiber resulting from the breeding of feral cashmere goats with angora goats.

Cashmere is the hair fiber produced by the cashmere goat.

Cationic dyes are a dye class used primarily with acrylic fibers.

Caustic treatment is a finishing step for some polyester fabrics to produce a more natural hand and comfortable fabric.

Cavalry twill is a steep, pronounced, double-wale line, smooth-surfaced twill fabric.

Cellulose is a polymer of glucose found in all plant fibers.

Certification programs describe agreements between fiber and fabric producers regarding product performance and trade names or trademarks.

Ceramic is a fiber composed of metal oxide, metal carbide, metal nitride, or other mixtures.

Challis (shal'-ee) is a lightweight, spun-yarn, balanced-plainweave fabric with a soft finish.

Chambray (sham'-bray) is a plain-weave fabric, usually of cotton, rayon, or blended with polyester. Usually chambray has white yarns in the filling direction and yarn-dyed yarns in the warp direction. Iridescent chambray is made with one color in the warp and a second color in the filling. It can also be made with stripes.

Chantilly (shan-tihl'-ē) lace is a bobbin lace with a double ground and a filling of flowers, baskets, or vases.

Cheesecloth is a lightweight, sheer, plain-woven fabric with a very soft texture and a very low count. It may be natural colored, bleached, or dyed. If dyed, it may be called bunting and could be used for flags or banners.

- Chemical adhesive is a compound used to bond fibers together in fiberwebs.
- Chemical oxygen demand (COD) describes the amount of oxygen necessary to reduce a soluble organic compound to carbon dioxide and water.
- **Chemical reactivity** indicates the type of chemical reaction to which individual fibers are susceptible.
- **Chemical wash** is a finish in which the fiber surface is modified in some way by a chemical. Often used as a means of softening fabric hand, increasing comfort, or modifying fabric appearance.
- Chenille yarn is fringed yarn made by producing a leno fabric, cutting it into narrow strips, and blooming open the yarn fringes to create a fuzzy yarn.
- **Chiffon (shi-fahn')** is a sheer, very lightweight, balancedplain-weave fabric with fine-crepe twist yarns of approximately the same size and twist used in warp and filling.
- **China silk** is a soft, lightweight, opaque, plain-weave fabric made from fine-filament yarns and used for apparel.
- Chino (chee'-nō) is a steep-twill fabric with a slight sheen, made in a bottom-weight fabric of cotton or cotton/polyester. Commonly, it is made of combed two-ply yarns and vat-dyed in khaki.
- **Chintz** is a medium- to heavyweight, plain-weave, spun-yarn fabric finished with a glaze. Chintz may be piece-dyed or printed. It is often referred to as glazed chintz.
- **Circular loom** is a type of loom in which the warp yarns form a full circle to weave tubular fabric.
- **Circular machine** refers to a knitting machine that knits a fabric tube.
- **Ciré finish** is a process in which a thermoplastic fabric is calendered with one roll hot enough to slightly melt and flatten the fiber surfaces.
- Clean Air Act is the federal law that focuses on air quality. Cleaned wool (*See* Scoured wool.)
- **Cleaning** is the process of removing soil from fabric; it is also a step in preparing fabrics for additional finishing steps.
- Clean Water Act is the federal law that focuses on surfaceand ground-water quality.
- Clipped-dot fabric is an extra-yarn fabric made with extra filling yarns inserted so that they interlace with some warp yarns and float across some filling yarns. Part of the float may be cut away in finishing, leaving a fringe to add fabric texture.
- **Clip spot** refers to a fabric in which design is created with an additional yarn that interlaces with the ground fabric in spots and floats along the technical back of the fabric. The floats are removed by shearing.
- **Cloque (klō-kay')** fabric is a general term used to refer to any fabric with a puckered or blistered effect.
- Cluny (klu'-nē) is a coarse, strong bobbin lace.
- **Coated fabric** is a multiplex fabric with a thin plastic film combined with a woven, knit, or fiberweb fabric.
- COD (See Chemical oxygen demand.)
- **Code of Federal Regulations** is the document published each work day in which changes in federal laws and regulations are announced.

- **Codes** are systematic bodies of laws or regulations that often focus on safety or health areas.
- **Cohesiveness** refers to the ability of fibers to cling together, especially important in yarn spinning.
- **Coir** is the fiber obtained from the fibrous mass between the outer shell and the husk of the coconut.
- **Colorfastness** refers to a colorant that does not shift hue, fade, or migrate when exposed to certain conditions.
- Color-grown cotton (See Naturally colored cotton.)
- **Color matching** describes the process of developing a formula to reproduce a color.
- **Color measurement** is the process of assigning numerical values to a color to assist in color matching and shade sorting.
- Color problems refer to any aspect that creates difficulty for consumers, producers, or manufacturers due to dyes, pigments, or technique used in coloring the fabric. See specific color problems: bleeding, frosting, fume fading, migration.
- Color scavenger describes a tendency of nylon to pick up color from soil or dyes that bleed when fabrics are wet.
- **Color theory** describes a complex phenomenon combining the physics of light, the chemistry of colored objects, the biology of the eye, the behavioral sciences in terms of what colors mean to society or the individual, and the aesthetics of appreciating what one sees.
- **Color-transfer inhibitors** are present in some detergents to prevent any dye that bled in the wash from redepositing on lighter colored products.
- Colorway refers to various color options available in one fabric.
- **Combed yarn** is a uniform spun yarn with long-staple fibers and few protruding fiber ends.
- **Combination** refers to a fabric of two or more generically different fiber types in which ply yarns consist of strands of each generic type.
- **Combing** is an additional step in the production of smooth, fine, uniform spun yarns made of long-staple fibers.
- **Comfort** describes the way a textile product affects heat, air, and moisture transfer and the way the body interacts with the textile product.
- **Comfort stretch** refers to the ability of a fabric to elongate slightly as the body moves and to recover a significant portion of that elongation when the stretching force is removed.
- **Composite fabric** is a fabric that combines several primary and/or secondary structures such as fiberweb and film, yarn and base fabric, or two layers of fabric.
- Composite yarn is regular in appearance along its length; it is made with both staple and filament fiber components.
- Compound needle is a type of needle used in warp knitting. Compressibility is resistance to crushing.
- Compressive shrinkage process refers to finishing that removes stress from weaving and earlier finishing.
- **Compressional resiliency** describes the ability of a fabric or pile to return to its original thickness after compression.
- Conservation refers to special handling, storage, cleaning, and display techniques used for textiles that are valued for their age, history, or type.

Consumer Product Safety Commission is the federal agency responsible for ensuring the safety of products used by consumers.

Continuous dyeing is a process in which large pieces of fabric are colored in ranges with separate compartments for wetting-out, dyeing, aftertreatment, washing, and rinsing.

Continuous processing describes working with long pieces of fabric that move in and out of solution.

Conventional cotton describes cotton grown and processed by regular mainstream practices.

Conventional spinning (See Ring spinning.)

Converted goods (See Finished goods.)

Converters refers to firms that finish fabrics.

Convolutions are ribbonlike twists along a cotton fiber.

Copolymer refers to a polymer composed of more than one type of mer.

Cord consists of two or more ply yarns held together by twist or some other means.

Cordonnet lace is a type of lace in which heavier yarns emphasize certain elements in the design.

Corduroy is a filling-yarn pile fabric. The pile is created by long-filling floats that are cut and brushed in finishing. The ground weave may be a plain or a twill weave.

Core-spun yarn is made with a central sheath of fibers completely covered by other fibers spun around it.

Coronizing is a finish specific to fiberglass to assist in yarn production and printing.

Cortex is the main part of wool fibers; it contains two cell types.

Cost is the amount paid to acquire, use, maintain, and dispose of a product.

Cotton refers to several fibers produced by the genus *Gossypium* used to produce commercial and craft textile products.

Cottonize describes the process of cutting ramie, linen, hemp, and other fibers into shorter fibers to facilitate blending with cotton or processing on equipment designed for cotton.

Count refers to yarns per inch in warp and filling direction in woven fabrics.

Course refers to the yarn's path in a filling knit fabric as it moves across the fabric.

Cover is the ability to occupy space for concealment or protection.

Covered yarn has a central ply that is completely wrapped by another ply.

Covert was first made in England to meet a demand for a fabric that would not catch on brambles or branches during fox hunts. This tightly woven fabric is made from a two-ply yarn, one cotton and one wool. Because the cotton and wool did not take the same dye, the fabric had a mottled appearance. Cotton covert is always mottled. It may be made with ply yarns, one ply white and the other colored. It is a $\frac{2}{1}$ twill, of the same weight as denim, and used primarily for work pants, overalls, and service coats. Wool covert is made from woolen or worsted yarns. It may be mottled or solid color of suit or coat weight. It may be slightly napped or have a clear finish. The mottled effect is obtained by using two different-colored plies or by blending different-colored fibers.

Crabbing is a process used to set wool fabrics.

Crash is a medium- to heavyweight, plain-weave fabric made from slub or irregular yarns to create an irregular surface.

Crease-retention finish (See Durable-press.)

Creel a rack of spools or cones of yarn so that they can be removed without tangling; a rack on which warp yarns are wound.

Creep is delayed or gradual recovery from elongation or strain.

Crepe (krāp) refers to any fabric with a puckered, crinkled, or grainy surface. It can be made with crepe yarns, a crepe weave, or such finishes as embossed or plissé. Fabric examples include chiffon, crepe-back satin, georgette, and crepe de Chine. For more information, see these fabric names.

Crepe-back satin (or Satin-back crepe) is a reversible satinweave fabric in which the filling yarns have a crepe twist. The technical face has satin floats and the technical back resembles crepe.

Crepe de chine (krāp-duh-sheen) is a lightweight, opaque, plain-weave, filament-yarn fabric with a medium luster. Silk crepe de chine usually is made with crepe yarns.

Crepeing is a compacting process that softens fabric hand.

Crepe twist refers to a yarn with extremely high twist and great liveliness.

Crepe weave (See Momie weave.)

Crepe yarn refers to a yarn with crepe or very high twist.

Cretonne (**kreh**'-**tahn**) is a plain-weave fabric similar to chintz, but with a dull finish and a large-scale floral design.

Crimp is a two or three dimensional aspect in which fibers or yarns twist or bend back and forth or around their axis

Crinoline (krihn'-uh-lihn) is a stiff, spun-yarn, plain-weave fabric similar to cheesecloth, used in book bindings, hats, and stiffening for apparel.

Crocheted lace is lace done by hand with a crochet hook.

Crocking describes a color problem in which abrasion transfers color to the abradant.

Cross dyeing describes a special method of dyeing fiber blends in which each fiber type is dyed a different color.

Cross links are temporary or permanent bonds that connect adjacent molecular chains.

Crushed velvet is a warp-pile fabric in which the pile yarns are crushed in a random pattern by mechanically twisting the fabric when it is wet.

Crystalline describes molecular chains that are parallel to each other in a fiber or in regions within a fiber.

Cuprammonium rayon is a rayon produced in Europe by the cuprammonium process.

Cut refers to needles per inch in knitting machines; another term for *gauge*.

Cuticle is a waxlike film covering the outermost layer of a cotton fiber.

Damask (dam'-ask) is a reversible, flat, jacquard-woven fabric with a satin weave in both the pattern and the ground. It can be one color or two. In two-color damasks, the color reverses on the opposite side. It is used in apparel and furnishings.

- **Darned lace** has a chain stitch outlining the design on a mesh background. The needle carries another yarn around the yarns in the mesh. The mesh is square in filet lace and rectangular in antique lace.
- **Dead time** refers to time that a machine is not operating because of changing settings on the equipment so that another fabric can be processed.
- **Decating** is a process that produces a smooth, wrinkle-free surface on wool fabrics.
- **Decitex (dek'-ah-teks)** or **dtex (de'-teks)** is used to identify yarn or fiber size and is equal to 10 tex.
- **Decortication** is a process used to remove ramie fiber from the plant stem.
- **Defects** are flaws in fabrics that are assigned a point value based on their length or size.
- **Degree of polymerization** refers to the number of small molecules (monomers) connected to form a polymer.
- **Delustered fiber** describes a fiber with dull luster resulting from the incorporation of a white pigment within the fiber.
- **Denier (den'-yehr)** describes yarn or fiber size and is defined as weight in grams for 9000 meters of fiber or yarn.
- **Denier per filament (dpf)** is a way of describing fiber size. Dpf is calculated by dividing the yarn size by the number of filaments.
- **Denim** is a cotton or cotton/polyester blend, twill-weave, yarn-dyed fabric. Usually the warp is colored and the filling is white. It is often a left-hand twill with a blue (indigo) warp and white filling for use in apparel in a variety of weights.
- Density is the weight in grams per cubic centimeter of an object.
- **Dents** refers to the spaces within the reed that help establish warp yarn density in the woven fabric.
- **Desizing** is the physical or biological process in which warp sizing is removed after weaving.
- **Detergency** refers to the chemical action of a soap or detergent in removing soil from a textile.
- **Detergent** is a chemical compound specially formulated to remove soil or other material from textiles.
- **Developed dyes** are a dye class used primarily with cellulosics. **Differential printing** is a screen printing process on carpets. **Digital printing** (*See* Ink-jet printing.)
- **Dimensional stability** refers to a finish that minimizes fabric shrinkage or growth in use or during care.
- Dimity (dim'-ih-tē) is a sheer, lightweight fabric with warp cords created by using heavier-warp yarns at a regular distance, grouping warp yarns together, or using a basket variation with two or more warp yarns woven as one. It may be printed or piece-dyed and of combed-cotton yarns. Barred dimity has heavier or double yarns periodically in both the warp and filling.
- Direct dyes are a dye class used primarily with cellulosics.
- **Direct printing** describes a process in which the color is applied to its final location as a paste or powder.
- **Direct-roller printing** is a process in which a pattern is engraved on rollers. The roller picks up a colored paste and transfers the paste to the fabric as it passes under the roller. One roller is used for each color in the pattern.

- **Direct spinning** is a yarn spinning process that eliminates the roving step.
- **Discharge printing** describes a process in which color is removed from piece-dyed fabric in specific locations.
- **Disinfectants** are compounds used in cleaning to kill bacteria. **Disperse dyes** are a dye class used primarily with manufactured and synthetic fibers.
- **Dobby loom** is a loom with a punched-tape attachment or microcomputer control used to control warp yarn position and create dobby-weave fabrics.
- **Dobby weave** is a small-figured woven-in design in which fewer than 25 different warp yarn arrangements are required to create one design repeat.
- **Dope** (or **Spinning solution**) refers to the chemical solution extruded as a fiber.
- Dotted swiss is a sheer, light- or medium-weight, plain-weave fabric with small dots created at regular intervals with extra yarns, either through a swivel or clip-spot weave. Lookalike fabrics are made by flocking, printing, or using an expanded foam print.
- **Double cloth** is a fabric made by weaving two fabrics with five sets of yarns: two sets of warp, two sets of filling, and one set that connects the two fabrics.
- **Double-faced fabric** is made with three sets of yarns: two warp and one filling or two filling and one warp.
- **Double-filling knit** is made on a machine with two sets of needles in two needle beds.
- **Double-knit** is a general term used to refer to any filling-knit fabric made on two needle beds.
- **Double-knit jersey** is a fabric made on a rib gait double knitting machine. Both sides look like the technical face of a single jersey.
- **Double weave** is a fabric made by weaving two fabrics with four sets of yarns (two sets of warp and two sets of filling yarns) on the same loom. The two fabrics are connected by periodically reversing the positions of the two fabrics from top to bottom. Double weave is also known as *pocket cloth* or *pocket weave*.
- **Double-width loom** is a loom that weaves two widths of fabric side-by-side.
- **Doup attachment** is the device used on looms to create the leno weave, in which warp yarns cross over each other to create an open, stable woven structure.
- **Down** refers to the undercoating of waterfowl and relates to the fine, bulky underfeathers.
- **Drape** is the manner in which a fabric falls or hangs over a three-dimensional form.
- **Drawing** describes a fiber-finishing step in which a manufactured fiber is elongated after spinning to alter the molecular arrangement within the fiber, increasing crystallinity and orientation and resulting in a change in specific performance properties.
- **Draw-texturing** is a yarn texturing process in which oriented or partially oriented filaments are stretched slightly and heat set.
- **Drill** is a strong, medium- to heavyweight, warp-faced, twillweave fabric. It is usually a $\frac{2}{1}$ left-handed twill and piece dyed.

Dry cleaning describes a fabric-cleaning process that uses an organic solvent rather than water.

Dry foam cleaning is a cleaning technique for furnishings. A foam is worked into the textile and the soiled foam is removed by vacuuming.

Drying is the process of removing liquid water or other solvent from a textile so that it feels dry to the touch.

Dry-laid fiberweb is a layer of oriented or random fibers laid down by carding or air layering.

Dry spinning is a fiber-forming process in which a solution of polymer dissolved in solvent is extruded; the fiber coagulates as solvent evaporates.

Duchesse (dū-shes') is a bobbin lace with a fine net ground and raised pattern.

Duck is a strong, heavy, plain- or basket-weave fabric available in a variety of weights and qualities. It is similar to canvas.

Duplex printing describes a printing process in which both sides of the fabric are printed.

Duppioni silk is a naturally thick and thin silk resulting from two caterpillars having formed one cocoon.

Durable finish lasts for the life of the product, but the performance diminishes with time.

Durable press describes a finish that maintains a fabric's smooth, flat, unwrinkled appearance during use, care, and storage.

Durability describes how a product withstands use; the length of time the product is considered suitable for the use for which it was purchased.

Duvetyn (doov'-eh-ten) is a woven suede imitation that is lighter weight and drapeable. It has a soft, velvetlike surface made by napping, shearing, and brushing.

Dye is an organic compound with high color strength capable of forming a bond of some type with fibers.

Dye-transfer inhibitor are compounds often found in detergents that prevent any dye that bled in the wash from redepositing on other fabrics.

Dyeability is the fiber's receptivity to coloration by dyes; dye affinity.

Dyeing is the process of combining a fiber with a dye and achieving a bond of some type.

Dye process refers to the method of applying colorant to a textile.

Eco (ē'-ko) products (See Green products.)

Effect ply is the ply of a fancy yarn that creates visual or tactile interest.

Egyptian cotton (See Pima cotton.)

Elasticity is the ability of a strained material to recover its original size and shape immediately after removing stress.

Elastic recovery is the ability of fibers to recover from strain. Elastoester is a manufactured fiber in which the fiber forming substance is composed of at least 50% by weight of aliphatic polyether and at least 35% by weight of polyester.

Elastomer is a natural or synthetic polymer that, at room temperature, can be stretched repeatedly to at least twice its original length and that, after removal of the tensile load, will immediately and forcibly return to approximately its original length.

Electrical conductivity is the ability to transfer electrical charges.

Electrostatic printing is a type of printing with a dye powder. **Elongation** is the ability of a fiber to be stretched, extended, or lengthened.

Embossed refers to a finish in which a localized surface glazing of thermoplastic fibers is achieved or a three-dimensional effect is created to imitate a more elaborate fabric structure.

Embossed fabrics are created by applying a design with heated, engraved calenders. Often print cloths are embossed to imitate seersucker, crepe, or other structural-design fabrics.

Embroidered refers to stitching flat surface yarns to a fabric to create a pattern.

Emerizing is a surface abrasion finish applied to alter a fabric's appearance, hand, and drape.

Emulsion spinning is a fiber extrusion method in which polymerization and extrusion occur simultaneously.

Environmental impact refers to the effect on the environment of the production, use, care, and disposal of textiles and textile products.

Environmental Protection Agency (EPA) is the federal agency responsible for issues related to the quality of the natural environment.

Enzyme is a biological chemical compound that reduces complex organic compounds to simpler compounds.

Enzyme wash is a fabric finish that uses cellulase enzyme to remove surface fuzz from cellulosic fabrics.

Etched (See Burned out.)

Even-sided twill is a type of twill weave. The fabric's technical face is formed by equal amounts of warp and filling yarns.

Expanded film is a film with tiny air cells incorporated into the solution.

Expanded foam is a permanent surface texture or pattern created on fabric by printing.

Extra-yarn weave is made with extra yarns of a different color or type from the ground yarns that are used to create a pattern in the fabric.

Extrusion is the process of forcing the dope or spinning solution through the openings in a spinneret to form a fiber.

Eyelet embroidery is a type of embroidered fabric with a thread pattern around and connecting small holes in the fabric.

Fabric A planar substance constructed from solutions, fibers, yarns, fabrics, or any combination of these.

Fabrication refers to the method used to produce a fabric.

Fabric crimp refers to bends caused by distortion of yarns in a fabric.

Fabric grading refers to the process of inspecting fabrics and assigning grade or quality levels based on the number, size, and kinds of defects present.

Fabric inspection describes the process of examining a fabric for irregularities, defects, flaws, or other appearance problems.

Fabric quality refers to a fabric's freedom from defects, uniform structure and appearance related to the fabric type,

and performance during production and in consumer use. Fabric quality is graded by totaling defect points within a piece of fabric.

Fabric softener is a compound used in finishing and cleaning to improve fabric hand.

Fabric weight describes fabric mass or how much a fabric weighs for a given area or length of fabric; described as oz/yd² or g/m².

Face weight refers to the mass or weight of the tuft yarns used in a carpet or pile fabric.

Faille (file) is a medium- to heavyweight, unbalanced, plainweave fabric with filament yarns and warp-faced, flat ribs created by using heavier filling yarns. It has a light luster.

Fake fur (see Sliver-pile-knit fabric.)

False-twist process is a method of texturing filament yarns by twisting the yarn, heat setting it, and untwisting it.

Fancy weave refers to any weaving method, other than plain, twill, or satin weave, used to create a fabric with a surface texture or pattern resulting from the interlacing pattern.

Fancy yarn describes a yarn with an irregular or unusual appearance as compared with simple, basic yarns.

Fasciated yarn is a yarn made with a filament grouping of fibers wrapped with staple fibers.

Fashioning is the process of adding or dropping stitches during knitting to shape garment parts.

Federal Trade Commission (FTC) is the federal agency that enforces interstate and international trade regulations.

Federal Insecticide, Fungicide, and Rodenticide Act (FIFRA) is the federal law that requires that products containing insecticides, fungicides, and rodenticides provide label information regarding content and safety precautions.

Felt is a fiberweb fabric of at least 70 percent wool made by interlocking the scales of the wool fibers through the use of heat, moisture, and agitation.

Feltability refers to the ability of fibers to mat together.

Felting refers to a method of producing a fabric directly from wool fibers by interlocking the fibers' scales.

Fiber is any substance, natural or manufactured, with a high length-to-width ratio and with suitable characteristics for being processed into a fabric.

Fiber additives are compounds added to manufactured fiber dope to improve appearance or performance.

Fiber blend refers to an intimate mixture of two or more generic fiber types in the yarns of a fabric. Usually used to refer to the presence of more than one generic fiber in a fabric.

Fiber crimp refers to waves, bends, twists, coils, or curls along the length of the fiber.

Fiber density describes fiber weight or mass per unit volume. **Fiber dyeing** is the addition of color, generally as dyes, to textiles while they are in fiber form. Also refers to adding pigment to fiber solutions before fibers are extruded.

Fiberfill is a lofty, weak structure of fibers designed to be incorporated as the center layer in a quilted fabric.

Fiber modifications are changes in the parent manufactured fiber to improve performance relative to a specific end use.

Fiber spinning is the process of producing a manufactured fiber from a solution.

Fiberweb refers to a fabric made directly from fibers.

Fibrillation refers to the longitudinal shattering of some fibers into fibrils or tiny fibers when exposed to abrasion.

Fibroin is the protein of silk fibers.

Filament refers to fibers that are extremely long (length measured in miles or kilometers); or yarns made of these fibers.

Filament tow is an intermediate stage in the production of staple manufactured fibers; manufactured fibers produced in large bundles in filament length and crimped prior to cutting or breaking into staple fibers.

Filament yarn is a yarn made from filament fibers; smooth or bulky types are possible.

Fillers are compounds used in some detergents to add bulk and to assist in cleaning.

Filling refers to the yarns perpendicular to the selvage that interlace with warp yarns in a woven fabric.

Filling-faced twill is a type of twill weave in which the majority of the fabric's technical face is formed by filling yarns.

Filling-pile fabric is a fabric in which the pile is created by extra filling yarns.

Filling sateen is a spun-yarn satin-weave fabric in which yarns form the fabric's technical face.

Filling or **weft knitting** is a process in which one yarn or yarn set is carried back and forth or around and under needles to form a fabric.

Film is a fabric made directly from a polymer solution in a dense, firm sheet form.

Finish is any process used to convert gray, unfinished goods into a completed fabric.

Finished goods are fabrics that have completed the production process and are ready to be made into apparel or furnishings.

Fire block seating is a layer of flame-retardant material between the upholstery and the padding of furniture to minimize flame spread.

Fire retardance is the resistance to combustion of a material when tested under specific conditions.

Flame resistance is the property of a fabric whereby burning is prevented, terminated, or inhibited following application of an ignition source.

Flame-resistant finish is any finish that is designed to reduce the flammability of a textile.

Flame-retardant finish is a finish that makes a fabric resistant to combustion when tested under specific conditions.

Flammability describes the characteristics of a fabric that pertain to its relative ease of ignition and ability to sustain combustion.

Flammable Fabrics Act is a federal act that prohibits the marketing of dangerously flammable textile products.

Flannel is a light- to heavyweight, plain- or twill-weave fabric with a napped surface.

Flannelette is a light- to medium-weight, plain-weave cotton or cotton-blend fabric lightly napped on one side.

Flatbed machine refers to a knitting machine that makes a flat width of fabric.

- Flat-screen printing is a resist printing method. For each color, a flat screen is treated so that print paste passes through openings to create a design on the fabric.
- **Flax** is the bast fiber (often called linen) produced by the flax plant.
- Fleece is a type of weft-insertion knit fabric.
- **Flexibility** is the ability of a fiber to bend repeatedly without breaking.
- **Float** is the portion of a yarn that is on the surface or back of fabric.
- **Float** or **miss stitch** is a type of knit stitch in which yarn lengths float past but do not interloop with the previous stitch. It is used to create a more stable structure or a pattern in the fabric.
- **Floats** are formed when a yarn in one direction, such as warp, crosses over more than one yarn at a time in the other direction, such as filling.
- **Flocking** refers to the bonding of very short surface fibers onto a fabric to produce an imitation pile appearance.
- **Fluorescent dyes** are a dye class used primarily to create or maintain white fibers. Found in some laundry detergents.
- **Fluorescent whitening agent** is a compound used to mask the natural color of fibers, yellowing from aging, or other colors resulting from soil.
- **Fluoropolymer** is a manufactured fiber containing at least 95 percent of a long-chain polymer synthesized from aliphatic fluorocarbon polymers.
- Foam refers to a mixture of air and liquid used in the application of finishes, dyes, or pigments; also refers to a textile product in which a high percentage of air is mixed with the polymer to form a bulky, lofty material.
- **Foam coating** is a back coating of acrylic foam on light weight drapery fabrics to block air flow, minimize heat transfer, and finish the back side of the fabric.
- Foam finishing refers to processes in which the chemical is suspended in a foam.
- **Foam–flame process** uses foam partially melted by heat to adhere two layers of fabric together to create a laminate.
- Foam printing is a type of printing in which the colorant is suspended in foam prior to application.
- **Foil printing** is a printing process in which a special adhesive is screen printed onto fabric, an aluminum-coated polyester film is pressed onto the fabric, and the foil adheres only to areas with the adhesive.
- **Formaldehyde** is a restricted hazardous chemical that is used in finishing and dyeing textiles.
- Foulard (foo'-lahrd) is a soft, lightweight, filament-yarn, twill-weave fabric. It is woven in a $\frac{2}{2}$ twill weave and piecedyed or printed.
- **French terry** is a weft-insertion filling knit, but the fabric is not napped, to develop a fleecelike hand.
- **Friction calendering** is a type of calendering in which one cylinder rotates more quickly than the other, shining or polishing the fabric surface; used to produce polished cotton with or without a resin.
- **Friezé** (**frē**'-**zay** or **frēz**) is a strong, durable, heavy-warp-yarn pile fabric. The pile is made by the over-wire method to create a closed-loop pile.

- **Frosting** is a problem with color retention related to a dye's inability to penetrate deeply in the fiber. Abrasion removes the colored portion and reveals the uncolored portion. Also refers to a chemical or abrasive finish that deliberately produces this whitish cast on fabrics.
- **Full fashioning** is the process of shaping knit garments during the knitting process by adding or decreasing stitches.
- **Fulling** is a finish of woven or knitted wool fabrics that produces a tighter, more compact fabric by a carefully controlled felting process.
- **Fume fading** is a color-retention problem. Colors alter when exposed to gases, fumes, or other atmospheric pollutants.
- **Fume-fading-resistant finish** refers to a finish designed to minimize the effect of atmospheric pollutants on dyes.
- Functional finish (See Special-purpose finish.)
- **Fur** is any animal skin or hide to which the hair is attached and that has been processed to protect the hide from rotting.
- Fur cleaning is a specialized process of removing soil from fur so that the hide does not lose its color or suppleness and the hair is not damaged.
- **Fur Products Labeling Act** regulates the labeling of fur products to protect the consumer from unscrupulous trade practices.
- **Fusible nonwoven** is a type of fiberweb with a chemical adhesive on its technical back.
- Gabardine (gaberdine) is a tightly woven, medium- to heavyweight, steep- or regular- angle, twill-weave fabric with a pronounced wale. The fabric can be wool, a wool blend, or synthetic fibers that resemble wool. Gabardine can also be 100 percent texturized polyester or a cotton/polyester blend.
- **Gaiting** describes the arrangement of needles in a double-knitting machine. (*See also*, Interlock and Rib Gaiting.)
- Garment dyeing (See Product dyeing.)
- Garment or product dip process (See Immersion process.)
- **Garnetted** is a term for shredding wool yarns or fabrics to produce wool fibers for recycling.
- Gauge (gāj) refers to needles per inch in the machines used in making knits or tufted fabrics.
- **Gauze** (gawz) is a sheer, lightweight, low-count, plain- or leno-weave balanced fabric made of spun yarns. It is often cotton, rayon, or a blend of these fibers. *Indian gauze* has a crinkled look and is available in a variety of fabric weights.
- **Gel spinning** is a spinning method in which the dissolved polyethylene polymer forms a viscous gel in the solvent, followed by extrusion through the spinneret, solvent extraction, and fiber drawing.
- **Generic group** refers to fibers with similar chemical composition.
- **Generic name** refers to the family of manufactured or synthetic fibers that have similar chemical composition.
- **Georgette** is a sheer, lightweight, plain-weave or momie-weave fabric made with fine-crepe yarns. It is livelier and less lustrous than chiffon.
- **Gin** is a mechanical device used to separate cotton fibers from the seed.

Gingham is a yarn-dyed, plain-weave fabric that is available in a variety of weights and qualities. It may be balanced or unbalanced and of combed or carded yarns. If two colors of yarn are used, the fabric is called a *check* or a *checked gingham*. If three or more colors are used, the fabric is referred to as a *plaid gingham*.

Glass is a manufactured fiber in which the fiber-forming substance is glass.

Glass transition temperature (Tg) refers to the temperature at which amorphous regions of fibers are easily distorted. It is used in heat setting fabrics.

Glazed refers to a fabric that has been treated with a friction calender to polish the surface.

Glazed chintz (See Chintz.)

Glazing is a flattening of the cross section of heat-sensitive fibers or yarns resulting from exposure to high temperatures.

Gore-Tex is a poromeric multiplex fabric combining fluoropolymer film with fabric to produce a water-impermeable but comfortable fabric. It is produced by W. L. Gore & Associates.

Grading wool refers to judging a wool fleece for its fineness and length.

Graft polymer is a type of copolymer; another type of mer is attached to the backbone polymer chain.

Grain refers to the natural surface characteristic of leather and is related to the species of animal. It also describes the relationship of warp to filling yarns in a woven fabric.

Grain-sueded (or **nubuck**) **leather** is leather that has been napped on the grain side of the skin or hide.

Granite cloth is a wool momie-weave fabric. The term may be used for any momie-weave fabric.

Gray goods (or **Grey goods** or **Greige goods**) is a general term used to describe any unfinished woven or knitted fabric.

Grease wool (See Raw wool.)

Green cotton describes cotton fabric that has been washed with mild natural-based soap, but it has not been bleached or treated with other chemicals, except possibly natural dyes.

Green products are those sold with claims, valid or not, that they have been produced using systems that have minimal environmental impact.

Grin-through occurs when some elastomeric fibers break and the broken ends or loops of broken fibers appear on the fabric's surface. In pile and tufted fabrics, it describes where the base structure shows through the pile surface.

Grosgrain (grow'-grain) is a tightly woven, firm, warp-faced fabric with heavy, round filling ribs created by a high warp count and coarse filling yarns. Grosgrain can be woven as a narrow-ribbon or a full-width fabric.

Ground ply is the ply of a fancy yarn that forms the foundation for the effect ply.

Guanaco is the fiber produced by the South American guanaco.

Habutai is a soft, lightweight silk fabric, heavier than China silk.

Hackling is a process of separating bast fiber bundles into individual fibers and removing short irregular fibers.

Hairiness describes excessive fiber ends on a yarn's surface that may create problems in fabrication or in consumer use because they are more sensitive to abrasion and pilling.

Halogenation is a finish for wool that partially dissolves fiber scales in order to produce a washable fabric.

Hand is the way a fiber feels to the sense of touch.

Hand builders are compounds that soften a fabric's hand.

Handkerchief linen is similar in luster and count to batiste, but it is linen or linen-like with greater body.

Handling refers to the physical form of the fabric in terms of length and width during finishing.

Handmade lace includes several types of lace made by people. Hard twist is a high amount of yarn twist in the range of 30 to 40 tpi, which produces a harsher fabric hand.

Harness is the part of the loom that forms the weave by controlling the up or down position of warp yarns.

Heat conductivity is the ability to conduct heat away from the body.

Heat retention is the ability of a fiber to retain heat or to insulate

Heat sensitivity is the ability to soften, melt, or shrink when subjected to heat; *see also* Thermoplastic.

Heat setting describes the process of producing fiber, yarn, or fabric stability through the use of heat.

Heat-transfer printing describes a process of adding color to fabric by using heat to cause a pattern printed on paper to transfer to the fabric.

Heddle is a rigid wire in the loom through which a warp yarn is threaded and which is held in place in a harness.

Hemp is a bast fiber produced by Cannabis sativa.

Henequen is a smooth, straight, yellow leaf fiber similar to sisal.

Herringbone is a broken twill-weave fabric created by changing the direction of the twill wale from right to left and back again. This creates a chevron pattern of stripes that may or may not be equally prominent. Herringbone fabrics are made in a variety of weights, patterns, and fiber types.

Hessian (see Burlap.)

High-bulk yarn is a bulk yarn with little or no stretch.

High-tenacity fibers have been modified in the spinning process to increase fiber strength.

High-wet-modulus rayon is a modification of rayon with better performance characteristics.

Hollow fibers contain air space in their interiors.

Homespun is a coarse, plain-weave fabric with a handwoven look.

Homopolymer refers to a polymer composed of a single type of mer.

Honan (hō'-nahn) Originally of Chinese silk, honan is now made of any filament fiber. It is similar to pongee, but it has slub yarns in both warp and filling.

Hopsacking is a coarse, loose suiting- or bottom-weight, basket-weave fabric often made of low-grade cotton.

Hot-melt lamination is a method of combining outer fabric, adhesive, and liner fabric into a composite fabric with the use of heat and pressure.

- **Hot-water extraction** is a cleaning technique for furnishings in which a hot-water–detergent solution is injected into the textile and the soiled solution is removed by vacuuming.
- **Houndstooth** is a medium- to heavyweight, yarn-dyed, twill-weave fabric in which the interlacing and color pattern create a unique pointed-check or houndstooth shape.
- **Huck** or **Huck-a-back** is a medium- to heavyweight fabric made on a dobby loom to create a honeycomb or bird's-eye pattern. Often the filling yarns are more loosely twisted to increase fabric absorbency.
- **Hydroentangled web** is a layer of fibers in which jets of water are forced through the web after extrusion to entangle the fibers.
- **Hydrogen bonds** are attractions between positive hydrogen atoms of one molecule and negative oxygen or nitrogen atoms in another molecule.
- **Hydrophilic** describes fibers with high moisture absorbency or regain.
- **Hydrophobic** describes fibers with low moisture absorbency or regain.
- **Hygroscopic** describes fibers with high moisture absorbency or regain and the ability to remain dry to the touch.
- **Ikat** is a resist printing method; yarns are treated to resist dye in certain areas, dyed, and woven into a fabric.
- **Immersion process** is a process for creating durable-press items in which the finished item is immersed in a finishing agent mixed with appropriate additives to control for hand and performance, pressed, and cured.
- **Ink-jet printing** refers to adaptation of paper ink-jet methods to textile printing.
- **Insect-** and moth-control finish uses chemical compounds to reduce a fabric's attraction to insects including moths.
- **Inspection** describes the finishing step in which fabric quality is assessed.
- **Intarsia** is a type of filling-knit fabric in which yarns that appear on the surface of the fabric are discontinuous. Intarsia is a knit counterpart to a true tapestry weave.
- **Interlacing** is the point at which a yarn changes its position from one side of the fabric to the other.
- **Interlock** is a firm, double-filling knit. The two needlebeds knit two interlocked 1×1 rib fabrics. Both sides of the fabric look like the face side of jersey.
- Interlock gaiting refers to a double-needlebed arrangement.

 Needles in one bed are directly opposite needles in the other bed. Used to produce interlock and other double-knits.
- **Isotactic** refers to the same type of spatial arrangement of side groups attached to the backbone chain throughout the polymer.
- **Jacquard double-knit** is a patterned fabric made on a double knitting machine.
- **Jacquard jersey** is a jersey knit with a pattern that uses a combination of knit, tuck, or miss stitches.
- **Jacquard loom** is a loom with warp yarns individually controlled by punched cards or a microcomputer used to create jacquard fabrics.

- **Jacquard weave** Large-figured designs that require more than 25 different arrangements of the warp yarns to complete one repeat design.
- **Jean** is a warp-faced twill of carded yarns. It is lighter weight than drill, and it has finer yarns but a higher warp-yarn count.
- **Jersey** is a single filling-knit fabric with no distinct rib. Jersey can have any fiber content and be knit flat or circular.
- **Jet dyeing** is a process in which the fabric is in a continuous loop when dyed.
- **Jet printing** is the application of color to fabric by spraying dye through tiny nozzles to create the pattern.
- **Jig dyeing** is a process for dyeing fabric in open width form. **Jute** is a bast fiber used to produce burlap and other industrial fabrics.
- **Kapok** is fiber removed from the seed of the Java kapok or silk cotton tree.
- Kenaf is a bast fiber removed from the kenaf plant.
- Keratin is the protein found in animal fibers.
- **Kersey** is a very heavy, thick, boardy, wool coating fabric that has been so heavily fulled and felted that it is difficult to see the twill weave. Kersey, heavier than melton, may be either a single or a double cloth.
- **Knit-deknit process** is a filament yarn texturing process in which a yarn is knit into a fabric, heat set, and unknit.
- **Knit stitch** is the basic stitch that forms the majority of knit fabrics.
- Knitted terrycloth is a filling-knit fabric with a loop pile.
- Knit-through (or sew-knit) fabric includes several types of composite fabric made by knitting a fine yarn through a thin fiberweb or by knitting fibers or yarns to lock laid yarns in place.
- **Knitting** refers to the production of fabric by interlooping yarns.
- **Knot, spot, nub,** or **knop yarn** is a fancy yarn. The effect ply is twisted many times around the ground ply in the same place.
- **Labeling requirements** refer to information required by law or regulation that must be available to the consumer at the point of purchase.
- Lace is an openwork fabric with yarns that are twisted around each other to form complex patterns or figures. Lace is hand or machine made by a variety of fabrication methods, including weaving, knitting, crocheting, and knotting.
- La coste is a double-knit fabric made with a combination of knit and tuck stitches to create a meshlike appearance. It is often a cotton or cotton/polyester blend.
- **Lamb's wool** is wool removed from animals less than 7 months old.
- Lamé (lah-may') is any fabric containing metal or metallic yarns as a conspicuous feature.
- **Laminated fabric** describes a composite fabric created by adhering two layers of fabrics with a thin foam.
- **Laminates** are composite fabrics in which two layers of fabric are adhered by foam or adhesive.

Lastrile is a synthetic rubber in which the fiber-forming substance is a copolymer of acrylonitrile and a diene composed of not more than 50 percent but at least 10 percent by weight of acrylonitrile units.

Latch needle is a type of needle used in knitting fabrics from coarse yarns.

Lawn is a fine, opaque, lightweight, plain-weave fabric usually made of combed-cotton or cotton-blend yarns. The fabric may be bleached, dyed, or printed.

Leaf fiber refers to fiber removed from the leaves of a plant. **Leather** is processed from the skins or hides of animals, birds, reptiles, or fish so that it does not rot.

Leather cleaning is a specialized process of removing soil from treated animal hides so that color and suppleness are not lost.

Leavers lace is a type of machine-made lace in which bobbins move back and forth and around warp yarns to create the fabric's open pattern.

Leno (lē'-nō) refers to any leno-weave fabric in which two warp yarns are crossed over each other and held in place by a filling yarn. This requires a doup attachment on the loom.

Level refers to a colorant that is uniform throughout the fabric or product.

Licensing describes the situation in which one company legally uses another company's trademarks and expertise to make, use, and/or sell a product.

Light-reflecting finishes incorporate fluorescent dyes or small glass retroreflective spheres or prisms to enhance fabric visibility in low-light conditions.

Light-stabilizing finish incorporate light-stabilizing or ultraviolet-absorbing compounds to minimize damage from light exposure.

Line refers to long, combed, and better quality flax fibers. Linen (See Flax.)

Lining twill is an opaque, lightweight, warp-faced twill of filament yarns. It may be printed.

Lint refers to usable cotton fibers removed in the ginning process. It also refers to fiber debris that creates pills on fabrics or accumulates in dryer lint traps.

Linters are very short cotton fibers that remain attached to the cotton seed after ginning.

Liquid-barrier finish protects fabrics from liquids penetrating through them.

Liquor ratio refers to the weight of water or other solvent as compared with the weight of fabric in a solution.

Lisle (pronounced **lyle**) is a high-quality jersey made of fine two-ply combed cotton yarns.

Llama is the fiber produced by the South American llama.

Loft, or compression resiliency, is the ability to spring back to original thickness after being compressed.

London shrunk is a relaxation finishing process for wool fabrics.

Loom is the machine used to make woven fabrics.

Loop, curl, or **bouclé yarn** is a fancy yarn. The effect ply forms closed loops at regular intervals along the length of the yarn.

Looping machine is used to join knit garment parts in a way that is hidden.

Low-elongation fibers are used in blends with weaker fibers to increase fabric strength and abrasion resistance.

Low-pilling fibers have been engineered to have a lower flex life, thus decreasing pill formation.

Low twist is a very small amount of twist used in filament yarns that keeps fibers together in processing and fabrication.

Lumen is a hollow central canal through which nutrients travel as a cotton fiber develops.

Luster refers to the way light is reflected from the fiber or fabric surface.

Luster finish is a fabric treatment that changes the light reflectance characteristics of the fabric.

Lyocell (lī'-ō-sel) is a manufactured fiber composed of solvent-spun cellulose.

Madras (mad'-ras) gingham or madras shirting is a lightto medium-weight, dobby-weave fabric in which the pattern is usually confined to vertical stripes.

Maltese lace is a bobbin lace with a Maltese cross in the pattern.

Man-made fibers (See Manufactured fibers.)

Manufactured or **man-made fibers** are made from chemical compounds produced in manufacturing facilities. The material's original form is not recognizable as a fiber.

Manufactured regenerated fibers are produced in fiber form from naturally occurring polymers.

Marquisette (mahr-kui-zet') is a sheer, lightweight, lenoweave fabric, usually made of filament yarns.

Mass pigmentation (See Solution dyeing.)

Matelassé (mat-luh-sā') is a double-cloth fabric woven to create a three-dimensional texture with a puckered or almost quilted look. Matelassés are made on jacquard or dobby looms, often with crepe yarns or coarse cotton yarns. When finished, the shrinkage of the crepe yarn or the coarse cotton yarn creates the puckered appearance. It is used in apparel as well as in furnishings.

Mechlin (mek'-lihn) lace is a bobbin lace with a small hexagonal mesh and very fine yarns.

Melamine is a manufactured fiber in which the fiber forming substance is a synthetic polymer composed of at least 50% by weight of a cross-linked melamine polymer.

Medulla is an airy, honeycombed core present in some wool fibers.

Melt-blown fiberweb is made by extruding the polymer into a high-velocity air stream that breaks the fiber into short pieces that are held together by thermal bonding and fiber interlacing.

Melton is a heavyweight, plain- or twill-weave coating fabric made from wool. It is lighter than kersey and has a smooth surface that is napped, then closely sheared. It may be either a single or double cloth.

Melt spinning is the process of producing fibers by melting polymer chips and extruding the molten polymer in fiber form. Coagulation occurs by cooling.

Mercerization is a finish in which sodium hydroxide is used to increase cotton's absorbency, luster, and strength. *See also*, Slack mercerization and Tension mercerization.

Merino is a sheep breed that produces superior quality wool.

Metallic coating is a surface application of a thin layer of metal, usually aluminum, primarily to minimize heat transfer through the fabric or to add a metallic luster to the fabric.

Metallic fibers are manufactured fibers composed of metal, plastic-coated metal, metal-coated plastic, or a core completely covered by metal.

Metallic yarn is a yarn made with at least one metal monofilament fiber.

Metamerism (meh-tam'-uhr-izm) describes when two items match in color under one light source, but not under another light source.

Metered-addition process is a durable-press process in which finished goods are sprayed with a controlled amount of the finishing agent mixed with additives that control hand and performance, tumbled to distribute the finish evenly, pressed, and cured.

Microdenier refers to a fiber of less than 1.0 denier per filament.

Microencapsulated finishes incorporate a water-soluble material in a tiny capsule form, which may contain fragrance, insect repellents, disinfectants, cleaning agents, or other materials.

Migration describes a color problem in which the dye shifts from the area where it was applied to adjacent areas of the same fabric or a fabric in close proximity.

Milanese machine uses two sets of yarns, one needlebed, and one guide bar to knit milanese fabrics.

Mildew control describes a finish that inhibits the growth of mold or mildew.

Mildew resistance is resistance to the growth of mold, mildew, or fungus.

Mill-finished describes a fabric finished by the same company that produced the fabric; a type of vertical integration within the textile industry.

Milling (See Fulling.)

Minimum or **Minimum** yardage refers to the shortest length of fabric a textile firm will produce or sell to another firm.

Mixed-denier filament bundling combines fibers of several denier sizes, such as microfibers (0.5 dpf) with macro or regular denier (2.0 dpf) fibers, in one yarn.

Mixture is a fiber blend. Yarns of one generic type are present in one fabric area (i.e., the warp) and yarns of another generic type are present in another fabric area (i.e., the filling).

Modacrylic is a manufactured fiber in which the fiber-forming substance is any long-chain synthetic polymer composed of less than 85 percent but at least 35 percent by weight acrylonitrile units except when the polymer qualifies as rubber.

Modulus is the resistance to stress/strain to which a fiber is exposed.

Mohair is the hair fiber produced by the Angora goat.

Moiré (mwah-rā') calendering describes a finish that produces a watermarked or wood-grain texture on rib or unbalanced plain-weave fabrics like taffeta.

Moiré pattern is a wood grain or watermarked pattern produced on some unbalanced plain-weave fabrics by finishing.

Moisture vapor transport rate (MVTR) measures how quickly moisture vapor moves from the side of the fabric next to the body to the fabric's exterior side.

Mold control (See Mildew control.)

Moleskin is a napped, heavy, strong fabric often made in a satin weave. The nap is suedelike.

Momie weave is a class of weaves with no wale or other distinct weave effect, resulting from an irregular interlacing pattern.

Momme (also known as *Momie* or *Mommie* (mum'mē), abbreviated mm, is a standard way to describe the weight of silk fabrics; one momme weighs 3.75 grams.

Monk's cloth is a heavyweight, coarse, loosely woven, basketweave fabric usually in a 2×2 or 4×4 arrangement made of softly spun, two-ply yarns in oatmeal color.

Monofilament yarn is a filament yarn consisting of a single fiber.

Mordant dyes are a class of dye that require the use of a metal salt (mordant) to bond with the fiber.

Moss crepe combines a momie weave with crepe-twist yarns. **Moth resistance** describes a finish in which the wool fabric is treated to be unpalatable or harmful to insects.

Multihead embroidery refers to the machine that creates several identical designs or emblems simultaneously.

Multiple-shed weaving is a type of loom in which the filling yarn is inserted in a series of sheds that form as the filling yarn moves across the fabric.

Multiplex fabric describes fabrics that combine fibers, yarns, fabrics, or a combination of these into one fabric; another term for a composite fabric.

Multiprocess wet cleaning (See Professional wet cleaning.)
Muslin is a firm, medium- to heavyweight, plain-weave cotton fabric made in a variety of qualities.

Nap refers to fiber ends on the fabric's surface due to finishing.

Napping is a finish in which fiber ends are brushed to the surface to produce a softer hand.

Napping twist is a small amount of twist used to produce lofty spun yarns for fabrics that will be napped.

Narrow fabric describes any fabric up to 12 inches wide.

Natural bicomponent fiber contains the two types of cortex cells; wool fiber is an example.

Natural dyes are a dye class produced by plants and other natural sources used primarily with natural fibers.

Natural fibers are grown or developed in nature in recognizable fiber form.

Natural protein fiber is a fiber of animal or insect origin.

Naturally colored cotton is cotton grown in colors of brown, tan, yellow, green, rust, etc.

Needlepoint lace includes Alençon, which has a hexagonal mesh, and rosepoint and Venetian point, which have an irregular mesh.

Needle punching is a fiberweb made by passing barbed needles through a fiber web to entangle the fibers.

Neoprene describes a composite fabric combining a film of polychloroprene with a woven, knitted, or fiberweb fabric.

- **Nep** is a small knot of entangled fibers. The fibers may be immature or dead and create problems in dyeing.
- **Net** is a general term used to refer to any open-construction fabric, whether it is created by weaving, knitting, knotting, or another method.
- **Netlike structure** includes all fabric structures formed by extruding one or more polymers as film that is embossed and partially slit or by extruding a network of ligaments or strands.
- **Network yarn** is a yarn made from fibers that are connected at points along their length.
- Ninon (nee'-nohn) is a sheer, slightly crisp, lightweight, plainweave fabric made of filament yarns. The warp yarns are grouped in pairs, but ninon is not a basket-weave fabric.
- **Nodes** are irregular crosswise markings present in many bast fibers.
- Nonreinforced film (See Plain film.)
- Nonwoven is a general term for fabrics directly made from fibers.
- Novelty yarn is another term for a fancy yarn.
- **Novoloid** is a manufactured fiber in which the fiber-forming substance contains at least 35 percent by weight of cross-linked novolac.
- **Nylon** is a manufactured fiber in which the fiber-forming substance is any long-chain synthetic polyamide in which less than 85 percent of the amide linkages are attached directly to two aromatic rings.
- Occupational Safety and Health Administration (OSHA) is the federal agency that enforces laws and regulations that ensure safety in the workplace.
- **Off-grain** refers to a fabric in which the warp and filling yarns do not cross each other at a 90-degree angle.
- **Off-grain print** describes a fabric defect in which the print pattern does not line up with the fabric grain.
- Off-shade describes when one fabric or portion of a product does not precisely match the color of another fabric or portion of a product.
- **Olefin** is a manufactured fiber in which the fiber-forming substance is any long-chain synthetic polymer composed of at least 85 percent by weight of ethylene, propylene, or other olefin units except amorphous (noncrystalline) polyolefins qualifying as rubber.
- Oleophilic refers to fibers that have a high affinity for oil.
- **Open-end rotor spinning** is a spun yarn process that eliminates roving and twisting.
- **Opening,** an initial step in the production of spun yarns, loosens fibers from bale form and cleans and blends the fibers.
- **Open-width finishing** refers to holding the fabric out to its full width during finishing.
- **Optical brighteners** are chemical compounds used to produce a white appearance.
- **Organdy** is a transparent, crisp, lightweight, plain-weave fabric made of cotton-spun yarns. The fabric has been parchmentized or treated with acid to create the crisp, wiry hand.

- **Organic cotton** describes cotton produced following state fiber-certification standards on land where organic farming practices have been used for at least 3 years.
- **Organza** is a transparent, crisp, lightweight, plain-weave fabric made of filament yarns.
- **Orientation** refers to the alignment of the fiber's polymers with its longitudinal axis.
- Osnaburg (osnaberg) is a coarse, bottom-weight, low-count cotton fabric characterized by uneven yarns that include bits of plant debris.
- Ottoman is a firm, plain-weave, unbalanced fabric with large and small ribs made by adjacent filling yarns of different sizes that are completely covered by the warp.
- **Outing flannel** is a medium-weight, napped, plain- or twill-weave, spun-yarn fabric. It may be napped on one or both sides. It is heavier and stiffer than flannelette.
- **Out-of-register** is a problem with some printed fabrics. The edges of a print do not match as the designer intended.
- Over-wire method is one technique used to create pile fabrics such as friezé.
- Oxford chambray is an oxford cloth made with yarn-dyed warp yarns and white, or sometimes yarn-dyed, filling yarns.
- Oxford cloth is a light- to medium-weight fabric with a 2×1 half-basket weave.
- Package dyeing is a process for dyeing yarn cones or other textiles, in which the dye bath is forced through the textile.
- Padding machine passes the fabric through a solution, under a guide roll, and between two padding rolls to evenly distribute a finish across the fabric.
- Pad dyeing is a process for dyeing fabric in open-width form, where dye is forced into the fiber by nip or squeeze rollers.
- **Panné velvet** is a warp-pile fabric in which the pile yarns are pressed flat in the same direction.
- **Parchmentizing** is an acid finish for cotton fabrics that produces a thinner fabric with a crisper hand than the original fabric; used to produce organdy.
- Parent fiber is the simplest form of a fiber that has not been modified in any way.
- **PBI** is a manufactured fiber in which the fiber-forming substance is a long-chain aromatic polymer having recurring imidazole groups as an integral part of the polymer chain.
- **PBO** is a special use fiber made of polyphenylene benzobisox-azole.
- Peau de soie (pō'-deh-swah) is a very smooth, heavy, semidull, satin-weave fabric of silk, acetate, or other manufactured fibers. It often has satin floats on both sides of the fabric.
- **Percale** is a balanced-plain-weave, medium-weight, piece-dyed or printed fabric finished from better-quality print cloths.
- **Performance** is the manner in which a textile, textile component, or textile product responds when something is done to it or when it is exposed to some element in the environment that might adversely affect it.
- **Performance fibers** are fiber modifications that provide comfort and improve human performance for products such as active sportswear.

Performance testing refers to subjecting textiles to selected procedures and determining how the textile reacts.

Perfume is a compound added to some detergents to mask an unattractive odor with one that is more pleasant.

Permanent finish describes a finish whose effectiveness will not diminish with time or use.

Phase-change finish is a chemical compound that changes physical state (solid or liquid) as it absorbs or loses heat.

Picking is the step in weaving in which the filling yarn is inserted in the shed.

Piece dyeing describes adding color to a textile when it is in fabric form. (See also, Union dyeing and Cross-dyeing.)

Pigment is a colorant that is insoluble and must be attached to the fiber with the use of a binding agent.

Pile jersey is a filling knit made with two sets of yarns, in which one set forms the base structure and the other set forms the pile.

Pile weave is a three-dimensional structure made by weaving an extra set of warp or filling yarns with the ground yarns so that loops or cut yarn ends create a pile.

Pilling is the formation of tiny balls of fiber ends and lint on the surface of the fabric.

Pilling-resistant finish is any finish designed to minimize the formation of pills on a fabric.

Pima cotton is a type of extra-long-staple cotton.

Piña is a leaf fiber obtained from the pineapple plant.

Pinsonic quilting is the production of a composite fabric by using ultra-high-frequency sound to heat-seal face fabric, fiberfill, and backing fabric together in localized areas.

Piqué (pee-kay') is a fabric made on a dobby or jacquard loom with carded or combed yarns. Some piqués are made in a variety of patterns. Some have filling cords. Most have three or more sets of yarns.

Plain film consists of the polymer solution in sheet form with no supporting layer.

Plain weave is the simplest weave structure, in which two sets of yarns at right angles to each other pass alternately over and under each other to form the maximum number of interlacings.

Plastic coating is the surface application of a thin film to a fabric for increased luster and water repellency, or to minimize yarn slippage.

Pleated fabric is a special type of embossed fabric in which pleats are formed during finishing and heat set into the fabric.

Pleating calender is a special type of embossing calendering that produces three-dimensional pleats in the fabric.

Plissé (plih-sā') is a fabric usually finished from cotton-print cloth by printing on a caustic-soda (sodium hydroxide) paste that shrinks the fabric and creates a three-dimensional effect. The stripe that is printed usually is darker in piece-dyed goods because the sodium hydroxide increases the dye absorbency.

Plush is a woven warp-pile fabric with a deep pile.

Ply yarn consists of two or more strands of fibers held together by twist or some other mechanism.

Pocket weave (See Double weave).

Point paper is a type of paper used to diagram warp knits.

Polished cotton is a balanced, medium-weight, plain-weave fabric that has been given a glazed-calender finish.

Pollution Prevention Act is the federal law that focuses on waste minimization.

Polyamide is a generic term for polymers containing an amide group and a term used for nylon in some countries.

Polyester is a manufactured fiber in which the fiber-forming substance is any long-chain synthetic polymer composed of at least 85 percent by weight of an ester of a substituted aromatic carboxylic acid, including but not restricted to substituted terephthalate units or substituted hydroxybenzoate units.

Polyethylene is a type of olefin made from polymerizing ethylene.

Polyimide is a special use fiber made from polyetherimide.

Polymer is a very large molecule made by connecting many small molecules, or monomers, together.

Polymerization is the process of connecting many small molecules (monomers) to produce one very large molecule, called a polymer.

Polypropylene is a type of olefin made from polymerizing propylene.

Polytetrafluoroethylene is the polymer found in fluoropolymer fibers.

Pongee (pahn-jee') is a medium-weight, balanced-plainweave fabric with a fine regular warp and an irregular filling. Originally from tussah or wild silk, now pongee describes a fabric that has fine warp yarns and irregular filling yarns.

Poplin is a medium- to heavyweight, unbalanced, plain-weave, spun-yarn fabric that is usually piece-dyed. The filling yarns are coarser than the warp yarns. Poplin has a more pronounced rib than broadcloth.

Poromeric fabric incorporates a thin film that is microporous in nature.

Porosity-control finish is a finish that minimizes airflow through a fabric.

Postcured process is a durable-press process in which the fabric is saturated with the cross-linking solution, cut and sewn into a product, and cured.

Powder cleaners are dry, absorbent powders that combine detergent and solvent and are applied to the textile in dry form, worked in, and removed by vacuuming.

Power net is a raschel-warp knit in which an inlaid spandex fiber or varn produces high elongation and elasticity.

Power stretch refers to the ability of a fabric to exhibit high retractive forces that mold, support, or shape the body.

Precured process is a durable-press process in which the fabric is saturated with the cross-linking solution, cured, cut, and sewn into a product.

Preparation refers to a series of steps to get yarns ready for weaving or dyeing or fabrics ready for dyeing, printing, or finishing.

Pressing is a finishing process used with wool or wool blends in which the fabric is placed between metal plates that steam and press it.

Pretreatment includes a variety of chemicals that make it easier to remove stains during cleaning.

Primary fiber bundle refers to naturally occurring groupings of individual bast fibers that are difficult to separate completely and that contribute to the natural thick-and-thin appearance of yarns made from bast fibers.

Print cloth is a general term used to describe unfinished, medium-weight, balanced-plain-weave, cotton or cotton-blend fabrics. These fabrics can be finished as percale, embossed, plissé, chintz, cretonne, or polished cotton.

Printing is the localized application of color to the surface of the fabric or yarn. (*See also*, Resist printing, Screen printing, Direct printing, and Roller printing.)

Producer coloring (See Solution dyeing.)

Product development is the design and engineering of a product so that it has the desired serviceability characteristics, appeals to the target market, can be made within an acceptable time frame for a reasonable cost, and can be sold at a profit.

Product dyeing refers to the process of adding color to the textile after it has been cut and sewn into the final product.

Product testing refers to consumers using textile products and evaluating how the products perform.

Professional wet cleaning is a commercial alternative to dry cleaning that uses carefully controlled wet processes to clean textiles that cannot be machine washed.

Progressive shrinkage is shrinkage that occurs through several care cycles.

Projectile loom or **Gripper loom** is a type of loom in which the filling yarn is inserted in the shed with a small metal projectile or gripper.

Prototype is an original sample product used to assess fit, design, construction, and production decisions.

Puckered surface is created on nylon and polyester fabrics by printing them with a chemical that causes the fibers to shrink slightly when dry.

Pure silk and Pure dye silk describe 100 percent silk fabrics that do not contain any metallic weighting compounds or where the metallic weighting compounds are within the minimums set by the 1932 federal silk regulation.

Purl knit is made on a special type of double knitting machine that can produce plain jersey knits, rib knits, and purl knits.

Purl gaiting is a special type of needle arrangement for knitting machines that make purl knits.

Purl or Reverse stitch is a stitch that looks the same on both sides of the fabric.

Qiviut is the fine underwool fiber produced by the musk ox. **QSC** (*See* Quick Style Change.)

Quality refers to the sum total of product characteristics, including appearance, appropriateness for the end use, performance and interactions of materials in the product, consistency among identical products, and freedom from defects in construction or materials.

Quality assurance refers to the broad area of incorporating quality into and evaluating the quality of textile materials and products.

Quality control refers to inspecting textile and materials to determine if they meet quality requirements.

Quality-control standards refer to expected fabric performance.

Quality performance standards refer to expected criteria of behavior in standard fabric test methods.

Quick Style Change (QSC) describes changes in looms and loom control mechanisms to facilitate a rapid change for a loom from one structural design fabric to another.

Quilted fabric is a composite fabric consisting of a face or fashion fabric, a layer of fiberfill or batting, and a backing fabric. The three layers may be connected with heat (pinsonic quilting) or thread (regular quilting).

Ramie is a fiber removed from a perennial shrub grown in hot, humid climates.

Rapier loom is a type of loom in which the filling yarn is inserted in the shed using a rigid or flexible rod or steel tape.

Raschel (rah-shel') knit is a general term for patterned, warp-knit fabric made with coarser yarns than other warp-knit fabrics.

Raschel lace is a type of lace made using warp knitting.

Ratiné yarn is a fancy yarn. The effect ply is twisted in a spiral arrangement around the ground ply, with an occasional longer loop.

Raw or **Grease wool** is wool as it is removed from the animal with soil, suint, and other impurities present.

Raw silk, or Silk-in-the-gum, is silk that has not been processed to remove the sericin.

Rayon is a manufactured fiber composed of regenerated cellulose in which substituents have replaced not more than 15 percent of the hydrogens of the hydroxyl groups.

Reactive dyes are a dye class used primarily with natural fibers and rayon.

Reclining twill is a shallow twill with a wale angle of 35 degrees or less.

Recycled wool is wool that has been processed into fabrics, garnetted, and processed into another fabric.

Recycling is the process of using materials more than one time before they are disposed of when they can no longer be reused in any form.

Reed is the part of the loom through which warp yarns are threaded and which is used to push filling yarns into place after they have been inserted in the shed.

Reeling refers to the process of removing silk fibers from several cocoons and winding them onto a reel.

Reembroidered lace (See Cordonnet lace.)

Regular twill is a twill with a wale angle of approximately 45 degrees.

Relaxation shrinkage refers to loss of dimensions resulting from tensions introduced during fabric production or finishing.

Renewable finish is a finish that, when its effectiveness has been decreased or destroyed, can be replaced by consumers, dry cleaners, or other firms.

Rep is another term for an unbalanced plain weave.

Repairing is a finishing step in which minor flaws in fabrics are corrected.

Resiliency is the ability to return to original shape after bending, twisting compressing, or a combination of these deformations.

- Resist printing refers to a coloration process in which a portion of the yarn or fabric is treated so dyes will not be absorbed during dyeing; includes screen printing, ikat and batik.
- Resource Conservation and Recovery Act is the federal law that regulates solid and hazardous materials from their generation to final disposal.
- **Retting** is the process of bacterial rotting or decomposing the pectin in plant stems in order to remove bast fibers.
- **Reworking** refers to inspecting fabric and repeating steps in finishing that were done incorrectly to achieve appropriate performance.
- **Rib** is a ridge formed in the fabric when the balance is something other than 1:1 or when the size of one yarn set is significantly greater than the size of the other yarn set in the fabric. Also refers to double knit structures when one stitch is made on one bed and the next stitch is made on the other bed.
- **Rib gaiting** refers to the double-needlebed arrangement. Needles in one bed are directly opposite spaces in the other bed. Used to produce rib knits and other double-knits.
- Ring spinning is a process for producing spun yarns. A series of operations removes fibers from a bale, removes debris, makes the fibers parallel, draws them into a fine strand, and adds twist to hold them together.
- **Rippling** is the process of removing seeds by pulling a plant through a machine in order to obtain a bast fiber.
- **RN number** refers to the manufacturer's identification number assigned to the firm, as allowed for in the Textile Fiber Products Identification Act.
- **Roller printing** is the application of color in localized areas through the use of rollers.
- **Rope finishing** refers to allowing the fabric to roll and fold in on itself and form a tube or rope during finishing.
- **Rotary-screen printing** is a resist printing method. A cylindrical screen is treated so that print paste passes through openings to create a design on the fabric. One screen is used for each color in the pattern.
- **Rot-proof finish** is a finish that improves the longevity of fabrics used outdoors.
- **Roving** is a step in the production of some spun yarns. The drawn sliver is reduced in size, fibers are made more parallel, and a small amount of twist is inserted.
- **Rubber** is a manufactured fiber in which the fiber-forming substance is comprised of natural or synthetic rubber.
- **Run** describes a quantity of fabric receiving the same processing at the same time. For knits, it also refers to the collapse of a wale.
- **Safety** describes the ability of a textile or textile product to protect the body from harm.
- Sailcloth is a bottom-weight half-basket-weave (2×1) , unbalanced fabric of spun- or textured-filament yarns that can be piece-dyed or printed.
- Sand crepe is a momie-weave fabric with a repeat pattern of 16 warp and 16 filling yarns that produce a sanded or frosted appearance.

- **Saran** is a manufactured fiber in which the fiber-forming substance is any long-chain synthetic polymer composed of at least 80 percent by weight of vinylidene chloride units.
- Sateen is a strong, lustrous medium- to heavyweight, spunyarn, satin-weave fabric that is either warp-faced or fillingfaced. A warp-faced, spun-yarn fabric with a satin weave may be called cotton satin.
- **Satin** is a strong, lustrous medium- to heavyweight, filament-yarn, satin-weave fabric.
- **Satin weave** is a weave in which each warp or filling yarn floats across four or more filling or warp yarns with a progression of interlacings by two to the right or to the left.
- **Scales** are a horny, nonfibrous layer on the exterior of wool fibers.
- **Schiffli embroidery** is the application of decorative thread on the fabric's surface to achieve a pattern, as in eyelet embroidery.
- **Schreiner calender** etches hundreds of fine lines on a fabric's surface to increase cover, as in tricot, or to add a subtle luster, as in sateen.
- **Scoured** or **Cleaned wool** is wool that has been cleaned to remove soil, suint, and other impurities.
- **Scouring** refers to a finishing step in which soil, excess chemicals, or fiber coatings such as natural waxes or oils are removed.
- **Screen printing** is a process during which application of color to a fabric's surface is controlled by a specially prepared screen so that dye or pigment paste penetrates the screen in selected areas only. Includes rotary and flatbed screen printing.
- **Scroop** refers to the natural rustle made when two layers of silk fabric are rubbed together.
- **Scutching** is a process in which bast fiber plant stems are passed through fluted metal rollers to break up and remove the woody outer layers.

Sea Island cotton (See Pima cotton.)

- Seed fiber refers to fiber removed from a plant's seed pod.
- **Seersucker** is a light- to heavyweight, slack-tension-weave fabric made in a variety of interlacing patterns. It always has vertical crinkled or puckered stripes made by two sets of warp yarns: one set at normal weaving tension, the other set at a much looser, slack tension.
- **Self-twist spinning** is an alternative method of spinning yarn from S- and Z-twist roving that can be used with staple and filament fiber strands.
- **Selvage** is the self-edge of the fabric where filling yarns end or turn to go through another shed.
- **Serge** is a general term used to refer to wool or wool-like twillweave $\frac{2}{2}$ fabrics with a flat right-hand wale.
- **Sericin** is the water-soluble protective gum that surrounds silk when extruded by a caterpillar.
- **Sericulture** is the production of cultivated silk.
- **Serviceability** is the measure of a textile product's ability to meet consumers' needs.
- **Sewing thread** is a yarn specifically designed for stitching together fabrics or other materials.
- **Shade sorting** describes a manufacturer's grouping of fabrics by color so that all fabrics of one color match.

Shagbark is usually a gingham with an occasional warp yarn under slack tension. During weaving, the slack-tension yarns create a single loop at intervals, giving the fabric a unique surface appearance.

Shampooing (see Wet cleaning.)

Shantung is a rough-textured, plain-weave, filament-warp yarn and irregular-spun filling-yarn fabric that is heavier than pongee.

Shape-retention finish refers to any finish that controls wrinkling or creasing with heat or resin; includes crease-retention and durable-press finishes.

Sharkskin is a wool or wool-like $\frac{2}{2}$ left-handed twill made with alternating warp and filling yarns of two different colors and having a smooth, flat appearance. Occasionally a plain-weave or basket-weave fabric is called sharkskin.

Shearing cuts away protruding fiber or yarn ends to achieve a level pile, surface nap, or sculptured effect.

Shed is the space that is formed between warp yarns when at least one harness is raised and at least one harness is lowered during weaving.

Shedding is the step in weaving during which the harnesses are raised or lowered.

Shifting resistance describes a characteristic of fiberfill, batting, and wadding, in which the fibers do not move or shift with use.

Shin-gosen (shin' gōsen) is an ultrafine fiber, often polyester, with modified cross sections and occasional fiber irregularities. It is produced in Japan.

Shrinkage control refers to finishes that minimize fabric tension during finishing to reduce shrinkage during use by consumers.

Shrinkage resistance is the ability of a textile to retain its original size during cleaning.

Shuttle is the part of some looms that is used to carry filling yarns through the shed.

Shuttle embroidery is a technique that produces an all-over embroidered pattern on a fabric; similar to Schiffli embroidery but a more advanced process.

Silence cloth is a white double-faced fabric used under table linens to minimize noise during dining.

Silk is the fiber produced by several varieties of caterpillars, including *Bombyx mori*, *Antheraea mylitta*, and *Antheraea pernyi*.

Silk-in-the-gum (See Raw silk.)

Silk noils refers to staple silk from broken filaments and inner portions of cocoons or waste silk from cocoons in which the caterpillar matured into a moth.

Simple calendering is a mechanical finish. The fabric is passed between two rollers or calenders to remove wrinkles; the simplest calendering process, often precedes printing.

Simplex machine is similar to the tricot machine but uses two needle bars and two guide bars to create a simplex knit.

Simple yarn is a yarn alike in all its parts.

Singeing burns fiber ends from the fabric to produce a smooth surface.

Single-figured jersey is a type of jacquard jersey.

Single-filling knit is the simplest filling knit; it is made using one set of needles.

Single-jersey fabric (See Jersey.)

Single yarn consists of one strand of fibers held together by some mechanism.

Sisal is a leaf fiber produced in Africa, Central America, and the West Indies.

Sizing is a starch, resin, or gelatinous substance added to yarns and fabrics to increase body and abrasion resistance; especially important in preparing warp yarns for weaving.

Skew describes an off-grain problem. Filling yarns interlace with warp yarns at an angle less than or greater than 90 degrees.

Skye (sky) is the process of exposing fabric or yarn to air to oxidize the leuco or soluble colorless form of certain dyes to the pigment or nonsoluble colored form.

Slack mercerization is a treatment of cotton fabric with sodium hydroxide to increase absorbency; especially important as a preparation step in dyeing.

Slack-tension weave is a weave in which two warp beams are used with one beam at regular loom tension and the other beam at a lower tension for weaving seersucker and terrycloth.

Slashing is the process of adding sizing to warp yarns prior to weaving.

Slippage is a tendency in some woven fabrics of warp yarns to slide or slip over filling yarns or vice versa and leave open areas in the fabric; most often occurs in fabrics of low density or smooth filament yarns.

Sliver is a very weak rope of fibers produced in intermediate steps in the production of spun yarns.

Sliver-pile knit is a filling-knit fabric in which the pile is created by using fibers from a sliver.

Slub effects refer to true slub yarns and to yarns that incorporate small tufts of fiber to create an appearance similar to a true slub yarn.

Slub yarn is a single thick-and-thin fancy yarn.

Smooth-filament yarn is a yarn of filament fibers that have not been crimped or textured.

Soap is a cleaning compound made from sodium or potassium salts of fatty acids.

Softener refers to a compound used to remove hardness ions from water (water softener) or to improve the hand of fabric (fabric softener).

Soil describes contaminants on fabric.

Soil-release finish is a chemical surface coating on fabrics to improve soil removal during cleaning.

Soil-release polymer is a chemical present in some detergent that bonds with soil and that releases the soil in the wash.

Solution dyeing describes the addition of colored pigments to polymer solutions prior to fiber extrusion; *also called* Mass pigmentation.

Solvent is a liquid that dissolves other materials; includes water and dry-cleaning solvents.

Solvent finishing refers to processes in which the finishing chemical is dissolved in a liquid other than water.

Solvent spinning is a fiber-forming method in which the raw material is dissolved in amine oxide, spun into weak amine oxide solution, and precipitated out of the solution. The amine oxide is recycled.

Sorting is the process of grouping textiles of similar characteristics to avoid creating problems in cleaning or to allow similar treatments.

- Sorting wool refers to dividing a fleece into different-quality fibers
- **Sourcing** is the business of identifying, locating, and investigating firms to provide raw materials, intermediate components, and services to enable a firm to supply goods to the market.
- **Spandex** is a manufactured fiber in which the fiber-forming substance is a long-chain synthetic polymer consisting of at least 85 percent of a segmented polyurethane.
- **Special-purpose finish** includes all finishes that improve fabric performance or minimize fabric problems.
- Specific gravity is the ratio of the mass of the fiber to an equal volume of water at 4° C.
- **Spike** or **Snarl yarn** is a fancy yarn in which the effect ply forms alternating open loops along both sides of the yarn.
- **Spinneret** is the thimblelike nozzle through which the solution is extruded to form a fiber.
- **Spinning** refers to the process of producing a yarn from staple fibers; it also refers to the production of a fiber by extruding a solution through tiny holes in a spinneret.
- Spinning solution (See Dope.)
- **Spiral** or **Corkscrew yarn** is a fancy yarn in which two plies that differ in size, texture, type, or color are twisted together.
- **Split leather** is one of the inner layers of leather removed from a thick hide.
- **Split-fiber method** is an inexpensive method used to produce tape yarns from olefin film.
- **Spring-beard needle** is a type of needle used in knitting fabrics from fine yarns.
- **Spun-bonded** is a process of producing a fabric directly from fibers by adhering melt-spun fibers together before cooling.
- **Spun-laced** is a process of producing a fabric directly from fibers by using water to entangle staple fibers and create a pattern in the fabric.
- **Spun yarn** is a continuous strand of staple fibers held together by some mechanism.
- **Stabilization** refers to any finish that is designed to minimize shrinkage or growth of fabric during care.
- Stainless steel is a type of metallic fiber.
- Stain-release finish (See Soil-release finish.)
- **Staple fiber** is any natural or manufactured fiber produced in or cut to a short length measured in inches or centimeters.
- **Starching** is a process of adding a sizing material to a fabric to add weight or body.
- **Steep twill** is a twill with a wale angle of approximately 63 degrees.
- **Stencil printing** describes a hand process of adding color to a fabric by using a form to control where the color strikes the fabric.
- **Stiffness** is the resistance to bending or creasing of a fabric.
- **Stitch** or **Loop** is the basic unit of construction in a knitted fabric.
- **Stitch-bonded fabric** is a multiplex fabric in which fine lengthwise yarns in a warp knit are chain stitched to interlock the fiberweb base structure or inlaid yarns.

- **Stock dyeing** refers to a fiber-dyeing process in which loose fibers are colored.
- **Stockinette (stockinet)** is a coarse yarn, single-filling, heavy-knit jersey fabric.
- **Storage** refers to conditions when the textile or textile product is not being used, worn, or cleaned.
- **Stuffer box** is a method used to add crimp and texture to filament yarns.
- **Strength** is the ability to resist stress and is expressed as **tensile strength** (pounds per square inch) or as **tenacity** (grams per denier). Breaking tenacity is the number of grams of force to break a fiber.
- **Stretching** is the process of pulling a fiber so that the molecular chains rotate and slide until they become oriented and form crystals within the fiber to enhance certain fiber properties.
- **Stretch yarn** is a yarn with high degrees of potential elastic stretch and yarn curl.
- **Striations** are the lengthwise lines present on several manufactured fibers, such as rayon.
- **S-twist** refers to a direction of yarn twist that conforms to the slope direction of the central portion of the letter **S**.
- **Subtractive finish** is a finish that removes some portion of the fabric through either a mechanical or chemical process to enhance the fabric's appearance.
- **Suede** (swād) is a leather that has been brushed or napped to pull fibrils to the surface and create a softer surface and a more matte luster.
- **Suede cloth** is a plain- or twill-weave or knitted fabric that is napped and sheared on one or both sides to resemble suede leather.
- **Suiting-weight fabric** is a general term for heavyweight fabrics of any fiber type or fabric construction.
- **Sulfar** is a manufactured fiber in which the fiber-forming substance is a long-chain synthetic polysulfide in which at least 85 percent of the sulfide linkages are attached directly to two aromatic rings.
- **Sulfur dyes** are a solubility-cycle dye class used primarily with cotton.
- **Sunlight resistance** is a finish or fiber modification to minimize the degradative effects of sunlight on fiber or dye.
- Sun protective finish (See Ultraviolet protective finish.)
- **Supported film** is a composite fabric that combines a fiberweb, woven, or knitted fabric with a film for greater durability.
- **Supported-scrim structure** is a composite fabric consisting of foam bonded to a yarn structure scrim; fibers may be flocked on the surface to simulate a pile or suede fabric.
- Surah (soor'-ahē) (See Foulard.)
- **Surface coating** is a finish, usually metallic or plastic in nature, applied to the face of the fabric. Also refers to a polyamide solution applied to wool fabrics to minimize felting shrinkage.
- **Surfactants** are sulfonate organic compounds used in detergents to assist in soil removal.
- **Swivel-dot fabric** is an extra-yarn weave made with a tiny shuttle that wraps extra yarns around some selected warp yarns to create a spot in the fabric.

- **Synthetic fibers** are produced from synthetic polymers made from basic raw materials.
- **Synthetic leather** refers to a variety of fabrications or finishes that produce a surface that resembles leather in appearance or texture; some may be brushed to resemble suede.
- Taffeta (taf'-et-uh) is a general term that refers to any plain-weave filament-yarn fabric with a fine, smooth, crisp hand. Unbalanced taffeta has a fine rib made by heavier filling yarns and more warp yarns. Faille taffeta has a crosswise rib made by using many more warp yarns than filling yarns. Moiré taffetas have an embossed watermark design. Balanced taffetas have warp and filling yarns of the same size.
- **Take-up** is the step in weaving when the woven fabric is wound on the cloth beam and warp yarn is let off the warp beam so that more fabric can be woven.
- **Tanning** is a finishing step in the production of leather to prevent rotting of the hide or skin.
- **Tapa cloth** refers to a hand-produced fiberweb fabric made from the inner bark of selected trees.
- **Tapestry (tap'-ehs-tree)** is a firm, heavy, stiff, jacquard-weave fabric made with several warp and filling yarn sets. Tapestry is also used for fabric made by hand in which the filling yarns are discontinuous. In these tapestries, the filling yarn is used only in the areas where that color is desired.
- **Tape yarn** is an inexpensive yarn produced from extruded polymer film by extrusion or the split-fiber method.
- **Technical back** refers to the inner or under side of the fabric as it is made.
- **Technical face** refers to the outer or upper side of the fabric as it is made.
- **Temporary finish** describes a finish that is removed during the first care cycle or that has a very short life span.
- **Tenacity** describes the strength of a fiber; usually referred to as breaking tenacity, which describes the force at which the fiber ruptures or breaks.
- **Tender goods** describes very weak fabrics that have been exposed to some environmental factor or incorrect processing.
- **Tendering** describes the weakening of fibers due to exposure to degradants or a deleterious interaction between fiber and dye or finish.
- **Tension mercerization** is the treating of cotton yarn, thread, or fabric with sodium hydroxide while under tension.
- **Tentering** is a finishing step in which the fabric is stretched out to full width; often combined with other finishing steps like heat-setting. If poorly done, contributes to bow and skew.
- **Terrycloth (terry)** is a slack-tension, warp-yarn pile fabric with loops on one or both sides of the fabric. It may have a jacquard pattern and be made with plied yarns for durability. There are also weft- or filling-knit terrycloths.
- **Tex system** is a direct yarn-numbering system. The yarn size is the weight in grams of 1000 meters of yarn.
- **Textile** is a general term used to refer to fibers, yarns, or fabrics or anything made from fibers, yarns, or fabrics.

- **Textile Fiber Products Identification Act** regulates use of fiber names in labeling textile products to protect consumers from unscrupulous trade practices.
- **Texture** describes the nature of a fabric's surface as perceived by sight or touch.
- **Textured-bulk-filament yarn** is a uniformly bulky filament yarn in which the bulk is added by crimping or texturizing the filament fibers.
- **Textured** or **bulk yarn** is another term for a textured-bulk-filament yarn.
- **Textured yarn** is a yarn with notably greater apparent volume than a similar conventional yarn.
- **Texturing** refers to the process of adding bulk to yarns or modifying fabric surfaces.
- Thermal finish (see Phase change finish.)
- **Thermoplastic** describes a fiber's sensitivity to heat; fibers that melt or glaze at relatively low temperature.
- **Thermosol process** is a method of dyeing synthetic fibers with disperse dyes by padding and by applying dry heat to set the dye.
- **Thick-and-thin fibers** vary in diameter throughout their length so that in some areas they are thinner and in other areas they are thicker.
- **Throwing** refers to the process of twisting silk filaments into a yarn or to the process of twisting and texturing synthetic fiber filament yarns.
- **Ticking** is a general term used for fabrics of any weave used for mattress covers, slipcovers, and upholstery. It may also be used in apparel.
- **Tie-dye** is a resist dyeing process. Portions of the fabric or yarn are tied to prevent dye absorption in those areas.
- **Tigaring** (tigering) is a surface napping of knit fabrics to produce a suedelike texture; also refers to the removal of loose fiber from a pile or napped fabric.
- **Tissue gingham** is a lightweight yarn-dyed plain-weave fabric. **Top** is a precursor of a worsted yarn.
- **Top grain** refers to the outermost layer of leather and includes the grain features of the hide or skin. It is the highest quality of leather removed from a thick hide.
- Topical finish (See Additive finish.)
- **Torchon (tor'-shohn) lace** is a rugged bobbin lace with very simple patterns.
- **Torts** include behaviors that interfere with personal rights, such as substandard professional performance or deliberate wrongful acts.
- Tow refers to short flax fibers or to a large assembly of filament fibers to facilitate handling and processing during the production of manufactured staple fibers.
- **Tow-to-top system** refers to a process of converting filament fibers to staple fibers by cutting or break stretching.
- **Tow-to-yarn system** refers to a process of converting filament fibers to staple fibers by break stretching, drawing the fibers, adding twist, and winding the yarn on a bobbin.
- **Trade name** is a term used to identify a company's products. **Trademark** is a word, symbol, device, or combination used to designate the product of a particular company.
- **Transition cotton** refers to cotton produced on land where organic farming is practiced, but the 3-year minimum for certified organic cotton has not been met.

Translucence is the ability of a fiber, yarn, or fabric to allow light to pass through the structure.

Triacetate is a manufactured fiber in which the fiber-forming substance is cellulose acetate in which not less than 92 percent of the hydroxyl groups are acetylated.

Triaxial refers to a fabric made with three sets of yarns interlaced at 60-degree angles to each other.

Tricot is a warp-knit fabric made with filament yarns with one or more bars. Tricot has fine, vertical wales on the technical face and horizontal ribs on the technical back.

Tricot machine is a warp knitting machine used to produce tricot warp knits.

Trilobal shape refers to a three-sided fiber cross-sectional shape that is designed to imitate silk.

True crepe is a fabric made with at least one set of crepe-twist yarns.

True tapestry is a patterned unbalanced plain weave fabric with a discontinuous filling.

Tubular finishing (See Rope finishing.)

Tuck stitch is a type of knit stitch in which the previous stitch is not cleared from the needle. It creates a pucker in the fabric and is used in creating patterns.

Tuft density describes the number of yarn tufts per inch.

Tufting is a method of producing an imitation pile surface by stitching yarns to the surface of an existing fabric; used to produce carpeting and upholstery.

Tulle (tool) is a mesh tricot fabric used as a support fabric or as an overlay in apparel.

Turns per inch (tpi) is a measure of yarn twist.

Turns per meter (tpm) is a measure of yarn twist.

Tussah silk is a type of wild silk.

Tweed is a general term for wool or wool-like fabrics made of flock or flake novelty yarns in plain, twill, or twill-variation weaves.

Twill flannel is one of several wool or wool-like fabrics made in a twill weave.

Twill weave is a weave in which each warp or filling yarn floats across two or more filling or warp yarns with a progression of interlacings by one to the right or to the left, forming a distinct wale.

Twist is the spiral arrangement of fibers around the yarn axis. **Twist-on-twist** refers to using the same direction of twist in plying two yarns into one yarn as in the production of each individual ply.

Twistless spinning is a method of producing staple fiber yarn that eliminates twist and uses starch or sizing to lock fibers in place.

Twist setting is a yarn-finishing process used to help make permanent the very high twist in crepe yarns.

Ultrafine denier refers to a fiber of less than 0.3 denier per filament.

Ultrasonic cleaning is a cleaning technique for furnishings that uses high-frequency sound waves to clean the textile.

Ultraviolet-absorbent finish is a finish that absorbs ultraviolet energy and protects the wearer. Includes optical brighteners, many dyes, and other chemicals.

Unbalanced plain weave is a plain weave in which the ratio of warp to filling yarns is significantly greater than 1:1; common types are 2:1, 3:1, and 1:2.

Union dyeing is dyeing a fabric made of two or more fibers to one solid color.

Upholstered Furniture Action Council is an industry group that issues voluntary standards for upholstered furniture.

Vacuuming is a cleaning technique for furnishings in which particulate soil is removed from the textile by suction.

Valenciennes (val-en-sehnz') is a bobbin lace with a diamond-shaped mesh.

van der Waals' forces are weak attractive forces between adjacent molecules that increase in strength as the molecules move closer together.

Vapor phase is a type of durable-press finish in which the finishing chemical is applied to the product in vapor form in a closed chamber and cured in the chamber.

Vat dyes are a solubility-cycle dye class used primarily with cotton and some polyester.

V-bed machine is a type of knitting machine used to produce double-knits.

Velour is a general term used to describe some woven or knit pile fabrics with dense, long, or deep pile.

Velvet is a warp-pile fabric most often made as a double cloth with five sets of yarns. One pair of ground warp and filling create one side of the fabric and a second pair of ground warp and filling create the other side. A fifth set of yarns (pile warp) interlace between the two sets of ground fabrics. The woven fabric is separated into two complete fabrics when the pile warp is cut. Velvet is usually a filament-yarn fabric.

Velveteen is a filling-pile fabric with a plain or twill ground weave made with long floats that are cut in the finishing process to form a short pile. Velveteen is usually a spunyarn fabric.

Venetian (veh-nē'-shuhn) point lace is a needlepoint lace with an irregular mesh.

Vicuña is the fiber produced by the South American vicuña.

Vinal is a manufactured fiber in which the fiber-forming substance is any long-chain synthetic polymer composed of at least 50 percent by weight of vinyl alcohol units and in which the total of the vinyl alcohol units and any one or more of the various acetal units is at least 85 percent by weight of the fiber.

Vinyon is a manufactured fiber in which the fiber-forming substance is any long-chain synthetic polymer composed of at least 85 percent by weight of vinyl chloride units.

Virgin wool is wool that has never been processed into a fabric before.

Viscose rayon is the most common type of rayon.

Viyella™ (vī-el'-uh) is a medium-weight, twill-weave fabric made of an intimate blend of 55 percent wool and 45 percent cotton.

Voile (voyl) is a sheer, lightweight, low-count, plain-weave, spun-yarn fabric in which the yarns have a high, hard (voile) twist to give the fabric a crisp hand. It has a lower count than lawn.

Voile twist (See Hard twist.)

Wadding is a loose assemblage of waste fibers used in textile products as lining and support layers.

Waffle cloth is a dobby-weave fabric in which the interlacing pattern creates a three-dimensional honeycomb.

Wale refers to the diagonal line developed by the interlacing pattern of twills; or the column of stitches made by one needle in a knit fabric.

Warp is the group of yarns threaded through the loom in a woven fabric; parallel to the selvage.

Warp beam is a metal or wood cylinder on which the warp yarns are wound and is a critical part of the loom.

Warp-faced twill is a type of twill weave in which the majority of the technical face of the fabric is formed by warp yarns.

Warp-insertion warp knit is a warp knit in which a yarn was laid in the lengthwise direction as the fabric was being knit.

Warp knitting is a process in which yarn sets are interlooped in essentially a lengthwise direction to form a fabric.

Warp-pile fabric is a fabric with pile created by extra warp yarns.

Warp printing is a process of printing a pattern on warp yarns before weaving.

Warp sateen is a spun-yarn satin-weave fabric in which warp yarns form the technical face of the fabric.

Warranty is an implied or written indication that the product is suitable for the purpose for which it was marketed.

Washdown describes color loss that occurs over time as a fabric is laundered or cleaned.

Wash-off refers to rinsing soil, excess chemicals, contaminants, or unused dye off the fabric; usually done with water.

Wastewater treatment describes the procedures necessary to return water to a potable and usable condition.

Water is a common solvent used in fiber processing, finishing, dveing, and cleaning textiles.

Water-absorbent finish is a chemical added to a fabric that will increase its ability to absorb moisture.

Water-bath finishing refers to processes in which the chemical is dissolved in water.

Water-jet loom is a type of loom in which, the filling yarn is inserted in the shed with a stream or jet of water.

Waterproof fabric refers to a coated or composite fabric that water will not penetrate regardless of the amount of time it is in contact with the fabric or the force with which it hits the fabric.

Water-repellent finish minimizes the wettability of a fabric; it may result in stain resistance as well.

Water softeners are compounds used to sequester minerals present in hard water.

Weaver's cloth is a general term for balanced plain-weave cotton suitings.

Weaving is the process of producing a fabric by interlacing two or more yarns at right angles.

Weft insertion is a single-filling-knit jersey in which a second yarn is laid in a course or knit into the fabric to add stability and that may be napped to create a fuzzy surface on the technical back of the fabric.

Weft-insertion filling knit (See Weft insetion.)

Weft-insertion warp knit is a warp knit in which a yarn was laid in the crosswise direction as the fabric was being knit.

Weighted silk designates a silk fabric to which a metallic salt was added (at an amount specified by federal law) to improve hand, dve affinity, or drape.

Weighting is the treatment of silk with metallic salts to increase the fabric's weight, hand, and dye affinity; it may result in accelerated degradation of the silk.

Wet-adhesive method uses a chemical adhesive to make laminates.

Wet cleaning is a cleaning technique for furnishings in which a water-based detergent is worked into the textile and the soiled solution is removed by vacuuming.

Wet-laid fiberweb is a layer of fibers made from a slurry of fiber and water.

Wet-process finishes are those applied in liquid form.

Wet spinning is a fiber-forming process in which the polymer is dissolved in a solvent and the solution is extruded into a chemical bath.

Whiteners (See Fluorescent whitening agents.)

Wicking is the ability of a fiber to transfer moisture along its surface.

Wild silk refers to naturally grown staple silk that is more irregular in texture and color compared to cultivated silk.

Wilton rugs are figured pile rugs made on a jacquard loom. Winch dyeing is a process for dyeing a loose rope of fabric.

Winding is the process of transferring yarn from one package to another.

Wool refers to fiber from various animals including sheep, Angora and cashmere goats, camel, alpaca, and llama.

Woolen yarn is a slightly irregular bulky wool or wool-like yarn that has not been combed.

Wool Products Labeling Act is the federal law that protects the textile industry and consumers from the undisclosed presence of fibers other than wool and that informs the consumer of the source of the wool fiber.

Worsted yarn is a smooth, straight, and uniform wool or wool-like yarn that has been processed to remove short fibers and make the remaining fibers more parallel.

Woven-pile fabrics are three-dimensional structures made by weaving an extra set of warp or filling yarns into the ground yarns to make loops or cut ends on the surface.

WPL number refers to the manufacturer's identification number assigned to the firm, as allowed for in the Wool Products Labeling Act.

Wrap-spun yarn is a yarn with a core of staple fibers wrapped with filament fibers.

Wrinkle resistance is the ability of a fiber to recover from deformations such as bending, twisting, or compressing.

Wrinkle-resistant finish keeps wrinkling to a minimum.

Yak is the fiber produced by the Tibetan ox.

Yarn is an assemblage of fibers twisted or laid together so as to form a continuous strand that can be made into a textile fabric.

Yarn dyeing is a process of adding color, usually a dye, to yarns. Yarn number describes the size of a yarn.

Z-twist refers to a direction of yarn twist that conforms to the direction of the slope of the central portion of the letter **Z**.

INDEX

Abaca, 47 Abrasion resistance, 22, 24-25, 304 Abrasive washes, 293 Absorbency (moisture regain), 22, 25 Acetate, 87-89 Acrylic(s), 113-18 Acetone test, 80 Additive finishes, 281, 285 Aerosol cleaning, 356 Aesthetic finishes, 280-95 Aesthetics, 9, 21, 24 Aging resistance, 22 Air jet, 142 Air-jet loom, 174 Air-jet spinning, 148-49 Air-laid webs, 243 Air-permeable finishes, 306 Allergenic potential, 22 Alpaca, 61 Alum tanning, 263 Ammoniating finish, 275-276 Amorphous molecular chains, 21 Angora, 59-60 Anidex, 389 Anionic softeners, 307 Antibacterial compounds, 350 Antibacterial fibers, 75 Antibacterial finishes, 308-309 Anticreasing fabric, 301 Antifading agents, 349 Anti-fume-fading finish, 304 Antimicrobial finishes, 308-309 Antiodor finishes, 309 Antipesticide protective finishes, 310 Antiredeposition agents, 349 Antiseptic finishes, 309 Antislip finishes, 304 Antisoil finishes, 303-304 Antistain finishes, 303-304 Antistatic fibers, 74 Antistatic finishes, 307 Appearance, 270 Appearance retention:

defined, 9

26-27 finishes and, 270, 303-305 Applied designs, 281-82 Aramid, 126-127, 133, 391 Area-bond calendering, 245 Astrakhan cloth, 162 Atmospheric-fading protective finishes, 304 Average twist, 156-58 Azlon, 389 Back coatings, 304-5 Backfilling machine, 282, 284 Bacteriostatic finishes, 309 Balance, 178 Balanced plain weave, 183-86 Bark cloth, 204 Basket weaves, 188-89 Bast fiber(s), 42-47 Batch dyeing, 321 Batch processing, 273 Batik, 327 Batiste, 184 Batten, 173 Battenberg lace, 249, 251 Batting, 245 BCF (bulk-continuous-filament) yarns, 141 Beam dyeing, 318 Beating up, 173 Beck dyeing, 321 Bedford cord, 188, 202 Beetling, 292 Bengaline, 187 Bicomponent fibers, 75 Bicomponent-bigeneric fibers, 75 Binder staple, 73 Biological-control finishes, 308-9 Bio-polishing, 274 Bio-scouring, 274 Bird's-eye, 198 Bird's-eye piqué, 202 Bleaches, 345, 349-50 Bleaching, 274

Bleeding, 334, 336

Blended-filament yarns, 152

Blend(s), 150-52

fabric properties related to,

Blending, 145, 151-52 Block printing, 326 Bluing, 351 Bobbin lace, 249, 251 Boiled wool, 292 Boiling-off of cotton, 273 Boil-off process, 294 Boll, 34 Bottom-weight fabric, 185-86 Bouclé yarn, 162 Bow, 177-78 Bowed fabric, 177-78 Braids, 248 Breaking tenacity, 25 Brides, 249 Brighteners, 74–75 Bright fibers, 73-74 Broadcloth, 186-87 Brocade, 203 Brocatelle, 203 Broken twill, 192-93 Brushed tricots, 235 Brushing, 286 Buckram, 184 Builders, 348-49 Bulk yarns, 141-43 Bulk-continuous-filament (BCF) yarns, 141 Bulked yarns, 143 Bull's-eye piqué, 202 Bunting, 184 Burlap, 185 Burn test, fiber identification and, 29-30 Burned-out effects, 286 Butcher cloth, 185

C Calendering, 251 area-bond, 245 defined, 277 point-bond, 245 Calico, 184 Camel's hair, 60 Cams, 220 Canvas, 189 Caracol, 337 Carbon, 132–34 Carbonizing, 278

Carded sliver, 145 Carded yarns, 146-48 Carded-combed yarns, 147 Carding, 145 Care. See specific fibers labeling requirements and, 347, 361, 367 storage and, 354-55 symbols regarding, 362 of textile products, 343-57 Career(s), 375-85 Cashmere, 60-61 Cationic softeners, 307 Caustic treatment, 294 Cavalry twill, 193 Cellulose, 38, 40 Cellulosic fibers, 32-48 classification of, 33 properties common to, 34 regenerated, 79-90 synthetic fibers versus, 92 Ceramic fibers, 134 Challis, 184 Chambray, 184-85 Cheesecloth, 184 Chemical additives, 308 Chemical adhesives, 245 Chemical oxygen demand (COD), 278, 369 Chemical reactivity, 22 Chemical wash, 293 Chemicals, resistance to, 27-28 fibers with, 125-34 Chenille varn, 163, 205 Chiffon, 183-84 China silk, 184 Chino, 192 Chintz, 184 Chrome tanning, 263 Circular loom, 175-76 Ciré finish, 282 Clean Air Act of 1970, 369 Clean Water Act of 1972, 369 Clean wool, 51 Cleaning, 273, 344-56 professional, 354 Clipped-dot designs, 198 Clipped-spot designs, 198 Coated fabrics, 251-53

Coated film, 241	Cotton flannels, 292	Dobby loom, 198, 200	winch, 321
Coating, 251	Cotton gin, 33–35	Dobby weaves, 198–202	yarn, 318, 320
COD (chemical oxygen demand),	Cottonizing, 43	Donegal tweed, 186	Dye-transfer inhibitors, 349
278, 369	Count, 177–78	Dope, 69. See also Spinning	
Code of Federal Regulations (CFR), 246, 361	Cover, 22 Covered yarns, 164	solution Dope dyeing, 318	E "Eco" products, 368
Cohesiveness, 22	Covert, 192	Double cloth, 205–7	Effect ply, 161, 162
Coir, 42	CPSC (Consumer Product Safety	Double weaves, 206	Egyptian cotton, 35, 38, 210
Cold storage, 308	Commission), 361–63	Double-cloth method, 209	Elastane, 123
Color, 314–18, 333–36	Crabbing, 278	Double-faced fabrics, 206–7	Elastic recovery, 22, 26, 27
Color matching, 314	Crash, 185	Double-filling knits, 226-30	Elasticity, 22, 25, 27
Color measurement, 314	Creaset, 303	Double-knit jersey, 228	Elastoester, 125
Color scavenger, 100	Creeling, 173–74	Double-latch needle, 215, 217	Elastomer, 122
Color theory, 314–15	Creep, 22	Double-width loom, 175	Elastomeric fibers, 122-25
Colorants, 315-317, 334	Crepe, 62, 185, 203–4	Doup attachment, 204	Electrical conductivity, 22
Coloration, 276	Crepe de chine, 186	Down, 246	Electrostatic printing, 332
mass, 318	Crepe twist, 156–57	DPF (denier per filament), 19, 71	Elongation, 22, 25, 26
Colorfastness, 314, 333–34, 336	Crepe weave, 203	Drape, 22, 24, 285–86	ELS (extra-long-staple) cotton,
Colorways, 323	Crepe yarns, 158	Drawing, 21, 95, 145	35, 38
Combed sliver, 146 Combed yarn, 146–48	Crepe-back satin, 193 Crepeing, 294	Drawn sliver, 145 Draw-texturing, 142	Embossed designs, 284–85 Embossed fabrics, 286
Combination dyeing, 151,	Cretonne, 184	Drill, 192	Embroidered fabrics, 288–90
322–23	Crimp, 20, 53	Dry cleaning, 345, 352–54, See	Emerizing, 293
Combing, 145–146	Crinoline, 184	specific fibers and leather or	Emulsion spinning, 132
Comfort, 9, 25–26, 305–7	Crocheted lace, 249	fur	Ends, 171
Comfort stretch, 122	Crocking, 334, 336	Dry foam cleaning, 356	Environment, 367–373
Comfort-related finishes,	Cross dyeing, 319-20	Dry prints, 325	Environmental impact, 356-57,
305-307	Cross links, 300	Dry spinning, 113	368-70, See specific fibers
Compact spinning, 148	Cross-dyeable fibers, 74	Drying, 277, 345, 352	and processes
Composite fabrics, 251–63	Cross-laid webs, 243	Dry-laid fiberwebs, 243	defined, 9, 27–28
Composite yarns, 163–65	Cross-sectional shape, 20	Duck, 189	of dyeing, 337
Compound needle, 215, 217	Crushed velvet, 209	Duplex printing, 326	of finishing, 278–79
Compressibility, 22	Crystalline molecular chains, 21	Duppioni silk, 62	of knitting, 218
Compressional resiliency, 100 Compressive shrinkage, 298	Cupra rayon, 82 Cuprammonium process, 82	Durability, 9, 24–25 Durable finishes, 271, 300–303	of manufactured fibers, 76–77 of printing, 337
Computer-aided design (CAD),	Curl yarn, 162	Durable press, 300–303	of weaving, 176
203, 323, 377, 381–82	Cut, 217	Duvetyn, 292	of yarn processing, 152–53
Computer-aided fabric evaluation	Cuticle, 36, 53-54	Dye(s), 315–17	Enzymatic presoaks, 351
(CAFE) systems, 171		defined, 315	Enzyme washes, 293–94
Computer-aided manufacturing		detergents and, 349	Enzymes, 349
(CAM), 323	D	fiber, classification of, 317	Even-sided twills, 191
Conservation, 356	Dacron, 103	fluorescent, 315–17	Expanded films, 241
Consumer education specialists,	Damask, 203	natural, 337	Expanded foam, 290
384	Dead times, 333	tie-, 327–28	Extra-long-staple (ELS) cotton,
Consumer Product Safety Act of	Decating, 278	Dyeability, 22	35, 38
1972, 362	Decitex (dtex), 159	Dye-affinity fibers, 74	Extra-yarn weaves, 198, 200–201
Consumer Product Safety Commission (CPSC),	Decortication, 45	Dyeing, 317–22, 331, 337 batch, 321	Extruded-net process, 248 Extrusion, 69, 140
361–63	Defects, 171 Degree of polymerization, 21	beam, 318	Eyelet, 290
Contact poisons, 308	Degumming, 273	beck, 321	Lyclet, 270
Continuous dyeing, 322–23	Delustering, 73–74	combination, 322–23	F
Continuous machines, 322–23	Denier, 19–20	cross, 319–20	Fabric(s):
Continuous processing, 273	defined, 19, 158	dope, 318	assortment of, 8
Conventional spinning, 144-47	per filament (DPF), 19, 71	environmental impact of, 337	defined, 4, 170
Converted goods, 271	yarn and, 158–59	fiber, 318–319	environmental issues regarding
Converters, 270	Denim, 8, 192, 335, 374	gel, 318	367–73
Convolutions, 36	Density, 23, 26	jet, 322, 331	grading of, 171
Copolymers, 114–15	Desizing, 273	jig, 322	grain, 177
Cord, 160	Detergent(s), 346–347, 350	package, 318, 322	inspection of, 28–29, 278
Cordonnet lace, 250	Differential printing, 329	pad, 322	preparation, 273–274
Corduroy, 208–9, 286–87, 321 Core-spun yarn, 164	Digital (ink-jet) printing, 329–32	product, 321 recent developments in, 333	prices, 10, 271
Corkscrew fancy yarn, 161	Dimensional stability, 22, 26–27	reel, 321	quality of, 12, 171 repairing, 278
Coronizing, 292–93	Direct printing, 326–27	skein, 318	selected trade names for, 392
Cortex, 53	Direct spinning, 148, 150	stages of, 317–20	skewed, 177
Cost, 9–10, 28	Direct-roller printing, 326	stock, 318–19	weight of, 179
Cotton, 33-41, 184, 210, 273,	Discharge prints, 326–27	top, 318	width of, 179
348, 391	Disinfectants, 351	union, 320	Fabric count, 177-78

Eshuis suiman 20
Fabric crimp, 20
Fabric density, 177–78
Fabric grading, 171
Fabric inspection, 28-29, 278
Fabric mass, 179
Fabric mercerization, 275
Fabric pills, 93
Fabric preparation, 273–74
Fabric quality, 12, 171
Eshair and frames 207 240 251
Fabric softeners, 307, 349, 351
Fabric weight, 179
Fabrication, 272–73
Face weight, 258
Faille, 187
Fake-fur fabrics, 209, 224-25,
256-57
False-twist process, 141-42
Fancy twill, 193
Fancy weave(s), 197–212
Federal Insecticide, Fungicide,
and Rodenticide Act
(FIFRA), 365
Fancy yarns, 161–63
Fasciated yarns, 152, 164-65
Federal Trade Commission
(FTC), 359
Care Labeling Regulation of,
347, 361, 367
fills defined by, 246
textile fiber products and, 28,
360
water-repellent fabrics and, 305
wool labeling and, 51, See
specific manufactured and
synthetic fibers
synthetic fibers Felt, 247–48
Felt, 247–48
Felt, 247–48 Feltability, 22
Felt, 247–48 Feltability, 22 Felting, 53–54
Felt, 247–48 Feltability, 22 Felting, 53–54 Fiber(s):
Felt, 247–48 Feltability, 22 Felting, 53–54 Fiber(s): defined, 4, <i>See</i> specific fiber
Felt, 247–48 Feltability, 22 Felting, 53–54 Fiber(s): defined, 4, <i>See</i> specific fiber types or modifications
Felt, 247–48 Feltability, 22 Felting, 53–54 Fiber(s): defined, 4, <i>See</i> specific fiber types or modifications names of, in foreign languages,
Felt, 247–48 Feltability, 22 Felting, 53–54 Fiber(s): defined, 4, See specific fiber types or modifications names of, in foreign languages, 387
Felt, 247–48 Feltability, 22 Felting, 53–54 Fiber(s): defined, 4, <i>See</i> specific fiber types or modifications names of, in foreign languages,
Felt, 247–48 Feltability, 22 Felting, 53–54 Fiber(s): defined, 4, <i>See</i> specific fiber types or modifications names of, in foreign languages, 387 properties of, 17–31
Felt, 247–48 Feltability, 22 Felting, 53–54 Fiber(s): defined, 4, See specific fiber types or modifications names of, in foreign languages, 387
Felt, 247–48 Feltability, 22 Felting, 53–54 Fiber(s): defined, 4, <i>See</i> specific fiber types or modifications names of, in foreign languages, 387 properties of, 17–31 selected trade names for, 391–92
Felt, 247–48 Feltability, 22 Felting, 53–54 Fiber(s): defined, 4, <i>See</i> specific fiber types or modifications names of, in foreign languages, 387 properties of, 17–31 selected trade names for, 391–92 shape, 20, 72
Felt, 247–48 Feltability, 22 Felting, 53–54 Fiber(s): defined, 4, <i>See</i> specific fiber types or modifications names of, in foreign languages, 387 properties of, 17–31 selected trade names for, 391–92 shape, 20, 72 surface contour of, 20
Felt, 247–48 Feltability, 22 Felting, 53–54 Fiber(s): defined, 4, <i>See</i> specific fiber types or modifications names of, in foreign languages, 387 properties of, 17–31 selected trade names for, 391–92 shape, 20, 72 surface contour of, 20 Fiber blends, 150–52
Felt, 247–48 Feltability, 22 Felting, 53–54 Fiber(s): defined, 4, <i>See</i> specific fiber types or modifications names of, in foreign languages, 387 properties of, 17–31 selected trade names for, 391–92 shape, 20, 72 surface contour of, 20 Fiber blends, 150–52 Fiber density, 23, 26, 245
Felt, 247–48 Feltability, 22 Felting, 53–54 Fiber(s): defined, 4, See specific fiber types or modifications names of, in foreign languages, 387 properties of, 17–31 selected trade names for, 391–92 shape, 20, 72 surface contour of, 20 Fiber blends, 150–52 Fiber density, 23, 26, 245 Fiber dyeing, 318–19
Felt, 247–48 Feltability, 22 Felting, 53–54 Fiber(s): defined, 4, See specific fiber types or modifications names of, in foreign languages, 387 properties of, 17–31 selected trade names for, 391–92 shape, 20, 72 surface contour of, 20 Fiber blends, 150–52 Fiber density, 23, 26, 245 Fiber dyeing, 318–19 Fiber modifications, 71–76
Felt, 247–48 Feltability, 22 Felting, 53–54 Fiber(s): defined, 4, See specific fiber types or modifications names of, in foreign languages, 387 properties of, 17–31 selected trade names for, 391–92 shape, 20, 72 surface contour of, 20 Fiber blends, 150–52 Fiber density, 23, 26, 245 Fiber dyeing, 318–19 Fiber modifications, 71–76 Fiber processing, 272
Felt, 247–48 Feltability, 22 Felting, 53–54 Fiber(s): defined, 4, See specific fiber types or modifications names of, in foreign languages, 387 properties of, 17–31 selected trade names for, 391–92 shape, 20, 72 surface contour of, 20 Fiber blends, 150–52 Fiber density, 23, 26, 245 Fiber dyeing, 318–19 Fiber modifications, 71–76 Fiber processing, 272 Fiber property charts, 28
Felt, 247–48 Feltability, 22 Felting, 53–54 Fiber(s): defined, 4, See specific fiber types or modifications names of, in foreign languages, 387 properties of, 17–31 selected trade names for, 391–92 shape, 20, 72 surface contour of, 20 Fiber blends, 150–52 Fiber density, 23, 26, 245 Fiber dyeing, 318–19 Fiber modifications, 71–76 Fiber processing, 272 Fiber property charts, 28 Fiber spinning, 69–71, 73, 75–76
Felt, 247–48 Feltability, 22 Felting, 53–54 Fiber(s): defined, 4, See specific fiber types or modifications names of, in foreign languages, 387 properties of, 17–31 selected trade names for, 391–92 shape, 20, 72 surface contour of, 20 Fiber blends, 150–52 Fiber density, 23, 26, 245 Fiber dyeing, 318–19 Fiber modifications, 71–76 Fiber processing, 272 Fiber property charts, 28
Felt, 247–48 Feltability, 22 Felting, 53–54 Fiber(s): defined, 4, See specific fiber types or modifications names of, in foreign languages, 387 properties of, 17–31 selected trade names for, 391–92 shape, 20, 72 surface contour of, 20 Fiber blends, 150–52 Fiber density, 23, 26, 245 Fiber dyeing, 318–19 Fiber modifications, 71–76 Fiber processing, 272 Fiber property charts, 28 Fiber spinning, 69–71, 73, 75–76
Felt, 247–48 Feltability, 22 Felting, 53–54 Fiber(s): defined, 4, <i>See</i> specific fiber types or modifications names of, in foreign languages, 387 properties of, 17–31 selected trade names for, 391–92 shape, 20, 72 surface contour of, 20 Fiber blends, 150–52 Fiber density, 23, 26, 245 Fiber dyeing, 318–19 Fiber modifications, 71–76 Fiber processing, 272 Fiber property charts, 28 Fiber spinning, 69–71, 73, 75–76 complex modifications and, 75–76
Felt, 247–48 Feltability, 22 Felting, 53–54 Fiber(s): defined, 4, See specific fiber types or modifications names of, in foreign languages, 387 properties of, 17–31 selected trade names for, 391–92 shape, 20, 72 surface contour of, 20 Fiber blends, 150–52 Fiber density, 23, 26, 245 Fiber dyeing, 318–19 Fiber modifications, 71–76 Fiber processing, 272 Fiber property charts, 28 Fiber spinning, 69–71, 73, 75–76 complex modifications and, 75–76 methods of, 70–71
Felt, 247–48 Feltability, 22 Felting, 53–54 Fiber(s): defined, 4, See specific fiber types or modifications names of, in foreign languages, 387 properties of, 17–31 selected trade names for, 391–92 shape, 20, 72 surface contour of, 20 Fiber blends, 150–52 Fiber density, 23, 26, 245 Fiber dyeing, 318–19 Fiber modifications, 71–76 Fiber processing, 272 Fiber property charts, 28 Fiber spinning, 69–71, 73, 75–76 complex modifications and, 75–76 methods of, 70–71 modifications in, 75
Felt, 247–48 Feltability, 22 Felting, 53–54 Fiber(s): defined, 4, See specific fiber types or modifications names of, in foreign languages, 387 properties of, 17–31 selected trade names for, 391–92 shape, 20, 72 surface contour of, 20 Fiber blends, 150–52 Fiber density, 23, 26, 245 Fiber dyeing, 318–19 Fiber modifications, 71–76 Fiber processing, 272 Fiber property charts, 28 Fiber spinning, 69–71, 73, 75–76 complex modifications and, 75–76 methods of, 70–71 modifications in, 75 molecular structure and
Felt, 247–48 Feltability, 22 Felting, 53–54 Fiber(s): defined, 4, See specific fiber types or modifications names of, in foreign languages, 387 properties of, 17–31 selected trade names for, 391–92 shape, 20, 72 surface contour of, 20 Fiber blends, 150–52 Fiber density, 23, 26, 245 Fiber dyeing, 318–19 Fiber modifications, 71–76 Fiber processing, 272 Fiber property charts, 28 Fiber spinning, 69–71, 73, 75–76 complex modifications and, 75–76 methods of, 70–71 modifications in, 75 molecular structure and crystallinity modifications
Felt, 247–48 Feltability, 22 Felting, 53–54 Fiber(s): defined, 4, See specific fiber types or modifications names of, in foreign languages, 387 properties of, 17–31 selected trade names for, 391–92 shape, 20, 72 surface contour of, 20 Fiber blends, 150–52 Fiber density, 23, 26, 245 Fiber dyeing, 318–19 Fiber modifications, 71–76 Fiber processing, 272 Fiber spinning, 69–71, 73, 75–76 complex modifications and, 75–76 methods of, 70–71 modifications in, 75 molecular structure and crystallinity modifications and, 73
Felt, 247–48 Feltability, 22 Felting, 53–54 Fiber(s): defined, 4, See specific fiber types or modifications names of, in foreign languages, 387 properties of, 17–31 selected trade names for, 391–92 shape, 20, 72 surface contour of, 20 Fiber blends, 150–52 Fiber density, 23, 26, 245 Fiber dyeing, 318–19 Fiber modifications, 71–76 Fiber processing, 272 Fiber spinning, 69–71, 73, 75–76 complex modifications and, 75–76 methods of, 70–71 modifications in, 75 molecular structure and crystallinity modifications and, 73 spinneret modifications and,
Felt, 247–48 Feltability, 22 Felting, 53–54 Fiber(s): defined, 4, See specific fiber types or modifications names of, in foreign languages, 387 properties of, 17–31 selected trade names for, 391–92 shape, 20, 72 surface contour of, 20 Fiber blends, 150–52 Fiber density, 23, 26, 245 Fiber dyeing, 318–19 Fiber modifications, 71–76 Fiber processing, 272 Fiber property charts, 28 Fiber spinning, 69–71, 73, 75–76 complex modifications and, 75–76 methods of, 70–71 modifications in, 75 molecular structure and crystallinity modifications and, 73 spinneret modifications and, 71–73
Felt, 247–48 Feltability, 22 Felting, 53–54 Fiber(s): defined, 4, See specific fiber types or modifications names of, in foreign languages, 387 properties of, 17–31 selected trade names for, 391–92 shape, 20, 72 surface contour of, 20 Fiber blends, 150–52 Fiber density, 23, 26, 245 Fiber dyeing, 318–19 Fiber modifications, 71–76 Fiber processing, 272 Fiber property charts, 28 Fiber spinning, 69–71, 73, 75–76 complex modifications and, 75–76 methods of, 70–71 modifications in, 75 molecular structure and crystallinity modifications and, 73 spinneret modifications and, 71–73 Fiberfill, 245–46, 261
Felt, 247–48 Feltability, 22 Felting, 53–54 Fiber(s): defined, 4, See specific fiber types or modifications names of, in foreign languages, 387 properties of, 17–31 selected trade names for, 391–92 shape, 20, 72 surface contour of, 20 Fiber blends, 150–52 Fiber density, 23, 26, 245 Fiber dyeing, 318–19 Fiber modifications, 71–76 Fiber processing, 272 Fiber spinning, 69–71, 73, 75–76 complex modifications and, 75–76 methods of, 70–71 modifications in, 75 molecular structure and crystallinity modifications and, 73 spinneret modifications and, 71–73 Fiberfill, 245–46, 261 Fiber-reinforced materials,
Felt, 247–48 Feltability, 22 Felting, 53–54 Fiber(s): defined, 4, See specific fiber types or modifications names of, in foreign languages, 387 properties of, 17–31 selected trade names for, 391–92 shape, 20, 72 surface contour of, 20 Fiber blends, 150–52 Fiber density, 23, 26, 245 Fiber dyeing, 318–19 Fiber modifications, 71–76 Fiber processing, 272 Fiber property charts, 28 Fiber spinning, 69–71, 73, 75–76 complex modifications and, 75–76 methods of, 70–71 modifications in, 75 molecular structure and crystallinity modifications and, 73 spinneret modifications and, 71–73 Fiberfill, 245–46, 261

File: III. 1 - 1 - 1 - 218
Fibrillated-net process, 248
Fibrils, 36
Fibroin, 63
Filament (s), 19, 71
Filament fibers, 69
Filament tow, 19, 69, 149–50
Filament yarn(s), 69, 140–49
blended-, 152
bulk-continuous- (BCF), 141
fiber length and, 155
filament-wrapped, 165
smooth-, 140
textured-bulk-, 155
texturing, 141–43
Filature, 62
Fillers, 349
Filling (or weft) knitting, 215,
218–30
warp knitting versus, 233–34
Filling knit fabrics, 221–30
Filling sateen, 194
Filling yarns, 171, 176–77
Filling-faced twills, 191 Filling-pile fabrics, 208, 210
Films, 240–41, 253
Finish(es), See specific type
additive, 281, 285
classification of, 271
defined, 4, 270–71
subtractive, 281, 285
trade names for, selected, 392
Finished goods, 271
Finishing, 269–79, 304–5
Fire retardance, 309–10
Flame-resistant fibers, 75,
125–34, 309–10
Flame-retardant finishes, 310
Flammability, 22, 310
Flammable Fabrics Act of 1953
(Amended), 361–64
Flannel, 185, 191, 292
Flannelette, 184, 292
Flatbed machines, 218–19, 227,
229
Flat-screen printing, 329
Flax, 33, 43–45
Fleece, 225
Flexibility, 22, 25
Float(s), 176, 189
Float stitch, 220
"Flock worker's lung," 288
Flocking, 287–89
Fluorescent brightening agents,
349
Fluorescent dye, 315–17
Fluorescent whitening agents,
349
Fluoropolymer, 132
Foam(s), 242, 290
Foam coatings, 304–5
Foam finishing, 271, 304–5
Foam prints, 325
Foam technique, 251–52
Foam-flame process, 259
Foil printing, 332–33
Formaldehyde, 371
Foulard, 191

French terry, 225

Friction calendar, 282 Friezé, 209–10 Frosting, 335–36 Full-grain leather, 263 Fulling, 292
Fume, 87 Fume fading, 304, 334, 336 Fume-fading-resistant finishes, 304
Fumigants, 308 Functional finishes, 297 Fungal fibers, 90 Fungicides, 308 Fur, 264–65 labeling and, 360
Fur (furrier) dry cleaning, 265, 353–54 Fur fiber, 359
Fur Products Labeling Act of 1952 (Amended 1980), 360 Furlike fabrics, 209, 224–25, 256–57
Fusible nonwovens, 246
Gabardine, 192–93 Gait, 226 Garnetting, 51–52
Gauge, 217, 258 Gel dyeing, 318 Gel spinning, 110
Generic group, 20–21 Generic name, 360 Georgette, 183–84 Germicidal finishes, 308
Gin, 33–35 Gingham(s), 184–85 madras, 198
Glass fiber, 127–29, 133, 348 Glass transition temperature, 299 Glazed chintz, 184 Glazing, 92, 282
Glucose, 38 Gore-Tex, 132, 253 Grading wool, 51
Graft polymers, 114–15 Grain, 177, 263 Grain-sueded leather, 264 Granite cloth, 204
Granite weave, 203 Graphite fiber, 122, 132 Gray goods, 4, 271
Grease wool, 51 Green cotton, 40 "Green" products, 368 Greige goods, 4, 271
Grey goods, 4, 271 Grey goods, 4, 271 Grin-through, 124 Grosgrain, 187–88
Ground ply, 161–62
Habutai 62 184

H
Habutai, 62, 184
Hackling, 42–43
Hairiness, 165
Halogenation, 299–300
Hand, 22, 24, 29, 270
Hand builders, 294, 307

Hand knitting, 218 Handling, 273 Handmade lace, 249 Hangtags, 360 Hard twist, 158 Harness, 172 Harris tweed, 185-86 Heat conductivity, 23 Heat retention, 23-24, 26 Heat sensitivity, 23, 26-27, 87, 92 Heat setting, 95-96, 277, 299 Heat-transfer printing, 330-32 Heavyweight fabrics, 185-88 Heddle, 172 Hemp, 46 Henequen, 47 Herringbone, 191 Hessian, 185 High-bulk yarns, 149-50 High-shrinkage fibers, 150 High-tenacity fibers, 73, 96 High-wet-modulus (HWM) rayon, 81-82 Hollow fibers, 73 Home solvent cleaning, 354 Homespun, 185 Homopolymers, 114-15 Honan, 185 Hopsacking, 189 Horizontal-axis washing machines, 352 Hosiery, 225-26 Hot-melt lamination, 259-60 Hot-water extraction, 356 Houndstooth, 191 Huck, 198 HWM (high-wet-modulus) rayon, 81 - 82Hydroentangled webs, 244 Hydrogen bonding, 21 Hydrogen peroxide, 274 Hydrophilic fibers, 23, 25 Hydrophobic fibers, 25-26 Hygroscopic fibers, 23, 26, 50

Ι Ikat, 328 Immersion process, 301-2 Indian madras, 185 Ink, 315 Ink-jet (digital) printing, 329-32 Insect-control finishes, 308 Insecticides, 308 Insect-repellent finishes, 308-9 Inspection, fiber, 28-29, 278 Intarsia, 222-23 Interlacing, 176 Interlock, 228, 230 Interlock gaiting, 226-28 Iridescent taffeta, 187 Irish linen, 43

J Jacquard double-knits, 228 Jacquard jersey, 221–22 Jacquard loom, 202–3 Jacquard tapestry, 203 Jacquard weaves, 202–3

1 102	11 (1	NCH C : 1 - 1 C1 : - 271	•
Jean, 192 Jersey(s), 221–28	Llama, 61 Localized parchmentizing,	Mill-finished fabrics, 271 Minimums, 273	0 Odors, 308
Jet dyeing, 322, 331	285–86	Miss stitch, 220	Off-grain fabrics, 177
Jig dyeing, 322	Loft, 23	Mixed-denier filament bundling,	Off-grain prints, 335–36
Jute, 46	London shrunk, 298	72	Off-shade, 336
	Long-staple cotton, 35	Mixture, 150–51	Oil tanning, 263
K	Loom(s), 172-76	Modacrylic fibers, 118–19, 348,	Olefin, 109–113
Kapok, 42	dobby, 198, 200	391	Oleophilic fibers, 23, 95
Kenaf, 46–47 Keratin, 54	jacquard, 202–3 Loom state goods, 4, 271	Modulus, 23 Mohair, 58–60	On-grain fabrics, 177 Opacifiers, 315, 350
Kersey, 206	Loop dryer, 277	Moiré pattern, 282, 284	Open-end rotor spinning, 147–4
Kevlar, 126–27	Loop yarn, 162	Moiré taffeta, 187–88, 284	Opening, 145
Kier boiling of cotton, 273	Looping machine, 225	Moisture regain (absorbency), 22,	Open-width finishing, 273
Knit fabric(s), 213–38	Loops, 215	25	Optical brighteners, 274
Knit stitch, 220	Low twist, 156–57	Moisture vapor transport rate	Optical brightening agents, 349
Knit-deknit process, 142–43	Low-count sheer fabrics, 184	(MVTR), 112	Optical whitening agents, 349
Knitted terrycloth, 223–24	Low-elongation modifications,	Mold-control finishes, 308	Organdy, 184, 285
Knit-through fabrics, 260–61	73	Momie weaves, 203–4	Organic cotton, 40
Knitting, 215–37 Knitting machine(s), 218–19,	Low-pilling fibers, 73, 96 Lumen, 36	Momme, 62 Monk's cloth, 189	Organza, 184 Orientation, 21
225–27, 229, 231, 233–38	Luster, 23–29	Monofilament yarns, 140, 156–	OSHA (Occupational Safety and
Knitting needles, 215–18	Luster finishes, 282, 284–85	57	Health Administration), 368
Knop yarn, 162	Lyocell, 84-86, 89, 348, 391	Moss crepe, 204	371
Knot yarn, 162		Moth resistance, 23	Osnaburg, 185
	М	Moth-control finishes, 308	Ottoman, 187
L	Machine knitting, 218–19	Multicellular fibers, 73	Outing flannel, 184–85, 292
Labeling:	Machine-made lace, 249–510	Multihead embroidery, 289–91	Out-of-register, 335–36
fiber products and, 360–61 fur products, 360	Machine-pleating process, 287 Madras, 185, 198	Multiple-shed loom, 175 Muslin, 178, 184	Over-wire method, 209–10 Oxford, 189
legal requirements regarding,	Manufactured fiber(s) See specific	MVTR (moisture vapor transport	Oxiora, 187
347, 361, 367	fibers and modifications	rate), 112	P
mandatory and voluntary	defined, 18, 68	,,	Package dyeing, 318, 322
programs regarding,	generic names for, 68	N	Pad dyeing, 322
365–66	identification of, 80	Nap, 291	Padding machine, 281–82
wool products, 359–60	manufacturing of, 67–78	Napped tricots, 235	Paddle dyeing, 323
Labeling requirements, 347, 361	process of, 67–78	Napping, 291–92	Paddle machines, 322
Lace, 235–36, 248–51 Lamb's wool, 51, 52	Manufactured regenerated fibers, 79–90	Napping twist, 156–58 Narrow fabrics, 183, 211–12, 237	Panné velvet, 209 Paper-pattern technique, 287
Laminates, 258–60	synthetic fibers versus, 92	Natural bicomponent fiber, 53	Parchmentizing, 285–86
Lamination, 129, 251, 259–60	Marquisette, 205	Natural dyes, 337	Parent fiber, 71
Lanolin, 51	Mass coloration, 318	Natural fibers:	PBI, 130–31, 133
Lastrile, 122, 389	Mass pigmentation, 74, 318	defined, 18	PBO (polyphenylene
Latch needle, 215–18	Matelassé, 206	manufactured fibers and,	benzobisoxazole), 134
Latent shrinkage potential, 150	Medium-weight fabrics, 184–87	comparison of, 77	Peach skin, 293
Laundering, 347–51	Medulla, 52–53	Naturally solored setten 37	Percale, 178, 184
Lawn, 184 Laws, textiles and, 359–65	Melamine, 134 Melanin, 53	Naturally colored cotton, 37 Needle punching, 244–45	Performance, 10–12, 270 fiber ratings related to, 24
Leaf fiber(s), 33, 47	Melt spinning, 94, 95	Needlepoint lace, 249	Performance fibers, 75–76
Leather, 263–64, 345	Melt-blown fiberwebs, 244	Needling, 244–45	Performance testing, 11, 376
Leather dry cleaning, 264,	Melton, 206	Neoprene, 123, 251, 253	Perfumes, 349
353–54	Mercerization, 274-75	Nep, 165	Permafresh finishes, 309
Leavers lace, 250	Merino wool, 51–53	Netlike structures, 248	Permanent Care Labeling
Leavers machine, 249–50	Metal fibers, 129–30	Network yarns, 141	Regulation of 1972
Leno weaves, 204–5	Metalizing process, 129 Metallic coatings, 304–5	NFPA 701 Small Scale Test, 367 NFPA 702 Large Scale Test, 367	(Amended 1984), 347, 361 367
Level, 314, 318 Licensing, 366	Metallic fibers, 129–30	Ninon, 183	Permanent finish, 271
Light resistance, 11, 23, 24, 27,	Metallic soaps, 305–6	Nodes, 43	Permanent press, 300
74–75	Metallic yarns, 162–63	Noils, 147	Permethrin, 308
Light-reflecting finishes, 310	Metamerism, 314	Nonionic softeners, 307	Peroxide bleaches, 274
Light-stabilizing finishes, 305	Metered-addition, 301-2	Nonreinforced films, 240–41	Phase-change finishes, 307
Lightweight opaque fabrics, 184	Microencapsulated finishes, 309	Nonslip finishes, 304	Picking, 173
Lightweight sheer fabrics, 183–84	Microfibers, 71	Nonwovens, 242–47	Picks, 171
Linen, 43, 290 Lining twill, 191–92	Microporous fabrics, 253 Microscopy, fiber identification	Novelty yarns, 161 Novoloid, 130	Piece dyeing, 320 Pile jersey, 222–23
Lining twiii, 191–92 Lint pills, 93	and, 30	Npi (needles per inch), 217	Pile weaves, 207–10
Linters, 34	Migration, 334, 336	Nub yarn, 162	Pillars, 235
Liquid-barrier finishes, 310	Milanese machine, 233, 237	Nubuck leather, 264	Pilling, 23, 92–93, 96
Liquor ratio, 321	Mildew resistance, 23	Nylon, 18, 68, 96-103	Pilling-resistant finishes, 305
Lisle, 222	Mildew-control finishes, 308	Nytril, 389	Pima cotton, 35, 38, 210

Dia. 47	
Piña, 47	
Pin-wale piqué, 201	
Piqué weaves, 201–2	
PLA (polylactide), 89-90	
Plain films, 240-41	
Plain tricot, 234-35	
Plain weave, 182–88	
Plastic coatings, 304–5	
Pleated fabric, 287	
Plissé, 275, 285, 287	
Plush, 209	
Ply yarn, 160	
Plying, 160	
Pocket cloth, 206	
Pocket weave, 206	
Point-bond calendering, 245	
Point-paper notation, 230–31	
Polished cotton, 184	
Pollution fading, 87	
Pollution Prevention Act of 1990.	
369	•
Polyamides, 98	
Polyester, 103–9	
Polyethylene, 110	
Polyimide, 134	
Polylactide (PLA), 89-90	
Polymer, 21	
Polymerization, 20-21	
Polyphenylene benzobisoxazole	
(PBO), 134	
Polypropylene, 110	
Polytetrafluoroethylene (PTFE),	
132–33	
Pongee, 185	
Poplin, 187	
Poromeric fabrics, 253, 392	
Porosity-control finishes, 306	
Postcured process, 301–2	
Powder cleaners, 356	
Power net, 236	
Power stretch, 122	
Preboarded hosiery, 226	
Precured process, 301–2	
Preparation, 272–274	
Presoaks, 351	
Pressing, 278	
Pretreatments, 351	
Print cloth, 184	
Printing, 323–33	
block, 326	
differential, 329	
digital (ink-jet), 329–32	
direct, 326–27	
dry, 325	
duplex, 326	
electrostatic, 332	
environmental impact of, 337	
foam, 325	
foil, 332–33	
heat-transfer, 330–32	
ink-jet (digital), 329–32	
methods of, 324–25	
process of, 323	
resist, 327–29	
screen, 328–29	
stencil, 329	
warp, 326-27	
wet, 325	

Processing aids, 350

Producer-colored, 318
Product development, 7–13,
376–78
defined, 8
the same of the sa
performance and, 10–12
quality and, 11-12
serviceability and, 9-10
Product dyeing, 321
Product testing, 376
Production, 380
Professional wet cleaning, 354
Progressive shrinkage, 297,
299–300
Projectile loom, 175
Proofing, 330
Protein fibers, 50
Prototypes, 376
Puckered surfaces, 287
Pure dye silk, 62, 359
Purl gaiting, 227
Purl knits, 228–29
Purl stitch, 220
Q
Qiviut, 59–60
Quality, 11–12, 171
quality assurance (QA) and,
378
Quality assurance (QA), 378
Quality performance standards,
303
Quilted fabrics, 261-62
Quotas, 376
Quotas, or o
n
R
Ramie, 45-46
Ramie, 45-46
Ramie, 45–46 Random webs, 243
Ramie, 45–46 Random webs, 243 Ranges, 322–23
Ramie, 45–46 Random webs, 243 Ranges, 322–23 Rapier loom, 174–75
Ramie, 45–46 Random webs, 243 Ranges, 322–23 Rapier loom, 174–75 Raschel laces, 250–51
Ramie, 45–46 Random webs, 243 Ranges, 322–23 Rapier loom, 174–75 Raschel laces, 250–51
Ramie, 45–46 Random webs, 243 Ranges, 322–23 Rapier loom, 174–75 Raschel laces, 250–51 Raschel-warp knits, 235–36
Ramie, 45–46 Random webs, 243 Ranges, 322–23 Rapier loom, 174–75 Raschel laces, 250–51 Raschel-warp knits, 235–36 Ratiné yarns, 162
Ramie, 45–46 Random webs, 243 Ranges, 322–23 Rapier loom, 174–75 Raschel laces, 250–51 Raschel-warp knits, 235–36 Ratiné yarns, 162 Raw silk, 62
Ramie, 45–46 Random webs, 243 Ranges, 322–23 Rapier loom, 174–75 Raschel laces, 250–51 Raschel-warp knits, 235–36 Ratiné yarns, 162 Raw silk, 62 Raw wool, 51
Ramie, 45–46 Random webs, 243 Ranges, 322–23 Rapier loom, 174–75 Raschel laces, 250–51 Raschel-warp knits, 235–36 Ratiné yarns, 162 Raw silk, 62 Raw wool, 51
Ramie, 45–46 Random webs, 243 Ranges, 322–23 Rapier loom, 174–75 Raschel laces, 250–51 Raschel-warp knits, 235–36 Ratiné yarns, 162 Raw silk, 62 Raw wool, 51 Rayon, 18, 68, 80–84
Ramie, 45–46 Random webs, 243 Ranges, 322–23 Rapier loom, 174–75 Raschel laces, 250–51 Raschel-warp knits, 235–36 Ratiné yarns, 162 Raw silk, 62 Raw wool, 51 Rayon, 18, 68, 80–84 Reclining twill, 190–191
Ramie, 45–46 Random webs, 243 Ranges, 322–23 Rapier loom, 174–75 Raschel laces, 250–51 Raschel-warp knits, 235–36 Ratiné yarns, 162 Raw silk, 62 Raw wool, 51 Rayon, 18, 68, 80–84 Reclining twill, 190–191 Recycled wool, 51–52, 360
Ramie, 45–46 Random webs, 243 Ranges, 322–23 Rapier loom, 174–75 Raschel laces, 250–51 Raschel-warp knits, 235–36 Ratiné yarns, 162 Raw wool, 51 Rayon, 18, 68, 80–84 Reclining twill, 190–191 Recycled wool, 51–52, 360 Recycling, 372–73
Ramie, 45–46 Random webs, 243 Ranges, 322–23 Rapier loom, 174–75 Raschel laces, 250–51 Raschel-warp knits, 235–36 Ratiné yarns, 162 Raw silk, 62 Raw wool, 51 Rayon, 18, 68, 80–84 Reclining twill, 190–191 Recycled wool, 51–52, 360
Ramie, 45–46 Random webs, 243 Ranges, 322–23 Rapier loom, 174–75 Raschel laces, 250–51 Raschel-warp knits, 235–36 Ratiné yarns, 162 Raw silk, 62 Raw wool, 51 Rayon, 18, 68, 80–84 Reclining twill, 190–191 Recycled wool, 51–52, 360 Recycling, 372–73 Reed, 173
Ramie, 45–46 Random webs, 243 Ranges, 322–23 Rapier loom, 174–75 Raschel laces, 250–51 Raschel-warp knits, 235–36 Ratiné yarns, 162 Raw silk, 62 Raw wool, 51 Rayon, 18, 68, 80–84 Reclining twill, 190–191 Recycled wool, 51–52, 360 Recycling, 372–73 Reed, 173 Reel dyeing, 321
Ramie, 45–46 Random webs, 243 Ranges, 322–23 Rapier loom, 174–75 Raschel laces, 250–51 Raschel-warp knits, 235–36 Ratiné yarns, 162 Raw silk, 62 Raw wool, 51 Rayon, 18, 68, 80–84 Reclining twill, 190–191 Recycled wool, 51–52, 360 Recycling, 372–73 Reed, 173 Reel dyeing, 321 Reeling, 62
Ramie, 45–46 Random webs, 243 Ranges, 322–23 Rapier loom, 174–75 Raschel laces, 250–51 Raschel-warp knits, 235–36 Ratiné yarns, 162 Raw wool, 51 Rayon, 18, 68, 80–84 Reclining twill, 190–191 Recycled wool, 51–52, 360 Recycling, 372–73 Reed, 173 Reel dyeing, 321 Reeling, 62 Reembroidered lace, 250
Ramie, 45–46 Random webs, 243 Ranges, 322–23 Rapier loom, 174–75 Raschel laces, 250–51 Raschel-warp knits, 235–36 Ratiné yarns, 162 Raw silk, 62 Raw wool, 51 Rayon, 18, 68, 80–84 Reclining twill, 190–191 Recycled wool, 51–52, 360 Recycling, 372–73 Reed, 173 Reel dyeing, 321 Reeling, 62
Ramie, 45–46 Random webs, 243 Ranges, 322–23 Rapier loom, 174–75 Raschel laces, 250–51 Raschel-warp knits, 235–36 Ratiné yarns, 162 Raw wool, 51 Rayon, 18, 68, 80–84 Reclining twill, 190–191 Recycled wool, 51–52, 360 Recycling, 372–73 Reed, 173 Reel dyeing, 321 Reeling, 62 Reembroidered lace, 250
Ramie, 45–46 Random webs, 243 Ranges, 322–23 Rapier loom, 174–75 Raschel laces, 250–51 Raschel-warp knits, 235–36 Ratiné yarns, 162 Raw wool, 51 Rayon, 18, 68, 80–84 Reclining twill, 190–191 Recycled wool, 51–52, 360 Recycling, 372–73 Reed, 173 Reel dyeing, 321 Reeling, 62 Reembroidered lace, 250 Regenerated fibers, 79–90 synthetic fibers versus, 92
Ramie, 45–46 Random webs, 243 Ranges, 322–23 Rapier loom, 174–75 Raschel laces, 250–51 Raschel-warp knits, 235–36 Ratiné yarns, 162 Raw silk, 62 Raw wool, 51 Rayon, 18, 68, 80–84 Reclining twill, 190–191 Recycled wool, 51–52, 360 Recycling, 372–73 Reed, 173 Reel dyeing, 321 Reeling, 62 Reembroidered lace, 250 Regenerated fibers, 79–90 synthetic fibers versus, 92 Regular twill, 190–91
Ramie, 45–46 Random webs, 243 Ranges, 322–23 Rapier loom, 174–75 Raschel laces, 250–51 Raschel-warp knits, 235–36 Ratiné yarns, 162 Raw wool, 51 Rayon, 18, 68, 80–84 Reclining twill, 190–191 Recycled wool, 51–52, 360 Recycling, 372–73 Reed, 173 Reel dyeing, 321 Reeling, 62 Reembroidered lace, 250 Regenerated fibers, 79–90 synthetic fibers versus, 92 Regular twill, 190–91 Regulations, textiles and, 359–65
Ramie, 45–46 Random webs, 243 Ranges, 322–23 Rapier loom, 174–75 Raschel laces, 250–51 Raschel-warp knits, 235–36 Ratiné yarns, 162 Raw wool, 51 Rayon, 18, 68, 80–84 Reclining twill, 190–191 Recycled wool, 51–52, 360 Recycling, 372–73 Reed, 173 Reel dyeing, 321 Reeling, 62 Reembroidered lace, 250 Regenerated fibers, 79–90 synthetic fibers versus, 92 Regular twill, 190–91 Regulations, textiles and, 359–65 Reinforced film, 241
Ramie, 45–46 Random webs, 243 Ranges, 322–23 Rapier loom, 174–75 Raschel laces, 250–51 Raschel-warp knits, 235–36 Ratiné yarns, 162 Raw wool, 51 Rayon, 18, 68, 80–84 Reclining twill, 190–191 Recycled wool, 51–52, 360 Recycling, 372–73 Reed, 173 Reel dyeing, 321 Reeling, 62 Reembroidered lace, 250 Regenerated fibers, 79–90 synthetic fibers versus, 92 Regular twill, 190–91 Regulations, textiles and, 359–65
Ramie, 45–46 Random webs, 243 Ranges, 322–23 Rapier loom, 174–75 Raschel laces, 250–51 Raschel-warp knits, 235–36 Ratiné yarns, 162 Raw wool, 51 Rayon, 18, 68, 80–84 Reclining twill, 190–191 Recycled wool, 51–52, 360 Recycling, 372–73 Reed, 173 Reel dyeing, 321 Reeling, 62 Reembroidered lace, 250 Regenerated fibers, 79–90 synthetic fibers versus, 92 Regular twill, 190–91 Regulations, textiles and, 359–65 Reinforced film, 241 Relaxation shrinkage, 297–98
Ramie, 45–46 Random webs, 243 Ranges, 322–23 Rapier loom, 174–75 Raschel laces, 250–51 Raschel-warp knits, 235–36 Ratiné yarns, 162 Raw wool, 51 Rayon, 18, 68, 80–84 Reclining twill, 190–191 Recycled wool, 51–52, 360 Recycling, 372–73 Reed, 173 Reel dyeing, 321 Reeling, 62 Reembroidered lace, 250 Regenerated fibers, 79–90 synthetic fibers versus, 92 Regular twill, 190–91 Regulations, textiles and, 359–65 Reinforced film, 241 Relaxation shrinkage, 297–98 Renewable finish, 271
Ramie, 45–46 Random webs, 243 Ranges, 322–23 Rapier loom, 174–75 Raschel laces, 250–51 Raschel-warp knits, 235–36 Ratiné yarns, 162 Raw wool, 51 Rayon, 18, 68, 80–84 Reclining twill, 190–191 Recycled wool, 51–52, 360 Recycling, 372–73 Reed, 173 Reel dyeing, 321 Reeling, 62 Reembroidered lace, 250 Regenerated fibers, 79–90 synthetic fibers versus, 92 Regular twill, 190–91 Regulations, textiles and, 359–65 Reinforced film, 241 Relaxation shrinkage, 297–98 Renewable finish, 271 Reseau, 249
Ramie, 45–46 Random webs, 243 Ranges, 322–23 Rapier loom, 174–75 Raschel laces, 250–51 Raschel-warp knits, 235–36 Ratiné yarns, 162 Raw silk, 62 Raw wool, 51 Rayon, 18, 68, 80–84 Reclining twill, 190–191 Recycled wool, 51–52, 360 Recycling, 372–73 Reed, 173 Reel dyeing, 321 Reeling, 62 Reembroidered lace, 250 Regenerated fibers, 79–90 synthetic fibers versus, 92 Regular twill, 190–91 Regulations, textiles and, 359–65 Reinforced film, 241 Relaxation shrinkage, 297–98 Renewable finish, 271 Reseau, 249 Resiliency, 23–24, 26
Ramie, 45–46 Random webs, 243 Ranges, 322–23 Rapier loom, 174–75 Raschel laces, 250–51 Raschel-warp knits, 235–36 Ratiné yarns, 162 Raw wool, 51 Rayon, 18, 68, 80–84 Reclining twill, 190–191 Recycled wool, 51–52, 360 Recycling, 372–73 Reed, 173 Reel dyeing, 321 Reeling, 62 Reembroidered lace, 250 Regenerated fibers, 79–90 synthetic fibers versus, 92 Regular twill, 190–91 Regulations, textiles and, 359–65 Reinforced film, 241 Relaxation shrinkage, 297–98 Renewable finish, 271 Reseau, 249
Ramie, 45–46 Random webs, 243 Ranges, 322–23 Rapier loom, 174–75 Raschel laces, 250–51 Raschel-warp knits, 235–36 Ratiné yarns, 162 Raw silk, 62 Raw wool, 51 Rayon, 18, 68, 80–84 Reclining twill, 190–191 Recycled wool, 51–52, 360 Recycling, 372–73 Reed, 173 Reel dyeing, 321 Reeling, 62 Reembroidered lace, 250 Regenerated fibers, 79–90 synthetic fibers versus, 92 Regular twill, 190–91 Regulations, textiles and, 359–65 Reinforced film, 241 Relaxation shrinkage, 297–98 Renewable finish, 271 Reseau, 249 Resiliency, 23–24, 26 Resist prints, 327–29
Ramie, 45–46 Random webs, 243 Ranges, 322–23 Rapier loom, 174–75 Raschel laces, 250–51 Raschel-warp knits, 235–36 Ratiné yarns, 162 Raw silk, 62 Raw wool, 51 Rayon, 18, 68, 80–84 Reclining twill, 190–191 Recycled wool, 51–52, 360 Recycling, 372–73 Reed, 173 Reel dyeing, 321 Reeling, 62 Reembroidered lace, 250 Regenerated fibers, 79–90 synthetic fibers versus, 92 Regular twill, 190–91 Regulations, textiles and, 359–65 Reinforced film, 241 Relaxation shrinkage, 297–98 Renewable finish, 271 Reseau, 249 Resiliency, 23–24, 26 Resist prints, 327–29 Retting, 42–43
Ramie, 45–46 Random webs, 243 Ranges, 322–23 Rapier loom, 174–75 Raschel laces, 250–51 Raschel-warp knits, 235–36 Ratiné yarns, 162 Raw wool, 51 Rayon, 18, 68, 80–84 Reclining twill, 190–191 Recycled wool, 51–52, 360 Recycling, 372–73 Reed, 173 Reel dyeing, 321 Reeling, 62 Reembroidered lace, 250 Regenerated fibers, 79–90 synthetic fibers versus, 92 Regular twill, 190–91 Regulations, textiles and, 359–65 Reinforced film, 241 Relaxation shrinkage, 297–98 Renewable finish, 271 Reseau, 249 Resiliency, 23–24, 26 Resist prints, 327–29 Retting, 42–43 Reverse spirals, 36
Ramie, 45–46 Random webs, 243 Ranges, 322–23 Rapier loom, 174–75 Raschel laces, 250–51 Raschel-warp knits, 235–36 Ratiné yarns, 162 Raw wool, 51 Rayon, 18, 68, 80–84 Reclining twill, 190–191 Recycled wool, 51–52, 360 Recycling, 372–73 Reed, 173 Reel dyeing, 321 Reeling, 62 Reembroidered lace, 250 Regenerated fibers, 79–90 synthetic fibers versus, 92 Regular twill, 190–91 Regulations, textiles and, 359–65 Reinforced film, 241 Relaxation shrinkage, 297–98 Renewable finish, 271 Reseau, 249 Resiliency, 23–24, 26 Resist prints, 327–29 Retting, 42–43 Reverse spirals, 36 Reverse stitch, 220
Ramie, 45–46 Random webs, 243 Ranges, 322–23 Rapier loom, 174–75 Raschel laces, 250–51 Raschel-warp knits, 235–36 Ratiné yarns, 162 Raw wool, 51 Rayon, 18, 68, 80–84 Reclining twill, 190–191 Recycled wool, 51–52, 360 Recycling, 372–73 Reed, 173 Reel dyeing, 321 Reeling, 62 Reembroidered lace, 250 Regenerated fibers, 79–90 synthetic fibers versus, 92 Regular twill, 190–91 Regulations, textiles and, 359–65 Reinforced film, 241 Relaxation shrinkage, 297–98 Renewable finish, 271 Reseau, 249 Resiliency, 23–24, 26 Resist prints, 327–29 Retting, 42–43 Reverse spirals, 36
Ramie, 45–46 Random webs, 243 Ranges, 322–23 Rapier loom, 174–75 Raschel laces, 250–51 Raschel-warp knits, 235–36 Ratiné yarns, 162 Raw wool, 51 Rayon, 18, 68, 80–84 Reclining twill, 190–191 Recycled wool, 51–52, 360 Recycling, 372–73 Reed, 173 Reel dyeing, 321 Reeling, 62 Reembroidered lace, 250 Regenerated fibers, 79–90 synthetic fibers versus, 92 Regular twill, 190–91 Regulations, textiles and, 359–65 Reinforced film, 241 Relaxation shrinkage, 297–98 Renewable finish, 271 Reseau, 249 Resiliency, 23–24, 26 Resist prints, 327–29 Retting, 42–43 Reverse spirals, 36 Reverse stitch, 220 Reworking, 277–78
Ramie, 45–46 Random webs, 243 Ranges, 322–23 Rapier loom, 174–75 Raschel laces, 250–51 Raschel-warp knits, 235–36 Ratiné yarns, 162 Raw wool, 51 Rayon, 18, 68, 80–84 Reclining twill, 190–191 Recycled wool, 51–52, 360 Recycling, 372–73 Reed, 173 Reel dyeing, 321 Reeling, 62 Reembroidered lace, 250 Regenerated fibers, 79–90 synthetic fibers versus, 92 Regular twill, 190–91 Regulations, textiles and, 359–65 Reinforced film, 241 Relaxation shrinkage, 297–98 Renewable finish, 271 Reseau, 249 Resiliency, 23–24, 26 Resist prints, 327–29 Retting, 42–43 Reverse spirals, 36 Reverse stitch, 220

Ribbed fabrics, 186-88

Rigidity (stiffness), 23 Ring spinning, 144–47, 149 Rippling, 42 RN number, 359–60, 367 Rope finishing, 273 Rotary drums, 322 Rotary screen technique, 251 Rotary-screen printing, 329 Rotofil yarns, 152 Rot-proof finishes, 308 Roving, 146 Rubber, 122–23 Run, 215, 273 Rush, 47
Safety: codes and, 366–67 environment and, 371 fabrics and, 9, 309–10 fire, 361–67 laws and regulations related to,
361–65
Safety-related finishes, 309–10 Sailcloth, 189 Salicylanilide, 308
Sand crepe, 203–4 Sanding, 293
Sandwich blending, 145
Saran, 131 Sateen, 194
Satin, 193–94
Satin weave, 193–94
Scales, 53
Schiffli embroidery, 289 Schreiner calendar, 284
Scoop, 63
Scoured wool, 51
Scouring, 273–74
Screen printing, 328–29
Scutching, 42–43
Seagrass, 47 Sea Island Cotton, 35
Secondary wall, 36
Seed fiber(s), 33–42
Seersucker, 210–11
Self-twist spinning, 149
Selvages, 178–79 Sequestering, 347
Serge, 191
Sericin, 61
Sericulture, 61–62
Serviceability, 9–10, 21
Sewing thread, 160 Sew-knit fabrics, 260–61
Shade sorting, 314–15
Shagbark, 210
Shampooing, 355
Shantung, 187
Shape-retention finishes, 300–303 Shaping, 54
Sharkskin, 191
Shattered silk, 64
Shearing, 286
Shed, 172–73
Sheer fabrics, 183–84 Shifting resistance, 245
Shirting resistance, 245 Shir gosen, 72

Rib-gait machine, 226

Shiners, 215 Shoddy wool, 52 Short-staple cotton, 35 Shrinkage control, 297-300 Shrinkage resistance, 27 Shuttle, 172-73 Silence cloth, 207 Silicone softeners, 307 Silk, 18, 61-65 boil-off process and, 294 China, 184 degumming of, 273 FTC regulations regarding, 359 Silk noils, 62 Silk waste, 62 Silk-in-the-gum, 62 Silver-pile knits, 224-25 Simple calendar, 277 Simple yarn, 159-60 Simplex machine, 233, 237-38 Singeing, 273-74 Single, 62 Single yarn, 160 Single-jersey fabric, 221 Sisal, 33, 47 Sizing, 286, 351 Skein dyeing, 318 Skew, 177, 214-15 Skewed fabrics, 177 Skyed yarn, 323 Slack mercerization, 275 Slack-tension pile method, 210 Slack-tension weaving, 210-11 Slashing, 272 Slippage, 186 Slip-resistant finishes, 304 Sliver, 145, 149 Slot die technique, 251 Slub effects, 161 Slub yarn, 161 Smooth-filament yarns, 140 Snagging, 11, 215 Snarl yarn, 162 Soaps, 346-47, 350 Soil, removal of, 246, 344 Soil-release finishes, 303-4 Soil-release polymer, 350 Solubility test, fiber identification and, 30 Solution dyeing, 74 Solution-dyed, 318 Solutions, fabrics from, 240-42 Solvent finishing, 271 Solvent spinning, 84-85 Solvents, 347, 352, 354 Sorting, 351 Sorting wool, 51 Spandex, 122-25, 348, 391 Special-purpose finishes, 276, 296-312 Special-use fibers, 121-35 Specific gravity, 23, 26 Spike yarn, 162 Spinneret(s), 61, 69, 71–73 Spinning into fiber, 82, 84-85, 94-95, 110, 113, 132 yarn, 146-150 Spinning solution, 69, 73-75 Spiral fancy yarn, 161

Split leather, 263 Split-fiber method, 140-41 Spray technique, 252 Spring-beard needle, 215, 217 Spun silk, 62 Spun yarn(s), 143-44, 155, 164 Spun-bonded webs, 243 Spun-dyed, 318 Spun-lace webs, 244 Spun-laid webs, 243 Stainless-steel fibers, 129-30 Terylene, 103 Tex, 19 Stain-release finishes, 303-4 Staple fibers, 19, 144-47 Starch, 351 Textile(s): Starching, 286 Static electricity, 93 Steep twill, 190-91 defined, 4 Stem fiber. See Bast fiber(s) Stencil printing, 329 Stereospecific polymerization, 110 Stiffness (rigidity), 23 Stitch(es), 215, 220 Stitch-bonded fabrics, 260-61 Stock dyeing, 318-19 Stockinette (or stockinet), 222 Storage, 354-55 Strength, 23 376 Stretch varns, 143 Stretching, 21 Striations, 82 Structural designs, 282 Stuffer box, 142 S-twist, 156 Subtractive finishes, 281, 285 Suede, 264, 292, 345 Suedelike fabrics, 254 Sueding, 293 Suint, 51 Suiting-weight fabrics, 185-86 Sulfar, 131, 133 Sunlight resistance, 11, 23-24, 27, 74-75 Sun-protective finishes, 306 Supima cotton, 35, 38 Supported film, 241 Supported-scrim structures, 262 Surah, 191 Surface coatings, 299-300, 304-5 Surface-active agents, 306 Surfactants, 348 Swivel-dot designs, 198, 200 Toile, 249 Synthetic fiber(s), 91-120 defined, 92 fiber modifications and, 95-96 Torts, 367 identification of, 95 manufacturing of, common processes used in, 94-96 overview of, 92-96 properties common to, 92-93, T Taffeta, 185, 187 Translucence, 23

moiré, 187-88, 284 Take-up, 173 Tanning, 263 Tapa cloth, 242 Tape yarns, 140-41

Trash, 37

Acetate

Triaxial loom, 175

Triacetate, 87, 389. See also

Tapestry(ies), 203, 211 Technical back, 217 Technical face, 217 Temporary finish, 271 Tenacity, 23, 25, 96 Tendering, 285, 334-36 Tensile strength, 23 Tension mercerization, 275 Tentering, 276-77 Terrycloth, 210, 223-25 Tex system, 159 care of, 343-57 careers in. See career(s) disposal of, 372-73 environmental issues regarding, 9, 27-28, 367-73 flammability and, 361-65 industrial, examples of, 5 information sources and, 12 laws and regulations regarding, 359-65, 369 performance testing and, 11, properties of, 17-31 recycling of, 372-73 selected trade names for, 391-92 storage of, 354-55 technical, examples of, 5 Texture, 23-24, 29, 286-93 Textured varns, 143 Textured-bulk yarns, 155 Textured-bulk-filament varns, 155 Texturing, 141-43 TFPIA (Textile Fiber Products Identification Act) of 1960 (Amended), 360-61 Thermal cloth, 236 Thermal retention, 23-24, 26 Thermoplastic fiber, 87, 299 Thermosol process, 323 Thick-and-thin fiber types, 72-73 Throwing, 62, 140 Thrown yarn, 62 Tie-dye, 327-28 Tissue ginghams, 184 Top dyeing, 318 Top grain, 263 Tow, 19, 44, 69, 149–50 Tow-to-top system, 149 Tow-to-yarn spinning, 149 Tpi (turns per inch), 156 Tpm (turns per meter), 156 Trade names, 366, 391-92 Trademark, 366 Transfer coating, 252 Transition cotton, 40

Tricot, 234-35 Tricot machine, 230, 233-36 Trilobal shape, 72 Tropical worsted suitings, 186 True crepe, 185 True moiré, 282 True tapestries, 211 Tubular finishing, 273 Tuck stitch, 220 Tuft density, 255 Tufted-pile fabrics, 254-59 Tufting, 254-55, 258-59, 288 Tulle, 235 Tumblers, 322 Turns per inch (tpi), 156 Turns per meter (tpm), 156 Tussah silk, 62 Tweed, 185-86 Tweed varn, 161 Twill flannel, 191 Twill weave, 189-93 Twist, 155-58 Twistless spinning, 148-49

UBC (Unified Building Code), 366 UFAC (Upholstered Furniture Action Council), 363-64 Ultrafine fibers, 71-72 Ultrasonic cleaning, 356 Ultraviolet (UV) absorbers, 350 Ultraviolet (UV) blockers, 306 Ultraviolet-absorbent finishes, 306 Unbalanced plain weave, 186–88 Union dyeing, 320 Upholstery cleaner, 355 Upland cotton, 35 UV (ultraviolet) absorbers, 350 UV (ultraviolet) blockers, 306

Vacuuming, 355 Van der Waals' forces, 21 Vapor-phase process, 301-3 V-bed machines, 226-27 Vegetable tanning, 263 Velour, 223-24 Velvet, 209-10 Velveteen, 208 Vertical-axis washing machines, 352 Vicuña, 61 Vinal, 131-32, 389 Vinyon, 131, 389 Virgin wool, 51-52, 360 Viscose rayon, 81-82, 89 Visual inspection, fiber identification and, 28-29 Voile, 184 Voile twist, 156-58 Volatile Organic Compounds (VOCs), 371

Wadding, 245 Waffle cloth, 198 Wale, 189 Warp beam, 172 Warp insertion, 236 Warp knitting, 215, 230-37 filling knitting versus, 233-34 Warp printing, 326-27 Warp sateens, 194 Warp yarns, 171, 176-77 Warp-faced twills, 191-93 Warp-knit fabrics, 234-37 Warp-pile fabrics, 208-10 Warranties, 366 Washdown, 315 Washing, 344-45, 351-52 Washing machines, 344, 352 Wash-off, 315 Wastewater, 369 Water, as solvent, 347 Water softeners, 351 Water-absorbent finishes, 306 Water-bath finishing, 271 Water-jet loom, 175 Waterproof fabrics, 305-6 Water-repellent fabrics, 305-6 Water-repellent finishes, 305-6 Wax emulsions, 305-6 Weave(s): basic, listed, 180 basket, 188-89 crepe, 203 dobby, 198-202 double, 206 extra-yarn, 198, 200-01 granite, 203 jacquard, 202-3 leno, 204-5 momie, 203-4 pile, 207-10 piqué, 201-2 pocket, 206 satin, 193-194 slack-tension, 210-11 tapestry, 211 Weaver's cloth, 185 Web(s), 243-44 Weft, 171 Weft insertion, 236 Weft (or filling) knitting, 215, warp knitting versus, 233-34 Weft-insertion jersey, 224–25

Weighting, 63, 286 Wet prints, 325 Wet processes, 297 Wet spinning, 82 Wet-laid fiberwebs, 243 Whiteners, 74 Whitening, 274 Wicker furniture, 47 Wicking, 23 Wide-wale piqué, 201 Wild silk, 62 Wilton rugs, 203

Winch dyeing, 321 Winding, 173 Wool(s), 51-61, 273, 278, 292, 299-300, 303, 308, 359Woolen yarns, 146
Woolen-worsted yarns, 147
Worsted yarn, 146–47
Woven fabric(s), 171–72
characteristics of, 176–79
flow chart of, 181
knit fabrics and, comparison of, 216–17
naming and diagramming, 179, 181–82
properties of, 179–80
shrinkage control and, 298
Woven figures, 198
WPL number, 359–60, 367

Wrap-spun yarn, 164 Wrinkle recovery, theory of, 300 Wrinkle-free products, 300– 301 Wrinkle-resistant fabrics, 300– 301

Y Yak, 61 Yarn(s), 139–66 bulk, bulky, textured, 141–43, 155 carded-combed, 147–48 composite, 163–65 cord, 160
core-spun, 164
covered, 164
crepe, 158
defined, 5, 140
filament, staple, classification,
154–66
filling, 171, 176–77
number and, 158–59
processing of, 139–53, 272
quality of, 165
regularity of, 159–65
selected trade names for,
392

simple, 159–60 single, 160 size and, 158–59 woolen-worsted, 146–47 Yarn dyeing, 318, 320 Yarn hairiness, 165 Yarn mercerization, 275 Yarn number, 158–59 Yarn preparation, 272 Yarn processing, 272 Yarn quality, 165

Z Z-twist, 156